Sensational Page Ideas for
scrapbooks

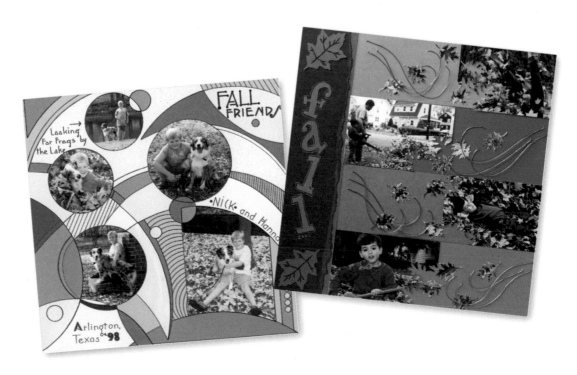

MEMORY MAKERS BOOKS

table of contents

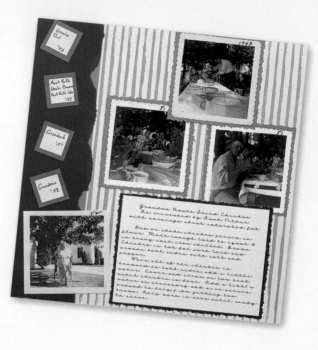

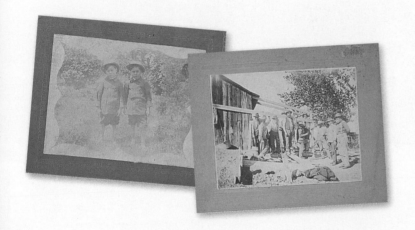

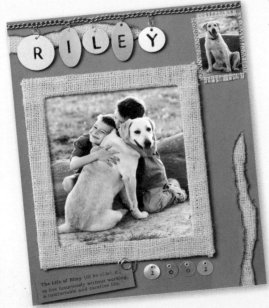

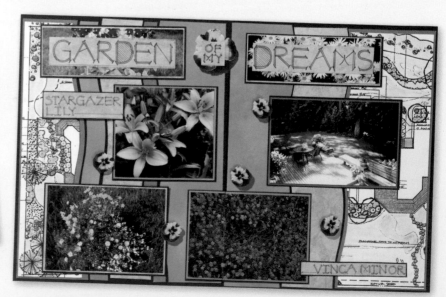

Sizzling Seasonal
Scrapbook Pages . . . *252*

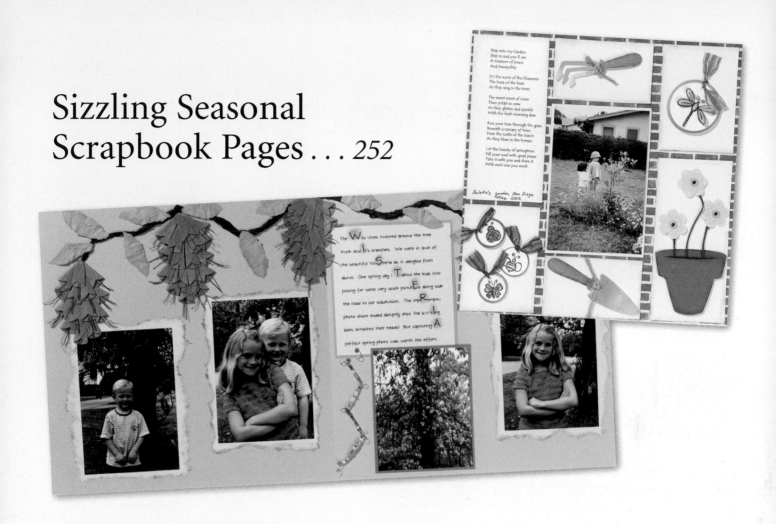

Quick & Easy
Scrapbook Pages . . . *348*

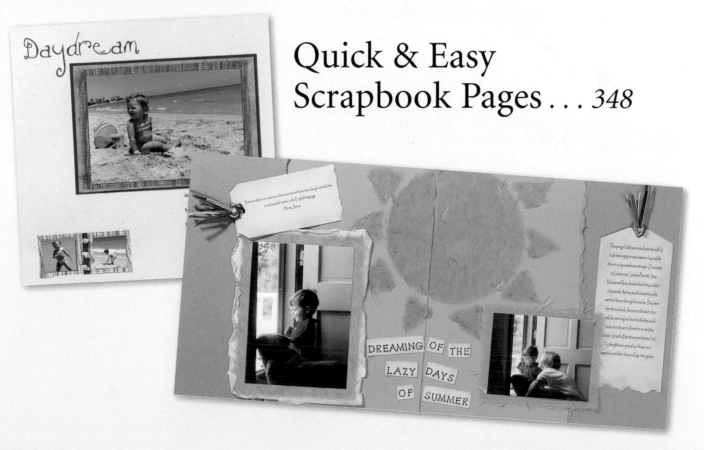

introduction

There's nothing more precious than family. And *Sensational Page Ideas for Scrapbooks* was created to supply you with the inspriation and information necessary to make each scrapbook page as cherished as the event it represents. You get over 500 page ideas for your scrapbooks; the best of the best, including creative, cutting-edge techniques as well as how to overcome photography challenges. We have also included a variety of time- and money-saving tips, as well as a sampling of ready-to-use page design templates, inspirational quotes and a tutorial on color-mood psychology. Whether you want to find a quick and easy way to make the most of a few hours of work, or spend time lavishing over your scrapbook, you'll find it all here.

Sensational Page Ideas for Scrapbooks provides you with the ideas and advice you need to ensure that those memories remain well-preserved and beautifully displayed for generations to come.

~New Ideas for~

CRAFTING HERITAGE ALBUMS

Bev Kirschner Braun

BETTER WAY BOOKS

CINCINNATI, OH

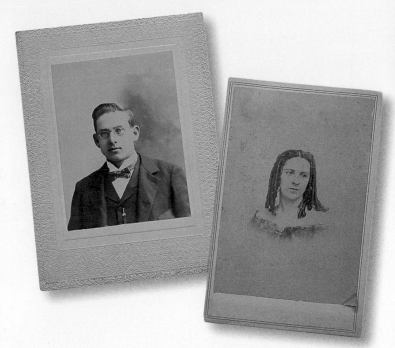

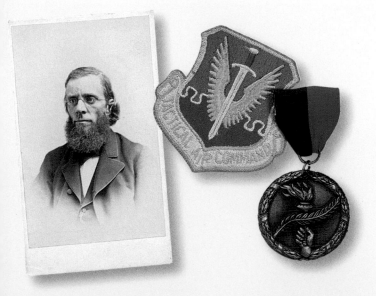

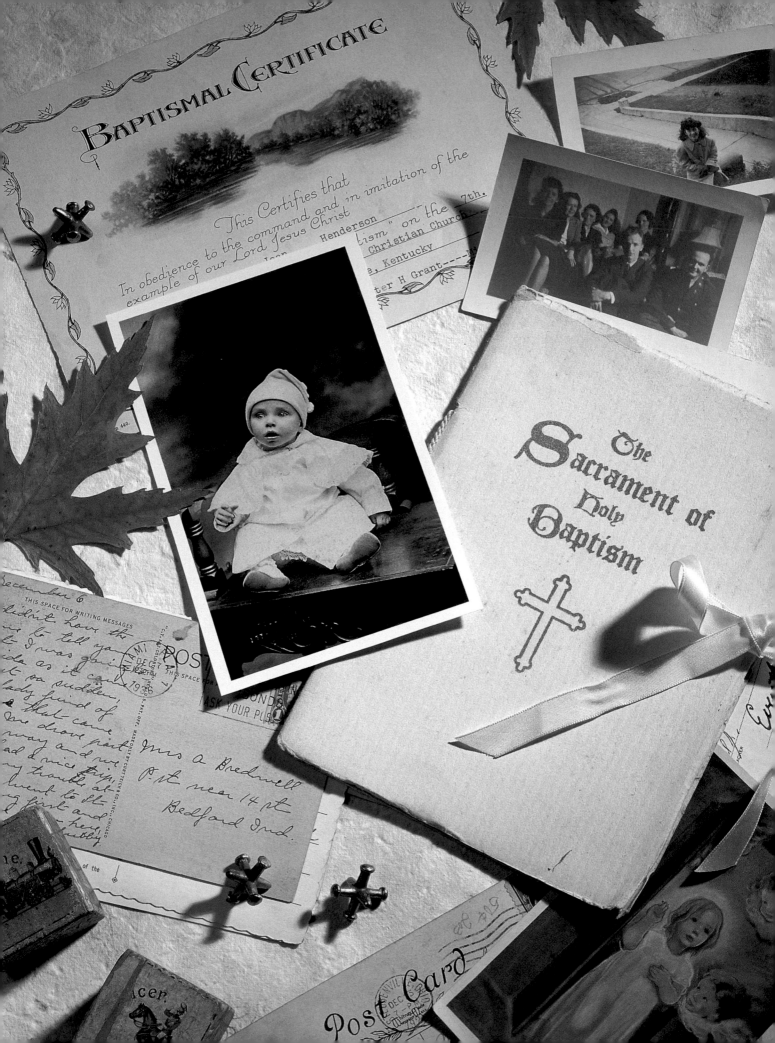

INTRODUCTION ℘

When I first began creating scrapbook pages, I experimented with traditional color cardstock and old photographs. After the first few pages, I knew this is what I wanted to spend my time doing—creating a heritage album for each of my family lines. Now, only a few years later, I have hundreds of completed layout pages documenting my heritage.

I take my heritage albums to family reunions and holiday get-togethers. Everyone thoroughly enjoys looking through the pages and reading the journaled details. Family members are fascinated by the large extended family we've identified over several generations. Sharing the family history makes our reunions more meaningful and more fun, and gives everyone a true sense of family. As we look around at the several generations of family members in attendance, we see the similarities in their looks and mannerisms with the photographs and stories we have of our ancestors.

My heritage collection has grown by leaps and bounds over the past few years. It's difficult to keep everything organized. I've found new cousins from different branches of the family that I didn't know about before. Some I've found through the Internet and some through family and friends. We share information and keep each other motivated to look for just one more piece to the puzzle.

Many people want to know how the Internet can help them with their genealogical research. With the changes in technology, you can get things done faster and, in most cases, cheaper than ever before. Genealogical research is a very enjoyable and rewarding hobby, and for some a lucrative and worthwhile profession. If you haven't started your research yet, I encourage you to get started as soon as you can. You'll meet many wonderful people who are also searching for their heritage. You become part of a large community with the same objective rather than being out there on your own pursuing something no one else has any interest in.

Heritage scrapbook makers are the same. When you get together in a group to work on your albums, the time just flies by. There is never enough time to finish all the things you want to do once you actually find the time to sit down and start working on your pages. You get inspiration from one another by looking at the creativity that goes into showing off your family treasures.

My inspiration for creating *New Ideas for Crafting Heritage Albums* is to give you encouragement, ideas and guidance on some of the current techniques and technological tools available to help you discover and share your ancestral heritage with family and friends. My hope is that the creative motivation you may need to produce a unique, well-documented family heritage album will come from information in this book. You may want to do more in-depth research and learn more about some of the technology tools and techniques on your own. The heritage album seeds have been planted. It's now up to you to nurture them and help them grow into a treasured family heirloom.

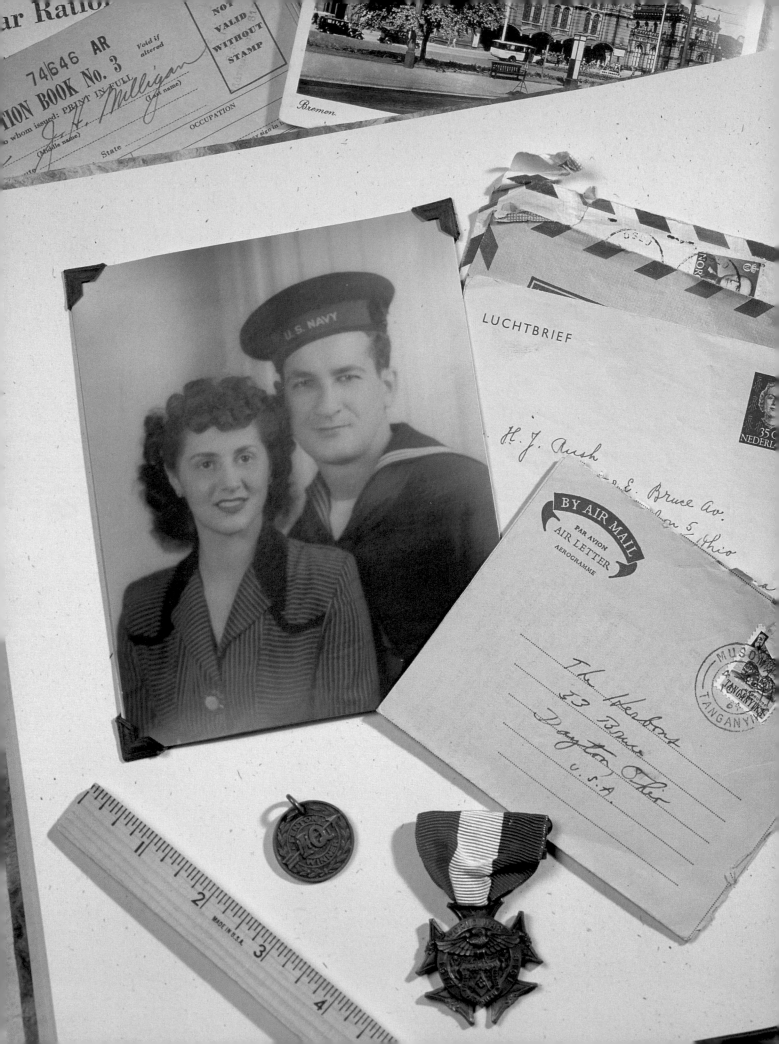

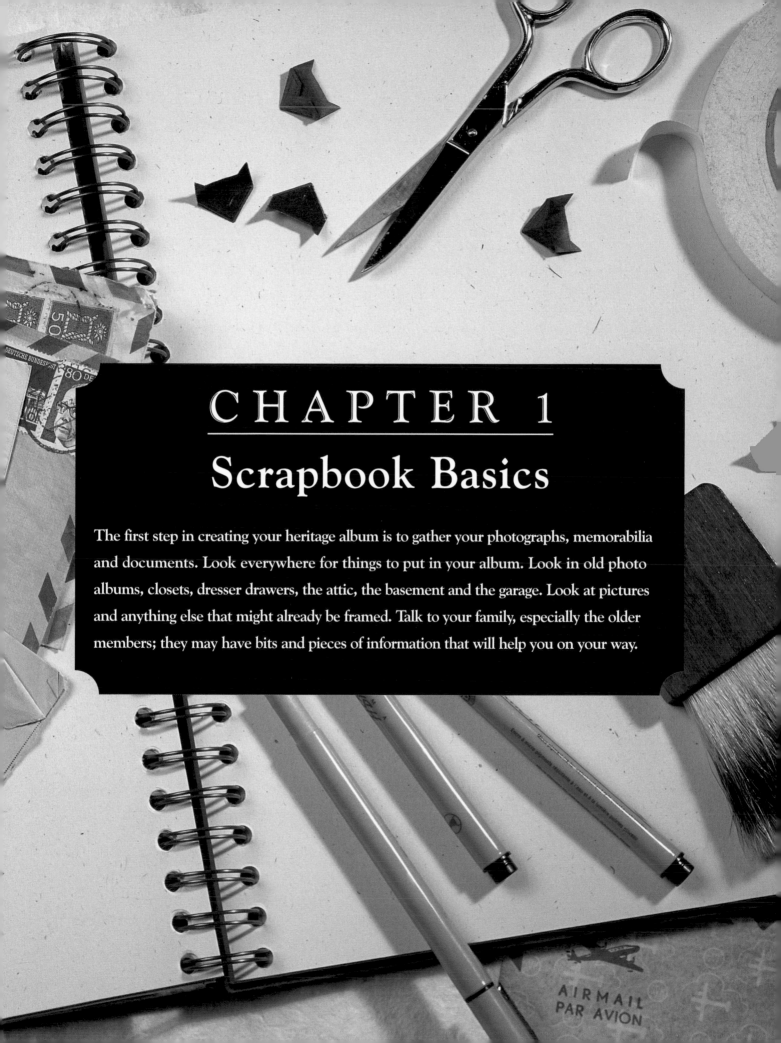

CHAPTER 1
Scrapbook Basics

The first step in creating your heritage album is to gather your photographs, memorabilia and documents. Look everywhere for things to put in your album. Look in old photo albums, closets, dresser drawers, the attic, the basement and the garage. Look at pictures and anything else that might already be framed. Talk to your family, especially the older members; they may have bits and pieces of information that will help you on your way.

GATHERING AND ORGANIZING

Gathering all of your family history collection in one location is a good start. As you begin to organize your collection, you'll probably be surprised with just how much information you have to work with. Ask family and friends of your family if they have items they can share with you. Once you get the first few pages of your heritage album completed and share them with family members, they may be much more willing to add to your collection.

ORGANIZATION

Organization is so important when creating a heritage album, as it is in any other project you work on. Most of us have our family treasures spread all over the house. The more time you spend organizing and planning up front, the more time you'll be able to spend actually working on your album.

Find a clean work area to use while you are organizing your collection. You will need a large table where you can spread things out, sort them into stacks, and begin putting items into the appropriate storage containers until you get ready to put them into your heritage album.

INFORMATION TO SAVE

There are so many items you can save and include in your heritage album. Keep these items organized so you can easily find them when you want to add them to your heritage album. Collect anything that will give meaning and purpose to your heritage album. These articles will help explain what was going on in a person's life at a specific time in history.

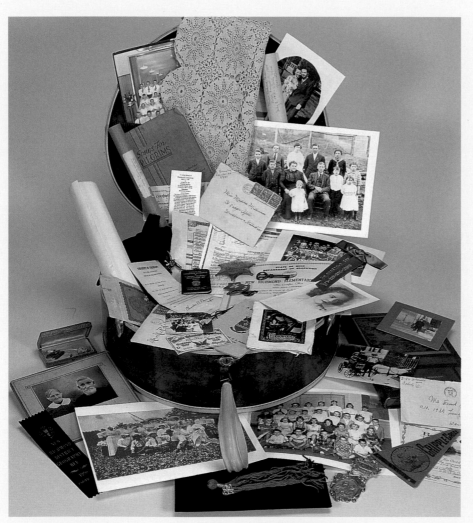

Everyone has an old suitcase or junk drawer with heritage items in it. Gather them and create a priceless family heirloom with a heritage album.

Information to Save

- newspaper articles about family members or close friends

- diplomas, certificates of achievement, special awards

- invitations, announcements (birth, engagement, wedding, graduation)

- family tree information

- death information (obituary, memorial and prayer cards)

- military records

- college or high school transcripts, old report cards

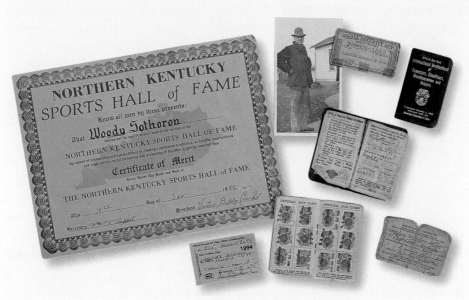

Awards and special achievements should be included as part of your heritage album. Future generations can only appreciate the significance of these awards if they know about them.

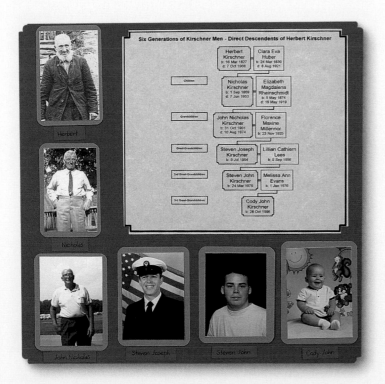

Documenting family relationships will help current and future family members easily recognize their family lines.

What to Include

You will have many items as you sort through your collection. To ensure a well-documented history of each person or family in your heritage album, here are suggestions on some items to include:

- information about primary person's spouse and family members (parents, siblings, children)
- pictures of primary family members with names and relationships to you
- graphical representation of immediate family members, such as an ancestral or pedigree chart
- copies of official documents (birth, death, baptismal, marriage, naturalization papers, land deeds) that will prove your heritage
- time lines of major known facts about the family (employment histories, residences, births, deaths, marriages)
- information about family members' occupations, where they attended school, the homes they lived in over the years
- personal histories about family provided by oral histories, family members, family traditions, anecdotes, historical documents, published family history stories
- personal family mementos to share with future generations (war medals and military dog tags, hospital birth bracelets, picture lockets, hobby samples, old cigarette cases)

ARCHIVAL INFORMATION

To ensure your heritage album won't start deteriorating in twenty to thirty years, you must use 100 percent archival products. Archival means materials are acid-free and chemically stable to ensure acids won't eat away your photographs and documents. You are creating a priceless heirloom for future generations and do not want to worry about its longevity after all your hard work.

As well as the items that will actually go into your heritage album, you need to preserve the rest of your collection for future generations. There is other information on proper preservation of photographs, documents and memorabilia in this book. Be sure to read the information to help you determine just how to store your items so they will not suffer damage and deterioration.

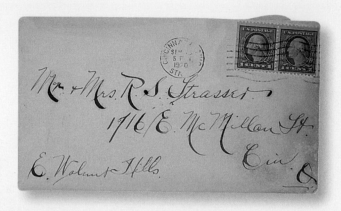

This is an example of acid migration caused from the newspaper that was adhered directly to these pages in the early 1930s.

LAYOUT BASICS

Look through scrapbook and craft magazines to see some of the ideas that others have used to design their pages. Also check out the resource section in the back of this book for scrapbook web sites. Most of these have heritage album sections you can get ideas from.

Do not clutter your pages, and always leave plenty of room for journaling. Remember, you are documenting your family history. You need to tell the story that goes along with the pictures and documents on your pages.

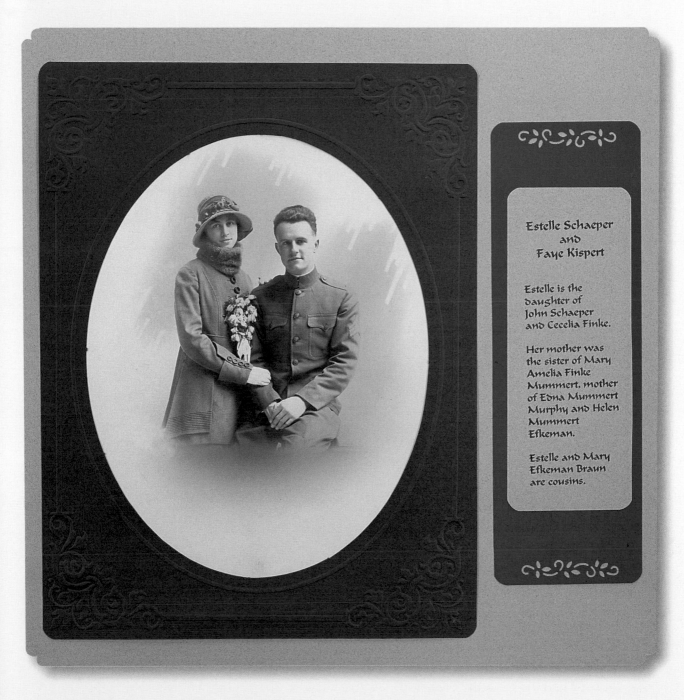

Estelle Schaeper
and
Faye Kispert

Estelle is the daughter of John Schaeper and Cecelia Finke.

Her mother was the sister of Mary Amelia Finke Mummert, mother of Edna Mummert Murphy and Helen Mummert Efkeman.

Estelle and Mary Efkeman Braun are cousins.

This simple design creates a classic heritage page layout that includes the details and relationship information.

MULTIPLE PAGE LAYOUTS

Sometimes your heritage layout will require more than one page. Make sure the information is presented side by side so the viewer knows what goes together. Using coordinating papers also helps tie the pages together.

However, don't make all of your layouts multiple pages just because you have a lot of photographs. Choose only the best ones, and give the rest away or put them in a photo album to include in one of your other scrapbooks.

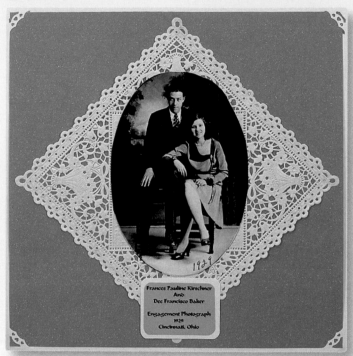

Either of these pages could stand alone in your album. By placing them side by side, they really make for an elegant two-page layout.

FOCAL POINT

Ask yourself, "When people look at this page, what do I want to be sure they see and read? What is the story behind the pictures? What memories do I have that I can share with others to make this page more interesting?" Each page should have a focal point.

Decide what photo or document you want to stand out on the page, and then arrange other items around it.

Choose one to two photographs to focus on your message; use a bolder, larger font (either hand-written or computer) to draw atten-tion; choose color and paper weight that work best to deliver your mes-sage; or place the photograph at an angle to focus attention on it.

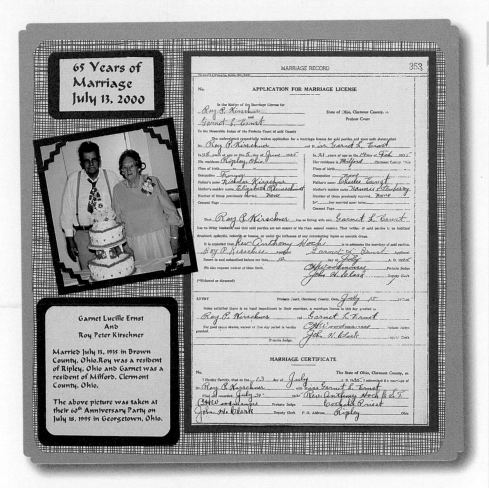

By setting the photograph at an angle, you draw the viewers to focus on that first then to the other items on the page.

Creating a Focal Point

- Use different types of fonts—headings larger than subheadings.

- Contrast bold vs. semibold vs. plain.

- Put bolder colors behind important information areas to make them stand out.

- Leave white areas around information.

- Pick best location—reader usually starts in the upper left corner.

- Place pictures at a slight angle.

- Put picture next to important journaling since it will attract the eye and reinforce the focus.

- Put a shape or border around the type, or give it an interesting shape.

- Use reverse type (white lettering on black background) to draw attention to it.

BALANCE

Good balance means that each side of the page has the same visual "weight." Decide if your page can be divided into equal halves, quarters or thirds. Each section of your page should be a mirror image of the other section or sections. Each item you add on your page adds weight—mats on your photos, journaling and embellishments all add different degrees of weight to the page. The secret is to keep these weights balanced so that no one section of the page looks too heavy.

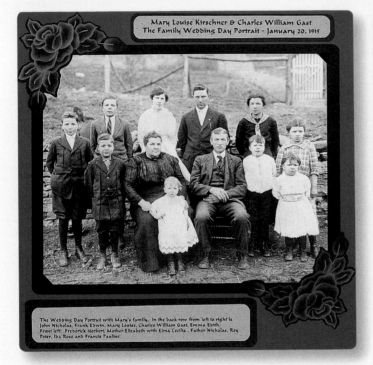

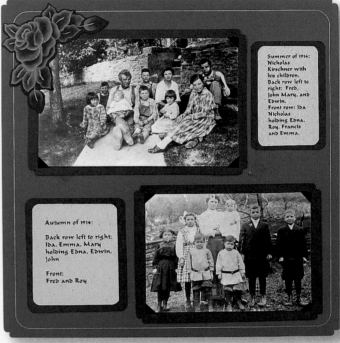

This two-page layout is pleasing to look at because both pages appear to be visually equal even though the photographs are different sizes on the two pages.

BORDERS

When you are designing a page layout, consider using a simple border, which can enhance the color on a page. Many borders are fast and easy to do. They take up only a little space on the page, leaving lots of room for photographs and journaling.

The type of border you use will determine how much space you have remaining on the page for the rest of the layout. Use plain or decorative paper, fancy scissors, paper punches, fancy rulers and pens, stickers, and clip art. There are many examples of fast and simple borders on the layouts in this book that you can copy or adapt for your own pages.

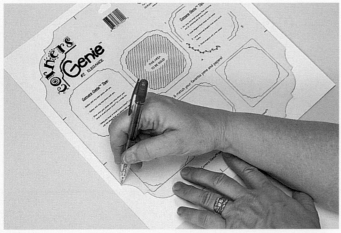

Using the Corners Genie template, trace the design on the wrong side of the paper with a light pencil.

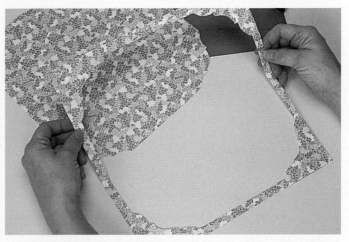

Use a craft knife to cut out the design. Use the middle piece on another coordinating layout.

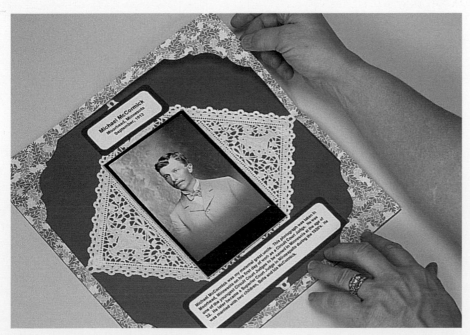

Place the outside border on your layout page. Adhere the border to the page with permanent acid-free adhesive when the design is complete.

PAGE TOPPERS

Simple page toppers can illustrate the focus of your layout. You can buy them ready-made, make your own using your computer and color printer, or use alphabet templates. Whichever method you choose, page toppers can add to the overall themes on your album pages.

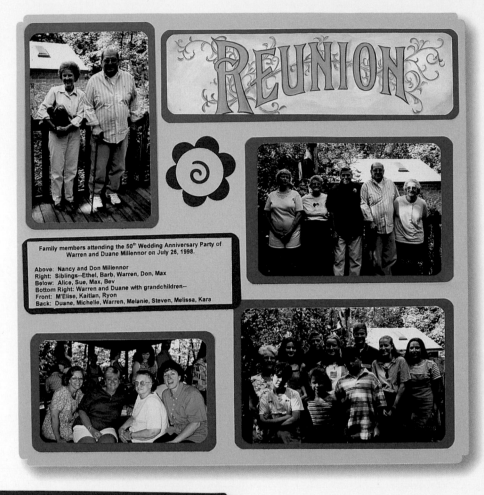

Page toppers create a focal point and enhance your heritage pages.

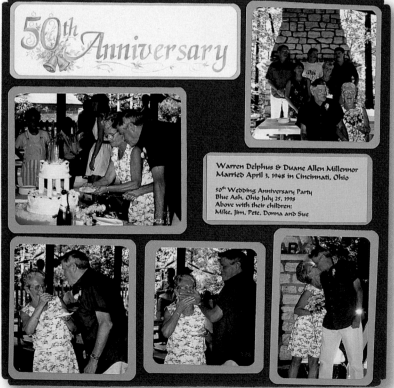

JOURNALING

Journaling is what makes a heritage album different from a photo album or scrapbook. Always try to include as much information as you can for your family now and in the future. This may be information people won't remember unless it is documented.

Our memories are too elusive to be depended upon. Stories are passed down from generation to generation, but they may lose some of the details and accuracy depending on who is listening and who is retelling the stories. If you want to keep the facts straight (or if you want to pass along a family legend that may have questionable details to it), write down the story and include it.

Your heritage album is a work in progress. If you don't know what the story behind the picture is right now, leave enough space on the page to add information later. As family and friends look through your book, they may be able to tell you a story or give you additional information that you will want to include with the pictures.

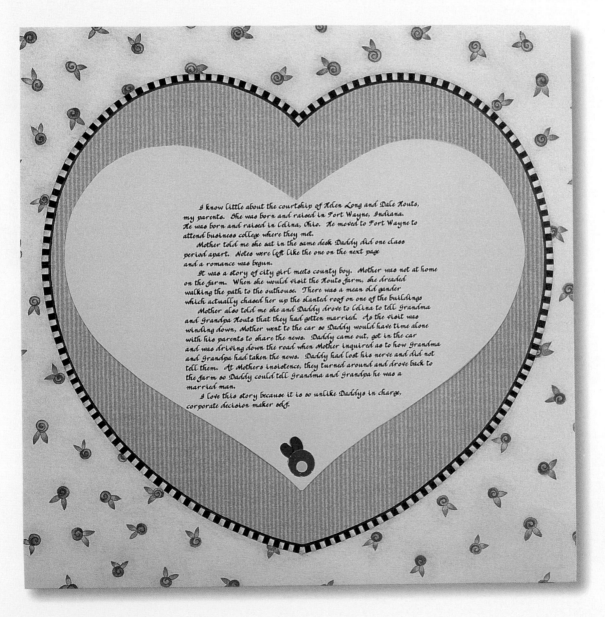

I know little about the courtship of Helen Long and Dale Houts, my parents. She was born and raised in Fort Wayne, Indiana. He was born and raised in Celina, Ohio. He moved to Fort Wayne to attend business college where they met.

Mother told me she sat in the same desk Daddy did one class period apart. Notes were left like the one on the next page and a romance was begun.

It was a story of city girl meets county boy. Mother was not at home on the farm. When she would visit the Houts farm, she dreaded walking the path to the outhouse. There was a mean old gander which actually chased her up the slanted roof on one of the buildings.

Mother also told me she and Daddy drove to Celina to tell Grandma and Grandpa Houts that they had gotten married. As the visit was winding down, Mother went to the car so Daddy would have time alone with his parents to share the news. Daddy came out, got in the car and was driving down the road when Mother inquired as to how Grandma and Grandpa had taken the news. Daddy had lost his nerve and did not tell them. At Mothers insistence, they turned around and drove back to the farm so Daddy could tell Grandma and Grandpa he was a married man.

I love this story because it is so unlike Daddys in charge, corporate decision maker self.

Documenting details about your ancestors is a valuable part of your heritage album—even if there are no pictures to go with the stories.

Journaling Everyday Events

It is important to capture everyday events in our lives to let others know what a routine day is like. These are the memories that we lose over time because we tend to forget the routine days and remember only those when something significant happened.

How many times have you wondered what your parents or grandparents did on a typical Saturday? Capture your typical memories, and document them for your children and grandchildren. Keep items from everyday lives that may be significant pieces of the past for future generations.

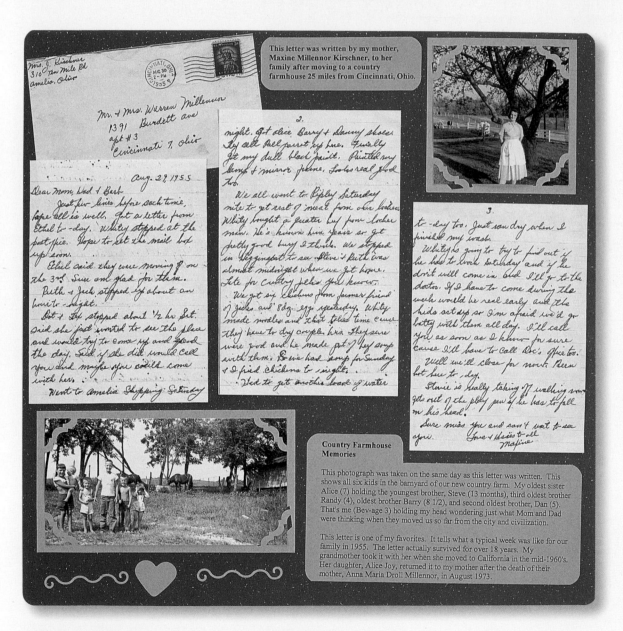

This letter explains what a typical week was like for my family in 1955.
This letter is a wonderful example of a real treasure for a family historian.

TELLING THE WHOLE STORY

When you are including photographs on your pages, always include names, ages, dates, places and events, if you know them. If you don't know what the story is behind the picture, ask relatives or friends who might know more about the photograph.

When you begin to think about what to write, try to answer questions that someone might have when they are looking at what is on the page. Questions such as:

- Who is in the photograph (names, ages)?
- Where was the picture taken?
- When was it taken, and who took it?
- What were they doing?
- Who are they related to?
- Why do they look so happy or sad?
- What other details can you tell about in the photograph, such as a car or house?

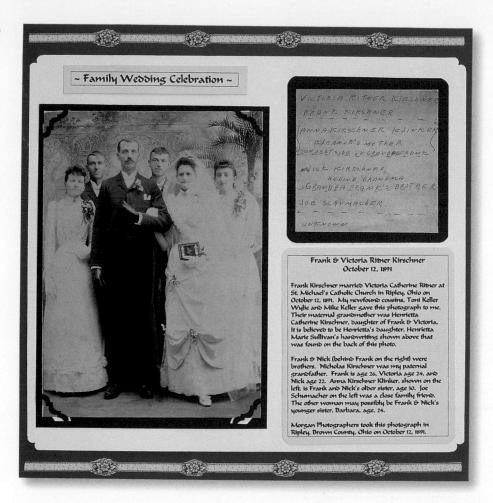

Documented information and accurate details add valuable information for viewers of your heritage album.

INCLUDING GENEALOGICAL INFORMATION

The journaling in your heritage album should always include basic genealogical facts. Include names, birth and death dates, relationships to you and other family members ("parent of" and/or "child of," etc.). Include as much information as you have on events in family members' lives, such as when and where they were born, when and where they were married, what they did for a living, what property they owned, and who their neighbors and friends were. This information will help family and friends piece together the family relationships.

Remember that you are documenting your family history and this information is critical to the overall validity of your heritage album. It doesn't matter if the information is handwritten or displayed in a chart form as long as it is documented and accurate.

If you are including genealogy documents, include the source information. You must do your research and validate the information. Others will know you have validated the data if your sources are listed along with your documentation.

If the document is a court record, include
- name of the court (indicate if it is a local, state, or federal court)
- name of the building where it was found
- what city or town it is in
- volume, page number, document record number, and date found

If it is a church record, list the name and address of the church.

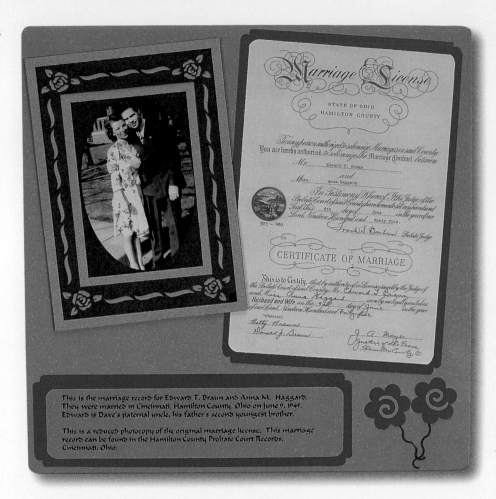

It is important to include information about the sources of your documents in case someone needs to obtain another copy to validate their research.

USING SCRAPS FOR JOURNALING

When using a computer for journaling, you can waste a lot of good paper trying to get your journaling to fit exactly where it should on the page. Try this easy technique to use your scrap pieces of cardstock paper to journal on your pages.

Type your journaling into your computer and set your margins to fit the space you want.

Print on plain white paper first to see if it fits the space on your layout page.

With temporary adhesive, secure a piece of scrap cardstock over the printed journaling on the white paper.

Feed back through the printer so it prints on the scrap paper this time.

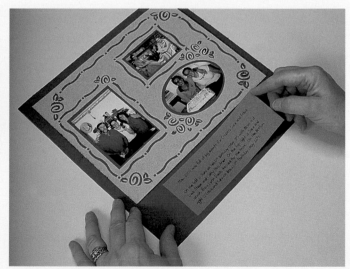

Remove the scrap paper. Put permanent adhesive on the back, and adhere to your final layout page.

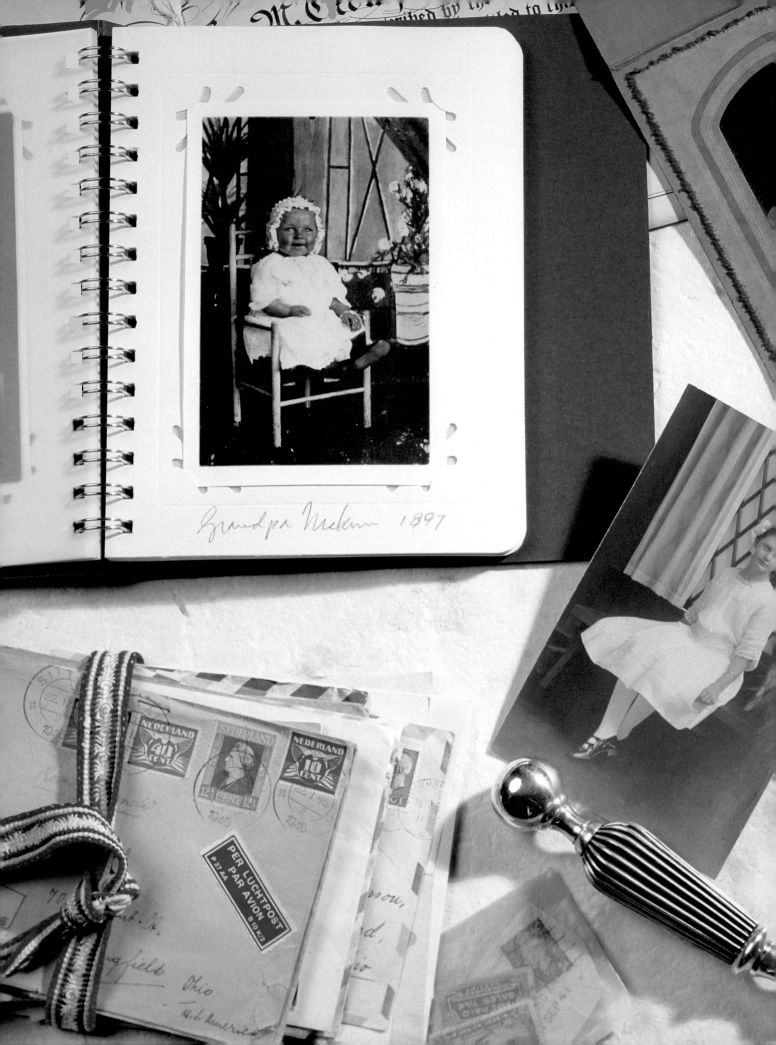

CHAPTER 2
Photographs and Documents

Preservation of photographs and documents is of utmost importance if they are to last for future generations. Proper care and storage using archival products will help ensure that they will. You must also take the time to document your photographs. If you have a collection of old photos with no information about them, ask family members to help you identify any information they can. Someone may give you valuable information.

PHOTOGRAPHS AND FAMILY HISTORY

Photographs are such an important part of our everyday lives that we sometimes take them for granted. We can purchase a throwaway camera for just a few dollars. We take our pictures, turn the camera in for processing, and end up with great pictures, and we don't have to worry about taking care of a camera or film. We record our memories on film with little effort—reunions, marriages, graduations, births, major events, cemetery visits, etc. With the aid of technology, these memories can be shared with family and friends around the world in a matter of minutes.

Photography is a great way to help preserve family history and heritage. When we include photographs with our family history findings, we make our heritage much more interesting and alive to those who read it. Photographs help us pass on a part of our histories that cannot be captured any other way. Photos illustrate and document people, places and things

that cannot be adequately conveyed through words alone. So take the time to preserve your heritage by properly caring for your photographs for future generations.

DOCUMENT YOUR PHOTOS

You need to treat photographs in the same manner you would any other item you collect as part of your family history. It is just as important to document your photographs as it is the other genealogy documents you acquire. There is specific information that should be included in your documentation.

• Give the full name of each person in the photograph (and if it is a group picture, each subject's position in the picture).

• Document exactly where the photograph was taken, including the city, county, state, county and full date or at least an approximate time period.

• Document any specific information such as the event (wedding, birth, family reunion), or if it is at someone's house, at a historical location, etc.

• If you know who took the picture, list that also. If you took the picture, note any information you can think of that will help preserve the memory of the photograph.

• If you send a lot of digital photographs, some software will allow you to include text. Give as much of the above information as possible so the photograph retains its history.

Use a photographic marker to document details on the back of each photograph. These special markers will not damage or bleed through to the front like a ballpoint pen or pencil will. These pens are inexpensive and are available at photography and craft stores or by mail order from scrapbook and photography suppliers.

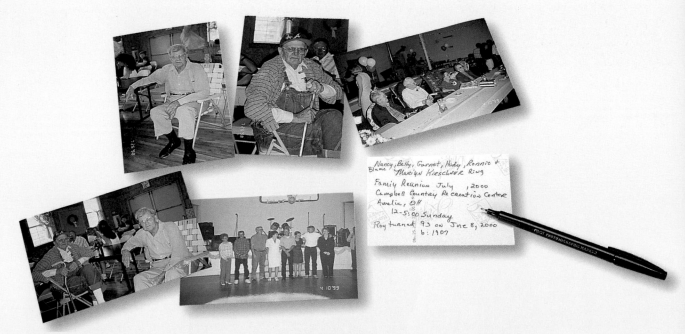

Documenting your photographs will ensure the details are available when you are ready to assemble your heritage album pages.

Taking Better Photos

Picture too dark
Wrong shutter speed or film speed may have been used; check camera settings. Electronic flash was not properly recharged; there may not have been enough light for a simple camera. You might have been too far away from your subject for the flash to give you enough light.

Picture too light
You might have been too close to the subject and the flash created too much light; check the manual for your camera and flash to see what the proper distances are. You may have used the wrong film speed, or the shutter speed was too slow.

No picture
Camera shutter did not open. You may have left the lens cap on when taking pictures. You may have accidentally taken an unexposed roll of film in to have it processed. In 35mm cameras, the film may have failed to advance.

Blurred picture
There might have been camera movement. Shutter speed on a 35mm might be too slow; use a higher shutter speed. Maybe you were too close to the subject, or focusing may not have been set at the proper distance. If just the person in the photo is blurred, he or she may have moved when you took the picture.

Light streaks or fogging
Check to make sure the camera back is closed tightly after loading the film. Load your film into the camera only in the shade or low light of an indoor room. Don't open the camera back until you are sure the film is rewound into the canister.

Correcting white eyes in pets requires a special pet correction pen. There is also a red-eye pen for people.

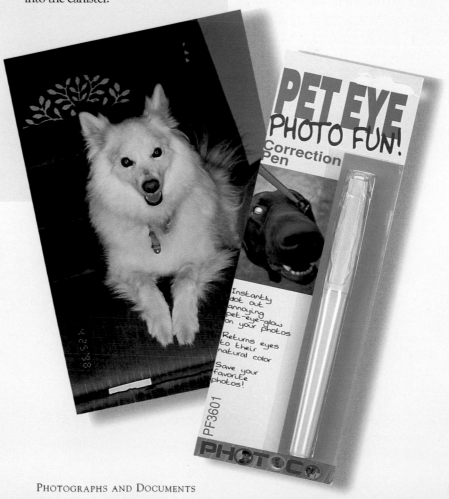

THE ENEMIES

There are three enemies in the life of your photographs: humidity, light and temperature. Exposing your photographs to any of these will speed up the deterioration process.

HUMIDITY

If at all possible, photographs should be stored in a room in your home that maintains a relative humidity (the amount of moisture in the air) between 30 and 40 percent. If the climate you live in goes up and down a lot, store photographs in an air-conditioned room. Use a humidifier (to add moisture) or a de-humidifier (to reduce moisture) to help safely store your photographs and documents.

LIGHT

It is a natural process for a photograph to begin fading as soon as it is printed and light hits it. How long the fading process takes depends on how your photographs are stored. Store photographs in acid-free storage boxes and photo sleeves until you are ready to put them in your album. Use only archival products in your heritage album to ensure photos won't be damaged. Do not display photos under bright indoor lights or in direct sunlight.

TEMPERATURE

Photographs are covered with a light-sensitive coating made up of silver and gelatin called an emulsion. If you've ever left a photograph in your car on a hot summer day, you've seen it warp and curl as the emulsion became soft and shifted. Photographs should not be exposed to temperatures above 75°F. If your photographs are accidentally exposed to a higher temperature for a short period of time, put them in a room that is between 60 and 70°F and let them cool to room temperature before handling them.

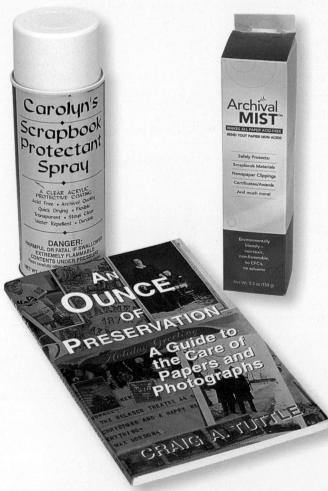

To learn more about caring for your photographs and documents, do your research and use only archival-safe products in your heritage album.

PHOTO PRESERVATION

COLOR PHOTOGRAPHS

All color photographs will eventually lose their color. It can take anywhere from 20 to 60 years depending on several factors. If you have color photographs that are 20 or 30 years old and are beginning to fade, have them reprinted if you have the negatives.

Some professional photography shops will use archival-quality paper if requested. This can be expensive and it takes more time, so you will want to be selective about which photographs you request to have printed this way. Most commercial labs use the same type of chemicals and techniques, but some use different types of paper to print your photographs. Do a little research to see what papers are best, and select a commercial lab that uses the better papers.

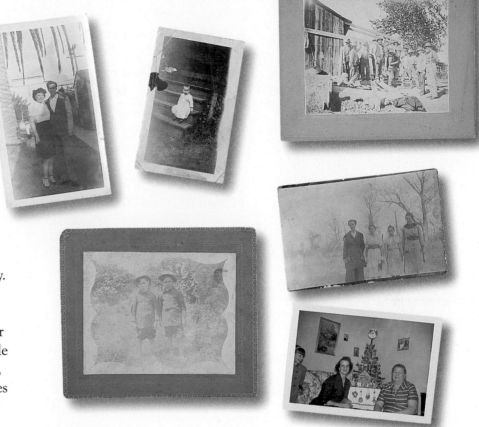

Improper care and storage have caused these photographs to deteriorate over time.

HANDLING

Your hands should be clean and oil free when handling photographs and documents. Oil and dirt can rub off your fingers and onto the documents and photos causing damage and deterioration. Using a pair of inexpensive photography cotton gloves will help keep oily fingerprints from causing long-term damage.

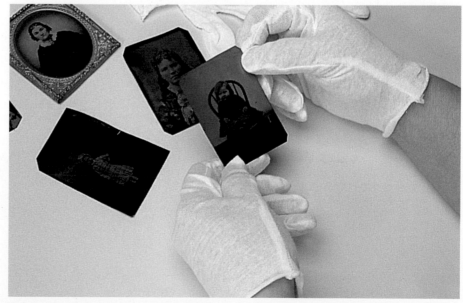

When handling photographs and documents, protect your heritage collection by wearing photographic cotton gloves.

PAPER PRESERVATION

Documents, newsprint, color photographs and books printed on poor-quality paper are all prone to deterioration due to the acid in the paper. The poorest quality of paper is usually newsprint and tends to be the first to deteriorate. It will turn brown and brittle. Another problem that causes paper deterioration is acid migration. This occurs when low-quality paper bleeds onto neighboring pieces of paper. Some old letters, invitations, or documents may have brown stains on them that were caused by the acid migration. The better the quality of the paper, the less acid migration you will see.

For some paper items, the best solution is to photocopy the information on acid-free buffered paper. This works especially well for newspaper clippings. Place the photocopy in your heritage album. Store the original document in an acid-free page protector to help preserve it because it may continue to deteriorate.

You may want to include the original document in your heritage album. For those items, use Preservation Technologies Archival Mist de-acidification spray. It allows you to remove most of the acid content from paper and newsprint. You spray both sides of the document or newspaper item with Archival Mist, and this product will help protect paper against deterioration and crumbling for hundreds of years. You can then place the treated newsprint or document in your heritage album on a mat of buffered paper to reduce further acid migration. Archival Mist cannot be used on photographs.

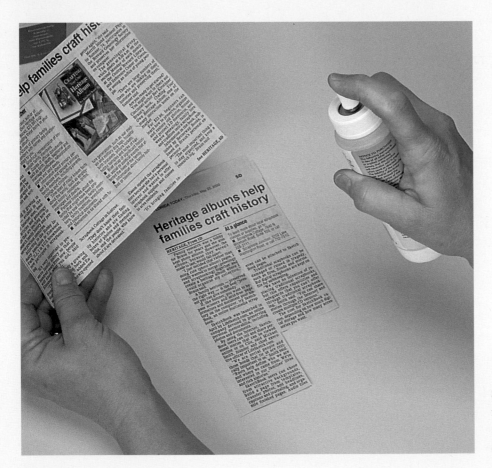

Safe and easy-to-use Archival Mist neutralizes acids in paper and coats it with an alkaline buffer to protect against future exposure.

MOUNTING PHOTOGRAPHS

ORIGINAL PHOTOGRAPHS

Decide first if you are going to include original photographs in your heritage album. I suggest you make duplicates of these and store the originals in a safe place. However, if you decide you do want the originals in your album, there are some great choices for mounting that will allow you to remove the photos at a later time if you need to make copies.

PHOTO CORNERS

Photo corners are easy to apply and hold your photographs securely, although you can remove them from the page, if necessary. Photo corners come in black, gold, white, transparent and a variety of pastel colors. Some are self-adhesive and others need to be moistened to activate the adhesive on them. I found it is easiest to put the photo corners on each corner of the photograph and then attach the corners to the mat or album page.

CORNER SLOT PUNCHES

Decorative corner slot punches are punches that add a beautiful decorative enhancement to the photo mat without taking away from the photos. You can easily slip the photographs off the mat and replace them again since no additional adhesive is used on the page.

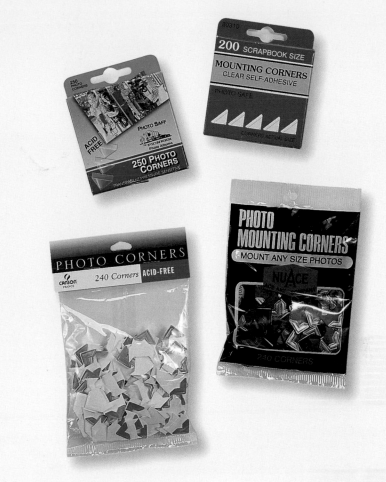

Acid-free photo corners provide an attractive way to mount your photos without permanently adhering them to the page.

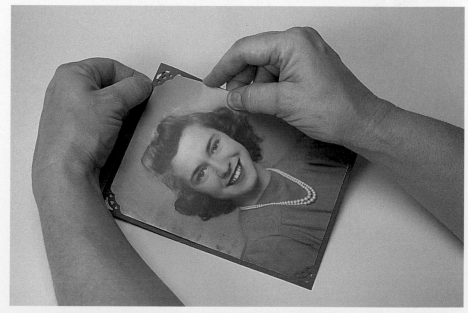

Decorative photo corner punches are another option for placing photos if you want to remove them later.

PHOTOCOPYING PHOTOGRAPHS

An inexpensive option I use most is to make photocopies of photographs on acid-free paper. This is an economical way to make good-quality copies of just the photos you want to use in your heritage album. You can make beautiful copies of black-and-white photos on a color copy machine by setting it on the black-and-white setting. Put the copy in your heritage album, and store the original photograph using one of the safe storage methods mentioned in a later section.

PH-Neutral Pen

Be sure the paper in the photocopier is acid-free. Carry your pH-neutral pen with you, and check the paper before you spend money making your copies. Remember:

Blue (line doesn't change colors)—no acid

Green (line changes from blue to green)—some acidity in the paper

Yellow (line changes from blue to yellow)—too much acid in the paper to be safe

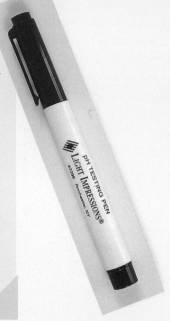

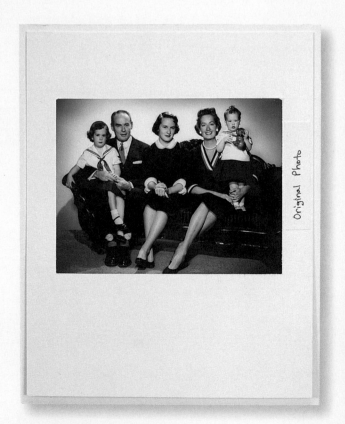

Original Photo

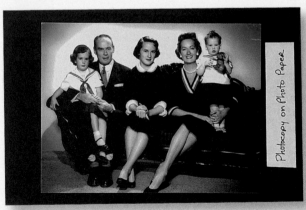

Photocopy on Photo Paper

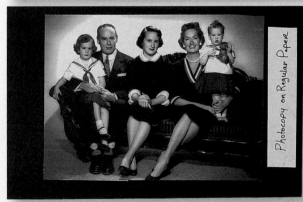

Photocopy on Regular Paper

This example shows the photocopy of the original photo made on regular paper and then on photographic paper. Either copy is good enough to be included in your album. The original can then be stored in a safe place.

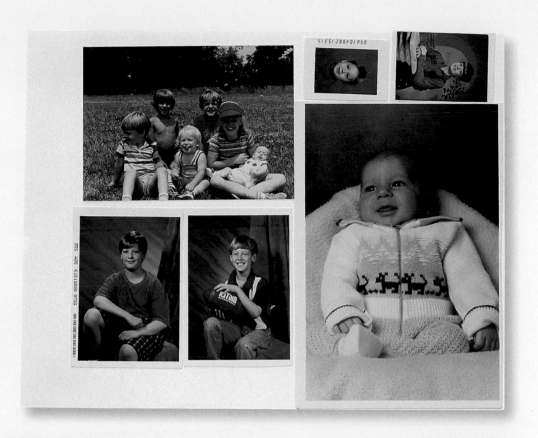

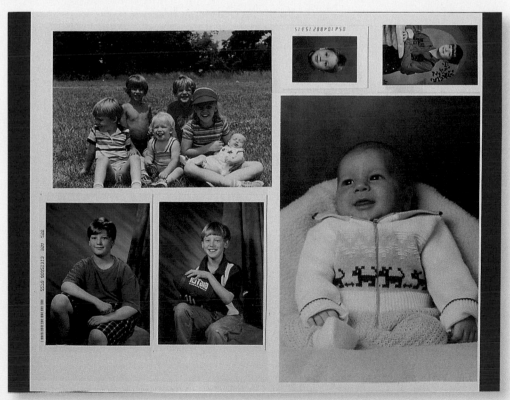

These color photocopies look as good as the original photos for use in your heritage album.

PHOTOCOPYING DOCUMENTS

Sometimes important documents (or photocopies) are not in very good condition. You can clean them up and make copies for your heritage album so they look more attractive without taking away from the authenticity.

If you have photocopies of documents, try copying them onto a cream-colored paper to make them look older and more authentic.

Another reason to photocopy documents for your heritage album is so that you can resize them to fit on the page with the rest of your layout.

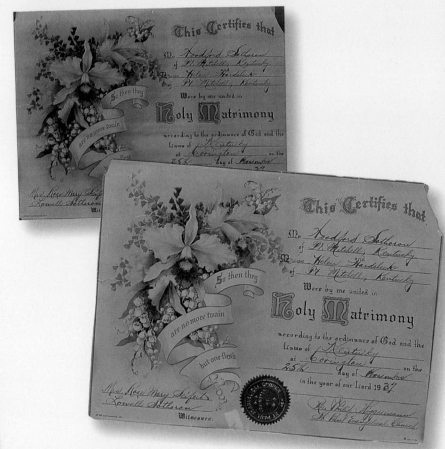

Photocopying documents allows for resizing to fit your layout page.

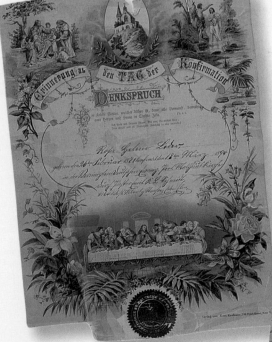

This original document (on the left) is too large and too fragile to include in your album. A reduced photocopy (on the right) offers a better option for your album page.

KODAK PICTURE MAKER

Another great option is to use the Kodak Picture Maker systems available in many of the national chain stores to make copies and enlargements of photos without negatives. You can make duplicate photographs in different sizes from wallet size to 8" x 10". Other features can enhance pictures as they are being made. Using this system, you can intensify the photo's color if it has faded, zoom in and crop out unwanted background items, eliminate red-eye, and add borders, words, and other options. If you are new to using this system, ask the store associate for help. The store usually has at least one person who has been trained and really knows how to use all the features on these systems. He or she can show you some cool stuff to make your photos look great.

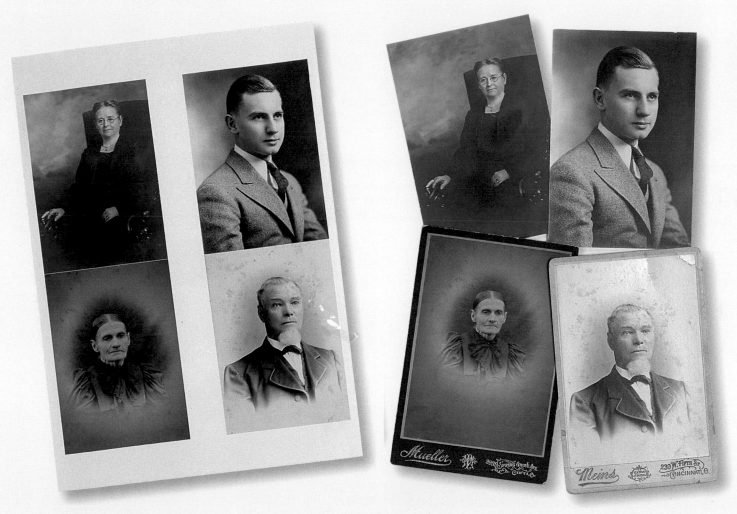

Four individual photographs were scanned and printed on one page using the Kodak Picture Maker systems.

STORAGE

What should you do with all the photographs and negatives you now have? Sort through them and decide which photos to keep for your heritage album and which photos to give away or file.

Store those you decide to keep in archival safe negative protector sleeves, and keep them in three-ring binders. This will protect your photographs from rubbing against each other and from being torn or crushed. Archival-safe sheet protectors will hold larger photographs and protect them from oily fingerprints, dirt, dust and spills.

Sort the photographs and keep them in acid-free shoebox-type photo boxes. If you are not sure they are acid-free, line the inside with acid-free buffered paper. Change the buffered paper periodically to ensure any acid migration from the box to the paper does not harm your photographs. If you make your own dividers for your photo boxes, also use acid-free buffered cardstock for these.

To prevent damage or further deterioration to the old letters, documents, photographs, and newspaper clippings in your collection, store them safely until they are placed in your heritage album.

Proper storage is important to preserving your family documents and photographs. It can significantly increase the life span of any piece of paper . Light, humidity, heat and improper handling of paper cause the most reduction in a paper's life span.

Warning!

Do not store your negatives and photographs together. I suggest keeping the negatives in a bank safety-deposit box or at someone else's house. If a disaster strikes, like a fire, flood, or tornado, and your photographs are destroyed, you will still have the negatives if they are stored in a separate place.

Here's another storage option: Record details of special events on the outside of the acid-free Easy Sort Envelope System and enclose your photos, documents, negatives and memorabilia on the inside.

Paper Storage Tips

• Place a document or newspaper clipping between two pieces of blank archival-safe paper, which can then be thrown away if acid migration occurs.

• Place paper items in archival-safe page protectors to prevent them from rubbing against each other and causing further deterioration. Store papers open and flat, not folded.

• Don't hang one-of-a-kind documents or photographs in direct sunlight. They will quickly fade and deteriorate.

• Don't use self-adhesive tapes or glue to repair torn paper or book-binding. In the long run, it will cause more damage to the paper. There are several types of acid-free adhesive tapes that can be used on the backs of photographs to repair them.

• Don't laminate family heir-looms and one-of-a kind documents unless you use a copy of the original. This will not prolong the life of the paper and cannot be undone.

• Don't use staples, paper clips, or other metal objects with paper, as they will eventually rust.

• Don't store documents or photographs in attics (usually hot and humid) or in basements (usually damp). They should be stored in a cool, dry place.

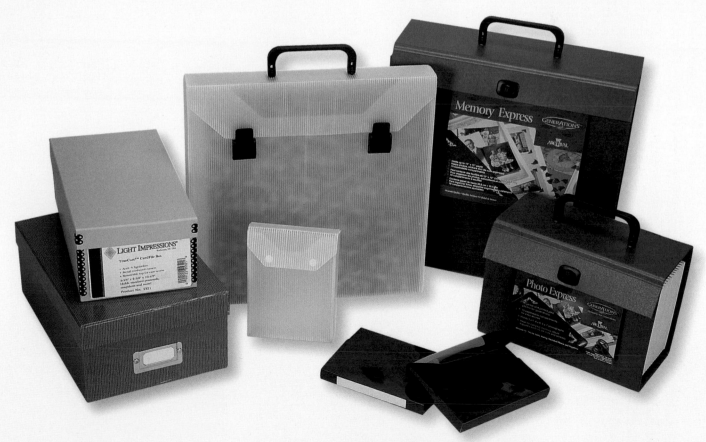

Acid-free paper and photographic storage units will protect your documents and photographs from damage and deterioration.

PHOTOGRAPH RESTORATION

If you have a one-of-a-kind photograph to be repaired or restored, don't attempt to make any physical repairs yourself. Take the photograph to a qualified professional photographic conservator. This process is expensive, sometimes ranging from $50 to as much as $250, but the results will be worth it if it is done correctly. Expensive restorations should be displayed in archival-safe frames out of direct sunlight. If you decide to have restoration work done, do your research so you understand exactly what is involved.

HOME SCANNING

A less expensive option is to use a home flatbed scanner, scanning software and a photo-quality printer attached to your computer. A flatbed scanner is a piece of equipment that connects to your personal computer.

Photo-imaging software is fairly simple to use, and most scanning software offers several features to allow easy restoration of old photographs. Do some research and check with friends and family to see what they use and what they like best. You can get great results with photographs and documents using these features if you learn how to use a scanner and the software correctly. Read the user's manual (or help section online that comes with the software), and practice doing photo restorations on your computer. You must have a good photo-quality printer to get the best results when printing your own photographs.

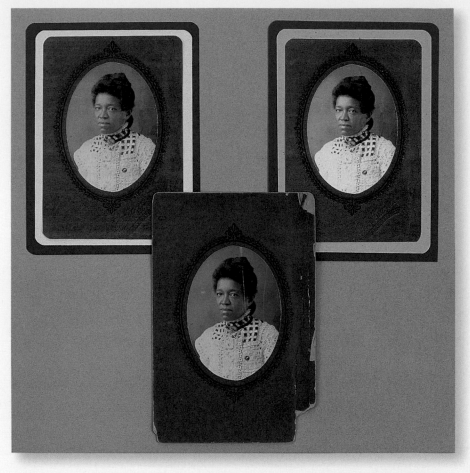

Photo-imaging software features allow easy restoration for your heritage album photos.

ARCHIVAL PRINTER INKS AND PAPER

Until recently, ink cartridges in most photo-quality printers have not been considered archival and permanent. Photographs printed were expected to last only about three to four years. If you store your photos digitally, you can always reprint them if they begin to fade. Now, there are several new photo-quality inkjet printers being offered with both archival and permanent ink available. More will be offered in the future, so check to see which models offer archival and permanent inks before investing in a new inkjet printer.

New inkjet printers offer standard archival and permanent ink cartridges. When used with heavyweight matte photographic paper, they produce a beautiful image that should last twenty years or more. If you are in the market for a new photo-quality printer, be sure to do your research and find out which printers and inks are best for the type of work you will want to do. If you are printing all of your own images for your heritage album, take precautions to ensure images won't fade five years from now. There are also archival sprays for your printed photographs to protect and help them last longer.

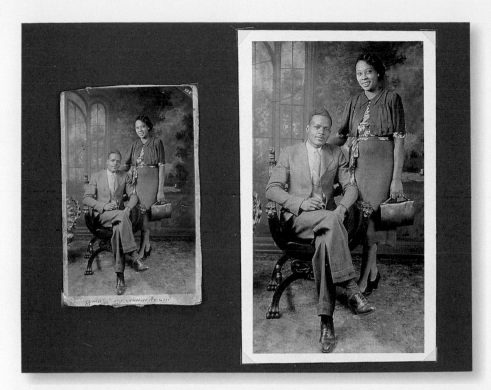

Great restoration results using home scanning software and your computer can bring old photos back to life.

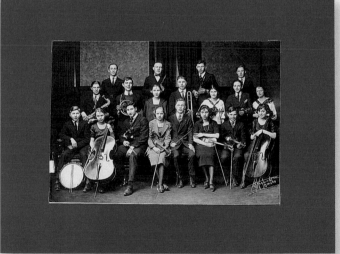

The restore option in the photo-imaging software allowed for quick repair of the tear in this original photograph.

RESIZING DIGITAL PHOTOGRAPHS

Sometimes your photographs and documents are just too small or too large to fit the layout you have designed. If you have the items in a digital format (such as scanned, on CD-ROM, or on a diskette), you can print them on a photo-quality printer in just about any size you need.

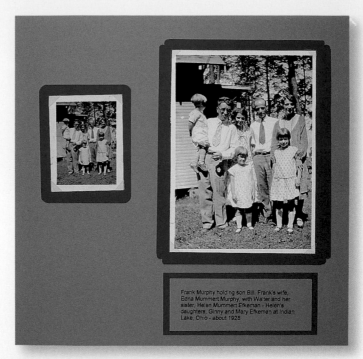

Digital formats of your photos allow you to enlarge them to fit the design you've chosen for your layout page.

These photographs were scanned and resized so they would both fit on the layout page.

CREATING NEGATIVES

If you have an old photograph but no negative, you can have a copy negative made.

A copy negative is made of an original photograph and then additional photographs can be made from the new negative. During the duplication process, corrections can be made to the new negative to improve the quality of the finished photograph. You can also request archival-quality finishing and paper from the photographic lab to add to the long-term stability of the copy negative and print. A copy negative allows you to produce reprints in quantities and provides you with protection for your precious family photographs so they won't deteriorate and be lost forever. Remember to store the new negative in an acid-free negative sleeve and keep it in a safe storage place.

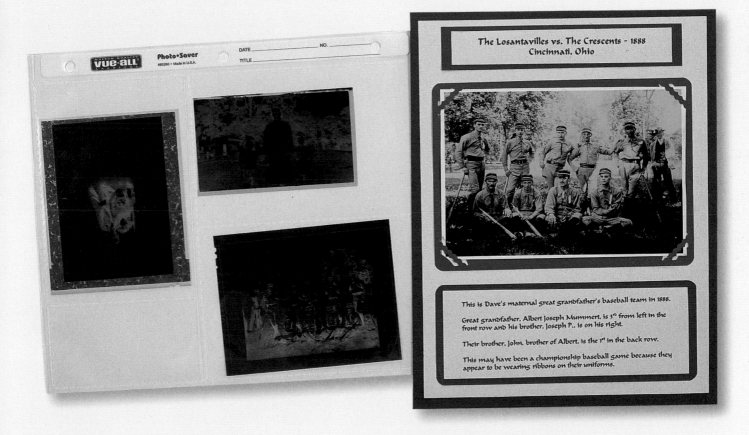

This photograph was originally taken in 1888, but the negative was lost over time. A copy negative was made from the photograph, and additional photos were then made from the new negative.

PHOTOGRAPHIC PAPER SCRAPS

Save those scrap pieces of photograph paper and put them to good use. Here are a few quick steps to help you use those scraps to print great photographs for your heritage album. Your photos need to be in digital format to begin this process.

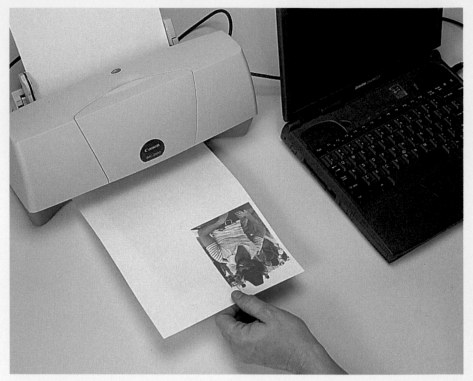

1. Print a copy of the photo onto plain paper to see what position it will be on the paper.

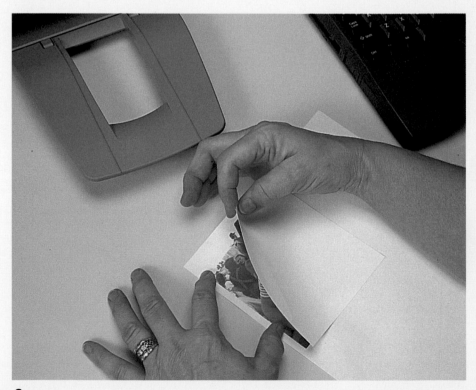

2. Select a piece of scrap photographic paper slightly larger than the finished photo size.

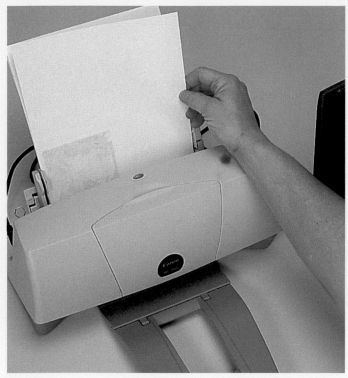

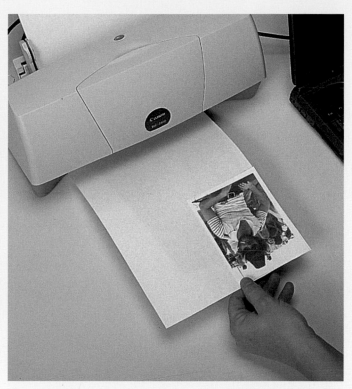

3. Place temporary adhesive on the back of the photo paper, and place it over the original print on the white paper.

4. Feed the white paper back through the printer and reprint the photograph in "best" mode so it prints on the photo paper this time.

5. Remove the printed photograph from the paper. You may need to crop or mat it before using it on your layout page.

Going Digital

Everyone wants to know, "What's the big deal about digital cameras and how do I know if I need one?" The answer may just depend upon what you want to use the camera for. Take a look at the advantages and disadvantages listed below; once you've decided that you do indeed want a digital camera, there are a few specific features you need to look for (besides just the price).

DIGITAL CAMERAS

Make sure the camera you are thinking about purchasing is compatible with your home computer. Not all of the software is compatible with both the Macintosh and PC-compatible computers.

Consider the resolution or pixels. You want to consider a minimum of two megapixels (resolution in the thousands). The higher the pixels, the better the resolution you will get and the larger the photograph you can print without it looking distorted. Remember, the higher the pixels, the faster your storage medium will fill up.

Another item to consider is the storage capacity. This determines how many photographs you can store before you need to download the images to your computer. Low-end digital cameras may not have any storage capacity, which means you have to download your images right away to a diskette or your computer. The minimum you should consider is 8MB but a 16MB will allow you to take approximately twenty to thirty digital photos before you have to download them. You should also consider a camera that allows you to review the photos you have taken and delete any you don't want, which frees space to take more photos.

Consider a camera that allows you to take closer shots of people far away or take close-up shots of documents, cemetery headstones, landmark signs, etc.

Whatever camera you decide to buy, make sure you read the owner's manual carefully. You will want to be able to use the camera to its fullest capabilities. Practice using the camera before you go to an important event or have the opportunity to take that once-in-a-lifetime shot. You don't want to miss it because you don't know how to operate the zoom or don't know how to tell how much storage space you have left on the memory module.

PROCESSED FILM STORAGE

If you currently have a 35mm camera, whether it is a single lens reflex (SLR), a disposable, or something in-between, you don't have to rush out to buy a new digital camera to take advantage of the newest technologies. Several film processing options will give you some of the same benefits as a digital camera. You still have to take or send the film to be processed, which means the photos won't be available instantly. But with the following options, you won't have to figure out how to sort and store all those extra photos or the negatives you don't want.

Digital Photography

Advantages

- Instant—there's no waiting in line for processing.
- You know immediately if the photo is in focus and you have the shot you want. If not, you may have the opportunity to retake it.
- The same memory card records images and transfers them to your PC or other digital storage device— no more film.
- Print only those images that you want.
- Delete images from your memory card and keep only the ones you want as you are taking photographs, which reduces the number of bad photos you end up with.
- You don't have to sort and store extra photos and negatives.
- You can share digital photos with family and friends instantly using e-mail or a web page.

Disadvantages

- Equipment (camera, computer, printer, photo paper, ink) is expensive.
- Only a few inkjet printers offer archival and permanent ink. Images will only last three to four years if you do not use the newest printers with archival and permanent inks.
- Images can be displayed only on computer screen, or you need a photo-quality printer that accepts the memory card directly so you can print onto photo paper.
- You have to keep images organized and file names meaningful to be able to find an image if you need to print it.
- Images can occupy an enormous amount of your computer's hard drive, so you need to know which file type to save them in or save them to disk.

DISKETTE

Having your film transferred to a diskette is the most economical way to digitize your photographs. It costs around five dollars for twenty-four to twenty-seven photos. Most stores also include the software that you need to retrieve the images on the diskette. The downside of this is that the photographs are saved at a low-resolution, which means that if you want to print a photo larger than a 3" x 5" it will look distorted. You have to be careful with the way you store the diskettes because they are prone to damage.

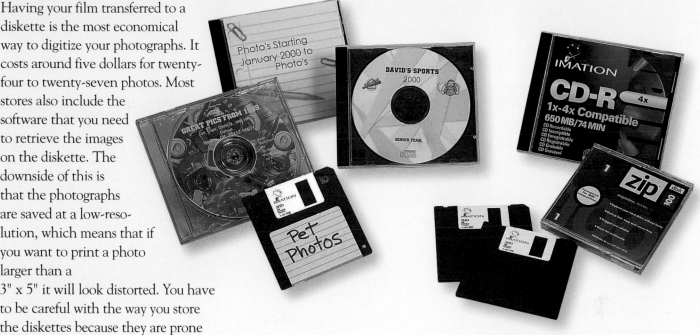

There are many options available if you want to store your photographs in digital format rather than having processed prints and negatives.

CD STORAGE

This option costs about twelve dollars at the time of processing—about one-hundred images on CD. This would allow you to take pictures of your heritage album pages and store them on a CD as a backup. There are different types of CD storage, so when shopping for this option, check to see which is better for your needs—CD-ROM (read-only) or a CD-RW (erasable/rewritable) drive.

Photographic images stored on CD are expected to last fifty to one-hundred years or more, if they are properly cared for according to published specification by the manufacturers. This means storing them in a safe environment (dust free and stable humidity) and handling them only by the edges.

Storing your images on your hard drive of your computer is not the best method of storage. If something happens to your hard drive, you've lost all of your images. You need to keep a current backup copy of them every time you add more images. If you keep them on CDs, you will be able to use them on any computer that has a compatible CD or DVD drive (CD-ROM, CD-RW or DVD-ROM drive).

When you copy your images to a CD it also automatically changes the file to a read-only file so that you don't accidentally write over that image. You can do this on your hard drive, but it is a manual process for each file that you save as an image.

ONLINE PROCESSING SERVICES

There are several online services where you can save your images online. (See the resources section for details.) Each offers some special features, so check them out before you decide which one to use. You may want to use different services for different processing depending on the purposes of the photos.

TRANSFERRING TO DIGITAL

You can also have any of your photographs, negatives, documents and artwork transferred to a digital format at any time. It is best to have it done at the time of the processing, but if you have any of these items that you would like transferred to diskette, online or to a CD, you can have that done. Check with your local photo-developing centers to see what services they provide.

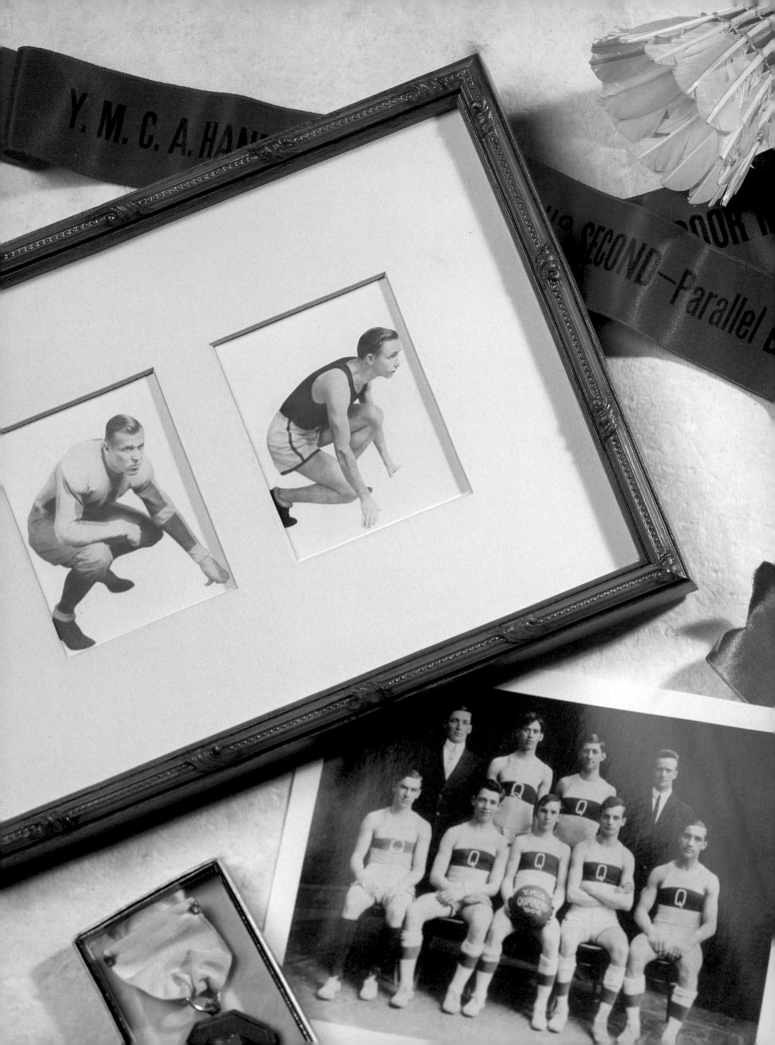

CHAPTER 3
Memorabilia

As you gather your heritage collection, you will find all kinds of memorabilia to include in your album. One way or another, you can display just about anything you have. Included in this section are just a few examples and options for displaying some of the bulkier three-dimensional items. New products for showcasing memorabilia are coming out on the market everyday to help preserve and protect your family treasures.

ALBUM DISPLAY

You can display just about anything in a heritage album. Some items might be too heavy or would be damaged if they were put in your heritage album and handled a lot. You could take a color picture or make a color photocopy of the item to include on the album page. Many options are now available for displaying items such as small booklets, jewelry, award ribbons and medals, ticket stubs, coins, etc., right in your heritage album.

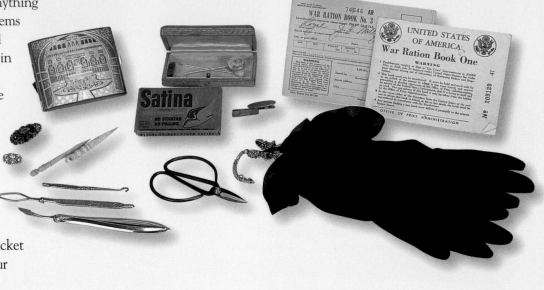

Here are just a few of life's little treasures that you can include in your heritage album.

OVERSIZED ITEMS

Sometimes your memorabilia may just be too large to include in your heritage album. Here are a couple of suggestions to include copies of an item so the memories and the story can be passed on to future generations. You can make color photocopies of the memorabilia and include it on the page along with your journaling.

You can also take a photograph of family members with their memorabilia and include it on the page with the journaling.

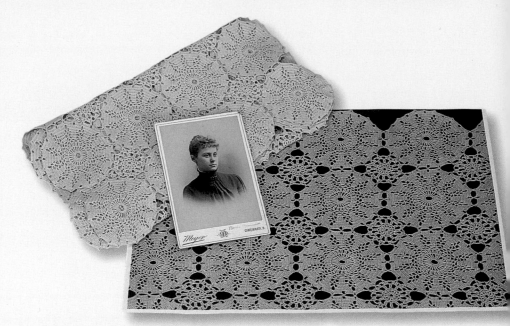

This family heirloom is almost one-hundred years old and is too large to include in a heritage album. Make a photocopy of the tablecloth and include it along with the photograph and documented information. The original can be stored in an acid-free box and tissue paper.

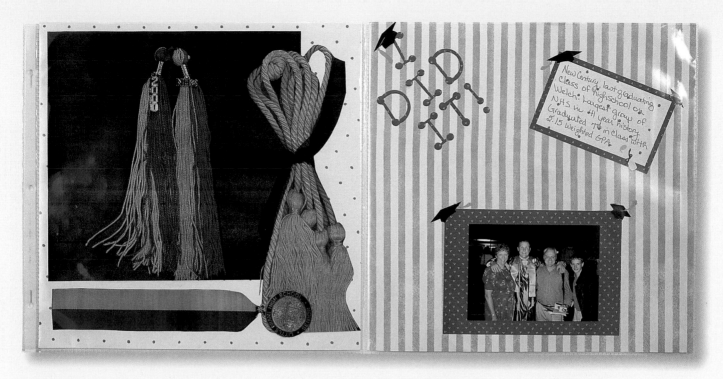

Photograph or photocopy memorabilia such as a graduation cap and gown, place it on the page with journaling, and don't forget to show the graduate.

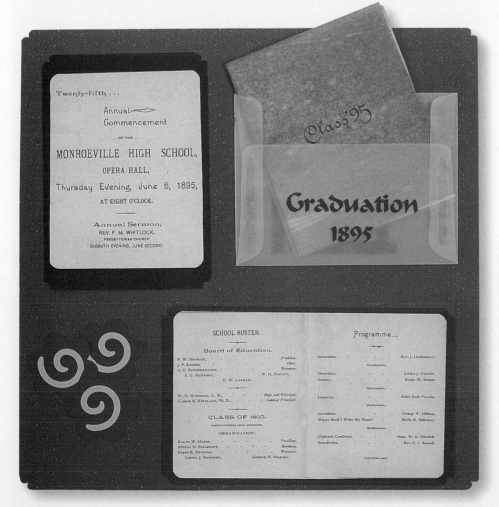

Acid-free vellum pages can hold items you may want to remove and read. Print directly on vellum envelopes with your inkjet or laser printer.

MEMORABILIA POCKETS

These are clear, archival-safe, self-adhesive pockets in a variety of sizes for encapsulating items that may contain acid, but that you want to display in your album. These would hold small, almost flat items, such as coins, a lock of hair, sand from your beach vacation, ticket stubs, note cards and cassette tapes. The pockets have full adhesive backs that are ready to stick on your paper. They have self-adhesive flaps that you can close and open as often as you like.

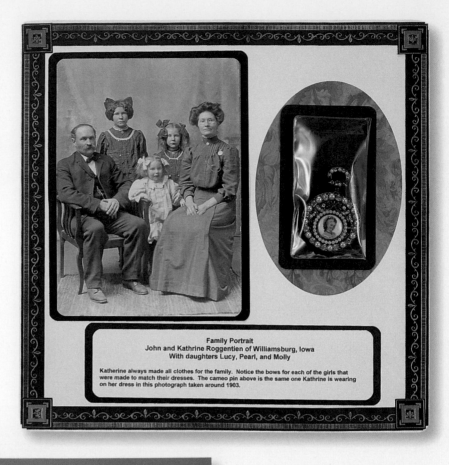

Family Portrait
John and Kathrine Roggentien of Williamsburg, Iowa
With daughters Lucy, Pearl, and Molly

Katherine always made all clothes for the family. Notice the bows for each of the girls that were made to match their dresses. The cameo pin above is the same one Kathrine is wearing on her dress in this photograph taken around 1903.

(Above) This cameo pin can be removed to wear and easily returned to this memorabilia pocket.

(Left) This cigarette case from the 1930s will become a family heirloom over the next few generations.

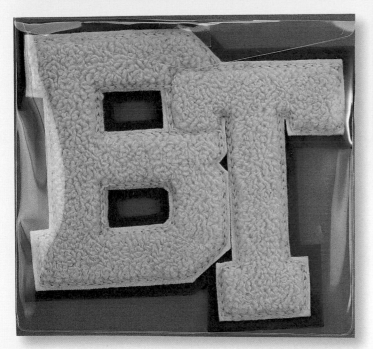

Memorabilia pockets come in a variety of sizes to hold small 3D items on your pages.

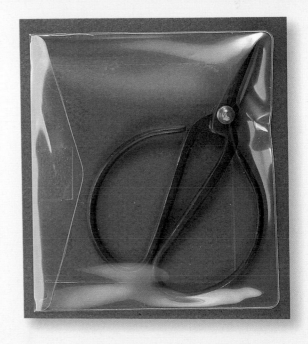

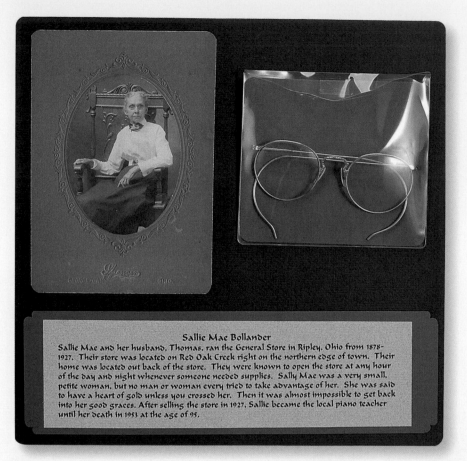

These eyeglasses worn in the photograph are a perfect example of memorabilia you should include with your photographs and journaling in your heritage album.

Sallie Mae Bollander

Sallie Mae and her husband, Thomas, ran the General Store in Ripley, Ohio from 1878–1927. Their store was located on Red Oak Creek right on the northern edge of town. Their home was located out back of the store. They were known to open the store at any hour of the day and night whenever someone needed supplies. Sally Mae was a very small, petite woman, but no man or woman every tried to take advantage of her. She was said to have a heart of gold unless you crossed her. Then it was almost impossible to get back into her good graces. After selling the store in 1927, Sallie became the local piano teacher until her death in 1953 at the age of 95.

TREASURE BOX

Some items are too large to fit into a heritage album, but you'll want to preserve them. Decorate an acid-free Highsmith Keepsake Case so you can share the items with future generations.

KEEPSAKE KEEPERS

Display three-dimensional items in acid-free archival safe plastic trays. They come in two sizes, 8½" x 11" and 11" x 14", that include four to six different-shaped compartments totally enclosed and fully visible. They are hole-punched to fit into most scrapbooks.

The acid-free Keepsake Keeper will hold your three-dimensional memorabilia and fit in your heritage album. Items can be removed and replaced back in the Keepsake Keeper for storage.

The larger Keepsake Keeper is also three-hole punched to fit in your album for attractive display and easy archival storage.

CLEAR POCKET HOLDERS

Some of the memorabilia you have will be best displayed by using a simple clear pocket holder on the page. Make these yourself by cutting down a clear page protector to the exact size you need. Use a clear permanent adhesive to close the edges and adhere it to the page. Leave the top or one side open to insert the booklet or card. Make a photocopy of the inside of the item to display on the page so viewers can see what is inside the booklet or card without taking it out of its holder.

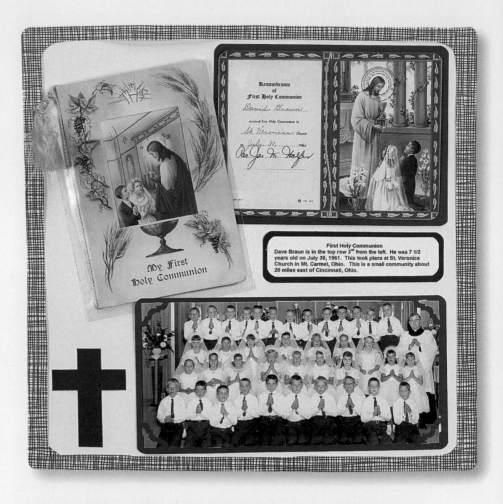

A clear pocket page allows you to remove and replace this booklet on this page.

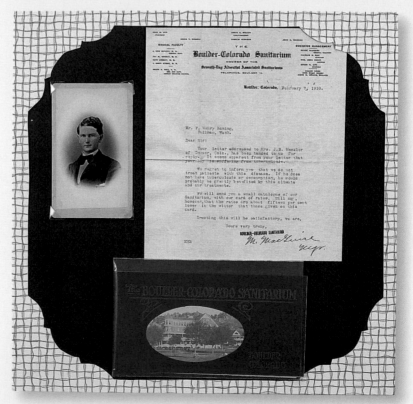

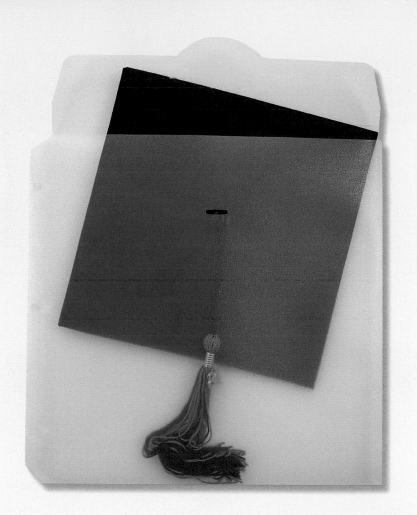

Generations Memorabilia Envelope will encapsulate items such as this mortarboard in a three-hole-punched, archival-safe envelope right in your heritage album.

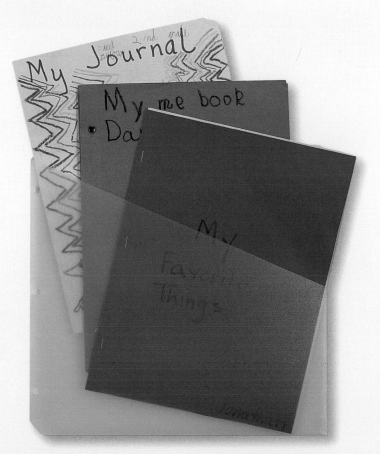

Generations Slash Pockets are ideal for including these kids' journals made in elementary school about their family history.

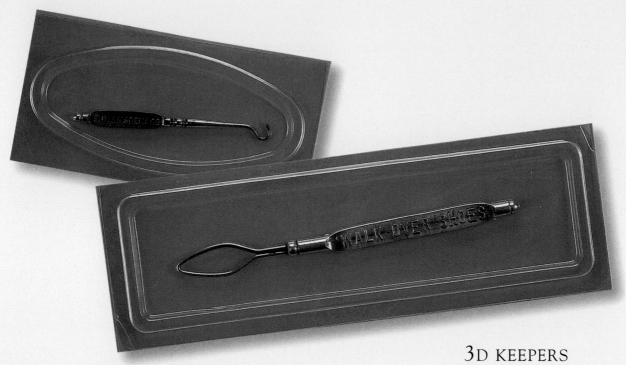

3D KEEPERS

These antique hooks for buttons and boots can easily be included on your album page using archival-safe 3D Keepers.

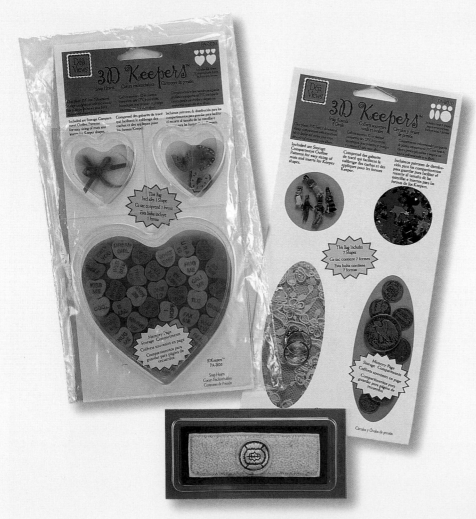

3D Keepers come in a variety of sizes and shapes to display your memorabilia in your heritage album.

VIDEO AND AUDIO CARE

Preserving family memories on video-cassette recording (VCR) tapes has been very popular over the past decade or so. However, VCR tape is even more fragile than color photographs and you need to take extra precautions to ensure proper storage and handling of these tapes.

VCR tapes, like photos, are subject to harmful reactions from light, humidity and heat. These elements can cause chemical reactions that speed up the tape's deterioration. Dirt is also a deadly enemy of the VCR tape. Usually, dirt gets into the VCR and scratches the tape, causing a loss of the image over time.

VCR tapes are expected to last about ten years. If proper care and storage precautions are taken, it is very possible that another high-quality copy of the VCR tape can be made to preserve your memories.

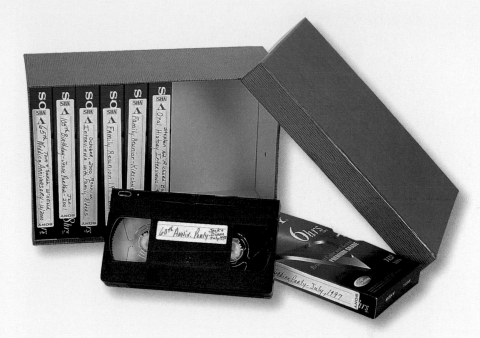

Videotapes should be stored in an archival box on end in an air-conditioned room to help preserve them longer.

Tips on Audio and Video Preservation

• Make a backup copy of your original tape that you will keep in a safe place. This copy can later be used to make another copy when the original begins to deteriorate. Also, break off the tab on a video-cassette to prevent accidentally re-recording over the original tape.

• Minimize tape handling at all times. Avoid dropping them.

• Buy only high-quality VCR tapes. There are reports that are published in magazines and on the Internet that will let you know what brand-name tapes are best for

what you want to record. Cheap VCR tapes are not going to last nor be good enough to preserve your family memories.

• Store VCR tapes and cassettes standing vertically upright, on their ends. Audio or videocassettes should not be stored lying flat.

• VCR and audio tapes should not be stored in the rewound or fast-forwarded position. You should play a tape completely through, then store it without rewinding. Wait to rewind it just before playing it again.

• Keep an eye on changing technology. You may need to have your audio and videocassette tapes copied to a newer medium in the future. Fifty years from now, there may not be any playback devices available to play your audio and videocassette tapes. So keep up with the technology changes and have your precious memories transferred to a new medium to ensure you will be able to still play and see those memories in the future.

PRESERVING CLOTHES

Now that the big day is over and you have all the pictures you need of the big event, it's time to think about how you want to preserve your christening or wedding dress.

The christening dress shown here is over 150 years old. It has been used for four generations of christenings and multiple times during each generation. To ensure that it will last another 150 years, it must be properly cleaned and stored.

You first need to have the dress professionally cleaned by a company who specializes in cleaning and storing of christening, Communion and wedding gowns. Don't take the dress to just any local dry cleaner. Make sure the cleaner knows how to properly clean and care for your gown. I wouldn't trust it to someone who has to send it out to have it cleaned. Have it cleaned on the premises, and make sure you are able to look it over carefully when you pick it up. Some cleaning services will seal it in a storage bag before you pick it up. If this happens, you'll have no way to know that it was cleaned and is in good condition before you store it.

After it is cleaned and you have inspected it, it is ready to be stored in archival-safe materials. You will need to get acid-free and lignin-free tissue paper and a storage box big enough to comfortably store the dress without cramming it in. The gown should be wrapped in tissue paper before it is folded in the box. The tissue paper will protect the fabric from rubbing against itself and from creating permanent folds in the dress. Do not store the dress hanging on a hanger. The weight of the fabric will weaken the fibers and stretch the dress out of shape.

Place it in an acid-free box after wrapping it in the tissue paper. Store it lying flat, and don't place anything heavy on top of it. The ideal storage area is in an air-conditioned room where the temperature stays fairly constant year round and is low in humidity—similar to the same storage conditions for your photographs and documents.

The general guideline costs for having a wedding gown professionally cleaned and for a preservation package to store it in will cost about $200 to $350. A christening dress cleaning and preservation package will run around $60 to $125. These costs will not include the cost for any restoration processes (if the dress has turned yellow or the fabric needs to be repaired).

You may need to change the tissue paper and box about every two to three years to ensure no damage occurs to the fabric of the dress as a result of acid buildup. You can use your pH-testing pen from your scrapbook supplies to test the tissue paper and box to be sure no acid has built up on either.

If you cannot store the dress in an air-conditioned part of your house, there are other types of packing boxes that museums use that will help protect it more from heat and humidity changes. These are harder to find, but you can check with professional conservator services and on the Internet to find sources for these boxes.

Whenever you handle the dress, it is a good idea to wear a pair of cotton gloves. This will keep any dirt or oil from your fingertips from getting on the fabric.

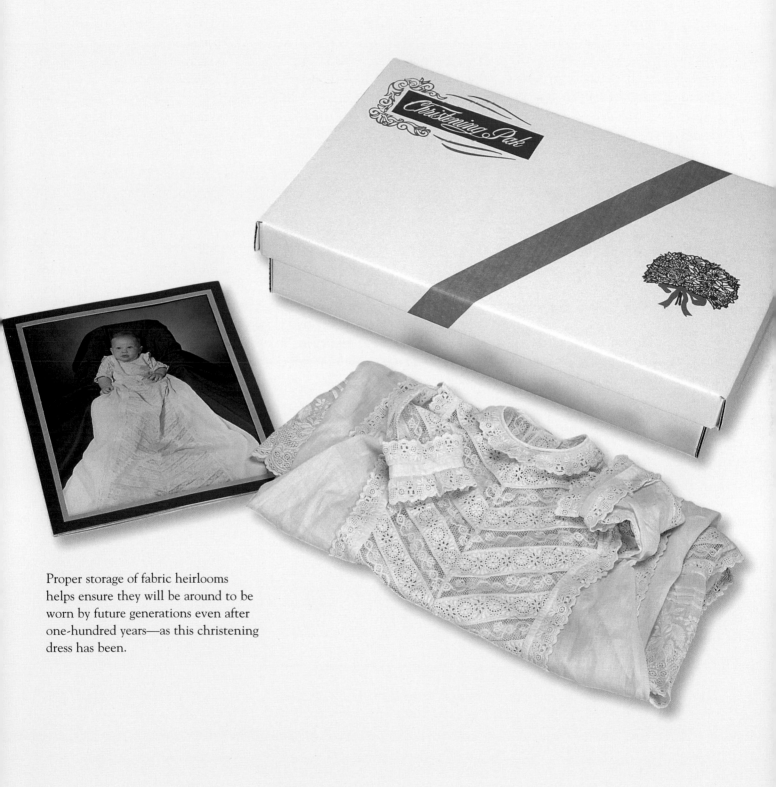

Proper storage of fabric heirlooms helps ensure they will be around to be worn by future generations even after one-hundred years—as this christening dress has been.

WALL DISPLAY

Another option for sharing your family heritage items is to display some of your old photographs. If you decide to do this, you need to take some precautions to ensure your photos are displayed safely and will not end up with damage or deterioration.

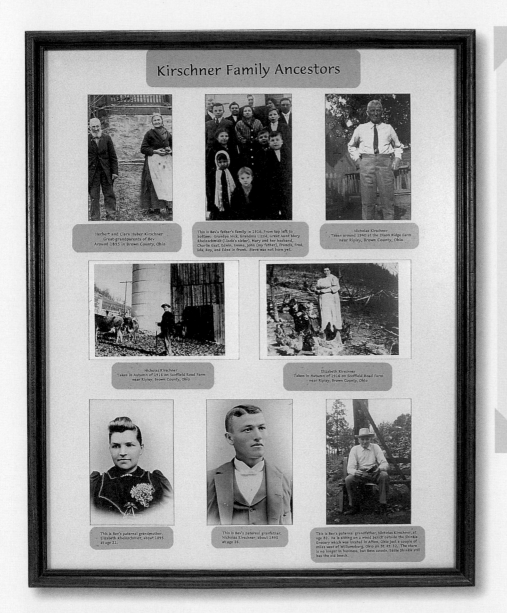

Kirschner Family Ancestors

These are photocopies of photographs displayed in an inexpensive photo collage frame. Details were added under each photograph to identify these ancestors for family and friends.

Rules for Display

• Don't hang photographs in direct sunlight or under bright indoor lights. It is best to be able to control the amount of light that hits the photos.

• Use ultraviolet filtering Plexiglas and archival, acid-free paper in the frame behind the photo if you are displaying originals.

• Keep a close eye on the originals to ensure they are not fading or deteriorating in any way.

• Make copies of your original photographs and display the duplicate copy instead of the original.

• Keep food and beverages away from your display area. Accidental spills can cause irreversible damage.

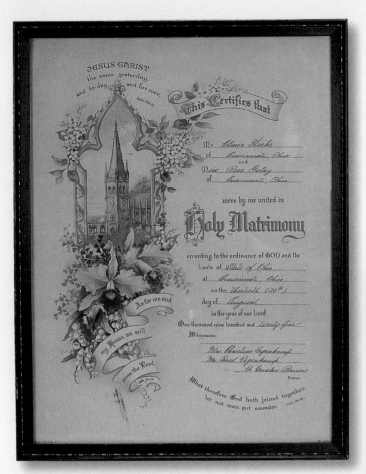

Share a family marriage record by displaying it in a frame. Keep it out of direct light, and use an archival-quality frame to protect it from fading and deterioration.

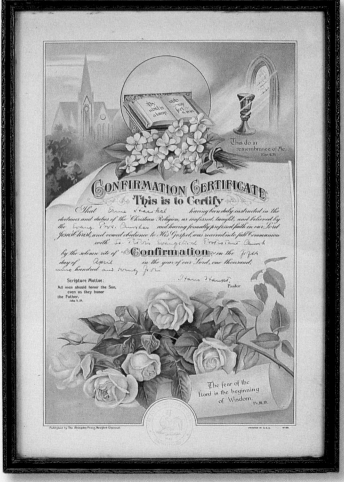

This confirmation document is too large to include the original in your heritage album. Make a photocopy for your album, and display the original in an archival frame.

Oatmeal Refrigerator Cookies

Ingredients
 1/2 cup soft shortening
 1/2 cup sugar
 1/2 cup brown sugar - packed tight
 1 egg
 1/2 teaspoon grated lemon rind
 1/2 tablespoon molasses
 1 1/2 teaspoon vanilla
 1/2 cup sifted flour (equals 3/4 c + 2 tbsp.
 7/8 cup sifted flour (equals 7/8 cups)
 1/2 teaspoon soda
 1/2 teaspoon salt
 1 1/2 cup rolled oats

Mix in bowl:
 Shortening, white and brown sugar
 1 egg, lemon rind, molasses, vanilla
 Stir vigorously 'till smoothly blended

Sift into bowl:
 sifted flour, soda and salt
 Stir gently 'till smooth.

Add rolled oats. Stir. Make
into ball of dough. Put on waxed paper.
Roll 5 inches x 2 1/2 in. diameter
Chill dough in refrigerator 'till ready to cook.
Remove. Use thin sharp knife, slice thin
(1/8 inch) Place on lightly greased sheet - 400°
from 8 to 10 minutes

350 -
to 50 minutes or
crust in center
heated to

PANS
to 2 deep 9" pie pans

mix
over
eat down
lean in center

ROSE
STRIKE
MA

EYER
treasures
YER MIXER

CHAPTER 4
Family Recipes

Recording your family's food-related traditions is just one more way to preserve your ancestral history. Family recipes and food play an intricate part in the job of recalling our lifelong memories. Adding photographs and stories with these recipes ensure the memories and traditions can be carried on by present family members and future generations.

CAPTURING MEMORIES

Over the years, the kitchen has always been the main gathering place in our home, in my parents' home, and in my grandparents' home. All kinds of memories come to mind when I remember the family meetings, the birthday parties, Sunday afternoon dinners, the wedding and bridal showers, and sports events. It seems all of those memories include food—a great appetizer, a full-course meal, or just some scrumptious dessert that was to die for. Not only does the food conjure up memories, but the sounds of laughter, conversation, music and dishes clanging add to those memories.

When we built our house, we skipped the formal dining room. We knew our family and friends would be more comfortable in a big old-fashioned open kitchen with the dining area at the far end. This way everyone could congregate in the kitchen before, during and after the meal. And they do. We also opted for two large porches—one on the front and one on the back of the house. With such a large family, the only sit-down dinners we have are buffet-style meals. You fill your plate then grab a chair wherever you can find one and strike up a conversation with whomever is nearest. That's about as formal as it gets at our house.

These are the memories you want to capture for your heritage album. Memories are not just about great recipes that have been enjoyed for as long as you can remember, but all the other remembrances as well. We want to know who tells the best (and worst) stories during the family gatherings and which family members always get the party going when they show up. Record some of the funniest memories your family has about past food disasters. Like the burnt brownies Uncle Mike thought he'd cover up with icing and Grandma Jane's annual holiday fruitcake sent out every year that has been buried in the bottom of the freezer for the past several years.

And don't forget to keep the camera handy if you are going to start capturing these traditions for future generations. Sometimes a picture can be worth a thousand words, but it is always better when we add our journaling to the page with all the details of what was going on in the photograph.

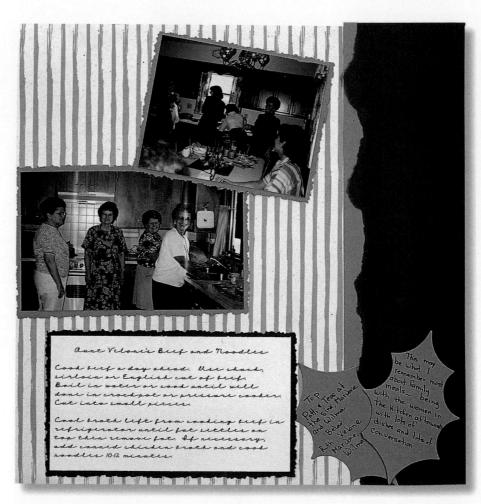

Remembrances of family gatherings and good food are special memories we want to capture for all times.

Family recipes passed down from generation to generation are heirlooms that are commonly overlooked when we are researching our family histories. Family recipes can reveal specific details about our ancestors that may be difficult to uncover in other ways. They can reveal what region of a country our ancestors came from and the religion they embraced. Gathering these recipes and taking the time to prepare them for family and friends to enjoy is one way to celebrate your ancestry.

Just about everyone has special memories associated with food. Even though the food created from our special recipes may be delicious, what really makes them special for us are the memories associated with that favorite dish or dessert. These are the memories that we especially want to capture. Some of those memories come from our childhood, and some from friends and family during our adult lives. They need to be written down and kept as part of our family histories so they are not forgotten.

People may ask, "Why was it so special to you?" Now you can let them and future generations know just what was so special about the food and the memories you keep telling them about. By writing down these memories along with the recipe, and adding a photograph or two, you can keep these memories alive. Family members are much more likely to try these recipes and create their own special memories if they can appreciate the meaning behind why one is so special to you.

You can almost smell the delicious cakes baking in the oven as you look over the recipes in this old family cookbook.

Old family cookbooks can add important details related to your ancestor's culinary pleasures plus add important historical facts to your family history.

AWARD WINNING RECIPES

We may have special recipes from past generations that are considered just so special we wouldn't think of not including them in our albums. Some of them are award winning, and some of them should be. In our modern world of fast food and microwaves, there is little time to cook and bake. Some of the best recipes may never be shared with our families and friends unless we take the time to document the recipes and our memories. After all, some of the memories we have can only be appreciated with pictures and the words that go with them.

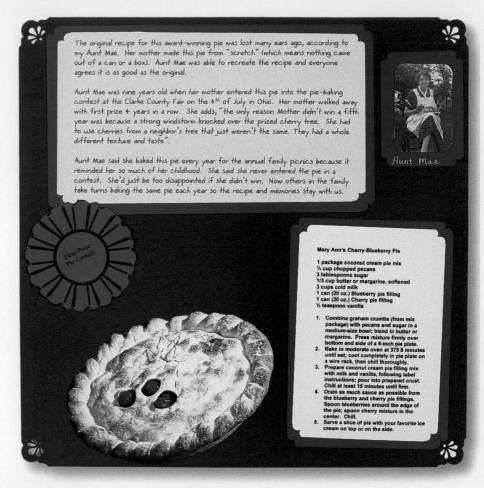

The original recipe for this award-winning pie was lost many ears ago, according to my Aunt Mae. Her mother made this pie from "scratch" (which means nothing came out of a can or a box). Aunt Mae was able to recreate the recipe and everyone agrees it is as good as the original.

Aunt Mae was nine years old when her mother entered this pie into the pie-baking contest at the Clarke County Fair on the 4th of July in Ohio. Her mother walked away with first prize 4 years in a row. She adds, "the only reason Mother didn't win a fifth year was because a strong windstorm knocked over the prized cherry tree. She had to use cherries from a neighbor's tree that just weren't the same. They had a whole different texture and taste".

Aunt Mae said she baked this pie every year for the annual family picnics because it reminded her so much of her childhood. She said she never entered the pie in a contest. She'd just be too disappointed if she didn't win. Now others in the family take turns baking the same pie each year so the recipe and memories stay with us.

Aunt Mae

First Prize Pie Contest

Mary Ann's Cherry-Blueberry Pie

1 package coconut cream pie mix
½ cup chopped pecans
3 tablespoons sugar
1/3 cup butter or margarine, softened
3 cups cold milk
1 can (20 oz.) Blueberry pie filling
1 can (20 oz.) Cherry pie filling
½ teaspoon vanilla

1. Combine graham crumbs (from mix package) with pecans and sugar in a medium-size bowl; blend in butter or margarine. Press mixture firmly over bottom and side of a 9-inch pie plate.
2. Bake in moderate oven at 375 8 minutes until set; cool completely in pie plate on a wire rack, then chill thoroughly.
3. Prepare coconut cream pie filling mix with milk and vanilla, following label instructions; pour into prepared crust. Chill at least 15 minutes until firm.
4. Drain as much sauce as possible from the blueberry and cherry fillings. Spoon blueberries around the edge of the pie; spoon cherry mixture in the center. Chill.
5. Serve a slice of pie with your favorite ice cream on top or on the side.

Special memories like these are certainly priceless additions in your heritage album.

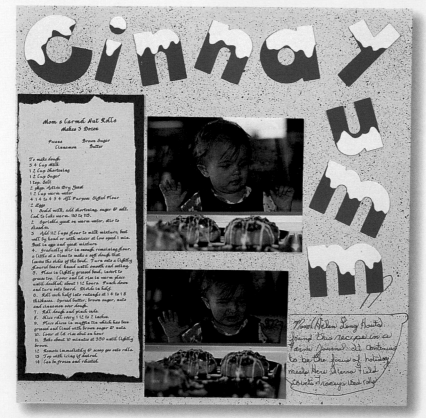

68

HOLIDAY MEMORIES

Many of our most special memories are traditions we've carried out during our many holidays such as Hanukkah, Christmas, Kwanzaa, Easter, July Fourth (Independence Day in the United States), Thanksgiving Day, Valentine's Day and Mother's Day (or Mothering Day as England refers to it).

If you want these traditions to l ast, it is a good idea to record your memories associatcd with specific holidays. Some of these traditions have been carried on for so many years, we may not even remember the true beginning of these holidays and traditions.

Many countries celebrate holidays in a similar manner but with slightly different traditions. If your family celebrates these holidays, you may want to do a little research and find out how your family traditions differ from those of your ancestors in their home country.

An example is that both Canada and the United States celebrate Thanksgiving Day. However, these holidays are celebrated at different times of the year and have very different traditions associated with them. These traditions and memories need to be captured so future generations can see the differences, especially if your family includes members from both countries and you want to celebrate both the United States and Canadian Thanksgiving holidays.

THANKSGIVING

In the United States, Thanksgiving Day is the number one food holiday. More food is consumed on Thanks-

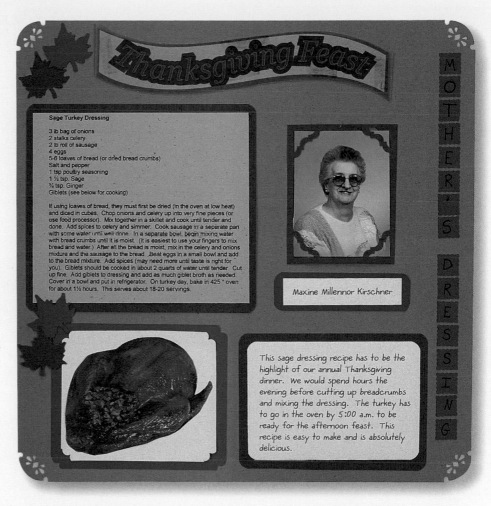

Renowned family recipes handed down for generations should be the first ones we document and include at our annual family holiday gatherings.

giving Day than on any other day of the year. (The second food holiday is Super Bowl Sunday—the annual ultimate American football game celebration.) Thanksgiving Day in the United States is always celebrated on the fourth Thursday of November. The traditional turkey dinner (stuffing, cranberries, yams, and pumpkin pie) is something few of us will forget if you have experienced it. Thanksgiving Day in the United States commemorates the first harvest feast with the Pilgrims and the Native American people.

THANKSGIVING IN CANADA

The Canadian traditional Thanksgiving meal is very similar to that in the United States. The Canadian harvest comes earlier in the fall, so Canada celebrates it on the first Monday of October and it has nothing to do with the Pilgrims.

CHRISTMAS

Christmas is celebrated in the United States and in England with pretty much the same traditions.

In England, Christmas is a particularly special time. The preparations begin several weeks in advance as both the traditional Christmas cake and Christmas pudding need to be made at least a month before to allow their flavors to develop. In both the United States and England, homes are decorated with garlands, a Christmas tree, and often holly wreaths. Children place stockings above the fireplace in the hope that Santa Claus will leave them a present on Christmas morning. In England, sometimes children leave out a mince pie on Christmas Eve to thank Santa for their presents (and a carrot for Rudolph the red-nosed reindeer). In the U.S. cookies and milk are the traditional treats for Santa. In both countries, gifts are opened on Christmas morning before breakfast.

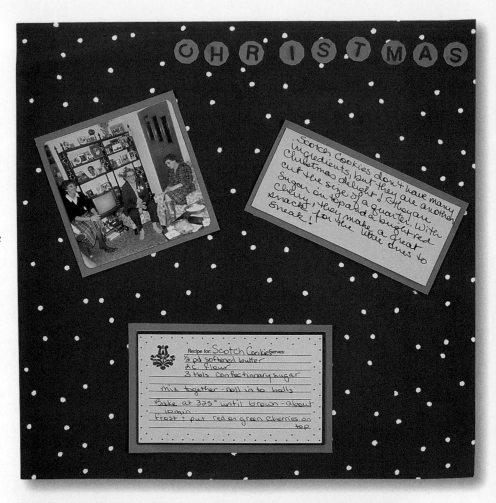

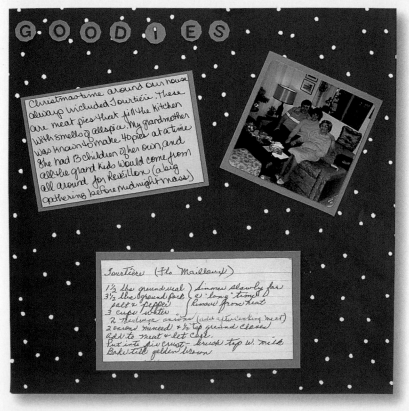

Everyone has special recipes and recollections to share during the holidays that have become a tradition over the years.

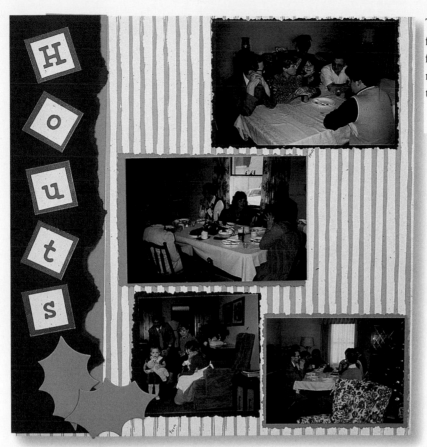

Traditions are sometimes just annual family gatherings that we can take for granted if we don't capture the memories. Let others know just why these get-togethers are special.

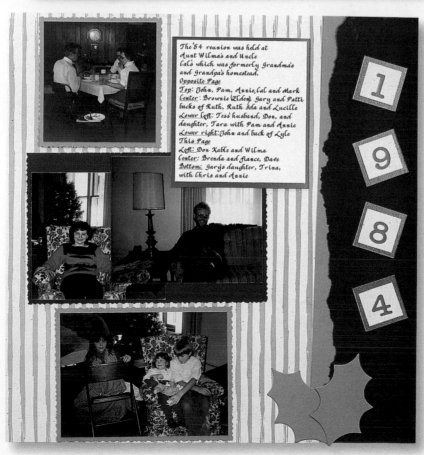

The '84 reunion was held at Aunt Wilma's and Uncle Cal's which was formerly Grandma's and Grandpa's homestead.
Opposite Page
Top: John, Pam, Annie, Cal and Mark
Center: Brownie Elden, Gary and Patti, backs of Ruth, Ruth Ida and Lucille
Lower left: Tess' husband, Don, and daughter, Tara with Pam and Annie
Lower right: John and back of Lyle
This Page
Left: Don Kable and Wilma
Center: Brenda and fiance, Dave
Bottom: Gary's daughter, Trina, with Chris and Annie

CAKES

BIRTHDAY CAKES

Around the world, it seems that birthdays are always a special time for children. A birthday is sometimes the highlight of the year. Family and friends send birthday cards and buy presents. The home is often decorated with balloons or streamers, and there is usually a special birthday cake with candles to celebrate each year of the person's life. People have parties to celebrate with family and friends; this usually consists of a special meal, which ends with the birthday cake and everyone singing "Happy Birthday." Not everyone may have wonderful memories associated with his or her birthdays. However, just a simple card or saying, "Happy Birthday" to someone can make her feel a little special on her day.

Take the time to record these memories, and if you baked a cake, include the recipe and a photograph even if the cake wasn't "baked from scratch ingredients."

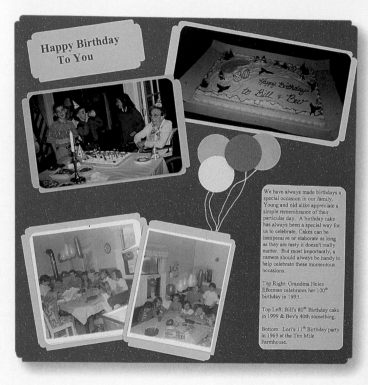

Happy Birthday To You

We have always made birthdays a special occasion in our family. Young and old alike appreciate a simple remembrance of their particular day. A birthday cake has always been a special way for us to celebrate. Cakes can be inexpensive or elaborate as long as they are tasty it doesn't really matter. But most importantly, a camera should always be handy to help celebrate these momentous occasions.

Top Right: Grandma Helen Efkeman celebrates her 100th birthday in 1993.

Top Left: Bill's 80th Birthday cake in 1999 & Bev's 40th something.

Bottom: Lori's 11th Birthday party in 1969 at the Ten Mile Farmhouse.

Birthday cakes have been a tradition for generations in our family—enjoyed by young and old alike.

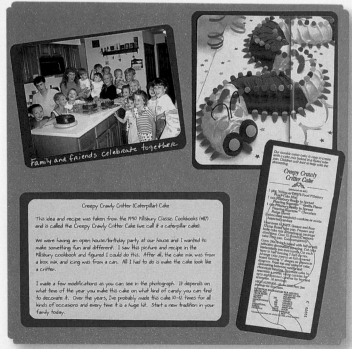

Family and friends celebrate together

Creepy Crawly Critter (Caterpillar) Cake

This idea and recipe was taken from the 1990 Pillsbury Classic Cookbooks (#87) and is called the Creepy Crawly Critter Cake (we call it a caterpillar cake).

We were having an open house/birthday party at our house and I wanted to make something fun and different. I saw this picture and recipe in the Pillsbury cookbook and figured I could do this. After all, the cake mix was from a box mix and icing was from a can. All I had to do is make the cake look like a critter.

I made a few modifications as you can see in the photograph. It depends on what time of the year you make this cake on what kind of candy you can find to decorate it. Over the years, I've probably made this cake 10-12 times for all kinds of occasions and every time it is a huge hit. Start a new tradition in your family today.

Family traditions can start with any generation. Start one with your family and make sure you capture the details so the traditions and memories are carried on.

SPECIAL OCCASION CAKES

We commemorate all kinds of special occasions with a cake as the central part of sharing our joy and best wishes for all who take part in these celebrations. We observe special achievements in our lives, such as graduations, baptisms, job promotions, anniversaries, retirement parties, and weddings. Cakes are an easy way to help celebrate these special days.

Many families have at least some-one in the family who enjoys making and decorating the cakes for all of these celebrations. Or, you can always go to the local bakery or supermarket and have a cake decorated with what-ever theme you want for your next festivity. Don't forget the camera, and be sure to include the details of these special memories on your heritage album pages.

Wedding memories are some of the happiest memories we have. Weddings are often large, lavish affairs or can be simple, private celebrations. Most people have special memories of weddings throughout their lives—whether their own or someone else's. Wedding guests always check out the wedding cake to see what is special about it compared to others they have seen. There is usually a lot of food, whether the family made it them-selves and brought it to share with the guests or had it catered in grand style.

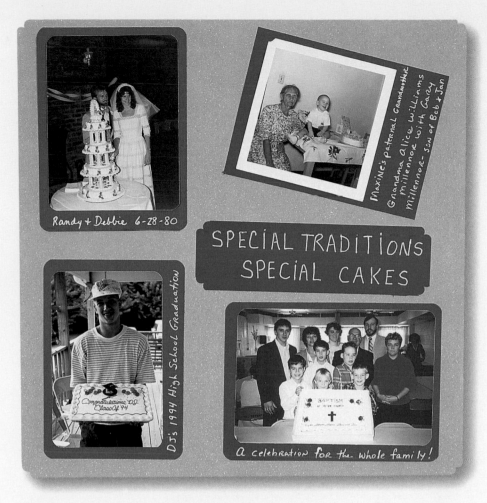

Randy + Debbie 6-28-80

Maxine's paternal Grandmother Grandma Alice Williams Millennor with Gary Millennor– son of Bob + Jan

SPECIAL TRADITIONS SPECIAL CAKES

DJ's 1994 High School Graduation

Congratulations '00 Class Of 94

a celebration for the whole family!

Many special occasions are celebrated with cakes. Be sure to include these happy memories in your heritage album.

EVERYDAY TRADITIONS

Not all food memories are associated with holidays, birthdays or other special occasions. Some of our memories may be associated with everyday events in our lives that happen throughout the year. These just may be the best memories of all that we can capture and pass along to our descendents.

If you can't think of any traditions that you celebrate throughout the year, think about starting one or two. A friend was telling me that every September family and friends celebrate the harvest moon with a big bonfire and campout at a campsite on a nearby lake. They have been holding this annual party for almost seventy-five years now. Whatever weekend the harvest moon falls on

that year, that is the weekend of their fall festivities and campout.

I asked her how it got started and she told me that when her parents were children, they lived on neighboring farms. When the harvest moon came out, it was so bright that it meant a couple more hours of light that they could finish harvesting the crops from the field. After the chores were finished, families and neighbors would sit around a campfire at the edge of this lake and share stories about things that had happened to them and their families during the past year. Even though some of them no longer work on farms or are actually harvesting crops, they still carry on the tradition of gathering around the campfire and sharing

stories with family and friends. Over the years, they began to bring covered dishes and desserts, and it has turned into more of a harvest feast that lasts long into the night—therefore the overnight campout also became a part of the tradition for many of them.

Some of our fondest memories are related to the everyday meals and desserts we remember just because the foods are so tasty and special. Every time we think of them or taste them, a flood of memories comes back to us. So make the time to take a few photographs, write down those recipes and the memories that go with them. Your family will be grateful you did.

This recipe has been passed down for generations in my family because it is simple to make and so delicious.

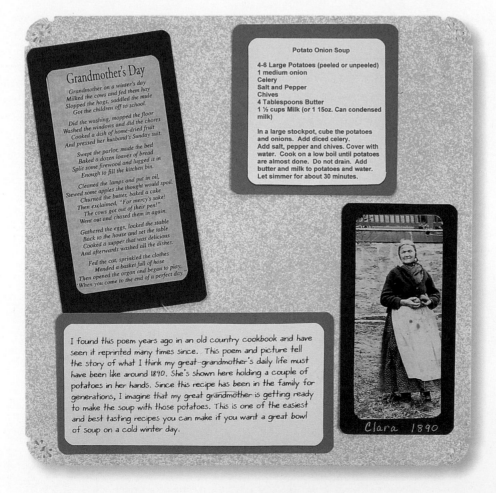

Grandmother's Day

Grandmother on a winter's day
Milked the cows and fed them hay
Slopped the hogs, saddled the mule
Got the children off to school.

Did the washing, mopped the floor
Washed the windows and did the chores
Cooked a dish of home-dried fruit
And pressed her husband's Sunday suit.

Swept the parlor, made the bed
Baked a dozen loaves of bread
Split some firewood and lugged it in
Enough to fill the kitchen bin.

Cleaned the lamps and put in oil,
Stewed some apples she thought would spoil.
Churned the butter, baked a cake
Then exclaimed, "For mercy's sake!
The cows got out of their pen!"
Went out and chased them in again.

Gathered the eggs, locked the stable
Back to the house and set the table
Cooked a supper that was delicious
And afterwards washed all the dishes.

Fed the cat, sprinkled the clothes
Mended a basket full of hose
Then opened the organ and began to play.
"When you come to the end of a perfect day."

Potato Onion Soup

4-6 Large Potatoes (peeled or unpeeled)
1 medium onion
Celery
Salt and Pepper
Chives
4 Tablespoons Butter
1 ½ cups Milk (or 1 15oz. Can condensed milk)

In a large stockpot, cube the potatoes and onions. Add diced celery. Add salt, pepper and chives. Cover with water. Cook on a low boil until potatoes are almost done. Do not drain. Add butter and milk to potatoes and water. Let simmer for about 30 minutes.

I found this poem years ago in an old country cookbook and have seen it reprinted many times since. This poem and picture tell the story of what I think my great-grandmother's daily life must have been like around 1890. She's shown here holding a couple of potatoes in her hands. Since this recipe has been in the family for generations, I imagine that my great grandmother is getting ready to make the soup with those potatoes. This is one of the easiest and best tasting recipes you can make if you want a great bowl of soup on a cold winter day.

Clara 1890

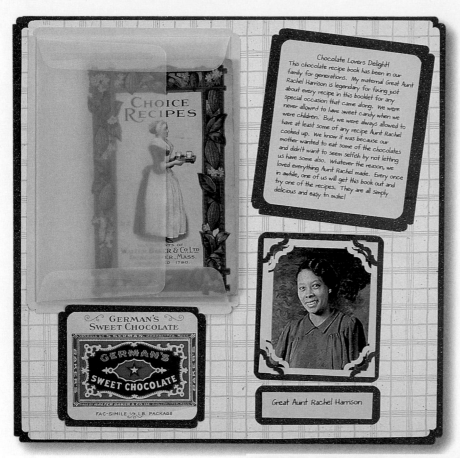

You can almost smell the chocolate in the room as you read over this recipe!

Chocolate Lovers Delight!
This chocolate recipe book has been in our family for generations. My maternal Great Aunt Rachel Harrison is legendary for fixing just about every recipe in this booklet for any special occasion that came along. We were never allowed to have sweet candy when we were children. But, we were always allowed to have at least some of any recipe Aunt Rachel cooked up. We know it was because our mother wanted to eat some of the chocolates and didn't want to seem selfish by not letting us have some also. Whatever the reason, we loved everything Aunt Rachel made. Every once in awhile, one of us will get this book out and try one of the recipes. They are all simply delicious and easy to make!

Great Aunt Rachel Harrison

MORE FOOD FUN

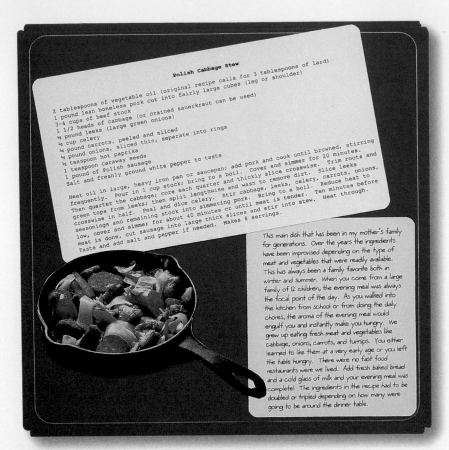

This one-skillet recipe conjures up memories of cold winter nights and a kitchen filled with wonderful aromas.

Polish Cabbage Stew

2 tablespoons of vegetable oil (original recipe calls for 3 tablespoons of lard)
1 pound lean boneless pork cut into fairly large cubes (leg or shoulder)
3-4 cups of beef stock
1 1/2 heads of cabbage (or drained sauerkraut can be used)
½ pound leeks (large green onions)
¼ cup celery
¼ pound carrots, peeled and sliced
¼ pound onions, sliced thin, separate into rings
½ teaspoon hot paprika
1 teaspoon caraway seeds
1 pound of Polish sausage
Salt and freshly ground white pepper to taste

Heat oil in large, heavy iron pan or saucepan; add pork and cook until browned, stirring frequently. Pour in 1 cup stock; bring to a boil. Cover and simmer for 20 minutes. Then quarter the cabbage; core each quarter and thickly slice crosswise. Trim roots and green tops from leeks; then split lengthwise and wash to remove dirt. Slice leeks crosswise in half. Peal and dice celery. Stir cabbage, leeks, celery, carrots, onions, seasonings and remaining stock into simmering pork. Bring to a boil. Reduce heat to low, cover and simmer for about 40 minutes or until meat is tender. Ten minutes before meat is done, cut sausage into large thick slices and stir into stew. Heat through. Taste and add salt and pepper if needed. Makes 6 servings.

This main dish that has been in my mother's family for generations. Over the years the ingredients have been improvised depending on the type of meat and vegetables that were readily available. This has always been a family favorite both in winter and summer. When you come from a large family of 12 children, the evening meal was always the focal point of the day. As you walked into the kitchen from school or from doing the daily chores, the aroma of the evening meal would engulf you and instantly make you hungry. We grew up eating fresh meat and vegetables like cabbage, onions, carrots, and turnips. You either learned to like them at a very early age or you left the table hungry. There were no fast food restaurants were we lived. Add fresh baked bread and a cold glass of milk and your evening meal was complete! The ingredients in the recipe had to be doubled or tripled depending on how many were going to be around the dinner table.

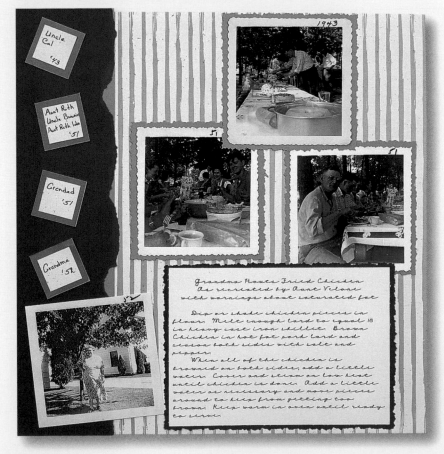

This page recalls the famous fried chicken recipe shared at many wonderful family outings.

Recipes are even more special when we have them in our ancestor's own handwriting.

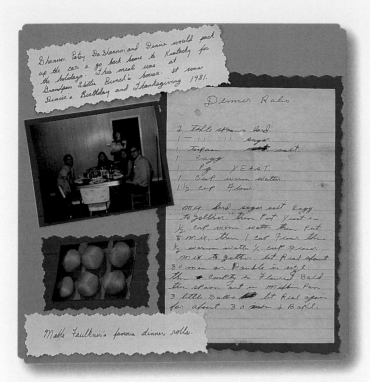

CREAMY LEMON MERINGUE PIE
(Makes one 8- or 9-inch pie)

1 (8- or 9-inch) graham cracker crumb crust
3 eggs, separated*
1 (14-ounce) can Eagle® Brand Sweetened Condensed Milk (NOT evaporated)
½ cup ReaLemon® Reconstituted Lemon Juice
1 teaspoon grated lemon rind
¼ teaspoon cream of tartar
½ cup sugar

Preheat oven to 350°. In medium bowl, beat egg yolks; stir in sweetened condensed milk, ReaLemon and rind. Pour into crust. In small bowl, beat egg whites with cream of tartar until foamy; gradually add sugar, beating until stiff but not dry. Spread meringue on top of pie; seal carefully to edge of crust. Bake 12 to 15 minutes or until meringue is golden brown. Cool. Chill before serving. Refrigerate leftovers.

*Use only Grade A clean, uncracked eggs.

NO-BAKE CHERRY CHEESE PIE
(Makes one 9-inch pie)

1 (9-inch) graham cracker crumb crust
1 (8-ounce) package cream cheese, softened
1 (14-ounce) can Eagle® Brand Sweetened Condensed Milk (NOT evaporated)
½ cup ReaLemon® Reconstituted Lemon Juice
1 teaspoon vanilla extract
Canned cherry pie filling, chilled

In medium bowl, beat cheese until light and fluffy. Add sweetened condensed milk; blend thoroughly. Stir in ReaLemon and vanilla. Pour into crust. Chill 3 hours or until set. Top with desired amount of pie filling before serving. Refrigerate leftovers.

KEY LIME PIE
(Makes one 9-inch pie)

1 (9-inch) baked pastry shell, cooled
4 eggs, separated* (reserve 1 white for filling, 3 for meringue)
1 (14-ounce) can Eagle® Brand Sweetened Condensed Milk (NOT evaporated)
½ cup ReaLime® Reconstituted Lime Juice
Few drops green food coloring, optional
½ teaspoon cream of tartar
⅓ cup sugar
Mint leaves, optional

Preheat oven to 350°. In medium bowl, beat egg yolks; stir in sweetened condensed milk, ReaLime and food coloring. In small bowl, stiffly beat 1 egg white; fold into sweetened condensed milk mixture. Turn into shell. Beat remaining egg whites with cream of tartar until foamy; gradually add sugar, beating until stiff but not dry. Spread meringue on top of pie; seal carefully to edge of shell. Bake 12 to 15 minutes or until meringue is golden brown. Cool. Chill before serving. If desired, garnish with mint leaves. Refrigerate leftovers.

*Use only Grade A clean, uncracked eggs.

TRADITIONAL PUMPKIN PIE
(Makes one 9-inch pie)

1 (9-inch) unbaked pastry shell
1 (16-ounce) can pumpkin (about 2 cups)
1 (14-ounce) can Eagle® Brand Sweetened Condensed Milk (NOT evaporated)
2 eggs
1 teaspoon ground cinnamon
½ teaspoon salt
½ teaspoon ground ginger
½ teaspoon ground nutmeg
Whipped cream and nuts, optional

Preheat oven to 425°. In large bowl, combine filling ingredients; mix well and turn into shell. Bake 15 minutes; reduce oven temperature to 350° and continue baking 35 to 40 minutes or until knife inserted 1 inch from edge comes out clean. Cool before cutting. If desired, garnish with whipped cream and nuts. Refrigerate leftovers.

These scrumptious and easy pie recipes might make you try a new homemade pie every week.

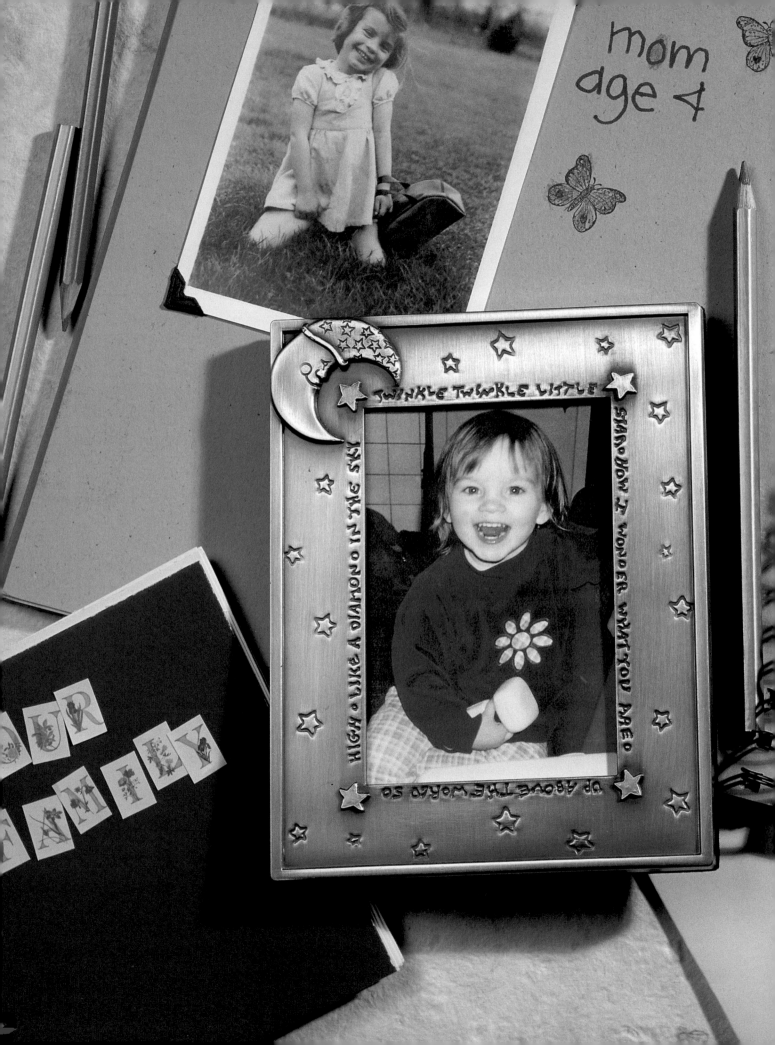

mom
age 4

TWINKLE TWINKLE LITTLE

HIGH • LIKE A DIAMOND IN THE SKY

STAR HOW I WONDER WHAT YOU ARE

UP ABOVE THE WORLD SO

CHAPTER 5
Family Projects

Getting family members involved in family research can be a rewarding experience for all. Trying to find different ways to spark that interest can sometimes be a challenge in itself. Sharing family history information in a variety of ways with family members may be just the inspiration they need to begin their own ancestral quest. It can also foster new and stronger bonds among family researchers.

FAMILY REUNIONS

When we think of summertime, many of us think of family reunions. Family history always seems to be a big part of my family reunion. We share photographs, documents and stories. The family charts are updated throughout the year, and the most current one is displayed for everyone to enjoy.

If you are going to take family history information with you, you may want to make copies to share with others. I take my laptop, scanner, and personal color copier with me, but not everyone has these available or has electricity nearby. If you don't want your one-of-a-kind originals to get damaged or lost, you may want to make copies ahead of time to share with family members.

If you use genealogy software to keep track of your family files, make copies of the GEDCOM files and place them on diskette. A GEDCOM (Genealogical Data Communications) file is a standard file format for transferring genealogy files from one computer program to another. Remember to exclude personal information about living relatives before sharing your files. Most genealogy software has this feature built in to privatize data about living relatives. If not, use a program like GedCLEAN from RaynOrShyn Enterprises to prevent personal information from being given out when swapping family history information with others.

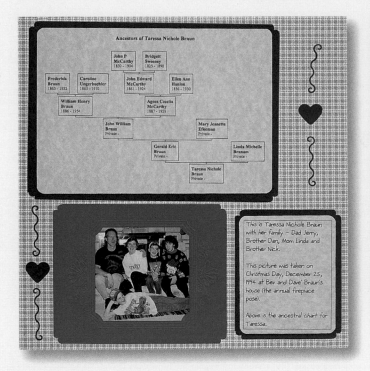

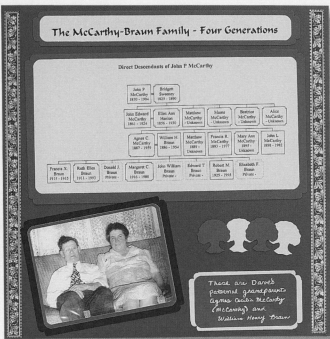

When you are sharing genealogy data with others, remember to use a feature to privatize data about living relatives as shown on the ancestral chart.

FAMILY REUNION SCRAPBOOK

If you hold annual family reunions, invite a few members of the extended family together to create a reunion scrapbook for past family reunions. Each member can work on a different year if you have enough information; or, have several people work on the same-year reunion collection. Include items such as photographs, guest list, and a copy of the invitation on your layout pages. Ask family members to write up a short highlights story which can include who traveled the farthest, who were the oldest and youngest family members at the reunion, and important details such as the date and place it was held, and who were the organizers. If family members brought potluck dishes or desserts, include some of the recipes and photos if you have them.

For your next family reunion, ask family members to create a layout page on loose cardstock of either 8½" x 11" or 12" x 12" from the previous reunion to bring with them. These can be placed in sheet protectors and hung on a large board during the reunion festivities. Afterward, place them in an archival album to be shared at future reunions with everyone.

Creating new pages from your annual family reunion is one way of celebrating your heritage with the rest of your family and it can be shared with future generations too.

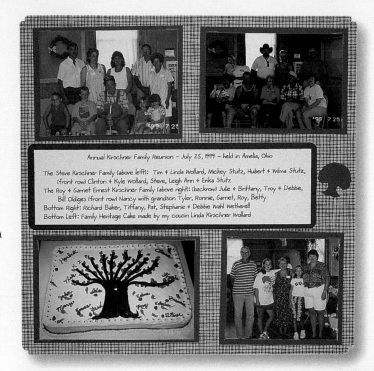

Annual Kirschner Family Reunion – July 25, 1999 – held in Amelia, Ohio

The Steve Kirschner Family (above left): Tim + Linda Wollard, Mickey Stutz, Hubert + Wilma Stutz, (front row) Clinton + Kyle Wollard, Steve, Leigh Ann + Erika Stutz
The Roy + Garnet Ernest Kirschner Family (above right): (backrow) Julie + Brittany, Troy + Debbie, Bill Oldiges (front row) Nancy with grandson Tyler, Ronnie, Garnet, Roy, Betty
Bottom Right: Richard Baker, Tiffany, Pat, Stephanie + Debbie Wahl Wetherell
Bottom Left: Family Heritage Cake made by my cousin Linda Kirschner Wollard

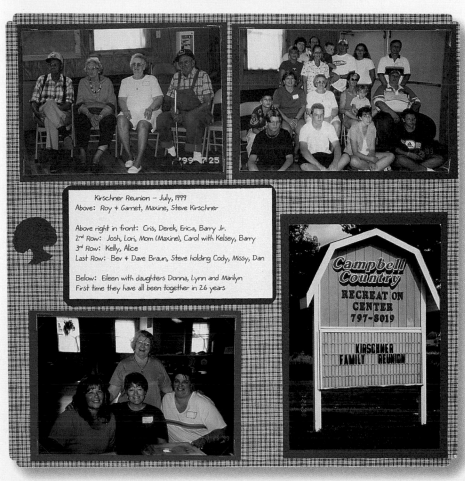

Kirschner Reunion – July, 1999
Above: Roy + Garnet, Maxine, Steve Kirschner

Above right in front: Cris, Derek, Erica, Barry Jr.
2nd Row: Josh, Lori, Mom (Maxine), Carol with Kelsey, Barry
3rd Row: Kelly, Alice
Last Row: Bev + Dave Braun, Steve holding Cody, Missy, Dan

Below: Eileen with daughters Donna, Lynn and Marilyn
First time they have all been together in 26 years

FAMILY NEWSLETTERS

Family newsletters can be a great source of information on everyday events in the lives of you and your family members. To make them interesting to others, you won't want to make the articles too short or include too much detail. Try to include a variety of stories that will have a broad appeal if you are going to distribute this to a fairly large number of family members.

Remember that if you have a large, extended family, not everyone will know one another. You may need to make brief references in your stories about what lineage the person has so others will know how they are related to one another. This will also help future generations understand relationships if these newsletters are kept with the rest of the family history information.

If this is the first newsletter you are attempting to write, most desktop publishing and word processing software include templates for newsletters. You can just edit these templates and include the information about your family.

As you become more comfortable at writing the newsletter, you can become more creative. For some great ideas for family newsletters, check out *Creating Family Newsletters* by Elaine Floyd, published by Betterway Books.

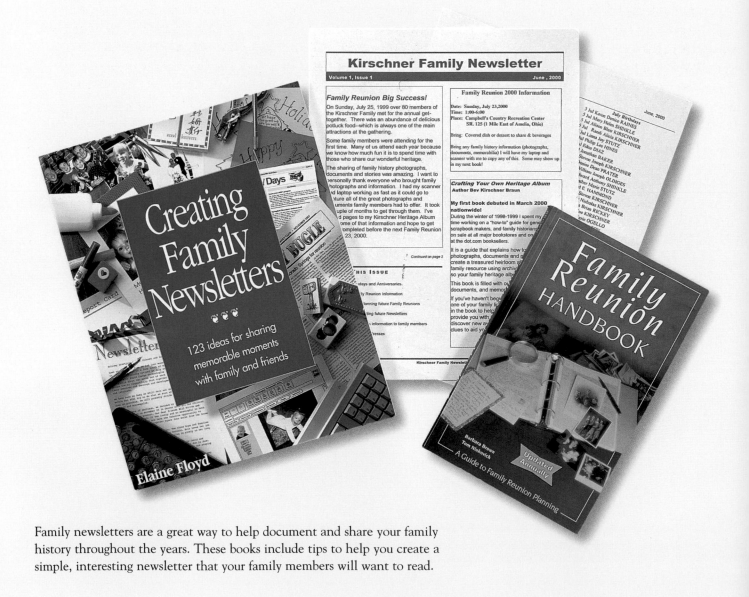

Family newsletters are a great way to help document and share your family history throughout the years. These books include tips to help you create a simple, interesting newsletter that your family members will want to read.

Tips for Better Newsletters

- In an opening paragraph, make a point to mention that the stories included in this newsletter may end up as part of your family heritage in the future. Some recipients may not see the value in the information you include in the newsletter. However, those of us who spend most of our spare time searching for family history news and information will treasure each of the newsletters. Most people don't write letters or send cards to family and friends anymore. If they write at all, they use e-mail. Everyday events will be harder to capture unless the electronic messages are printed and become part of your family history collection.

- Make the print large enough so that the readers don't have to strain to read the text. It should be between 12 and 14-point. Headlines should be larger (16-18 point) and in bold letters

- Don't include details of everything that has happened during the past year. Be selective and balance the good and the bad. Include a section where you can share family accomplishments giving the basic who, what, when, where, why and how.

- Include information on births, anniversaries and birthdays (include the month and day for the birthday and omit the year). After a certain age, not everyone may want the year of his or her birth published.

- Briefly discuss the unexpected crises, disappointing news such as major illnesses or accidents, deaths, or maybe a catastrophic event if a family member was a victim of a fire, flood, hurricane, or earthquake. It is best to check with the family involved first to be sure it is OK to share this information in the newsletter. If they agree, give just enough information to let family members know who was involved and what the general circumstances were. If readers want more information, they can personally contact the person or family involved. Too much detail may offend or cause a misunderstanding between family members if the information is not relayed and received in the right way.

- Include your e-mail address in the newsletter, and ask family members to submit information and stories to you to use in future newsletters. Ask if family members would like to receive the newsletter electronically rather than by regular snail mail. If they would, get their e-mail addresses from them. Sending the newsletter electronically is less expensive than having copies made and mailing them. It is also much quicker to distribute. Be sure to save it in a format that everyone will be able to access. Not everyone will have the most current versions of the same software you have.

- If you can get others to contribute information for the newsletter, try to include their information, editing what they submit if you need to. Family members will be more likely to contribute information in the future if they know you will share their stories in the newsletters.

- If you decide to include photographs, make sure you identify who is in the photograph and what the photograph is about.

FAMILY HISTORY WORD PUZZLES

There are several inexpensive types of software to create word games from your family history information. There are different levels of difficulty so you can make them easier for younger children and more difficult for the adults. You simply select the type of word puzzle you want to create, key in your clues and answers, and the software creates the puzzle (and the completed puzzle showing all the answers). These puzzles are not only fun to create but also a challenge to those filling them in to see if they can come up with the right answers.

You will be helping family members learn more about the details of their family history and, hopefully, getting them interested in doing some family history research themselves. It doesn't take much to get hooked on genealogy as a hobby. It is definitely one of the fastest growing hobbies in the world. Who knows, if more family members get involved in researching your ancestors, you might have enough help to put together several heritage albums from your family history information.

FAMILY TREE BOOKS FOR KIDS

MAKE YOUR OWN

To get the younger children interested in their family history, help them put together their own family history book. There are many styles of pre-printed acid-free scrapbook paper pages available in 8½" x 11" and 12" x 12" pages for just this purpose. You need to add family photographs and write in the family history information. Some adults I talked to have no idea who their grandparents and great-grandparents are. Don't let this happen in your family. Start your children and grandchildren early in their lives knowing their family history. It will help build their self-esteem and give them a sense of belonging by learning their heritage at an early age.

Spending time with a child putting together a family album will be a great time for both of you. Use a sturdy binder, and add sheet protectors on the pages. Children will want to share this with family and friends, and you won't want to worry about the pages getting dirty or torn. You can personalize the pages by adding some stickers and die-cuts to the pre-printed pages to make them special for your family history.

PURCHASED FAMILY BOOKS

Several books are available at the bookstores to create a family tree book for kids. These already include pre-printed pages for you to add photographs and genealogical details. These are a quick way to get a family history album completed for children and introduce them to their family ancestors.

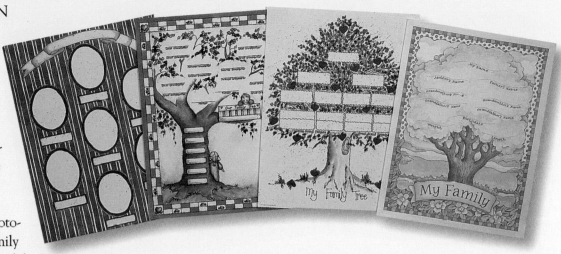

These colorful preprinted papers make creating a family tree book with your kids fast and fun.

A variety of blank family tree books are available—just add photos and journaling to create your family history pages.

CHAPTER 6
Genealogy Online

Using the Internet offers so many opportunities for discovering your ancestors that it may be difficult to know where to begin. Some major misconceptions are that the Internet is the answer to everybody's questions. You will not be able to just type in a family name and have a completed family history pop up on your computer screen. You may, however, be able to speed up your research time and save on expenses along the way. Good old fashioned off-line research skills are still required to compliment today's technology.

WHERE DO I BEGIN?

If you are new to genealogy research, one of your first question might be, "Where do I begin?" One of the first things you will need to do before ever getting online is write down everything you know about your family history. Begin with yourself and work backward. There are two basic forms that you can use to get started documenting your family history—the ancestral and the pedigree charts. The information on these forms should include all of the names, dates and places you know about. Complete a chart for each line of the family tree you want to research. Do the same if you are researching family lines for your spouse or another person not related to you.

I covered general offline genealogical research techniques in my first book, *Crafting Your Own Heritage Album*. Included in the back of that book are some forms for you to copy and use for your research process. I also included general information on using genealogical software to help you organize and track your family history information on your computer. You will still need to utilize all of the

Books and magazines can be of great assistance. Genealogy-specific magazines can offer lots of useful information for both online and offline research by covering topics on the newest and the latest in research tools and techniques, and the best web sites for what you are looking for.

other traditional offline research methodologies for your genealogical research. Going online and using the Internet is just one more very powerful research option now available to you whenever you have time to sit down at the computer and take advantage of the information that is available to you.

Keep in mind that you will not be able to type a surname into a database and come out with a completed family

history report. The Internet is going to be another source that you can add to the list of tools already available to you, such as libraries, the LDS Family History Centers, printed family histories, genealogical societies, professional organizations and researchers, etc., but it is not the only tool you need or should use. With the Internet you now have an online tool that is available twenty-four hours a day, seven days a week. If you need a dictionary, a map, forms, an address on where to send for something, or if you want to trade information with someone on the other side of the globe, the Internet will be available whatever time of the day you are working.

PRIMARY AND SECONDARY SOURCES

The primary purpose of any genealogical research is to systematically search for specific information and then validate it ultimately with primary source documents. The Internet will not contain digital copies of all the documents available throughout the world for each ancestor you may want to research—the same way no one book or one facility contains all of the copies you may be looking for. It can, however, significantly speed up the time it takes to locate these sources and save you money by doing so.

One thing you must keep in mind is that even though you find printed information on the Internet, this does not mean it is true and/or accurate. All of the records were originally compiled by humans and are prone to mistakes. Don't just trust the information you find unless you have some official source of information to validate it, which is where your primary and secondary source documents come in.

Primary sources are records of events from an eyewitness at the time of the event or shortly thereafter, documents that were recorded by someone who had direct knowledge of the event, such as a baptismal record completed by the attending church official. Other primary source documents would include letters, diaries, family Bibles that have birth, marriage and death dates associated with the names, video or voice recordings, oral family history accounts, census records and firsthand newspaper accounts.

Copies of primary and second documents will validate the information you collect on your ancestral heritage.

Secondary sources are seen as those documents or information where the information may have come from a secondhand source. A death certificate can have both primary and secondary information on it. Information about the date and circumstances of the death may be completed by a physician or a coroner at the time of the death and are considered primary sources. However, a family member or friend who may not know the accurate details may provide some information pertaining to specific information about the individual.

VITAL RECORDS

Vital records were created because an event had enough significance or was importance enough that it was documented and the record was collected and maintained by some level of the government. This includes documents such as birth, marriage, death, naturalization, and passports.

DO YOUR HOMEWORK

If you are new to using a computer and are not yet familiar with the Internet, I recommend you refer to some of the books in the resource guide in the back of this book. Go to the library or local bookstore, read through some of these books, and select one to learn more about going online. If you don't already have a personal computer, most public libraries have computers connected to the Internet. You can spend a little time using their computers before you invest a lot of time and money in a computer system at home, just to be sure this is something you are going to feel comfortable with.

There are numerous articles, journals, and entire specialty books on all aspects of researching online using the Internet, from the basics to very technical how-to manuals. Here are just a few of the things you'll need to know about:

- computer hardware and a modem
- software for your PC's operating system
- Internet software

There is also an enormous amount of information about what you can find once you get online. You'll need to know some of the basic terminology and where to look in order to make your time online useful and efficient. A few of the basics include how to determine an objective and develop a search plan, what types of search tools are available for genealogists and what types of information they will help you find once you get online, how you should begin your search (depending on your search objective), and what kind of genealogy software you need to organize the information you collect.

I want to try to explain some of the very basic terms and information you will need to know. I can't begin to give you enough detailed information to adequately prepare you for researching online. There are resources in the back for books, magazines and web sites that will steer you in the right direction. You will have to read through some of these to prepare yourself for your online adventures. Your experience online will not be productive if you don't read and educate yourself. You will get discouraged and possibly give up. Don't. There is so much valuable information on the Internet for you to discover and make part of your family history. You just need to figure out the best way to find the information that is of most value to your research and take advantage of it.

GENEALOGY SOFTWARE

Genealogy software offers a wide variety of features—some you will want to use, some not. Do some research to see how the products differ and select one based on what you want to do with the information you collect. Most genealogy magazines and journals offer current reviews of many of the popular programs and their features.

Some of the primary reasons you will want to consider using genealogical software to aid in your family history research include the following:

• It will help you organize your family history information.

• It will help you sort and search for data quickly and easily. You'll be able to find individuals and information about them by entering specific data such as name and dates.

• You will be able to create charts and reports to see exactly where new entries into your file fit into the overall family tree.

• You can keep track of all those little bits of information that you don't know what to do with.

• Most will allow you to create a research journal that you can print and work from the next time you are doing online or offline research so you can pick up where you left off.

• Many will let you add pictures, sound, documents, etc., to create a digital family history file.

• You can avoid adding duplicates and check for errors on individuals you already have (like when a child's birth date is after the death of a parent).

Versions of these software packages change frequently, and new enhancements and features are included. Many of the Internet web sites for genealogy software offer demo copies so you can try before you buy. This is a good idea. Sometimes just the way the data is presented to you on the computer screen may not be pleasing to you. Select a software package that has the most agreeable features to what your goals are for your family history research. Try different views, print sample reports, and try creating a custom report to see if you get the

results you expect. Ask family and friends what software they use and what they like most about it.

Note: When you are entering dates on your forms, on research sheets, or into your genealogical software, the formats need to be consistent. Dates should always be written as day-month-year using the three-letter abbreviation for the month: 03 Aug 1856. When you look at this date, there is no doubt that it means the third of August 1856. If the date is written as 08/03/56 or even 08/03/1856, it can be misunderstood by someone else who is reading it. It may be difficult to tell if the month is August or March and what century you are referring to. Always use the full year in all of your documentation. Your research can span ancestors over several centuries, and many of them will have the same names. The only differentiation in many cases is the dates associated with that specific ancestor.

ONLINE KNOW-HOW

As I said before, there is a lot of information about the Internet that you will need to know to make your online time productive. Here is a brief description of some terms and useful information that will get you started. To learn more about the specifics of the information, refer to the resources in the back of this book. There is also a vast amount of information available at the library and local bookstores about researching on the Internet.

TOOLS TO USE

There are many tools and techniques available to use to pursue ancestral data online. There is no single online tool or technique that will be the answer to all of your investigative searches. No one tool can be used successfully in all cases. By gaining an understanding of each of these online tools, you will be much more successful. You will also be able to work around some of the weaknesses of these online tools if you take the time to become more familiar with how they actually work.

There are several tools you can use to help you take advantage of the information that is available on the Net. Some of these tools include:

- World Wide Web (WWW or sometimes just the Web)
- mailing lists
- file transfer protocol (FTP)
- telnet
- electronic mail or e-mail

None of these tools provides the best access to online genealogy data by itself. You will need to take the time to learn about each one of these a little more to see if it is a tool that can help in your quest for family history data.

WORLD WIDE WEB

There is a lot of technical detail about how the World Wide Web actually works, and I'm not going to go into too much detail here. Your eyes will probably just glaze over and you won't want to read it anyway. If you are interested in more detailed information, there are a lot of sources available.

Just to give you a general overview, the Web starts out with powerful host computers, called servers, that hold the data that makes up the Web pages you view, the actual documents. The files are named and are linked together so the server knows which files to pull up when you click on a link. These links are based on URLs, or Uniform Resource Locator, that tell the service which file you want. When you click on the link, your Web browser tells the server to get the printed text and graphics that go together. They are loaded on the screen and display much like a printed text page would.

For those of you who use America Online (AOL), keep in mind that AOL is not the Internet. It is a huge collection of proprietary information that has been collected for databases to assist members in easily finding whatever information they need. But it is not the true Internet. If you use only the information found on AOL, you are limiting yourself to only one source of information available to you on the World Wide Web.

MAILING LISTS

There are many Internet-based special interest groups, also known as mailing lists or discussion groups, that are dedicated to genealogy. There are thousands of genealogy mailing lists.

Web Site Address Endings

.com — indicates the site is a commercial site, which includes corporate home pages or individual home pages. Commercial sites provide reliable information about product information, business enterprises, online technical support for hardware and software, and many provide online ordering capabilities for products.

.gov — indicates the site is an official government entity, usually the federal government. These sites can be deemed reliable as they are responsible for providing their constituents with accurate information on regulations, finances, laws, etc.

.edu — indicates an educational institution such as a college, university, or other school computer system operates this site. Examine the information carefully as these sites contain both authentic and superficial information, depending on the school's policy for its users.

.mil — indicates a military organization, such as the Pentagon.

.net — indicates a networking company, such as an ISP, operates the site.

.org — indicates nonprofit organization or associations run the site. If researching a specific area, you can obtain a great deal of credible information from professional and research organizations.

Many of these are centered on geographic interests (those with ancestors in Ireland or Indiana), military interests (Civil War or WWII), or ethnic groups (Jewish or African American). Mailing lists make it easy to find other researchers who are interested in the same topics, surnames and locales you are researching.

Subscribing to or joining one of these groups is much like joining a club or organization except you don't have to pay any fees or dues to join. To join you just send an e-mail message to the computer that distributes the messages to all of the users on the mailing list for that group. There is usually a specific way to subscribe (join) and unsubscribe (discontinue) your participation in a mailing list group. Be sure to read and follow the instructions exactly and keep a copy for future reference.

Most experienced researchers suggest you use a different e-mail address for posting messages than you do for subscribing to lists. After you join a new group, don't jump right in and start sending out long messages or queries to the group. Read the incoming messages from the group for about a week or more to get to know how the group works and the type of information they send and receive. Find out how the group responds to messages. Some people respond to the group as a whole, and some will respond directly to you.

FILE TRANSFER PROTOCOL (FTP)

FTP is an application that allows users to send and receive files between remote computers. It allows you to upload and download computer files from one computer to another. When you download a file from the Web, your computer normally retrieves it using FTP. FTP is also used to upload files so that they can be viewed on the World Wide Web. If you are transferring a large file to someone, it is almost always best to use FTP rather than e-mail. FTP is much better suited for this than e-mail. You can download a file to a disk, disconnect from the remote computer, and then view or execute the file on the local machine without having to stay connected over a telephone line to the remote computer.

You may also hear the term anonymous FTP. This allows a user to receive files from a remote computer without having to have an account on the remote system. Some commercial sites maintain anonymous FTP sites for the convenience of their customers so they can download updates for program files to their machines without having to request diskettes through the mail.

TELNET

Telnet is an application that allows you, as a user, to connect to a remote computer and use it as if your own computer were connected directly to that computer. It will allow the user to run programs that are based on that remote machine. Telnet sites can access such things as databases and library catalogs.

E-MAIL

There are specific guidelines for using e-mail and dos and don'ts that you need to know before you start sending messages. Otherwise, you can easily offend someone on the receiving end of the message and she will not want to help you with your research.

First, be clear when writing messages. This is essential for online communication. You must include all of the relevant information pertaining to your request, including important names, dates, and places pertaining to the question being asked. Keep the information short and concise, but don't leave out important details. People reading this message on the other end need to have a general idea of just how much research effort and time you've spent already. You can give information about the parents or siblings of the individual that you are researching to help others make a better connection.

E-MAIL ETIQUETTE

Before sending a detailed, lengthy e-mail message to someone you have not corresponded with before, send a short introductory message first. Tell the person in a brief paragraph or two about your interest in genealogy. Don't go into a lot of detail until you find out if they share your interest in family history. Some Internet users may have to pay for each e-mail message they send and receive, so don't waste their time or their money without knowing if they want to hear from you. Otherwise, you may have cost yourself a friend and a potential research partner.

E-mail is not private and never assume it is. Even if it has been deleted, it can still be recovered and read if necessary. Don't send personal or confidential information to a group forum, even if it is available somewhere else on the Internet. You can never be sure how and where that information may be used in the future.

RESEARCH ONLINE

The first thing you should understand is that all of the extensive holdings of available genealogical data throughout the world is not available online. There are thousands of books, rolls of microfiche and microfilm, and documents in the United States alone that are not yet available on the Internet.

Even if you find family history information online, it must be validated. You will need to reference the original documents in the library, local courthouses, and public libraries to verify the information you find as accurate and complete. The indexes online may give only a very limited amount of the information the original document contains.

To help you prepare for what type of information you can search for online, refer to books and magazine, listed in the resource sections. These will help you determine if it is worth your while to search online for these records or whether the records may be available only in a certain research facility. If you are an experienced researcher, I hope some of these sites will give you additional information to help you achieve success during your online research. These sites will provide you with

- information on basic research techniques
- tips on how to avoid common pitfalls that will leave you frustrated and confused
- tips on successful research strategies
- forms you can download for free to help you write down what you already know
- search databases for document indexes to find a match on family surnames
- portal sites to mailing lists,

There are numerous reference books that will help you make the most of both with your online and offline family history search.

bulletin boards, chat rooms and message boards to find people searching in the same locale or searching the same surnames you are

USING A SEARCH PLAN

There is just too much genealogical information on the World Wide Web for you to read through all the Web sites. One key to finding the information you want among all of the databases and Web sites is to begin by creating an established search plan. This will help you stay focused and on track with your research. It will also help you keep track of some of the most useful Web sites you have searched and eliminate others.

Without a search plan, you will be wandering around the Internet just like you would if you went to a super mall looking for a gift without any idea what you were looking for. Before going online, decide what you want to find. Here are a few suggestions to help you

get started creating a search plan. What are you looking for?

- census records for a specific period of time and locale
- land records
- birth records
- a marriage certificate
- someone else who is researching the same ancestral lines you are

Without a good search plan, you can easily become frustrated with all of the information available and how little information you find that is useful to your research. This can also lead to false assumptions when your searches do not turn up ancestors you are searching for. You assume that they are not there and may go on to something else. In fact, they may be in the database you are searching, but you are unable to find them because you may not be using good search techniques. If you get stuck while searching online, try checking out the research bulletin boards to see what successes others have had and what techniques they use to find their ancestors.

Internet Research Log

Ancestor's Name: Gouge – GRANT County, Ky – California Connection

What are you looking for? Gouge/Williams			URL Address Searched: www.usgennet.org
DATE	Type of Record Searched	Information found that may be relevant to search?	What follow-up is required to validate information found
11/15/00	Family Histories	Gonge, Eliza	name could be Gouge
11/15	Marriages–GRANT County, Ky	1820 –1828 NONE found	N/A
11/15	http://gouge~1@rootsweb.com CA Death INDEX	Marietta Gouge	Marietta rather than Henrietta – name + dates in Ky + CA Are the same
			OBTAIN Death Certificate from CA – printed forms

Prepared by:

Date:

c:\data\genforms\internetresearch

Using a research form can help you keep track of what information you find online and where and when. It will also help you eliminate sites that are not useful to your search right now.

Internet Research Log

Ancestor's Name:

What are you looking for?			URL Address Searched:
DATE	Type of Record Searched	Information found that may be relevant to search?	What follow-up is required to validate information found

Prepared by:

Date:

c:\data\genforms\internetresearch

SEARCH ENGINES

There are several large web sites that specialize in providing free search engines to web pages. A search engine is a utility that locates resources via searches for keywords and phrases that you type in a search box. Each search engine is designed a little differently from the others. They will not return the same results even if you type in the same search words. Standard search engines do not find every single web page on the Internet.

Most screens include a search box on them. If you begin your online search by typing in the word *genealogy*, you will soon find out that there are several thousand sites that include a reference to genealogy. A better way to begin your search is to combine at least two words, such as *Irish Genealogy* or *Bristol Family* to narrow your search choices .

When you begin to use the search engines, spend the time reading their help section on each site. Each search engine handles the search words differently, and depending upon how it handles those words, each site will return different results. If you use more than one word in your search string, the search engine may default to *and*, or it may default to *or*. The help section will tell you what the defaults are so you know exactly how to enter your search string to get the results you want. It will save you time and help you find what you are looking for that much faster.

Some sites use Boolean logic, which means they allow you to use words rather than characters to filter your search. These are terms like *and*, *or*, *near*, and *and not*. Again, these are explained on each Web search engine page. You'll need to find out exactly how to use them so you get the results you want.

STANDARD SEARCH ENGINES

Just a few of the standard search engines are

- Excite
 www.excite.com
- Infoseek
 www.infoseek.com
- Google
 www.google.com
- Northern Light
 www.northernlight.com
- AltaVista
 www.altavista.com
- WebCrawler
 www.webcrawler.com

GENEALOGY SEARCH ENGINES

You will want to use multiple search engines during your online research. If you can't find the information you are looking for, try another search engine. There are several search engines that are specific to genealogy research and will be more useful than others. However, no single search engine will return everything that is available on the Internet.

Genealogy search engines scour specific databases or genealogy-only sites rather than searching all sites on the Internet. There are genealogy-specific sites that search for particular types of genealogy information. There are thousands of genealogy-specific web sites that can assist you in your research. Many of those are listed in the genealogy resources at the back of the book, including these two examples:

- Bureau of Land Management
 www.blm.gov
- Census Records
 www.census.com

Common Search Engine Commands

- Putting one or more words between quotation marks tells the search engine to look for those words in a phrase. Use quotation marks around proper name such as "Manchester, England" so it finds Web pages with that phrase in it instead of thousands with just the word *England* or *Manchester*.

- An asterisk is used as a wildcard. If you enter a term such as *photo*, it will find sites with the words *photo*, *photograph*, *photography*, *photographer*, *photographs*.

- Putting a plus sign in front of a word means the sites must contain all of the words in the string, such as *Genealogy + Baltimore + Maryland*.

- Putting a minus sign means the web page should not contain that word or words.

OUTDATED MEDICAL TERMS

When you are searching old records, especially hospital records and death certificates, you will come across some old medical terms that you may not be familiar with. At right is a list of a few of those terms. There are reference books in the library and web sites online where you can reference more information on medical terms if you come across one that is not listed here.

Outdated Term	New Term
acute mania	severe insanity
ague	used to define the recurring fever and chills of malarial infection
apoplexy	stroke
bad blood	syphilis
Bright's disease	glomerulonephritis (serious kidney disease)
camp fever	typhus
chorea (St. Vitus' dance)	nervous disorder
consumption	tuberculosis
cretinism	hypothyroidism, congenital
dropsy	congestive heart failure
falling sickness	epilepsy
fatty liver	cirrhosis
glandular fever	mononucleosis
jail fever	typhus
lockjaw	tetanus
lung fever	pneumonia
lung sickness	tuberculosis
mania	insanity
nostalgia	homesickness
putrid fever	diphtheria
quinsy	tonsillitis
remitting fever	malaria
screws	rheumatism
septicemia	blood poisoning
ship's fever	typhus

FAMILY RELATIONSHIP TERMS

When you are working on your family history, sometimes it is helpful to know how to describe family relationships more precisely. Here are some definitions that should help you, whether you are the one using them or you come across them in your research.

• Cousin (first cousin)—your first cousins are the children of your aunts and uncles. They are members of your family who have two of the same grandparents as you do.

• Second cousin—these are family members who have the same great-grandparents as you do but not the same grandparents.

• Third, fourth and fifth cousins—third cousins have the same g-g-grandparents; fourth cousin family members have the same g-g-g-grandparents; fifth cousins have the same g-g-g-g-grandparents and so on.

• Removed—when this term is used, it means that the two people being described in the relationship are from different generations. The term once removed means there is one generation difference between you; twice removed means there is a two-generation difference.

Below is a relationship table that should help you figure out the exact relationship of different family members and terminology to use when describing family members.

1. Select any two people in your family and determine what ancestor they have in common. An example: If you select yourself and one of your cousins, you both would have the same common grandparent.

2. Next look at the top row and find the first person's relationship to that common ancestor. Your cousin would be the grandchild of your grandparent.

3. Then look at the first column on the left and find the second person's relationship to that same common ancestor. You would also be the grandchild of your grandparent.

4. Go across the chart and find the correct row and column that shows where those two relationships meet. The intersecting row and column would be "first cousin" for the two of you since your common ancestor would be a grandparent.

Common Ancestor	Child	Grandchild	Great Grandchild	Great-Great Grandchild
Child	brother or sister	nephew or niece	grandnephew or grandniece	great-grandnephew or great-grandniece
Grandchild	Nephew or Niece	first cousin	first cousin, once removed	first cousin, twice removed
Great-Grandchild	grandnephew or grandniece	first cousin, once removed	second cousin	second cousin, once removed
Great-Great-Grandchild	great-grandnephew or great-grandniece	first cousin, once removed	second cousin, once removed	third cousin

AMERICAN SOUNDEX TABLE

A Soundex is not an alphabetic index; it is a phonetic index. The key feature to Soundex is that it codes surnames (last names) based on the way a name sounds rather than on how it is spelled.

Soundexing was first used for the 1880 census in 1935. It was created as a means of providing birth information for the newly created Social Security System. It was not designed for the genealogical researcher. The Rand Corporation was hired by the Census Bureau to formulate a phonetic coding system. Hundreds of Works Progress Administration (WPA) workers created the Soundex indexes. Most last names can be spelled in a variety of ways, for example "Smith" can also be spelled "Smythe," "Smithe," and "Smyth."

The WPA workers created Soundex cards for the heads of households for the 1880, 1900 and 1920 censuses. The cards were then arranged in order by the Soundex codes. The Soundex system has become a great tool for genealogists by identifying spelling variations for a given surname.

When searching online, check to see if the Soundex index feature is available. In many cases it is not, especially when you are searching indices that are just scanned or transcribed copies of the original records. However, if it is available take advantage of it. It can certainly help you find leads on surnames that you may not have considered before.

To use the Soundex index feature, you must first create the code for your surname. On this page is the table used to convert surnames from alphabetic to the phonetic Soundex system. Each Soundex code consists of one letter and three numbers, such as R216, no matter how long the name is. The letter is always the first letter of the surname (S for Smith). The rest of the consonants in the name determine the numbers in the code, and the vowels are always ignored.

There is a lot more information about the Soundex system available online and at the library if you want more details about how to use it more effectively.

Soundex Table

1	b, f, p, v
2	c, g, j, k, g, s, x, z
3	d, t
4	l
5	m, n
6	r
no code	a, e, h, i, o, u, y, w

GALLERY ❧

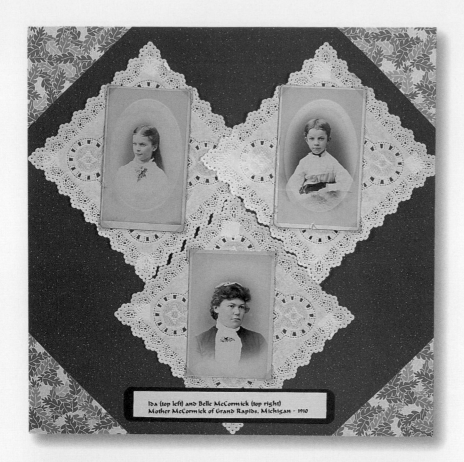

Triangle corner borders and paper doilies showcase these heritage photographs.

Ida (top left) and Belle McCormick (top right)
Mother McCormick of Grand Rapids, Michigan - 1910

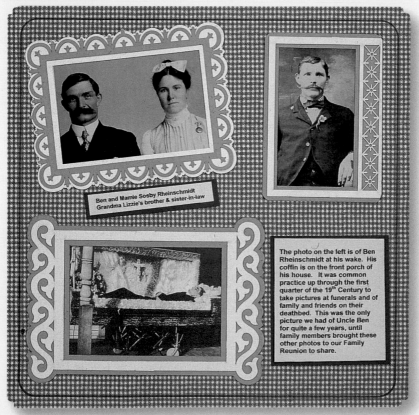

Dress up old-time photographs with pretty paper and fancy pre-cut frames.

Ben and Mamie Sosby Rheinschmidt
Grandma Lizzie's brother & sister-in-law

The photo on the left is of Ben Rheinschmidt at his wake. His coffin is on the front porch of his house. It was common practice up through the first quarter of the 19th Century to take pictures at funerals and of family and friends on their deathbed. This was the only picture we had of Uncle Ben for quite a few years, until family members brought these other photos to our Family Reunion to share.

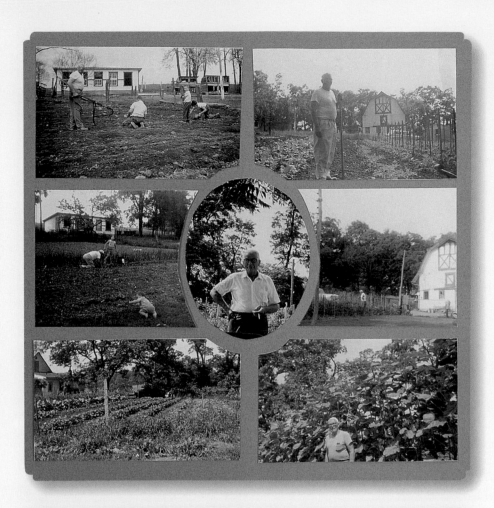

A Puzzle Mate template was used to create one page (left) of a two-page layout. To complement the template layout, journaling and some of the original sunflower seeds from the garden were added to the second page (below).

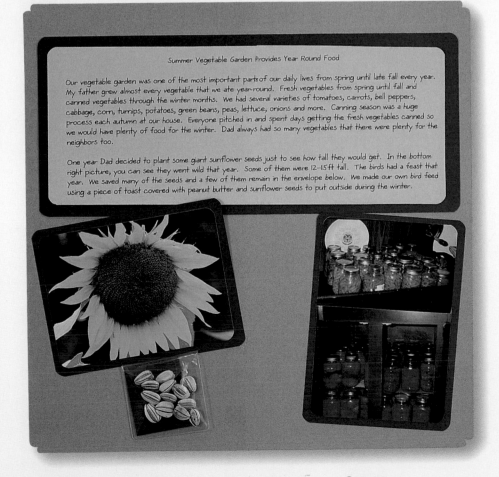

Summer Vegetable Garden Provides Year Round Food

Our vegetable garden was one of the most important parts of our daily lives from spring until late fall every year. My father grew almost every vegetable that we ate year-round. Fresh vegetables from spring until fall and canned vegetables through the winter months. We had several varieties of tomatoes, carrots, bell peppers, cabbage, corn, turnips, potatoes, green beans, peas, lettuce, onions and more. Canning season was a huge process each autumn at our house. Everyone pitched in and spent days getting the fresh vegetables canned so we would have plenty of food for the winter. Dad always had so many vegetables that there were plenty for the neighbors too.

One year Dad decided to plant some giant sunflower seeds just to see how tall they would get. In the bottom right picture, you can see they went wild that year. Some of them were 12-15 ft tall. The birds had a feast that year. We saved many of the seeds and a few of them remain in the envelope below. We made our own bird feed using a piece of toast covered with peanut butter and sunflower seeds to put outside during the winter.

Family reunions hold special memories for everyone. This two-page layout highlights those memories with photos and journaling.

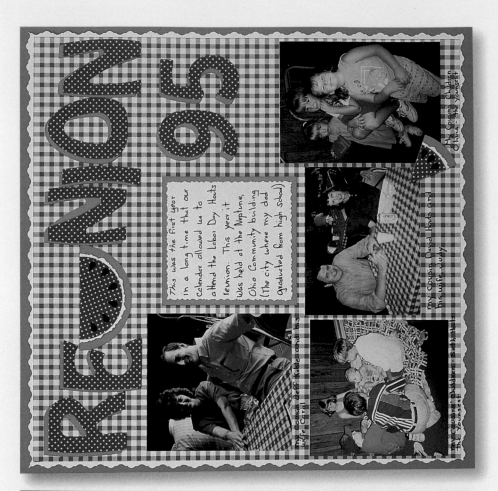

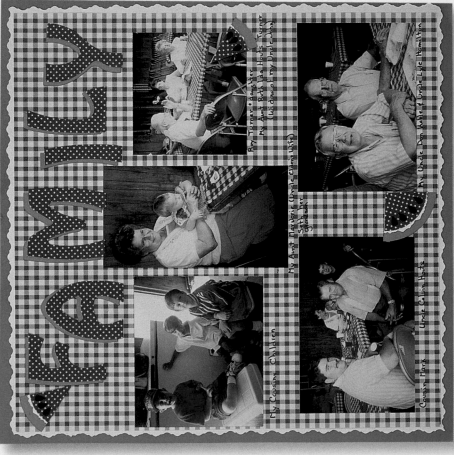

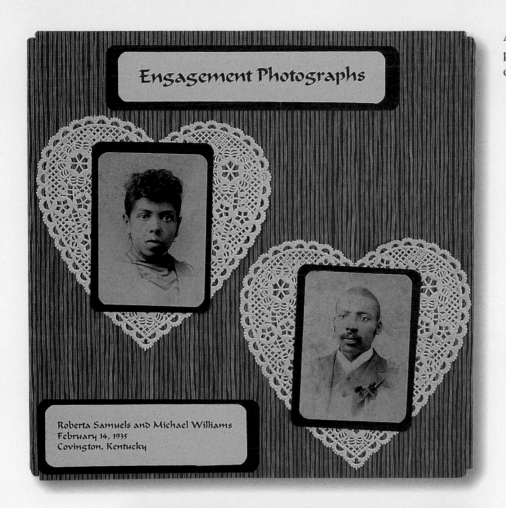

Acid-free paper hearts and pretty paper enhance the romance of this engagement design.

Engagement Photographs

Roberta Samuels and Michael Williams
February 14, 1935
Covington, Kentucky

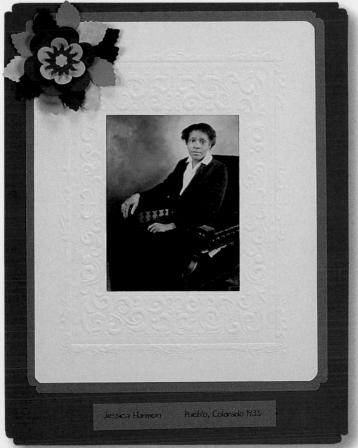

Use craft punches to add a three-dimensional embellishment.

Jessica Harmon Pueblo, Colorado 1935

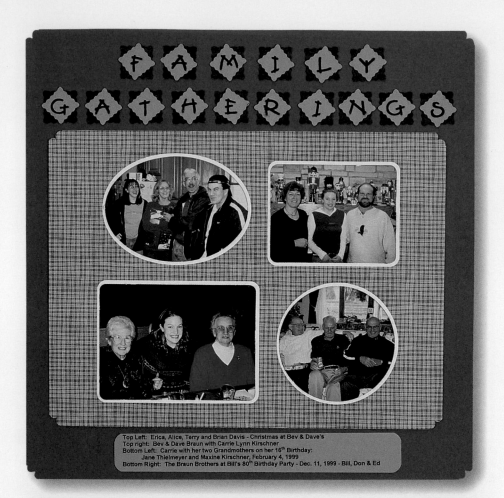

Top Left: Erica, Alice, Terry and Brian Davis - Christmas at Bev & Dave's
Top right: Bev & Dave Braun with Carrie Lynn Kirschner
Bottom Left: Carrie with her two Grandmothers on her 16th Birthday:
Jane Thielmeyer and Maxine Kirschner, February 4, 1999
Bottom Right: The Braun Brothers at Bill's 80th Birthday Party - Dec. 11, 1999 - Bill, Don & Ed

Add photos and journaling to a pre-cut frame, and paper-punched squares and alphabet stickers for classic-looking layouts.

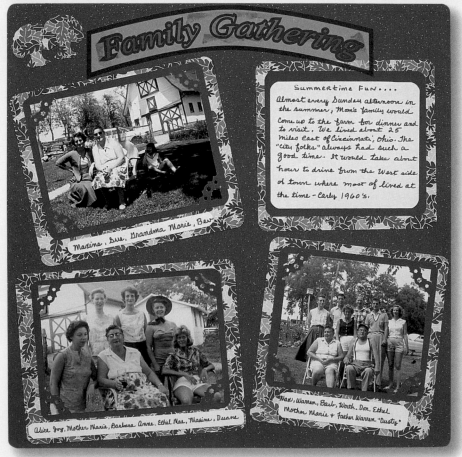

Family Gathering

Maxine, Sue, Grandma Marie, Bev

Summertime Fun....
Almost every Sunday afternoon in the summer, Mom's family would come up to the farm for dinner and to visit. We lived about 25 miles east of Cincinnati, Ohio. The "city folks" always had such a good time. It would take about hour to drive from the West side of town where most of lived at the time - Early 1960's.

Alice Joy, Mother Marie, Barbara Anne, Ethel Mae, Maxine, Duane

Max, Warren, Barb, Worth, Don, Ethel
Mother Marie & Father Warren "Dusty"

Bring your black and white photos to life using some of the beautiful papers now available.

Paper-punched flowers create a lovely enhancement on this portrait.

Helen Lucille Long
1945

Mary Jeannette Efkeman Braun
with younger sister
Helen Virginia Efkeman Hammond.

Top: abt. 1931- Mary at age 10 & Ginny at age 6.

Bottom: abt. 1929 - Mary at age 8 & Ginny at age 4

Intricate acid-free lace photo frames are ideal for showing off your heritage photographs.

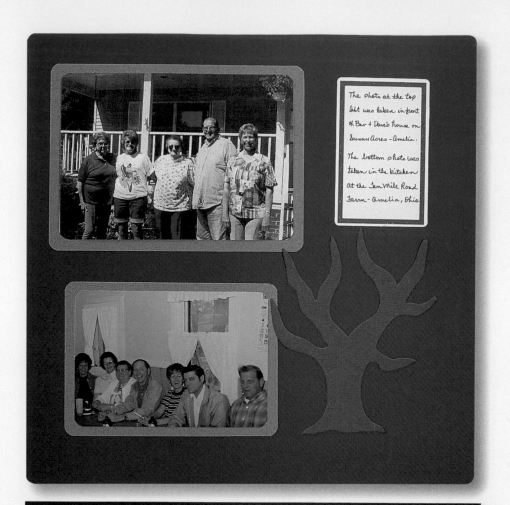

Photos of siblings taken decades apart show how little or how much family members change over the years.

The photo at the top left was taken in front of Bev + Dave's house on Sunny Acres - Amelia.

The bottom photo was taken in the kitchen at the Ten Mile Road Farm - Amelia, Ohio.

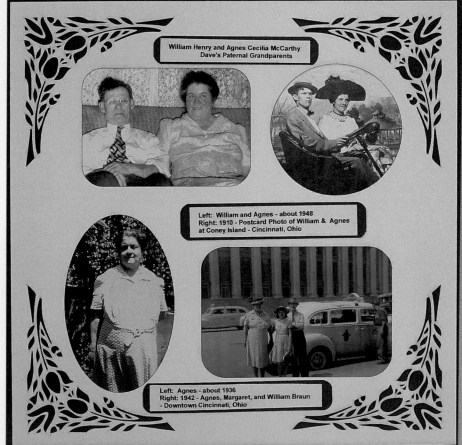

These elegant photo frames make stunning layout pages.

William Henry and Agnes Cecilia McCarthy
Dave's Paternal Grandparents

Left: William and Agnes - about 1948
Right: 1910 - Postcard Photo of William & Agnes at Coney Island - Cincinnati, Ohio

Left: Agnes - about 1936
Right: 1942 - Agnes, Margaret, and William Braun - Downtown Cincinnati, Ohio

Include important details with your photographs to commemorate important events in your ancestor's lives.

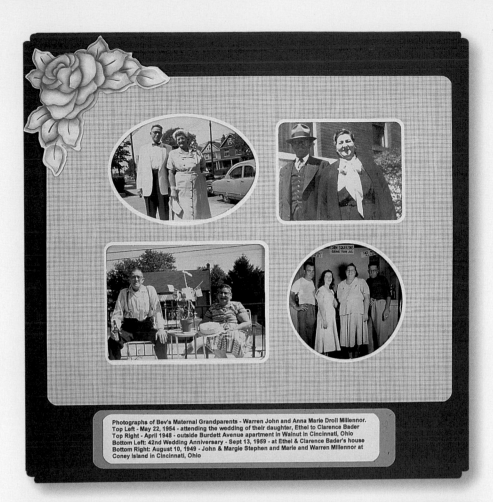

Photographs of Bev's Maternal Grandparents - Warren John and Anna Marie Droll Millennor.
Top Left - May 22, 1954 - attending the wedding of their daughter, Ethel to Clarence Bader
Top Right - April 1948 - outside Burdett Avenue apartment in Walnut in Cincinnati, Ohio
Bottom Left: 42nd Wedding Anniversary - Sept 13, 1959 - at Ethel & Clarence Bader's house
Bottom Right: August 10, 1949 - John & Margie Stephen and Marie and Warren Millennor at Coney Island in Cincinnati, Ohio

The photo in the top right corner of this frame was scanned and cleaned up from an old blackened tintype photograph.

Elizabeth Rheinschmidt Kirschner
Bev's Paternal Grandmother
Photographs taken around Ripley, Ohio abt. 1905-1918

From a Tintype in 1907

With youngest daughters Frances & Edna

Milking the Cow at Logan's Gap

Getting a laugh from 2 of the Gast Boys

Several photographs of one ancestor can be displayed in a collage frame to show a glimpse of the changes over the years.

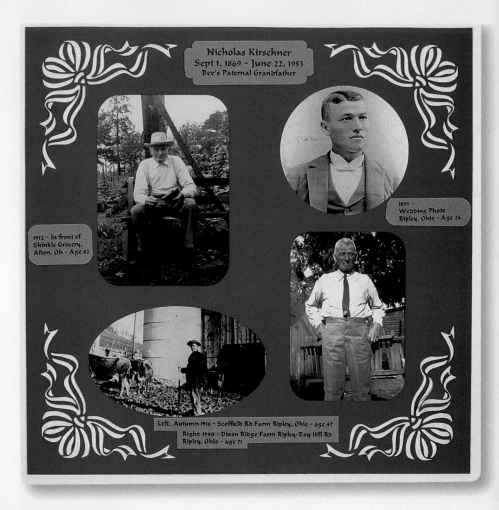

Nicholas Kirschner
Sept 1, 1869 – June 22, 1953
Bev's Paternal Grandfather

1895 –
Wedding Photo
Ripley, Ohio – Age 26

1952 – In front of
Shinkle Grocery,
Afton, Oh – Age 82

Left: Autumn 1916 – Scoffield Rd Farm Ripley, Ohio – age 47
Right: 1940 – Dixon Ridge Farm Ripley–Day Hill Rd
Ripley, Ohio – age 71

A pre-embossed frame with an attractive embellishment offers a striking design to showcase photos.

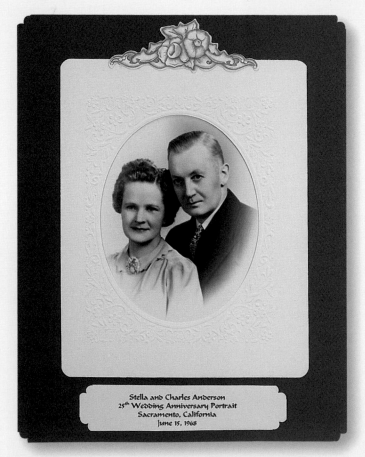

Stella and Charles Anderson
25th Wedding Anniversary Portrait
Sacramento, California
June 15, 1968

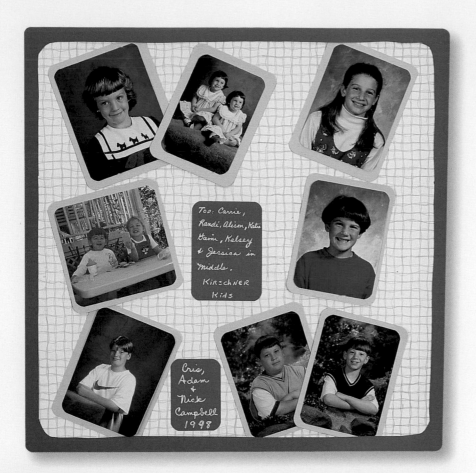

Pictures of the youngest members of the family will become the heritage photographs of the future.

Photocopy magazines and newspaper articles to include on your heritage pages to capture the story behind the memories.

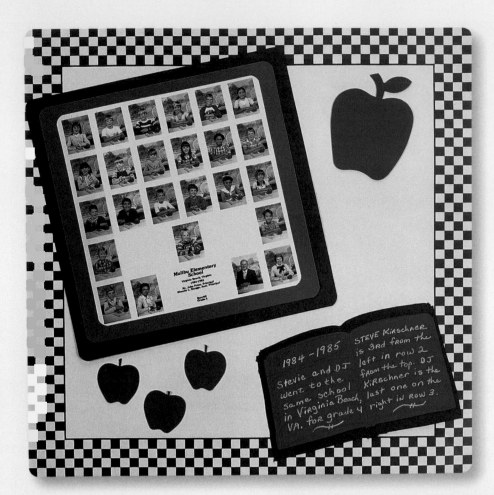

School photographs are an important part of our family history.

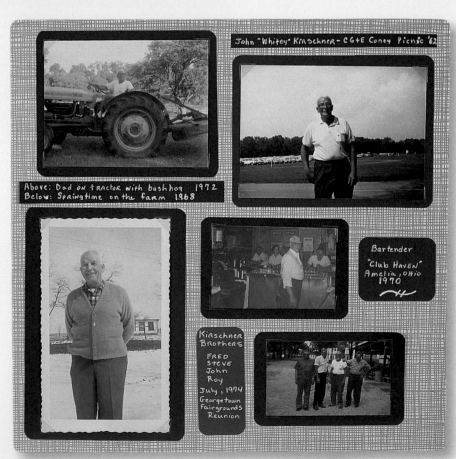

Balancing a layout with lots of photos is easy using the Plan-a-Page templates from EK Success.

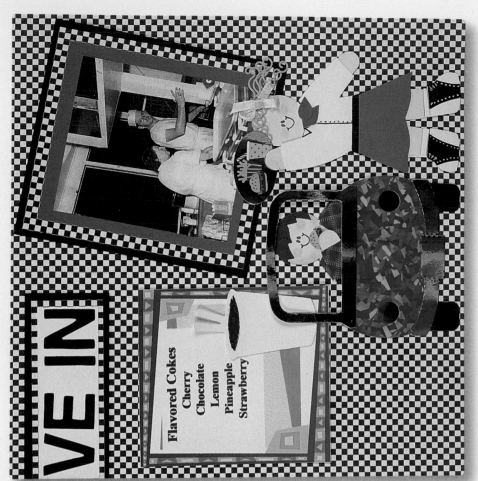

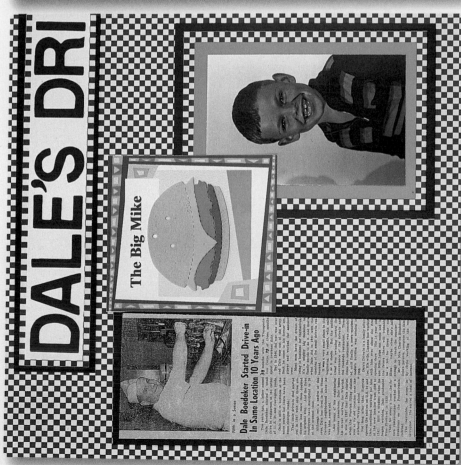

Including photographs and information on a family business is an excellent way of documenting your heritage.

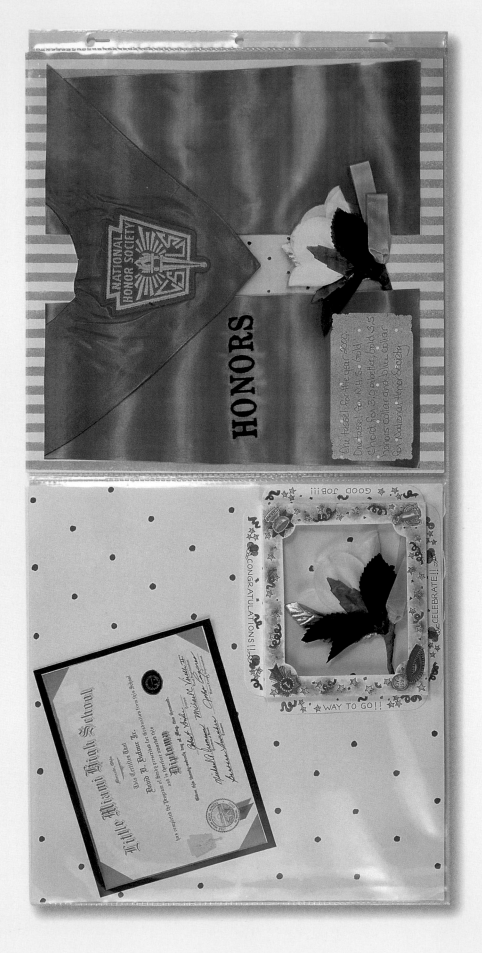

Photocopying memorabilia too large to include in your album captures the essence of significant events and achievements in our lives.

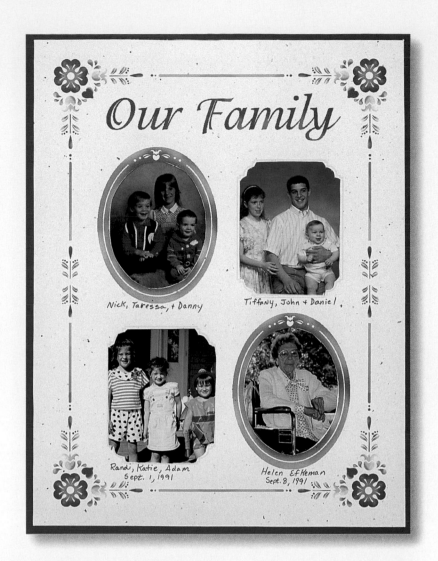

Computer generated layouts offer many choices for your heritage album.

Corner borders printed off a computer add a floral frame to this photo.

Title pages can help keep family history information organized.

The Thomas Calvert Family Heritage Album
Three Generations

Calvert Family and In-Laws:
Back Left: Thomas, Mary Jane, Ella, Sadie Jobs, Clarence Calvert, Ernest Yager, Richard Calvert, John Jobs
Front: Truman Calvert, Libby Yager, Edna and Helen Jobs, Bonnie Calvert.

Photos and information of ancestors' occupations is an important part of documenting your heritage.

Gold Miners in Cripple Creek, Colorado

The photograph above was taken outside one of the many Gold mines near Cripple Creak, Colorado on October 18, 1900. These miners were part of the gold rush days that hit this area and put Cripple Creek on the map in 1890. In 1899, $59 million in gold ore was taken out of the ground and sent out of the camp.

The photo on the right was taken a several years later around the Colorado Springs area.

Miramont Castle - Manitou Springs, CO

Document historical homes and events that hold special memories for you.

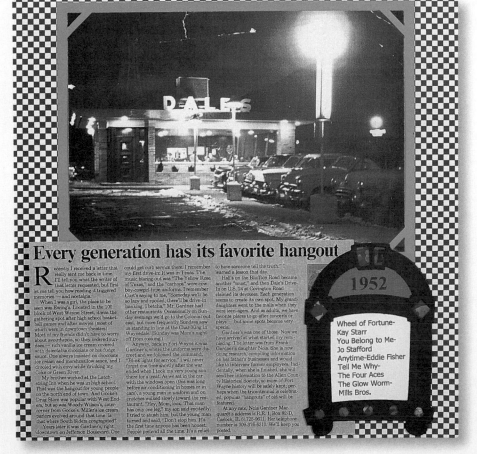

Every generation has its favorite hangout

Color photocopy newspaper articles about family businesses to include in your album for future generations to enjoy.

SCRAPBOOK RESOURCES ❧

The Archival Company
P.O. Box 101
Holyoke, MA 01040
Phone: (800) 442-7576
www.archivalco.com
Materials for the preservation of photos and collectibles, including museum-quality albums, scrapbooks, storage boxes, other holiday gift ideas

Avery Dennison Consumer Service Center
50 Pointe Dr.
Brea, CA 92821
Phone: (800) 462-8379
Fax: (800) 831-2496
www.avery.com
Archival binders, dividers, acid-free sheet protectors

Canson, Inc.
21 Industrial Ave.
South Hadley, MA 01075
Phone: (800) 628-9283
www.canson-us.com
Acid-free paper, archival binders, artistic materials and supplies

Center for Life Stories Preservation
137 Bates Ave.
St. Paul, MN 55106-6328
Phone: (651) 774-5015
www.storypreservation.com
Resource for capturing family and life stories and memoirs. Easy how-to books, plus a web site full of free tips and ideas (interviewing, memory triggering, publishing).

Close to My Heart
1199 W. 700 S.
Pleasant Grove, UT 84062
Phone: (888) 655-6552
Fax: (801) 763-8188
www.closetomyheart.com
Acid-free, lignin-free papers, scrapbook sup-plies, page protectors, rubber stamps and inks

**Cock-A-Doodle Design, Inc./
Topline Creations**
3759 W. 2340 S., Suite D
Salt Lake City, UT 84120
Phone: (800) 262-9727
www.cockadoodledesign.com
Acid-free, lignin-free page toppers, page doodler markers, page frames, page pieces, page pocket guides, page printables

Creative Card Company
1500 W. Monroe St.
Chicago, IL 60607
Phone: (312) 666-8686
Embossed photo frames and mattes, archival paper

Creative Memories
3001 Clearwater Rd.
P.O. Box 1839
St. Cloud, MN 56302-1839
Phone: (800) 468-9335
www.creativememories.com
Direct sales through consultants offering photo-safe scrapbook albums and accessories

Creative Xpress!
295 W. Center St.
Provo, UT 84601
Phone: (800) 563-8679
Fax: (801) 373-1446
www.coluzzle.com
www.creativexpress.com
Award-winning Coluzzle Cutting System, which lets you create custom collage puzzles and photo page layouts from templates

Crop in Style (Platte Productions)
7855 Hayvenhurst Ave.
Van Nuys, CA 91409
Phone: (888) 700-2202
Fax: (818) 700-9728
www.cropinstyle.com
Totes and binders for all your scrapbook supplies

The C-Thru Ruler Company
6 Britton Dr.
Bloomfield, CT 06002
Phone: (860) 243-0303
Fax: (860) 243-1856
www.cthruruler.com
C-Thru rulers, stencils, templates, edgers, 3D Keepers, acid-free alphabet letters

Cut-It-Up
P.O. Box287
Gold Run, CA 95717
Phone: (530) 389-2233
Supply totes for all your scrapbooking supplies, Ruler-It-Up rulers and idea books, creative lettering idea books

EK Success Ltd.
125 Entin Rd.
Clifton, NJ 07014-1141
Phone: (800) 524-1349
Fax: (800) 767-2963
www.eksuccess.com
Zig Memory System and Photo Twin pens, paper shaper punches, memory pencils, Jell-Pop archival pens, adhesives, Border Buddy borders, corners and alphabet templates, Circle Scissor and Circle Ruler

Emagination Crafts, Inc.
463 W. Wrightwood Ave.
Elmhurst, IL 60126
Phone: (630) 833-9521
www.emaginationcrafts.com
Unique collection of paper craft punches, photo-mounting corners and decorative scissors

Epson America, Inc.
P.O. Box 93107
Long Beach, CA 90809-3107
Phone: (800) 873-7766
Fax: (562) 290-4401
www.epson.com
Specialty papers for all home printing projects, plus printers with archival and permanent inkjet cartridges

Family Archives
12456 Johnson St.
Mission, BC
Canada V2V 5X4
Phone: (888) 622-6556
www.heritagescrapbooks.com
The Theorem Collection—acid-free scrapbook accessories designed specifically for black-and-white photos

Family Treasures
24922 Anza Dr., Unit A
Valencia, CA 91355
Phone: (661) 294-1330
Fax: (800) 891-3520
www.familytreasures.com
Scrapbook supplies, punches, corner slots, decorative scissors, albums, stencils, markers, and clip art books

Fiskars, Inc.
7811 W. Stewart Ave.
Wausau, WI 54401
Phone: (800) 500-4849
www.fiskars.com
Paper trimmer, decorative paper scissors, corner edgers, rotary cutters, circle cutter, writing utensils, storage products, photo-memory software

Frances Meyer, Inc.
P.O. Box 3088
Savannah, GA 31402-3088
Phone: (800) 372-6237
Fax: (800) 545-8378
www.francesmeyer.com
Lignin and acid-free heritage themed products, elegant papers, coordinating stickers, alphabet stickers, panoramic page protectors and binders

Gaylord Bros.
P.O. Box 4901
Syracuse, NY 13221-4901
Phone: (800) 634-6307
www.gaylord.com
Archival supply specialists with a complete and comprehensive range of archival and preservation products

Generations by Hazel/Cardinal Brands, Inc.
12312 Olive Blvd.
St. Louis, MO 63141
Phone: (800) 282-7261
Fax: (800) 750-7530
www.fingerfriendly.com
Offers organizers such as the Memory Tote and Crop Station

Gina Bear LLC
P.O. Box 80406
Billings, MT 59108
Phone: (888) 888-4453
Fax: (406) 652-6614
www.ginabear.com
Intricate indivdually cut frames and die-cuts —acid-free, lignin-free

Heartland Paper Co.
616 W. 2600 S.
Bountiful, UT 84010
Phone: (801) 294-7166
www.heartlandpaper.com
Huge selection of archival patterned paper, stickers and photo-crafting supplies

Highsmith Inc.
W5527 St. Rd. 106
P.O. Box 800
Fort Atkinson, WI 53538
Phone: (800) 554-4661
Fax: (800) 558-9332
Acid-free Corruboard Basics scrapbook supply and storage units

Hiller Industries
631 N. 400 W.
Salt Lake City, UT 84103
Phone: (801) 521-2411
Large selection of photo-safe albums

JM Company/Centis
777 Terrace Ave.
Hasbrouck Heights, NJ 07604
Phone: (888) 236-8475
Sheet protectors

Keeping Memories Alive
260 N. Main
Spanish Fork, UT 84660
Phone: (800) 419-4949
Fax: (800) 947-3609
www.scrapbooks.com
Cottage collection memory papers—acid-free and lignin-free; complete line of preservation materials for scrapbooks and memory books, online shopping

Kodak
Phone: (800) 23Kodak
www.kodak.com
Film and photo processing, Kodak Picture Maker System for photo duplicating without negatives

Light Impressions
P.O. Box 787
Brea, CA 92822-0787
Phone: (800) 828-6216
Fax: (800) 828-5539
www.lightimpressionsdirect.com
Offers the world's largest variety of fine archival storage, display and presentation materials for your negatives, transparencies, CDs, photographs, artwork and documents

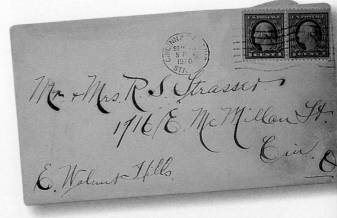

Making Memories
1168 W. 500 N.
Centerville, UT 84014
Phone: (801) 294-0430
Fax: (800) 636-3103
www.makingmemories.com
Embossed frames, creative letters, creative
circle cutter and books

Marco Printed Products Company, Inc.
14 Marco Lane
Centerville, OH 45458
Phone: (888) 433-5239
www.marcopaper.com
Archival paper products

Mary Engelbreit Studios
(314) 726-5646
www.maryengelbreit.com
Unique designs for 6,000-plus retail products
includes paper, albums, rubber stamps,
stickers, greeting cards

McGill Inc.
131 E. Prairie Street
Marengo, IL 60152
Phone: (800) 982-9884
Fax: (815) 568-6860
www.mcgillinc.com
Paper and border craft punches, decorative
scissors, totes for punches and scissors

Me & My BIG Ideas
20321 Valencia Circle
Lake Forest, CA 92630
www.meandmybigideas.com
Acid-free stickers, paper, idea books and a
scrapbook mug

Mrs. Grossman's Paper Company
Petaluma, CA 94955
Phone: (800) 429-4549
Fax: (707) 763-7121
www.mrsgrossmans.com
Acid-free stickers, cards, bags, sticker and
craft kits

Paper Adventures
P.O. Box 04393
Milwaukee, WI 53204-
Phone: (800) 727-0699
Fax: (800) 727-0268
www.paperadventures.com
Acid-free cardstock, albums, adhesives, page
protectors, organizers, and decorative scissors

Paper Reflections/DMD Industries, Inc.
2300 S. Old Missouri Rd.
Springdale, AR 72764
Phone: (800) 805-9890
www.dmdind.com
Wheel punches, bags, papers, memory books

Pebbles in My Pocket
368 S. State St.
Orem, UT 84058
Phone: (800) 438-8153
www.pebblesinmypocket.com
Online store with the newest scrapbooking
products (punches, die-cuts, paper, adhe-
sives, pens, and papers), plus scrapbooking
tips, ideas and layouts

Pillsbury
Number One General Mills Blvd.
Minneapolis, MN 55426
www.pillsbury.com
Classic cookbooks filled with wonderful
recipes and photographs

Pioneer Photo Albums, Inc.
P.O. Box 2497
Chatsworth, CA 91313-2497
Phone: (800) 366-3686
www.pioneerphotoalbums.com
Acid-free memory albums, adhesive mounts,
templates

Plaid Enterprises
P.O. Box 7600
Norcross, GA 30091-7600
Phone: (800) 842-4197
www.plaidenterprises.com
Keepsake Keepers—acid-free, archival-safe
three-hole-punched memorabilia keepers in
two sizes for your scrapbooks for displaying
your 2D and 3D treasures

PM Designs (formerly Puzzle Mates)
417 Associated Rd., #A205
Brea, CA 92821
Phone: (888) 595-2887
Fax: (714) 671-2043
www.puzzlemates.com
Three sizes per set to make quick page
layouts with photographs in a variety
of shapes

Preservation Technologies, L.P.
111 Thomson Park Dr.
Cranberry Township, PA 16066
Phone: (800) 416-2665
Fax: (724) 779-9808
www.ptlp.com
Archival Mist and other products and
services for libraries, archives and now
consumers worldwide

PrintFile, Inc.
P.O. Box 607638
Orlando, FL 32860-7638
Phone: (407) 886-3100
Archival storage products for photo-
graphs, negatives, prints, slides and
transparencies

Provo Craft
151 E. 3450 N.
Spanish Fork, UT 84660
Phone: (800) 937-7686
Fax: (801) 794-9006
www.provocraft.com
Acid-free papers, repositional alphabits,
Coluzzle nested and alphabet templates
system

Therm O Web, Inc.
770 Glenn Ave.
Wheeling, IL 60090
Phone: (800) 323-0799
www.thermoweb.com
Acid-free scrapbook mounting adhesives
and paper

3L Corporation
685 Chaddick Dr.
Wheeling, IL 60090-0247
Phone: (800) 828-3130
www.3lcorp.com
Adhesives, photo corners, Put-in-Strips, archival-safe, self-adhesive pockets that prevent acid-transfer

Tombow U.S.A.
355 Satellite Blvd., Suite 300
Suwanee, GA 30024
Phone: (800) 835-3232
Fax: (678) 318-3347
www.tombowusa.com
Brush markers, adhesives and glues

Uchida of America, Corp.
3535 Del Amo Blvd.
Torrance, CA 90503
Phone: (800) 541-5877
Fax: (800) 229-7017
www.uchida.com
Quality office, craft, and art-related materials

Victoria Larsen Home Decor
1011 W Mukilteo Blvd.
Everett, WA 98203
Phone: (425) 258-6812
Laser Cut Lace Heritage archival-quality products with over sixty styles to choose from

RUBBER STAMP RESOURCES

The Schooner Genealogy Company
(new owners of Rootstamps)
214 Second St.
Smolan, KS 67457-8071
Phone: (785) 668-2175
www.schoonergenealogy.com
Largest line of genealogy rubber stamps in the country, books, CDs, atlases and maps, T-shirts, gifts and more

Stampin' Up
Phone: (800) StampUp
www.stampinup.com
Rubber stamps and supplies, scrapbook supplies available through home-based workshops

SCRAPBOOK-RELATED WEB SITES

Clarke Historical Library Preservation
www.lib.cmich.edu
Designed to help individuals take better care of the things that preserve their memories. This includes information on how to find and use archival-quality supplies, and how to care for letters, diaries, books and other paper memories.

Cropping Corner, The
www.croppingcorner.com
Page layout ideas categorized by themes, products and online shopping, tips and ideas for scrapbookers

dMarie
www.dmarie.com
Thousands of layouts by categories (including a heritage album section), secure online shopping, poems, page toppers, time capsule (historical database of facts to spice up your heritage pages), chat rooms and bulletin boards

Graceful Bee
www.gracefulbee.com
Online scrapbooking magazine with lots of ideas and inspiration, memory preserving plans and timesaving techniques

jangle.com/Accu-cut
1035 E. Dodge St.
Fremont, NE 68025
Phone: (800) 288-1670
Fax: (800) 369-1332
www.jangle.com
Product information, ideas, news, sayings and contests, live chat room, message boards, news, retail directory and a daily tip section

Journals at About.com
www.journals.about.com
Largest collections of journaling information on the Web. Includes sample journaling prompts, articles, links to a variety of journals, online classes, supplies, chat groups and message boards.

Scrapbook Obsession, The
www.geocities.com/Heartland/Ranch/2637
Includes tip and poem of the month, layouts, chat rooms, message boards, and online sentiment greeting cards to send to scrapbooking friends

Scrapbook SuperStore
665 Duluth Hwy., Suite 804
Lawrenceville, GA 30045
Fax: (770) 888-9734
www.scrapbooksuperstore.com
Online store with 4,000-plus products.; weekly specials and very competitive prices on the Internet

Scrapbooking.com
5900 La Place Ct., Suite 105
Carlsbad, CA 92008
Phone: (760) 929-7090
Fax: (760) 929-9978
www.scrapbooking.com
Offers an award-winning, monthly online magazine serving the scrapbooking industry, plus sample layouts, tips and techniques, community events, product reviews and more

Stampin' and Scrappin', Inc.
www.stampinscrappin.com
Online catalog and secure shopping, popular virtual community message forum, convention news, tips, and retail store locator

MAGAZINES

Creating Keepsakes Scrapbook Magazine

955 Borra Place
Escondido, CA 92029
Phone: (888) 247-5282
Fax: (760) 745-7200
www.creatingkeepsakes.com
Ten issues per year filled with layout,
journaling ideas, scrapbook basics, tips, page
makeovers, product reviews

Ivy Cottage Creations Scrapbook Magazine

Ivy Cottage Creations, LLC
P.O. Box 50688
Provo, UT 84605-0688
Phone: (888) 303-1375
Fax: (801) 235-0865
www.ivycottagecreations.com

Memory Makers Scrapbook Magazine

12365 Huron St., Suite 500
Denver, CO 80234
Phone: (800) 254-9124
www.memorymakersmagazine.com
Six issues per year with ideas featuring family
photo journalism, scrapbook ideas and stories

Paperkuts Scrapbook Magazine

P.O. Box 91836
Long Beach, CA 90809-9960
Phone: (888) 881-5861
Six issues per with full-color page layout ideas;
instructions and supply lists for each layout

Personal Journaling

F+W Publications
4700 E. Galbraith Rd.
Cincinnati, OH 45236
www.journalingmagazine.com
Debuted in 2000; deals with all aspects of
journaling

Reminisce and Reminisce Extra

Reiman Publications
5400 S. 60th St.
Greendale, WI 53129
Phone: (800) 344-6913
www.reimanpub.com
Two magazines with six issues each per year
filled with vintage photographs and stories
generally from 1930s, 40s and 50s. These are
ideal gifts for nostalgic friends and relatives

Hoover Auditorium, Lakeside, Ohio

GENEALOGY RESOURCES 🙠

GENEALOGY SOFTWARE

Brother's Keeper
6907 Childsdale Ave
Rockford, MI 49341
http://ourworld.compuserve.com/
homepages/Brothers_Keeper
Shareware (not freeware) genealogy
program to help organize your family history
information and very nice variety of charts
and reports; available for Windows 95, 98,
NT, ME, 2000 or XP; no charge to down-
load trial software; purchase for $45

Family Origins
www.familyorigins.com
Comprehensive but easy-to-use geneal-
ogy software that allows you to store,
organize, and analyze virtually unlimited
information

The Family Tree Maker
Phone: (800) 548-1806
www.familytreemaker.com
Easy to use in Windows and Mac formats.
FTM offers complete web site with online
classes; Internet Family Finder (your
searches locate only genealogical-related
information); over 100 CD-ROMs; how-to
articles and tips for researching;
GenealogyLibrary.com, a subscription serv-
ice that includes online books, databases,
family finding resources, and daily updates.

GedClean32
RaynOrShyn Enterprises
www.raynorshyn.com
A small utility software program that
cleans all information about living
individuals, except name, gender, and
relationships, from your genealogical
database before sharing it with family or
other researchers, submitting it for pub-
lication, or creating a web site from it.
GedClean can be downloaded from the
Internet for a nominal fee.

Generations Grand Suite
Sierra Home
Phone: (800) 757-7707
www.sierrahome.com
Generations Grande Suite—most complete
set of research tools and resources with
twelve CDs containing over 2 million
names, access to over 31,000 genealogy
Web links, Snapshot SE photo-enhancing
software, and MasterCook Heritage Edition
software

Personal Ancestral File (PAF)
50 North West Temple St.
Salt Lake City, UT 84150
Phone: (800) 453-3860 ext. 22331
www.familysearch.org
PAF software from The Church of Jesus
Christ of Latter-day Saints. It may be
downloaded for free or the church plans
to distribute it on CD-ROM for a
nominal fee.

GENEALOGY MAGAZINES

Family Chronicle
P.O. Box 1111
Niagra Falls, NY 14304-1111
Phone: (888) 326-2476
Fax: (416) 491-3996
www.familychronicle.com
Magazine for family researchers, written by
people who share an interest in genealogy
and family history research.

Family Tree Magazine
F+W Publications
4700 Galbraith Rd.
Cincinnati, Ohio 45236
Phone: (800) 289-0963
www.familytreemagazine.com
For genealogists, family historians and
scrapbookers. The web site features an
online bookstore, articles, links to useful
genealogy sites and weekly online news-
letter.

History Magazine
P.O. Box 1111
Niagra Falls, NY 14304-1111
Phone: (888) 326-2476
Fax: (416) 491-3996
www.history-magazine.com
New magazine/web site that debuted in
late 1999, from the publishers of *Family
Chronicle*. The goal is to help researchers
link social history with the lives of their
ancestors.

WEB SITES

Acadian and French Canadian Ancestral Home
www.geocities.com/heartland/pointe.6106/
frames.htm
Includes Acadian and French Canadian
genealogy, history, census records, depor-
tation lists, lists of exiled ancestors, and
some Italian genealogy.

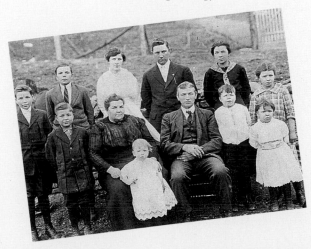

Adoptee Searcher's Handbook—Canada
www.ouareau.com/adoptee/index.html
Not a registry. Site is designed for people
searching on their own. It catalogs other
people's sites under clearly defined chapter
headings.

Adoptees' Liberty Movement Association
The ALMA Society
www.almanet.com
Offers a national registry for adoptees and
birth parents

African American Genealogy
www.coax.net.people/lwf/

Afro-American Genealogical Research
http://lcweb.loc.gov/rr/genealogy/
bib_guid/afro.html
Offers a how-to guide for African-American
Research from the Library of Congress

American Civil War Homepage
http://sunsite.utk.edu/civil-war

Ancestry
Phone: (800) 262-3787
www.ancestry.com
One of the largest collections of family his-
tory data online. New databases and refer-
ence materials are added daily to the library
to provide the fastest, simplest and most
complete resource for family history
research. There are also message boards,
online books, searchable databases, daily
and weekly online newsletters and how-to
articles.

Bureau of Land Management
(Land Records)
www.glorecords.blm.gov
One of the best searchable databases on land
records. Site includes access to more than 2
million federal land sales (patents) and
warrants between 1820 and 1908, which
document land transfers from the govern-
ment to individuals. There is also general
current and historical information about
land ownership and use.

**Census Online—Census Sites on the
Internet**
www.census-online.com
Provides information on how to find a wide
variety of census data online

**Christine's African-American Genealogy
and Black History Web site**
www.ccharity.com
Wealth of African-American resources for
genealogy

Ellis Island
www.ellisisland.org
Over 40 percent of all Americans can
trace their roots to an ancestor who came
through Ellis Island. There were about 12
million immigrants who entered the
United States here between 1892 and
1954. Currently no records to search here,
but if you have an ancestor among the 12
million, it's worth a look. Offers links to
hundreds of ethnic Internet resources.

Family Tree Maker Online
www.familytreemaker.com
Offers online courses for beginners, search-
able databases, downloadable forms, help for
its Family Tree Maker software, over 100
CD-ROMs, articles, and tips for researching.
At GenealogyLibrary.com, a subscription
service offers online books, databases, family
finding resources, and daily updates.

German-American Web Links
www.serve.com/shea/germusa/germusa.htm
Offers links to lots of sites dealing with
German-American history, topics, resources.

Heritage Quest
www.heritagequest.com
Publishers of *Heritage Quest* magazine. Prod-
ucts include the United State's largest pri-
vate collection of more than 250,000 titles
of family history data on microfilm, accord-
ing to Heritage Quest.

LDS Site
www.familysearch.org
The Church of Jesus Christ of Latter-day
Saints Family History Library Records
FamilySearch Internet with four kinds of
searches: Ancestor Search, Keyword
Search, Custom Search, and Browse
Categories. The Ancestral File contains
over 35 million names organized into
families and pedigrees. The International
Genealogical Index (IGI) contains over
600 million names extracted from vital
records around the world. Volunteers
reviewed thousands of web sites and
categorized them to help researchers
find relevant family history information
fast. Site includes online research guid-
ance, glossary and location information
for nearest Family History Centers
worldwide.

**National Underground Railroad
Freedom Center**
www.undergroundrailroad.org
Part of the NURR Freedom Center, sched-
uled to open in Cincinnati, Ohio in 2004,
The Family History Program will bring to-
gether historical records, family stories, and
African-American genealogies. Special areas
of interest include the stories of Under-
ground Railroad conductors, freed and
escaped slaves, white and black indentured
servants, slave owners and slave traders,
black and white abolitionists, as well as
Native Americans who were slaves, were
slave owners, or harbored escaped slaves.

Native American Resources
www.cowboy.net/native/index.html

Pennsylvania Dutch Family History
http://midatlantic.rootsweb.com/padutch
Dedicated to the history, culture and geneal-
ogy of Americans whose ancestors came from
German-speaking countries prior to 1800
and first settled in Pennsylvania.

RootsWeb
www.rootsweb.com
Claims to be the Internet's oldest and
largest genealogy community and is the
home to the RootsWeb surname list of
more than 700,000 entries and offers on-
line genealogical courses and three e-
newsletters

Surname Search

www.surnamesearch.com
Offers loads of links to surname databases and more

USGenWeb Web site (Census Records)

www.usgenweb.net
Very useful and valuable source of information for family researchers. Kentucky volunteers began Census Project in 1997, creating a framework for sharing information via the Internet with others. Now all fifty states, as well as the District of Columbia and the Indian Territory (early Oklahoma), are represented.

Vital Records

www.vitalrec.com
Provides information on where to obtain vital records (such as birth, death and marriage certificates and divorce decrees) from each state, territory and county, including information on the charge for records, the years records are available and the addresses to write. There are links to non-United States vital records sites.

WorldGenWeb Project

www.worldgenweb.org
Not-for-profit project. The goal is to have every country represented by a Web site hosted by researchers based in that country or familiar with its resources. Currently, there are fifteen geographic regions that are then divided into individual countries. All data collected is shared free of charge.

PORTALS AND LINK INDEXES

Cyndi's List

www.cyndislist.com
Absolutely the best site for any researcher when you are not sure where to go to find what you are looking for on the Internet; more than 210,400 links to thousands more

The Genealogy Home Page

www.genhomepage.com
Updated fairly regularly and contains over 4,000 links for general research and to individual family histories

Genealogy Pages

www.genealogypages.com
Broken into fourteen areas from adoption to software

Genealogylinks.net

www.genealogylinks.net
Includes 3,000 pages and over 28,000 links of which most are to ships' passenger lists, church records, cemetery transcriptions, military records and censuses for USA, UK, Canada, Australia and New Zealand.

FAMILY AND FAMILY REUNION WEB SITES

Family Reunion

www.family-reunion.com
Shares tips on how to gather up your long-lost relatives for a reunion and gives great ideas for activities once you get together. Site offers a newsletter, software information, resource guide, reunion locations, and a message board. There are searchable databases.

Hattie's Clothesline

www.hattiesclothesline.com
Offers a leading line of genealogy gifts, such as T-shirts, sweatshirts, coffee mugs, tote bags, and mouse pads for your family reunion or genealogy group

MyFamily.com

www.myfamily.com
An online version of a family reunion. It has a network of family history web sites that include RootsWeb, FamilyHistory.com and Ancestry.com. Site will host your family's page for free, and you give access to anyone you want to. Include photos, set up private message boards, keeps track of birthdays and a variety of other things to stay in touch with family members around the world.

BOOKS

The Complete Idiot's Guide to Genealogy by C. Rose and K. G. Ingalls (Alpha Books) Great guide for beginning genealogy researchers, featuring basic research techniques along with valuable tips on using genealogy computer programs

Cyndi's List
by Cyndi Howells
(Genealogical Publishing Company)
The organized, cross-referenced index to over 40,000 genealogy and family history web sites on the Internet. This is the printed version of Howell's web site to help researchers prepare in advance to make the most of their time online. Just be cautious that as fast as the Internet changes, the printed version may contain sites that are no longer available, but it is still an invaluable tool, especially to those who have to pay for Internet connectivity by the minute.

Genealogist's Guide to Discovering Your Immigrant and Ethnic Ancestors
by Sharon D. Carmack (Betterway Books) Some of this author's other genealogy books: *Discovering Your Female Ancestors* and *Organizing Your Family History Search*. She is a certified genealogist and her books provide specialized guidance for uncovering new sources, documenting what you find, and organizing your research.

Genealogy Online for Dummies
by M. L. Helm and A. L. Helm (IDG)
A book on how to use the Web to begin or expand the search for your family history. This is an excellent introductory guide to genealogical research online. It explains how to use a home computer to maintain and publish your genealogy information.

Handybook for Genealogists
Everton Publishers
Great sourcebook for working with various government records (federal, state, and county) for genealogical research. This reference book lists each state and all its counties that ever existed with details including name, map index reference number, date created, population per latest census, dates, U.S. Census Reports available, parent county or territory from which organized, county seat including zip code (for requesting copies of documents). This book is must-have for all levels of researchers.

The Internet for Genealogists
by B. Renick and R. Wilson (Compuology)
Completely revised and updated guide. It is a well-written, easy-to-understand beginner's guide to the world of online resources for searching your family history on the Net. Included are more than 200 addresses to genealogy sites, maps, gazetteers, bookstores, libraries and catalogs.

Netting Your Ancestors: Genealogical Research on the Internet
by Cyndi Howells
(Genealogical Publishing Company)
Designed to help you make the most of the Internet as a research tool. Cyndi Howells is the creator of the award-winning web site Cyndi's List of Genealogy Sites on the Internet. This book is a definite must-have for all those who are interested in using the Internet as a research tool to the fullest extent.

Searching for Your Ancestors: The How and Why of Genealogy
by Gilbert Doan and James Bell
(Univ. of Minnesota Press)
Offers step-by-step guidance to help you construct a family tree; uses new computer research methods to trace elusive ancestors. It includes information to help you utilize Family History Center, Library of Congress's Local History and Genealogy Room, National Archives, and regional public libraries.

GENEALOGICAL SOCIETIES AND ORGANIZATIONS

The Afro-American Historical and Genealogical Society
P.O. Box 73086
Washington, DC 20056-3068
www.rootsweb.com/~mdaahgs/index.html
Group of historians and genealogists dedicated to sharing resources and methodology in pursuing historical and genealogical research of all ethnic groups with special focus on African Americans. AAHGS publishes a journal semiannually and a bi-monthly newsletter, *AAHGS News,* and holds quarterly meetings, present special programs and conducts annual conference.

Federation of Genealogical Societies (FGS)
P.O. Box 200940
Austin, TX 78720-0940
Phone: (888) FGS-1500
Fax: (888) 380-0500
www.fgs.org
E-mail: fgs-office@fgs.org
A nonprofit nationwide organization and great source to locate a genealogy society in a geographic locale that you are doing research in. It has over 500 member societies in Canada and the United States. It sponsors a national conference each year for genealogists of all levels of experience.

The National Genealogical Society (NGS)
4527 17th Street North
Arlington, VA 22207-2399
Phone: (800) 473-0060
Founded in 1903 and continues to assist members in researching family histories. NGS serves over 17,000 members including individuals, families, genealogical societies, family associations, libraries, and other related institutions. It offers accredited on-line courses for beginners and experienced researchers, plus a beginner's kit, online forms and research aids.

LIBRARIES AND ARCHIVES

The Allen County Public Library
200 E. Berry St.
Fort Wayne, IN 46802
Phone: (260) 421-1200
www.acpl.lib.in.us
One of the best genealogical libraries in the United States. The site includes information on the holdings available at the library. Check some of this information before visiting the library to plan your strategy. You can search its electronic databases with a valid Indiana library card available to non-Indiana residents, too.

Library of Congress
www.loc.gov
Provides a variety of services via the Internet, including the library catalog, FTP service, discussion groups, and guides to resources on the Internet. The library serves as the research arm of Congress and is recognized as the national public library of the United States. Its extensive collections include published manuscript and microfilm works, as well as numerous finding aids and subject bibliographies that describe its holdings.

National Archives and Records Administration (NARA)
8601 Adelphi Rd.
College Park, MD 20740
Phone: (866) 272-6272
www.nara.gov
An independent federal agency that helps to preserve our nation's history by overseeing the management of all federal records. Location in Washington, DC, has research rooms and 13 regional service facilities in the United States with countless records useful for genealogical research.

MILITARY RECORDS AND HISTORY SITES

About.com Genealogy—Military Genealogy Resources
http://genealogy.about.com/hobbies/ genealogy/cs/military/index.htm
Military resources categorized by conflict, including histories of battles and battlefields, online veterans' memorials, soldiers and their military units, how to find records of your veteran ancestors.

A Guide to Military Information for Genealogists
http://geneasearch.com/military.htm
A source to numerous military-related websites for genealogy information on the Internet

The National Archives and Records Administration (NARA)
www.nara.gov/research/ordering/milordr.html
The official repository for records of military personnel who have been discharged from the U.S. Air Force, Army, Marine Corps, Navy and Coast Guard

The National Park Service
www.nps.gov
Provides information on all National Parks, historical and educational information, online bookstore, "This Day in History" link, information on collaborative projects involving the NPS with governmental and private organizations and businesses. It is a good place to find information and fill in specific historical details when journaling in your heritage album.

Naval Historical Center
www.history.navy.mil
Provides interesting information about various facets of current and historical naval life, including help for writing your own naval biography

U.S. Army Center of Military History
www.army.mil/cmh-pg
A good source of information about getting your own or an ancestor's military records, unit records and more

The U.S. Civil War Center
Louisiana State University
Raphael Semmes Dr.
Baton Rouge, LA 70803
Phone: (225) 578-3151
Fax: (225) 578-4876
http://www.cwc.lsu.edu/
Provides a center to promote the study of the Civil War from the perspectives of all professions, occupations and academic disciplines. Site does not contain genealogical records but provides links to over 5,500 Civil War-related sites.

PHOTOGRAPHS AND CONSERVATION

City Gallery
www.city-gallery.com
Full of helpful hints for researching old photos, building a family album online, identifying old photos and restoring photos, including advice on using a scanner. If you have or are searching for old photos, you can share them with others online.

Conservation Resources Intl., LLC
5532 Port Royal Rd.
Springfield, VA 22151
Phone: (800) 634-6932
www.conservationresources.com
Offers conservation products and technical information online

An Ounce of Preservation: A Guide to the Care of Papers and Photographs
by Craig A. Tuttle (Rainbow Books, Inc.)
Clear and concise guide on how to care for and preserve papers and photographs. It will also help you determine what type of old photographs you have and what time period they may be from.

The Photo Scribe—A Writing Guide: How to Write the Stories Behind Your Photographs
by Denis LeDoux (Soleil Press)
Practical step-by-step guide that can enable anyone to discover the depth of her memories; helpful for anyone creating a scrapbook.

Uncovering Your Ancestry Through Family Photographs
by Maureen Taylor (Betterway Books)
Step-by-step guide that shows you how to unlock the valuable stories and ancestral information hidden within the details of your family photos by genealogical photo expert Maureen Taylor

OTHER

Austrian National Archives
(Emigration records from 1861 to 1919)
Abteilung 1: Haus-, Hof- und Staatsarchiv
Bibliotheck, Minoritenplatz1,
A-1010 Vienna, Austria

Databases for the Study of Afro-Louisiana History and Genealogy, 1699-1860: Computerized Information from Original Manuscript Sources (CD-ROM)
(Lousiana State University)
This CD-ROM provides an exceptional research tool of well over 100,000 records from numerous civil documents, published census records and manuscripts to provide an unprecedented look into the lives of Africans, peoples of African descent in Louisiana, their owners and freers from earliest colonial times through 1860.

National Archives of the Federal Republic of Germany (since 1945)
Bundesarchiv, Portsdamer
Strasse 1, Postfach 320 D-56003
Koblenz, Germany
www.bundesarchiv.de

Swiss National Archives
Archivstrasse 4
CH-3003 Bern, Switzerland

GLOSSARY

SCRAPBOOK AND ARCHIVAL TERMS

Acid-free
Materials that have a pH of 7.0 or higher. This term indicates the absence of acid, which can quickly break down paper and photographs. This term is sometimes used incorrectly as a synonym for *alkaline* or *buffered*.

Acid migration
The transfer of acid from an acidic material to a less acidic material or pH-neutral material. Acid always migrates to neutral, never the other way around.

Archival quality
Indicates a material or product is permanent, durable or chemically stable, and that it can, therefore, safely be used for preservation.

Buffered paper
A paper that is pH neutral to begin with and has been made more alkaline to neutralize additional acids that may migrate to the paper.

Cropping
Cutting or trimming a photo to keep only the most important parts of the image and eliminate distracting backgrounds.

Journaling
Text on a scrapbook page giving details about the photographs. It can be done in your own handwriting, by computer or with adhesive letters, rub-ons, or stencils. This is the most important part of the heritage albums.

Lignin
Largely responsible for the strength and rigidity of plants. Its presence in paper is believed to contribute to chemical deterioration. Paper with less than 1 percent lignin is considered lignin-free. Lignin is believed to be more harmful to photographs than acid.

Mylar
Polyester or polypropylene, used as a protective clear covering for photos and album pages. Mylar is currently regarded as the highest-quality material used for this purpose.

Photo safe
A term loosely used by many companies to indicate that they feel their products are safe to use with photographs. Acid-free is the determining factor for a product to be labeled photo-safe.

Polyvinyl Chloride (PVC)
A substance found in some plastic products and adhesives that can break down to form acids.

GENEALOGY AND INTERNET TERMS

Abstract
Summary of a document or record that maintains every pertinent detail, such as the date of the record, every name appearing on the original, the relationship of each person named (if stated) and the individual's description (e.g., witness, executor, widow, etc.), and whether the person signed with a signature or mark.

Ancestry
All of your ancestors from your parents as far back as they are traceable.

Browser
Short for Web browser, it's the tool that allows you to surf the Web. The most popular Web browsers right now are Netscape Navigator and Internet Explorer.

Census records
An official account of the population in a particular area.

Citation
Form notation of the source from which the information was taken. In genealogy research, each fact needs at least one citation.

Cyberspace
Term used to describe the Internet.

E-mail (electronic mail)
Messages sent from one person to another electronically over the Internet.

FAQ
Acronym for Frequently Asked Questions.

Forum
An electronic meeting place where messages can be exchanged.

GEDCOM
A standard file format used for exchanging data between different genealogy databases and programs.

Heritage
Something handed down from one's ancestors or from the past, such as a culture, characteristic, tradition, etc.

HTML (Hypertext Mark-up Language)
Not really a programming language, but a way to format text by placing marks around the text. HTML is the basis for most web pages.

Http (Hypertext Transfer Protocol)
A protocol that tells computers how to communicate with each other. Most web page locations begin with http://.

Internet
A system of computer networks joined together by high-speed data lines called backbones.

ISP (Internet Service Provider)
Your connection to the Internet. You use an ISP to connect onto the Internet every time you log on.

Link
Transports you from one Internet site to another with just a click of your mouse. Links can be text or graphic and are recognizable once you know what to look for.

Location
An Internet address.

Maternal line
Line of descent traced through the mother's ancestry.

Modem
Allows computers to transmit information to one another over an ordinary telephone line.

Net
Short for Internet.

Online
Having access to the Internet.

Patent
A government grant of property in fee simple to public lands; land grant.

Paternal line
Line of descent traced through the father's ancestry.

Personal Web page
A page on the World Wide Web that was designed and posted by an individual or family.

Portal
Like a gateway or entryway to the Internet. Most portals provide the user with lots of information choices and you do not necessarily have to leave the portal site to go to any other sites.

Site
A place on the Internet. Every Web page has a location where it resides, which is called its site. And every site has an address usually beginning http://.

Surname
Last name, family name.

URL (Uniform Resource Locator)
Address of each web site. It usually begins with http://.

WWW
An acronym for the World Wide Web.

Warranty deed
Guarantees a clear property title from the seller to the buyer.

Web
Short for World Wide Web.

Web page
Also called a home page, a multimedia document that is created in HTML and is viewable on the Internet with the use of a browser.

World Wide Web
A multimedia database of information on the Internet. Like the name implies, the World Wide Web is a universal mass of web pages connected through links.

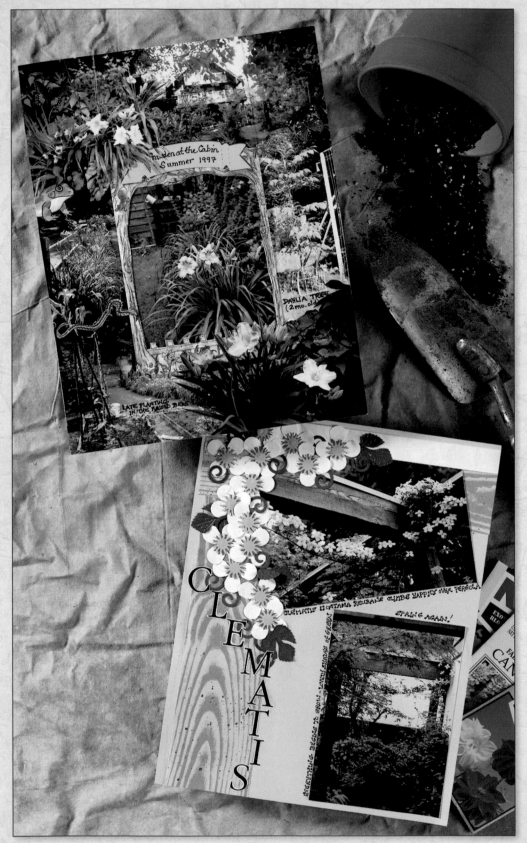

Pg 214

The *Best* of •MEMORY• MAKERS

OUTSTANDING SCRAPBOOK PAGES

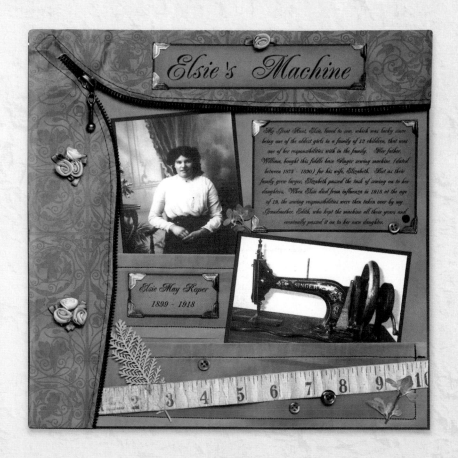

MEMORY
MAKERS
BOOKS

TABLE OF CONTENTS

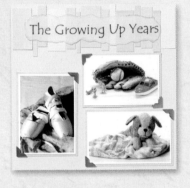

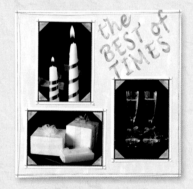

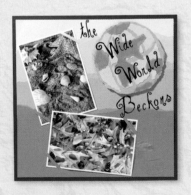

INTRODUCTION

The Best of Memory Makers *Outstanding Scrapbook Pages* was conceived as a tribute to those scrapbookers who have invested their time and talent in the creation of scrapbook pages which they graciously shared with *Memory Makers* readers over the years. From the first issue of our magazine in 1996, through issue #37 seven years later, we have showcased scrapbook art that pushes the envelope creatively, defining new standards for the craft and stirring the heart.

The decision to create this book was far easier than the actual selection of pages to be included. All art featured in the magazine over the years has been special and therefore narrowing down the pages to a precious few was somewhat like asking a parent to choose a favorite child. It was a task too large for any one person, and so the selections were made through committee.

Staff members reviewed every page of every issue of *Memory Makers* magazine. The process sucked us into a flood of nostalgia. I remembered photographing our very first cover featuring two scrapbook pages set artfully among a pile of apples. I recalled wondering what I was going to do with all those apples when the shot was complete! I imagined I could still smell the flowers used on the cover of issue #2 and reflected on cherished friendships developed with creators of different pages. I recalled crying with a scrapbooker over the story behind her photos. I remembered watching an artist skillfully working on a detailed border…

Memory Makers staff voted on favorite scrapbook pages. It was a challenge to weigh the merits of an early page made back in the days when supplies were limited and scrapbookers were just beginning to explore the art form, with today's cutting-edge art. Selections were ultimately chosen based on a wide range of criteria: Did the page impact scrapbooking trends? Was an extraordinary technique applied? Were the photos exceptional? Was the journaling memorable? Was the page uniquely designed? Was there a special something about the page that made it stand out?

The experience in creating this book has been satisfying for all of us at Memory Makers. It has been a trip down Memory Lane. We invite those of you who walked this path with us throughout the years to enjoy this nostalgic look back over the shoulder. Your passion for the preservation of life's moments has contributed to this book. And it is your passion that will mold the future of scrapbooking just as the pages you share with us will ultimately mold the future of our magazine and books.

These outstanding pages are sure to inspire us all.

Enjoy!

Michele

Michele Gerbrandt

The Growing Up Years

WONDER flows from a child's face when she looks at the captivating world crying out to be explored and conquered. Wonder fills a parent's heart as she watches her babbling infant grow into a confident young adult ready to take on life's challenges. Photos that capture the world through a child's eyes and those that capture the child through her parents' are held forever on scrapbook pages. Whether vibrant as a playtime giggle or as subdued as a sleepy sigh, pages featuring children are sure to capture the uniqueness of the individual boy or girl and the unspeakable love of the parent.

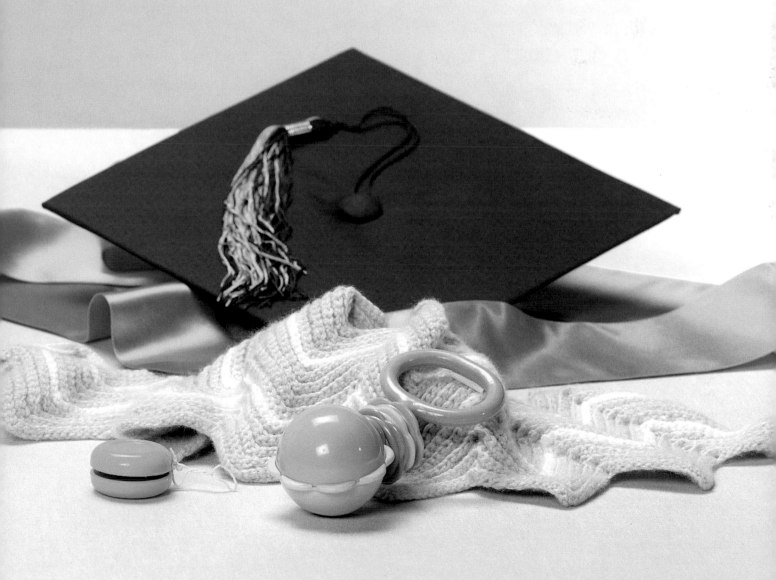

INFANTS AND TODDLERS

Babies grow and change so rapidly that what once were vivid memories of baby's birth, toothless smiles, hesitant steps and babbling words quickly merge into a blurry montage of vague recollections.

Unforgettable baby pages bring moments from this foggy past into a sharp focus that clearly portrays the physical, emotional and spiritual facets of a young and cherished personality.

TEN TINY FINGERS AND TOES
September/October 1998
Issue #8
Kristi Hazelrigg, Washington, Oklahoma

Wanting to capture her daughter's pretty hands and feet, Kristi snapped these photos when her daughter Alison was just four months old. The black-and-white shots have a universal appeal to anyone who has experienced the wonder of little baby fingers and toes. Simple embellishment keeps the focus on the photos.

FIRST PORTRAIT
March/April 2003
Issue #35
Nicole Keller, Rio Hondo, Texas

An easy mosaic design, accomplished with square and flower punches, provides an appealing frame for this chalk-tinted newborn portrait. The soft pastel shades and patterns add both color and contemporary flair to the timeless appeal of the black-and-white photo.

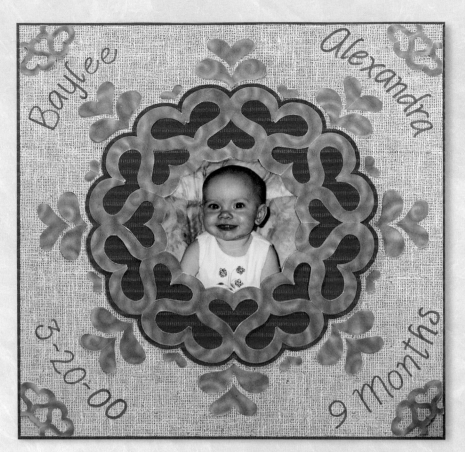

BAYLEE ALEXANDRA
January/February 2001
Issue #22
Memory Makers
Idea inspired by Heather Coffin,
Spring Hill, Florida

Created in only a few minutes by die cutting a letter S into a specially folded sheet of paper, this intricate heart design is a stunning way to frame any photo. Heather Coffin of Spring Hill, Florida, discovered the technique while experimenting with a die-cutting machine. This interesting die-cut method is among many first introduced in the pages of *Memory Makers*.

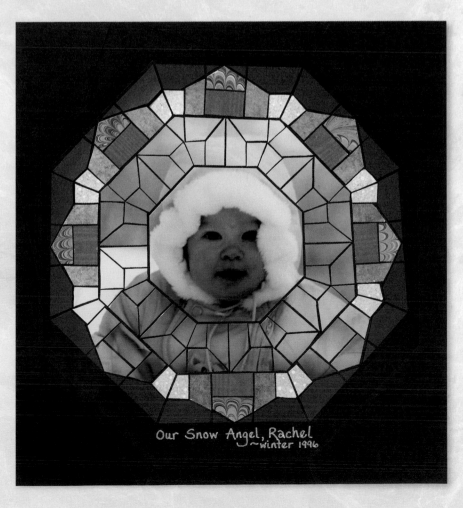

Our Snow Angel, Rachel
~winter 1996

OUR SNOW ANGEL
Holiday/Winter 1997
Issue #5
Joyce Feil, Golden, Colorado

The art of stained glass combines hundreds of glass pieces in a masterpiece of color and light that brilliantly glows within a framework of woven lead. Like many art forms, stained-glass concepts can be easily adapted to scrapbook layouts. This octagon design, inspired by a stained-glass pattern book, incorporates both a photo and complementary papers into its striking symmetrical arrangement.

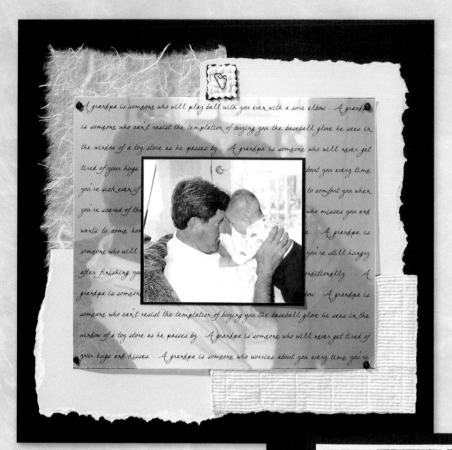

MEETING GRANDPA WEBB
May/June 2002
Issue #30
Tanya Webb, Tigard, Oregon

A monochromatic palette of soft yellows unifies this contemporary layout through various textures of handmade paper and black-and-white candids unconventionally tinted in the background. Wire accents and thorough computer journaling further accentuate the modern design. A photo enlargement, layered beneath computer-printed vellum, frames the same snapshot and provides perhaps the most dramatic yet subtle design element.

Meeting Grandpa Webb

Month 7

It was exciting to have Carter meet Grandpa Webb for the first time and seeing the two generations together. It was disappointing that Grandpa's visit lasted only a few days, but it meant so much to have him here and we were so glad that he could spend some time with his grandson. What I remember most about his visit was that he kept commenting about Carter not crying. He said that while he was here, he never heard him cry once which was the way Carter was during his first six months. From the time that Carter was about six weeks he rarely cried except when he wasn't feeling well. Even when he did cry, it didn't seem loud at all. The funny thing was that as soon as Grandpa left Carter became extremely vocal. He not only started really babbling but he also cried more and it seemed louder. So, while he discovered his voice, it was as if we heard his cry for the first time.

Natural Woman
November/December 2002
Issue #33
Anne Heyen, New Fairfield, Connecticut

Anne gave birth to her son Daniel after being told she could never get pregnant again. She says this Carole King song reflects not only her love for Daniel but also the Mother's Day photo taken "au naturel." Textural heart elements made from materials as varied as cork, raffia, jute and metal enhance a delightful mother-son love theme.

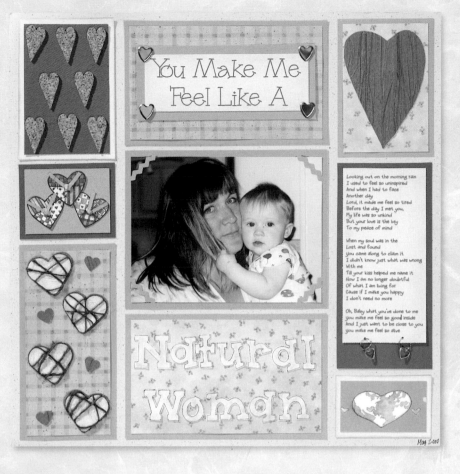

Me & My Dad
January/February 2002
Issue #28
Memory Makers
Photos Diana Bolinger

Because the hand-tinted, deckle-edged photos look so authentically vintage, this page's calendar date at first glance prompts a double take. Complemented by 1950s stripes, plaids and solids, the father-son candids give the impression that Daddy just pulled into the driveway in his '57 Chevy and stopped on the front step to greet little Johnny. Whimsical title lettering and a paper-pieced hat fit the old-fashioned illusion.

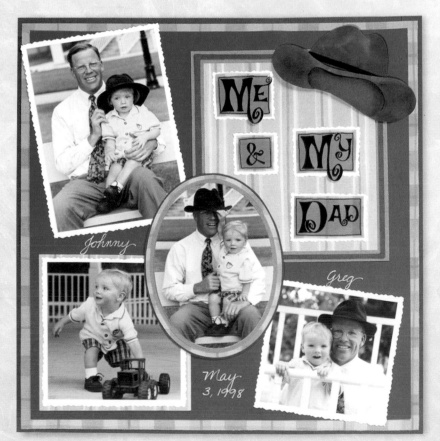

CHILI PEPPER BABY
September/October 1999
Issue #14
Rebecca Hanson, Gilbert, Arizona

Photographer Anne Geddes has inspired perhaps millions of photos mimicking her famous shots of babies dressed as flowers, animals, insects, fruits and vegetables. Inspired by Geddes' imaginative scenes, this page combines silhouette-cropped Halloween photos, vivid die cuts and thin tan strips to create the illusion of a braided chili pepper garland. The contrast between the red and green draws the eye to the cherubic baby faces.

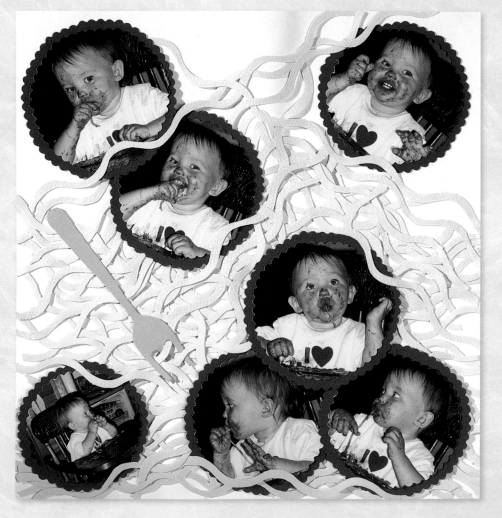

SPAGHETTI AND MEATBALLS
September/October 1998
Issue #8
Joanna Barr, Lowell, Michigan

Scalloped meatball photos tossed among piles of wavy noodles are the perfect recipe for this delicious page. Inspired by a baby's unforgettable spaghetti-smeared face, the cream-colored pasta provides both dimension and movement without overpowering the photos.

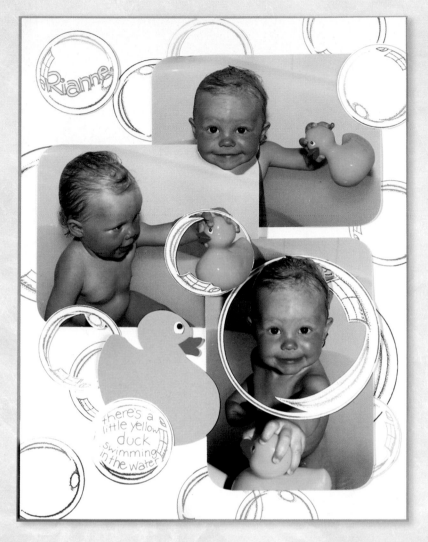

LITTLE YELLOW DUCK
September/October 1999
Issue #14
Cathie Allan, Edmonton, Alberta, Canada

Thin and delicate bubbles, simply stamped and cut out, not only provide a unifying design element but also fill this page with a sense of fun and adventure. Creative cropping and layering techniques lead the eye from the floating face near the upper edge down to the bubble-framed yellow duck and contented bath baby. Careful placement of the photos and paper-cut yellow duck reinforce this visual path.

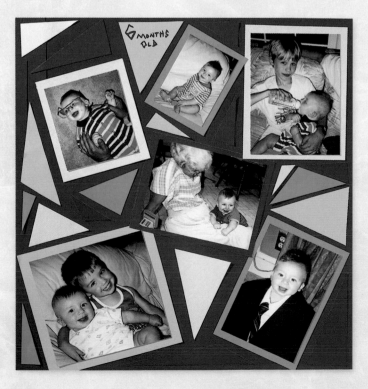

6 MONTHS OLD
September/October 1998
Issue #8
Denise Bennett, Midland, Georgia

A little boy's energy, vitality and joy are mirrored in the bold colors and geometric shapes that surround these baby photos. The stained-glass design is simple to create by arranging matted photos on a dark background and filling in with colored triangles. One straight photo anchors the page while the remaining snapshots are placed askew for a sense of whimsy and movement.

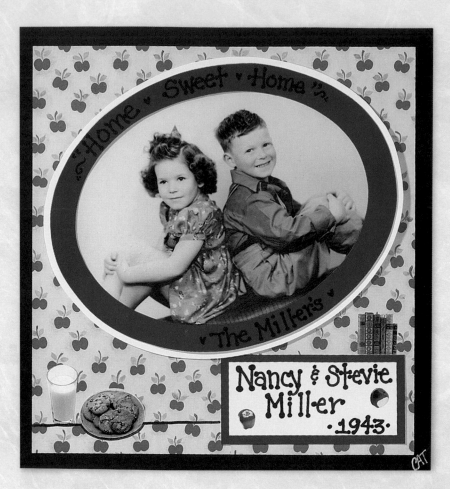

NANCY & STEVIE MILLER
July/August 2000
Issue #19
Cheryl Thomas, Highland, California

A classic black page wallpapered with folk-art apples makes this appealing heritage portrait look like it could be hanging in Grandmother's kitchen. Creamy white milk and homemade cookies along with carefully arranged schoolbooks further convey an all-American-kids theme, while simple lettering embellishments complete the old-fashioned country look.

FAMILY TRAITS
May/June 2002
Issue #30
Christina Chrushch, Rocky Mount, North Carolina

Family resemblances are strikingly apparent in this father-and-sons triptych created using photo editing software. With five carefully selected paper mats, the black-and-white portraits stand out against a background of rich navy and maroon. Downloaded computer fonts, letter stickers and padded adhesive are other modern conveniences that contribute to the balanced design.

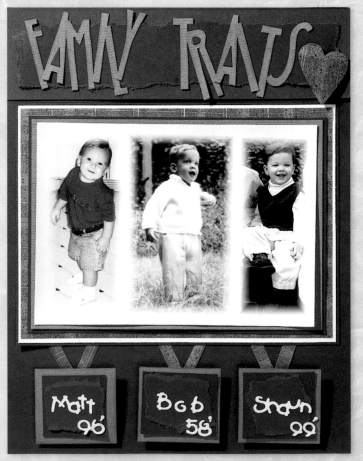

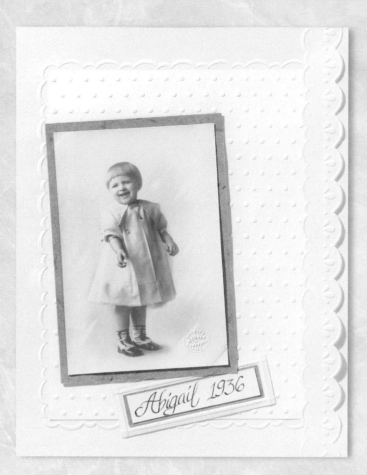

ABIGAIL 1936

Spring 1998
Issue #6
Memory Makers

Brass template embossing is one ideal solution for the perpetual scrapbooking problem of how to appropriately embellish heritage photos. The technique is easy enough for even a child to accomplish and requires only a light box, embossing template and stylus. The elegant tone-on-tone texture yields an almost irresistible temptation to rub the bumpy embossed surface.

1948

July/August 2000
Issue #19
Nadine Babbitt, San Diego, California

Nadine saved this lock of hair from her first haircut for about 50 years before encasing it on this page. Although the memorabilia pocket is modern, the retro lettering style, pink and black colors and checkerboard pattern instantly set the vintage photograph in its late 40s time-frame. The freehand-cut polka-dot bow and silver scissors add bold thematic elements. Even the black photo corners, here used as embellishments rather than to hold photos, recall the old-fashioned scrapbooks that might have previously held the vintage photo.

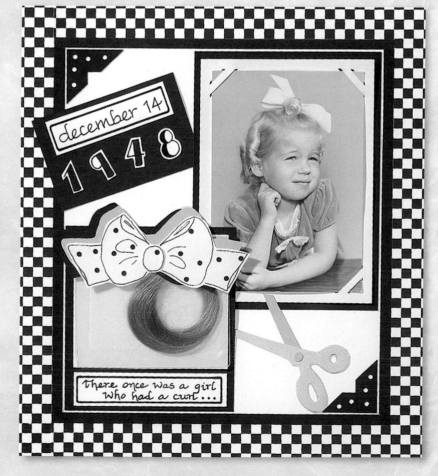

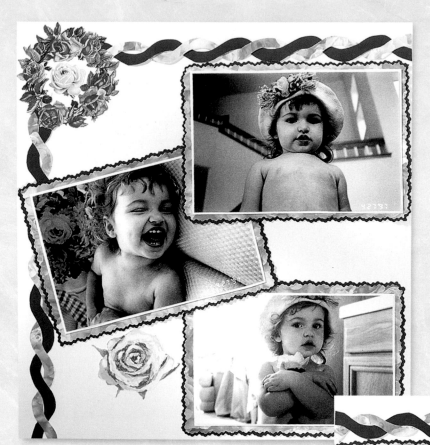

FLOWER GIRL
Spring 1998
Issue #6
Debbie Hewitt, Agoura, California

Just six black-and-white candids portray myriad facets of this captivating young personality—shy youth, giggling toddler, Daddy's girl or just a kid with an attitude. The simple border, woven from long wavy strips layered with floral stickers, accentuates the hand-tinted color and effectively frames the layout.

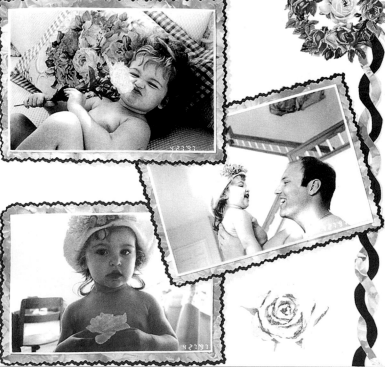

SUNMAID® SWEETHEART
March/April 1999
Issue #11
Johanna Large, Bloomington, Illinois

Although the raisin box held by Johanna's daughter was actually a bribe to get her to smile, it prompted this instantly recognizable design. The accurate rendition of the raisin box logo, lettering and colors imparts a sense of realism to the larger-than-life photo frame. Added details of the child's "net age" and personal journaling tell a sweet story.

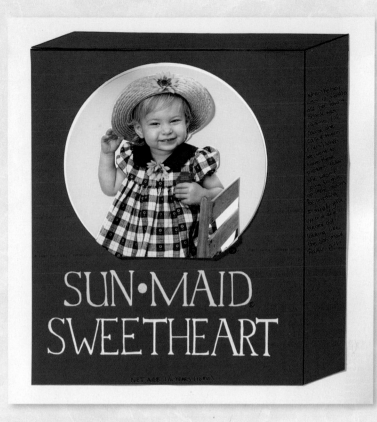

HILTON BEACH
July/August 2000
Issue #19
Jenny Lowhar, Miami, Florida

A bold spiraling sun perched above an ocean painted with shades of blue raffia provide strong graphic elements to both complement and balance the vivid beach candid. The end result is an impressionistic effect that keeps the layout simple while adding both texture and dimension.

A LOOK BACK: *Scrapbooking With Paper Dolls*

In the beginning, there were paper and scissors, the main tools available to make paper dolls. By the spring of 2002, when *Memory Makers Creative Paper Dolls* special edition was published, the scrapbook market was bursting with an enormous variety of paper doll products. Die cuts, templates, preprinted dolls, patterns, computer software, paper-piecing kits, stickers and punches now make it easy to customize a paper doll to match the theme, colors and mood of any layout.

The fun of paper dolls encompasses not only the simple pleasure of dressing a human figure and adding details to create an individual personality. For scrapbookers, paper dolls also offer a universal language that can write a visual story about human activity, emotion and relationships. This versatility gives paper dolls an appeal that will far outlast any scrapbooking fad.

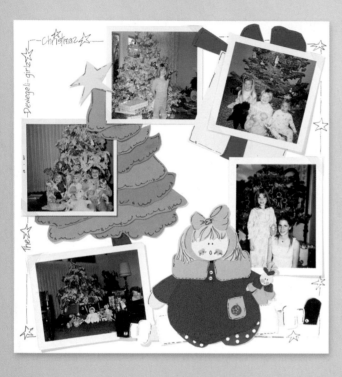

RAG DOLL
Winter 1997
Issue #2
Lorna Dee Christensen, Corvallis, Oregon

Simple pen work injects personality into a rag doll freehand cut and pieced from colored art paper. In addition to stitch lines on the clothing and highlights on the hair, two dots and a little round O are the perfect details to create a charming face. The old-fashioned figure brings life to the 1960s-era photos.

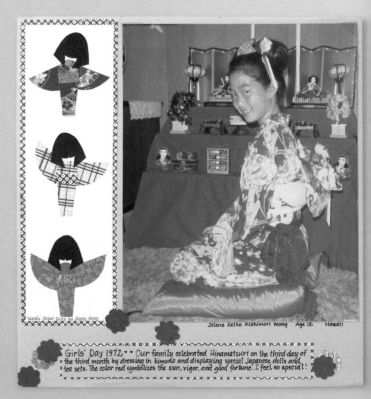

GIRLS DAY
January/February 1999
Issue #10
Jolene Keiko Wong, Monterrey, California

Adorned in colorful washi paper, abstract Japanese paper dolls stand with arms upraised to celebrate Girls' Day with a softly smiling maiden. The angelic poses of these abstract figures reflect her innocence and beauty, while their red kimonos convey a cultural message symbolizing the sun, vigor and good fortune.

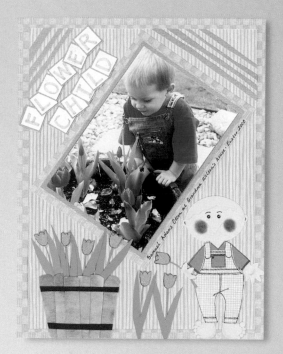

FLOWER CHILD

March/April 2001

Issue #23

Barbra Otten, Durand, Michigan

Spring brightly blooms in a paper doll scene that replicates each element of a vivid Easter photo. The aged flower barrel bursts with pink tulips, the rosy-cheeked die-cut doll is dressed to match the curious toddler, and circle punches provide tiny toes for his pudgy bare feet. The scene effectively expands the world of the photo beyond its physical borders.

MARY KAY LADIES

March/April 2002

Issue #29

Kathleen Childers, Christiana, Tennessee

Readily available body and hair die cuts jump-start a paper doll design while leaving room for custom details. In this case, matching outfits and heavy makeup accentuate the humor of the beauty queen snapshots and faked business card.

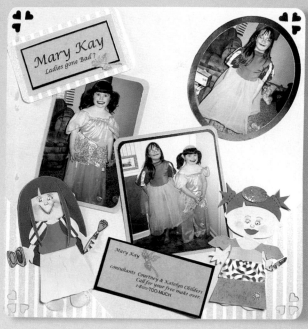

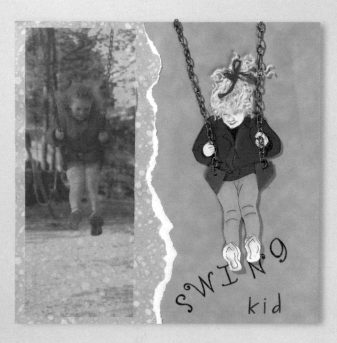

SWING KID

March/April 2003

Issue #35

Joan Fowler, Kingston, Ontario, Canada

Wind rushes through curly blond locks swept up in a bright red ribbon, and pink legs reach higher with each forward arc. Were it not for tiny hands grasping taut steel chains, this paper doll might jump off the page during her fearless flight. A photo-traced pattern, curly doll's hair and jewelry chain contribute to the realism of a child swinging with joyful abandon.

BOYS

James Thurber understood the elusive nature of boys, from toddler to teenager and beyond, when he quipped, "Boys are beyond the range of anybody's sure understanding, at least when they are between the ages of 18 months and 90 years."

Indeed, boys both young and old often challenge scrapbookers to discover hidden facets of the masculine personality. Boy-theme pages that capture this sense of intrigue and mystery, like the proverbial diamond in the rough, reveal a brilliance of unique character.

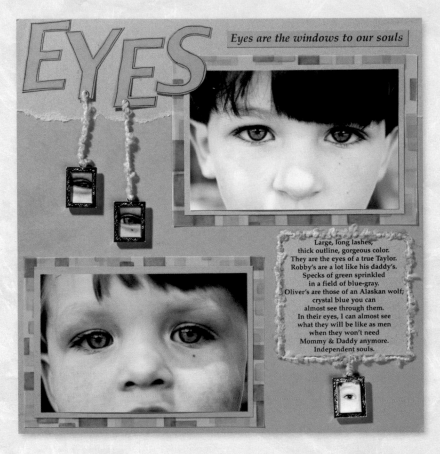

EYES
January/February 2003
Issue #34
Shannon Taylor, Bristol, Tennessee

A background of serene blues and greens pops these close-up photos of serious young eyes, while eloquent and detailed journaling shades them with heartfelt emotion. Tiny framed eyes suspended with nubby fiber complete a striking visual theme.

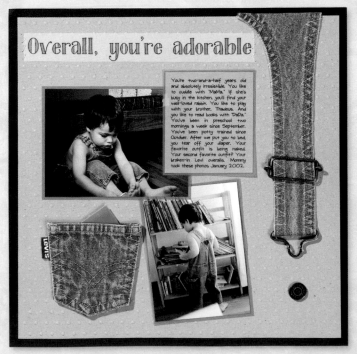

OVERALL
January/February 2003
Issue #34
Julie Labuszewski, Centennial, Colorado

Photographed from interesting viewpoints, black-and-white candids convey the independence of a little boy absorbed in his own private world. Denim embellishments hand-sewn to the page represent a favorite pair of overalls and inspire the witty title. Written from a mother's perspective, the journaling paints a charming personality portrait.

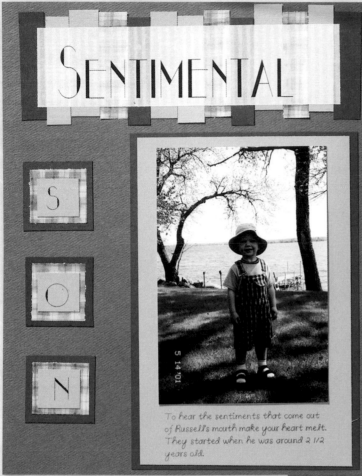

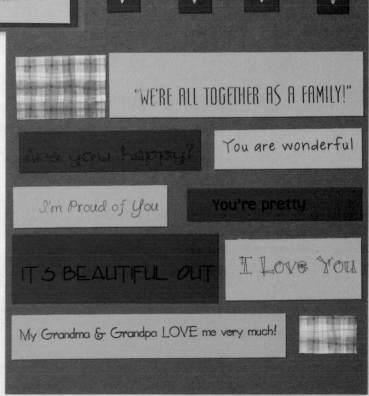

SENTIMENTAL SON
May/June 2002
Issue #30
Pam Lindahl, Chokio, Minnesota

Focusing on one aspect of a young son's personality, a bevy of decorative fonts repeat his sincerely uttered sentiments. A wavy plaid and shades of blue unify the color-blocked captions, folk-heart border and deco-style title. The photo embodies the down-home, country boy character of the layout.

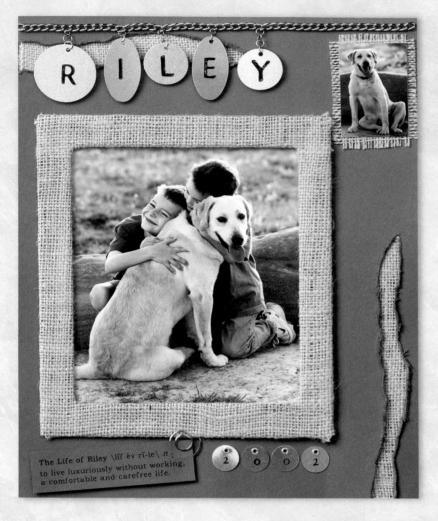

RILEY

July/August 2003
Issue #37
Kelli Noto, Centennial, Colorado

A dog may be called "man's best friend" but any boy with a pooch will tell you that dogs are a "boy's" best friend as well. This delightful page captures the camaraderie between kids and their pets, drawing a bit of rough-and-tumble into the design with a burlap frame and mat, personalized dog tags and a link collar.

SWAMPED

July/August 2001
Issue #25
Colleen Macdonald, Calgary, Alberta, Canada

Recalling "memories of childhood filled with days spent searching muddy waters for creatures of the swamps," the poetic caption is also a graphic element representing the rushing water. Handcut reeds and cattails embellished with punched frogs and dragonflies grow tall next to the visually flowing words. The simple pleasures of youthful water explorations are forever preserved in jar-cropped photos capped with mulberry "plastic" and brown paper rubber bands.

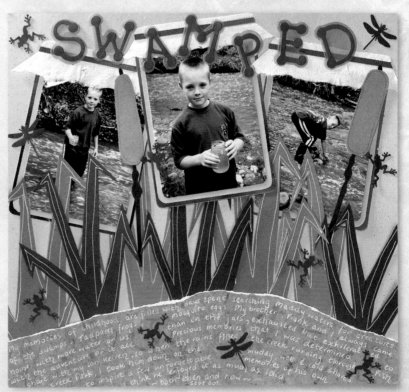

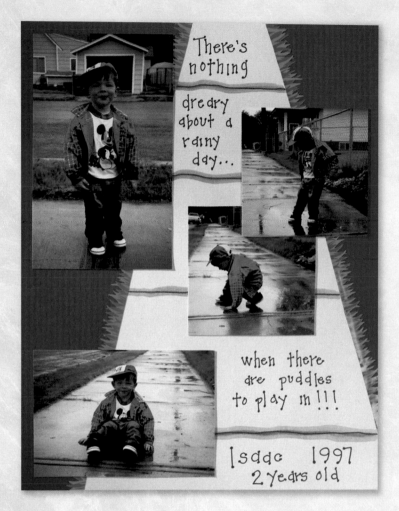

RAINY DAY
Spring 1998
Issue #6
Tami Comstock, Pocatello, Idaho

Puddle-stomping sneakers pounding wet cement epitomize the carefree days of childhood when time passes slowly and even rainy days are bright. A grass-lined sidewalk converging toward the horizon pulls the eye toward the focal photo of an all-American youthful explorer.

BEAM OF SUNLIGHT
January/February 2002
Issue #28
Christine Chrushch, Rocky Mount, North Carolina

Monochromatic color blocks give the illusion that this dreamy black-and-white candid hangs in a bright window. As if the boy were gazing into his future, the textured color and thoughtful quote symbolize a sunny future filled with hope, potential and possibility.

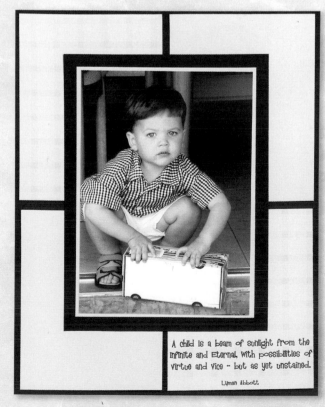

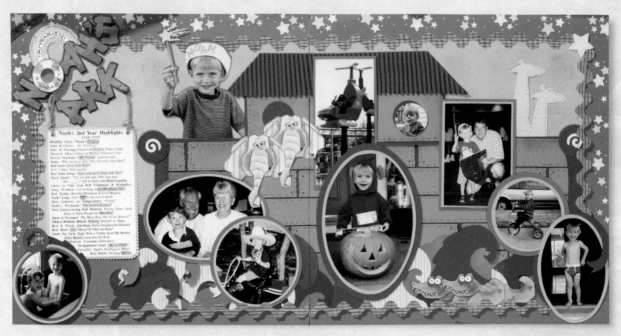

NOAH'S ARK
September/October 2000
Issue #20
Susan Badgett, North Hills, California

In this amazing year-in-review layout, nestled among a menagerie of animals and photos floating in a paper ark atop swirling ocean waves, is an incredibly creative journaling block. Besides predictable facts such as favorite foods and best sports, also listed are unusual highlights including meanest idea ("cutting up my brother's Pokemon card"), best name drop ("Jesus told me I sleep with you"), bad habits ("blowfish marathons and loud burping") and profanity ("you hockey pockey"). These delightful details shape an unforgettable character vignette.

CHRIS
January/February 2000
Issue #16
Memory Makers

While names and other labels are usually secondary to the photos, this page reverses the typical scrapbooking order by making the journaling the focus and embellishing each letter with photos. The diagonally arranged photo letters, created using alphabet puzzle templates, contribute a sense of boyish energy, and leftover photo scraps frame the page with interesting and unexpected details.

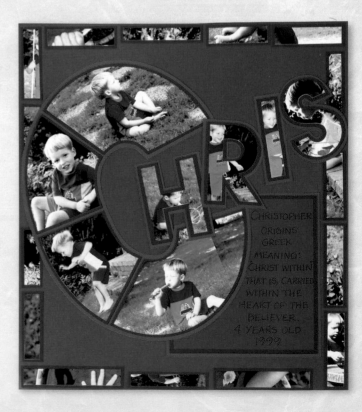

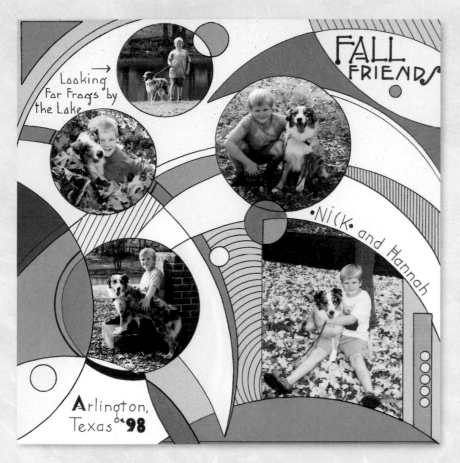

FALL FRIENDS
September/October 2000
Issue #20
Memory Makers
Photos Charlotte Wilhite, Arlington, Texas

Based upon the designs of Frank Lloyd Wright, this page is itself a work of art. The circle photos are completely integrated into a geometric design composed almost entirely of intersecting arcs that energetically sweep across the page. Inspired by Arts & Crafts-era colors, the soft olives, tans and browns emphasize the fall time frame and complement the colors in the boy-and-his-dog photos.

PIZZA NIGHT
November/December 2000
Issue #21
Memory Makers
Photos Pennie Stutzman, Broomfield, Colorado

Paper-punched olives and handcut mushrooms and green peppers top a tasty page that pictures a Friday-night-pizza tradition. Surrounded by family candids, the clink of frosty mugs, steaming slices and eager fingers, a son's beaming smile conveys his simple satisfaction.

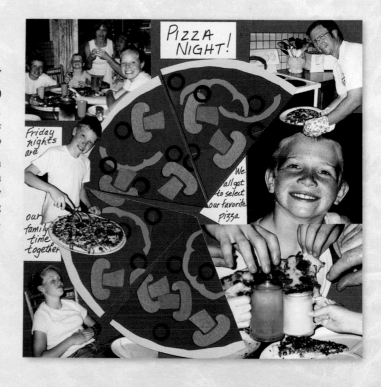

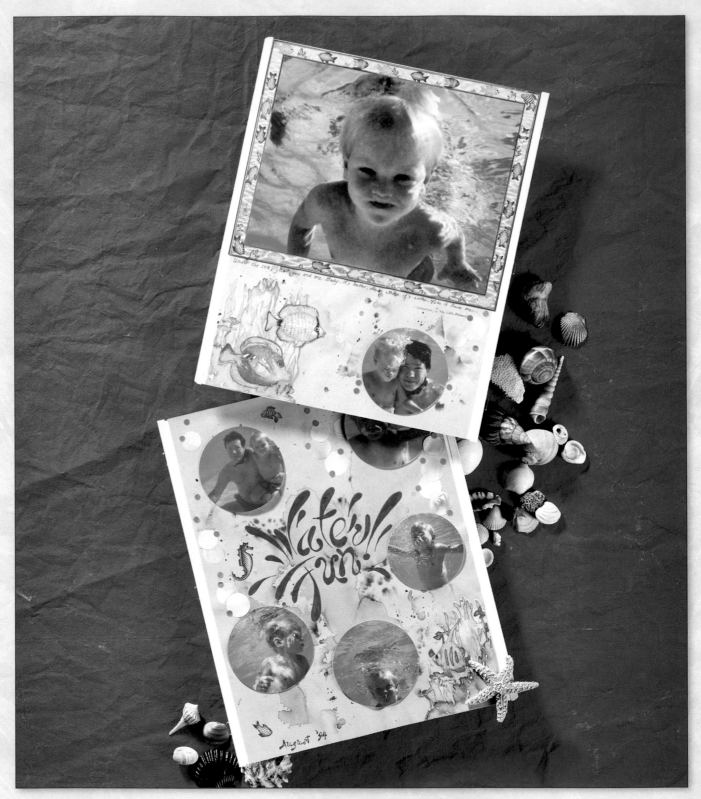

WATER FUN
July/August 1999
Issue #13
Charlotte Wilhite, Arlington, Texas

The title of this layout refers as much to its techniques as to its photos. The blue background painted with watery ink, fish-theme paper and stickers, photo-punched bubbles and splashy title letters all convey a sense of fun and excitement about a young boy's swimming accomplishments. An underwater disposable camera is the secret behind the interesting viewpoint of the enlarged photo.

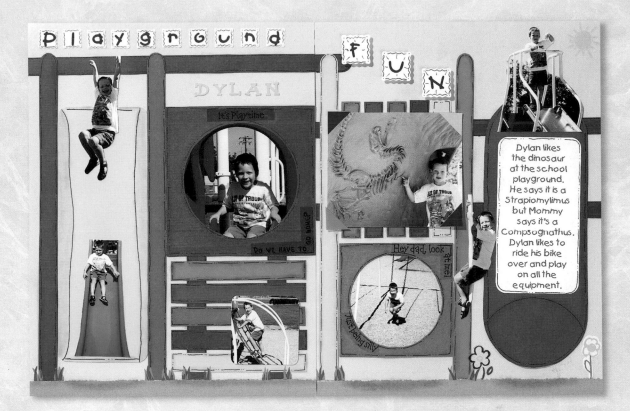

PLAYGROUND FUN

July/August 2002

Issue #31

Linda Jernigen, Fairfield, Ohio

A chalk-shaded and pen-detailed playground is an ideal backdrop for the carefree joys of swishing down a sun-warmed slide, hanging from monkey bars and playing airplane tummy-side-down on a chain-link strap swing. Quickly created from a paper-piecing kit and embellished with contemporary sticker accents, the familiar equipment places the photos in a colorful and instantly recognizable context.

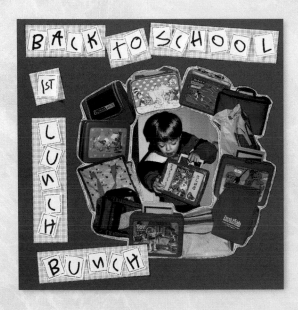

LUNCH BUNCH

September/October 1999

Issue #14

Julie Walkup, Silver Spring, Maryland

All it takes is a camera to compress a favorite lunch box into a scrapbook. The silhouetted bags and boxes tie in the "lunch bunch" theme and also reflect the stories and characters that influence contemporary children's culture—Toy Story, Barney, Disney, Dr. Seuss and Winnie the Pooh. For the title, photocopied letters of the child's own handwriting illustrate another creative use of memorabilia.

AT THE TRAIN DEPOT
July/August 2001
Issue #25
Susan Evans, Sparta, Tennessee

Photographed beside a classic luxury car, these modern boys dressed in argyle berets and elastic suspenders evoke the timelessness of a bygone era. The photo mats add a hint of fresh color, while the black photo corners and background confirm the old-fashioned theme.

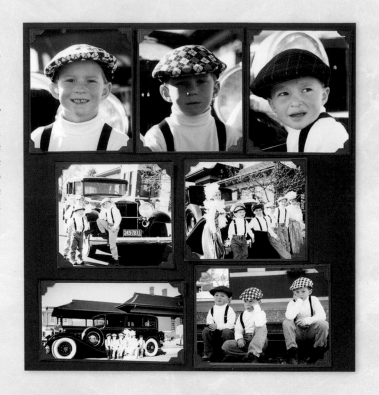

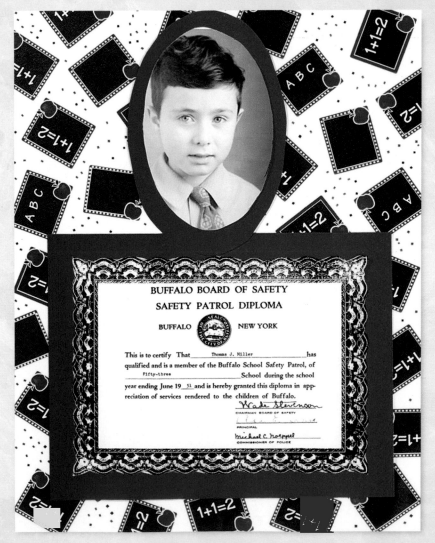

SCHOOL PORTRAIT
September/October 1999
Issue #14
Barbara Miller, West Linn, Oregon

This school portrait page puts a youthful heritage photo in perspective by linking it to an activity that, at the time, was highly honored. More than casual journaling, the diploma reveals a facet of this child that would not otherwise be revealed. The combined elements of the photo, background paper and certificate speak in a united voice to reflect a simpler time when children took pride in and were recognized for their community service.

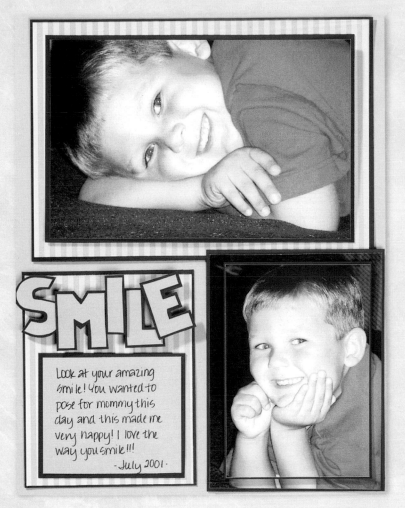

SMILE

January/February 2002
Issue #28

Christine Chrushch, Rocky Mount, North Carolina

It's not just the title that literally stands out on this page—the young man's charming grins are simply irresistible. Subtle tans and stripes keep the background neutral, and thin mats accent each page element with a touch of masculine red.

ALEX

July/August 2003
Issue #37

Trudy Sigurdson, Victoria, British Columbia, Canada

Dried flowers, leaves, charms, tiles, fibers, mesh, eyelets and other embellishments tell the story of a seek-and-find day at the lake. Right out of the pocket of the child and onto the page, this "shabby chic" grouping adds depth, color and texture to this all-boy design.

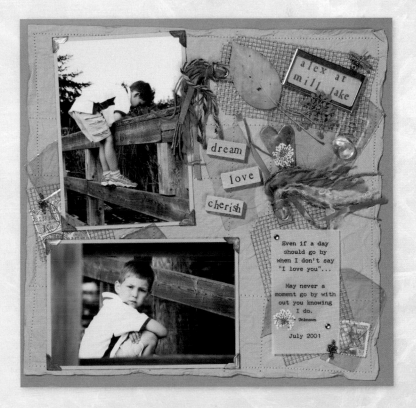

A LOOK BACK: *Scrapbook Journaling*

Penned in white ink on the black construction-paper pages of Grandma's old scrapbook, beside small black-and-white photos loosely held by lick-and-stick photo corners, are simple words describing people, places and events. Two generations later, written with an archival pigment pen on acid-free, lignin-free, buffered scrapbook pages, beside cropped color photos and elaborate embellishments, are surprisingly similar captions.

Times have changed, but even in a modern world of sophisticated computer fonts, decorative lettering templates, myriad pen colors and letter punches, die cuts and stickers, the fundamental value of the written word has not changed. Today's scrapbook pages still reflect the understanding that without words, photos eventually become meaningless. While retaining this core value, modern scrapbookers have also taken the words of their scrapbooks to an entirely new level in terms of both content and creativity.

DREAMS FOR SARA
September/October 1998
Issue #8
Kim Owens, Lynnwood, Washington

Complete sentences aren't always necessary to convey an eloquent message. In this simple design, a mother uses single words to communicate her dreams and hopes of the things she wants her child to have and become. Colored blocks provide visual pauses that punctuate the verbal paths around each photo.

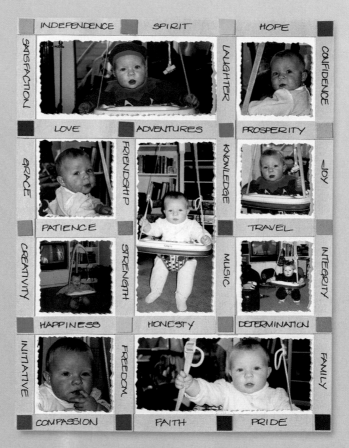

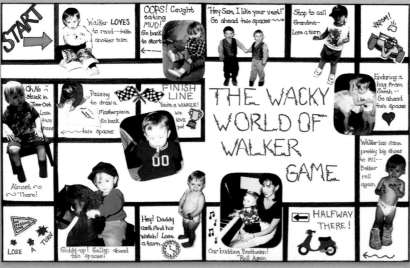

WACKY WORLD
March/April 1999
Issue #11
Melissa Evans, Lyons, Kansas

Everyday objects can inspire creative writing as well as page design. This board-game concept offers an intuitive journaling style that combines photo facts with play instructions. The captions verbally connect a dozen miscellaneous photos into an appealing design that reads in a clockwise fashion.

OUR FAMILY CIRCUS
March/April 1999
Issue #11
Helen Rumph, Las Vegas, Nevada

Look no further than the Sunday comics for both design and journaling inspiration. The familiar format makes it easy to illustrate any story, especially humorous anecdotes. Although the dialogue bubbles require few words, along with the images they accomplish the same goals as any great story—setting the scene, introducing characters, developing a plot and achieving a resolution, in this case, a punch line.

REMEMBER WHEN
September/October 2002
Issue #32
Andrea Steed, Rochester, Minnesota

Word pictures are an ideal way to include unphotographed memories in a scrapbook. The short stories on this layout illustrate that bringing these memories to life doesn't require a lot of verbiage. Just the simple facts are enough for the reader to shape a mental picture of the people and events. A variety of fonts printed on sheer vellum provides an interesting presentation.

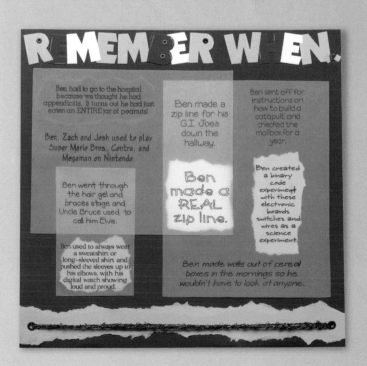

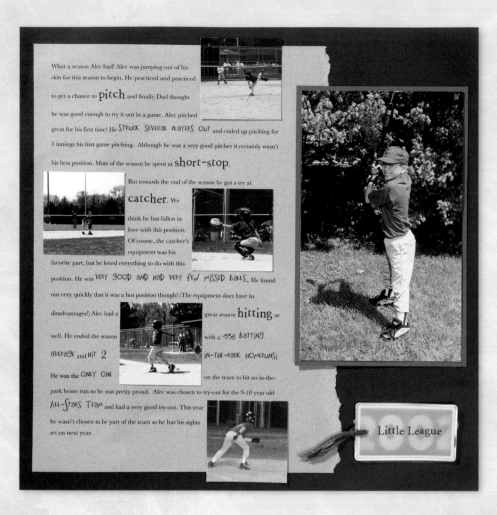

What a season Alec had! Alec was jumping out of his skin for this season to begin. He practiced and practiced to get a chance to **pitch** and finally Dad thought he was good enough to try it out in a game. Alec pitched great for his first time! He STRUCK SEVERAL PLAYERS OUT and ended up pitching for 5 innings his first game pitching. Although he was a very good pitcher it certainly wasn't his best position. Most of the season he spent at short-stop.

But towards the end of the season he got a try at catcher. We think he has fallen in love with this position. Of course, the catcher's equipment was his favorite part, but he loved everything to do with this position. He was VERY GOOD AND HAD VERY FEW MISSED BALLS. He found out very quickly that it was a hot position though! (The equipment does have its disadvantages!) Alec had a great season hitting as well. He ended the season with a .538 BATTING average and HIT 2 IN-THE-PARK HOMERUNS! He was the ONLY ONE on the team to hit an in-the-park home run so he was pretty proud. Alec was chosen to try-out for the 9-10 year old ALL-STARS TEAM and had a very good try-out. This year he wasn't chosen to be part of the team so he has his sights set on next year.

Little League
2007

LITTLE LEAGUE
March/April 2003
Issue #35
Donna Downey, Huntersville, North Carolina
Photos Debbie Krekel, Burlington, Iowa

Energetic computer fonts both emphasize the highlights of a boy's memorable Little League season and imbue the newspaper-style caption with movement and action. This journaling style requires only a basic knowledge of word-processing software and keeps the details of the season as fresh as the images.

ALIKE, DIFFERENT
May/June 2002
Issue #30
Kelli Noto, Centennial, Colorado

When writer's block strikes, sometimes the best remedy is to pose a question or reflect upon a theme. Pondering the similarities and differences of her children helped this mother to both write about and photograph her sons from a unique perspective. The page idea is further reinforced by the flip-flopped, color-blocked page design.

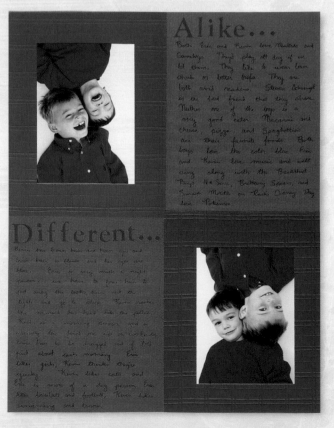

Alike...

Different...

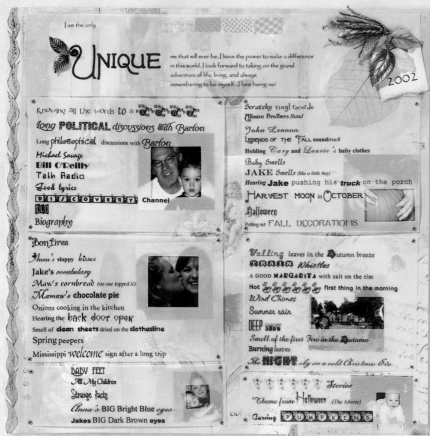

UNIQUE
March/April 2003
Issue #35
Pam Easley, Bentonia, Mississippi

Although scrapbookers invest huge quantities of time, energy and love in their family chronicles, they often forget to include information about themselves. Through words and photos of favorite people, places and things, this layout brings the often-invisible family historian to the forefront and tells her story through the ambitious use of more than 100 fonts. Photos layered beneath vellum windows and elegant leaf embellishments weave visual elements into the list of vivid phrases.

GIRLS

"There was a little girl who had a little curl, right in the middle of her forehead. When she was good, she was very, very good, but when she was bad she was horrid." Henry Wadsworth Longfellow's humorous reflection on the nature of little girls adds a dose of reality to the pithy "sugar and spice, and all that's nice" nursery rhyme.

Perhaps he understood, like many scrapbookers, that girls are a study in contrasts. Shy and outgoing, crying and giggling, or tough and tender can all describe a young girl, sometimes within the same ten minutes. Scrapbook pages that understand these contrasts convey the essence of a uniquely feminine individual without need of cliché.

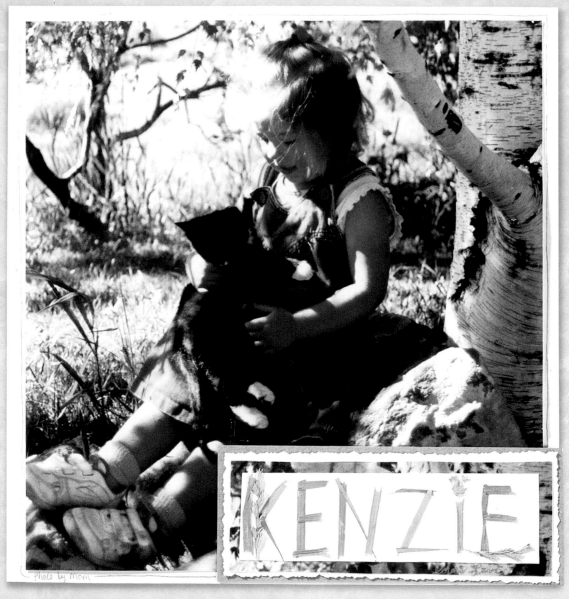

KENZIE

July/August 1999
Issue #13
Linda Strauss, Provo, Utah

Strong summer shadows filter through tree branches, casting golden patches of warmth onto a young girl lost in the pleasure of a kitten's soft fur. The organic title letters, spelled with dried grasses and flowers, echo the outdoor theme.

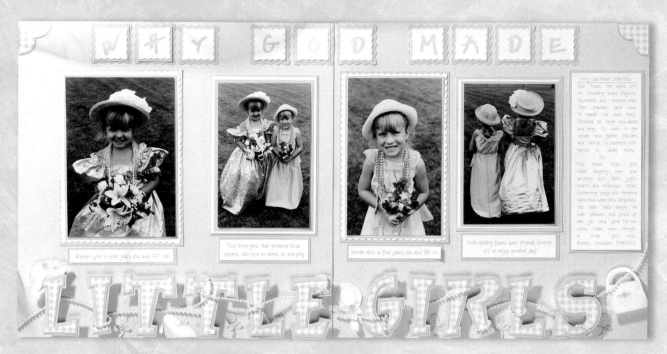

WHY GOD MADE LITTLE GIRLS

May/June 2002
Issue #30
Sheila Boehmert, Island Lake, Illinois

Straw hats, plastic beads, silk flowers and gowns bring wide smiles of delight to young girls absorbed in the make-believe lives of princesses and brides. The black-and-white photos ingeniously eliminate any clashing colors, allowing the pink and lavender palette to dominate. Ruffled mats, stamped dress-up accessories and a long strand of pearls tie up the feminine theme.

STRAW HAT

July/August 2000
Issue #19
Oksanna Pope, Los Gatos, California

Emerging from clusters of pale green leaves, lavender buds and blooms reach upward, drawing the eye toward the warm and vivid photo of the girl on the beach. Created with nonwrinkling paper paint and a sponge stamp set, the wildflowers reflect the child's natural beauty.

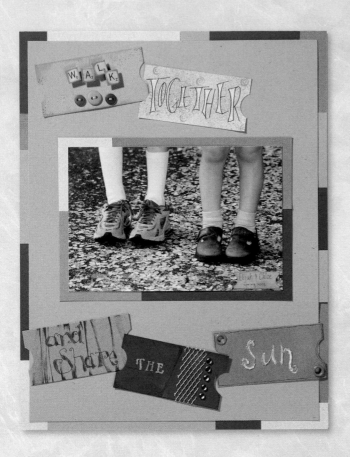

WALK TOGETHER
March/April 2003
Issue #35
Annie Wheatcraft, Frankfort, Kentucky

Big-brother and little-sister feet pause on a spring carpet of pink petals, suggesting the side-by-side companionship they may share. As if to illustrate the moral directive of the page, diverse elements such as Scrabble tiles, plastic buttons, metal mesh, shiny brads, painted eyelets, colored chalk, stamping inks and hand-sewn letters peacefully coexist in an eclectic and textured title.

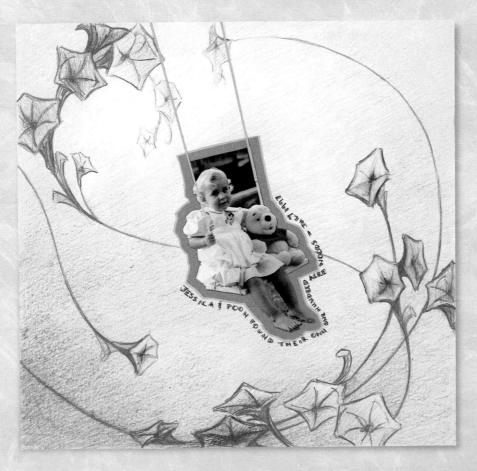

JESSICA & POOH
Summer 1998
Issue #7
Memory Makers
Photo Tonya Jeppson, Boise, Idaho

Like a vivid hummingbird frozen in mid-air, a girl and her bear pause in their swinging, suspended by taut tan ropes that stretch their imagined ties to strong honeysuckle vines. Soft blossoms swirl around the breezy blue background, softly sketched with colored pencils and oil pastels.

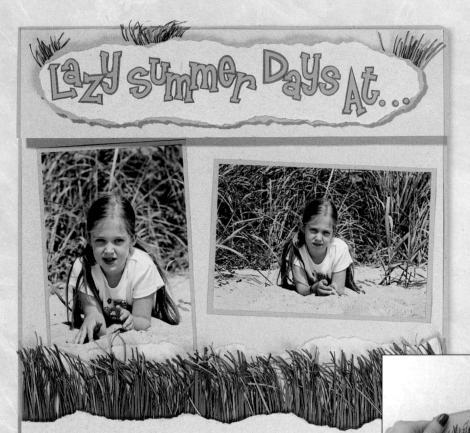

LAZY SUMMER DAYS
January/February 2003
Issue #34
Trudy Sigurdson, Victoria, British Columbia, Canada

Layered between torn paper sand dunes, masses of thin strips imitate the wind-blown beach grass in the sandy portraits. The title flap lifts up to reveal a detailed caption and the remaining title nestled among additional layers of sand and grass. The grass provides such a striking textural element that little additional embellishment is required.

LITTLE GIRLS
September/October 2000
Issue #20
Linda Astuto, Amarillo, Texas

A towering tree bursting with brown crayon branches and vibrantly watercolored leaves dwarfs a happily swinging child. Her diminutive appearance in relation to the tree as well as the blond hair and pink clothing perfectly illustrate both "little" and "girl." The juxtaposition of the tiny realistic photo against the grandiose painted backdrop reinforces the fairy-tale mood of a familiar poem.

Oh Beautiful Fall

September/October 2002
Issue #32

Erikia Ghumm, Brighton, Colorado
Photo Cheryl Rooney, Lakewood, Colorado

Simple stamping techniques tint this page with lush autumn color. Pressing a leaf stamp onto an inked block stamp yields the unusual reverse-image designs in the mosaic frame. A square block stamp provides the soft diamond shapes behind the title and captions. The warm red and green inks pull the colors in the brother-and-sister photo to the forefront.

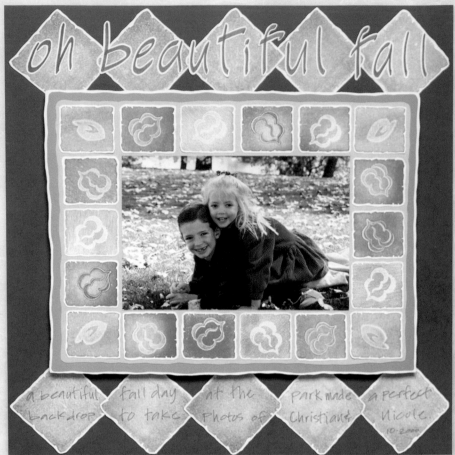

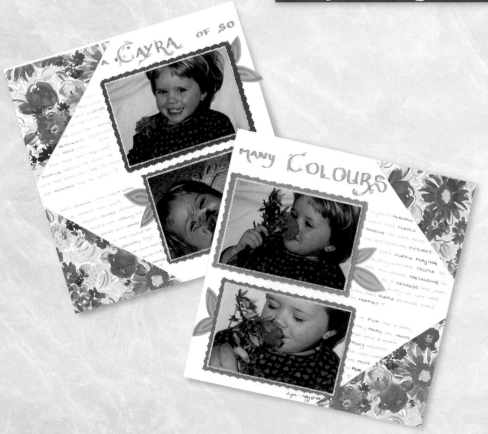

Cayra

March/April 2000
Issue #17

Deidre Tansey, Smithers,
British Columbia, Canada

How is a child like a color? Penned from an affectionate mother's perspective, four color-coded captions offer poignant and poetic answers to this question. Like many "accidental" inspirations, the page theme was sparked by indecision about which mat color to select. The resulting layout provides verbal and visual insights into a bright and bubbly feminine personality.

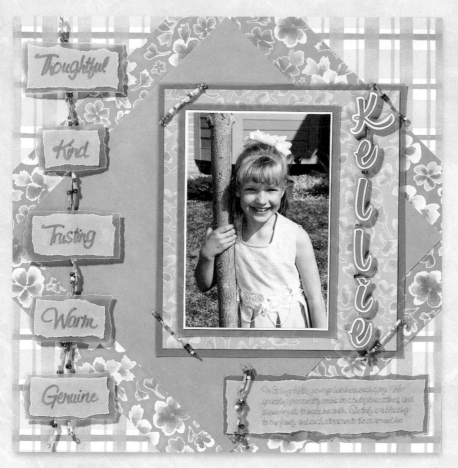

KELLIE
January/February 2003
Issue #34
Jodi Amidei, Lafayette, Colorado
Photo Leslie Aldridge, Broomfield, Colorado

A sunny spring day and the equally sunny smile of a little girl are paired perfectly with the refreshing hues of coordinating patterned paper arranged in this photo-flattering style. As if pulled straight from her own jewelry box, delicately strung beads suspend the qualities this child embodies. Torn vellum, additional bead accents, and a heartfelt caption create a softness that makes this page a lovely and loving tribute.

AYSHA AND I
May/June 2003
Issue #36
Trudy Sigurdson, Victoria,
British Colombia, Canada

Broken mirror chips bode anything but back luck for this beautiful mother/daughter page. Chips are added to tags, decorated with dried flowers and wrapped with decorative wire. The journaling block includes ragged chip-shaped boxes which highlight important words and add power to the heartfelt text.

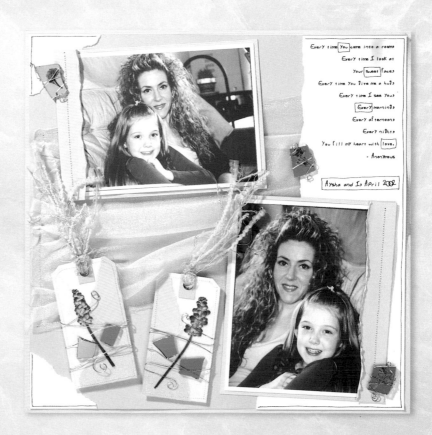

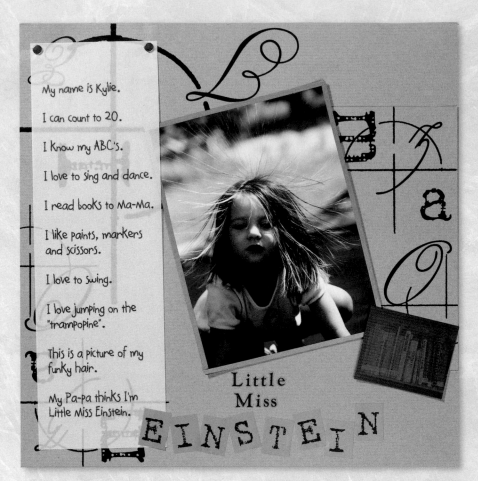

My name is Kylie.

I can count to 20.

I Know my ABC's.

I love to sing and dance.

I read books to Ma-Ma.

I like paints, markers and scissors.

I love to swing.

I love jumping on the "trampopine".

This is a picture of my funky hair.

My Pa-pa thinks I'm Little Miss Einstein.

Little Miss EINSTEIN

LITTLE MISS EINSTEIN
March/April 2002
Issue #29
Deb Lyle, Elida, Ohio

When a static-charged trampoline session stood a young brunette's hair on end, her grandmother was poised and ready. The humorous photo prompted the scientific theme personalized with self-descriptive journaling written from the girl's perspective. The specific, concrete elements that describe her abilities and preferences help capture the essence of her individuality.

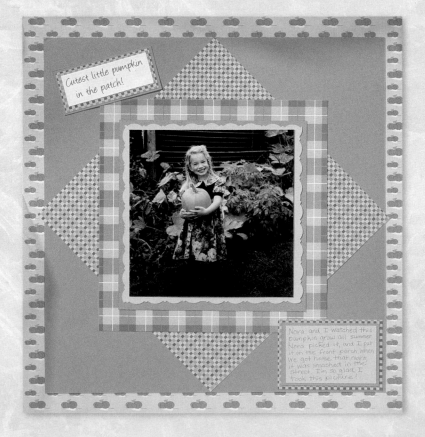

Cutest little pumpkin in the patch!

Nora and I watched this pumpkin grow all summer. Nora picked it, and I put it on the front porch. When we got home that night, it was smashed in the street. I'm so glad I took this picture!

CUTEST LITTLE PUMPKIN
September/October 2000
Issue #20
Karen Regep Glover, Grosse Point Woods, Michigan

Plump pumpkins, mini checks and pleasing plaids provide a softly patterned background that balances the vibrance of the grinning gardener. Diagonally mounting a photo mat is a simple technique that adds a sense of movement. The soft greens represent the idea of youth and nature, while the oranges stimulate the page with energy and warmth, suggesting the change of season.

FRIENDS FOR LIFE
September/October 2000
Issue #20
Adrienne Lubbe, Highway Gardens, South Africa

Soaring paper-cut trunks branch into spring blossoms, growing summer leaves, golden autumn color and bare winter boughs. The visual analogy pictures the seasons of life represented in the photos of lifelong friends taken 35 years apart. The symmetry of design mirrors the parallels between the photo pairs.

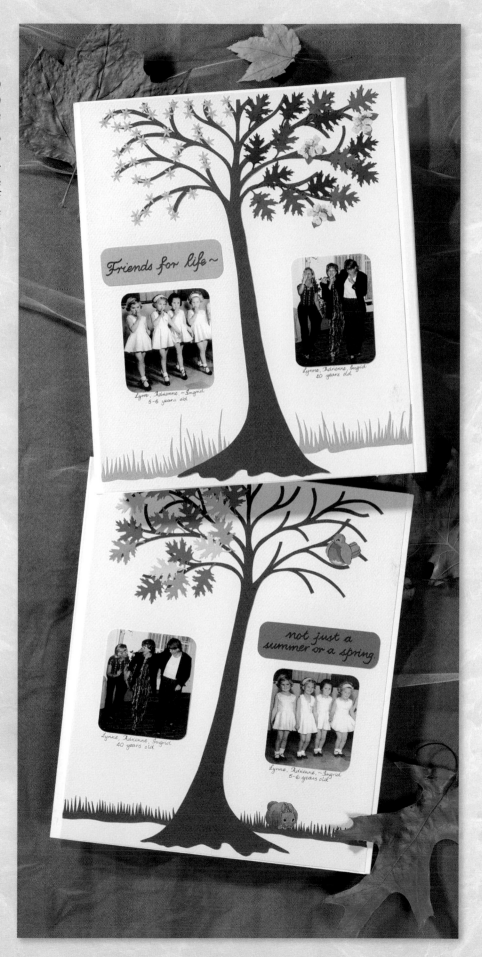

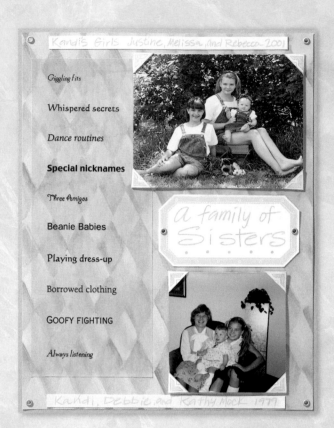

Kandi's Girls Justine, Melissa, and Rebecca 2001

Giggling fits

Whispered secrets

Dance routines

Special nicknames

Three Amigos

Beanie Babies

Playing dress-up

Borrowed clothing

GOOFY FIGHTING

Always listening

a family of Sisters

Kandi, Debbie, and Kathy Mock 1977

A FAMILY OF SISTERS
May/June 2002
Issue #30
Erikia Ghumm, Brighton, Colorado
Photos Debbie Mock, Denver, Colorado

A young Debbie Mock (*Memory Makers* editor) is wearing pigtails in the bottom photo, while her three nieces pose in the contemporary black-and-white portrait. The page draws attention to the striking similarities and describes with two-word, poetic phrases the universal experiences that sisters often share.

THE JOY OF SISTERS
May/June 2001
Issue #24
Teri Vokus, Sarasota, Florida

Little about the love and bond between sisters needs articulating beyond that which can be seen in their smiles when together. This connection is exemplified by the telling title and understated design of this page. Utilizing only minimal sticker embellishments and a string of selected sentiments, it incorporates childhood photos alongside a more recently captured moment, creating a sense of nostalgia. It speaks to the timelessness and transcendence that is sisterhood.

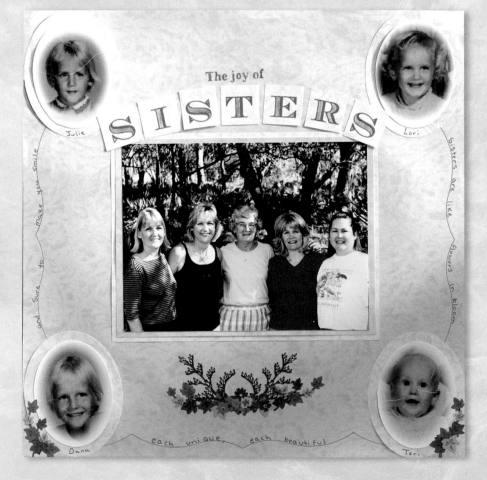

The joy of SISTERS

Julie

Lori

sisters are like flowers in bloom

and sure to make you smile

each unique, each beautiful

Dana

Teri

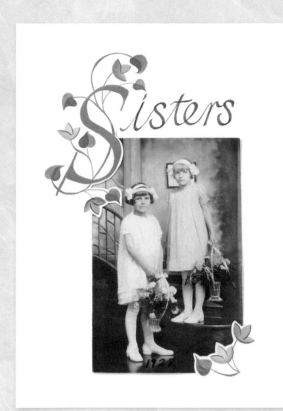

SISTERS
Spring 1998
Issue #6
Memory Makers

Reminiscent of old European manuscripts, illuminated letters are an easy and elegant way to embellish any page, and modern materials make this medieval art form accessible to crafters of all levels. Here, a single gold character intertwined with watercolored flowers gracefully frames a 1928 heritage photo. Tucking the photo beneath slits cut around the illuminated letter and flowers eliminates the need for permanent mounting.

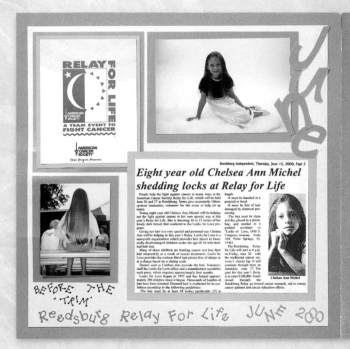

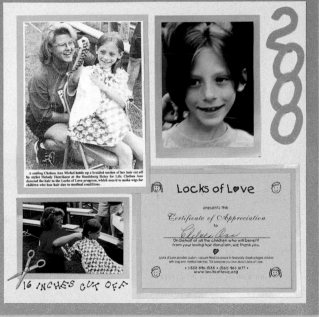

LOCKS OF LOVE
September/October 2001
Issue #26
Tish Michel, Reedsburg, Wisconsin

This layout is one of many inspiring entries in the Page for the Cure™ contest, an annual event that *Memory Makers* originated in 2000 to raise money for the Susan G. Komen Breast Cancer Foundation. In this prize-winning spread, shades of blue, pink and purple paper unify elements as diverse as photocopied newspaper articles, an event logo, candid photos, a formal portrait and a certificate. These elements cohesively present the story of a girl's remarkable act of generosity.

Stephanie taking picture in the mirror

Camera Ready,
Aim,
Shoot!

Stephanie Age 3

BUDDING PHOTOGRAPHER

January/February 2002
Issue #28
Debra Beagle, Milton, Tennessee

Putting a camera in a child's hands is an easy way for snapshot photographers to include themselves in their own scrapbooks. This layout not only unfolds the humorous story of a little girl's first picture-taking attempts but also depicts a loving mother-daughter relationship. Soft lavenders lend a feminine touch to support simple twisted-wire flowers.

A little crooked. Try again.

Smile!

August 2000

You were so cute this day, wanting to use Mommy's camera. You have this love for photography and scrapbooking, just like Mommy. I am so proud of these pictures you took of me. At 3½ you exhibit so many talents. I love you so very much and I am so proud of you.

Perfect!

Mommy Age 33

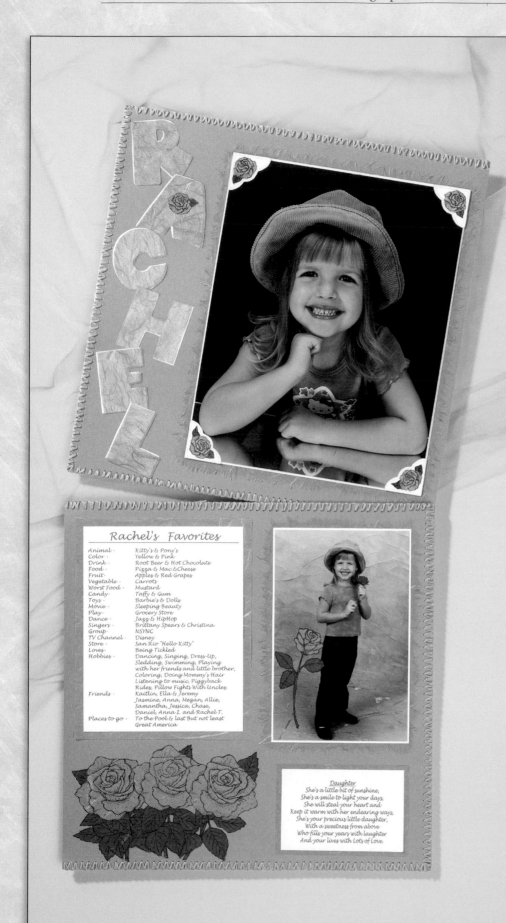

Rachel's Favorites

Animal ·	Kitty's & Pony's
Color ·	Yellow & Pink
Drink ·	Root Beer & Hot Chocolate
Food ·	Pizza & Mac & Cheese
Fruit ·	Apples & Red Grapes
Vegetable ·	Carrots
Worst Food ·	Mustard
Candy ·	Taffy & Gum
Toys ·	Barbie's & Dolls
Movie ·	Sleeping Beauty
Play ·	Grocery Store
Dance ·	Jazz & HipHop
Singers ·	Brittany Spears & Christina
Group ·	NSYNC
TV Channel ·	Disney
Store ·	San Rio "Hello Kitty"
Loves ·	Being Tickled
Hobbies ·	Dancing, Singing, Dress-Up, Sledding, Swimming, Playing with her friends and little brother, Coloring, Doing Mommy's Hair Listening to music, Piggyback Rides, Pillow Fights With Uncles.
Friends ·	Kaitlin, Ella & Jeremy Jasmine, Anna, Megan, Allie, Samantha, Jessica, Chase, Daniel, Anna I. and Rachel T.
Places to go ·	To the Pool & last But not least Great America

Daughter
She's a little bit of sunshine,
She's a smile to light your days,
She will steal your heart and
Keep it warm with her endearing ways;
She's your precious little daughter,
With a sweetness from above
Who fills your years with laughter
And your lives with Lots of Love.

RACHEL
March/April 2002
Issue #29
Sheila Boehmert, Island lake, Illinois

Feathery paper and beautifully stamped roses give these black-and-white portraits the special treatment they deserve. A detailed list of favorites sketches a word portrait to accompany the strong visual images of her ear-to-ear smiles. Pink embroidery floss hand-stitched around the edges further softens the mood.

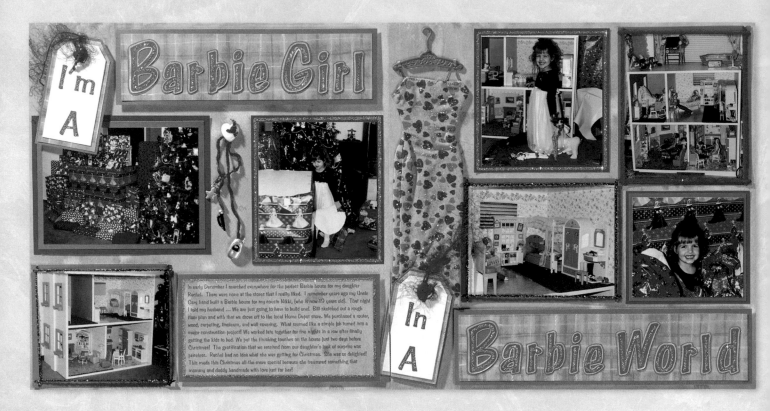

BARBIE GIRL
November/December 2002
Issue #33
Sheila Boehmert, Island Lake, Illinois

Wriggling long vinyl legs into a fashionable heart-print evening gown, pulling thin spaghetti straps over smooth white shoulders and slipping miniature high-heels on pointy feet are just the beginning of Barbie playtime joys. A well-equipped dollhouse is just the ticket once Barbie is all dressed up with no place to go. These photos visually document Barbie-gear details that can be enjoyed by even a grown-up Barbie girl.

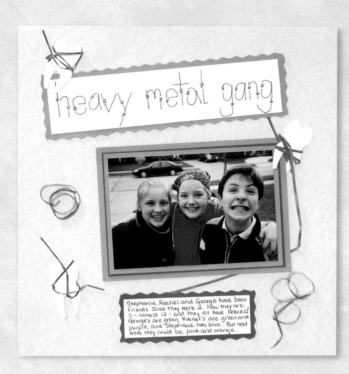

HEAVY METAL GANG
September/October 2001
Issue #26
Karen Regep Glover, Grosse Pointe Woods, Michigan

Unbendable friendships are cemented by shared experiences such as metal braces with colored bands. The lettering style lends a sense of electricity and excitement, while tooth die cuts wrapped in thin gray strips support the clever title.

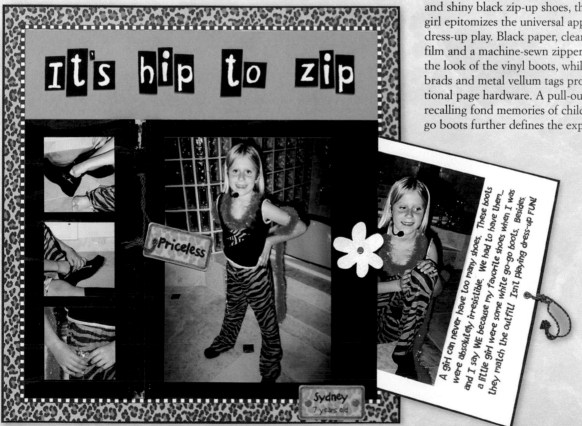

IT'S HIP TO ZIP
March/April 2003
Issue #35
Diana Hudson, Bakersfield, California

From a head-hugging microphone and fake-fur-trimmed tank top to hot pink tiger-print pants, dangling chain link belt and shiny black zip-up shoes, this modern girl epitomizes the universal appeal of dress-up play. Black paper, clear shrink film and a machine-sewn zipper replicate the look of the vinyl boots, while pink brads and metal vellum tags provide additional page hardware. A pull-out caption recalling fond memories of childhood go-go boots further defines the experience.

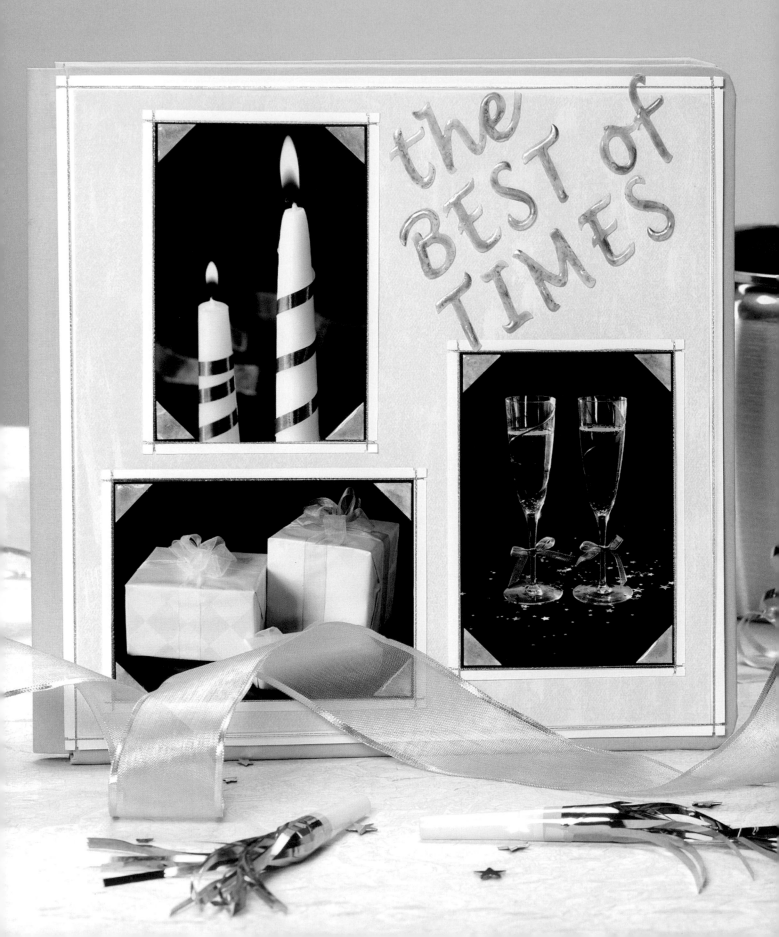

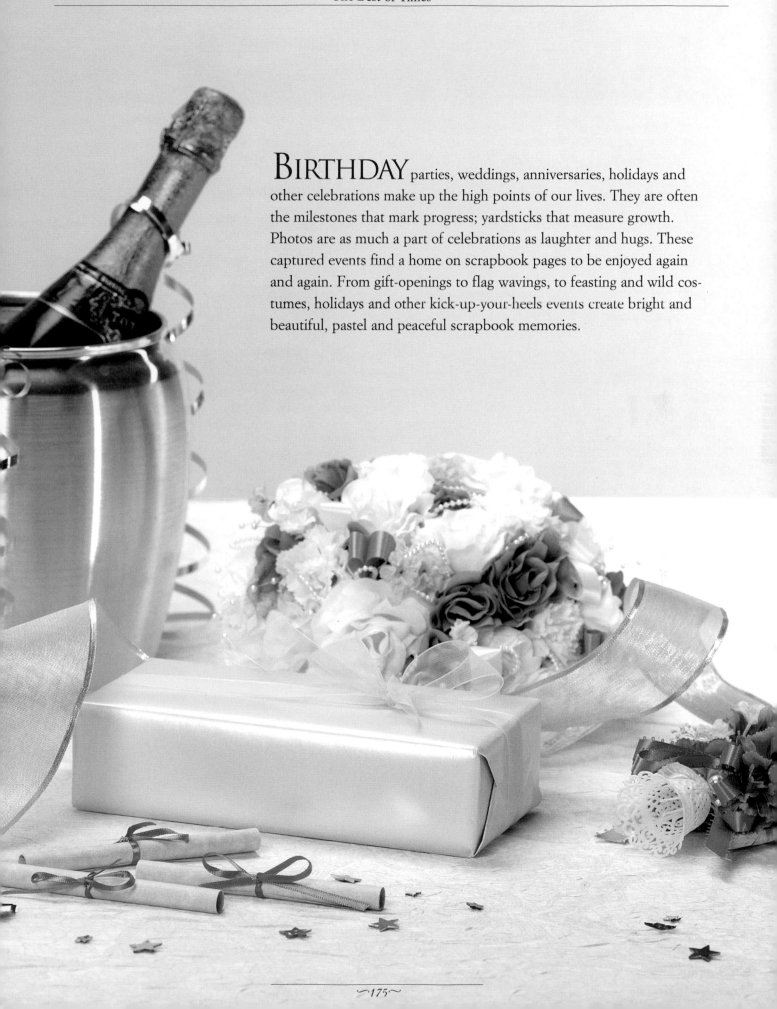

BIRTHDAY parties, weddings, anniversaries, holidays and other celebrations make up the high points of our lives. They are often the milestones that mark progress; yardsticks that measure growth. Photos are as much a part of celebrations as laughter and hugs. These captured events find a home on scrapbook pages to be enjoyed again and again. From gift-openings to flag wavings, to feasting and wild costumes, holidays and other kick-up-your-heels events create bright and beautiful, pastel and peaceful scrapbook memories.

LOVE YOU MOMENTS

Celebrations that commemorate relationships which are treasured and revered are some of the most significant of all. Valentine's Day, weddings, prom, Mother's Day and other special times speak loudly about the importance of sharing what we carry in our hearts.

FOREVER AND ALWAYS

July/August 2003

Issue #37

Pamela Frye, Denver, Colorado

Nothing captures the color of love quite like rich, deep hues of red and pink as those used in this page. Utilizing two different fonts and sizes for this tender title creates special emphasis, as does the artfully framed caption of sweet sentiments. Glossy embellishments, torn paper, and intricate borders whimsically offset the classic look and romantic feel of the black-and-white photograph, making this page an elegantly executed labor of love.

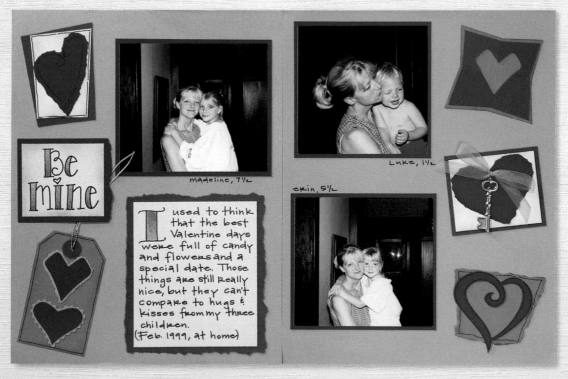

BE MINE

January/February 2001

Issue #22

Rebecca Sower, Springfield, Tennessee

Hearts of all styles—swirly, asymmetrical, angular or traditional—harmonize with mother-child Valentine's Day photos. A paper appliqué pattern played in shades of red, white and tan is the time-saving design secret. Like a visual love song, the layout sincerely voices a mother's perspective on the meaning of a traditional holiday.

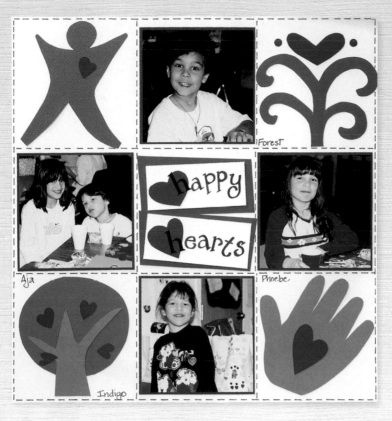

HAPPY HEARTS
January/February 2001
Issue #22
Teresa Villanueva, Aurora, Colorado

Freeform red hearts accent simple sil-
houettes of a celebratory figure,
blooming flower, stately tree and out-
stretched hand. A church brochure
designed by Sally Beck inspired the
contemporary appliqué designs in
this quilt-style Valentine's page. The
symmetrical arrangement pulls the
eye toward the central title and
theme.

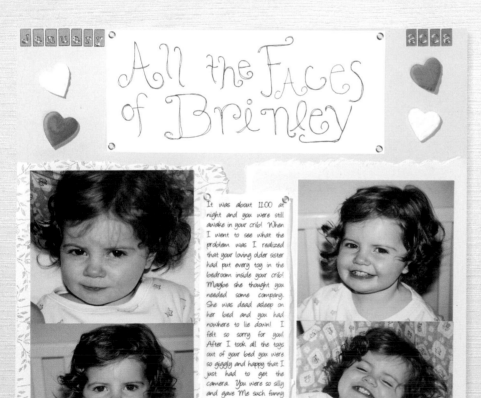

BRINLEY
January/February 2003
Issue #34
Brandi Ginn, Lafayette, Colorado

Fishing in a continuous stream of
new scrapbook products, *Memory
Makers* reels in the best catch of
innovative tools and techniques,
including many that save valuable
scrapbooking time. Here, a photo
mat quickly colored with a cube-
shaped texture stamp accents a coy
smile. Realistic eyelet stickers that
appear to hold the title and caption
in place eliminate the need for setting
eyelets with special tools. The dimen-
sional hearts are precut shrink-plastic
charms that require only heat.
Created in minutes, these contempo-
rary elements delightfully enhance the
cheesy and charming grins.

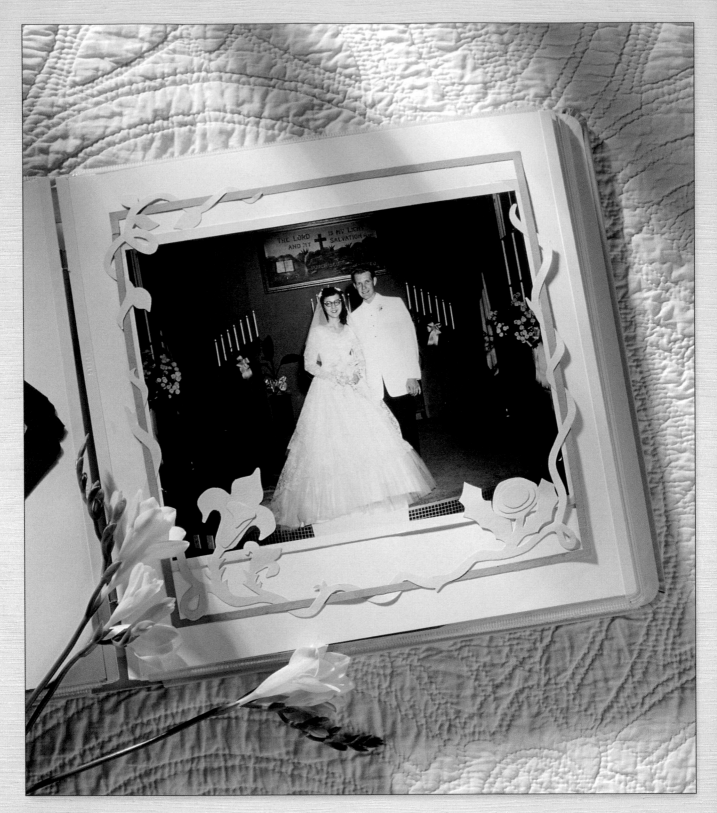

1946 WEDDING

Autumn 1996

Issue #1

Memory Makers

Photo Karen Gerbrandt, Broomfield, Colorado

Antique white, handcut vines and layered flowers entwined around a simple gray frame typify the "less is more" principle that applies to heritage page designs. The restrained use of color and embellishment allows the photo to remain the focus.

FIFTY GOLDEN YEARS
January/February 2000
Issue #16
Terry Van Ryn, Littleton, Colorado

A 50th-anniversary party portrait is lovingly embraced with an intricate embossed paper frame. Burgundy and gold, the colors chosen for the celebration, are carried through on this page and others in Terry's album, matching the golden anniversary theme.

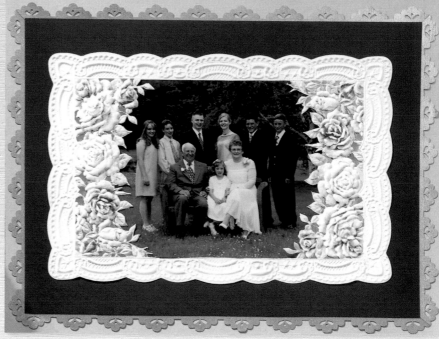

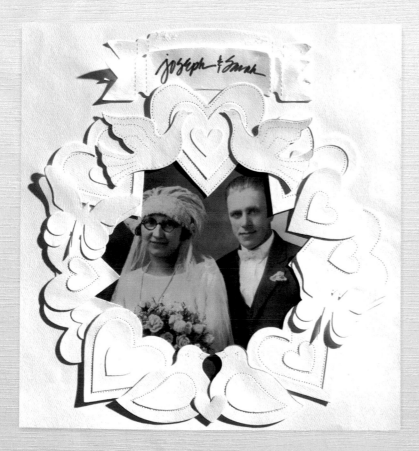

BRIDE & GROOM
Spring 1997
Issue #3
Sandi Genovese for Ellison Craft & Design, Lake Forest, California

Miniature doves, hearts and butterflies die cut from creamy white art paper encircle a 1920s wedding portrait with symbols of love and fidelity. Straight-pin piercing supplies detail, dimension and texture.

IMAGINE
May/June 2003
Issue #36
Amy Madzinski, Naperville, Illinois

"The sun was shining brightly and there was but one cloud in the sky," writes Amy of her wedding day. Her face shines with the faith and joy she feels about her new beginning as a wife. Vellum covers much of the page and poetic tags on a bead bracelet are the perfect accessory for a perfect wedding.

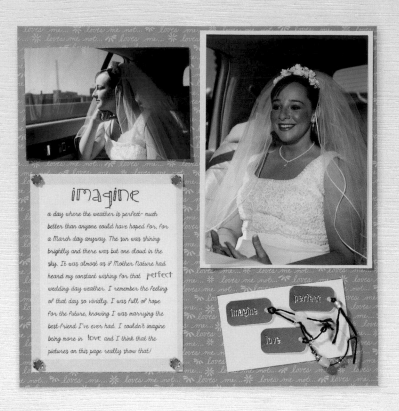

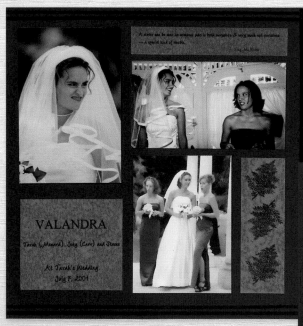

THEY SAY IT'S JUST A SISTER THING
May/June 2003
Issue #36
Jody Jackson, Parmelee, South Dakota

Sisters will be sisters, whether dressed up in bridal attire or dressed down in jeans and sweatshirts. Even in the midst of a formal occasion, these two sisters share the sillies as well as deep affection. A journaled vellum block overlays a photo of pillars; stamped and embossed ferns support the elegance of the wedding.

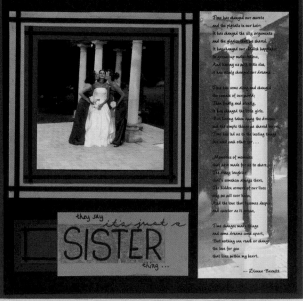

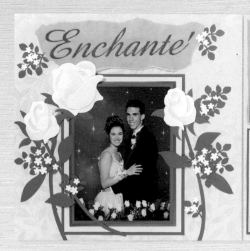

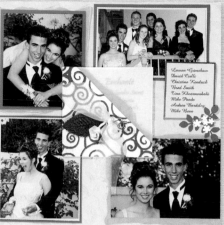

ENCHANTÉ
May/June 2003
Issue #36
Jeanne Ciolli, Dove Canyon, California

A prom memory should be golden, a message Jeanne Ciolli underlined with her glittering treatment commemorating her son's prom experience. Gold embossing powder and paper-pieced roses evoke a romantic evening while details of the "who's" and "where's" are detailed in a journaling block and on the invitation which has been included as a design element on the page.

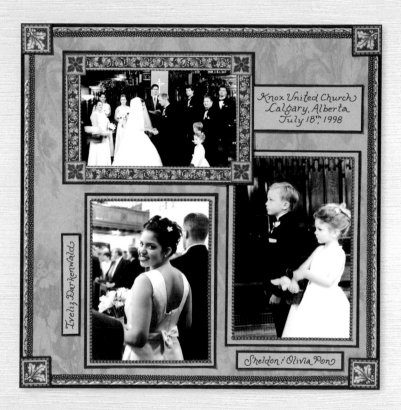

OUR WEDDING
July/August 2002
Issue #25
Michelle Minken, Littleton, Colorado

Heritage papers, borders and sticker embellishments lend an old-fashioned feel to a new union. This simple but elegant page was created in less than 20 minutes without compromising beauty. Minimal journaling, simply matted photos and coordinating corner accents tie the elements together beautifully.

DIAMONDS
May/June 2003
Issue #36
Diana Graham, Barrington, Illinois

A moonlight carriage ride, sparkling Christmas lights and a marriage proposal from the man she loved marked the beginning of engagement for Diana Graham. The perfect ring topped a never-to-be forgotten evening. The magic of that night is recorded forever on this page embellished with diamond-like mirrors, metallic papers, fibers, a charm and romantic heart, dove and flower stickers.

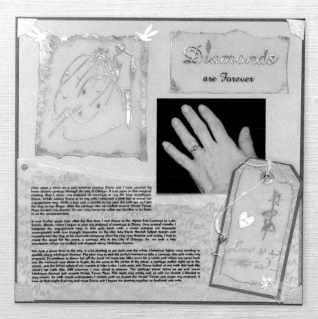

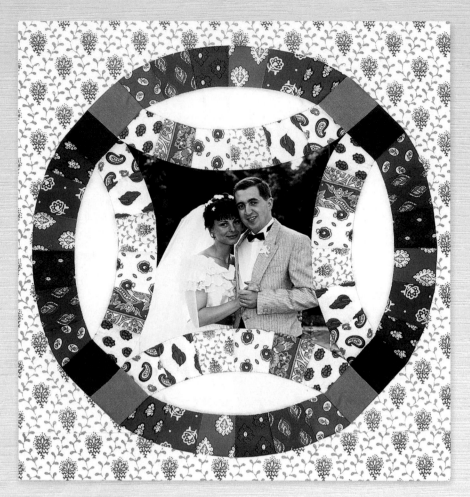

WEDDING RING QUILT
Spring 1997
Issue #3
Marie-Dominique Gambini, Lyon, France

A color-copied quilt sewn with traditional Provençal fabrics frames a young couple with the patterns and colors of their French heritage. The dark-colored outer wedding ring symbolizes eternal love and unity, while the light-colored inner arches pull the eye toward the central photo. With the symmetry, balance, colors and patterns built into the quilt, cutting out the inner frame was the sole design requirement for this page.

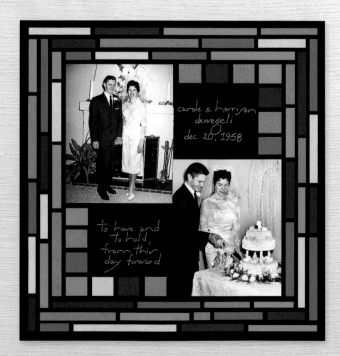

TO HAVE AND TO HOLD
January/February 2000
Issue #16
Sarah Fishburn, Fort Collins, Colorado
Photo Lorna Dee Christensen, Corvallis, Oregon

Layered on white paper between thin strips of black "leading," asymmetric rectangles of colored vellum achieve a luminous stained-glass effect. The design bathes the page with color and light without overwhelming the vintage wedding portraits. Silver lettering communicates key details with elegant style.

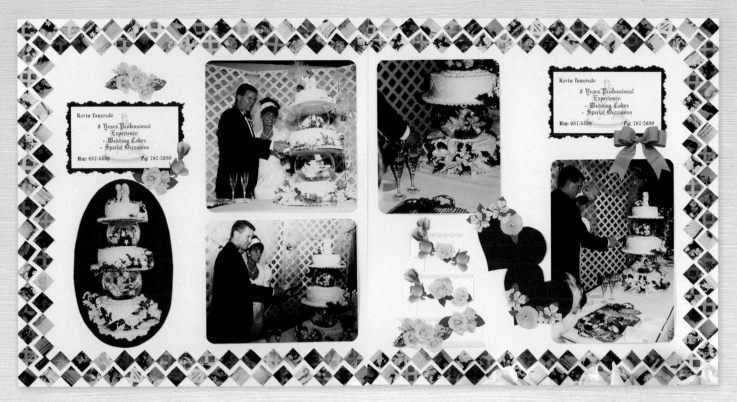

WEDDING CAKE

May/June 1999

Issue #12

Eileen Ruscetta, Westminster, Colorado
Photos Party Crashers, Littleton, Colorado

Traditional cake-cutting festivities inspire each design element in an elegant and energetic wedding layout. Meticulously pieced from photo scraps, a mosaic border ties in both the lattice backdrop and photo colors. Photo-realistic flower stickers adorn a paper-pieced replica of the three-tiered wedding cake. Burgundy paper accentuates the silhouetted cake masterpiece and pair of entwined hearts. Matted business cards even give credit to a skilled cake decorator.

OUR FLOWER GIRLS

May/June 2001

Issue #24

Matt Corwin, Ridge Manor, Florida
Photos Jolita Rishel, Pasadena, Florida

Wreathed in a bouquet of blossoms, these flower girls beam from a frame of sticker art. Companies, such as Mrs. Grossman's, make intricate sticker designs possible by producing stickers which are mirror images. These stickers can be set down in simple patterns to produce less-than-simple results. Minimal journaling keeps the focus on the frame and those fresh flowers within.

FAMILY TRADITIONS

Christmas, Chanukah, Thanksgiving, Easter and other yearly holidays hold some of the most cherished memories of both our early years and adulthoods. They symbolize a coming together of family and friends, and each time traditions are repeated they become richer and more important. The sharing of these occasions are truly gifts.

WHITE CHRISTMAS
November/December 1999
Issue #15
Susan Sigle, Pretty Prairie, Kansas

A background of deep navy and black immediately brings vintage wintry photos to center stage. Rich evergreen holly leaves, circle-punched berries and stamped-and-embossed snowflakes provide subtle embellishment. The Gothic-style lettering, handcut using a template, gives equal presence to the titles and captions.

GLAD TIDINGS
November/December 2001
Issue #21
Memory Makers
Inspired by Nancy Castaldo, Chatham, New York

On this 8½ x 11" page, 16 tiny greeting cards burst out of a translucent vellum envelope. Reducing the images on a color copier is the ingenious technique that eliminates holiday card clutter while still providing a way to enjoy the colorful photos and images.

HOLLY WREATH
November/December 2001
Issue #21
Nanette Morone, El Cajon, California

Realistically highlighted with pencil and a gold pen, a fluffy red bow crowns a holly wreath that features 20 photos and over 30 handcut holly leaves. Corrugated paper and two shades of evergreen impart a sense of depth and texture. Circle-punched berries provide additional splashes of color.

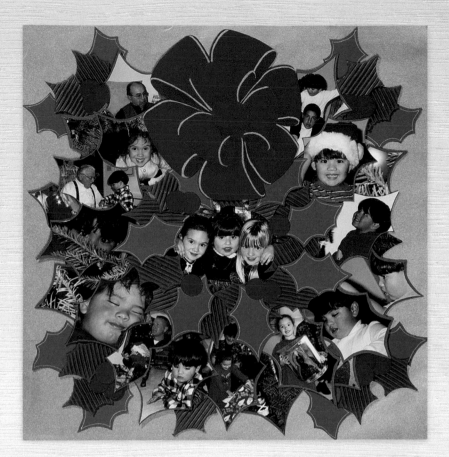

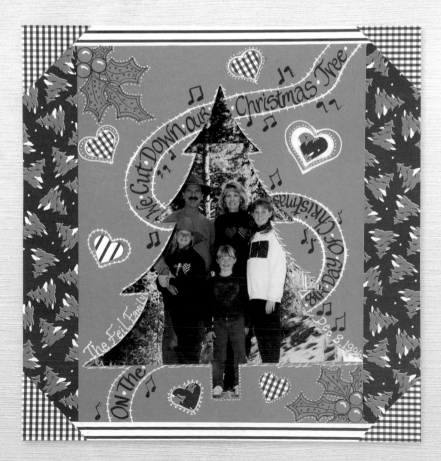

CHRISTMAS TREE
Holiday/Winter 1997
Issue #5
Joyce Feil, Golden, Colorado

Like giant, fluffy snowflakes, punched and doodled hearts flutter down a colorful Christmas page. The windy caption swirls around a die-cut tree frame, whistling a familiar holiday tune. Strips and triangles of festive paper border the happy tree-hunting theme.

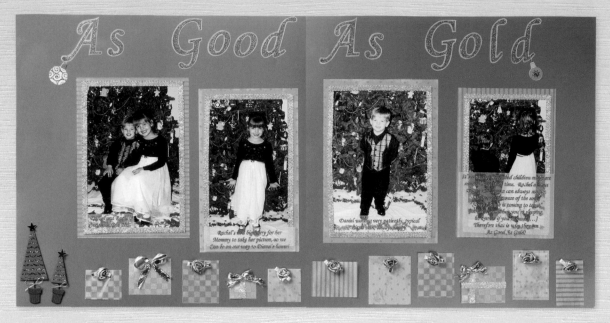

AS GOOD AS GOLD
November/December 2002
Issue #33
Sheila Boehmert, Island Lake, Illinois

Modern supplies and technology simplify this golden Christmas layout. Printed on vellum with an ink-jet printer and immediately heat-embossed with gold powder, the title and captions match the shimmering ribbon mats. Contemporary gold and silver patterned vellum wrap up beribboned holiday packages, and prepackaged tree and ornament embellishments require only peel-and-stick mounting.

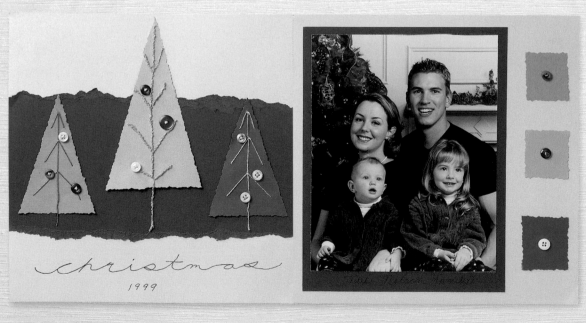

CHRISTMAS 1999
November/December 2002
Issue #33
Kate Nelson, Fountain, Colorado

An Internet idea inspired hand-sewn Christmas trees decorated with button ornaments. Stitched with only a needle and fiber, the trunks and branches enhance the simple folk-art appeal but keep the focus on the family portrait.

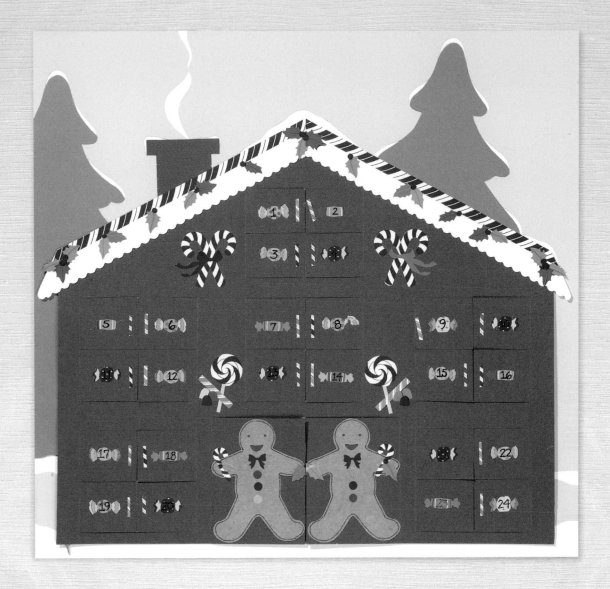

ADVENT CALENDAR
November/December 1998
Issue #9
Memory Makers

As shown in this cheerful Advent calendar, creative scrap-books can pass down holiday traditions as well as hold family memories. First created in the 19th century, Advent calendars originally contained Scriptures or drawings of biblical scenes to help teach children about the meaning of Christmas. Constructing a modern version is easy using the pattern in the original issue. The fun for scrapbookers is designing 24 tiny scenes using stickers, die cuts, small photos, captions and other embellishments. The fun for children is the excitement and anticipation of a personalized Christmas countdown.

Chanukah
Holiday/Winter 1997
Issue #5
Randi Green, Woodland Hills, California

Photographic candles add personal meaning to a traditional menorah. Smudged with a cotton ball, yellow ink adds a warm glow to each flame. Die-cut letters simply proclaim the holiday.

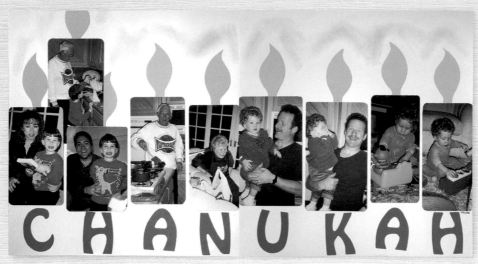

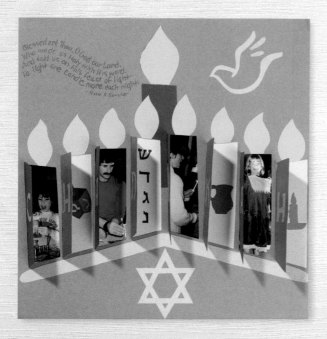

Chanukah
November/December 1998
Issue #9
Memory Makers
Photos Kerry Arquette, Arvada, Colorado

Inspired by the concept of an Advent calendar, each candle in this paper menorah opens like a door to reveal a photo or religious symbol. Connecting a visual triangle with a dove and Star of David, a simple flowing prayer captures the essence of the Feast of Lights.

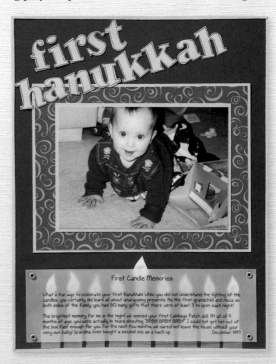

First Hanukkah
November/December 2002
Issue #33
Melissa Ackerman, Princeton, New Jersey

Perched on an embossed gold menorah, nine candles softly glow behind a vellum caption describing a young girl's delight with a new baby doll. Shades of purple enhance the photo and tie in the lavender title. For the outer border, thin mitered strips give the full-page matting effect while saving cardstock.

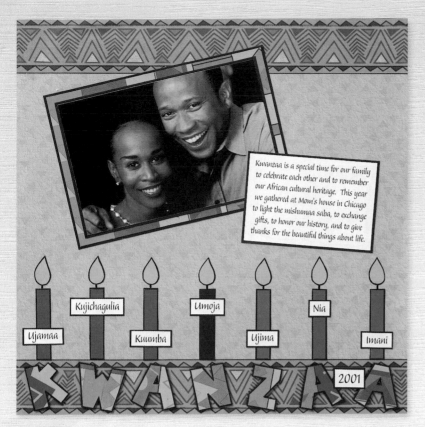

KWANZAA
November/December 2002
Issue #33
Amy Gustafson for Hot Off the Press, Canby, Oregon

Candles in symbolic colors shed light on the Swahili words for the seven principles of Kwanzaa. The tribal-inspired lines and patterns in the border, photo mat and title letters reflect the celebration of African heritage.

NEW YEARS EVE
January/February 2003
Issue #34
Tricia Morris for Club Scrap,
Greenville, Wisconsin

The elegant, contemporary tags on this New Year's layout illustrate one of many stamping techniques that have migrated from the stamping world into the pages of creative scrapbooks. Created with simple stamping and embossing, the double-sided tags are held in place with wire and eyelets so they are visible from both sides of the page. The tags provide an interesting textural embellishment that unifies both the paper and photo colors.

THANKSGIVING 2000
November/December 2001
Issue #27
Maria Loomis, Anacortes, Washington

A spectacular montage of autumn leaves and corn owes its impact to pigment ink and clear embossing powder. The background actually began as a sheet of ivory paper first stamped and heat embossed with clear ink and powder. Rubbing over the clear embossed images with shades of pigment ink brought them "to the surface." Additional leaves and corn stamped in black and a final clear embossing finished the shiny, almost enameled surface. The custom look reflects the fun of stamping techniques as much as Thanksgiving joviality.

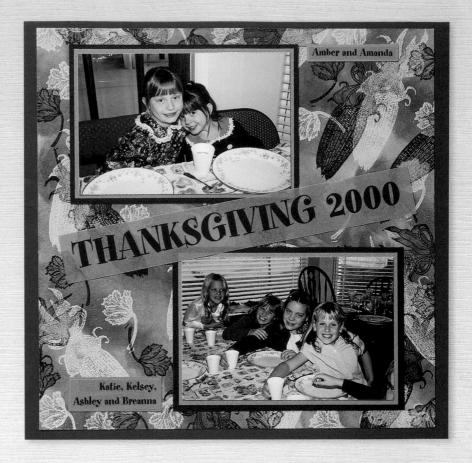

WE HAVE SO MUCH
November/December 2001
Issue #21
Memory Makers
Photo Amy Giacomelli, Monrovia, California

Printed paper scraps blended in an autumn-theme collage warmly enhance a Thanksgiving family portrait. The touch of blue marbled paper plays off the earth tones to keep the page from feeling too heavy. Paper-punched birch leaves accentuate the leaf motif, and seasonal stickers tie in the season and family theme.

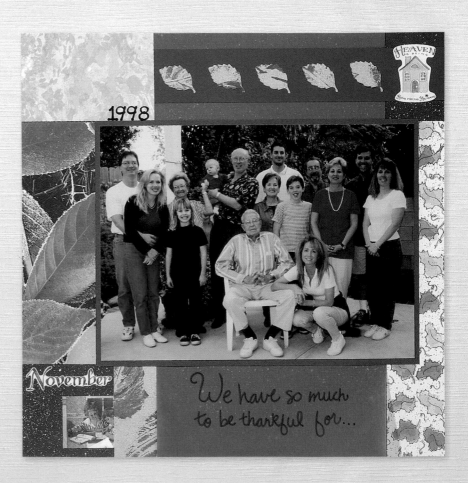

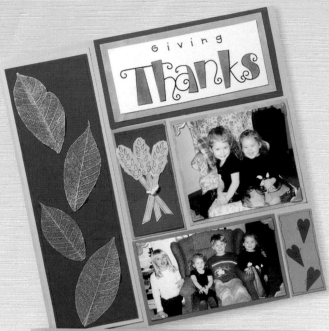

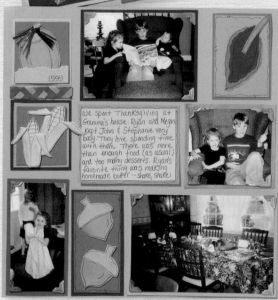

GIVING THANKS
November/December 2001
Issue #27
Peggy Kangas, Pepperell, Massachusetts

Emblems of autumn including wheat bundles, crimson leaves, ripe acorns and plump corn fill the spaces around young-cousin candids. Paper-piecing patterns make quick work of the cut and torn designs embellished with simple pen strokes. Stylized lettering colored with suede paper draws attention to the theme, while gold photo corners and lacy leaves add sparkle and shimmer.

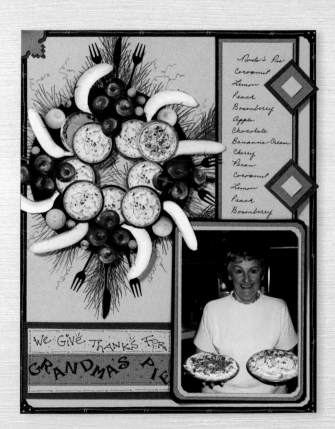

GRANDMA'S PIE
November/December 1999
Issue #15
Susan Badgett, North Hills, California

Coconut, lemon, peach, boysenberry, apple, chocolate, banana cream, cherry, pecan—pies in myriad flavors served on a delectable holiday wreath give literal meaning to "fruitful labor." Stamped pine needles spice up the background for circle-punched and silhouette-cropped lemons, apples and bananas. With shiny flatware stickers, this page is set and ready to serve.

A LOOK BACK: *Creative Photo Cropping*

Cropping, which is the process of cutting photos to enhance the image or eliminate portions of the shot, is the original creative scrapbooking technique that requires only photos and a pair of scissors. When the scrapbook market exploded in the late 1990s, so did the variety and availability of cropping tools, including decorative scissors and rulers, shape templates and cutters, die-cut machines, corner and shape punches, cutting mats and specialty craft knives.

As illustrated in countless scrapbook layouts and in *Memory Makers Creative Photo Cropping for Scrapbooks,* published in 2001, the ideas for creative cropping are as limitless as the photos themselves. Sometimes a photo itself dictates the need for cropping to remove a busy background, to eliminate photo imperfections or to improve a photo's focus. But any photo, other than historic, artistic or Polaroid photos, can be cropped simply to add style and variety or to create a unique work of art.

TEA SIPPING COUSINS
Winter 1997
Issue #2
Joyce Feil, Golden, Colorado

With pinkies delicately extended, beribboned and hat-clad young ladies sip grown-up pleasures if only for a moment before running off to play. Silhouette cropping suggests an imaginary Anne-Geddes-style world of giant red teacups filled with delightful young faces.

HANGING OUT TO DRY
Autumn 1997
Issue #4
Pat Brookes, Bonita, California

A thin clothesline laden with sleepers, socks, overalls and pants hangs from colossal, towering sunflowers. Cropped entirely from extra photos and interesting scraps, the photomontage integrates mismatched snapshots into a cohesive, fairy-tale-like scene. Generous documentation describes grandson joys and mishaps.

ROLLIN' ROLLIN' ROLLIN'
October 1998
Issue #8
Eve Lowey, Newport Coast, California

A series of baby-rolling-over photos shot in rapid succession show that creative photography often precedes creative cropping. Partial silhouetting and layering produces a motion-picture effect. The title and wavy border further emphasize the movement.

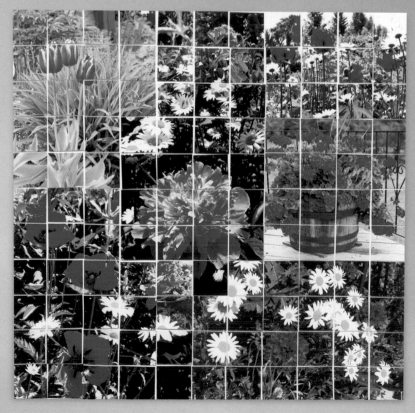

GARDEN MOSAIC
May/June 1999
Issue #12
Sandra de St. Croix, St. Albert, Alberta, Canada

Photo mosaics are an inviting technique that require only a few photos and an accurate paper trimmer, a simple square punch, or a mosaic template—whatever the favorite tool. Here the mosaic technique connects photos of a Canadian garden in full bloom, preserving the vivid colors for year-round enjoyment. Thin white spaces between the squares allow the eyes to rest as they peacefully wander from bloom to bloom.

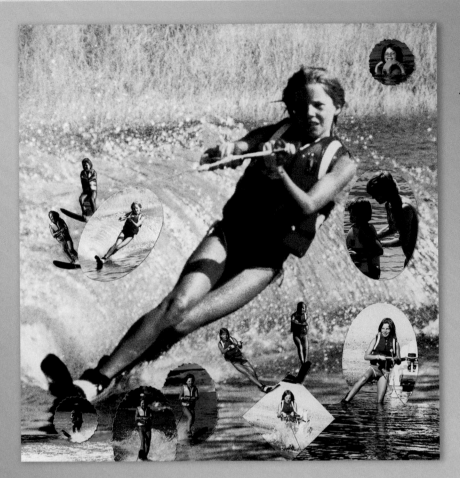

WATER SKIING
July/August 1999
Issue # 13
Barbara Wegener, La Quinta, California

An enormous enlargement makes it easy to see the details of a young water skier leaning into the wake, gripping a pull rope to stay afloat. The smaller photos are cropped and placed to blend into the water-filled scene. Each successive image adds another detail to the adventure.

1998
January/February 2000
Issue #16
Mette Harding, Burke, Virginia

From springtime tree climbs and summer beach balls to autumn hikes in the woods and holiday festivities, these jumbo-sized numbers pack in a year of memories. Photos are silhouette cropped and carefully layered so that each number appears to be cut from a single photo. The background fills in the details with a summary of the year's highlights.

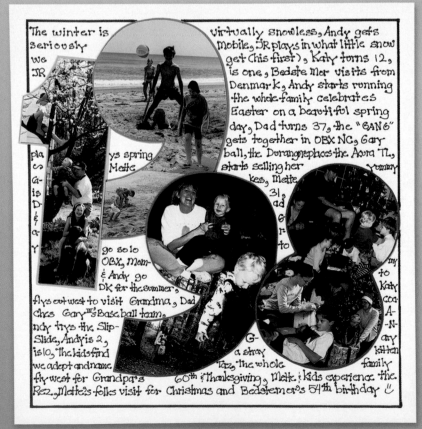

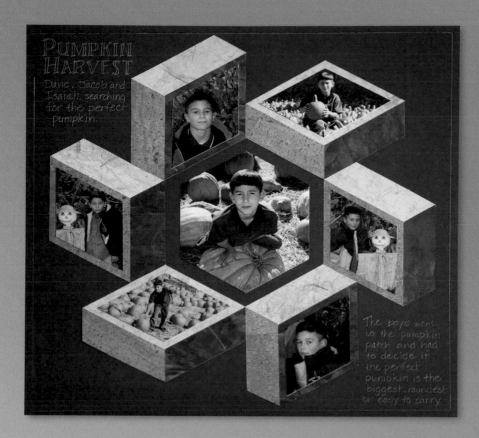

PUMPKIN HARVEST

September/October 2000
Issue #20
Memory Makers
Photos Sandra Escobedo, Manteca, California
Inspired by Hallie Schram, Billings, Montana

Understanding of both dimension and light are necessary to create intricate three-dimensional illusions. Photos are cropped to fit preordained spaces. Lighter photos are mounted on lighter blocks, while darker photos are mounted on darker paper. Continuity is the key to carrying off this complex pattern of cropped crates.

TAKE IN THE WONDER

January/February 2003
Issue #34
Julie Labuszewski, Centennial, Colorado

A barefoot walk along the beach gains a sense of movement from sliced and staggered photo edges. The simple cropping technique adds visual interest to balance the emotional impact of the artist-authored poem. A swirly sun stamp and hand-sewn sun rays fill extra space with subtle texture.

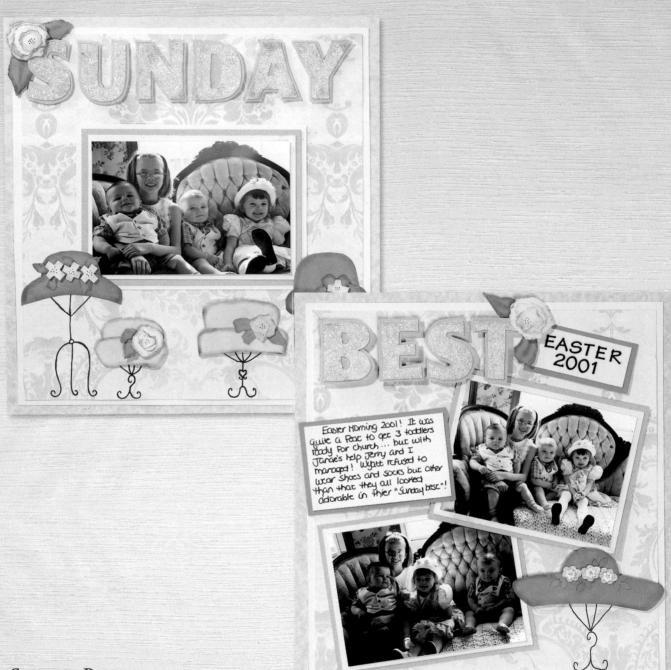

Easter Morning 2001! It was
quite a feat to get 3 toddlers
ready for church ... but with
Jance's help Jerry and I
managed! Wyatt refused to
wear shoes and socks but other
than that they all looked
adorable in thier "Sunday best"!

EASTER
2001

SUNDAY BEST
March/April 2002
Issue #29
Sandy Brown, Forest Grove, Oregon

Streaming Easter sunshine basks four angelic children with bright background light,
painting a golden halo above each smiling face. Pale shades of tan, pink and green pull
the sunlight into the old-fashioned layout. Mimicking the look of vintage wallpaper, the
damask background perfectly matches the antique settee. Delicately chalked velveteen
hats adorned with punched and torn flowers make the ultimate fashion statement for
this dressed-up layout.

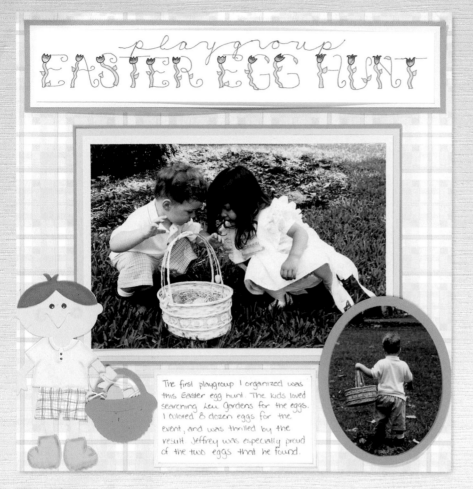

EASTER EGG HUNT
March/April 2002
Issue #29
Nancy Finch, Orlando, Florida

Pastel solids and plaids draw attention to a vivid photo of two explorers absorbed in the magic of a traditional Easter event. Dressed to match his photo counterpart, a die-cut egg hunter proudly displays a basket filled with punched eggs and paper grass. Lavender tulips bloom in each title letter, announcing the page with style.

NICOLE & ISABEL
March/April 2000
Issue #17
Memory Makers

A soft and fuzzy page literally makes an impression with the use of velvet stamping. Originally developed for reverse-embossing on real velvet, this technique works on velvet scrapbook paper using an iron and an inked or uninked rubber stamp. This soft and tactile background combines three basic designs and several shades of ink to enhance a cheerful Easter photo.

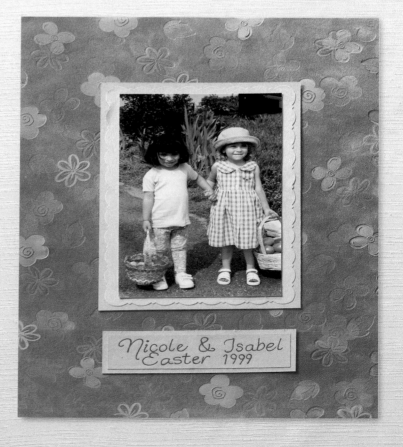

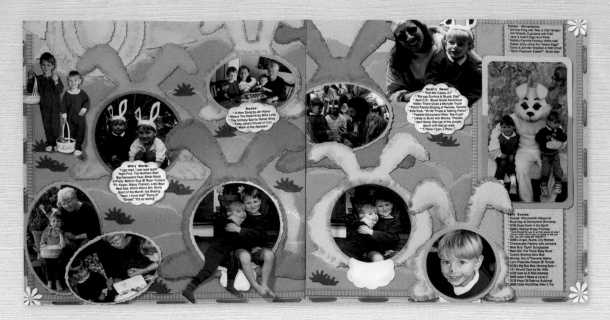

EASTER ATTRACTIONS

March/April 2000

Issue #17

Susan Badgett, North Hills, California

A deckle-cut sun peeps behind grassy green hills teaming with a drove of ink-smudged, cotton-tailed bunnies that almost seem to wriggle with excitement. Framed with striped stickers and woven ribbon, the warm and energetic layout beautifully integrates a dozen Easter photos as well as extensive, personalized journaling in a cohesive and fun-filled spring romp.

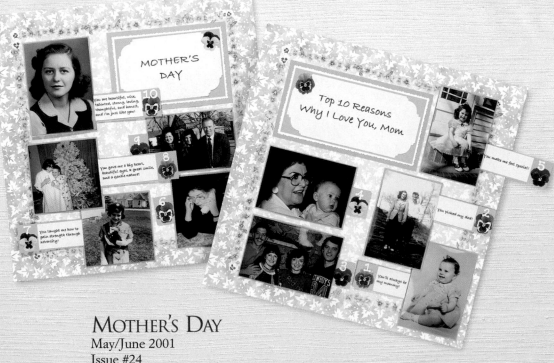

MOTHER'S DAY

May/June 2001

Issue #24

Stacey Shigaya, Denver, Colorado

Photos Connie Mieden Cox, Westminster, Colorado

Humorous or serious, witty or sentimental, top-ten lists provide an easy template for creative journaling that is both enjoyable to write and read. In this Mother's Day layout, ten pull-out captions offer personal meaning to 10 photos taken across the decades. Lovely pansies unify the diverse elements, and a soft and leafy background complements the feminine theme.

GOOD TIMES

Nineteenth-century zoologist Thomas Henry Huxley philosophized, "The secret of genius is to carry the spirit of childhood into maturity." Retaining the spirit of childhood is also the secret to the best birthday celebrations, whether for a country or individual. Fireworks, flag waving, hot dogs on the grill, ice-cream cake, helium balloons and, most important, family and friends, are the high points that mark these annual celebrations.

2000
July/August 2001
Issue #25
Cathie Allan, Edmonton, Alberta, Canada

Stamped paper strips laced through diagonal photo slits literally weave hopes and dreams around a proud graduate. The lines move upward and outward, conveying a sense of expanding horizons and a future exploding with limitless possibility. Festive balloons and folksy stars add to the sense of celebration.

MAY YOU HAVE JOY
May/June 2003
Issue #36
Gayla Feachen, Irving, Texas

Diplomas made from rolled and corded pieces of paper and gold embossed mortarboard stamps add just the right touch of ceremony to this graduation page. The journaled quote speaks as eloquently as any commencement speaker to a young graduate whose face beams with excitement at the thought of embarking on life's adventures.

May you have joy on this your graduation day. Always have a sense of how unique you are. Never doubt how much you have to give. Have faith in your abilities. Follow your dreams in every day you live.

A LOOK BACK: *Scrapbook Kaleidoscopes*

Peering through a kaleidoscope reveals a world of patterns and colors spinning and collapsing into each other. Peering into a scrapbook reveals the colors and patterns of life. When Judy Nurkkala of Bloomington, Minnesota, visualized a way to blend the two, her idea took the concept of photo art to a new level. The March/April 1999 edition of *Memory Makers* introduced her concept of cutting original and reverse-image photos into geometric angles and piecing them together to mimic the kaleidoscope's beautiful form and effect.

Memory Makers Photo Kaleidoscopes, also published in 1999, develops the technique in detail, including how to select a photo, obtain reprints, cut photo angles and assemble the cut pieces. Although photo kaleidoscopes may look complicated, the 350 entries in the May/June 2000 *Memory Makers* photo kaleidoscope contest attest to the fact that anyone can replicate the fascinating patterns, forms, movement, lines and colors.

 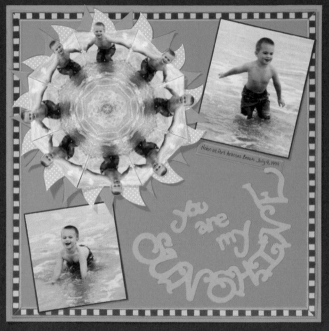

OUR VACATION AT THE BEACH
July/August 2000
Issue #19
Ashley Smith, Richardson, Texas

Against an intense blue sky, blazing sun rays emanate from a classic eight-piece photo kaleidoscope fashioned out of 45° pie shapes with silhouetted outer edges. The center spins like a swirling whirlpool. To complement the water theme, a fan-shaped kaleidoscope layered from six duplicate photos suggests a rushing ocean wave. Both kaleidoscopes merge in an interconnected layout of sky, sunshine and water.

ALL AMERICAN BOY
May/June 2000
Issue #18
Florence Davis, Winter Haven, Florida

Photos with repetitive patterns, intersecting lines, vivid colors and good light quality produce the most dramatic kaleidoscope effects. The photo in this eight-piece kaleidoscope fits all of these requirements with a linear deck fence, angular stars and stripes, bright hues and soft light. The center begins with an exquisite burst of summer blooms merging into a ring of fence spindles and solid brown railing. In the distinct outer layer, vivid flagpoles and pale green grass form a pleasing starburst pattern.

UNDERWATER JEWELS
May/June 2000
Issue #18
Linda Casali, Livermore, California

An exotic, eight-tentacled sea creature seems to glide through a murky blue ocean in this eight-piece kaleidoscope. Made from an underwater photo, the seascape kaleidoscope contains incredible detail and organic beauty.

COWBOY TYLER
May/June 2000
Issue #18
Dorthy Rohner, Albany, Oregon

Armed with a rope and a mega-caliber grin, this little cowboy supplied just the bang needed for a complex kaleidoscope page. Dorthy's artwork took the grand prize in *Memory Makers'* photo kaleidoscope contest.

FALL KALEIDOSCOPE
November/December 1999
Issue #15
Terah Brossart, Spokane, Washington

Celebrating the season with its own colorful confetti, a joyful leaf-pile jumper tosses crunchy autumn leaves. Small maple leaves punched from printed paper seem to fly off the corners, while large photo-punched leaves add a lacy effect around the outer edges. The stamped saying not only sums up the page but also disguises the center opening in the eight-way kaleidoscope.

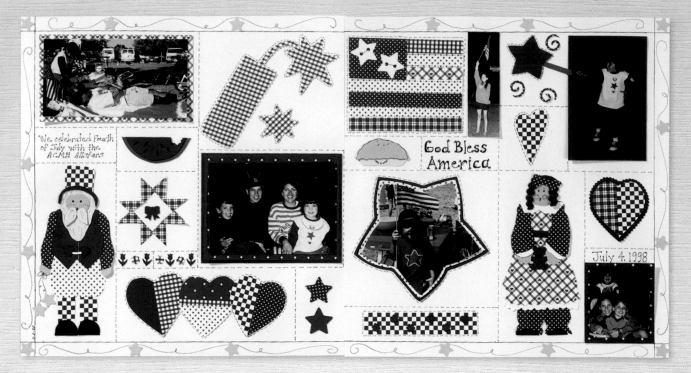

GOD BLESS AMERICA
July/August 1999
Issue #13
Teresa Ramirez, San Diego, California

A red, white and blue country patchwork celebrates all things American with familiar icons such as ripe watermelon, deep-dish apple pie, crackling firecrackers, gingham hearts and a folk-art flag. Inspired by a tole painting pattern book, paper dolls dressed in polka dots, checks and plaids brighten the layout with quaint personality. Black pen stitching and a loosely swirled star border round out the design.

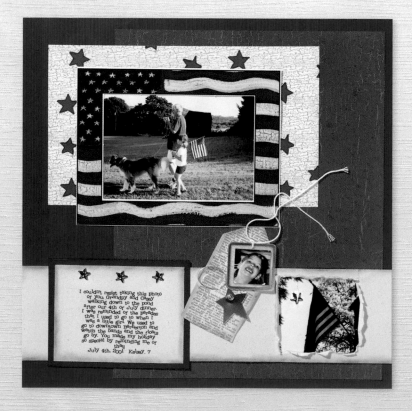

JULY 4TH
July/August 2003
Issue #37
Chris Douglas, Rochester, Ohio

Break out the band and strike up your favorite I Love America rendition, this special page will fit right in with weathered shades of red, white and blue and a heritage undertone. A star charm, glass bauble and photo are mounted on a tag which defines "freedom" in a multitude of ways. A gently ripped photo window and thoughtful journaling complete the story.

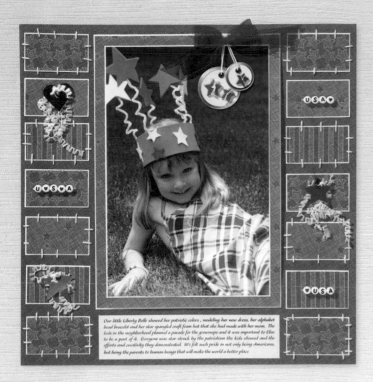

USA

July/August 2003
Issue #37
Shauna Berglund-Immel, for Hot Off The Press, Beaverton, Oregon

This red, white and blue page rings with patriotism from sea to shining sea. Beads, charms and fibers add dimension to coordinating patterned papers. Tags and stitching supply a home-sewn, homemade feeling while showcasing this darling Liberty Belle.

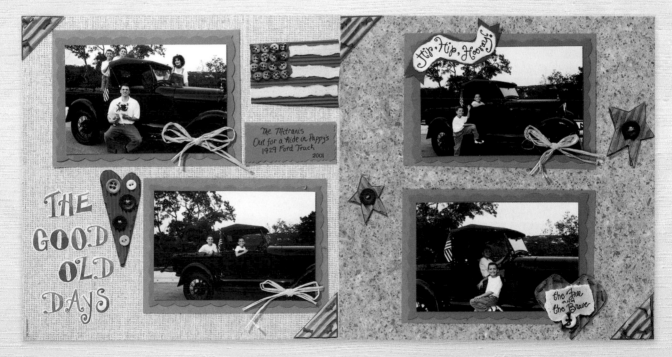

THE GOOD OLD DAYS

July/August 2002
Issue #31
Mendy Mitrani, The Woodlands, Texas

Textured backgrounds and muted mat colors echo the old-fashioned, Americana look of button-adorned, knotted and corrugated page elements. The embellishments including the heart, stars, flag, corners and antique-white captions are preprinted and ready to cut out, saving considerable scrapbooking time. Letter stickers further simplify the title lettering. Raffia bows hide unwanted dates on hand-tinted contemporary photos of an antique Ford truck.

HALLOWEEN
November/December 1999
Issue #15
Kristi Hazelrigg, Washington, Oklahoma

Scattered strands of straw raffia, plump orange pumpkins and golden-hued autumn leaves frame an unforgettable "don't-mess-with-me" toddler face. Her deadpan expression and piercing blue eyes humorously contrast with a jolly dressed-to-match scarecrow and cheerful punch-art turkey. The caption, which slips behind the portrait to reveal the hand-lettered title, provides essential who, what, when and where details.

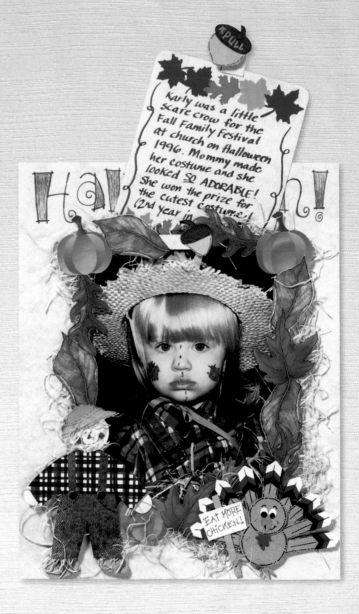

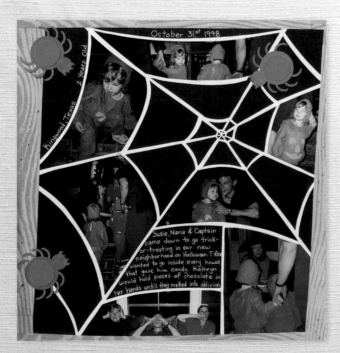

SPIDER WEB
September/October 2000
Issue #20
Donna Pittard, Kingwood, Texas

Happy trick-or-treating memories are woven into an artistically spiraled web handcut from a single sheet of white paper. The white lines against a black background direct the eye in a counter-clockwise motion from the smallest photo in the top right around to the bottom caption and focal photos. Created with swirl and circle punches, hot pink and purple spiders curiously survey the seasonal scenes with bright and bulging eyes.

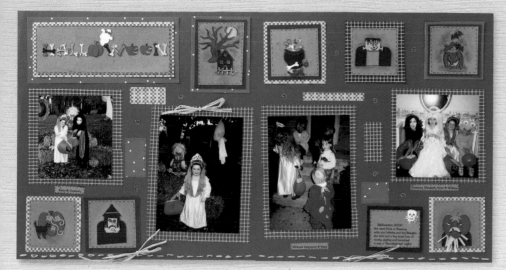

HALLOWEEN
September/October 2002
Issue #32
Kathleen Childers, Christiana, Tennessee

Inspired by Halloween symbols and spooky legends, miniature punch-art vignettes tell tiny stories of haunted houses, menacing jack-o-lanterns, creepy cats, green-faced monsters, boiling cauldrons, hovering ghosts and rattling bones. The texture and pattern of Magic Mesh, hand-sewn raffia and checkerboard paper visually unify the layout.

HALLOWEEN
September/October 2002
Issue #32
Pam Kuhn, Bryan, Ohio

Using a square punch to crop and mat the focal point of each pumpkin-carving photo puts double prints to good use. Navy mats further emphasize the punched photo squares and add dimension to the full-size photos. The orange, tan and green color scheme ties in the organic theme through green raffia, ivy and floral patterns and real pumpkin seeds. Cut and photocopied newspaper fonts form a whimsical title.

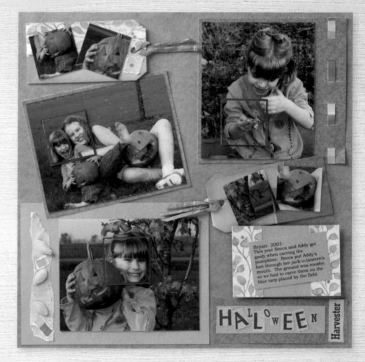

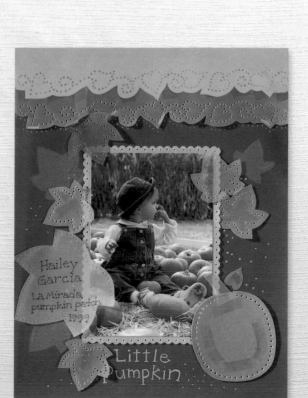

LITTLE PUMPKIN
November/December 2000
Issue #21
Sandy Holly, Laguna Hills, California

This little pumpkin is the pick of the patch when featured on an eye-catchingly crisp fall page. Paper-pieced vellum forms a canopy of autumn leaves above her head and wind-blown leaves that frame the photo. Intricate paper piercing adds visual interest.

It's a Party

July/August 2002

Issue #31

Brandi Ginn, Lafayette, Colorado

Lettering inspired by Tara Cowper, Portland, Oregon

Craft wire, sun and balloon punches and raffia help write the "Party Time" letters for this festive birthday page. In the confetti-strewn border, embroidery floss ties up pretty packages and quilling strips add dimension to paper party horns. Polka-dot paper and torn edges enhance the sense of celebration.

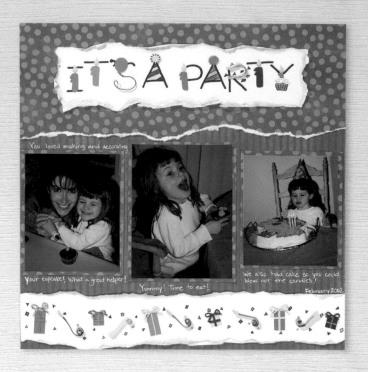

Happy Birthday

July/August 2002

Issue #31

Joy Carey, Visalia, Calfornia

Painted with watercolors on a single sheet of tan paper, soft background colors complement the vintage look of sepia-toned birthday photos. Mary-Engelbreit-inspired checkerboards outline eight different design blocks that include photos, captions and hand-painted designs. The yellow sun, twinkling stars and candle flame add just a touch of bright color.

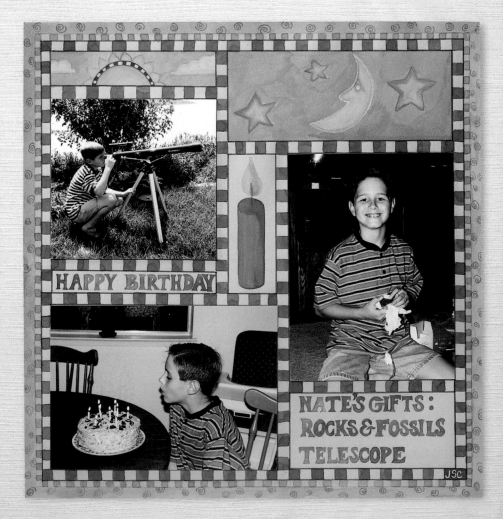

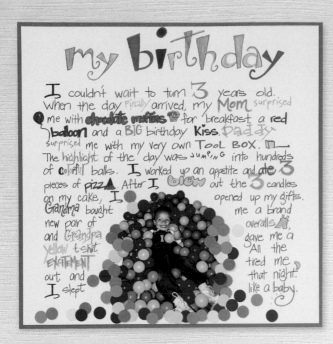

MY BIRTHDAY
March/April 2001
Issue #23
Julie Labuszewski, Centennial, Colorado

Similar to spoken words voiced longer or louder, written journaling can emphasize words and phrases with different colors and lettering styles. In this ball-laden birthday page, colorful pens jazz up the title and key words, spreading color throughout the page. A tiny chocolate muffin, pizza slice, tape measure, balloon, overalls and moon illustrate important elements of a fun-filled celebration.

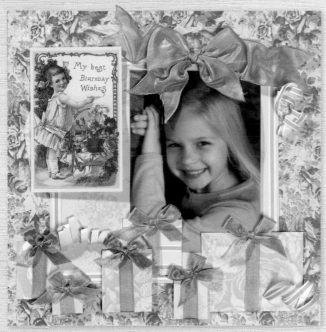

BIRTHDAY BOWS
July/August 2002
Issue #31
Frances Goldwasser Reed, Atlanta, Georgia

A young girl's beaming smile warms an old-fashioned floral background bordered by piles of pretty presents. A well-arranged blue bow almost seems to rest atop her golden tresses. Thin strips of paper curled around a pencil add a festive touch of confetti, and an antique postcard folds back to reveal a detailed caption.

PARTY TIME
July/August 2002
Issue #31
Melissa Caligiuri, Winter Park, Florida

Sweet as the icing on Connor's birthday cake, this bright page draws its color scheme from lemony star stickers. Party hats and corner accents were created to complement the festive mood of a first birthday celebration. While the birthday boy will grow older each passing year, the page design is timeless.

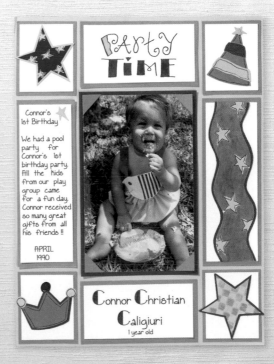

A LOOK BACK: *Scrapbook Paper Tearing*

Paper piecings, borders and other embellishments take on a whole new form when shapes are torn instead of cut. Perfect for outdoorsy or playful layouts, designs can look rugged, soft or whimsical. The beauty of this technique comes from its imperfections, so mistakes only add character. As further illustrated and explained in *Memory Makers Creative Paper Techniques for Scrapbooks*, published in 2002, paper tearing also offers a decorative edge that softens the look of any page element.

Perhaps because anyone can tear paper, the technique has an enduring appeal that provides surprising and spontaneous results depending upon the paper's texture, thickness and direction of the tear. The act of tearing is as satisfying as its delightful results.

DESERT BLOOM
Spring 1998
Issue #6
Pat Thuman, Scottsdale, Arizona

Simply torn mountains contribute soft texture to a serene landscape border. A die-cut cactus and sun complete the peaceful scene.

SECOND TO NONE
March/April 2000
Issue #17
Linda Strauss, Provo, Utah

An orange basketball soars toward a backboard in the hopes of swooshing through its woven net. Combined with photos placed askew, the angles of the pen-detailed design heighten the sense of movement and action. An energetic poem tells a story of "swishes, sweat, the ball, the net" with the compelling enthusiasm of a proud parent.

I Love Books

September/October 2000
Issue #20
Missy Rice, Whittier, California

A "cubby little tubby all stuffed with fluff" as well as a "very hungry caterpillar" prompted these whimsical illustrations of favorite book titles. The paper-torn designs recall the pleasures of many cozy reading sessions.

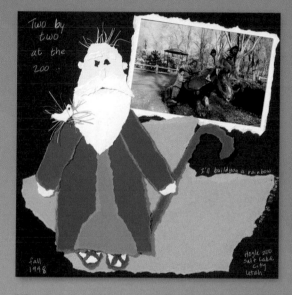

Two by Two

September/October 2000
Issue #20
Linda Strauss, Provo, Utah

A giant-sized Noah complete with beard, robes, staff and sandals seems to hold up this framed photo of a sunny day at the zoo. Thin paper wisps not only nestle the messenger dove but also humorously depict a balding patriarch.

When I was 4

July/August 2000
Issue #19
Memory Makers
Photo Christina Hutchinson, Corona, California

With visions of plump gray mice scurrying in their heads, two fancy felines purr contentedly in the corner of this cuddly page. Torn paper provides the "purrfect" technique for suggesting fur's soft texture.

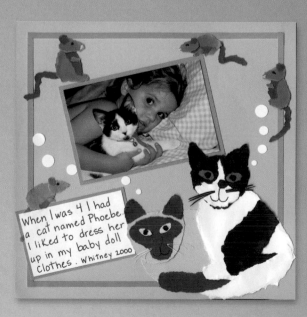

the Wide World Beckons

BEYOND your front yard, down the block, around the corner, throughout the nation and across the seas, the wide world calls. It is rich and ripe with nature, with adventure and growth. Whether gardening, dreaming, vacationing or otherwise interacting with the outdoors, spectacular photos are waiting to be taken and placed on album pages that tell the story of journeys beyond your front door.

SUMMER

When Shakespeare said that "summer's lease hath all too short a date," he probably wasn't thinking of pool parties and seaside vacations. But his observation still holds true— three months seem altogether inadequate to fully enjoy lazy days filled with sunny relaxation and recreation.

Summer pages, however, like a glass of fresh lemonade, squeeze photos and words into memorable refreshment that still tastes sweet when summer's blooms have long faded.

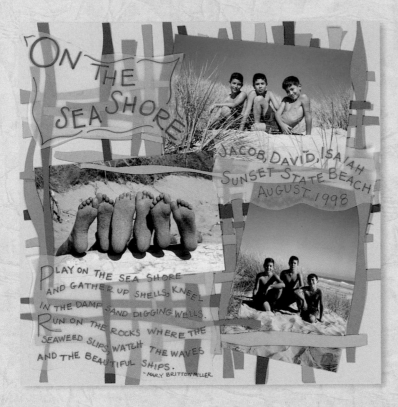

ON THE SEASHORE
July/August 2001
Issue #25
Memory Makers
Photos Sandra Escobedo, Manteca, California

Muddy feet and sandy toes peep from a textural background woven with freeform, wavy strips. The intense combination of aqua and orange ties in the water and sunshine, and the wavy title and captions further develop a sense of movement.

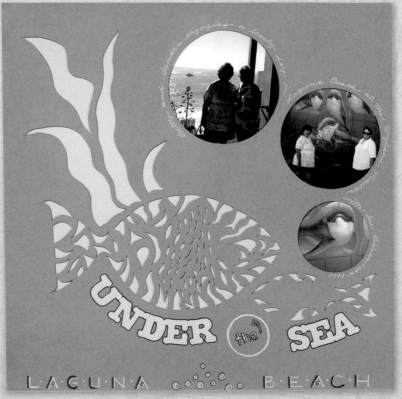

UNDER THE SEA
January/February 1999
Issue #10
Sandy Holly, Laguna Hills, California

In the hands of a scrapbooker, a good sharp craft knife is like an artist's paintbrush. Here, a fish design freehand cut from a single sheet of blue paper simulates the look of intricate stained glass. The technique creates a focal point with both texture and design interest.

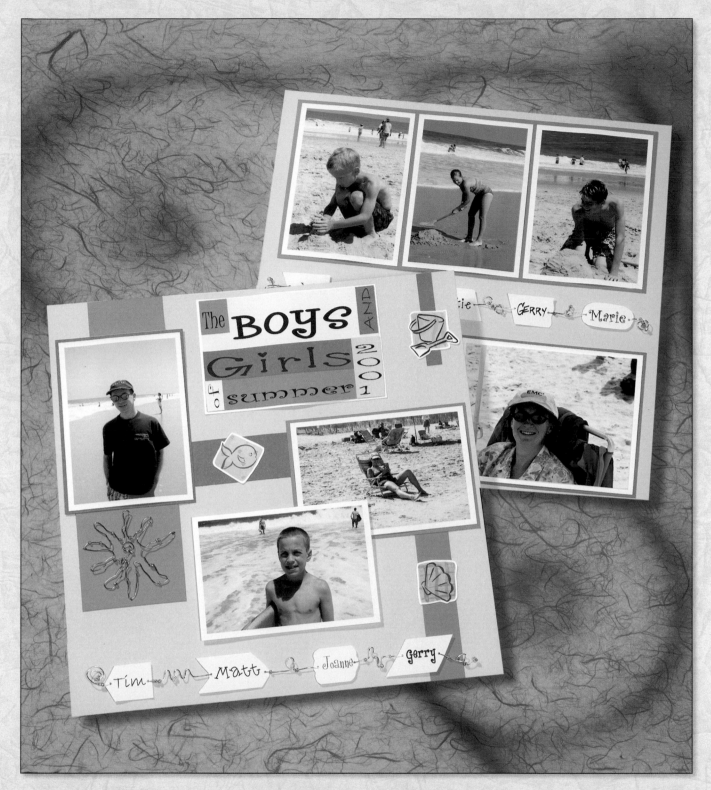

BOYS AND GIRLS OF SUMMER

March/April 2002
Issue #29

Marie Hazzard, Springfield, Pennsylvania

A deco-inspired beach layout dresses up with artistically bent, twisted and bead-adorned wire elements. The tag-style captions do double duty by holding the wire in place as well as identifying young faces in the bright and sandy photos. A variety of computer fonts contribute to the sense of whimsy, while pink and blue highlight the title and theme.

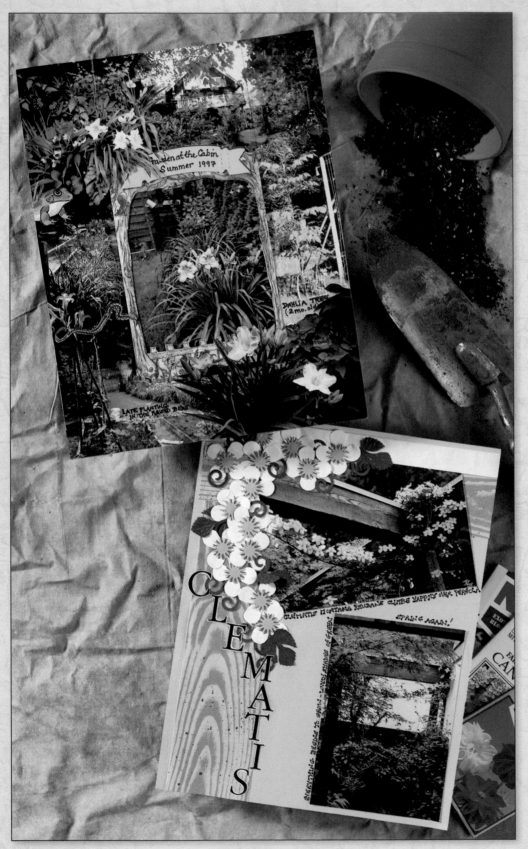

GARDEN AT THE CABIN
May/June 1999
Issue #12
Linda Schell, North Vancouver, British Columbia, Canada

Like a hidden-pictures game, close examination is required to find the spotted butterflies, spinning spider, slithering snake and croaking bullfrog that blend into the upper collage of summer garden photos. A graceful arbor cut from a sheet of stationery draws attention to prized daylilies. The lower page re-creates a lovely climbing clematis with heart, sun and spiral punches.

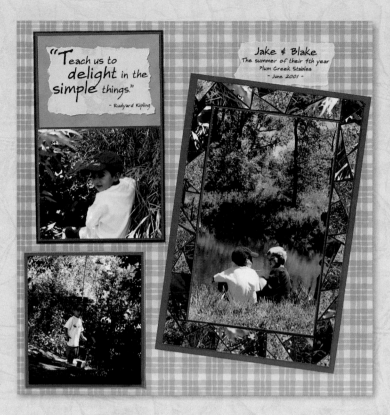

JAKE & BLAKE
November/December 2002
Issue #33
Kelly Angard, Highlands Ranch, Colorado

The colors, patterns and textures of summer find their way into a mosaic frame pieced from cropping leftovers. The design expands the glimmering photo of two boys by a pond and breaks up the rectangular theme with dynamic triangles and diagonals.

LAZY DAYS
July/August 2002
Issue #31
Oksanna Pope, Los Gatos, California

Hand-knotted with beige embroidery floss, a miniature hammock swings from summer trees laden with punched green leaves. The scene envelops the pages with a sense of cool breezes and restful undulation, suggesting the peace and serenity of hammock snuggles.

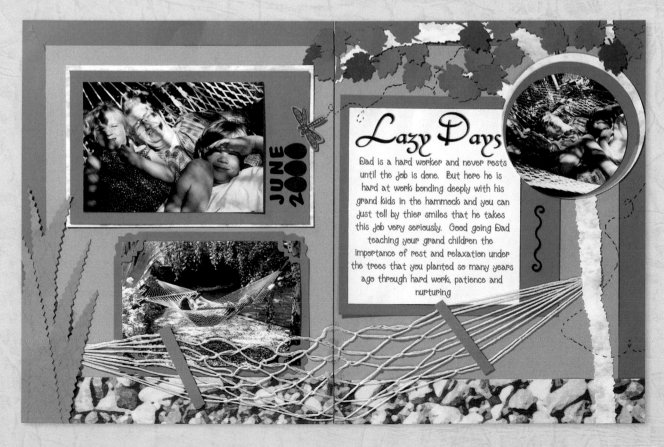

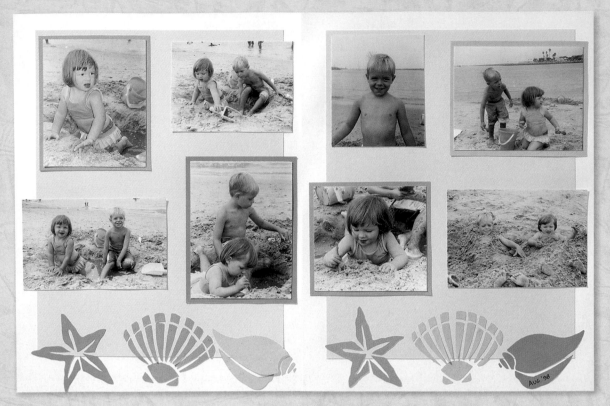

At the Beach
July/August 2000
Issue #19
Susan Walker, Oakbrook Terrace, Illinois

Hand-tinted photos match the soft colors of stencil-cut starfish, scallops and
tulip shells gently floating at the page bottom. Sheets of cream paper add
subtle background warmth.

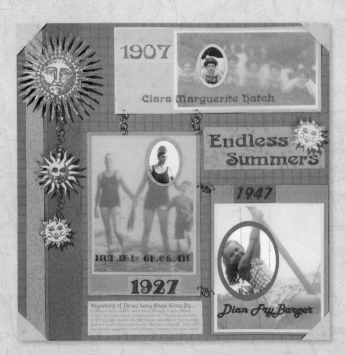

Endless Summers
January/February 2003
Issue #34
Torrey Miller, Thornton, Colorado

Like foggy memories, vellum symbolically fades these
heritage photos, while oval windows let viewers peer at
long-ago summertime faces. Connected with brass
chains against a colored background, stamped and
embossed copper suns light up a sharp, contemporary
present in contrast to a blurry, black-and-white past.

DREAMING OF THE LAZY DAYS OF SUMMER
January/February 2003
Issue #34
Kelli Noto, Centennial, Colorado

A sensitive touch and an artistic eye managed to combine this dreamy photo of brothers engaging frogs and dragonflies in a too-blue-to-be-real pond with cartoon-like clip art. Mulberry paper adds texture for reeds and cattails, while a butterfly sticker flutters, drawing the eye toward the title. This layout manages to be both cool as pond water and warm as a mother's hug.

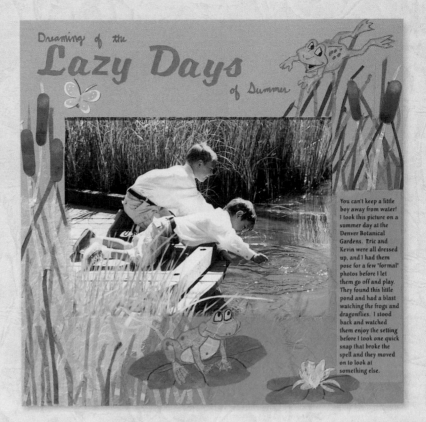

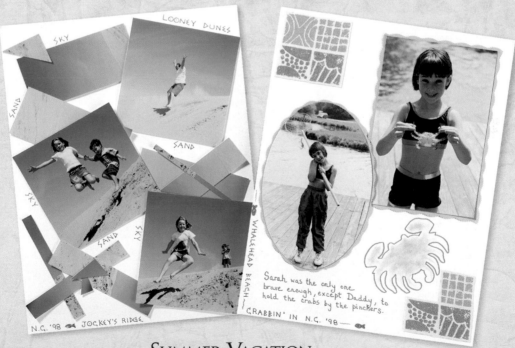

SUMMER VACATION
July/August 1999
Issue #13
Donna Leicht, Appleton, Wisconsin

Almost randomly scattered photo scraps sliced into strips and triangles convey the energetic movement of beach play as well as the dominant theme of sky and sand. Angular, color-coded lettering matches the jagged and triangular theme. On the facing page, fabric squares recycled from a favorite pair of shorts add further geometric embellishment.

FAVORITE THINGS
March/April 2002
Issue #29
Lisa Hanson, Hudson, Wisconsin

A simple color-blocking technique finds fresh texture with printed vellum layered over pale green rectangles and hand-stitched, zigzag borders. The wavy photo mat complements the design of the shiny embroidery floss, suggesting the movement of rolling waves. Shaded fill-in lettering draws attention to the strong focal photo of a grandmother and grandchild.

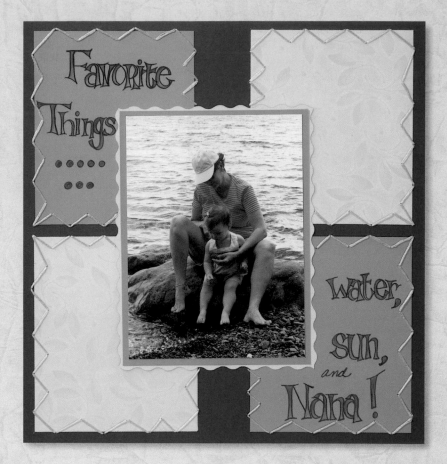

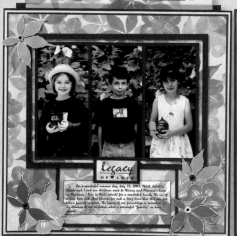

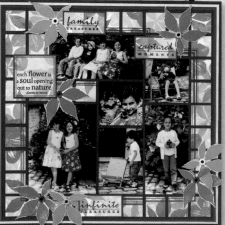

LEGACY OF LOVE
May/June 2003
Issue #36
Cathie Allan, Edmonton, Alberta, Canada
Photos Marie-Dominique Gambini, Lyon, France

Stamped flowers and leaves create a background of restful color for a lattice-framed garden of fresh summer photos. Flower eyelets add texture as well as attach additional foliage to the layout. Pull-out captions identify photo subjects with creative style.

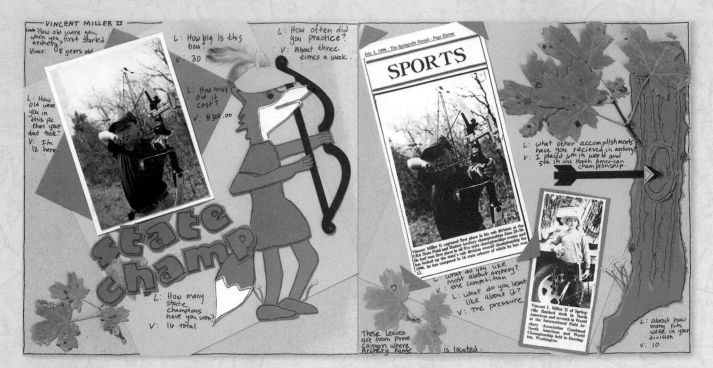

STATE CHAMP
March/April 2000
Issue #17
Linda Strauss, Provo, Utah

A bushy-tailed, beret-headed, bow-bearing fox struts across a layout honoring a young state archery champion. Pressed leaves grow from a paper-torn and pen-detailed tree trunk, and tiny punched flowers bloom at the roots. Interview-style journaling lets the champion humbly state his accomplishments.

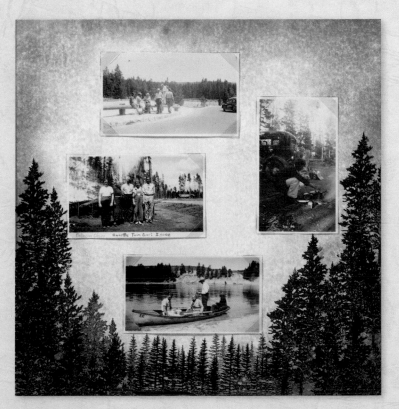

YELLOWSTONE
July/August 1999
Issue #13
Hallie Schram, Billings, Montana

Evocative of the eerie, natural beauty of our nation's first national park, a soft pastel sunset glows warmly against a thick forest of dark evergreens. Blended with texture and tree stamps, the background brings color to these 1930s-era photos without undue distraction.

A LOOK BACK: *Scrapbook Punch Art*

When the fourth issue of *Memory Makers* introduced the concept of combining simple punched shapes to create captivating artwork, punch-art fever rapidly spread in the scrapbooking and paper-crafting world.

Based on the concept that all things consist of basic shapes, punch art combines these shapes into clever designs that take on a life of their own, adding charm and whimsy to scrapbook pages.

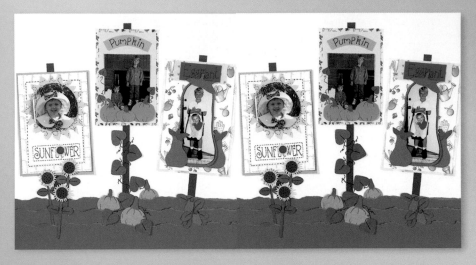

FRUITS AND VEGETABLES
May/June 1999
Issue #12
Marilyn Garner, San Diego, California

Furrowed with torn brown strips, fertile garden soil yields plump watermelons, lacy-topped carrots, red ripe strawberries, bright yellow sunflowers, spreading pumpkin vines and luscious lavender eggplants. The punch-art produce grows around labeled seed packets sprouting colorful photos and even more punch-art designs. Printed paper and creative lettering plant further country charm in a well-staked layout.

PUMPKIN FEST
September/October 2000
Issue #20
Donna Pittard, Kingwood, Texas

Ripe and rustling ears of corn incorporate photos, journaling and punch art into one unified design. Punched ovals, cut in half and meticulously layered, form each ear of Indian corn. Careful penwork provides effective detail for each leaf and stalk. Even the photo mats are inked around the edges to blend with the overall design.

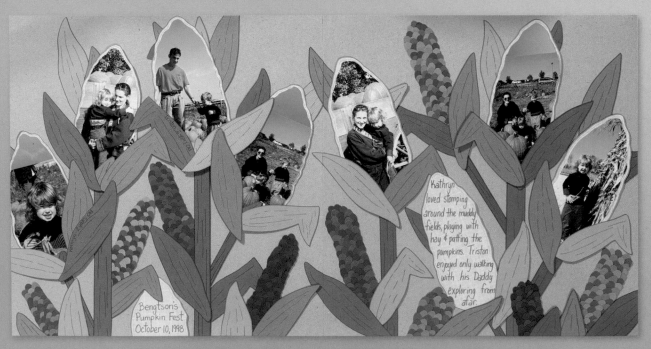

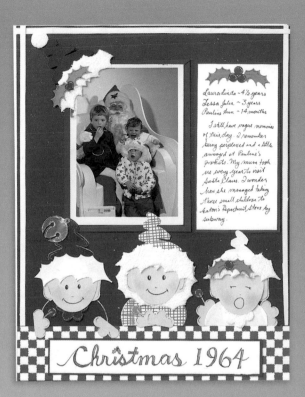

CHRISTMAS 1964
November/December 2002
Issue #33
LauraLinda Rudy, Markham, Ontario, Canada

The key to punch art is discovering new ways to use punched shapes. These whimsical elf hats with flannel edges are ingeniously created with a super giant contemporary tree punch paired with holly punches. The remaining elf features incorporate oval, teardrop, flower and circle punches. Painted with gel pens and colored chalk, each elf's expression matches the corresponding toddler in the photo. Although a dedicated mother's subway trip to Eaton's department store took its toll on the three young Santa sitters, the photo captures reality with small children much better than perfect smiles.

LAVENDER
January/February 2002
Issue #28
Véronique Grasset, Ruy-Montceau, France

Lavender, the symbol of the Provence region in France where it is widely grown, weaves a delicate border around captivating black-and-white candids. Hand-cut leaves and stems complement blossoms layered with punched and halved purple hearts.

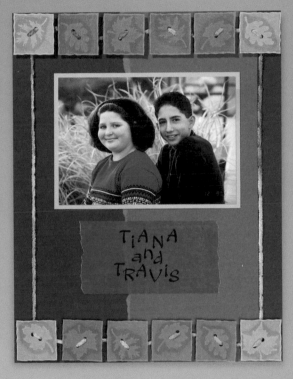

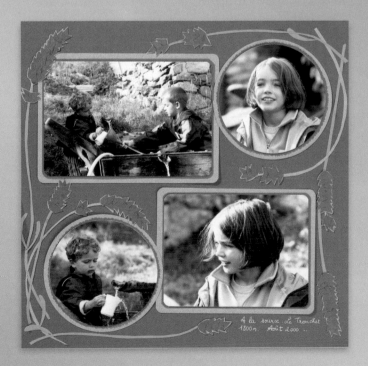

TIANA AND TRAVIS
September/October 2002
Issue #32
Pamela Frye, Denver, Colorado
Photo Shawna Rendon, Westminster, Colorado

While not actually mounted on the page, punched leaves contribute to these tone-on-tone leaf blocks. The technique involves placing a punched leaf on an inked block stamp and then stamping onto scrap paper. When the leaf is removed and discarded and the image is stamped again onto green paper, the result is softly silhouetted leaves.

FALL

"Autumn is a second spring when every leaf is a flower," observed French writer Albert Camus. His poetic description identifies the visual appeal of a season when color again explodes in nature, transforming green foliage into ever-changing hues of yellow, gold, orange and crimson. Autumn scrapbook pages reflect this visual transformation as well as other seasonal sights, sounds, tastes and textures.

PARC DE LA TÊTE D'OR (GOLDEN HEAD PARK)

May/June 2003
Issue #36

Cathie Allan, Edmonton, Alberta, Canada
Photos Marie-Dominique Gambini, Lyon, France

A single stamp and various shades of embossing powder add color and dimension to lovely maple leaves layered behind day-at-the-park photos. Purple, green, yellow and rust papers enhance the lush autumn feel. Smaller than the photo dimensions, stamped and matted frames draw attention to each family grouping.

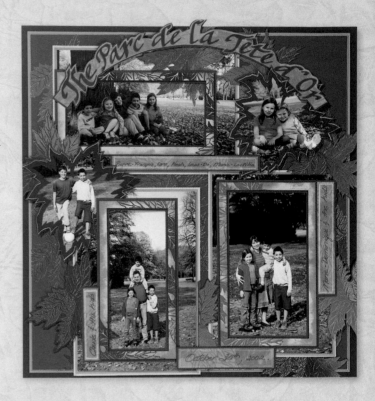

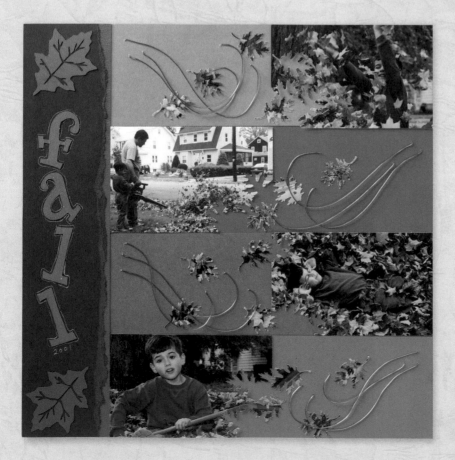

FALL

September/October 2002
Issue #32

Chris Peters, Hasbrouck Heights, New Jersey

Copper gusts scatter photo-punched oak leaves across a windy layout. Color blocking with warm autumn tones balances the freeform wire swirls. Laser die cuts and template lettering on a torn black border anchor the leaf-pile candids.

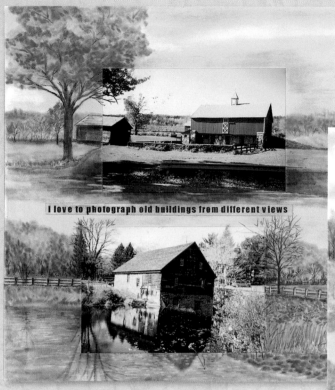

I love to photograph old buildings from different views

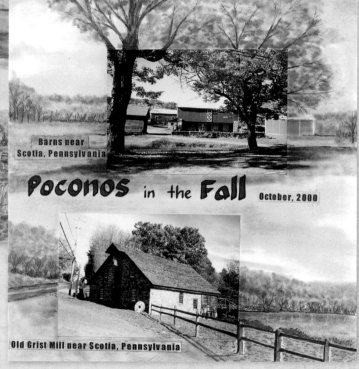

Barns near Scotia, Pennsylvania

Poconos in the *Fall* October, 2000

Old Grist Mill near Scotia, Pennsylvania

POCONOS IN THE FALL

January/February 2003
Issue #34
Joan Reynolds, Derwood, Maryland

Artful chalk drawing enlarges the world of a scenic photo without a trip to the photo lab. The photo-extension technique creates one-of-a-kind panoramas with a breathtaking sense of expansiveness and beauty.

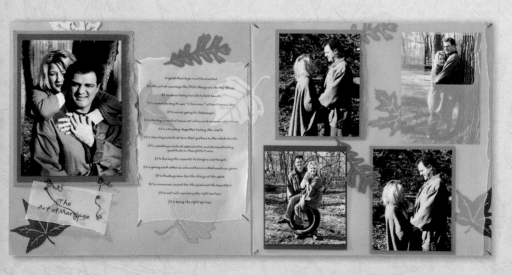

THE ART OF MARRIAGE

May/June 2002
Issue #30
Diana Graham, Barrington, Illinois

Die-cut leaves set above and below vellum create a romantic flavor for this couple's fall jaunt. While color choices and minimal embellishments add visual interest, it is the photos that captivate. Careful cropping and matting draw the viewer's eye to the subjects, with the same intimacy with which they view each other.

FISHING AT THE RIVER
January/February 2002
Issue #28
Nancee Testa, Fort Collins, Colorado

Black-and-white photos are coupled beautifully with colorful fall snapshots on this unusual page. A simple matting treatment using calm blues and greens ties the cropped images together. Branch and leaf stickers strategically placed along the page edge add a striking touch of both color and drama.

OCTOBER 2000
September/October 2001
Issue #26
Ruth Mason, Columbus, Ohio

Dimensional leaves that appear to hold each photo are created using the art of paper relief. The technique makes flat objects appear dimensional by shaping them with the back of a spoon and adding detail with dry embossing techniques. Careful layering and mounting further enhance the effect.

A PICTURE PERFECT FALL

I love living in Minnesota because the changing of seasons is so distinctive here. And by looking at these pictures, it's easy to see why I like spending so much time at the lake.

A Picture Perfect Fall
September/October 1999
Issue #14
Terri Robichon, Hawick, Minnesota

Carefully hung on a striped sage "wall," seven photos depict the glory of a Minnesota fall and reflect a love of nature and family. Hand-drawn picture hangers and gray shading augment the realism of each framed image.

AMAZING ADVENTURE
September/October 2002
Issue #32
Kathleen Childers, Christiana, Tennessee

A sublime fall day, warm and full of color, inspired an autumn layout that incorporates photos, detailed journaling, beautiful color and homemade paper. Machine-stitched to the background, sage and rust pockets conceal pull-out strips with additional photos. The upper right photo card folds back to reveal a detailed, vellum-printed caption. Lacy decorative leaves, fibers, a hand-woven mat, leaf buttons and raffia photo corners dress up the page with texture and pattern.

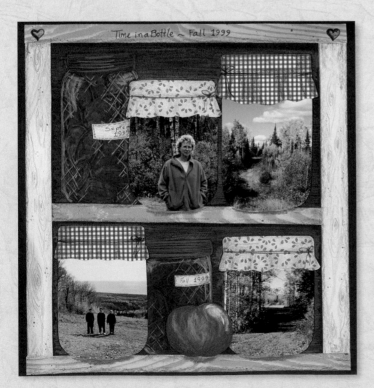

TIME IN A BOTTLE
September/October 2000
Issue #20
Thelma Molkoski, Kakabeka Falls, Ontario, Canada

Rustic wooden pantry shelves literally preserve autumn memories cropped in jar shapes and tied up with country printed paper. Colorful pencil sketches fill shelf space with glass canning jars whose labels identify the time frame of the photos. A juicy red apple completes the edible theme.

FALL

September/October 2002
Issue #32

Andrea Steed, Rochester, Minnesota

Color prints mixed with black-and-whites lend visual interest to a simple, elegant layout unified with subtle leaf patterned paper. Extensive journaling explains the significance of the fall season from a young couple's perspective.

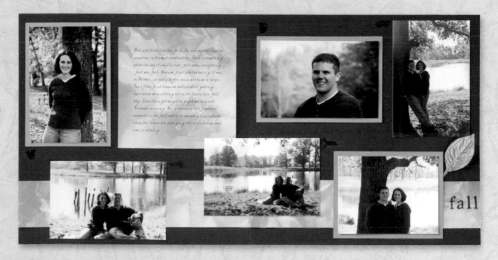

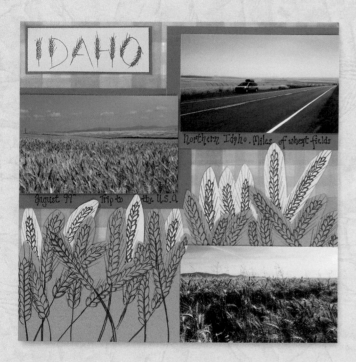

IDAHO

March/April 2001
Issue #23

Colleen Macdonald, Calgary, Alberta, Canada

Heavy with ripened grain, thousands of golden heads wave in the afternoon breeze, shimmering like ocean waves in the afternoon sun. These hand-drawn shafts provide close-up detail of the vast and expansive beauty of wheat fields ready for harvest. Tiny wheat heads pull the design element into the title as well.

DOUBLE OAK

September/October 2001
Issue #26

Cheryl Uribe, Grapevine, Texas

Perched on a crispy hay bale, two sisters pause during pumpkin-patch, farm-animal and hay-maze adventures for Mommy to snap a quick candid. Detailed journaling on a paper-cut fence gate fills in the remaining details of the autumn day outing. Inspired by the ranch logo, the jumbo-sized medallion includes two die-cut horses and a double-trunked tree filled with Texas-sized punched oak leaves.

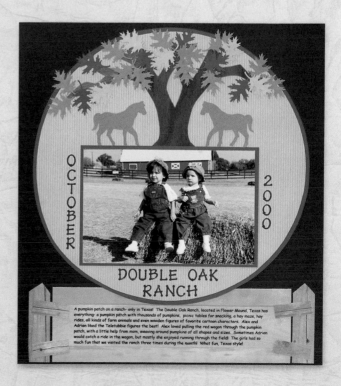

A LOOK BACK: *Scrapbook Embellishments*

Today's cutting-edge products and adornments have enabled scrapbookers to move beyond one-dimensional pages into a brave new world of artistic expression. Embroidery floss, fibers, wire and beads can be creatively used to add the depth and texture needed to make pictures pop. Sequins, rhinestones, eyelets and charms add wonderful whimsy when accenting a page.

Embossing, stamping, punch art and die cuts have elevated the scrapbook page to an artist's canvas. The exponential growth of page embellishments, the striking and savvy creations resulting from their usage, coupled with the lack of risk these embellishments pose to your photos all but negates the question "Can I put that on my scrapbook page?"

WET MITTENS
Winter 1997
Issue #5
Lisa Garnett, Littleton, Colorado

Buttons and jute are used to create innovative mitten ties on this romp of a page. Inspired by a wooden sign created by the artist some years earlier, the use of sewing materials was cutting-edge when this page was first published.

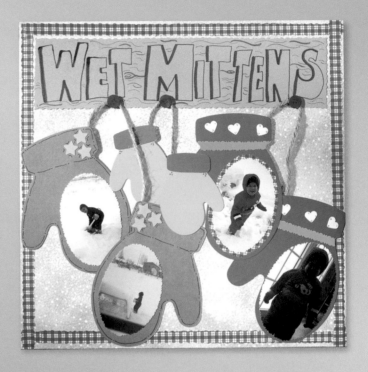

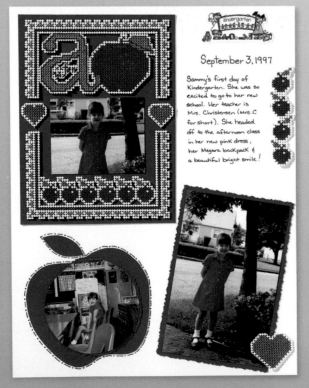

FIRST DAY OF KINDERGARTEN
September/October 1998
Issue #8
Lisa Dixon, East Brunswick, New Jersey

A cross-stitched sampler makes a stunning frame for this off-to-school page. Stitching, whether to add a simple pattern and texture to pages, to indulge a homey quilted look or to attach beads, fibers or other embellishments, became increasingly popular over the years.

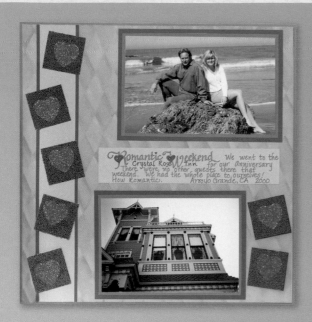

ROMANTIC WEEKEND
January/February 2002
Issue #28
Memory Makers
Photos Shelley Balzer, Bakersfield, California

Hearts punched from a strip of double-side mounting adhesive are adorned with tiny red glass marbles. The use of beads and marbles continues to gain popularity as scrapbookers recognize their bold and passionate appeal.

SUNFLOWER
September/October 2002
Issue #32
Andrea Hautala, Olympia, Washington

Fiber plays a key role in the creation of this powerful sunflower embellishment. A circle punched from brown paper is adorned with yellow fuzzy fiber. Multiple strands of fibers are twisted for the stem and woven through the title. The use of fibers, whether jute, ribbon, floss, thread or yarn helped open up new design horizons for modern scrapbookers.

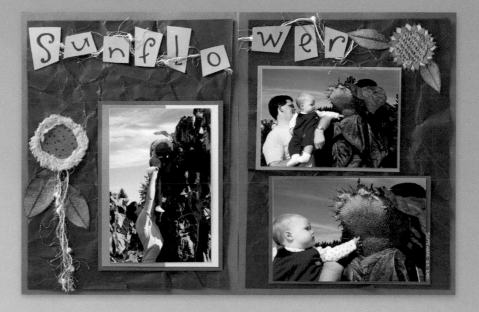

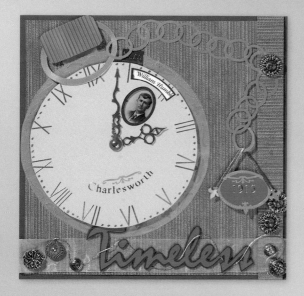

TIMELESS
January/February 2003
Issue #34
Torrey Miller, Thornton, Colorado

Interactive pages including this timeless beauty are easy to make with the wide range of products which became available as scrapbook pages began to be mobile. By spinning the wheel, new pictures are revealed. Additional embellishments of charms, buttons, ribbon, embroidery floss, punches and stickers make taking a trip back down Memory Lane something to look forward to.

WINTER

"In winter we lead a more inward life. Our hearts are warm and cheery, like cottages under drifts, whose windows and doors are half concealed, but from whose chimneys the smoke cheerfully ascends," wrote Henry David Thoreau, a 19th-century American philosopher.

His insight still applies to modern-day scrapbookers who, in the welcoming coziness of homes and cropping circles, chronicle warm memories of even the coldest winter moments.

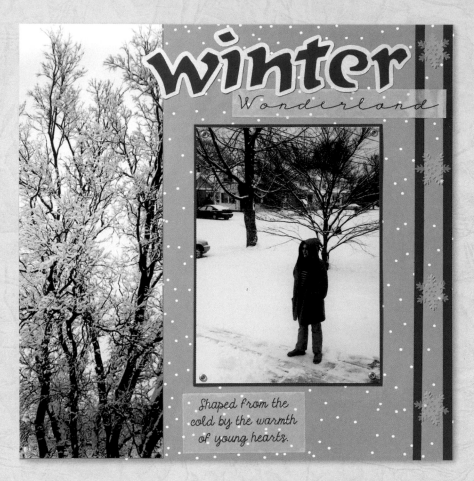

WINTER WONDERLAND
January/February 2003
Issue #34
Kenna Ewing, Parkside, Pennsylvania

A red photo mat, tall border strips and template-cut title letters warm up a thoughtful winter page. Polka-dot paper that suggests softly falling snow and a photo-quality border strip of lacy white trees expand the background of the pensive winter portrait.

PSALMS 42:1
January/February 2000
Issue #16
Pamela Zenger, Spokane, Washington

Bold die cuts give fullness to a snowflake wreath woven with curving, cream-colored vines. Against a softly patterned background, smaller snowflakes, punched and layered, develop a lacy effect to complement the jagged edges of the wandering winter stream.

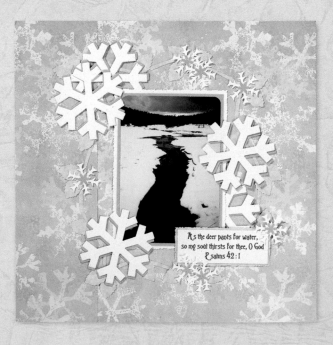

CATHEDRAL ARCHES
Holiday/Winter 1997
Issue #5
Memory Makers
Photos Erica Pierovich, Longmont, Colorado

A silhouetted frame offers a view of a winter panorama complete with deer, mountains and whirling snowflakes. A dark frame coupled with a collage of photos and printed papers create a glowing, surreal stained-glass window.

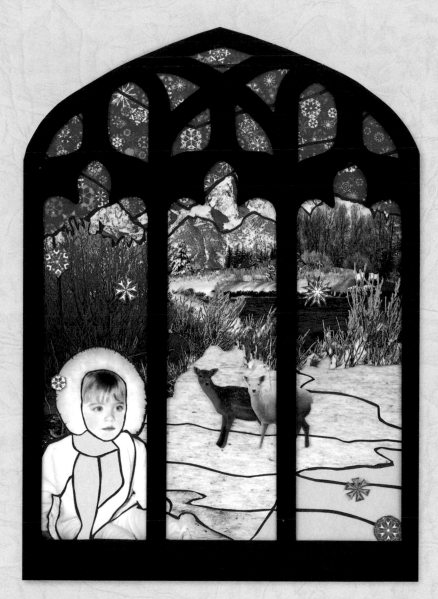

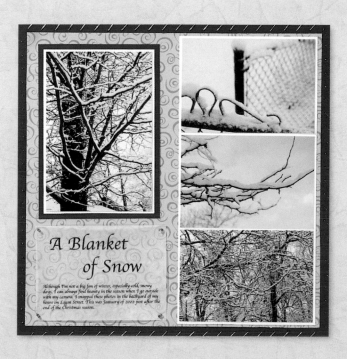

BLANKET OF SNOW
January/February 2003
Issue #34
Debbie Mock, Denver, Colorado

With edges wrapped in silver thread, deep navy paper sets off filigreed photos of snowy winter trees. Patterned paper stirs memories of the swirling storm that bequeathed a dazzling white blanket.

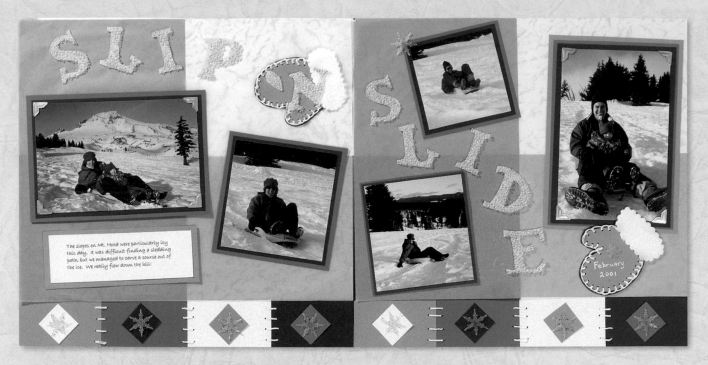

SLIP 'N SLIDE
January/February 2002
Issue #28
Teri Cutts, Portland, Oregon

A color-blocked background covered with printed vellum, snowflakes and letters textured with tiny clear marbles, and hand-stitched accents bring crisp creativity to a winter wonderland slide show. The blue color palette not only adds to the wintry feel but also ingeniously compensates for black-and-white photos that were printed a little too blue. Warm mittens with blanket-stitched edges and puffy flannel cuffs add a touch of cozy charm.

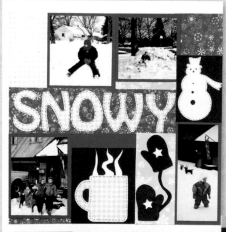

SNOWY DAYS
November/December 1999
Issue #15
Dorothy Ferreira, Woodcliff Lake, New Jersey

As cozy as a homemade quilt, this snowy day spread incorporates square cropped photos and blocks of coordinating patterned paper to piece together a comforting pattern. A freehand cut mug, mittens, snowman and other elements add charm, as does the pen "stitched" additions.

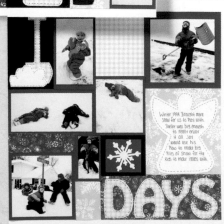

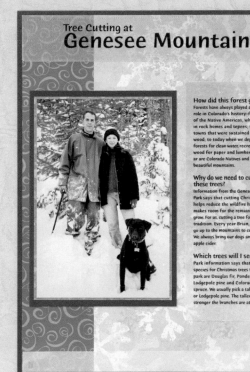

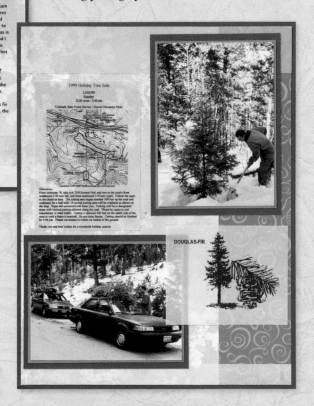

GENESEE MOUNTAIN
November/December 2001
Issue #27
Memory Makers

Saving brochures from a holiday tree sale made it easy to provide background information, maps and even illustrations for a snowy tree-cutting adventure. Photocopied onto vellum, the found elements blend well with the wintry patterned background paper and keep the focus on the three strong photographs.

WINTER HOW SWEET IT IS
January/February 2002
Issue #28
Tori Eaton, Springville, Utah

Sweet enough to rival chocolate? Yes! Young Adam's expression, captured in this animated photo, speaks louder than words. The simplicity of the page, embellished with letter stickers and a mini snowflake punch, supports the innocence of the age-old childhood pleasure of capturing elusive snowflakes on the tongue.

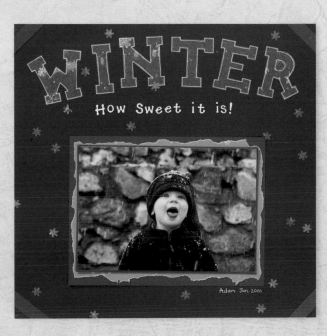

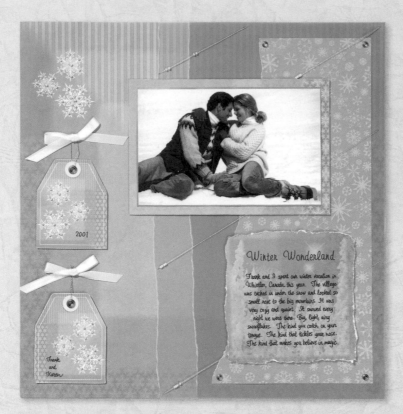

WINTER WONDERLAND

January/February 2003
Issue #34

Shauna Berglund-Immel, for Hot off the Press, Beaverton, Oregon

Beaded snowflake tags, eyelets, floss and ribbon work together to create a potent cool-weather page. Balance is what makes this layout work with larger embellishments coupled with more delicate decorative elements. The cool blues and patterened vellum support the loving photo.

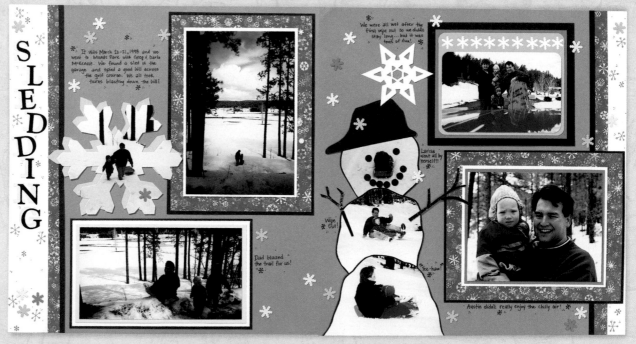

SLEDDING

November/December 1999
Issue #15

Linda Crosby, Phoenix, Arizona

Frosty never looked so good as when featured in this fun and funny winter spread. Cropped photos form his body while freehand-cut arms and hat and punched eyes and mouth complete his person and define his personality. Layered papers, matted photos and the world's biggest cropped-photo snowflake round out the winter wonderland.

SKI BABIES

November/December 2002

Issue #33

Kelly Angard, Highlands Ranch, Colorado

Saved photo scraps contribute more elements to this fun ski page than the photos themselves. Scraps of faraway ski photos help fill each block-style letter. Scrap-punched snowflakes contrast well with the navy background. Even the little square accents that border the caption are recycled from snowy photo scraps.

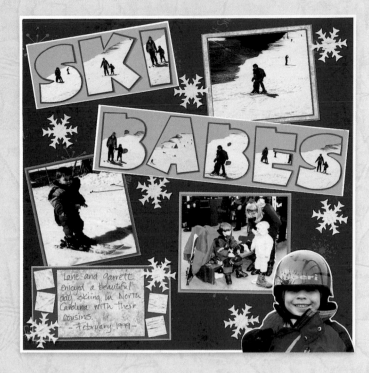

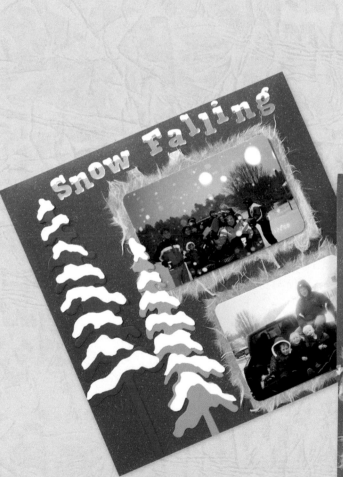

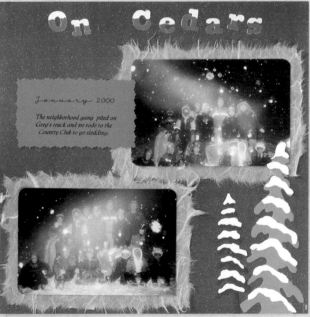

SNOW FALLING ON CEDARS

January/February 2001

Issue #22

Michelle Kirby, Newton, North Carolina

Torn mulberry lends feathery edges to happy sledding photos set against a speckled navy background. The trees and letters illustrate the title with hand-cut mounds of snow.

A Look Back: *Scrapbook Paper-Piecing*

Because paper has always been widely available to scrapbookers, paper-pieced designs have been a part of even the earliest creative scrapbook pages. Although in a sense every scrapbook page could be considered paper piecing, the term refers specifically to any cohesive design created with cut paper elements. The earliest examples were freehand cut and detailed with black pen. New products including templates, stencils, patterns, books, computer software, paper-piecing kits, punches and die cuts now make it easy to create a paper replica of just about anything. Whether freehand cut or assembled from a peel-and-stick kit, paper piecing offers an appealing way to incorporate dimensional themes onto a flat surface.

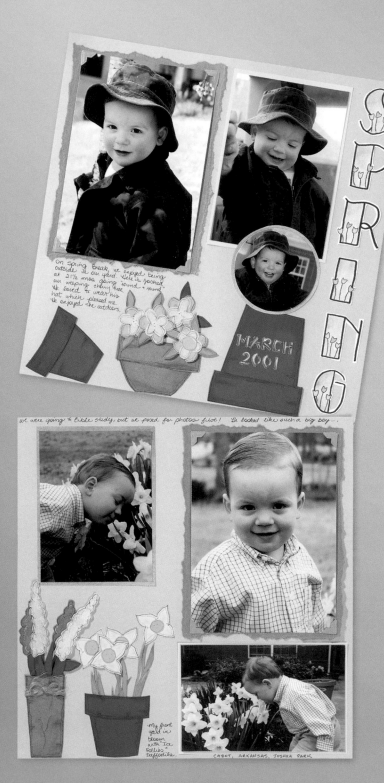

SPRING
March/April 2002
Issue #29
Marianne Park, Cabot, Arkansas

Chalk-shaded, pen-detailed and jute-wrapped flowerpots hold bright spring blooms. The pattern-cut yellow daffodils with pale yellow petals and deep golden centers match the "Ice Follies" variety in the photos. Clip-art lettering shaded with colored pencils repeats the floral theme.

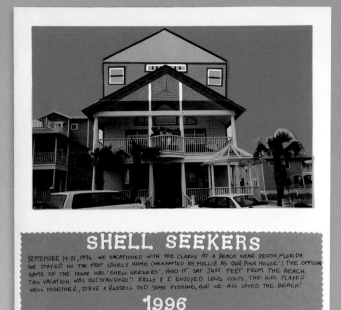

SHELL SEEKERS

September/October 1998

Issue #8

Leslie Graves, Pantego, Texas

Silhouette cropped and layered against a blue background, this beach home blends almost seamlessly with a paper-pieced second story that completes the picture. The layered paper design accurately reproduces the roof, windows, columns and other architectural details.

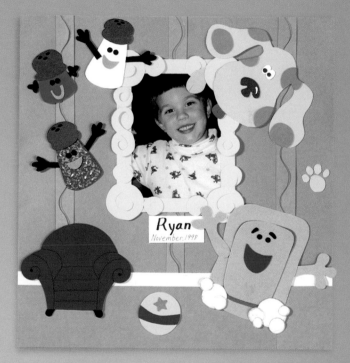

WILD ANIMAL PARK

July/August 2000

Issue #19

Terri Fusco, Claremont, California

A mosaic background randomly pieced from colored scraps creates a textured camouflage effect. In the foreground, a die-cut leaf border and a tall palm tree with a bright-eyed monkey further develop the jungle theme.

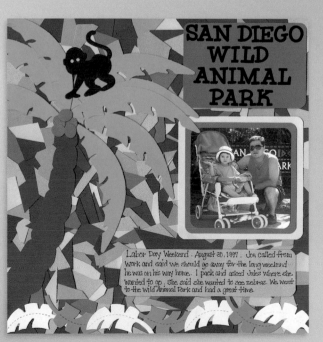

HAPPY HOME

September/October 1999

Issue #14

Vickie Mehallow, Troy, Illinois

Colored paper, colored pens and a bright grin are all it took to create this happy-go-lucky page. Elements, inspired by coloring book and storybook characters, are kicking up their heels with spirit that's infectious enough to make everyone want to join in the dance.

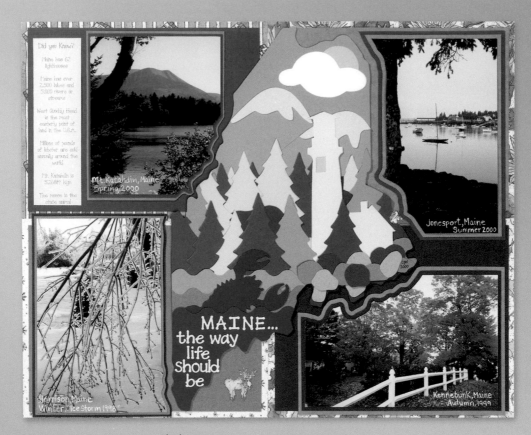

MAINE
May/June 2001
Issue #24
Christine Wallace, Steep Falls, Maine

A large state die cut forms the base for an intricate focal design pieced from both die-cut and hand-cut state icons. Photos in each corner, trimmed to silhouette the state outline and layered against solid and patterned papers, capture the natural beauty of Maine in all its seasonal glory.

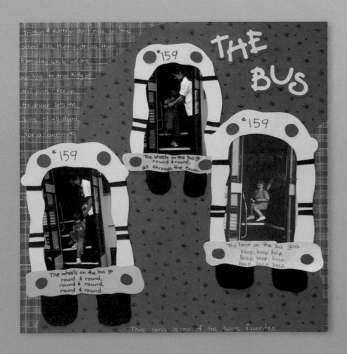

THE BUS
September/October 2001
Issue #26
Donna Pittard, Kingwood, Texas

These school buses will stop for pedestrians, but they won't stop being appreciated any time soon. Freehand-cut yellow arches, silver bumpers and black wheels are pieced together to form photo frames which embrace goin'-off-to-school adventure. Letter stickers and printed paper add even more zip to the scene.

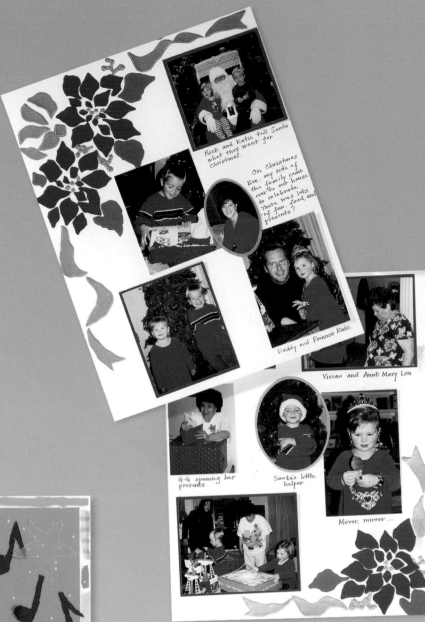

POINSETTIAS
November/December 2000
Issue #21
Susan Walker, Oakbrook Terrace, Illinois

Raised edges add a finishing touch to each section of these elegant poinsettias. Cut using a stencil and outlined with an embossing stylus, the designs pieced from rich reds, greens and golds echo the colors of Christmas as well as the simply cropped and captioned photos.

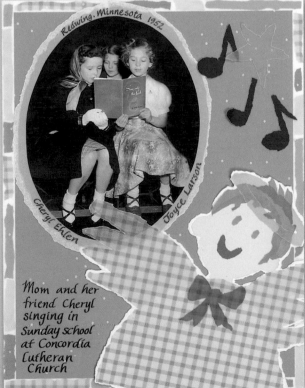

CONCORDIA LUTHERAN CHURCH
November/December 2000
Issue #21
Memory Makers

Simply torn and layered from solid and vellum paper, a whimsical angel smiles at young Sunday-school singers. Music notes and a star seem to float above in a starry green sky. Torn and pieced strips frame the page with color and pattern.

SPRING

Author Virgil A. Kraft wrote, "Spring shows what God can do with a drab and dirty world." Likewise, spring pages show what scrapbookers can do when inspired by nature's annual redecorating. Pages that burst with flowers, foliage, fresh air and blue sky reflect the hope and joy of this renewal.

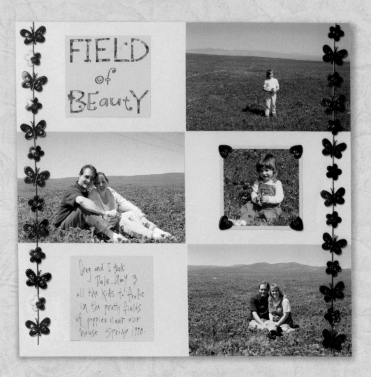

FIELD OF BEAUTY
July/August 2002
Issue #31
Pamela Frye, Denver, Colorado
Photos Chrissie Tepe, Lancaster, California

Borders of embossed confetti mirror the brilliant colors in poppy-field photos arranged in a balanced checkerboard design. The square title, caption and smaller photo further reinforce this symmetry. Contemporary letter stickers write an appropriate title.

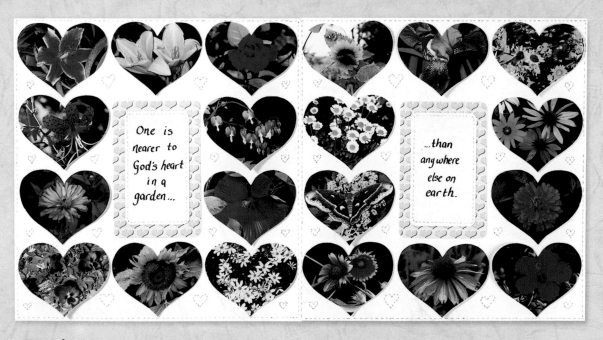

GOD'S HEART
May/June 1999
Issue #12
Lisa Laird, Orange City, Iowa

Daylilies, roses, pansies, sunflowers, daisies, bleeding hearts, iris, asters, marigolds and zinnias are only a few of the bright varieties displayed on a quilted layout stitched with a thin pink pen. Uniform heart shapes provide consistency and balance, allowing the vivid color to effectively frame a poetic sentiment.

OUR HOUSE
March/April 2001
Issue #23
Chris Peters, Hasbrouck Heights, New Jersey

Flourishing foliage and vivid spring blossoms are always a visual delight, especially in this careful arrangement of 1" mosaic squares. The design gives the illusion of looking at a lush garden through a many-paned window. Pale sage mats against the evergreen background bring focus to the heartfelt caption and house photo.

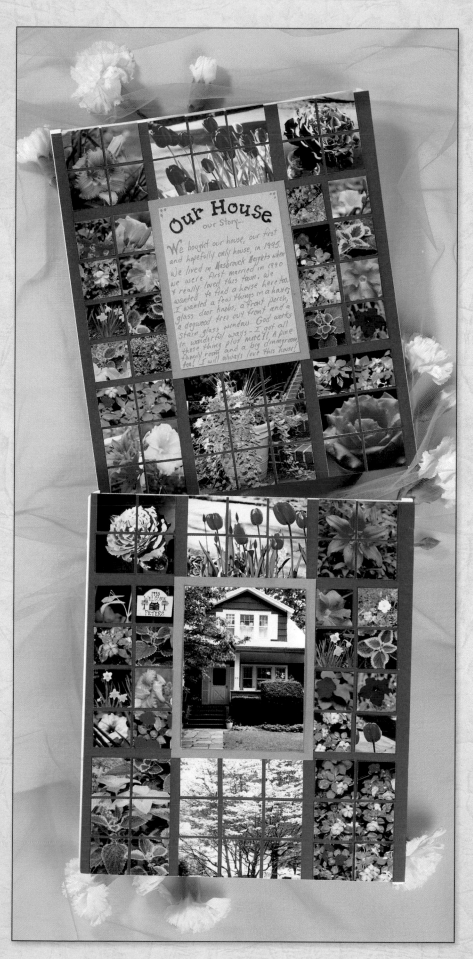

BUCHART GARDENS
July/August 2001
Issue #25
Cori Dahmen, for Me and My BIG Ideas, Lake Forest, California

Tied to the caption and affixed to the page edges with flower stickers, sheer pink ribbon adds a shimmering accent to richly colored garden photos. Colorful floral stickers fill in blooming title letters and add detail to corner embellishments.

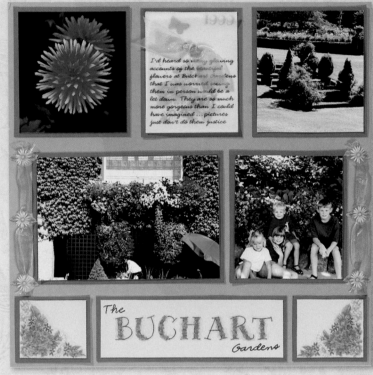

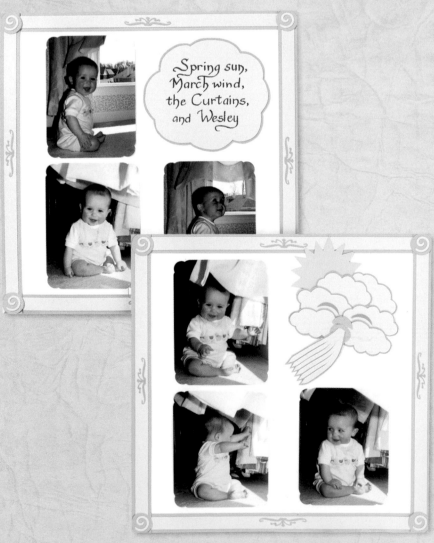

SPRING SUN, MARCH WIND
March/April 2000
Issue #17
Lois Carpenter, Bayfield, Colorado

Curtains tickle. Just ask Wesley, who shared the pleasures of a warm spring breeze with these drapes. Creamy colors and punched swirls frame this airy page. A freehand-cut cloud serves as a journaling block. Six small clouds are layered to form the wind's body while the rush of air he emits is freehand cut.

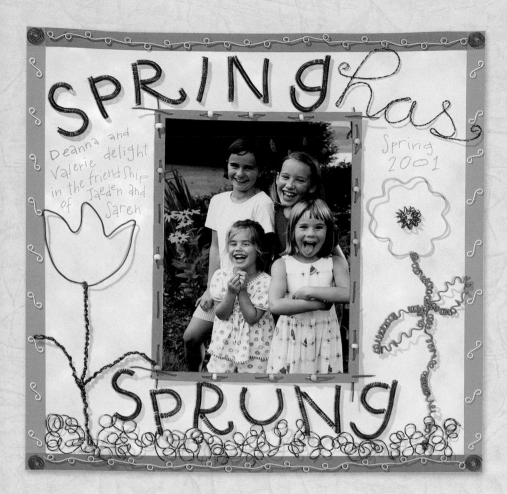

SPRING HAS SPRUNG
March/April 2002
Issue #29
Memory Makers
Photo Tina Heine, Carrollton, Georgia

Because of its literal flexibility, wire is a versatile material that is both easy and fun to bend, twist, wrap, coil, curl, bead and shape into uniquely entertaining page embellishments. In this well-wired page, a variety of colors and gauges frame four giggling girls with texture and dimension. Coiled title letters make the title a witty play on words.

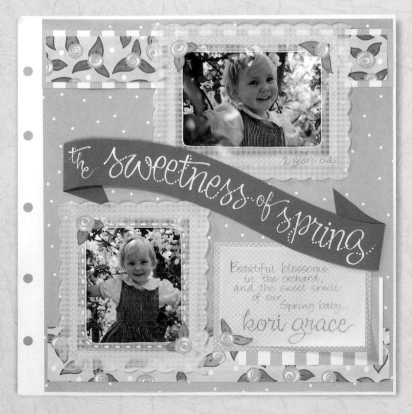

SWEETNESS OF SPRING
March/April 2001
Issue #23
Sharon Kropp, Paonia, Colorado

Artist-designed dotted script lettering on a softly curved banner heralds charming spring photos. The style ties in the polka dots in the blue, pink and floral papers. Vellum frames that overlay the matted photos soften the edges as well as accentuate winsome smiles.

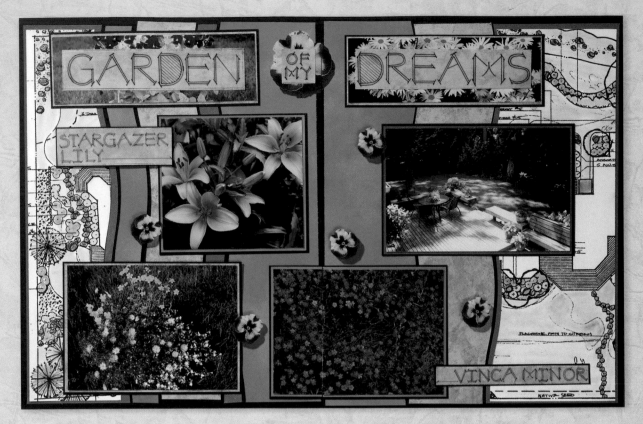

GARDEN OF MY DREAMS
May/June 2003
Issue #36
Kelly Angard, Highlands Ranch, Colorado

It has been said that blueprints are future dreams laid down on paper. Dreams of a perfect garden became the reality of a perfect scrapbook spread for Kelly. A photocopy of a garden blueprint, floral photos, vellum and penwork bloomed into a joyful explosion of spring color.

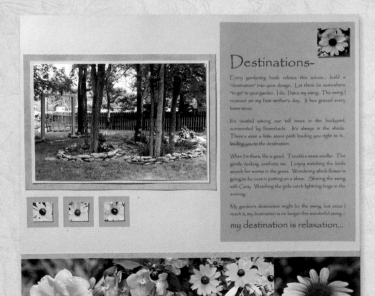

DESTINATIONS
May/June 2003
Issue #36
Jane Rife, Hendersonville, Tennessee

Everyone needs a quiet place, a gentle place, a place to heal and a place to dream. This garden is that and more. A brilliant floral border grounds the page. Other elements float on creamy daffodil colored paper. A substantial journaling block and a single photo add balance and warmth to this layout, like a well-planned garden on a gentle afternoon.

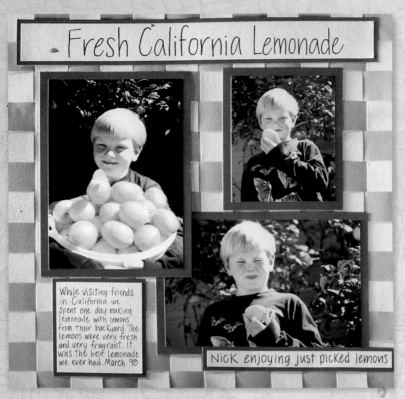

FRESH CALIFORNIA LEMONADE
July/August 2001
Issue #25
Memory Makers
Photos Charlotte Wilhite, Arlington, Texas

One-two-three...forget saying "cheese" and just pucker for the camera. A spring day collecting lemons for lemonade is honored on a lemon lime woven background that screams "citrus." Add a cup of sugar and you've got a page that's sweet as can be.

SKY HIGH
March/April 2001
Issue #23
Pennie Stutzman, Broomfield, Colorado

Created with duplicate panoramic photos mounted in opposite directions, a billowing, funnel-shaped spiral conveys the drama and movement associated with an exciting aerial adventure. Two adjacent photo panels dial up the intensity with saturated balloon colors, while elongated lettering mimics flying flags in a patchy blue sky. A photo pocket behind the left page holds a detailed, pull-out caption.

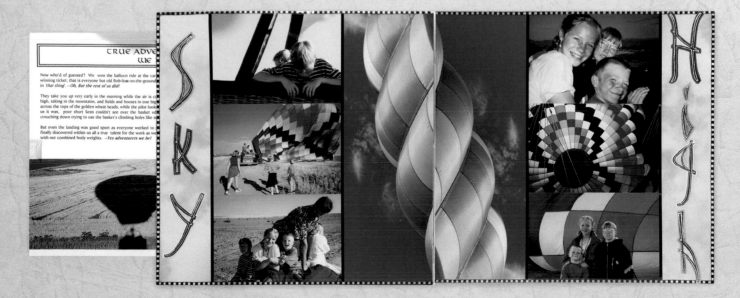

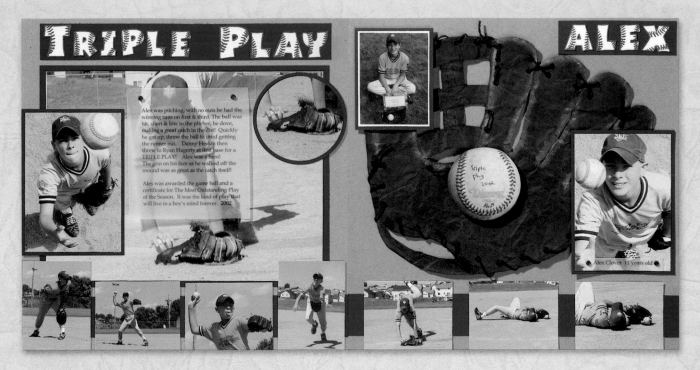

TRIPLE PLAY
March/April 2003
Issue #35
Deb Clover, St. Michael, Minnesota

An eyelet-studded, hand-stitched baseball glove replicates the well-worn gear that caught the first out in a memorable triple play. The color photo sequence breaks down the lightning-fast moment so the reader can feel the action. Sepia-toned photos, printed using an "antique" setting, heighten the drama with an interesting bird's-eye view. A detailed caption and baseball title lettering tell the exciting story.

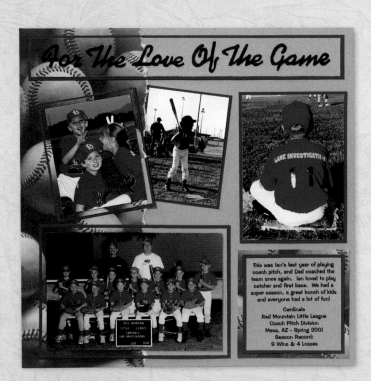

FOR THE LOVE OF THE GAME
July/August 2002
Issue #31
Beth Rogers, Mesa, Arizona

Printed baseball paper makes a torn background and mat that can't strike out. In fact, this whole page is something to cheer about. Bright red mats coordinate with team jerseys and pop against the light brown paper. Whether in the out-field or on the diamond, this page is a jewel.

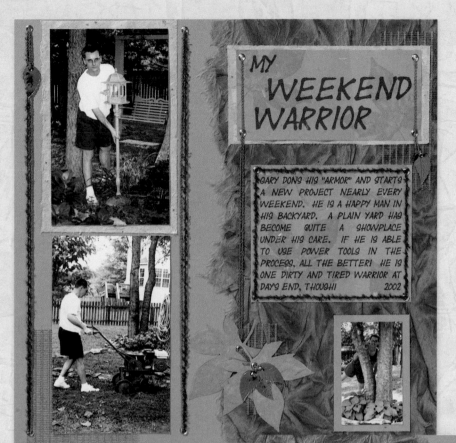

GARY DONS HIS "ARMOR" AND STARTS
A NEW PROJECT NEARLY EVERY
WEEKEND. HE IS A HAPPY MAN IN
HIS BACKYARD. A PLAIN YARD HAS
BECOME QUITE A SHOWPLACE
UNDER HIS CARE. IF HE IS ABLE
TO USE POWER TOOLS IN THE
PROCESS, ALL THE BETTER! HE IS
ONE DIRTY AND TIRED WARRIOR AT
DAYS END, THOUGH! 2002

MY WEEKEND WARRIOR
May/June 2003
Issue #36
Jane Rife, Hendersonville, Tennessee

Yardwork calls and Jane's husband is up
for the task. Photos of him tending to
business are mounted on handmade paper
embellished with stamped leaves. Mesh,
fiber and eyelets add an earthy, organic
feel to this outdoor page.

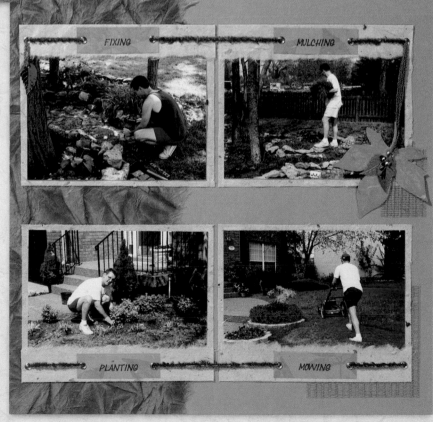

A LOOK BACK: *Quilted Scrapbook Pages*

Although quilters use fabric, batting, needles and thread, while scrapbookers use photos, paper, adhesive and pen stitching, both combine their materials into a collage of color, pattern and texture, carefully pieced to last generations. Because quilted pages require only photos, paper and a black pen, they have been a popular design technique from the earliest days of creative scrapbooking. *Memory Makers Quilted Scrapbooks*, published in 2000, compiles hundreds of quilt designs in a delightful, inspiring book that includes simple patchwork pages as well as more complex piecings.

Today's scrapbook market also offers specialized tools and templates that make page quilting even easier. Because the variations of any design are infinite, the beauty of scrapbook quilts is that no two designs turn out quite the same. Scrapbook quilts, like their cozy counterparts, wrap readers in the warmth and memory of friends, family and traditions.

HEARTS AND VINES
Spring 1998
Issue #6
Marilyn Garner, San Diego, California

A paper-punched garland of evergreen leaves and bright red berries frames a 12-heart quilt block filled with flowers, swirls and sweethearts. Simple pen stitching adds homespun detail.

FRESH FLOWERS
March/April 1999
Issue #11
Marilyn Garner, San Diego, Calfornia

Dry-embossed quilted designs come to light with thin pen-stitched outlines. With circle-cropped centers and pale green leaves, plump lavender flowers balance the dimensional mauve squares. A wavy stitched border fluidly hems the design.

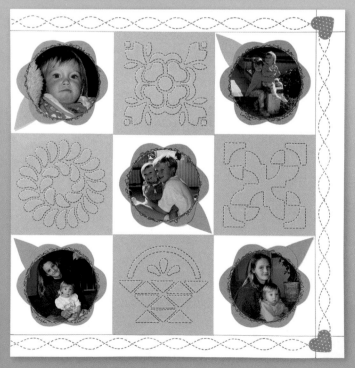

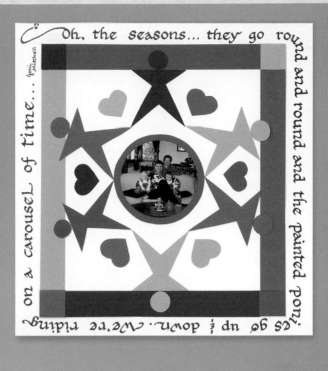

SEASONS
January/February 2001
Issue #22
Melody Sperl, Fairborn, Ohio

Beautifully penned Joni Mitchell lyrics border a kaleidoscope quilt that weaves a circle with geometric stick figures and paper hearts. The lines and angles pull the eye both inward to the central photo and outward to the colorblocked border and lacy calligraphy. The muted colors convey a quiet and peaceful tone.

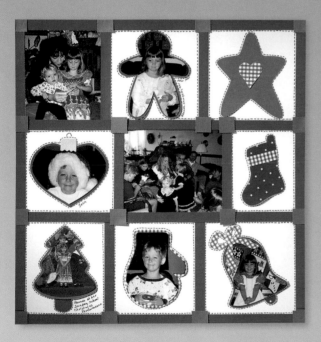

CHRISTMAS PATCHWORK
Winter 1997
Issue #5
Marilyn Garner, San Diego, California

Christmas programs, family gatherings and holiday smiles blend easily in this appliqué quilt. Traced from a book of quilting patterns, each folk-art shape represents a familiar Christmas icon. Red sashing strips and green corner squares unite the figures in a cohesive patchwork design.

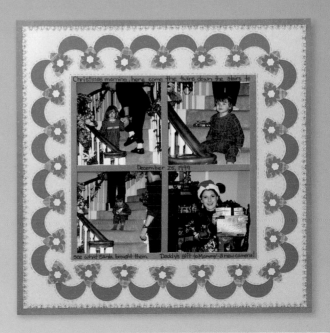

POINSETTIA GARLAND
November/December 2002
Issue #33
Donna Pittard, Kingwood, Texas

The detailed appliqués of Baltimore Album quilts inspired this punch-art reproduction crafted with a large circle, small heart, poinsettia and mini flower punches. The scalloped border provides a festive, lacy look to four square-cropped Christmas photos. The tan edges trimmed with pinking scissors and layered over patterned paper create the illusion of blanket stitching.

ILLUSTRATED GLOSSARY OF SCRAPBOOK TERMS AND TECHNIQUES

Modern scrapbooking evolved from a growing concern that products used in putting together memory albums were actually damaging, rather than preserving, both photos and memorabilia. One of the biggest culprits in the deterioration of photos was "magnetic albums" which gained popularity in the 70s. These convenient memory books allow scrapbookers to place their photos and memorabilia on sticky pages and cover them with an attached sheet of transparent plastic. Too late, it was discovered that the PVC coupled with adhesive and acidic papers create a "sandwich of death" which causes photos to yellow and become brittle. The need for higher quality scrapbooking products was apparent. Examples of safer products were found in memory books displayed at the 1980 World Conference on Records. These albums, created by members of the Mormon community, sparked an increased public interest in safe photo archiving. Creative Memories, a scrapbooking company founded in the late 1980s, spread the word about safe versus unsafe products as well as selling supplies and tools. In subsequent years, the craft's popularity grew. Scrapbooking and hobby stores clamored for supplies and tools. Manufacturers answered the cry. Eventually a vocabulary developed surrounding supplies, concerns and scrapbooking techniques which testifies to the commitment of scrapbookers and industry professionals to eradicate the mistakes of the past in order to preserve what is precious to us for the future.

ACCESSORIES
Page accents that you make or buy. Can include stickers, die cuts, stamped images and punch art. May also include baubles (beads, buttons, rhinestones, sequins), colorants (pens, chalk, inkpads), metallics (charms, wire, jewelry-making components, eyelets, fasteners), textiles (ribbon, embroidery floss, thread), or organics (raffia, pressed flowers and leaves, tiny shells, sand). While one-dimensional accessories traditionally adorned scrapbook pages, there now exists a limitless array of cutting-edge and even three-dimensional products that may be safely used on scrapbook pages.

ACID-FREE
Although acids were once prevalent in photo album papers and products, the damage caused by acids to photographs and memorabilia has been realized and should be avoided. Look for scrapbook products—particularly pages, paper, adhesives and inks—that are free from destructive acids that can eat away at the emulsion on your photos. Harmful acids can occur in the manufacturing process. Check labels for "acid-free" and "photo-safe."

ADHESIVES
A far departure from the gloppy glues of the past, modern adhesives come in both "wet" and "dry" applications depending on one's needs and are used to adhere or attach photos, accessories and memorabilia to scrapbook pages. Buy and use only acid-free and photo-safe adhesives in a scrapbook to dramatically extend the life of your photos and scrapbook materials.

ALBUM
The archival-quality book in which you place your finished scrapbook pages for posterity and for safekeeping. Available in a number of shapes and sizes, albums may be secure pages in post-bound, binder, spiral or strap-hinge style. Archival albums should be purchased in place of the previously popular magnetic albums, which can destroy photos and memorabilia; remove items and place in safer albums.

ARCHIVAL QUALITY
A nontechnical term suggesting that a substance is chemically stable, durable and permanent. This distinction suggests superior quality and low-risk for adverse effects to photography and memorabilia.

BORDER
The upper, lower and side edges or margins of a scrapbook page. Sometimes refers to a border design that is handmade or manufactured and attached to a page.

BUFFERED PAPER
Paper in which certain alkaline substances have been added during the manufacturing process to prevent acids from forming in the future due to chemical reactions.

CARDSTOCK
The heaviest of scrapbook papers; can be solid colored or patterned. While also used for die cuts and pocket pages, many scrapbookers now look to the innumerable colors of cardstock to serve as pages.

CD-ROM
A compact disc that can store large amounts of digitized photos and data files. In scrapbooking, font and lettering CDs as well as scrapbook software CDs have become helpful tools in individually personalizing the page-making process.

CROP
A term utilized by enthusiasts to describe an event attended by other scrapbookers for the purpose of scrapbooking, sharing ideas and tools and swapping products; held at conventions, craft and scrapbook stores, private homes, organized craft camps and crop-oriented vacations.

CROPPING
The act of cutting or trimming photos to enhance the image, eliminate unnecessary backgrounds or turn the photos into unique works of art. Whereas early albums most typically displayed photos in their entirety, safe and easy cropping tools have effectively undermined the notion that photographs should not be altered by means of cutting.

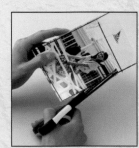

DE-ACIDIFY
To chemically treat paper memorabilia to neutralize acids while applying an alkaline buffer to discourage further acid migration from damaging photos.

DECORATIVE SCISSORS
While once pinking shears were a fancy departure from traditional straight-edge cutting, there now exists a multitude of scissors with special-cut blades or teeth that provide a wide array of cut patterns, designs and cutting depths. Flipping decorative scissors over will result in a varied cutting pattern.

DIE CUTS
Precut for purchase or self-cut paper shapes that come in both printed and solid colors. Decorative elements for adding a theme or accent to a page. Should be acid- and lignin-free.

DIGITAL
A computer-related term for the process of using numerical digits to create uniform photographic images as shot with a digital camera or scanned into a computer with a scanner and saved on and retrieved from a CD-ROM.

ENCAPSULATE
To encase paper or three-dimensional memorabilia in PVC-free plastic sleeves, envelopes and keepers for its own preservation and the protection of your photos.

JOURNALING
Refers to handwritten, handmade or computer-generated text that provides pertinent details about what is taking place in photographs.

LETTERING
The act of forming or creating letters to use in scrapbook page titles and journaling. Lettering can include freehand cut or drawn, sticker, die-cut, template-cut, stamped, punched letters or computer-generated letters.

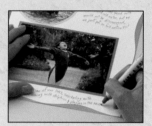

LIGNIN-FREE
Paper and products that are void of the material (sap) that holds wood fibers together as a tree grows. Most paper is lignin-free except for newsprint, which yellows and becomes brittle with age. Check product labels to be on the safe side.

MATTING
The act of attaching paper, generally cropped in the shape of a photo, behind the photo to separate it from the scrapbook page's background paper.

MEMORABILIA
Mementos and souvenirs saved from travel, school and life's special events—things that are worthy of remembrance.

MOUNTING
The process of attaching photos or memorabilia to an album page. Permanent mounting requires the application of adhesive to the back of a photo or mat. Nonpermanent mounting allows you to attach your items to a page and still have the option of easily removing them.

ORGANIZATION
The act of putting together ordered photos and memorabilia for the purpose of scrapbooking. Organization of the scrapbook tools and supplies provides for maximum scrapbooking efficiency.

PAGE PROTECTORS
Plastic sleeves or pockets that encase finished scrapbook pages for protection. Use only PVC-free protectors.

PAGE TITLE
A general or descriptive heading put on a scrapbook page that sums up the theme or essence. Conversely, a "title page" is the first page at the front of a scrapbook, often decorated and embellished (without photos), that describes the book's content.

PHOTO-SAFE
A term used by companies to indicate that they feel their products are safe to use with photos in a scrapbook album.

PIGMENT INK
Pigment inks are water-insoluble and do not penetrate the paper surface. Instead, they adhere to the surface, providing better contrast and clarity. For journaling pens and inkpads, look for "acid-free" and "photo-safe" on the label.

POCKET PAGE
A scrapbook page that has been transformed by the addition of a second sheet of cropped paper adhered to the surface, forming a "pocket" in which to place the paper memorabilia.

PRESERVATION
The act of stabilizing an item from deterioration through the use of proper methods and materials that maintain the conditions and longevity of the item.

PUNCHES
Tools in which paper is inserted and pressure is applied to produce particular shapes through a bladed configuration. Punches come in hundreds of sizes, shapes, designs, patterns, letters and numbers.

PVC OR POLYVINYL CHLORIDE
A plastic that should not be used in a scrapbook, it emits gases that cause damage to photos. Use only PVC-free plastic page protectors and memorabilia keepers. Safe plastics include polypropylene, polyethylene and polyester.

SHAPE CUTTERS
Shape cutters are bladed tools that are useful for cropping photos, mats and journaling blocks into perfect shapes. They can cut in circles, ovals and many other simple shapes.

STAMPS
A wood and rubber tool used to impress a design on paper or cloth; used with a stamp pad or inkpad. With just a few stamps and an inkpad, you can make delicate borders, lacy photo corners, stamped backgrounds, eye-catching photo mats, dressed-up die cuts and jazzy page accents.

STICKERS
Gummed with adhesive on one side and a design or pattern on the other, stickers are one of the easiest ways to embellish scrapbook pages. There are thousands of designs to choose from in a multitude of colors, themes and styles—including letter and number, border, journaling and design element stickers.

TEMPLATES
Templates are stencil-like patterns made of plastic, sturdy paper or cardboard. They can be homemade or purchased and can be used for creating letters, shapes, page borders, and journaling guides. Nested templates are transparent and have cutting channels for blades to travel along to cut paper and photographs into desired shapes.

ALBUM OF THE HEART

by Lois Duncan

As the year draws to an end
We grow close again,
Turning pages of our lives,
Pausing now and then

To recall a magic time
Or a special place.
Springtime sunlight leaps at us
From a smiling face.

Summer laughter rings anew,
Mixed with autumn tears.
Seasons blend and mesh and blur,
With the flying years.

Guard the album of the heart.
There the memories are—
Gentle as the drifting snow
Holy as the star.

SIZZLING
SEASONAL
SCRAPBOOK PAGES

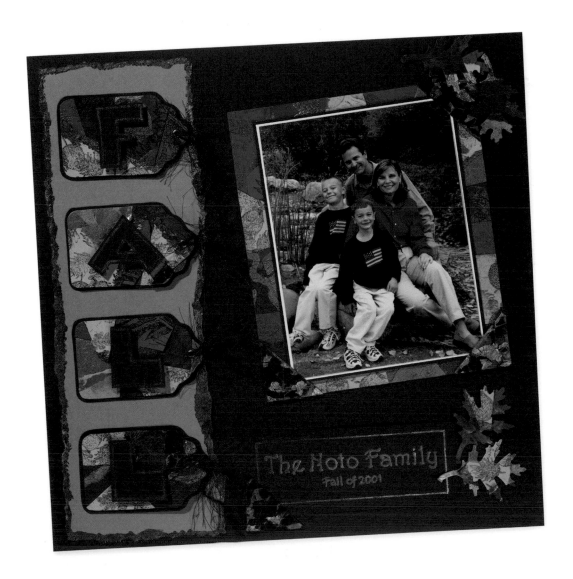

MEMORY
MAKERS
BOOKS

TABLE OF CONTENTS

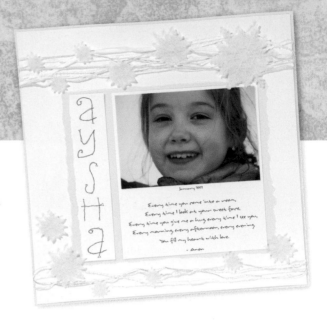

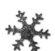
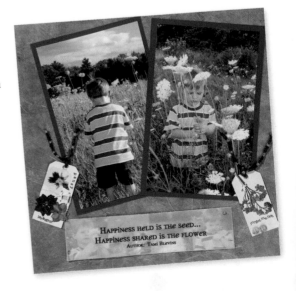

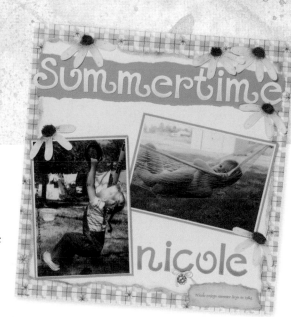

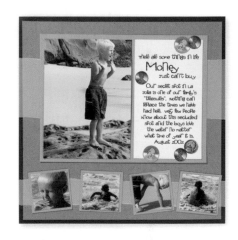

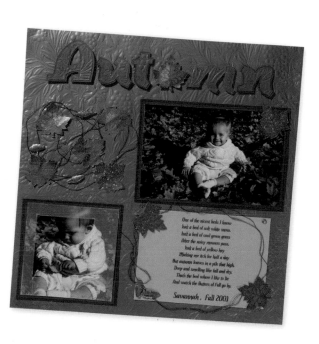

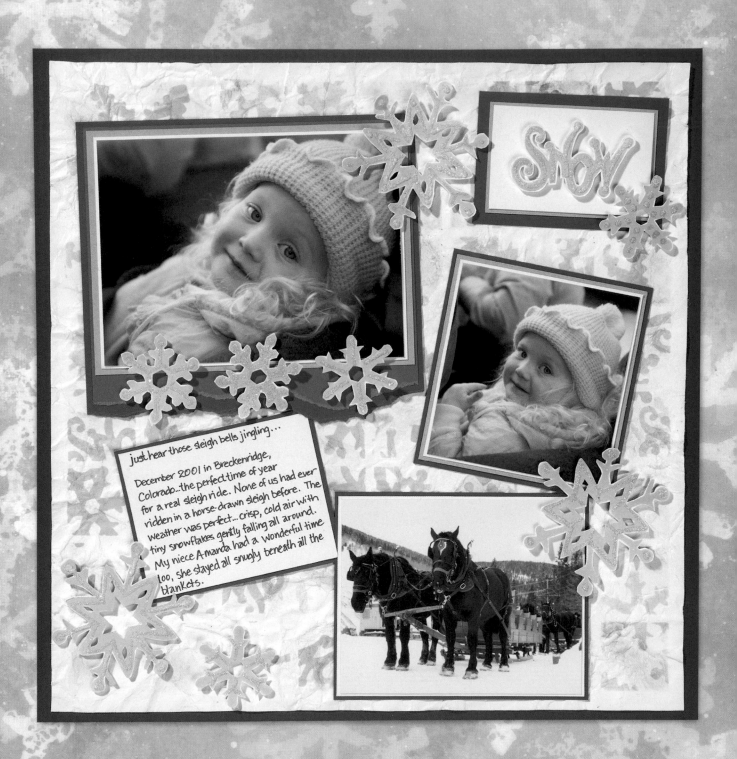

SNOW

just hear those sleigh bells jingling...

December 2001 in Breckenridge,
Colorado...the perfect time of year
for a real sleigh ride. None of us had ever
ridden in a horse-drawn sleigh before. The
weather was perfect... crisp, cold air with
tiny snowflakes gently falling all around.
My niece Amanda had a wonderful time
too, she stayed all snugly beneath all the
blankets.

Introduction

I've always loved the changing seasons: brilliant summer sunshine, colorful fall leaves, fragrant spring blossoms and winter's magical snow. The rotation of seasons offers more than just changing landscape—it allows people to break free from the comfort of their traditional cycles and experience new adventures.

The changing seasons also supply scrapbookers with an evolving panorama of wonderful memories to capture. One of my favorite seasonal memories involves a Christmas family sleigh ride in Breckenridge, Colorado. It was such a picture-perfect winter day, with the cold, crisp flurries falling delicately around our bundled-up bodies. Times like these just beg to be captured and preserved within our scrapbooks.

You undoubtedly have your own unique seasonal memories that are just waiting to find a home within your scrapbook album. This book, *Sizzling Seasonal Scrapbook Pages*, was created to supply you with the inspiration and information necessary to make each scrapbook page as cherished as the event or events it represents.

Inside, you'll find dozens of stunning scrapbook pages that highlight many of your favorite seasonal activities, including Super Bowl parties, backyard barbecues, graduation ceremonies, ski trips and, every child's favorite, back-to-school preparations!

The book also includes a plethora of creative, cutting-edge scrapbook techniques, as well as comprehensive photo lists that detail the most common seasonal events and activities your camera won't want to miss. As well, enjoy a special "photo tips" section, designed to help you meet season-specific photography challenges, such as how to create better composition, get rid of red-eye and capture those unexpected moments.

Every scrapbooker has her own favorite season and oodles of unique memories to go along with it. Whether you're a cold-weather fan, a budding spring lover or feel most connected to fall or summer, there's bound to be pages somewhere inside this book to inspire you.

Michele

Michele Gerbrandt
Founding Editor
Memory Makers magazine

Getting Started

Just like the seasons, the scrapbook market changes constantly. Dozens of new embellishments and accessories are created to help scrapbookers add creativity and pizazz to their pages. However, the basics of scrapbooking—the tools, the organization and the elements of a good layout—remain the same. Here's how to get started in a few easy steps.

1. Set Up a Work Area and Get Organized

Customize a well-lit, roomy work surface with access to photos, scrapbook supplies and idea books. Organize your photos into categories. Jot down memories on sticky notes as you go along. Group photos chronologically, by season or by holiday. Make sure to store photos and negatives in archival-quality binders, boxes or sleeves.

2. Basic Tools and Supplies

- Adhesives: Use "acid-free" or "photo safe" adhesives such as glues, tapes and mounting corners. Rubber cement, white school glue and cellophane tape contain chemicals that can harm photos over time.

- Papers: Acid- and lignin-free papers in a variety of patterns and textures are available in countless colors. Use these versatile papers for a background, an accent and to mat or frame photos.

- Albums: The quantity, physical size and theme of your photos will help determine what type of album you need. Albums come in three-ring binder, post-bound or strap-hinge style, allowing you to remove, add or rearrange pages as needed. Spiral-bound albums make great gifts.

- Design Additions and Embellishments: Elements such as stickers, die cuts, photo corners and pre-made embellishments can enhance the look of your page by building on the theme of your photos.

- Scissors and Paper Trimmer: A pair of sharp, straight-edge scissors and a paper trimmer are absolute necessities for photo cropping. Decorative scissors can add pizazz to a photo, matting or border element.

- Pencils, Pens and Markers: A rainbow of journaling pens and markers, with a variety of tips, make journaling and penmanship a snap. Photo-safe colored pencils can add colorful details to backgrounds and designs while wax pencils can be used for writing on the front or back of photos.

- Rulers and Templates: Decorative rulers and templates are the perfect accessory to crop photos or trace shapes onto paper, to cut decorative photo mats, or to create your own die cuts.

3. Create a Layout

- Focal Point: Select one photo for a focal point on the page; choose an enlarged, matted, unique or exceptional photo to draw the eye to the page.

- Balance: Make sure not to cluster too many photos in one area; leave space for journaling as well as room around the focal photo.

- Color: Select paper colors and patterns that don't distract from your photos.

4. Crop-n-Assemble

- Cropping: Photo cropping can add style, emphasize a subject or remove a busy background.

- Matting: Single or layered paper photo mats focus attention and add a finished touch to a photo.

5. Journaling

- Bullets: List the basics of who, what, when, where and why in bullet form.

- Captions: Expand information with complete sentences.

- Quotes, Poems and Sayings: Search out or write your own words pertaining to photo subject.

- Storytelling: Tell the story with creativity, just make sure to include the details!

6. The Complete Page

Enjoy the process and keep the focus on scrapbook fun and the preservation of your memories. Try not to get overwhelmed with the number of scrapbook products available. Be sure to let your own style come through!

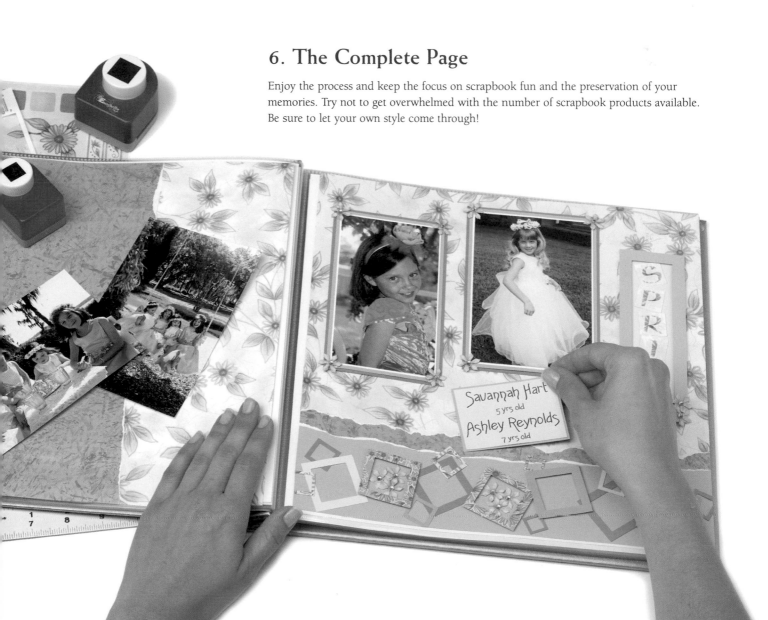

How to take great photos

Every sizzling seasonal scrapbook page begins with sensational photographs. Whether those images are of people, places or things, good photographs are the result of careful composition, attention to lighting, and tenacity. The seasons, however, pose unique challenges that can hinder even the best of photographic endeavors. Fortunately, for every problem, there is a solution.

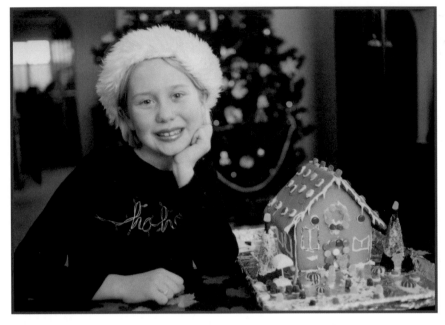

PROBLEM: Inside flashes produce red-eye and background shadows.
SOLUTION: Try using higher-speed film (ASA 400) while standing next to a window or other natural light source.

PROBLEM: Shooting pictures on snow causes subjects to be underexposed (dark). **SOLUTION:** If using a camera with manual or programmable exposure controls (i.e. shutter and aperture control) overexpose the scene by one stop. If your camera doesn't have programmable exposure control, use your camera's flash to properly expose the subject.

PROBLEM: Pictures that tend to look the same. **SOLUTION:** Shoot vertical, as well as horizontal, photos. Experiment with different focal lengths to gain new perspectives.

PROBLEM: Composition seems static and uninteresting. **SOLUTION:** Avoid placing your subject in the center of the frame. Instead, try placing it offside to create visual balance.

PROBLEM: It's difficult to capture those wonderful spontaneous moments of children on film. **SOLUTION:** Keep your camera loaded with fresh batteries, film and in a readily accessible location (such as on the top of the refrigerator) at all times.

PROBLEM: To fill up the frame with the subject, you have to get close, and that affects the spontaneity of the moment. **SOLUTION:** Use a telephoto lens, which will allow you to obtain closer shots while standing farther away.

PROBLEM: Shooting during the midday hours creates flat colors and harsh shadows. **SOLUTION:** Shoot on overcast days and during the "golden hours" (an hour before sunset or an hour after sun rise). If you must shoot midday, try taking your subjects into the shade.

PROBLEM: Pictures that are often "busy" and uninteresting. **SOLUTION:** Try focusing on "the little picture" as well as the scenic vistas. Look up, down and all around for unusual angles or subjects that tell your story.

WINTER

by Lois Duncan

What is springtime? Nothing now.
Ice-clad creeks are gray and still.
Snow is heaped in crusted drifts
In the woods and on the hill.

Branches stretch toward leaden skies,
Heartbreak-heavy, black and old.
Trees that have forgotten spring
Shiver, silent in the cold.

What is springtime? Nothing now.
Still, there is the faintest sound
Whispering beneath the earth—
Laughter deep in frozen ground.

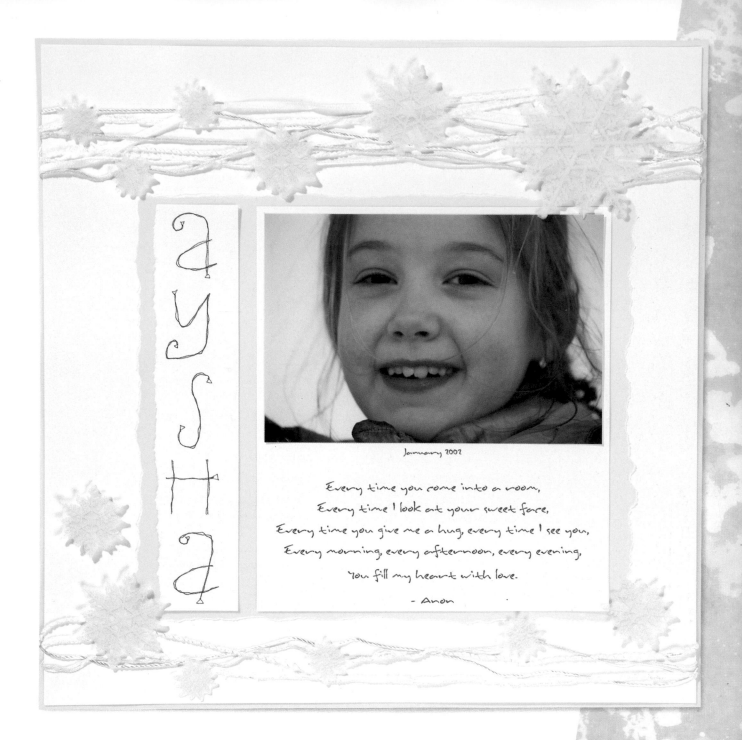

January, 2002

Every time you come into a room,
Every time I look at your sweet face,
Every time you give me a hug, every time I see you,
Every morning, every afternoon, every evening,
You fill my heart with love.

— Anon

Aysha

Trudy's sentimental layout and heartwarming poem is bordered with vellum snowflakes layered over touchably soft fiber strands. Print poem onto white cardstock, leaving room for photo; cut cardstock to size and mount photo. Freehand write title on white cardstock strip; paper tear left edge. Layer title block and photo with poem on light blue vellum (Paper Company) with paper-torn edges. Mount white and blue fiber strands (On The Surface, DMC) horizontally along top and bottom of page; wrap ends around back of page and secure. Mount vellum snowflake stickers (Autumn Leaves) over fibers. Mat page on blue vellum.

Trudy Sigurdson, Victoria, British Columbia, Canada

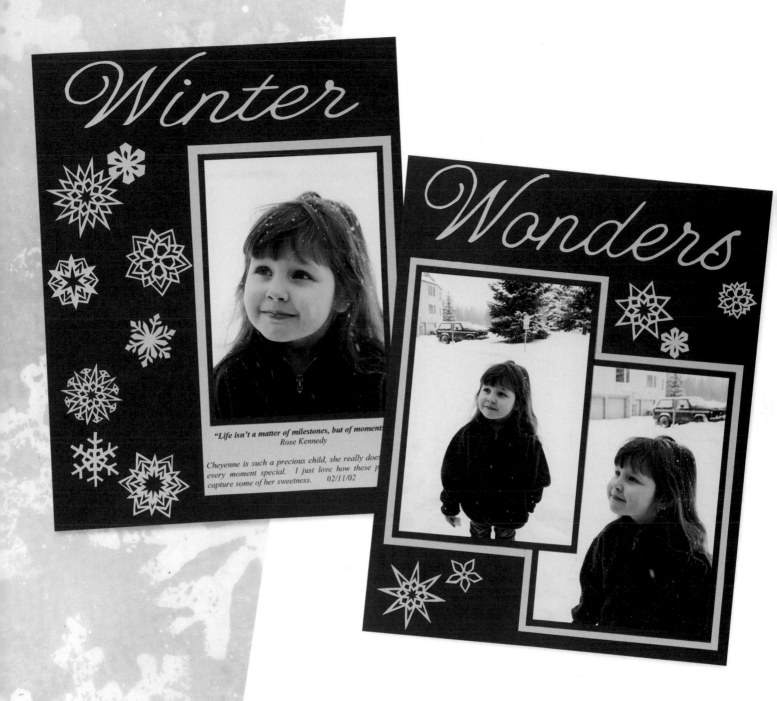

Winter Wonders

Brooke's patience and love for using a craft knife is evident when looking at her intricately detailed snowflakes. Download snowflake patterns from Internet clip art. Transfer patterns onto silver sparkled cardstock (Bazzill); carefully cut and detail with a craft knife. Alter some of the snowflake patterns slightly so that no two snowflakes look exactly alike. Single and double mat photos; overlap matting for photos on the right. Print journaling onto silver sparkle cardstock leaving space for matted photo. Print title; silhouette cut with craft knife.

Brooke Smith, Anchorage, Alaska

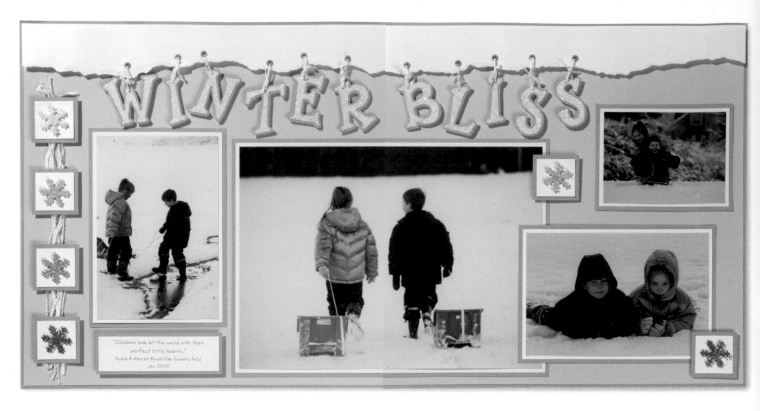

Winter Bliss

Dangling title letters sparkle just like fallen snow on Trudy's soothing, monochromatic page. Mat light purple cardstock with darker purple cardstock. Slice a 2½" strip of white cardstock; paper tear horizontally along one edge. Create title letters as illustrated below. Punch snowflakes (Emagination Crafts) from four different shades of purple cardstock; run through adhesive application machine before coating with glitter, as seen below. Mount on white 1¼" punched square with self-adhesive foam spacers. Mat on 1½" punched squares. Layer four matted snowflakes over fiber strands. Double mat photos; layer on page with remaining matted snowflakes. Print journaling on white cardstock; cut to size, mat and mount with self-adhesive foam spacers.

Trudy Sigurdson, Victoria, British Columbia, Canada

1 Using a Sizzix Die Cut Machine, cut out letters and run them through a adhesive application machine upside down.

2 Cover all letters with purplish-silver glitter, then run the letters glitter side up through the adhesive application machine again.

3 Mat letters on lavender cardstock. Punch ¹⁄₁₆" hole at the top of each letter and set aside. Tear two white strips of cardstock.

WINTER PHOTO CHECKLIST

- ❏ Christmas shopping
- ❏ Holiday decorating
- ❏ Cooking holiday meals
- ❏ First snow
- ❏ Family gatherings
- ❏ Snow sports (boarding/skiing/sledding/tubing)
- ❏ Snowman building, snowball fights, snow shoveling
- ❏ Ice-skating
- ❏ Winter dances
- ❏ Holiday parades
- ❏ Basketball games
- ❏ Hockey games/Stanley Cup
- ❏ Super Bowl parties
- ❏ College bowl games
- ❏ Christmas Eve/Day
- ❏ New Year's Eve/Day
- ❏ Hanukkah
- ❏ Kwanzaa
- ❏ Valentine's Day

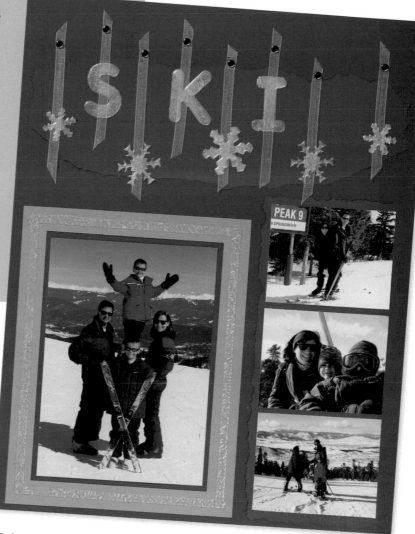

Ski

Kelli gives a unique textured twist to punched and die-cut shapes by embossing with ultra thick embossing enamel (Ranger). Punch snowflakes (All Night Media, Emagination Crafts) and die cut title letters from thick, double-sided tape (Suze Weinberg). Sprinkle with embossing enamel and heat from underside until bubbly. Layer letters and snowflakes over paper-torn strip adorned with sheer ribbon strips and nailheads. Double mat large photo; cut thin strips of tape and emboss for matting trim. Mat smaller photos on red cardstock; tear all paper edges.

Kelli Noto, Centennial, Colorado

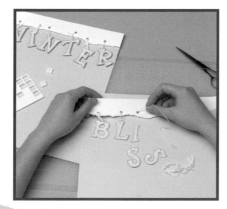

4 Punch holes in white cardstock strips and set eyelets. Hang letters from eyelets with fibers. Mount strips to page, attaching individual letters to page using self-adhesive foam spacers.

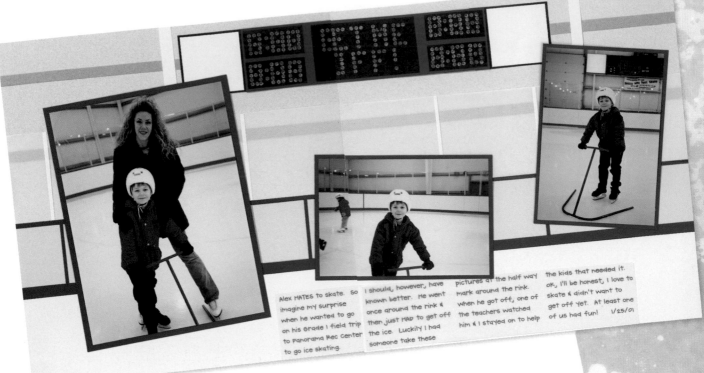

Alex HATES to skate. So imagine my surprise when he wanted to go on his Grade 1 field trip to Panorama Rec Center to go ice skating.

I should, however, have known better. He went once around the rink & then just HAD to get off the ice. Luckily I had someone take these

pictures at the half way mark around the rink. When he got off, one of the teachers watched him & I stayed on to help

the kids that needed it. OK, I'll be honest, I love to skate & didn't want to get off yet. At least one of us had fun! 1/25/01

Ice Skating

Ice skating is a hot cool-weather activity for young and old alike. Trudy cleverly recreated the graphic lines of the skating rink featured in her photos by layering sliced strips of vellum and cardstock. Experiment with various patterns before adhering pieces. To create the scoreboard title block punch ⅛" circles from vellum. Arrange circles to form letters and numbers. Mount on multi-colored cardstock scoreboard blocks. Print journaling onto vellum; cut to size and mount. Mat photos on red cardstock and mount at skewed angles.

Trudy Sigurdson, Victoria, British Columbia, Canada

Speed

Gayla's colorful 12-photo kaleidoscope conveys motion and high-speed excitement. Create kaleidoscope with easy angle template (This n' That Crafts); assemble and mount over patterned paper (Creative Imaginations). Cut two 6" wide strips of light blue paper; mount at outsides of each page. Layer enlarged and cropped photos down left side of page. Mount one enlarged photo on right side of other page. Adhere title sticker letters (Creative Imaginations) under large photo. Print journaling on vellum; cut to size and mount with eyelets. Complete page with shaved ice glitter (Magic Scraps) around kaleidoscope and on side borders.

Gayla Feachen, Irving, Texas

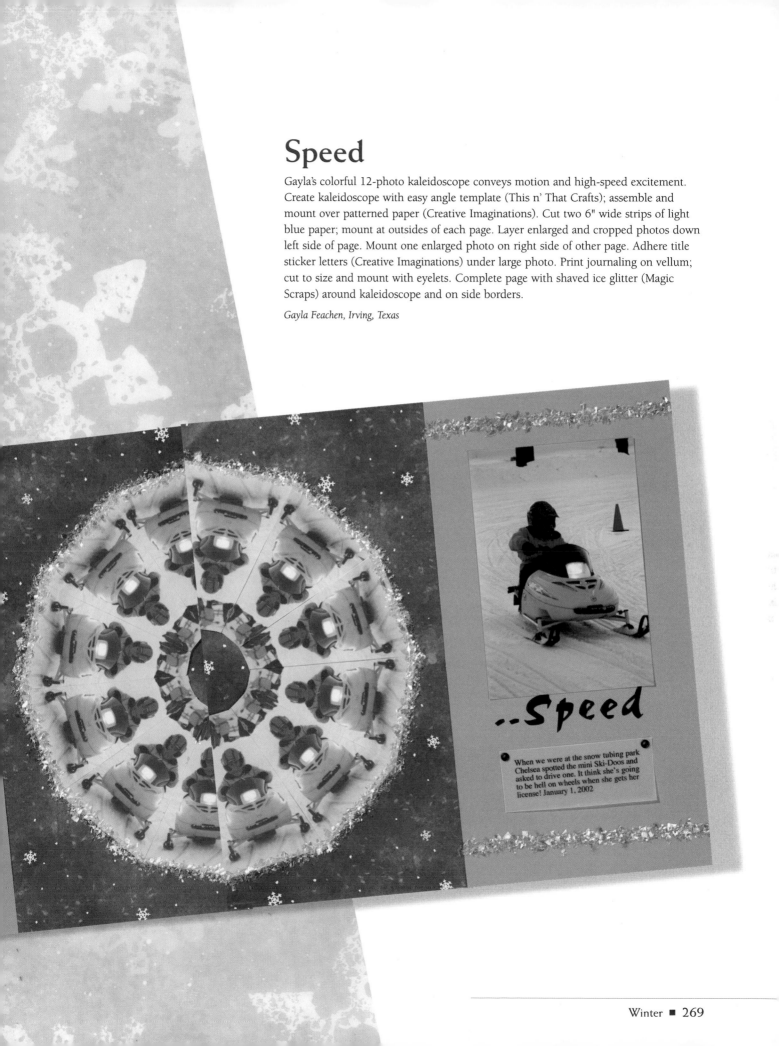

..Speed

When we were at the snow tubing park Chelsea spotted the mini Ski-Doos and asked to drive one. I think she's going to be hell on wheels when she gets her license! January 1, 2002

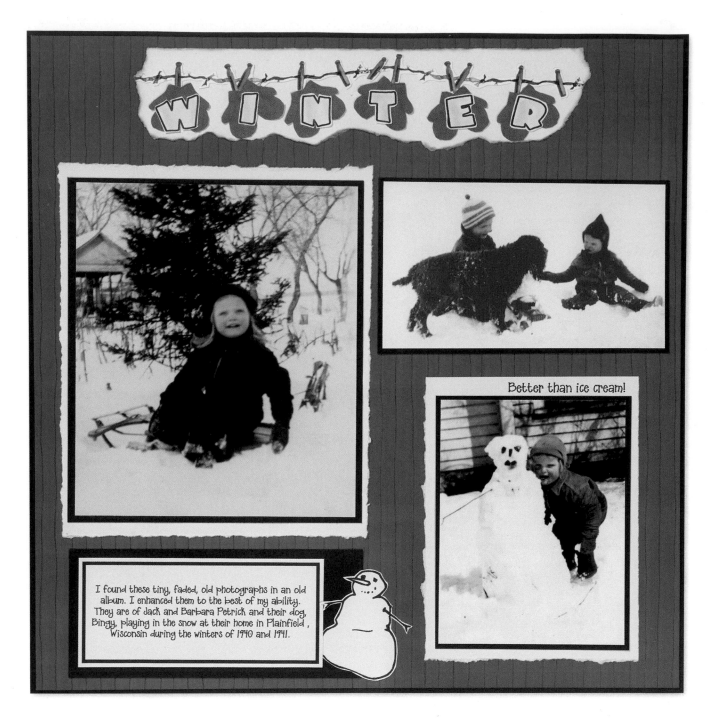

Better than ice cream!

I found these tiny, faded, old photographs in an old album. I enhanced them to the best of my ability. They are of Jack and Barbara Petrick and their dog, Bingy, playing in the snow at their home in Plainfield, Wisconsin during the winters of 1940 and 1941.

Winter

Barbara's simple embellishments give her page clean lines and provide a beautiful contrast for old black-and-white photos. Mat patterned paper (Provo Craft) with black cardstock. Single and double mat photos; tear edges of second matting. Print journaling and title letters on white cardstock. Mat journaling; silhouette cut title letters. Tear white cardstock for title block; brush with black chalk around the edges. Silhouette computer-printed clip art of clothesline and mittens (Provo Craft) and snowman (Broderbund). Mount clothesline and mittens on torn title block; layer silhouette cut title letters on mittens. Mount snowman at right side of journaling block.

Barbara Gardener, Scottsdale, Arizona

Snow

Dry-embossed shapes etched into vellum add elegant, transparent effects to Torrey's color-blocked layout. Divide page into quadrants; cut cardstock in shades of blue with decorative scissors. Print poem. Mount quadrant pieces on light blue cardstock, leaving a ⅛" border. Cut vellum block for border and title with decorative scissors (Fiskars). Create title letters, feathers and snowflake designs as shown in instructions below, using pattern on page 345 or sketching freehand. Mount vellum with embossed side toward page. Double mat photo; trim with decorative scissors.

Torrey Miller, Thornton, Colorado
Photo, Heidi Finger, Brighton, Colorado

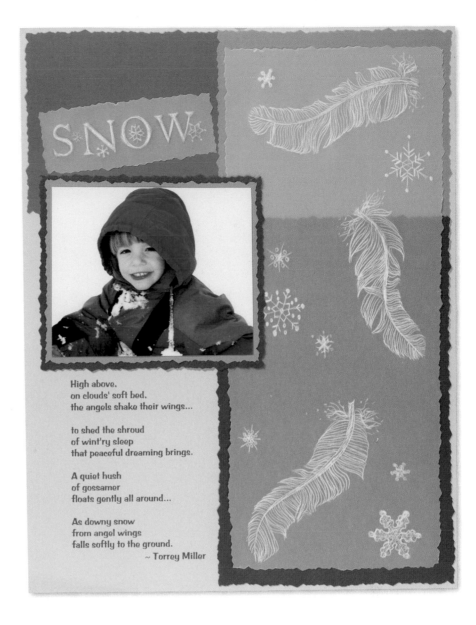

High above,
on clouds' soft bed,
the angels shake their wings...

to shed the shroud
of wint'ry sleep
that peaceful dreaming brings.

A quiet hush
of gossamer
floats gently all around...

As downy snow
from angel wings
falls softly to the ground.
~ Torrey Miller

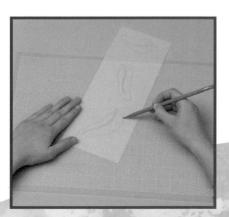

1 Use pattern or freehand sketch three feathers of approximately the same size on the right side of a sheet of vellum.

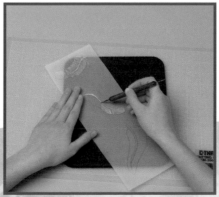

2 Using a stylus placed on top of a mouse pad, detail feathers by lightly pressing the stylus against the vellum and sketching softly.

3 Erase pencil marks; Freehand draw snowflake details using stylus pressed into the mouse pad.

Merry Christmas

Kristin's holiday mosaic only looks complicated. In reality, special scissors used for cutting stained-glass patterns make the process quick and easy. Using scissors, cut out a strip of paper, leaving a ¼" "leaded" space for a stained-glass look. Crop photos using a template (Frances Meyer). Position and layer photo shapes and die-cut letters on top of patterned paper (Autumn Leaves). Trace around shapes and letters with pencil. Draw design lines to use as a cutting guide. With a craft knife cut around shapes and letters ⅛" larger than actual photo for "leading." Starting at one corner of patterned paper, cut along guidelines with stained glass scissors, making sure to mount pieces on page as you go for easiest reassembly. Cut slices into photos and die-cut letters with scissors; mount.

Kristin Persson, Salem, Oregon

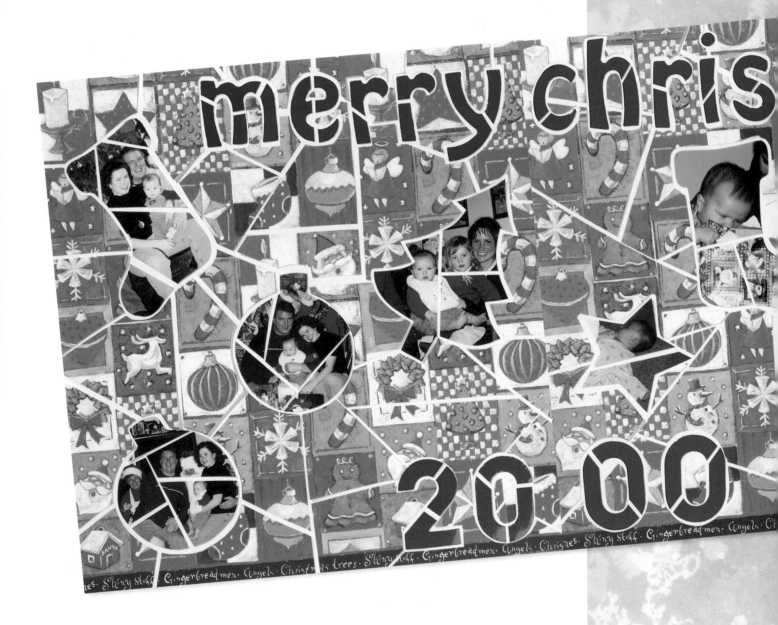

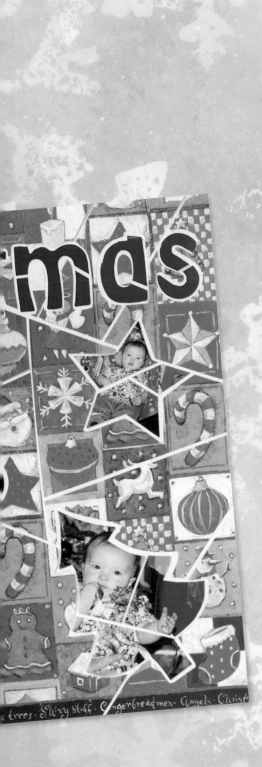

What shall we give the children?
Christmas is almost here.
Toys, games, and playthings
as we do every year?

Yes, for the magic toyland
is part of the Yuletide lore
To gladden the heart of childhood
but I shall give something more.

I shall give them patience,
a more sympathetic ear.
A little more laughter
or tenderly dry a tear.

I shall take time to teach them
the joy of doing some task.
I'll try to find time to answer
more of the questions they ask.

Time to read books together
and take long walks in the sun.
Time for a bedtime story
after the day is done.

I shall give these to my children
weaving a closer time.
Knitting our lives together
with gifts money can't buy.

-author unknown

What Shall We Give the Children?

Daintily wrapped presents tied with sentimental tags adorn Tina's heartwarming and meaningful page. Cut squares and rectangles in a variety of sizes from cranberry and green cardstock; mat on ivory cardstock. Tie with cotton threads (Making Memories). Print words for tags and poem on ivory cardstock. Freehand cut tag shapes around words; pierce a small hole at end and tie to "presents" with thread. Cut poem to size; highlight words with green chalk and mat. Double mat photo. Layer all pieces on patterned paper (Keeping Memories Alive).

Tina Chambers, Sardinia, Ohio

Trimming the Tree

Trudy adds sparkle and shine to a paper-torn background by adhering glittered embellishments. Tear strips of black cardstock; detail torn edges with black glitter before mounting on background. Using a craft knife and ruler, cut "windows" into torn background ¼" larger than photos; mat on purple cardstock. Mount photos in "windows" with self-adhesive foam spacers. Print partial title and journaling; cut to size and mat. Create glittered letters and embellishments by running gold and green cardstock through the adhesive application machine before coating with glitter. Cut title letters with template (Frances Meyer) and punch stars (EK Success, Emagination Crafts) from gold glittered cardstock. Mat letters on black cardstock; silhouette cut. Cut trees using template (Scrap Pagerz) from green glitter cardstock. Slice into sections; reassemble and mount on page. Decorate trees with bead strings (Magic Scraps). Wrap brown fibers (Magic Scraps) around small rectangle to create dimensional trunk.

Trudy Sigurdson,
Victoria, British Columbia, Canada

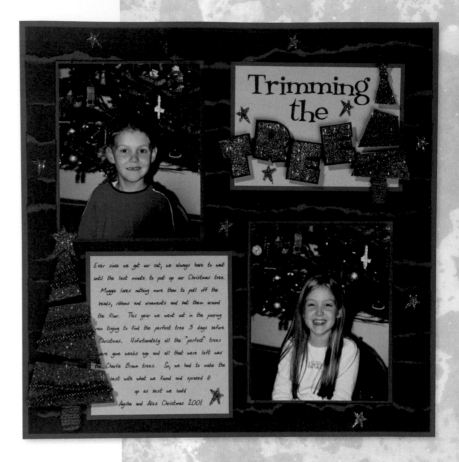

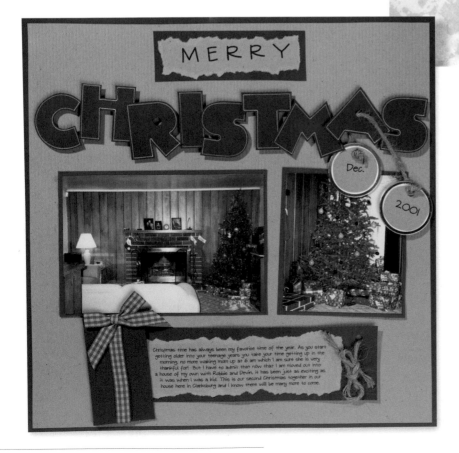

Merry Christmas

Liz's use of simple embellishments adds a warm and cozy feeling to her holiday page. Mat tan cardstock with red cardstock. Mat photos; mount. Cut title letters using template (Scrap Pagerz); outline with white gel pen. Mount on page with self-adhesive foam spacers. Print partial title, date and journaling. Cut title word to size; paper tear edges and mat. Cut month and date into circle shapes; mount on tags as shown. Cut jute; knot one end and slip on tag. Loop other end through title letter; slip on second tag and knot end. Cut journal block to size; paper tear edges and layer on matting detailed with jute bow. Mount pre-made embellishment at left side of journaling block.

Liz Ferrell, Clarksburg, Maryland

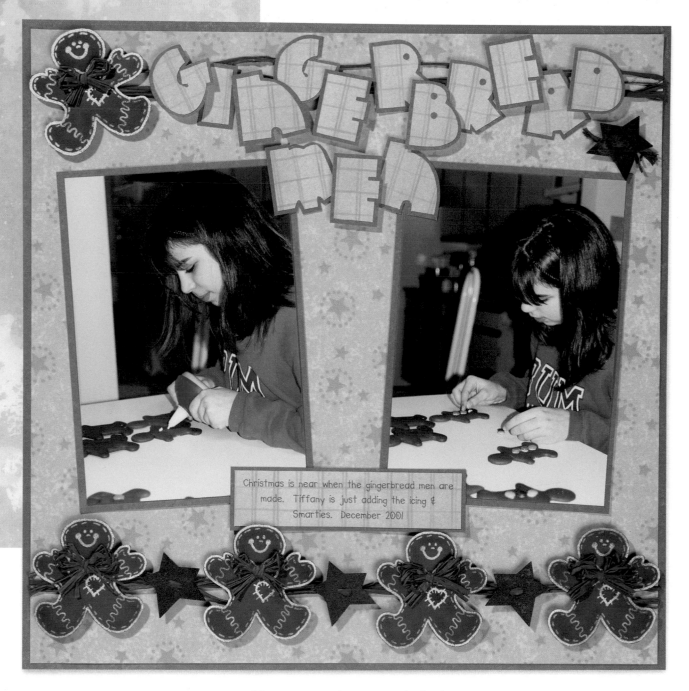

Christmas is near when the gingerbread men are made. Tiffany is just adding the icing & Smarties. December 2001

Gingerbread Men

Friendly, silhouette-cut and embossed gingerbread shapes make for a fanciful, festive border. Mat patterned paper (Sweetwater) with solid paper. Stamp gingerbread shapes (The Stamp Barn) onto brown paper with white ink; sprinkle with white embossing powder and set with heat embossing gun. Add colored details on shapes with pencil crayons (Sanford). Silhouette cut shapes; add green raffia bows. String metal stars (Provo Craft) onto green raffia strands across bottom of page. Mount gingerbread shapes over raffia with self-adhesive foam spacers. Mat photos; layer on page. Print title and journaling onto patterned paper (Provo Craft). Silhouette cut title letters; mat and silhouette cut again. Layer with self-adhesive foam spacers over green raffia. Mount one gingerbread shape and metal star with title.

Trudy Sigurdson, Victoria, British Columbia, Canada

Every Time a Bell Rings

Jodi gives her little angel a stunning pair of hand-crafted wings. Punch corners (Westrim) of background paper; mount over solid-colored paper. Craft feathers by following the instructions on the next page. Make wing shapes by layering feathers to form wings. Cut photo into oval shape; mat on gold paper trimmed with decorative scissors (Fiskars). Print journaling; cut to size and mat. Layer over sheer, gold-trimmed ribbon. Adhere sticker letters (Pioneer) on cream paper; silhouette cut and mount on sheer ribbon for title.

Jodi Amidei, Memory Makers

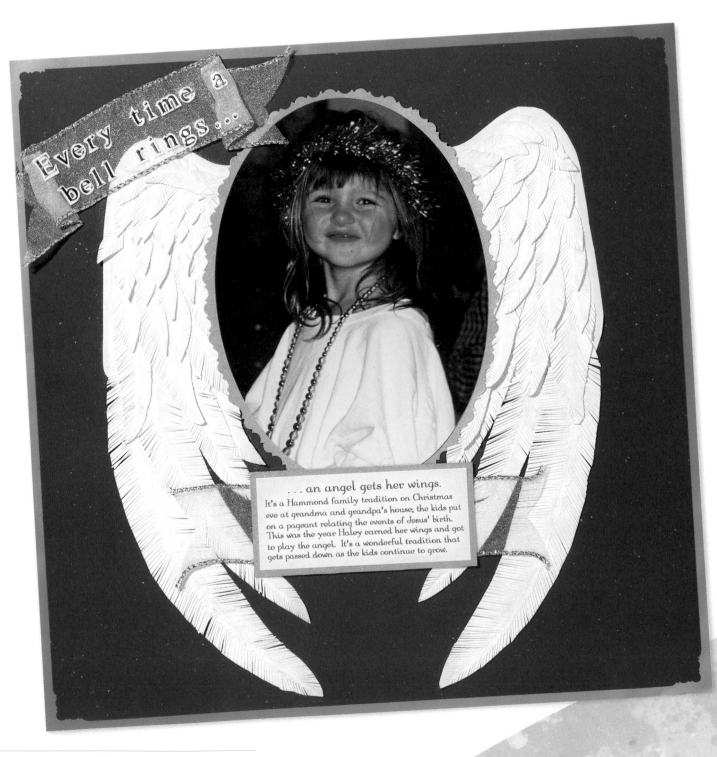

Every time a bell rings...

...an angel gets her wings.
It's a Hammond family tradition on Christmas eve at grandma and grandpa's house; the kids put on a pageant relating the events of Jesus' birth. This was the year Haley earned her wings and got to play the angel. It's a wonderful tradition that gets passed down as the kids continue to grow.

SONG-SATIONAL TITLES

Holiday songs are great for many things—including scrapbook page titles! Below, are some of the most popular holiday songs. Can you think of any scrapbook-worthy moments to illustrate them?

All I Want for Christmas Is My Two
Front Teeth
Blue Christmas
Feliz Navidad
(There's No Place Like) Home for
the Holidays
If Every Day was Like Christmas
White Christmas
It's Beginning to Look a Lot
Like Christmas

Rockin' Around the Christmas Tree
Santa Baby
Feliz Navidad
Silent Night
The Twelve Days of Christmas
'Twas the Night Before Christmas
Up on the Housetop
We Wish You a Merry Christmas
Winter Wonderland
Deck the Halls

1 Create angel wings by freehand drawing different sized feathers on cream-colored cardstock. Or use the pattern found on page 345. Draw a straight line down the center of each feather.

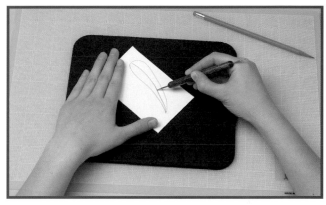

2 Place feathers on a soft surface, such as a mouse pad. Using a wooden stylus, press firmly on the center line of the feathers, tracing from top to bottom to give the feather a curve.

3 Cut out feathers. Carefully cut into each feather, creating slanted, razor-thin slices. Stop cutting just before reaching the feather's center. Feather will begin to curl as you cut.

4 Turn feather over so penciled side is facing downward and lightly dust pigment powder over feather with a small brush to give gold tint.

Channuka

Bold colors mixed with graphic lines and images work together to reflect Kelly's joyous holiday celebration. Mat medium blue cardstock over dark blue cardstock. Freehand cut small squares from lavender cardstock and wavy strips from dark blue cardstock; mount at bottom of page. Adhere stickers (Jewish Stickers) over squares. Cut large and small triangles from purple and yellow cardstocks; layer to create Star of David. Stamp swirl design (Hero Arts) with watermark ink onto yellow, dark blue and lavender cardstocks. Emboss with clear powder and set with heat embossing gun. Die cut hearts (Ellison) from embossed lavender and yellow cardstocks; mount on stars. Slice ¼" strips of yellow cardstock; mount diagonally. Cut title letters with template (Scrap Pagerz) from embossed dark blue paper; mount over strips at top of left page. Freehand cut large and small triangles for body and base of menorah. Slice ⅜" strips from yellow cardstock; cut candles in imperfect sizes. Freehand cut flames from purple and lavender cardstock. Mount glass beads (Magic Scraps) on small flames. Print journaling on blue cardstock; cut to size and mount on vellum. Mat photos on yellow and blue vellums.

Kelly Angard, Highlands Ranch, Colorado

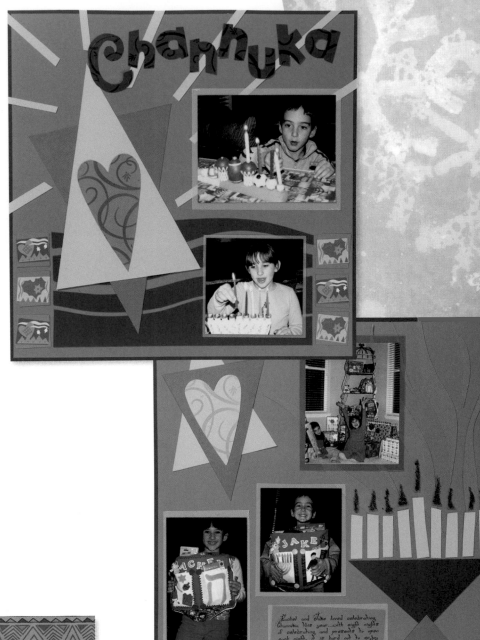

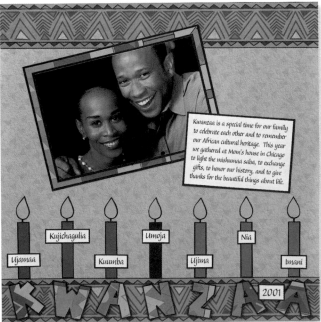

Kwanzaa

Kwanzaa, a festival of thanksgiving celebrated by African-Americans each December, is observed through the lighting of candles and the exchange of gifts. Create Amy's colorful page with tribal-inspired border paper (Hot off The Press). Use a template (EK Success) to cut title letters from patterned paper (Hot off The Press); cut photo frame from same paper. Mount framed photo. Mat letters on black cardstock and mount across lower border. Add freehand cut candles, name and journaling blocks.

Amy Gustafson for Hot Off The Press

New Year's

Metallic patterned paper and embossed metal letters emphasize the excitement of a millennium celebration. Mat gold metallic cardstock with gray metallic cardstock. Double mat photos on metallic cardstocks. Print partial title, journaling and quote on vellum. Cut to size for title block; mat on metallic patterned cardstock (Club Scrap) and mount photo. Trim charm tops from metal letters and numbers (Making Memories). Press letters/numbers onto clear watermark pad; sprinkle with glittered embossing powder and set with heat embossing gun; mount on vellum with glue dots. Freehand cut large tag from vellum with quote; mat on metallic patterned cardstock. Attach silver eyelet and tie with fibers (Making Memories). Mount embossed metallic numbers. Add sunburst design to circle charm (Making Memories) with stencil (Club Scrap) and watermark pen (Tsukineko); emboss with gold and silver powder and set with embossing gun. Tie to tag with fibers.

Diana Hudson, Bakersfield, California

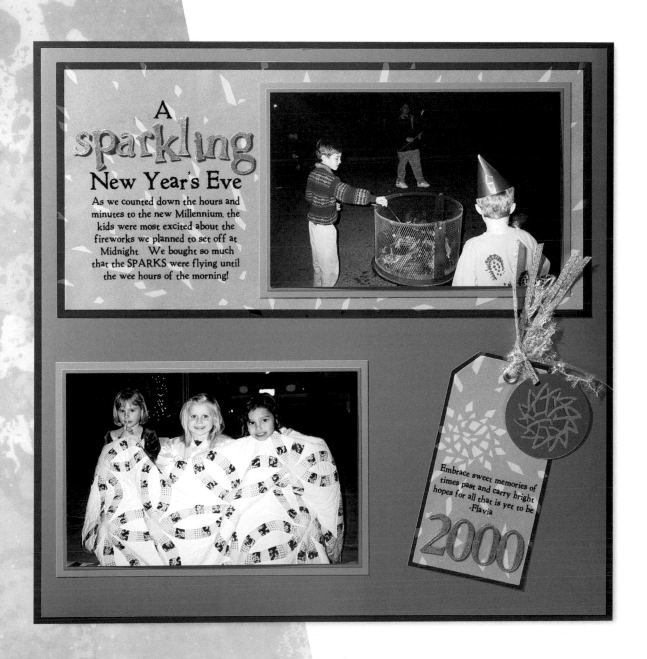

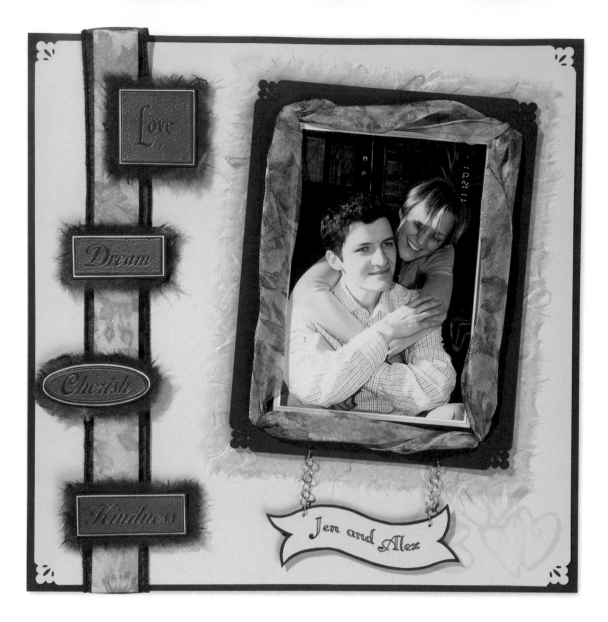

Jen and Alex

Jodi's words of love are perfectly expressed on a soft, romantic layout accented with elegant stamped and embossed details. Punch corner designs (All Night Media) on pink cardstock; mat with brown cardstock. Randomly stamp hearts with light pink ink. Wrap and mount sheer floral ribbon around white strip; layer over brown sheer ribbon as a vertical and horizontal border. Create stamped words by following the instructions on the right. Double mat large photo on left-hand page. Layer again on corner punched matting laced with twisted floral ribbon. Punch a ¼" hole at each corner of matting; feed ribbon strips through holes and mount in back. Mount matted photo with self-adhesive foam spacers over pink mulberry paper (PrintWorks). Handwrite title with marker; freehand cut into banner shape and mat. Punch small holes at top of banner and bottom of matting; link jewelry jump rings (Crafts, Etc.) together to form chain and "hang" banner. Secure banner with self-adhesive foam spacers. Mat photos for right-hand page; overlap and layer together on corner punched matting. "Hang" from horizontal border with jewelry jump rings. Write journaling on vellum; slip into vellum envelope made with template (JudiKins).

Jodi Amidei, Memory Makers

1 Stamp words (Stampa Rosa) onto brown cardstock with clear embossing ink.

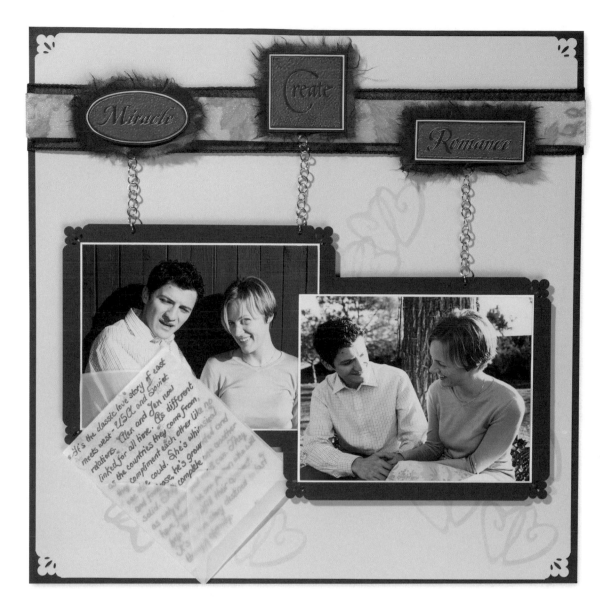

2 While ink is still wet, dust gold embossing powder over stamped images.

3 Using a heat gun, heat the embossing powder until it melts.

4 Cut out embossed word blocks and double mat. Lay over mulberry paper. Using a paint tip dipped lightly in water, draw around edges of mulberry and tear away. Mount torn shapes on border strips with self-adhesive foam spacers.

My Funny Valentine Brianna

Little love notes and a mini vellum pocket add perfect sentiment to Shauna's Valentine page. Mat color-tinted photos on white paper; layer with preprinted cut-out (Hot Off The Press (HOTP) over purple patterned paper (HOTP). Layer again over white paper trimmed with decorative scissors before mounting on patterned background paper (HOTP). Detail trimmed paper edges with black pen. Cut title letters with template (EK Success) from purple patterned paper. Layer over torn vellum strip with self-adhesive foam spacers. Mount small punched hearts to title letters; outline and detail with black pen. Print text for "love notes"; cut to size and mat. Create mini envelope with template (HOTP) from vellum. Mount heart die cut (HOTP) on envelope flap. Complete page with handwritten title words.

Shauna Berglund-Immel for Hot Off the Press

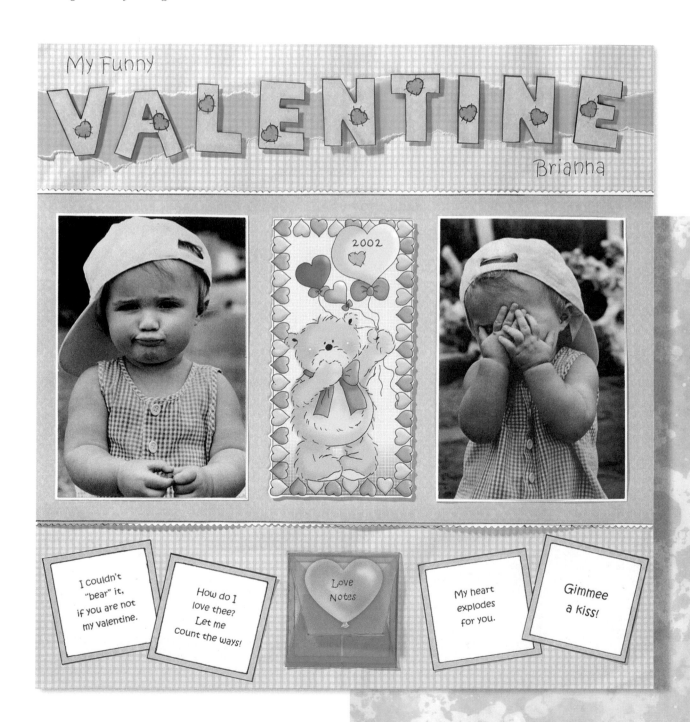

Beloved Child

A collection of soft and sweet embellishments detail Valerie's lovely tribute to her daughter. Diagonally tear embossed vellum (Paper Adventures); layer over light green cardstock. Double mat photo; tear edges of mulberry for second mat. Print poem on gray cardstock and title letters on pink cardstock. Cut poem to size and mat. Layer under photo corner on page. Cut 2" lace strips; mount at top of page with "stitched" buttons. Cut title letters; mount first letter on vellum tag (Making Memories) with lace strip. Mount balance of title letters on page. Cut three 2" squares from gray paper; mat on pink paper. Collage lace, mulberry paper (Paper Garden), button and punched hearts on matted squares.

Valerie Barton, Flowood, Mississippi

Valentine Love

Embellished creative lettering on handcrafted tags makes for an interesting title on Holle's romantic collage. Layer a wide strip of pink sparkled mesh (Magenta) over pink cardstock. Tear white paper and crumple; flatten and mount at top of page. Print journaling onto sparkled vellum (DMD); diagonally tear before matting on pink paper. Mount layers at upper right corner of layout. Freehand cut small tags from pink cardstock. Shape wire into "L"; layer over patterned mulberry paper (Pulsar Paper). Add gold heart nailhead (JewelCraft). Mount "O" letter pebble (Making Memories) over stamped words (Stampin' Up!); surround with red metal hearts (Scrapyard 329). Wrap top of tag with fibers (EK Success). Mount pre-printed die cut "V" (EK Success) on next tag under lavender mesh. Attach eyelet and tie fibers (EK Success). Write "E" on last tag with template (Wordsworth); color with pink marker. Mount heart sequins and wrap with tinsel (both, Magic Scraps). Mount embellished tags with self-adhesive foam spacers. Cut photo frame on left; tear all edges and curl gently with fingers. Cut frame for photo on right with craft knife; embellish with heart nailheads, metal hearts and tinsel. Add sheer ribbon bow; wrap around edges and secure.

Holle Wiktorek, Clarksville, Tennessee

SPRING

by Lois Duncan

This was a year when Spring forgot.

She stayed in the southlands far too long.

Ice lay slick on the garden path

And winter winds sang the robin's song.

The wood-burning fireplace lost its charm,

The beautiful snow turned slushy gray.

The mittens and jackets, the boots and scarves

Got damper and danker each passing day.

Then, full of apologies, Spring rushed home

To set things right. In a matter of hours

She changed all the icicles to leaves,

And all of the snowballs she turned to flowers.

Step Into My Garden

Gabrielle assembled a variety of creative techniques into an ensemble of garden-related novelties. Mat photo; brush edges of matting with brown chalk before mounting on background patterned paper (Provo Craft). Cut rectangles from cream-colored paper; brush around edges with brown chalk. Assemble laser die-cut gardening tools (Deluxe Cuts); mount. Stamp insects (Close To My Heart) on tags (Avery); detail with chalk. Stamp dragonfly image again on vellum; silhouette cut and chalk. Mount over previously stamped image; adhere at center of body, leaving wings free to lift off tag. Tie paper yarn (Making Memories) to tags. Punch flower shapes in three sizes from yellow paper. Layer graduated sizes; mount together with flower eyelet (Stamp Doctor). Mount flowerpot die cut (Making Memories) detailed with black chalk on rectangle with self-adhesive foam spacers. Cut paper yarn stems; mount with punched flower shapes coming out of pot. Print poem; cut to size and mount.

Gabrielle Mader, Whittier, California

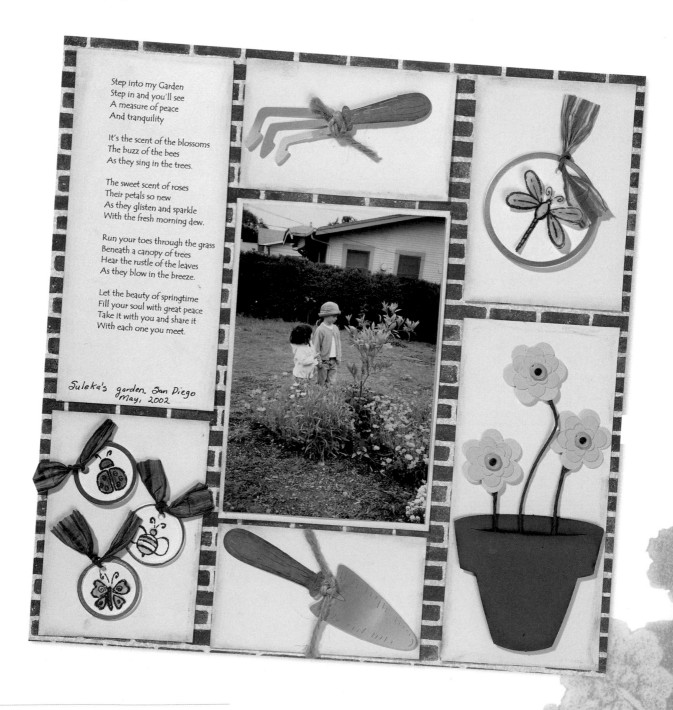

286

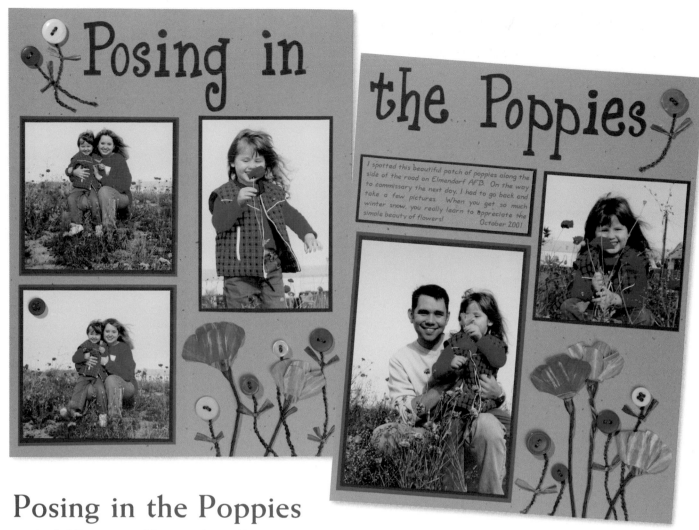

Posing in the Poppies

Handcrafted flowers created from paper yarn, fibers and buttons are blooming along the bottom of Brooke's layout. Single and double mat photos; layer over brown cardstock. Print title and journaling. Silhouette cut title. Trim journaling to size and mat. Create "poppies" by following the instructions below. Tie small paper yarn (Making Memories) pieces onto fiber strips (On the Fringe) to look like leaves; stitch buttons with green fiber before mounting on page.

Brooke Smith, Anchorage, Alaska

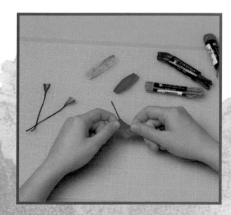

1 Unravel strips of yellow and red paper yarn completely. Unravel green paper yarn only at the top to create flower stem.

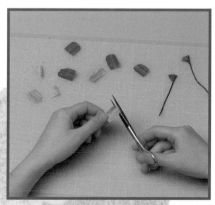

2 Trim red and yellow paper yarn into a U-shape to create flower petals.

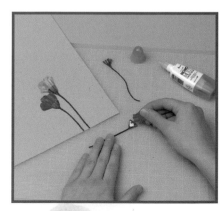

3 Assemble flowers on tan cardstock with adhesive. Arrange three petals into a fan shape, attach to stem, and then place the fourth petal vertically against the top of the stem.

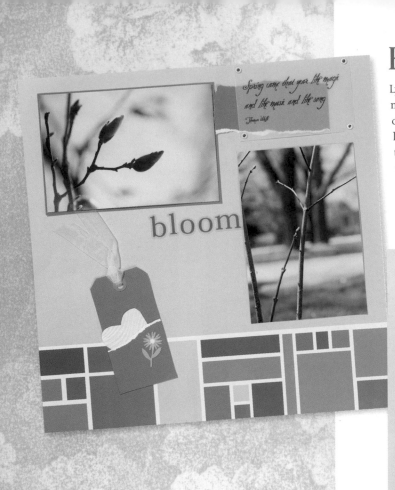

Bloom, Emerge

Lynne presents the beauty of spring's sudden arrival on monochromatic, preprinted color-blocked paper. Mat two photos; layer with other photos on patterned paper (SEI). Print journaling onto vellum; cut to size before mounting on page with eyelets. Adhere title sticker letters (SEI). Handcraft tag from mauve paper; layer with paper-torn strip. Adhere pre-made flower embellishment (EK Success) and tuck hand-cut heart from textured paper behind torn strip.

Lynne Rigazio Mau, Channahon, Illinois

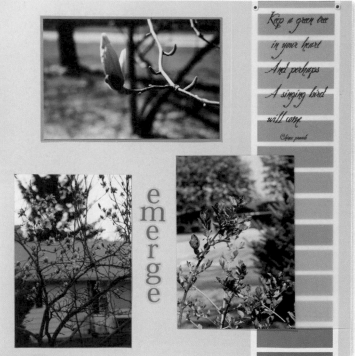

Joy, Dream, Love

Diana features blossoming flowers nestled in vellum layers for a soft, yet vibrantly colored layout. Mat yellow patterned paper (Close To My Heart) with brown cardstock. Mat two photos on yellow and brown cardstock. Slice a photo strip (Creative Imaginations) to use as an accent under vellum layer. Tear vellum pieces; layer with photos over background. Mount largest photo with yellow eyelets (Making Memories). Print title and journaling onto vellum. Tear around title words; gently roll torn edges with fingers. Distress journaling block; run vellum through adhesive machine for extra thickness. Tear around edges; crumple and flatten. Roll paper-torn edges with fingers before mounting. String beads (Magic Scraps) on copper-colored wire. Mount on title and journaling blocks with glue dots. Sprinkle seed beads on journaling block.

Diana Graham, Barrington, Illinois

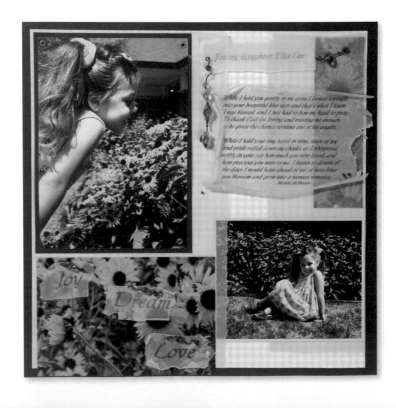

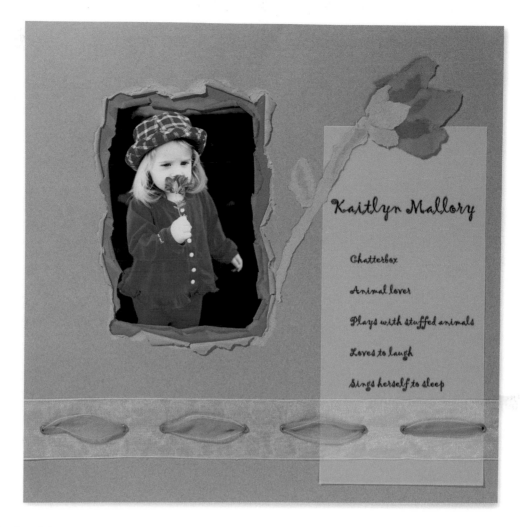

Kaitlyn Mallory

Chatterbox

Animal lover

Plays with stuffed animals

Loves to laugh

Sings herself to sleep

Kaitlyn Mallory

A paper-torn and curled frame provides a soft and interesting focal point on Valerie's elegant page. Lightly draw frame outline on pink cardstock. Punch through paper with scissors at center of frame and tear along penciled outline. Gently curl edges of torn paper with fingers. Repeat above steps with green cardstock, making a larger frame opening; mount over pink frame. Mount photo behind layered frame. Print journaling; cut to size and mount. Freehand draw flower shapes on green and pink cardstocks. Paper tear shapes; add yellow chalk details. Mount wide sheer ribbon across bottom of page; secure with pink eyelets. Weave thin sheer ribbon through eyelets.

Valerie Barton, Flowood, Mississippi

SPRING PHOTO CHECKLIST

❑ First communion
❑ Spring showers
❑ May flowers
❑ Gardening
❑ Opening day (baseball)
❑ Field day (track)
❑ Golf
❑ Soccer
❑ Easter
❑ Mother's Day
❑ Memorial Day

❑ Passover
❑ St. Patrick's Day
❑ Spring cleaning
❑ Prom
❑ Graduations
❑ Last day of school
❑ Spring break
❑ Mardi Gras
❑ Weddings
❑ Flying kites

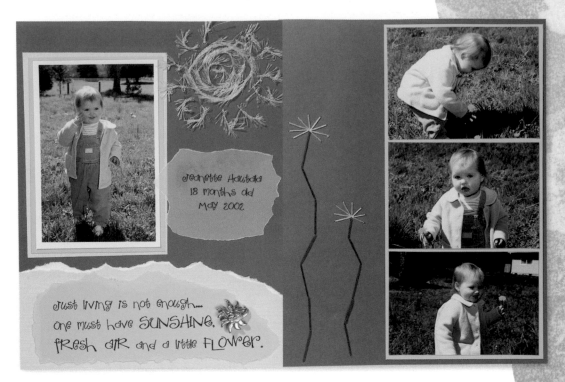

Sunshine

Fanciful fibers are layered and stitched into whimsical designs that accent the title of Andrea's page. Triple mat photo on left-hand page. Mount three photos on one mat for right-hand page. Print title on green paper and journaling on vellum. Paper tear around title; layer over yellow paper with torn edges. Mount gold sun button (JHB International) on title strip. Paper tear around journaling on vellum; mount on page. Mount yellow-fringed fibers in a spiral design with glue; cut and mount small fiber pieces to complete sun. Lightly draw flower design on page with pencil. Pierce holes for stitching flower with needle or paper piercer. Stitch flower design with yellow and green embroidery threads (DMC).

Andrea Hautala, Olympia, Washington

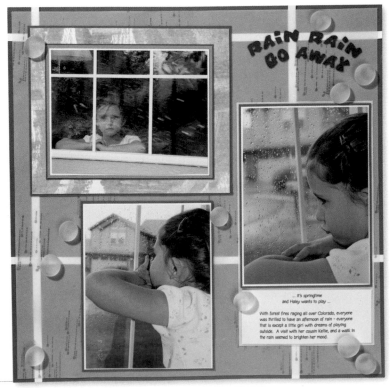

Rain, Rain, Go Away

Jodi re-creates a raindrop-splattered window to reflect the blue mood of a child wanting to go outside and play. Stamp raindrops (All Night Media) onto vellum; sprinkle with clear embossing powder and set with heat embossing gun. Turn vellum over; layer stamped side over ¼" strips of white cardstock mounted vertically and horizontally to resemble windowpanes. Double and triple mat photos. Print title onto blue cardstock and journaling onto white cardstock. Cut journaling to size; mat with one photo onto vellum. Silhouette cut title letters; detail with craft knife. Layer triple matted photo onto textured, patterned paper (Club Scrap); mat again. Complete page with frosted glass pebbles randomly mounted with glue dots.

Jodi Amidei, Memory Makers

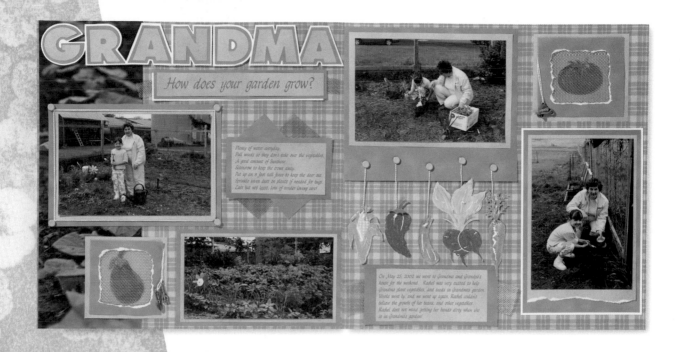

Grandma, How Does Your Garden Grow?

Sheila's colorfully stamped and silhouette cut vegetables dangle playfully among a variety of garden-themed embellishments. Layer large photo strip (Creative Imaginations) on left hand page over patterned background paper (Making Memories). Double and triple mat photos. Detail photo mats with paper-torn edges, flat eyelets and embroidery thread. Cut title letters (Sizzix) from solid-colored paper; mat and silhouette cut two times. Layer on page with self-adhesive foam spacers. Print balance of title and journaling onto solid-colored paper; cut to size and mat. Layer on page over metal mesh pieces. Stamp vegetables (Close To My Heart) with colored markers onto white paper. Create blended shades by using a variety of marker colors on back of stamp; lightly mist with water before stamping for a soft, washed look. Silhouette cut around shapes. Layer tomato and eggplant under paper-torn, metal mesh window frame on colored paper. Tie garden-themed charms (Charming Pages) with embroidery floss; tuck under paper-torn frame and mount. Dangle remaining vegetables from flat eyelets attached to photo mat with embroidery thread.

Sheila Boehmert, Island Lake, Illinois

Catch Me if You Can

Mary Anne's use of open space and simple embellishments makes for a visually appealing layout. Mat patterned paper (Provo Craft) onto solid ivory cardstock. Triple mat large photo; detail by dotting glitter glue on corners of second matting. Mat photos on solid-colored paper strips; mount along bottom of both pages. Print balance of title and journaling on vellum. Cut title letters using template (Scrap Pagerz) from solid green paper; mat on ivory cardstock and silhouette cut. Outline green letters with glitter glue before mounting on vellum. Cut photo corners from solid-colored paper; detail by dotting glitter glue on corners. Mount with vellum title/journaling block on page. Complete page with handcrafted bead dragonfly (pattern from *Beadlings* book by Klutz).

Mary Anne Walters, Monk Sherborne, Tadley, UK

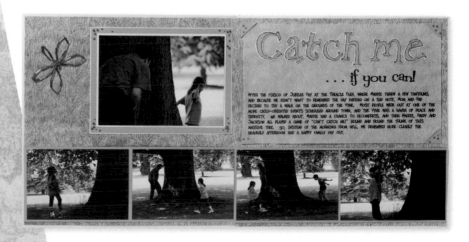

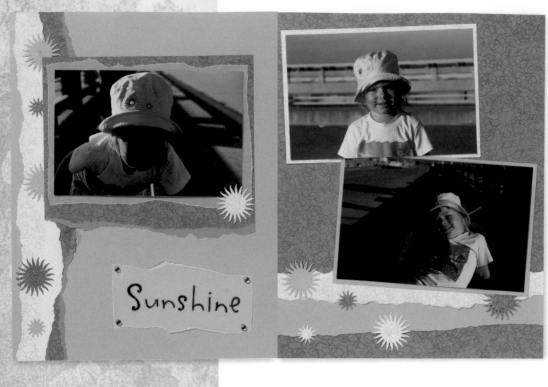

Sunshine

Punched sun shapes not only reflect the warmth and joy of a little girl, but also the cheerful embroidered design on Sheila's daughter's hat. Layer strips of cardstock torn from patterned paper (Crafter's Workshop) over solid and patterned paper. Punch small (EK Success) and large (Emagination Crafts) sunbursts; layer over torn paper strips. Single and double mat photos on solid and patterned paper and vellum; tear a few edges. Adhere title letter stickers (Colorbök) to vellum; tear edges and mount on page with small gold brads.

Sheila Riddle, Elk River, Minnesota

Happiness Held Is the Seed

A charming succession of square-cut photos rests behind a printed vellum strip, giving just a hint of captured innocence in Martha's layout. Mat enlarged photos on solid paper; layer on patterned paper (Scrap Ease). Cut preprinted tags (EK Success); punch holes and tie with fibers (Making Memories) before mounting on page. Mount four 2" square photos next to each other at bottom of page. Print title quote onto vellum; cut to size and mount over photos with clear vellum tape (3M).

Martha Crowther, Salem, New Hampshire

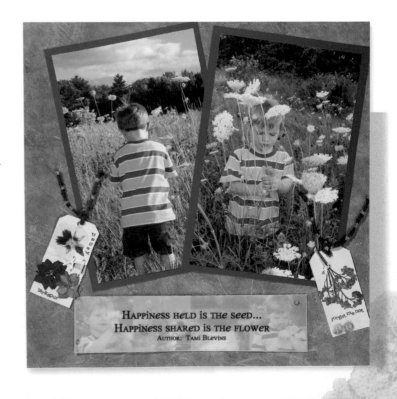

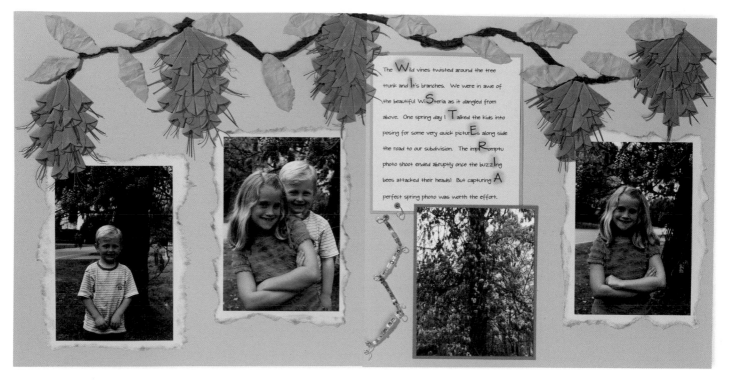

The Wild vines twisted around the tree trunk and It's branches. We were in awe of the beautiful WiSteria as it dangled from above. One spring day I Talked the kids into posing for some very quick picturEs along side the road to our subdivision. The impRomptu photo shoot ended abruptly once the buzzIng bees attacked their heads! But capturing A perfect spring photo was worth the effort.

Wisteria

Hanging wisteria vines created from punched and paper-torn shapes drape elegantly across the top of Valerie's page. Mat photos on lavender cardstock with paper-torn edges; detail with purple chalk around edges. Print journaling on lavender cardstock; cut to size and mat. Shade title letters with purple chalk. Attach purple eyelets under journaling; loop beaded and twisted wire embellishment through eyelets. Create wisteria vines by tearing and folding strips of brown mulberry paper into vine shapes; mount along top of page. Freehand draw leaf shapes onto green cardstock; paper tear along lines, crumple and shade with green chalk. Layer on vines. Create wisteria flower clusters by following the instructions to the left and below.

Valerie Barton, Flowood, Mississippi

1 Punch out 12-14 small (1") circles for each Wisteria bunch you plan to create.

2 Fold left edge of punched circle toward center. Overlap by folding right edge of circle inward to form petal.

3 Cut paper whispers. The thinner they are, the more they will curl. Glue paper whispers on the inside of folded punched shapes, allowing a small strip to project beyond the "petals".

4 Layer flowers on the page, arranging until you achieve the desired effect.

Easter 2002

A colorfully detailed stained-glass design frames a photo of Heidi's daughters in their holiday best. Cut vellum into quadrants; attach eyelets and link pieces with pink ribbon woven through the eyelets. Layer over patterned background paper (Making Memories). Print title on vellum. Trace over letters with embossing pen; sprinkle with embossing powder and set with heat gun. Add color to spaces in letters with pink marker; silhouette cut and mount on page. Create "stained glass" design on 8½ x 6½" piece of vellum paper. Place photo at center; trace around as guide; remove photo. Draw design lines with pencil; color in with markers. Mount strips and pieces of paper yarn (Making Memories) as "leaded lines" over penciled guidelines with glue. Layer entire design over white paper. Mount photo at center of design.

Heidi Schueller, Waukesha, Wisconsin

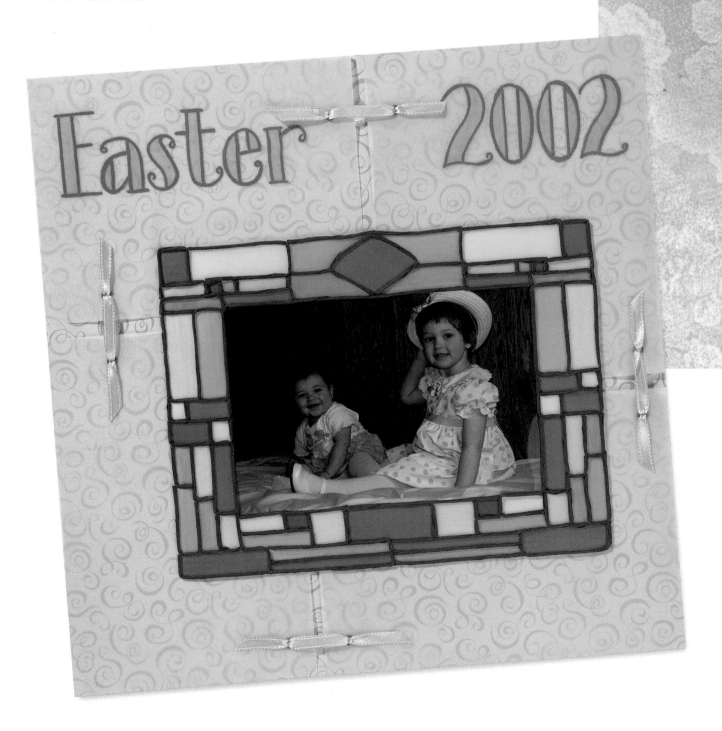

294

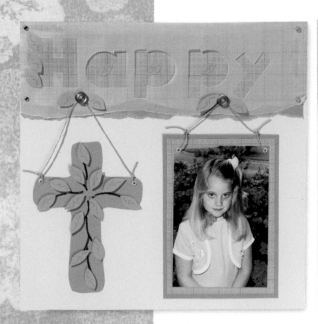

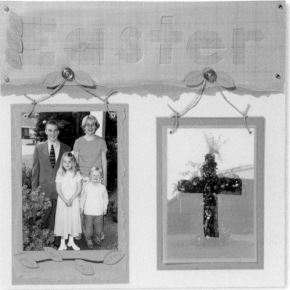

Happy Easter

Valerie's holiday photos and religious symbols are "hung" from a die-cut title border adorned with buttons and crystal lacquered leaves. Layer solid and patterned (Paper Fever) papers torn along the bottom edge over light yellow cardstock. Die cut letters (Accu-Cut) into vellum; set die-cut letters aside and use die-cut negative space. Tear bottom edge of vellum and mount with gold brads. Double mat photos with solid and patterned papers. Paper tear edges of one mat. Cut cross into vellum with craft knife before mounting over photo. Cut freehand drawn cross from solid tan paper. Draw decorative lines with brown marker. Trace over marker lines with crystal lacquer for dimension. Freehand cut leaves from solid green paper; detail with crystal lacquer (Sakura Hobby Craft). Mount leaves inside of title letters and on cross with self-adhesive foam spacers. Attach eyelets to cross and photos. Stitch buttons with jute string; loop ends through eyelets and tie. Mount buttons with self-adhesive foam spacers along border. Attach leaves behind buttons.

Valerie Barton, Flowood, Mississippi

Passover

Kelly tells the powerful story of Passover with colorful text and Judaic stickers adhered on a border and handcrafted tags. Create border with large stickers (Jewish Stickers) adhered to solid paper; mount on matted cardstock strip. Cut title with template (Scrap Pagerz); outline with fine-tip black pen. Mount matted sticker strip and letters on patterned paper (Scrappin' Dreams) with self-adhesive foam spacers; layer on purple background paper (Karen Foster Design). Adhere balance of title letter stickers (Making Memories). Print journaling onto vellum. Cut to size; frame with thin strips of black cardstock. Layer over colorful fiber scraps glued to white cardstock strip for a hint of decorative color. Mat photos; mount on page. Adhere small stickers to white matted strip. Layer over freehand cut matted tags tied with fibers (Making Memories).

Kelly Angard, Highlands Ranch, Colorado

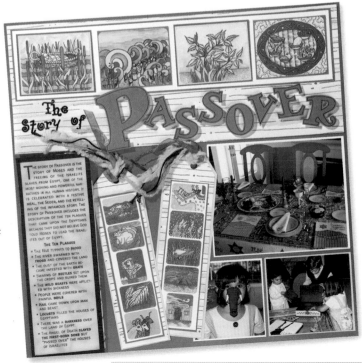

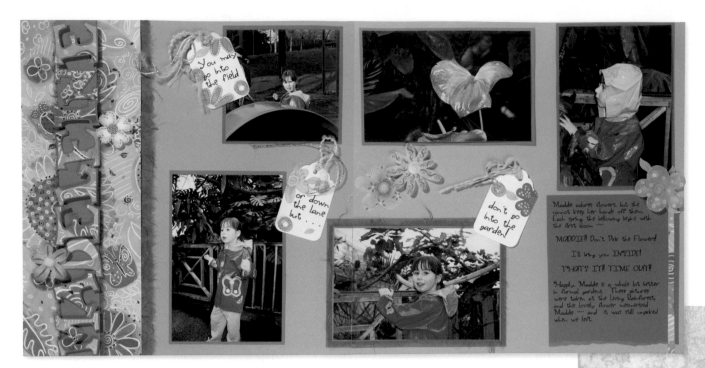

Madeleine

Mary Anne's whimsically embellished tags provide a colorful contrast to a subtle, muted background. Cut title letters using template (Scrap Pagerz) from patterned paper (Paper Adventures). Mat on purple cardstock; silhouette cut. Layer letters on border strip matted with torn blue mulberry paper. Layer again on wide patterned paper strip with torn mulberry border. Adhere vellum flower stickers (Stickopotamus) to border strip with self-adhesive foam spacers. Single and triple mat photos; tear edges of mulberry matting. Press small thin metal washers onto clear embossing pad; sprinkle with blue embossing powder and set with heat gun. Embellish tags with vellum flower stickers, embossed washers, fibers (Memory Crafts) and letter stickers (Colorbök). Print journaling onto teal cardstock; cut to size and tear bottom edge. Mount on page under thin patterned paper slice. Mount vellum flowers with self-adhesive foam spacers.

Mary Anne Walters, Monk Sherborne, Tadley, UK

Haley, Age 5

Lisa's vibrant, rainbow-colored tags tied with chunky braided fibers provide the perfect place for journaling details. Mount enlarged and cropped photo on solid-colored cardstock. Shade tags (DMD) with complementary chalk colors, blending well with fingers. Write journaling on tags with black fine-tip pen. Braid fibers (DMC) on tags before mounting over ribbon with self-adhesive foam spacers.

Lisa Francis, New Castle, Indiana

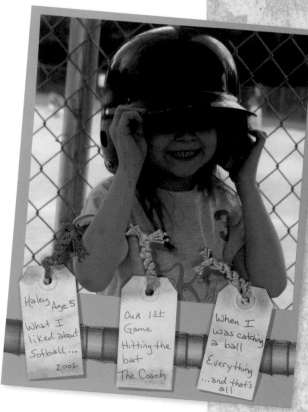

A Mother's Love

Softly torn and curled paper edges add a sweet, elegant look to Brandi's sentimental page. Tear yellow paper strip for border; mount at left side of page over blue cardstock. Gently curl edges with fingers. Tear matting for photos from yellow paper; tear piece from side of matting for a soft, unique detail. Pierce holes and lace with embroidery thread. Mount photos and buttons on torn matting. Stamp butterfly shapes (Hero Arts) with light blue ink on ivory paper; silhouette cut and mount with self-adhesive foam spacers. Print title words on ivory cardstock. Tear and chalk around edges using a metal-edged ruler as a guide.

Brandi Ginn, Lafayette, Colorado

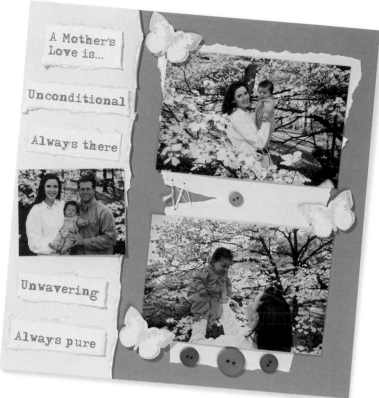

Mommy and Megan 1986

Peggy captures the serenity of a read-aloud moment shared with her daughter on Mother's Day 1986 in this simple but striking page. Offset photo on light blue mat. Mat again over vellum and then hand torn light brown cardstock before attaching to page. Print journaling block on vellum; tear. Punch holes in lower edge of journaling block; thread with white fiber; mount. Wrap fiber horizontally around upper page and journaling block. Punch sun shapes from brown cardstock and vellum; layer and adhere to page over fiber. Tear title block. Hand stitch stems and leaves and attach to flower eyelets. Punch small holes on background and thread flowers and stems through holes to secure; tie knots on backside of paper. Lay torn paper title over "stem" bottoms.

Peggy Roarty, Council Bluffs, Iowa

Beauty in Bloom

Gayla highlights the beauty of her daughters among the blue bonnets with enlarged photo border strips. Slice enlarged photos for borders; mount over blue background cardstock leaving ½" border. Mat photos; layer over green patterned paper (Club Scrap). Print title and journaling onto vellum; mount with eyelets over photo pieces sliced into strips and cut into squares.

Gayla Feachen, Irving, Texas

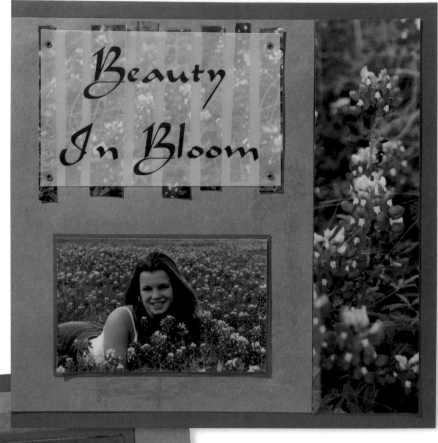

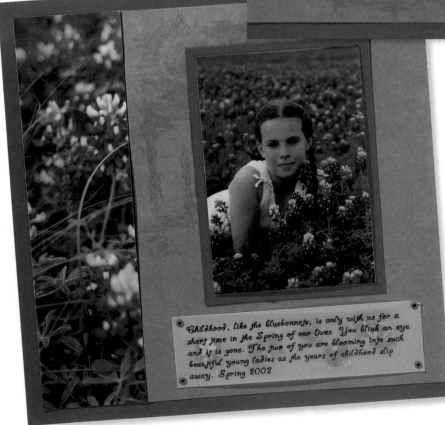

Fancy Little Violets

Heidi stamped an imaginative floral background onto textured paper to create a uniquely blooming background. Create the background by following the instructions below. Double mat photos. Adhere purple title letter stickers (Sandylion) on yellow paper; tear edges. Adhere white title letter stickers (Creative Memories) to vellum squares; mount on page. Punch flowers (EK Success) and mini circles from purple and yellow paper; mount along title and at bottom of page with flower eyelets (Making Memories).

Heidi Schueller, Waukesha, Wisconsin

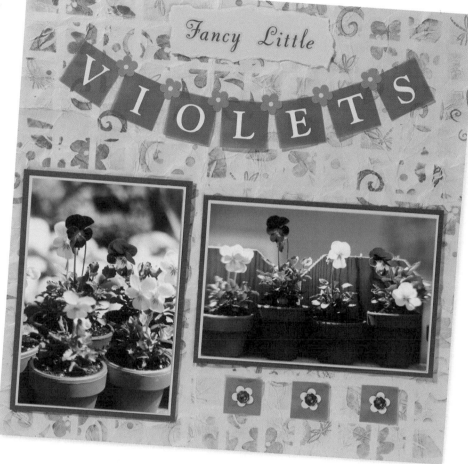

1 Crumple paper and then flatten. Using a ruler, make a tick mark at 1" intervals across the bottom of the paper. When finished, mark left and right sides of the paper in a similar manner, forming a grid.

2 Ink floral stamp pad with two different ink colors. Blot by stamping once on scrap paper.

3 Stamp image over masked squares. To avoid an overpowering image, stamp cardstock three or four times before re-inking.

4 Lightly dust stamped cardstock with chalk. Gently wipe one time with fingers or cotton ball. Remove masking tape to reveal stamped image. Erase tick marks and finish layout.

Happy Last Day of School

A variety of type fonts arranged on layers of complementary-colored papers provides visual interest to Oksanna's layout. Layer green patterned paper (Carolee's Creations) over yellow cardstock. Silhouette cut preprinted title (Carolee's Creations); mount with patterned paper frame (Carolee's Creations) over background with photo at center. Print partial title on yellow cardstock; cut to size and trim with decorative scissors (Fiskars). Detail curved edges with dimensional fabric paint (Duncan); double mat. Write partial title with marker on yellow paper scrap; double mat. Die cut letters (EZ2Cut) for balance of title from blue cardstock; outline with black fine-tip pen. Punch daisies (Fiskars) from yellow cardstock; mount gems at centers before layering on title letters.

Oksanna Pope, Los Gatos, California

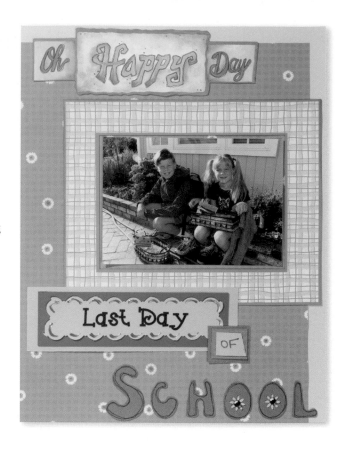

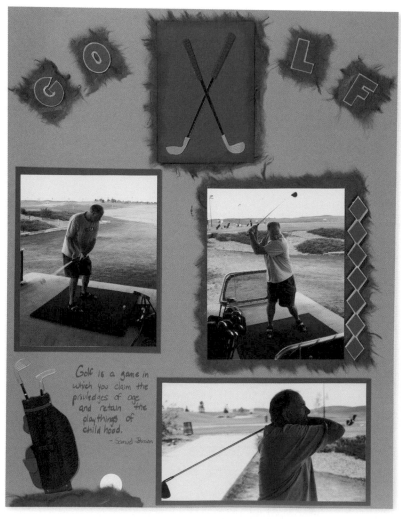

Golf

The sophisticated essence of the timeless game of golf is featured on Kelli's three-dimensional embellishment-filled page. Mat photos on solid-colored cardstock and torn mulberry paper (Paper Adventures); mount on solid-colored background. Punch diamond shapes from navy blue cardstock; mount end-to-end on silver metallic cardstock; silhouette cut. Mount with self-adhesive foam spacers on torn mulberry photo mat. Adhere premade golf club stickers (EK Success) on navy blue cardstock. Detail with black chalk around edges; mat on torn mulberry paper. Punch title letters (EK Success) from navy blue cardstock; mat on silver metallic cardstock and silhouette cut. Layer letters on torn pieces of mulberry paper; mount on page with self-adhesive foam spacers. Adhere golf bag and golf ball stickers at bottom of page under torn mul-berry paper strip. Complete page with journaling.

Kelli Noto, Centennial, Colorado

Kindergarten Graduation

Kelli's visually dramatic presentation of her son's graduation portrait is bordered with striking stamped and embossed letters. Stamp large title letters with gold ink along side of page. Write balance of title along top of page with gold embossing pen. Mount strips of heavy double-sided tape (Suze Weinberg) around title words. Sprinkle written words, stamped letters and double-sided tape with gold ultra thick embossing enamel (RANGER, Suze Weinberg); set with heat embossing gun. Single and double mat photos on gold metallic cardstock and vellum. Print journaling onto metallic vellum; mat and mount on page with self-adhesive foam spacers. Adhere strips of heavy double-sided tape on metallic vellum rectangle; sprinkle with black embossing enamel. Set with heat embossing gun. Mount graduation cap and gown (EK Success) on metallic vellum.

Kelli Noto, Centennial, Colorado

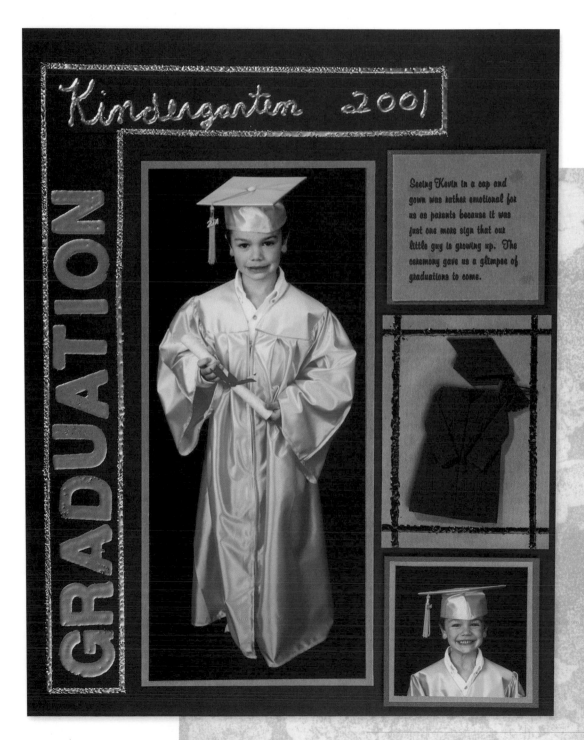

SUMMER

by Lois Duncan

The wealth of summer
Is dreamer's gold.
For so short a time
It is ours to hold—
Gold in the meadow,
Gold by the stream,
Riches enough for
a miser's dream.

Golden currency,
Ours to spend,
And here, where the sun
Warmed grasses bend,
A golden mattress
On which to lie
As the sun sinks low
In a golden sky.

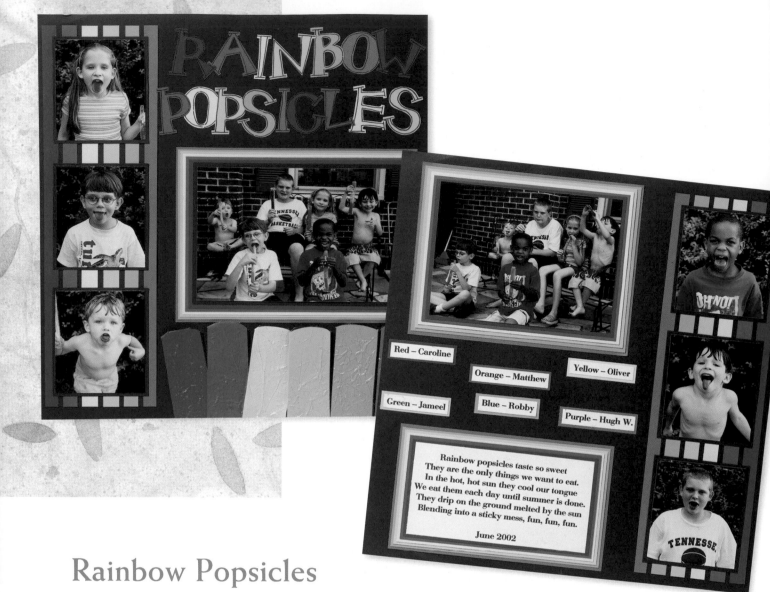

Rainbow Popsicles

Shannon's cleverly wrapped "popsicles" make for a vibrant and colorful addition along the bottom of her layout. Slice ½" strips of cardstock in six colors; mount ⅛" apart. Print journaling and names onto white cardstock; cut to size. Mat photos and journaling six times on colored cardstocks. Cut title letters from template (EK Success) in a variety of colors; outline with black fine-tip pen. Cut names to size; mat on colored cardstocks. Make "popsicles" by slicing 1¼" strips of colored cardstock, rounding edges at one end. Wrap slices with crumpled page protectors to resemble popsicle packaging; mount plastic at back of strip, then layer on bottom of page .

Shannon Taylor, Bristol, Tennessee

Warning! Not for Adult Use

Sandra's graphic, bold layout tells the humorous story of a slip-and-slide adventure gone wrong. Print title and journaling on yellow cardstock. Slice ⅜" and ¾" strips of red cardstock; mount at top and bottom of page. Cut a 7¾ x 12" piece of red cardstock; mount below title. Mount photos on yellow cardstock; tear bottom edge of matting. Mount red buttons on torn matting.

Sandra Stephens, Eden Prairie, Minnesota

Summertime Nicole

Linda captures the sweet essence of inno-
cent childhood moments with handmade
and detailed daisies scattered among sepia-
toned snapshots. Tear edges of tan card-
stock; shade with brown chalk before
mounting on patterned background paper
(Debbie Mumm). Double mat photos;
layer on page. Cut title letters with tem-
plate (Cut-It-Up) from two shades of blue
cardstock. Shade letters with blue chalk
for dimension before mounting on blue
paper-torn strip. Freehand draw daisies on
yellow cardstock; silhouette cut. Outline
flower petals with yellow marker; shade
center of flower and inner part of petals
with brown chalk. Add pen details. Cut
center of flower from brown cardstock;
add texture with cut pieces of embroidery
threads glued to center of flower. Mount
flowers on page. Print journaling on
brown cardstock; tear edges and shade
with brown chalk. Mount flower charm
tied with embroidery thread under name.

Linda Cummings, Murfreesboro, Tennessee
Photos, Regina Robinson, Lebanon, Tennessee

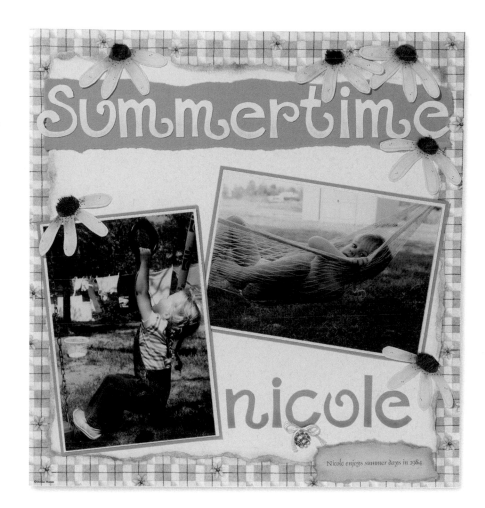

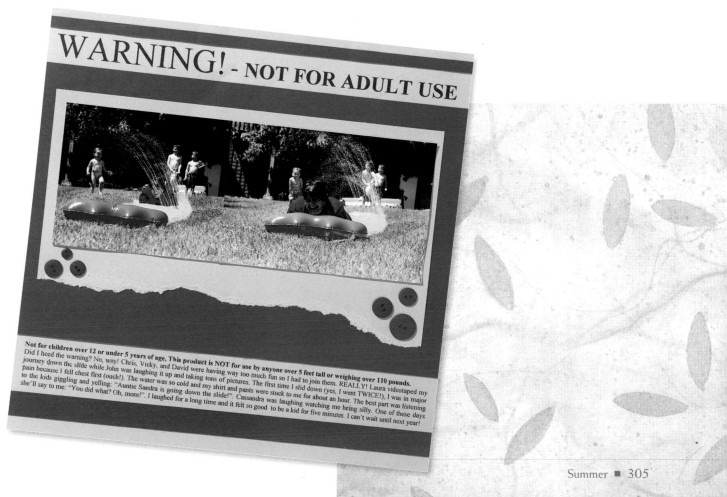

The Swing

Diana's desire to design a charming page with an old-fashioned look is achieved by using paper and embellishments that complement the sepia-toned photos. Double mat patterned background paper (Karen Foster Design) with patterned paper (Creative Imaginations) mounted on solid paper with eyelets. Print large photo with title; mount on page; detail at corners with fiber stitches (EK Success). Use square punch for small photo images. Distress edges of tags (Avery) with scissors and detail with brown colored pencil for antiqued look. Mount photos and buttons on tags. Tie with fibers; dangle from eyelets attached to matted photo. Print poem on tag; add chalk detail and distress edges for antiqued look. Mount wooden buttons and tie with fiber before mounting on page.

Diana Graham, Barrington, Illinois

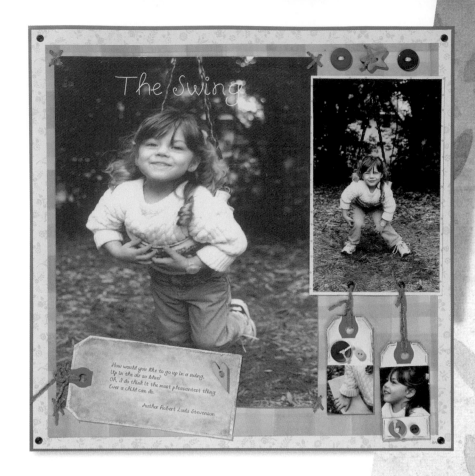

Fishing Dad

Jodi hand-tied flies to lend an authentic feel to her page, which reflects her father's love for fly fishing. Stamp and clear emboss background landscape design with a variety of stamped designs (PSX Design, Coronado Island Stamping, Stampscapes). Slice two strips of solid-colored paper; attach small brads. Mount net on left side of layout, wrapping around and securing to back of page with glue dots. Mount hand-tied flies to ovals cut using a template or oval cutter. Cut oval frames; mat and mount with foam tape for a dimensional effect. Stamp and emboss fish (PSX Design) and title letters (Plaid); silhouette cut. Punch small holes at mouth of fish; attach wire through holes. Triple mat photo. Dangle wired fish from small brads mounted on third photo mat; secure fish with self-adhesive foam spacers. Print journaling onto vellum. Cut to size and mount on page with small brads.

Jodi Amidei, Memory Makers

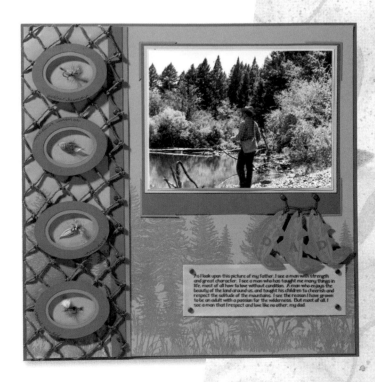

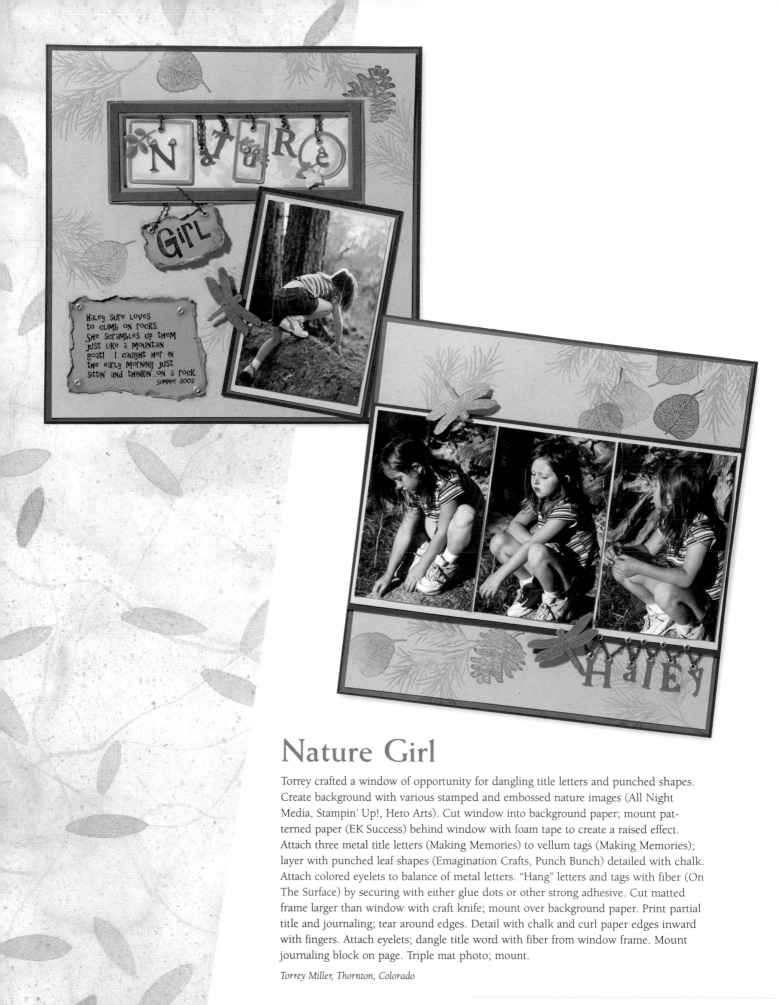

Nature Girl

Torrey crafted a window of opportunity for dangling title letters and punched shapes. Create background with various stamped and embossed nature images (All Night Media, Stampin' Up!, Hero Arts). Cut window into background paper; mount patterned paper (EK Success) behind window with foam tape to create a raised effect. Attach three metal title letters (Making Memories) to vellum tags (Making Memories); layer with punched leaf shapes (Emagination Crafts, Punch Bunch) detailed with chalk. Attach colored eyelets to balance of metal letters. "Hang" letters and tags with fiber (On The Surface) by securing with either glue dots or other strong adhesive. Cut matted frame larger than window with craft knife; mount over background paper. Print partial title and journaling; tear around edges. Detail with chalk and curl paper edges inward with fingers. Attach eyelets; dangle title word with fiber from window frame. Mount journaling block on page. Triple mat photo; mount.

Torrey Miller, Thornton, Colorado

Lazy Summer Days

Serendipity squares, crafted from collaged strips of patterned paper, make for a visually interesting border. Tear two 1" strips of gold metallic cardstock; mount at top and bottom of page. Layer patterned paper (Keeping Memories Alive, Hot Off the Press, Paper Adventures) strips on a large piece of teal cardstock. Punch 1½" squares from collaged cardstock. Embellish squares with gold embroidery thread, sea-life charms and micro glass beads. Slice a 1⅛" strip from enlarged photo; cut strip into squares. Mount all photo pieces on tan cardstock. Double mat smaller photos together. Print title and journaling onto blue and tan cardstock. Silhouette cut large title word; cut smaller words to size and mat. Cut journaling block to size; slice a serendipity square into thirds and mount at top of journaling block. Assemble shaker box by cutting one 7⅝ x 2⅜" rectangle from patterned paper and one 7⅝ x 2⅜" rectangle from teal cardstock. Slice a 6¾ x 1¾" window into rectangle with craft knife. Cut a piece of clear, plastic sheet in the same size; mount behind window. Cut strips of self-adhesive foam spacer tape; mount along back of window frame. Add broken seashells and micro glass beads; seal with last strip of foam tape. Mount silhouette cut title word and squares on top of shaker box.

Antuanette Wheeler, Center Hill, Florida

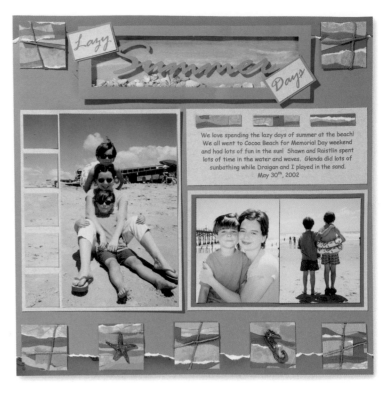

Endless Beauty

Brooke's shaker box holds tiny treasures from the sea, highlighting realistic details from photos. Tear two shades of tan cardstock; chalk. Mount the lighter cardstock at the bottom of a blue cardstock background. Slice curved triangle into corners of darker tan cardstock with a craft knife. Cut page protector, or other plastic sheet, large enough to cover window; mount at back of cardstock window. Cut strips of self-adhesive foam tape; adhere behind two sides of the window. Fill with small shells; seal with another piece of foam tape. Double mat photos; paper tear edges of second matting before mounting on page. Print title and journaling on tan cardstock. Silhouette cut title; mount at top of page. Cut journaling to size; mount on photo. Mount metallic fibers (On the Fringe) on second matting of large photo. Randomly glue small seed beads on title, matting and torn strips.

Brooke Smith, Anchorage, Alaska

Sweet Taste

Heidi's creative collection of colored glass pebbles and title fonts is assembled on a delightful layout that celebrates summer. Slice a 2½" strip of magenta cardstock at top of page; mount on dark blue background cardstock. Cut five 1¾" squares from white cardstock; mat on yellow cardstock and mount on border strip. Arrange colored glass and word pebbles (The Beadery) on squares. Mount with a strong adhesive. Outline squares with fuzzy fibers (Magic Scraps). Mat photos; outline smaller photos with fuzzy fibers. Print title on a variety of colored cardstocks. Cut words to size; piece together to form one large text block. Print journaling on purple cardstock, leaving room for embellishment at top. Cut to size; attach purple flower eyelets. String letter beads on fiber; mount through eyelets and secure at back of cardstock before mounting on page.

Heidi Schueller, Waukesha, Wisconsin

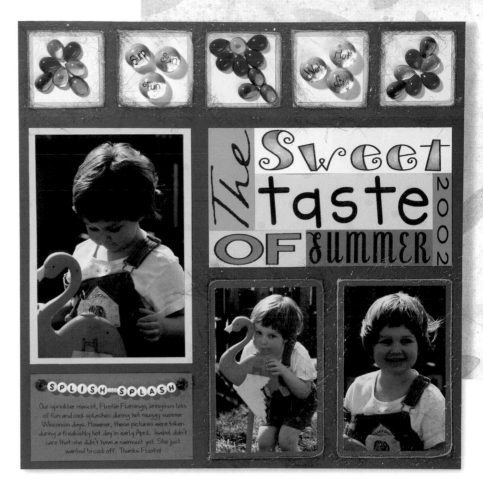

The View From the Porch

Pam memorializes favorite moments spent rocking on her front porch with conversational journaling and a refreshing glass of lemonade. Triple mat yellow patterned paper (Doodlebug Design) for background. Mount photos on matted background. Print title and journaling on vellum; cut oval into vellum before mounting on page. Assemble laser die cut glass of lemonade (Deluxe Cuts); mount over vellum.

Pam Easley, Bentonia, Mississippi

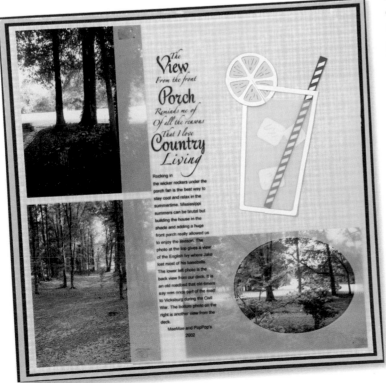

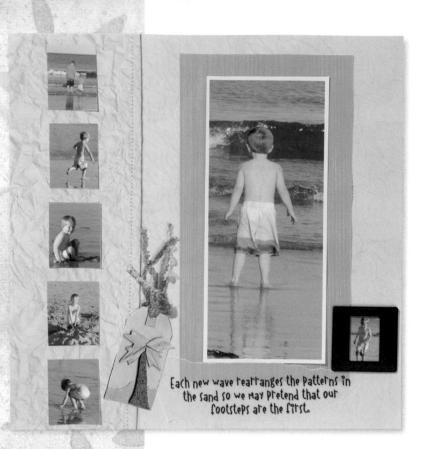

Each New Wave

A succession of small snapshots creates a slide show effect highlighting a fun day of frolicking on the beach. Crop photos to 1½ x 2"; mount in a vertical row on patterned paper (EK Success). Mat large photo on blue patterned paper (Two Busy Moms). Print journaling on vellum; paper tear around edges and layer at bottom of page. Cut pre-printed tag (EK Success); tie with fibers (Making Memories) before mounting on page. Mount smallest photo under plastic slide (Pakon).

Martha Crowther, Salem, New Hampshire

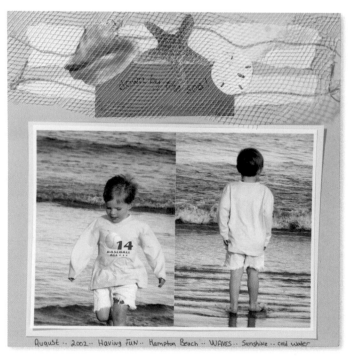

Down By the Sea

Photo die cuts, twine and netting bring images of the ocean to life on Martha's textured title block. Tear two strips of yellow cardstock; mount horizontally over light blue cardstock. Layer twine, title and photo die cuts (Ivy Cottage, Paper House Productions) over torn paper strips. Mount plastic netting over layers with glue dots. Mat two enlarged photos together on yellow cardstock; mount on page. Journal.

Martha Crowther, Salem, New Hampshire

Sandcastles

Martha's choice of imaged paper, torn and layered underneath an enlarged photo conjures images of soft sand between your toes. Diagonally tear photo paper; layer over solid background paper. Mat enlarged photo on yellow cardstock; mount inset photo at upper left corner with self-adhesive foam spacers. Attach fibers (Making Memories) around edges of matting with glue dots. Crop smaller photos; layer on page. Tie fibers to metal clips; attach to photos. Punch hole at top left corner of die cut (Ivy Cottage); tie fibers and mount on page.

Martha Crowther, Salem, New Hampshire

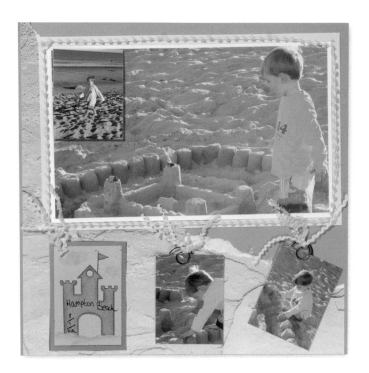

Mr. Sandman

A soft, textured background accented with eclectic details complements Martha's enlarged photo of her son romping in the sand. Texture green background by gently crumpling cardstock; flatten. Mat enlarged photo on light blue cardstock; mount on page. Print title on vellum; tear to size and mount. Cut preprinted tags (EK Success) to size; punch holes at top and tie fibers (Making Memories). Complete page with a collection of mounted fibers, sea glass and shells at lower right-hand photo corner.

Martha Crowther, Salem, New Hampshire

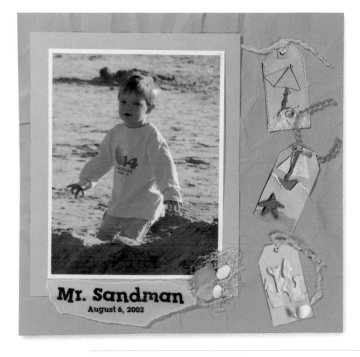

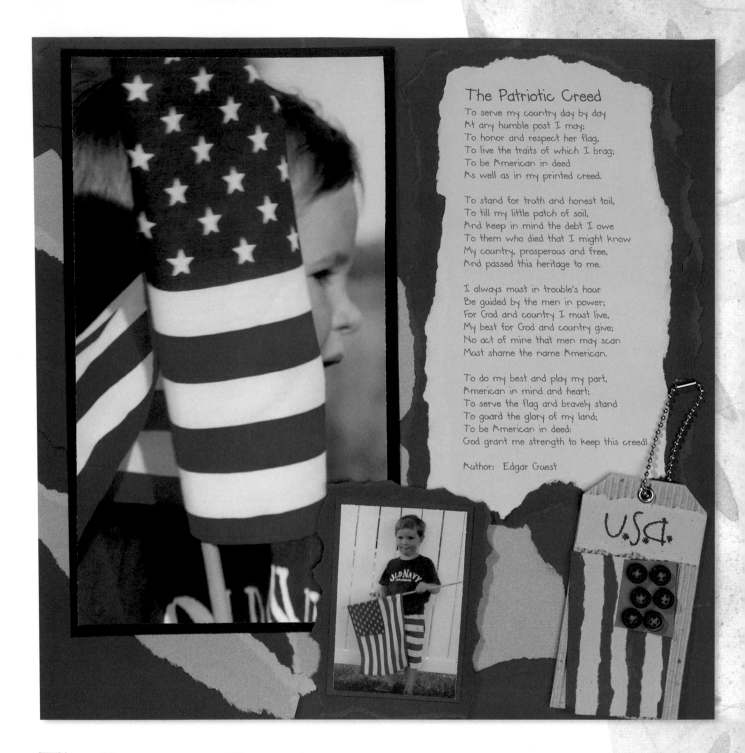

The Patriotic Creed

To serve my country day by day
At any humble post I may;
To honor and respect her flag,
To live the traits of which I brag;
To be American in deed
As well as in my printed creed.

To stand for truth and honest toil,
To till my little patch of soil,
And keep in mind the debt I owe
To them who died that I might know
My country, prosperous and free,
And passed this heritage to me.

I always must in trouble's hour
Be guided by the men in power;
For God and country I must live,
My best for God and country give;
No act of mine that men may scan
Must shame the name American.

To do my best and play my part,
American in mind and heart;
To serve the flag and bravely stand
To guard the glory of my land;
To be American in deed:
God grant me strength to keep this creed!

Author: Edgar Guest

The Patriotic Creed

Martha's soft paper-torn background is a nice contrast to the sharp, striking lines of the American flag. Tear strips of navy blue, tan and red cardstocks; collage and layer over red cardstock background. Mat enlarged photo on navy blue cardstock. Double mat smaller photo; paper tear edges of second mat. Print poem on tan cardstock; tear edges. Mat on navy cardstock; paper tear edges before mounting on page. Mount pre-made patriotic tag (EK Success) to complete page.

Martha Crowther, Salem, New Hampshire

Free to Be Just Anna

Pam builds on the theme of freedom by capturing her daughter's unabashed antics on patriotic paper. Tear edges of 12 x 12" vellum for both pages; layer over patterned paper (K & Company.) Double mat large photo on solid and patterned paper; attach star eyelets (Happy Hammer) around second matting. Mount photos on right hand page. Print title, journaling and descriptive words on vellum. Tear all to size; mount title words to page with small brads. Mount descriptive words on photos and journaling with clear vellum tape. String letter (Darice) and metallic beads on copper wire; curl edges into swirls to hold beads in place; mount on page with glue dots.

Pam Easley, Bentonia, Mississippi

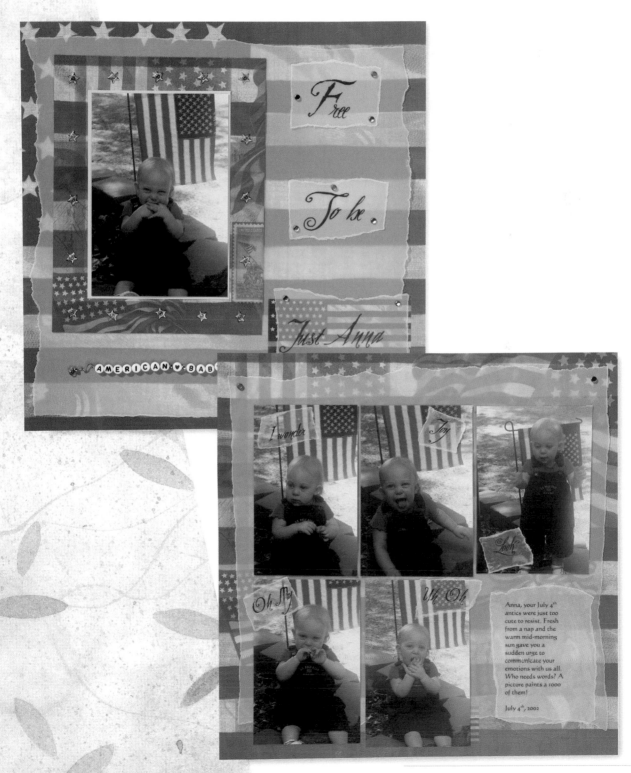

The Summer That Kevin Didn't Play Ball

Kelli's sharp attention to detail turns ordinary strips of cardstock into nostalgic artwork. To create "antiqued" paper baseball border see the instructions below. Print title and journaling on "antiqued" paper. Slice strip from title block; pierce holes and lace like border. Cut dialogue journaling to size; mat on black cardstock. Mat photos on black and "antiqued" cardstock; mount.

Kelli Noto, Centennial, Colorado

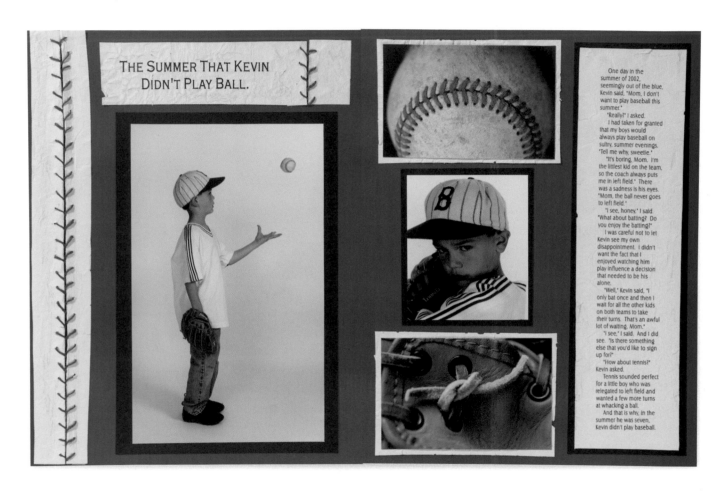

THE SUMMER THAT KEVIN DIDN'T PLAY BALL.

One day in the summer of 2002, seemingly out of the blue, Kevin said, "Mom, I don't want to play baseball this summer."

"Really?" I asked.

I had taken for granted that my boys would always play baseball on sultry, summer evenings. "Tell me why, sweetie."

"It's boring, Mom. I'm the littlest kid on the team, so the coach always puts me in left field." There was a sadness is his eyes. "Mom, the ball never goes to left field."

"I see, honey," I said. "What about batting? Do you enjoy the batting?"

I was careful not to let Kevin see my own disappointment. I didn't want the fact that I enjoyed watching him play influence a decision that needed to be his alone.

"Well," Kevin said, "I only bat once and then I wait for all the other kids on both teams to take their turns. That's an awful lot of waiting, Mom."

"I see," I said. And I did see. "Is there something else that you'd like to sign up for?"

"How about tennis?" Kevin asked.

Tennis sounded perfect for a little boy who was relegated to left field and wanted a few more turns at whacking a ball.

And that is why, in the summer he was seven, Kevin didn't play baseball.

1 Lightly spray a cream-colored paper strip with water and crumple. Gently flatten.

2 Iron crumpled paper strip with steam iron. Brush lightly with brown chalk to add definition. Edges should tear slightly or soften as you flatten out the strip.

3 Fold ¼" of the paper strip under and punch holes every ½" along this folded edge with a paper piercing tool or needle.

Challengers Baseball

Janice photojournals a delightful activity enjoyed by her special-needs son over the summer. Double mat three photos on white cardstock; mount at top of left page and bottom of right page. Single mat other photos. Print journaling on tan paper; cut to size. Detail edges with brown chalk and black fine-tip pen. Layer over preprinted die-cut baseball (EK Success). Print title; silhouette cut and mount on left page. Mount die-cut baseball hat (EK Success) under title.

Janice Carson, Hamilton, Ontario, Canada

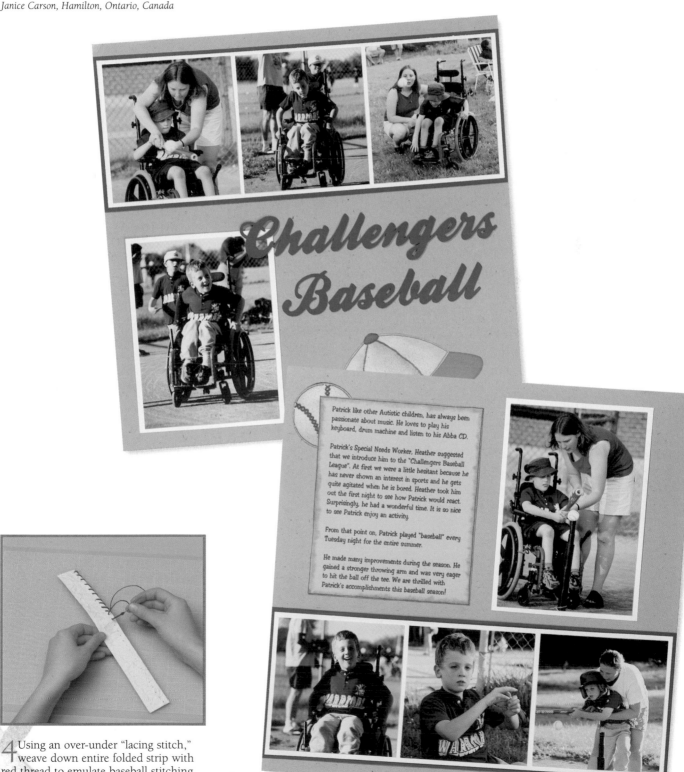

Patrick like other Autistic children, has always been passionate about music. He loves to play his keyboard, drum machine and listen to his Abba CD.

Patrick's Special Needs Worker, Heather suggested that we introduce him to the "Challengers Baseball League". At first we were a little hesitant because he has never shown an interest in sports and he gets quite agitated when he is bored. Heather took him out the first night to see how Patrick would react. Surprisingly, he had a wonderful time. It is so nice to see Patrick enjoy an activity.

From that point on, Patrick played "baseball" every Tuesday night for the entire summer.

He made many improvements during the season. He gained a stronger throwing arm and was very eager to hit the ball off the tee. We are thrilled with Patrick's accomplishments this baseball season!

4 Using an over-under "lacing stitch," weave down entire folded strip with red thread to emulate baseball stitching. Create right and left-sided borders. Mount toget-her down the left side of page.

Special Daddy Moments

Oksanna captures a treasured moment between father and daughter with torn vellum and punched embellishments. Double mat photo on burgundy vellum and green handmade (DMD) paper. Dot matting edges with gold dimensional fabric paint (Duncan). Mount on patterned background paper (Design Originals). Print title and journaling on vellum. Cut journaling to size; mat on tan cardstock before layering over green paper and burgundy vellum rectangles. Punch fern leaves (Punch Bunch) from light green cardstock; mount around upper left edges of matted journaling. Cut large title letter using template (C-Thru Ruler) from vellum; outline with black fine-tip pen. Layer large letter, title block and tan cardstock square and mount on page. Tear vellum pieces in graduated circle shapes; stamp swirl design (All Night Media) on smallest piece. Mount layered pieces together with small gold brad. Layer at corners with punched fern leaves.

Oksanna Pope, Los Gatos, California

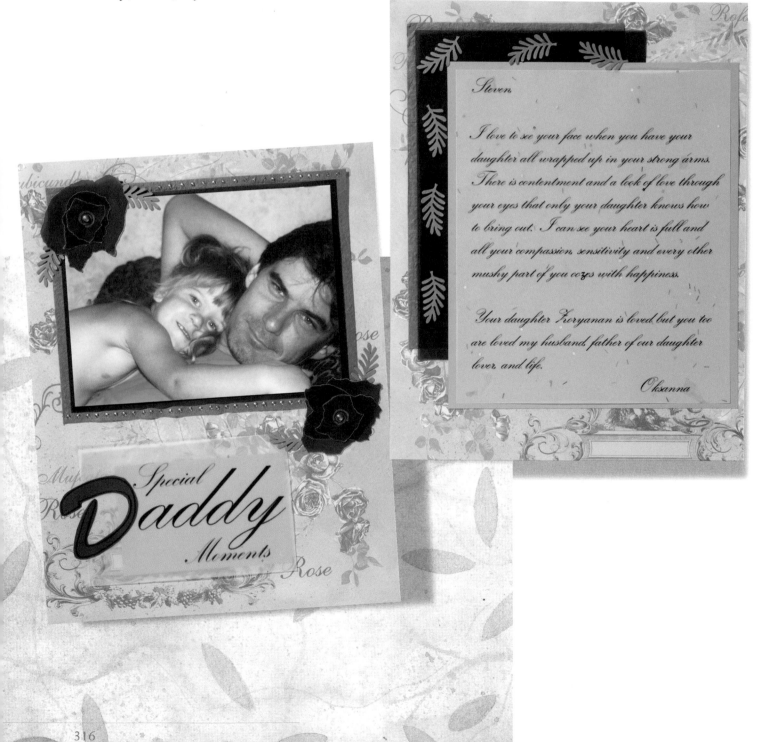

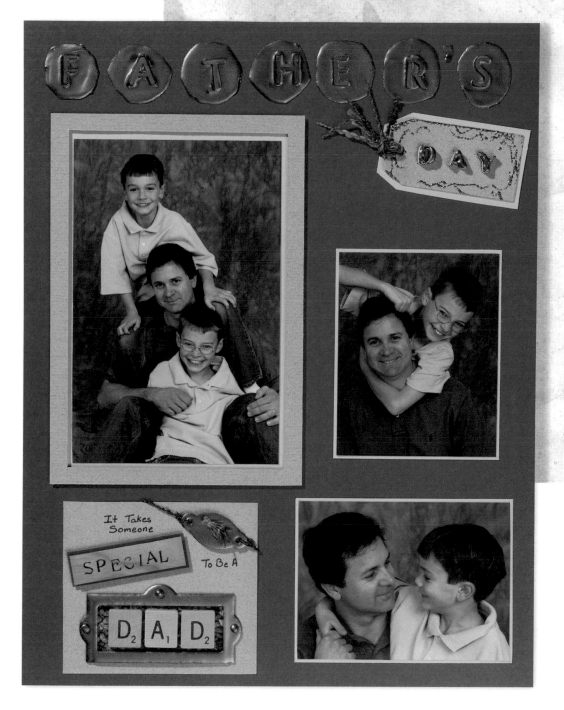

Father's Day

Title letters imprinted in thick copper embossing enamel (Ranger) make for an impressive masculine title. Cut circles from two-sided thick tape (Suze Weinberg); sprinkle with copper ultra thick embossing enamel (Ranger). Set with heat embossing gun; Repeat 2-3 times. When last layer is still warm, press letter stamps (Hero Arts) into enamel. Mat photos on tan cardstock. Cut frame for large photo from light green cardstock; slice window slightly larger than matted photo. Mount with self-adhesive foam tape. Freehand cut tag; mat and silhouette cut. Emboss self-adhesive foam spacer letters and edges of tag with copper embossing enamel. Cut square from green cardstock for embellished journaling. Tie fibers (On The Surface) to copper tag (Anima Designs); mount fishing fly to tag. Stamp letters (Hero Arts) on small piece of wood veneer; mat on green cardstock. Cut patterned paper (Paper Garden) to fit behind copper bookplate (Anima Designs); mount tile letters (Hasbro) in bookplate window.

Kelli Noto, Centennial, Colorado

Summer Barbecue

Dana knows summer just wouldn't be the same without family barbecues, watermelon and...ants! Double mat photos on patterned (Frances Meyer) and solid papers; layer on page. Freehand draw ant and line border with red and black fine-tip pens. Print title words on red cardstock and journaling on white cardstock. Freehand cut red cardstock with title words into watermelon slice shapes; double mat on white and green cardstocks. Draw seed details with fine-tip black pen. Freehand craft small watermelon slices in same manner; mount on photos with journaling. Cut journaling block to size and mat; adhere ant stickers (Mrs. Grossman's).

Dana Forti, Claremont, California

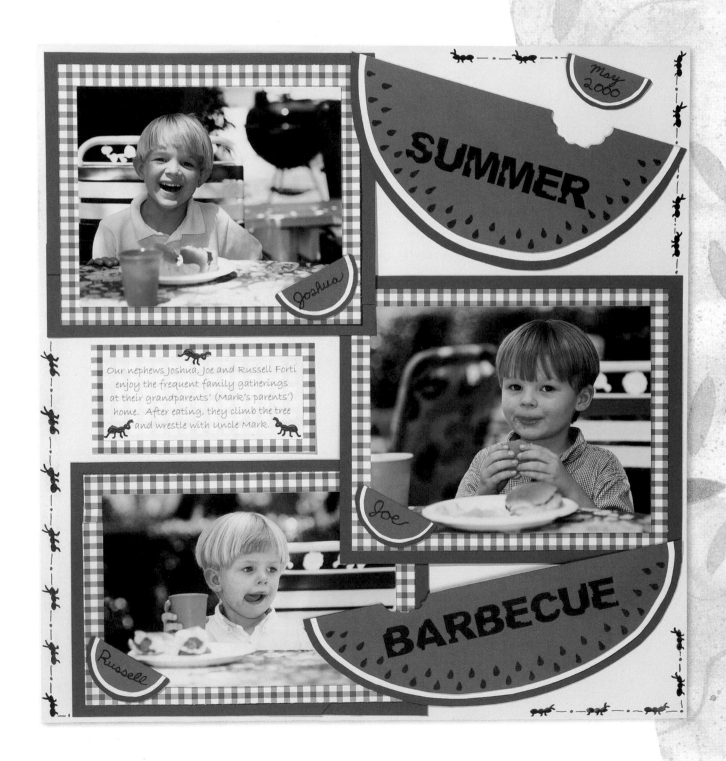

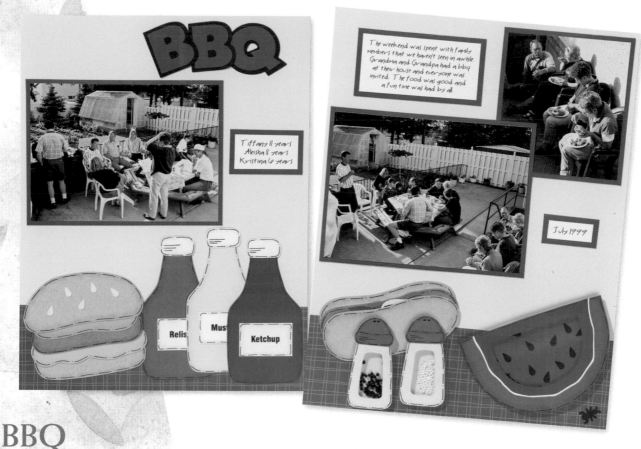

BBQ

Original paper-pieced and shaker box food and condiments add a touch of whimsy to Karen's BBQ table. Slice two 2½" strips of patterned paper (Scrapbook Sally); mount along page bottom as tablecloth. Enlarge patterns, found on page 345, for paper-pieced food and condiments. Trace patterns onto appropriate colors of cardstock, cut out and layer into designs. Add chalk and pen line details to finished pieces. To create salt and pepper shakers and watermelon follow the directions below. Print journaling; cut to size. Mat photos and journaling on red cardstock. Die cut shadow title letters (Sizzix) from red and black cardstocks; layer and mount. Punch small ant (EK Success); mount.

Karen Cobb, Victoria, British Columbia, Canada

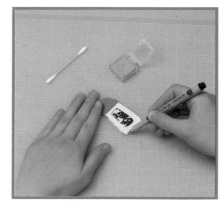

1 Double cut pattern pieces (page 345) for salt/pepper shakers and watermelon. Slice windows into one set of salt/pepper shakers and watermelon with craft knife. Leave second set uncut. From a plastic sheet or page protector cut one pattern of each piece

2 Mount cut plastic sheet or page protector to back of window. Cut self-adhesive foam tape; adhere to all sides.

3 Fill salt and pepper shakers with white and black seed beads. Fill watermelon with punched teardrop shapes. Seal shaker boxes by placing back piece on top of foam adhesive. Turn over and attach to page.

Some Things Money Can't Buy...

Alison highlights the "treasures" in her life with a clean and simple layout adorned with realistic coin photo stickers. Mat brown cardstock with black cardstock. Tear two strips of vellum, one wider than the other; mount on page. Print title/journaling on white cardstock; cut to size. Mat journaling and enlarged photo on tan cardstock before layering over wide torn vellum strip. Adhere coin stickers (Creative Imaginations) on matted journaling block. Crop smaller photos into 2⅛" squares; mat on tan cardstock and mount over thin, torn vellum strip.

Alison Beachem, San Diego, California

Scootin'

A combination of silver metallic fiber, paper, eyelets and brads reflects Dee's son's love for the "cool" sport of scootin'. Horizontally tear patterned bottom edge of vellum (Colorbök); mount with small silver brads. Attach silver eyelets to bottom of photos. Cut 5" pieces of metallic fibers (On the Fringe); loop through eyelets and adhere to backs of photos. Mount photos over patterned vellum. Print journaling on vellum; cut to size and mount with small black brads. Craft serendipity squares with collaged layers of glossy black cardstock, mul-berry paper, vellum, glitter and diamond glaze (JudiKins). Cut or punch seven 1½" squares from completed serendipity design; Mount. Cut title letters with template (Provo Craft) from silver metallic cardstock. Attach large silver eyelets to center of "O" letters. Attach small silver eyelets at top of each letter. Loop loose fiber ends through eyelets; adhere on backs of letters. Mount letters atop serendipity squares.

Dee Gallimore-Perry, Griswold, Connecticut

Hearts Rock

Mary Anne features a special family tradition with dimensionally accented photos alongside theme-appropriate die cuts. Slice two 3½" wide strips of red cardstock and two ½" wide strips of brown cardstock. Layer on page as top and bottom borders. Print titles on ivory and black cardstocks; print journaling on white cardstock. Silhouette cut title word on ivory cardstock. Cut title letters on black cardstock into retro-looking squares. Mount preprinted die-cut images (EK Success) on border strips. Using a craft knife, slice out photo detail to be highlighted. Mat on cardstock and silhouette cut; remount on photo, covering area that was cut. Mat photo on red cardstock. Triple mat large photo; tear mulberry paper (Paper Adventures) on third matting. Mount rock to page with wire.

Mary Anne Walters, Monk Sherborne, Tadley, UK

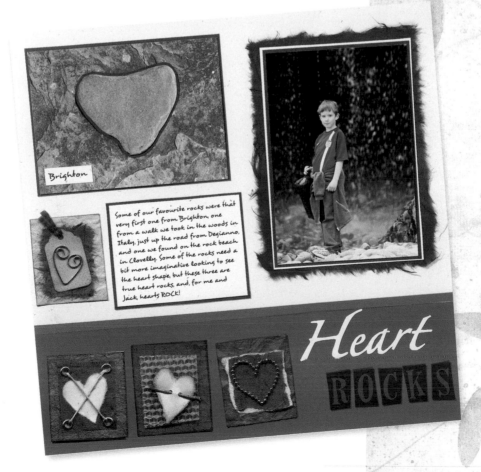

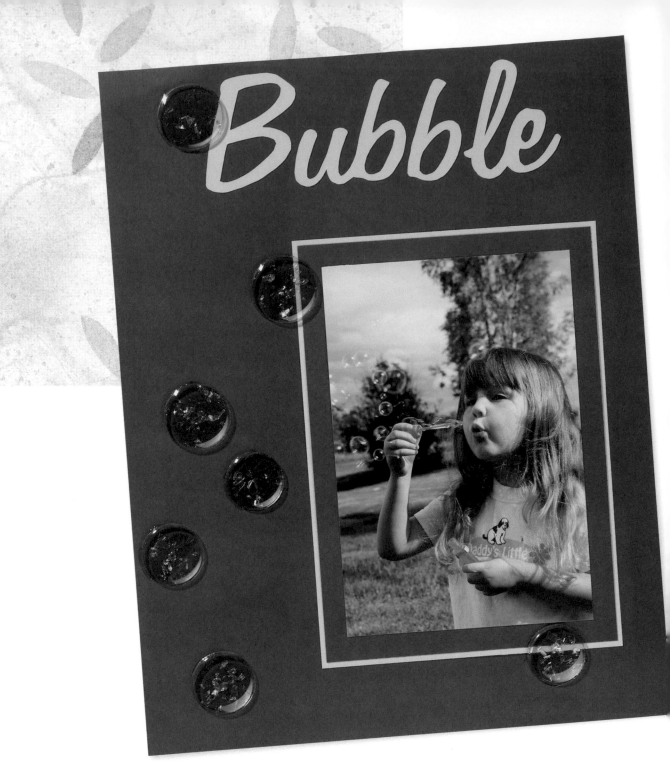

Bubble Blowing

Brooke captures realistic looking "bubbles" that are guaranteed not to pop or splatter on her pages! Create "bubbles" by following the instructions on the following page. Double mat photos. Print journaling on light blue cardstock before using as second mat for photos. Print title, silhouette cut with craft knife. Randomly mount "bubbles" on pages as shown.

Brooke Smith, Anchorage, Alaska

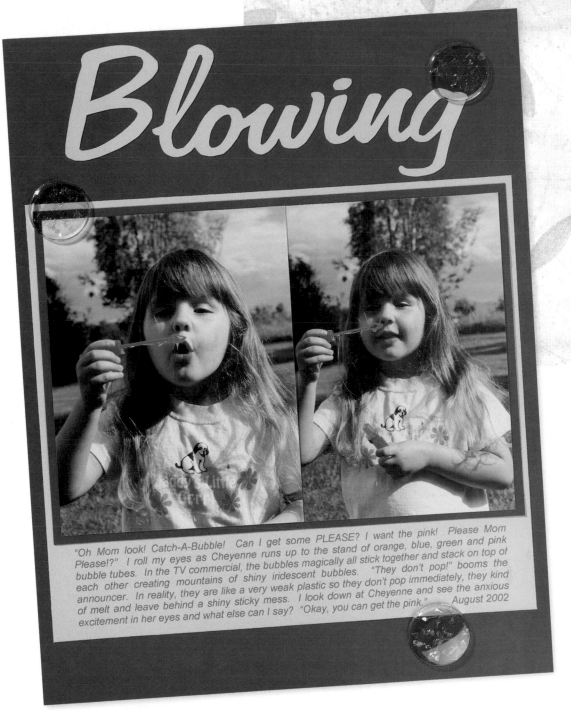

Blowing

"Oh Mom look! Catch-A-Bubble! Can I get some PLEASE? I want the pink! Please Mom Please!?" I roll my eyes as Cheyenne runs up to the stand of orange, blue, green and pink bubble tubes. In the TV commercial, the bubbles magically all stick together and stack on top of each other creating mountains of shiny iridescent bubbles. "They don't pop!" booms the announcer. In reality, they are like a very weak plastic so they don't pop immediately, they kind of melt and leave behind a shiny sticky mess. I look down at Cheyenne and see the anxious excitement in her eyes and what else can I say? "Okay, you can get the pink." August 2002

1 Draw circular shapes with crystal lacquer.

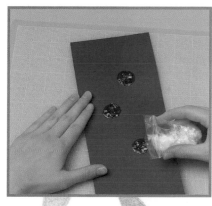

2 Sprinkle shaved ice into crystal lacquer circles.

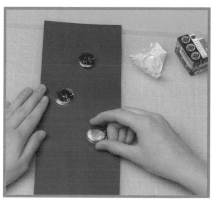

3 Cover top of crystal lacquer circles with plastic watch crystal.

FALL

by Lois Duncan

Up from the meadow a wind is blowing,

The wind we longed for the summer through.

The sky, which was gold and hot and glowing,

Is high above us and strangely blue.

There, where the apple tree was budding

Ready to bloom, we hear a sound

And turn to find it's an apple thudding

Heavy and hard to the sunbaked ground.

A line of geese sweeps up from the river,

Dry leaves crunch on the browning lawn.

We look at each other, surprised, and shiver,

And suddenly—swiftly—summer is gone.

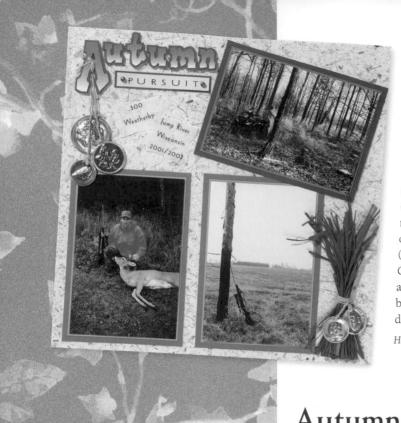

Autumn Pursuit

Unique stamped and embossed copper tags dangle on Heidi's rustic autumn layout. Double mat photos on solid-colored cardstocks; layer over textured patterned paper (source unknown). Print title and journaling on vellum and ivory cardstock. Silhouette cut title; mat on brown cardstock and silhouette cut again. Mount on page with self-adhesive foam spacers. Cut balance of title printed on cardstock to size, mat and mount on page with small copper brads. Paper tear journaling on vellum to size; mount under title. Stamp and emboss leaves (Hero Arts) onto light embossing copper (American Art Clay Co.). Cut into circles to fit tags (Avery). Tie with jute string; attach to first title letter. Create wheat stalk with colored raffia bunched together and tied with jute string. Attach copper tag designs to ends of jute string.

Heidi Schueller, Waukesha, Wisconsin

Autumn With Grandpa

Khristina collects memories of time spent with her grandfather like leaves on a lovely autumn day. Tear brown cardstock on all sides; brush edges with brown chalk and mount on tan cardstock. Brush brown chalk around edges of tan cardstock. Double and triple mat photos. Print title and poem on vellum, and journaling on tan cardstock. Paper tear edges around title and poem. Punch holes at top of title block; loop jute string through holes, tie in a knot and hang from twig. Mount twig with vellum attached on page over skeleton leaf (All Night Media). Mount poem over skeleton leaf on right-hand page. Freehand cut journaling into tag shape; mount leaf buttons (Jesse James) with glue dots and chalk around edges. Punch hole at top of tag and tie with fibers (On The Surface). Freehand cut smaller tags; punch hole and tie with fibers. Adhere leaf stickers (Mrs. Grossman's) over small patch of burlap mounted on tag.

Khristina Schuler, Oro Valley, Arizona

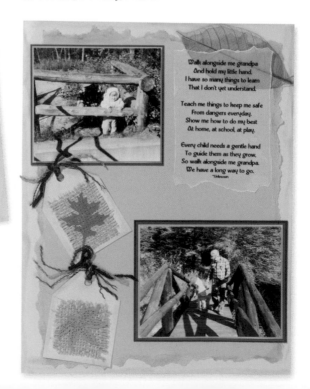

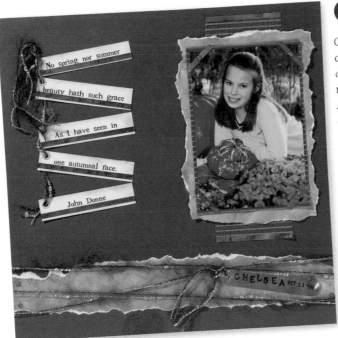

Chelsea

Gayla expresses adoration for her daughter with a sentimental quote embellished with soft fibers and colors. Print lines of text on white linen cardstock, leaving space to cut each line into rectangles. Cut to size; lightly rub brown chalk around edges. Adhere copper foil tape strip just under text. Attach large eyelets on each rectangle; weave fibers (Fibers by the Yard) through eyelets, linking pieces before mounting. Mat photo on mesh (Magenta) -covered cardstock. Cut four strips of copper foil tape; adhere diagonally at corners of photo; mount copper brad through all layers of matted photo. Mat again on torn patterned paper (Karen Foster Design) layered over a strip of mesh paper bordered with copper foil tape. Horizontally tear a 1½" strip of patterned paper; mount along bottom of page with small copper brads. Wrap page with fibers over paper-torn strip; attach copper tag (Anima Designs) with stamped name (Hero Arts) and date.

Gayla Feachen, Irving, Texas

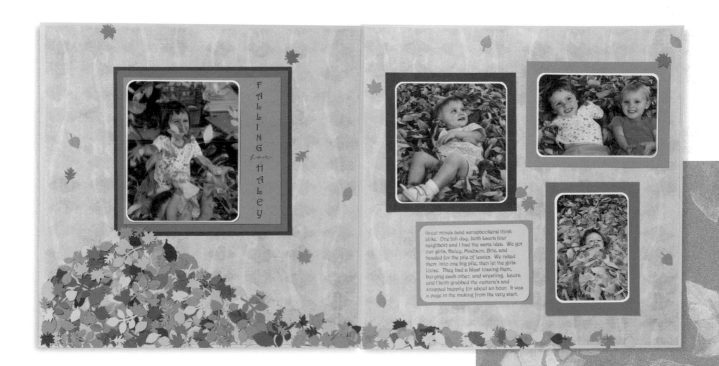

Falling for Haley

Jodi builds a soft pile of punched leaves in warm autumn colors and a variety of textured papers. Print title on brown cardstock and journaling on tan cardstock. Cut title to size as a photo mat. Quadruple mat photo using title mat as third matting. Crop remaining photos; round corners and double mat. Round corners on first matting. Cut journaling to size; round corners and mat. Punch a variety of leaf shapes (Emagination Crafts, Hyglo/American Pin, Punch Bunch) from cardstock, vellum and mulberry papers in shades of brown and green. Cut a tan paper strip to form hill shape. Run through self adhesive machine. Place on page, sticky side up. Mount leaves to fill pile; randomly scatter a few leaves among photos.

Jodi Amidei, Memory Makers

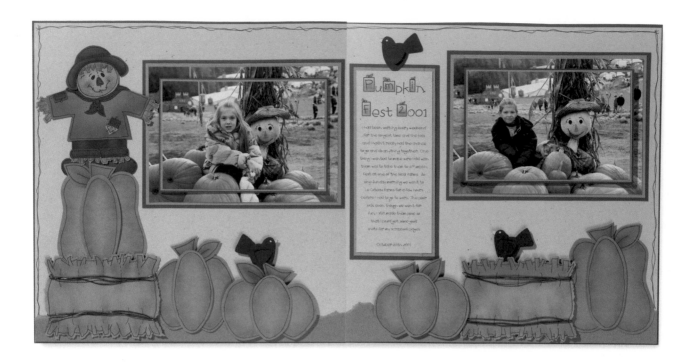

Pumpkin Fest

Trudy adds an interesting dimensional surprise to her layout with a secret flip-up photo flap. Mat tan cardstock with dark brown cardstock for background. Horizontally tear 1" green cardstock strips; mount along bottom of page. Draw border lines on side and top edges with brown fine-tip pen. Paper piece pumpkins, scarecrow, birds and hay bales (Naptime Scrap); add dimension with pen and chalk. Wrap hay bales with wire. Mount pumpkins, hay bales and birds with self-adhesive foam spacers. Craft flip-up photo flap on right-hand page by matting two photos on orange cardstock. Mat together on one piece of brown cardstock. Score a horizontal line between the two photos; fold on scored line. Mount a third matted photo on cover flap. Mount flip-up photo flap on double-matted enlarged photo with self-adhesive foam spacers. Double mat photo for left page; mount over enlarged double matted photo. Print journaling on tan cardstock; cut and double mat. Detail title with orange and green chalks.

Trudy Sigurdson, Victoria, British Columbia, Canada

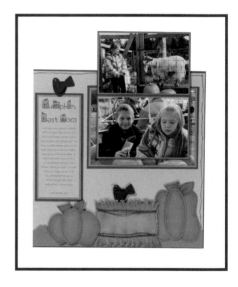

1 Cut out shapes using paper piecing patterns by Naptime Scrap. Use deckle-edged scissors for all straw pieces to create frayed look.

2 Chalk and do pen work to create outlines on paper pieces.

3 Assemble using self-adhesive foam spacers on pumpkin. Wire wrap to detail bale of hay.

Autumn

Copper-colored stamped and embossed foil leaves flutter among metallic fibers on Tammy's autumn-themed page. Double mat photos on brown and black cardstocks; layer on embossed copper-colored paper (K & Company). Print journaling on vellum and title letters on embossed cardstock (K & Company). Outline letters with gold gel pen; mat and silhouette cut. Trim journaling to size and mount on page with copper eyelets. Frame vellum with mounted metallic fibers as shown. Stamp leaves (Plaid) on copper colored foil paper (Embossing Arts); sprinkle with copper embossing powder. Set with heat gun. Silhouette cut shapes; layer atop metallic fibers. Mount title letters and leaf for letter "U" at top of page with self-adhesive foam spacers. Craft diamond-shaped foil embellishments by cutting long, thin triangles from foil paper. Roll "croissants"; randomly mount atop fibers.

Tammy Jackson, Spring Hill, Florida

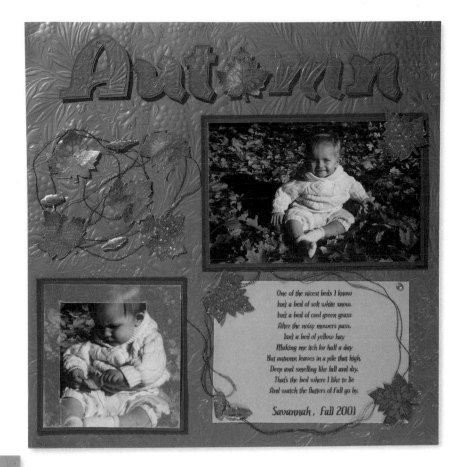

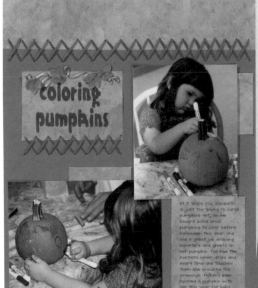

Coloring Pumpkins

Textural cross-stitching with multi-stranded embroidery floss lends a homey feeling to Kristen's page. Slice two 2" strips of patterned paper (Scrap in a Snap); mount at top of orange cardstock background. Lightly draw two horizontal pencil lines; one on patterned paper strip and the other on background cardstock for guidelines; add ticking marks every ½". Pierce holes with needle at ticking marks; erase pencil lines. Stitch cross-stitch design. Print title and journaling on patterned paper. Cut to size and mount on page. Crop photos; mount over patterned paper squares layered on background cardstock. Cut preprinted image (EK Success); mat on patterned paper. Embellish title block with stitching as described above. Twist and curl silver wire to resemble image on die cut. Punch leaves (EK Success) from green cardstock; detail with pen and chalks before mounting atop wire.

Kristen Swain, Bear, Delaware

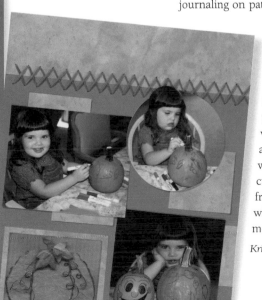

Some Mummy Loves You

Shannon has her page all "wrapped up" with a spooky textured background. Cut muslin strips; layer and mount on black cardstock. Triple mat photos on white and black cardstocks lightly brushed with black and white chalks. Print journaling on white cardstock; triple mat and brush with chalks. Write title on white cardstock; outline with black fine-tip pen. Mat on black cardstock and silhouette cut; mount at top of page. Complete page by randomly mounting plastic spiders.

Shannon Taylor, Bristol, Tennessee

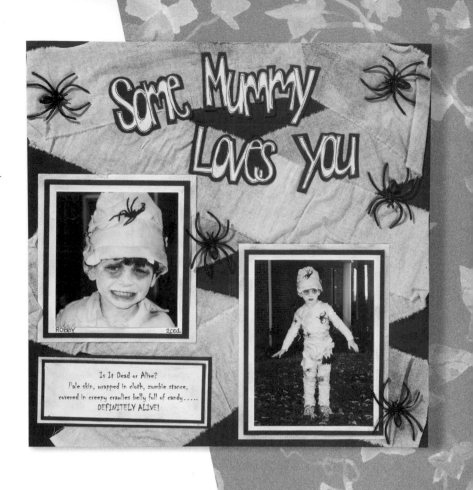

Halloween 1992

Karen's diverse use of a variety of fibers adds color, texture and visual interest to her Halloween page. Mat gray cardstock with black cardstock. Slice two 1¾" strips of purple cardstock; horizontally mount four strands of colored fibers and attach on back of strip. Mat strip with black cardstock. Mount fibered strips at top and bottom of page. Die cut title letters (Sizzix); outline with black fine-tip pen before mounting on fibers. Punch bats from two-sided tape; cover with black glitter. Mount on title letters. Print journaling and date on white cardstock; cut to size and mat. Die cut ghosts and pumpkins (Sizzix); outline shapes with black fine-tip pen and detail with glitter. Mat photo on black cardstock; pierce small holes at corners and along sides of matting with needle. Stitch border with orange embroidery thread; mount on page. Hand draw haunted house, tree and moon on solid-colored paper and cut out. Outline tree and moon with black fine-tip pen; detail with chalk over pen lines. Mount yellow vellum behind haunted house windows. Layer images on matted brown cardstock. Freehand cut date into arrow shape; outline with black fine-tip pen and detail with chalk around edges. Pierce small holes at bottom of arrow and top of matted haunted house scene; stitch together with black embroidery thread.

Karen Cobb, Victoria, British Columbia, Canada

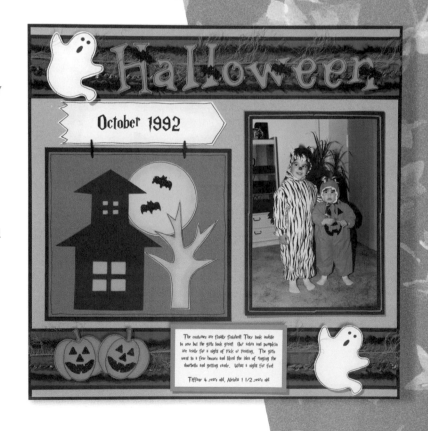

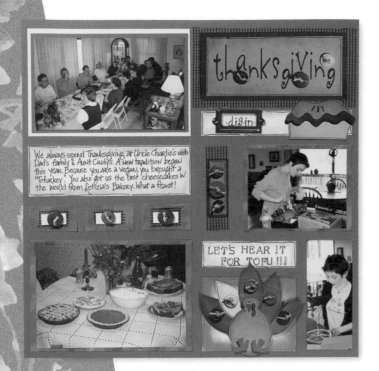

Vegan Thanksgiving

Lynne's comical approach to a vegan Thanksgiving is enhanced with colorful preprinted images and matching embellishments. Single and double mat photos on solid and patterned papers. Cut preprinted title and images (Kopp Design). Layer title block over mesh (Magic Mesh). Mount button images on mesh strip. Layer pie and metal frame (Anima Designs) on sliced strip of ivory cardstock detailed with black pen and brown chalk. Cut journal blocks from ivory cardstock; detail with pen and brown chalk. Stamp journaling quip with alphabet letters (Hero Arts). Tie threads on buttons; layer over punched rectangles, mesh and patterned paper pieces.

Lynne Rigazio Mau, Channahan, Illinois

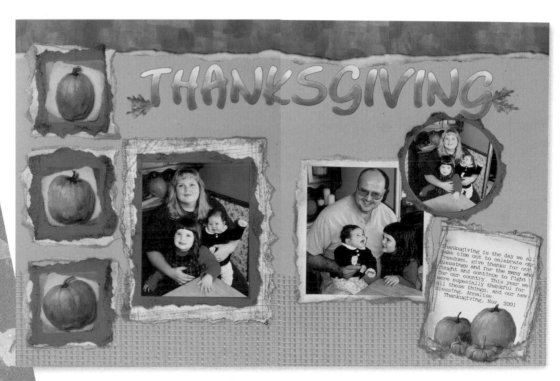

Thanksgiving

Kristen builds on the distressed look of the autumn-themed stickers with paper-torn matting detailed and distressed with chalk and ink. Adhere border sticker strips (Karen Foster Design) at top of solid-colored cardstock. Cut two 3" strips of mesh (Magic Mesh); mount at bottom of pages. Double mat pumpkin stickers (Karen Foster Design) on brown and ivory cardstocks; paper tear all edges. Press edges of matting on brown inkpad and brush edges with brown chalk. Single and double mat photos; paper tear all edges of matting. Distress mattings in similar fashion as matted stickers. Print journaling on ivory cardstock; distress. Adhere pumpkin stickers at bottom of journaling block. Cut title letters with template (Scrap Pagerz) on ivory cardstock. Shade with burgundy chalk, blending from light to dark. Adhere leaf stickers on title.

Kristen Swain, Bear, Delaware

Fall Fun

Textured leaves playfully settle on decorative borders. Tear tan cardstock strip for horizontal border on left-hand page; brush with brown chalk on torn edges. Punch leaves (Marvy/Uchida) from colored cardstocks and lightweight copper mesh (American Art Clay Co). Crumple cardstock leaves; brush with brown chalk. Layer over curled wire along torn border. For vertical border on right-hand page, layer punched, textured and chalked leaves on tags adorned with copper eyelets and twine. Dry emboss leaf design (Darice) onto copper foil (MetalWorks) as shown below. Cut to size; layer over torn cardstock square before mounting on tag. Detail tags with chalk and pen before layering on page. Crop and slice segments into photos before matting on torn tags, cardstock and copper mesh. Detail photo tags and photo mats with pen outline. Add copper brads and wire to one photo mat. Cut title using template from green and brown cardstocks. Layer one word over dry-embossed leaf designs in copper foil. Mount over textured cardstock leaves on red torn cardstock strip; mat on tan cardstock. Outline second title word with black fine-tip pen.

Stacey Bohmer, Monroe, Michigan

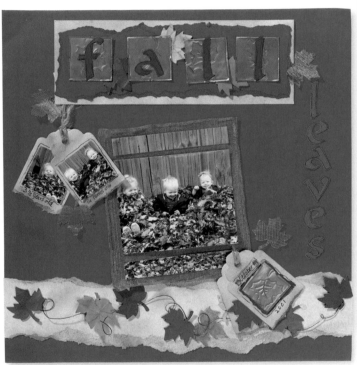

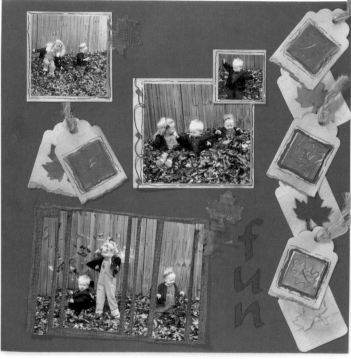

1 Punch out squares from light copper metal.

2 Using stylus, mouse pad and brass template; trace design into metal. Freehand draw veins and other details on each leaf.

3 Freehand draw a line around the square to add detail and dimension.

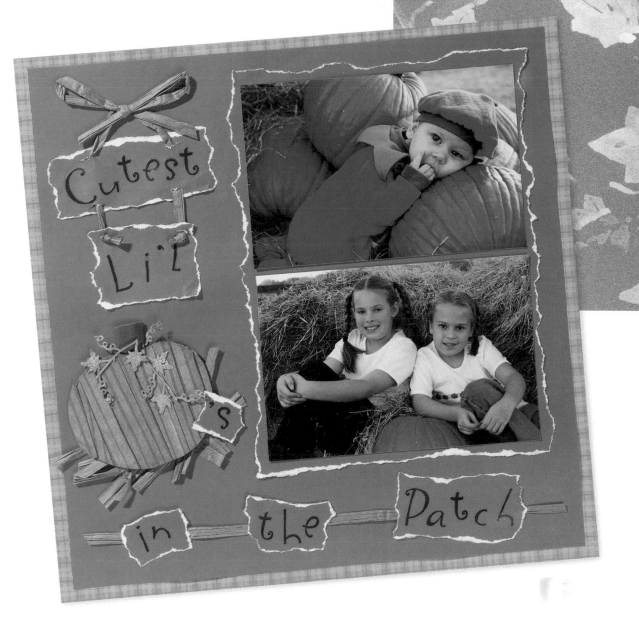

Cutest Li'l Pumpkins in the Patch

A dimensional paper-pieced pumpkin replaces a key word in the title of Gayla's fall layout. Double mat orange paper on patterned (Mustard Moon) and solid papers for background. Mat photos on orange paper; tear around edges. Adhere letter stickers (Colorbök) to scraps of orange paper with paper-torn edges. Slice slits in title blocks with craft knife; attach raffia and tie in a bow. Craft pumpkin with rolled patterned (Mustard Moon) paper strips. Slice strips of paper just longer than pumpkin shape about 1½" wide; roll tight and flatten with fingers. Mount on die-cut or freehand-drawn pumpkin shape; trim excess off around edges. Handcut stem from brown paper; brush brown chalk around edges of pumpkin for dimension. Mount wire leaf and vines (Crafts, Etc.) atop pumpkin before layering over raffia strips.

Gayla Feachen, Irving, Texas

4 Mount copper pieces on a torn square of brown cardstock and on top of a tag; detail with black pen, then add eyelet and jute.

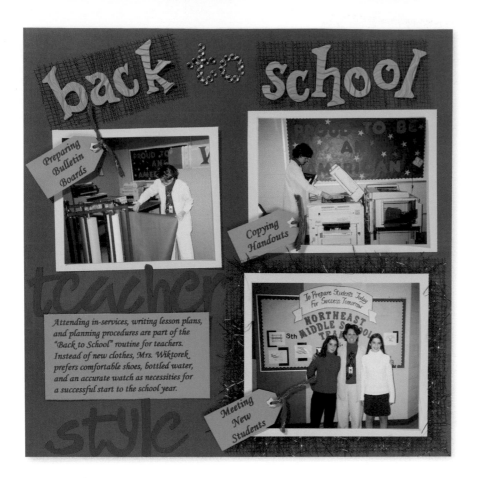

Back to School

Holle photojournals her "back-to-school" rituals as a middle school teacher with freehand cut tags and vibrant embellishments that reflect her excitement for teaching. Mat photos on yellow cardstock; feature one photo by layering over red tinsel (Magic Scraps) and mesh paper (Magenta). Die cut title letters (Sizzix) from green corrugated cardstock; layer over mesh paper. Mount rhinestones in letter shapes to form word "to." Cut balance of title letters with template (Wordsworth) from blue cardstock; set aside. Print journaling and photo captions for tags on green cardstock. Cut journaling block to size; layer with template title words and mount on page. Freehand cut tag shapes around photo text; mount star eyelet (Making Memories) and tie with yarn. Mount on photos with self-adhesive foam spacers.

Holle Wiktorek, Clarksville, Tennessee

Backpack to School

Diana makes the grade with clever refurbishing of an old backpack strap that sets the tone for a first-day-of-school page. Slice a 2¼" strip of green paper and a ¼" strip of white cardstock; mount on dark green cardstock near bottom of page. Take apart strap of an old backpack; remove spongy material inside strap. Fold and cut blue cardstock over spongy material to resemble strap; attach buckle and stitch design with sewing machine. Mount down left side of page with glue dots. Print journaling on green cardstock, leaving room for photo. Layer photo on cut journaling block; mount on page with small black brads. Punch small photo squares; layer with mesh (Magic Mesh) on journaling block. Freehand cut tag; machine stitch white title block to tag. Layer mesh pieces and stitch letter charm on tag with embroidery thread. Punch hole at top of tag; secure black ribbon through hole to back of tag. Write balance of title and photo captions on green cardstock scraps with black marker; mount on title block with black brad.

Diana Hudson, Bakersfield, California
Photos, Ramona Payne, Henderson, Nevada

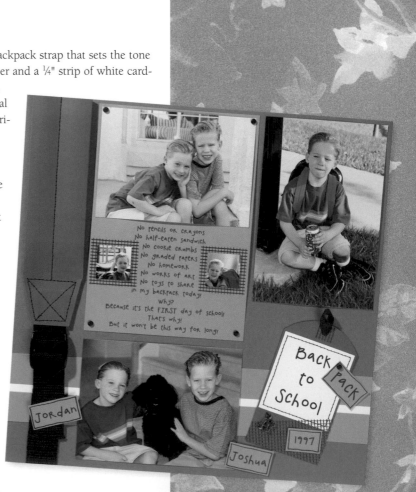

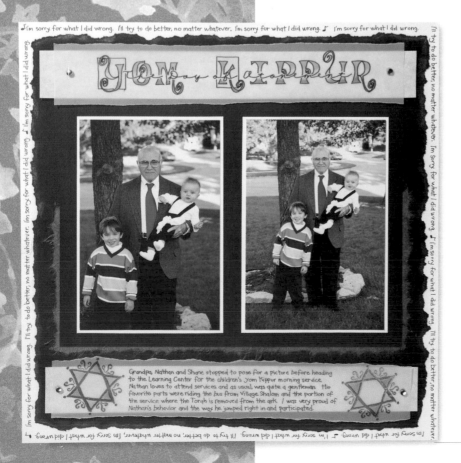

Are You Ready for Some Football

Kelli's textured football shape, laced and layered, begs an answer to the famous Monday Night question "Are you ready for some football?" Single and double mat photos on red and yellow cardstocks. Print partial title; cut to size and mat. Mount on page with self-adhesive foam spacers. Die cut (Accu-Cut) balance of title letters from textured paper; mat on white cardstock and silhouette cut. Freehand cut football shape from textured paper. Paint stripes with acrylic paints. Freehand cut stitched and laced area for football. Punch holes for laces; weave shoelace horizontally and vertically. Mount on football shape with self-adhesive foam spacers. Cut journal block to curve around football; mat with red cardstock and write with black fine-tip pen.

Kelli Noto, Centennial, Colorado

Yom Kippur

Debbie takes a solemn approach to the holiest of all Jewish holidays with dramatic layers of black cardstock detailed with colored chalks and torn mulberry paper (Stampin' Up!). Tear black cardstock on all edges; brush colored chalks with a heavy hand on torn edges in shades of blue, green and yellow. Mount on white cardstock background; write words to holiday song around edges as a border. Mat photos; mount on black cardstock layered over torn green mulberry paper. Print title and journaling on vellum. Tear printed vellum into strips; mount title strip at top of page over yellow cardstock strip with small brads. Stamp Star of David on journaling blocks; sprinkle with embossing powder and set with heat embossing gun. Color title words and embossed star with blue, green and yellow colored pencils. Mount journaling strip in same fashion as title strip.

Debbie DeMars, Overland Park, Kansas

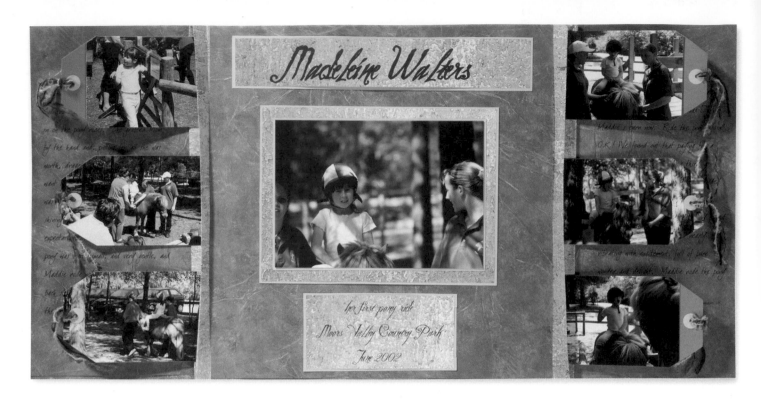

Madeleine Walters

Mary Anne tells a delightful story with an intriguing fold-out design that opens up to display pop-up photo tags. Slice two 6" wide strips of tan cardstock and two 4" strips of brown patterned paper (Faux Memories); score with bone folder. Start accordion fold at 1" toward inside of paper; fold back and forth at ½" intervals four times, leaving a 1" end on each side. Crop photos into tags; mount on cardstock. Punch ½" circles, mount at end of tag. Punch hole through circle layered on photo; tie fibers (Memory Crafts). Mount photo tags at center of accordion fold; reinforce by mounting a ⅜ x 4" strip cut from brown patterned paper. Mount around ends of center fold. Mount ends of "hinge" on page and flap. Cover "hinge" flaps with a 12 x 12" sheet of green patterned paper (Scrap-Ease). Print journaling on green patterned paper; cut 6" wide. Mount 6" journaling strip on inside flap, covering "hinge" flap. Triple mount enlarged photo on solid and patterned papers. Print title and journaling on brown patterned paper; cut to size and mat on yellow cardstock. Mount enlarged matted photo and title/journaling blocks. Stitch buttons to top and bottom inner edges with embroidery thread. Reinforce sewn buttons with two ½" punched circles layered under and over journaled paper. Pierce holes through layers before stitching. Mount 6" journaled strip with buttons. Tie 4½" piece of embroidery thread, embellished with beads, around buttons on left flap. Fold flaps toward inside; close and secure.

Mary Anne Walters, Monk Sherborne, Tadley, UK

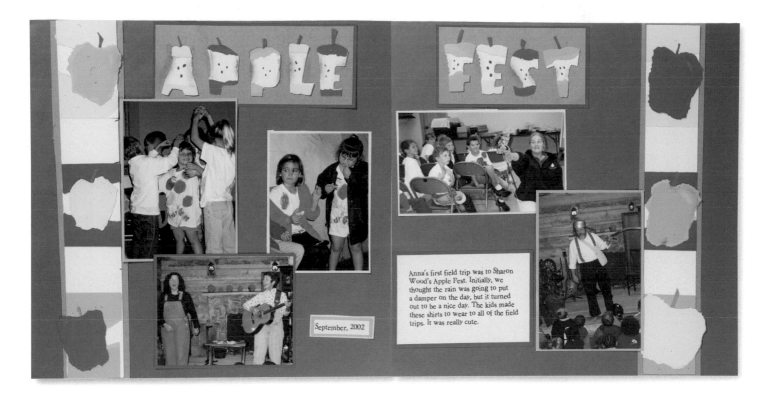

Apple Fest

Mary Faith cleverly modified and detailed template-cut title letters for her page to reflect the theme of her photos. Slice two 2¼" tan and two 1¾" cream strips of cardstock for vertical borders. Adhere cream strip to tan strip. Horizontally layer small sliced and torn strips of red, yellow and green cardstocks to cream strip border. Paper tear apple shapes from colored cardstocks; layer on border with cut "stems." Mat photos. Print journaling; cut to size and mat. Create title letters as shown on right and below.

Mary Faith Roell, Harrison, Ohio

1 Tear strips of yellow, green and red cardstock; mount on 2" strip of cream cardstock.

2 Using template (Scrap Pagerz), trace letters onto previously prepared strip of cream and colored cardstocks. Alternate color of letters throughout title.

3 Cut out letters. Create "bite marks" by allowing scissors to form an irregular pattern in the center of each apple letter.

4 Freehand cut apple stems; adhere. Add brown chalk to "bite mark" edges and draw in "seeds" using brown marker. Cut title block from tan cardstock; mount on red and adhere letters.

Within image 3:

September, 2002

Anna's first field trip was to Sharon Wood's Apple Fest. Initially, we thought the rain was going to put a damper on the day, but it turned out to be a nice day. The kids made these shirts to wear to all of the field trips. It was really cute.

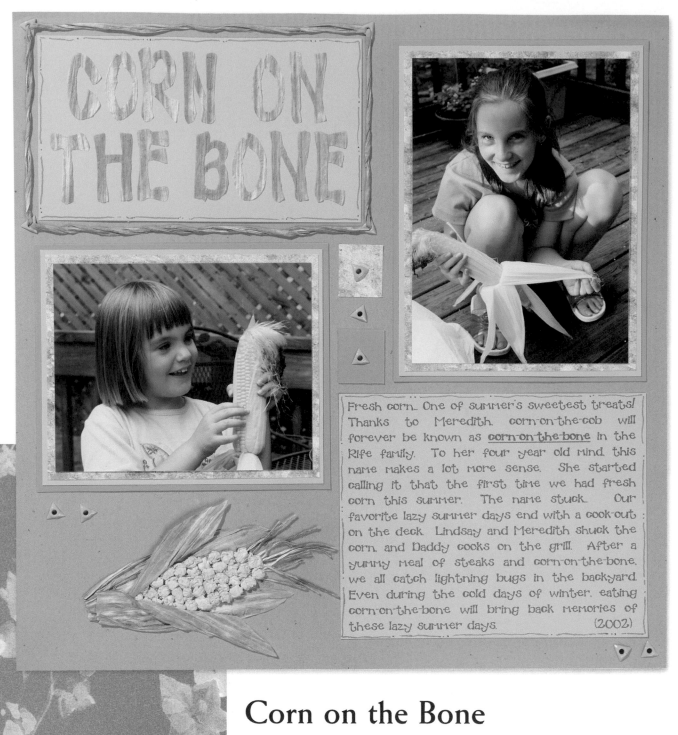

The journaling on the page reads:

Fresh corn. One of summer's sweetest treats! Thanks to Meredith, corn-on-the-cob will forever be known as corn-on-the-bone in the Rife family. To her four year old mind, this name makes a lot more sense. She started calling it that the first time we had fresh corn this summer. The name stuck. Our favorite lazy summer days end with a cook-out on the deck. Lindsay and Meredith shuck the corn, and Daddy cooks on the grill. After a yummy meal of steaks and corn-on-the-bone, we all catch lightning bugs in the backyard. Even during the cold days of winter, eating corn-on-the-bone will bring back memories of these lazy summer days. (2002)

Corn on the Bone

Jane takes paper yarn to new heights with a cleverly fashioned corn cob and title letters. Triple mat photos on patterned (Colorbök) and solid-colored papers. Print journaling on yellow cardstock; cut to size and outline shape with green fine-tip pen. Cut title letters from flattened paper yarn (Making Memories); mount on yellow cardstock. Add green pen-line details. Attach triangle eyelets (Happy Hammer) to page at corners around title block; frame with paper yarn. Weave through eyelets and secure to back of page. Craft corn cob out of flattened paper yarn; cut husk shapes from green paper yarn. Layer with yellow flattened paper yarn pieces rolled into balls. Slice thin strips of yellow paper yarn for corn "hairs"; shade ends with brown chalk. Attach eyelets over solid and patterned paper squares; randomly attach eyelets.

Jane Rife, Hendersonville, Tennessee

FALL PHOTO CHECKLIST

- ❏ Back-to-school shopping (for clothes and supplies)
- ❏ First day of school
- ❏ First practice/game (soccer, football, cheerleading)
- ❏ Harvest (garden, farm, orchard)
- ❏ Raking leaves
- ❏ Thanksgiving
- ❏ Halloween
- ❏ Labor Day
- ❏ Yom Kippur
- ❏ Rosh Hashanah
- ❏ Sukkot
- ❏ Pumpkin patches
- ❏ Hay rides
- ❏ Homecoming
- ❏ Haunted houses
- ❏ Leaving for college
- ❏ Rushing sororities/fraternities
- ❏ Baking
- ❏ Family visits
- ❏ Early Christmas preparations
 (putting up the lights/shopping)

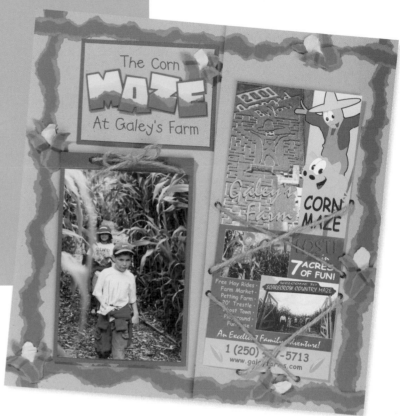

The Corn Maze

Trudy's page is bordered with colorful torn-paper corn stalks. Slice two 5½" strips of brown cardstock. Slice three 1 x 4" strips to attach flap to page. Horizontally mount sliced strips to back of flap and back of page. Attach eyelets to remaining 5½" cardstock strip. Weave jute string through eyelets in cross-cross fashion; attach string at back. Mount strip with eyelets and string to back of flap. Tear ½"-¾" strips of green cardstock; mount around edges of page and flap for border. Tear small pieces of green cardstock; layer with yellow torn cardstock. Mount layered torn pieces at upper right-hand corner. Mat photos on brown cardstock; slice one and mount on page. Cut three pieces of brown cardstock, each 4¼ x 6⅝". Mount photos on front and back of cardstock, leaving a ½" space at top. Mount one photo on third piece of cardstock; layer pieces together. Mount eyelets at top of first photo flap, 1" in from each side of cardstock. Punch two holes at top of second and third piece. Loop jute string through each layer's punched holes; tie together. Mount on page with strong adhesive. Print partial title and journaling on tan cardstock; cut to size and mount on brown cardstock. Cut remaining title letters with template (Frances Meyer) from yellow cardstock layered with dark yellow and green paper strips. Mat on brown cardstock and silhouette cut; mount on title block. Mount journaling block on outside of flap under jute string. Slip brochure under jute strings over journaling.

Trudy Sigurdson, Victoria, British Columbia, Canada

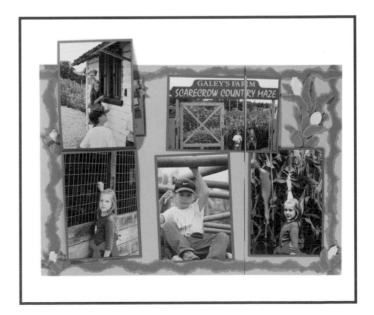

BEGINNING AGAIN

by Lois Duncan

The close of a year is a milestone.
We find it both painful and sweet.
A dawn has evolved into sunset,
A chapter of life is complete.

Its wonders are now only memories,
And all of the stories are told.
Tomorrow's adventures lie waiting
With new sagas yet to unfold.

Although we are glad to move onward,
The past is an intricate part.
Its memories, like beautiful music,
Were strummed on the strings of the heart.

So cherish those wonderful memories.
Hold them and cuddle them tight,
Then tuck them away in a scrapbook
And bid them a tender goodnight.

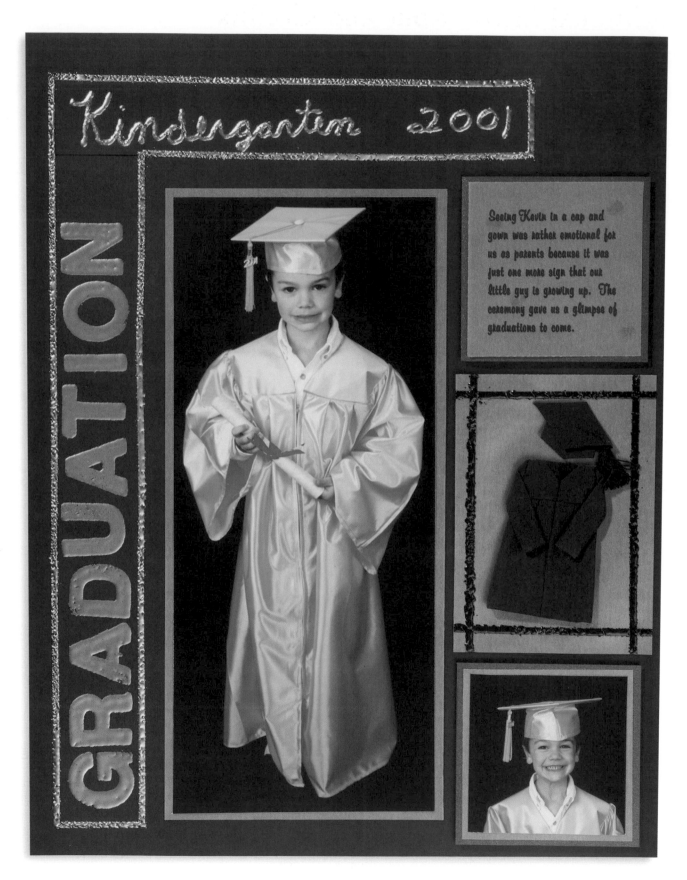

Kindergarten 2001

GRADUATION

Seeing Kevin in a cap and gown was rather emotional for us as parents because it was just one more sign that our little guy is growing up. The ceremony gave us a glimpse of graduations to come.

Pg 301

Additional Instructions and Credits

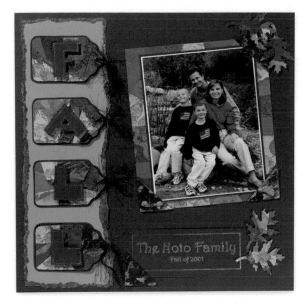

The Noto Family, *page 253*

Randomly emboss, stamp and add gold leaf to six sheets of coordinating cardstock. When finished, rip or cut papers into smaller pieces. On a sheet of 8½ x 11" paper, adhere pieces, overlapping, to create a collage. Use a tag-shaped template (Accu-Cut) to cut four tags. Punch multiple leaves (Family Treasures) from collaged paper. Cut photo frame from remaining portion of collaged paper. Double mat photo on white and burgundy cardstock before mounting on frame. Rip border; apply liquid glue to edges. When dried to tacky, press on gold leaf, removing excess when dry. Use block template to create title (Provo Craft) and a stencil to create journaling. Apply liquid glue to drawn stenciled letters and press on gold leaf. Mount "Fall" title letters on tags with self adhesive foam spacers. Add fibers to tags by tying through small punched holes set with eyelets.

Jodi Amidei, Memory Makers
Photo, Kelli Noto, Centennial, Colorado

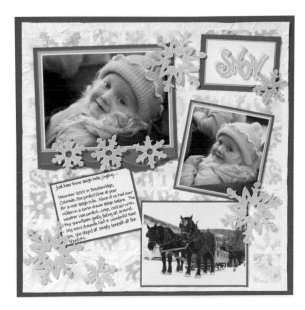

Snow, *page 256*

Crumple white cardstock for texture; flatten and mat with dark blue cardstock. Lightly adhere mosaic overlay (DieCuts with a View) onto white textured background. Stamp large and small snowflakes (Duncan) with lavender and blue ink onto background. Dust lightly with blue and lavender chalk. Gently remove overlay. Double and triple mat smaller photos. Quadruple mat larger photo; paper tear bottom edges of last two mats. Stamp title letters with lavender ink onto white paper; silhouette cut and mount on double-matted white square with self-adhesive foam spacers. Write journaling and mat. Stamp snowflake shapes on white cardstock; silhouette-cut using scissors and craft knife for small details. Add glitter glue on title words and snowflakes. Mount silhouette-cut snowflakes with self-adhesive foam spacers.

Jodi Amidei, Memory Makers
Photos, Michele Gerbrandt, Memory Makers

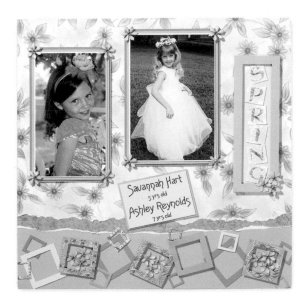

Spring, *page 259*

Assemble torn, patterned papers (Magenta) atop torn, solid paper strip to form background. Punch jumbo, large, medium and small squares (Emagination Crafts, Family Treasures, Punch Bunch) from complementary-colored cardstock and patterned papers (Magenta). Repunch squares with giant, jumbo, large and medium square punches to create the square frames. Arrange and adhere square frames randomly across lower page border, allowing corners to overlap playfully and using self-adhesive foam spacers occasionally for lift. Create framed, vertical title block with cardstock, foam tape for lift and letter stickers (ChYops/Mercer Motifs) over patterned paper; mount on side of page. Add triple-matted photos and journaling block. Finish page with floral sticker accents (EK Success) rubbed with chalk at photo, and title block corners and in square frames on lower page border.

Jodi Amidei, Memory Makers
Photos, Gloria Hart, Winter Haven, Florida

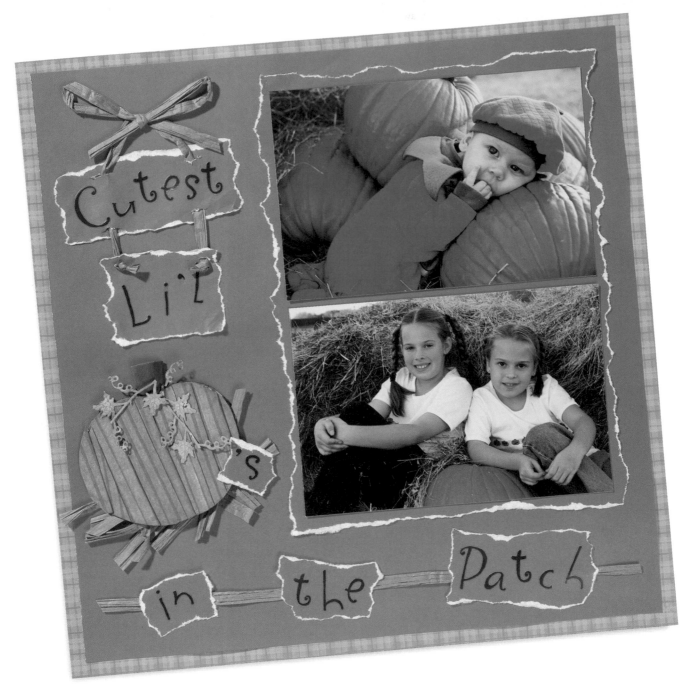

Pg 333

Glossary of Scrapbook Terms and Techniques

Acid-Free

Look for scrapbook products—particularly pages, paper, adhesives and inks—that are free from harmful acids that can eat away at the emulsion of your photos.

Archival Quality

A nontechnical term suggesting that a substance is chemically stable, durable and permanent and is safe to use alongside photos.

Buffered Paper

Paper in which certain alkaline substances have been added during the manufacturing process to prevent acids from forming in the future due to chemical reactions.

Embellishments

Page accents you can make or buy. Can include stickers, die cuts, stamped images, punch art, beads, buttons, rhinestones, sequins, pens, chalks, charms, wire, ribbon, embroidery floss, and thread.

Journaling

Refers to handwritten, handmade or computer-generated text that provides pertinent details about what is taking place in photographs.

Lignin-Free

Paper products that are void of the material (sap) that holds wood fibers together as a tree grows. Most paper is lignin-free except for newsprint, which yellows and becomes brittle with age.

Memorabilia

Mementos and souvenirs saved from travel, school and life's special events—things that are worthy of remembrance.

Page Protectors

Plastic sleeves or pockets that encase finished scrapbook pages for protection. Use only PVC-free protectors.

Pigment Ink

Pigment inks are water-insoluble and do not penetrate the page surface. Instead, they adhere to the paper, providing better contrast and sharpness.

PVC or Polyvinyl Chloride

A plastic that should not be used in a scrapbook, it emits gases, which cause damage to photos. Use only PVC-free plastic page protectors and memorabilia. Safe plastics include polypropylene, polyethylene, and polyester or Mylar.

Patterns

Use these patterns to complete scrapbook pages featured in this book. All patterns are shown at fifty percent. Use a photocopier to enlarge patterns before transferring them to your paper.

Page 271 Snow (50%)

Page 319 BBQ condiments, burger, hotdog and watermelon (50%)

Credits and Sources

The following Memory Makers Masters have contributed their talents and artwork to the creation of this book:

Valerie Barton, Brandi Ginn, Diana Graham, Diana Hudson, Torrey Miller, Kelli Noto, Heidi Schueller, Trudy Sigurdson, Holle Wiktorek

The following companies manufacture products showcased on scrapbook pages within this book. Please check your local retailers to find these materials. We have made every attempt to properly credit the items mentioned in this book and apologize to those we may have missed.

3M
(888) 364-3577
www.3M.com

Accu-Cut®
(800) 288-1670
www.accucut.com

All Night Media®, Inc.
(800) 782-6733

American Art Clay Co., Inc.
(800) 374-1600
www.amaco.com

American Pin
(800) 821-7125
www.american-pin.com

Anima Designs
(800) 570-6847
www.animadesigns.com

Art Accents, Inc.(merged with Provo Craft)
(877) 733-8989
www.artaccents.net

Autumn Leaves
(800) 588-6707 (wholesale only)
www.autumnleaves.com

Avery Dennison Corporation
(800) 462-8379
www.avery.com

Bazzill Basics Paper
(480) 558-8557
www.bazzillbasics.com

Beadery®, The
(401) 539-2432
www.thebeadery.com

Broderbund Software
(319) 247-3325
www.broderbund.com

Carolee's Creations™
(435) 563-1100 (wholesale only)
www.carolees.com

Close To My Heart®
(888) 655-6552
www.closetomyheart.com

Club Scrap
(888) 634-9100
www.clubscrap.com

C.M. Offray & Son, Inc.
(800) 344-5533
www.offray.com

Colorbök
(800) 366-4660 (wholesale only)
www.colorbok.com

Coronado Island Stamping
(619) 477-8900
www.cistamping.com

Crafter's Workshop, The
(877) CRAFTER
www.thecraftersworkshop.com

Crafts Etc! (formerly Stampabilities)
(800) 888-0321
www.craftsetc.com

Creative Imaginations
(800) 942-6487
www.cigift.com

Creative Memories®
(800) 468-9335
www.creative-memories.com

C-Thru® Ruler Company, The
(800) 243-8419
www.cthruruler.com

Cut-It-Up™
(530) 389-2233
www.cut-it-up.com

Darice, Inc.
(800) 321-1494
www.darice.com

Debbie Mumm®
www.debbiemumm.com

Deluxe Designs
(800) 96-DELUX
www.deluxecuts.com

Design Originals
(800) 877-7820
www.d-originals.com

DieCuts with a View™
(801) 224-6766
www.diecutswithaview.com

DMC Corp.
(973) 589-0606
www.dmc-usa.com

DMD Industries, Inc.
(800) 805-9890
www.dmdind.com

Doodlebug Design, Inc.™
(801) 524-0050

Duncan Enterprises
(800) 438-6226
www.duncan-enterprises.com

EK Success™ Ltd.
(800) 524-1349
www.eksuccess.com

Ellison® Craft & Design
(800) 253-2238
www.ellison.com

Emagination Crafts, Inc.
(630) 833-9521
ww.emaginationcrafts.com

EZ2Cut/Accu-cut
(8080) 288-1670
www.ez2cut.com

Family Treasures, Inc.®
(800) 413-2645
www.familytreasures.com

Faux Memories
(813) 269-7946
www.fauxmemories.com

Fibers by the Yard
(405) 364-8066
www.fibersbytheyard.com

Fiskars, Inc.
(800) 500-4849
www.fiskars.com

Frances Meyer, Inc.®
(800) 372-6237
www.francesmeyer.com

Happy Hammer, The
(720) 870-5248
www.thehappyhammer.com

Hasbro
(800) 844-3733
www.hasbro.com

Hero Arts®
(800) 822-4376
www.heroarts.com

Hot Off The Press
(800) 227-9595
www.craftpizazz.com

Ivy Cottage Creations
(888) 303-1375
www.ivycottagecreations.com

Jesse James & Co., Inc.
www.jessejamesbutton.com

JewelCraft, LLC
(201) 223-0804
www.jewelcraft.biz

Jewish Stickers, L.L.C.
www.jewishstickers.com

JHB International
(303) 751-8100
www.buttons.com

Judi-Kins
(800) 398-5834
www.judikins.com

K & Company
(888) 244-2083
www.kandcompany.com

Karen Foster Design
(801) 451-9779
www.karenfosterdesign.com

Keeping Memories Alive®
(800) 419-4949
www.scrapbooks.com

Kopp Design
(801) 489-6011
www.koppdesign.com

Magenta Rubber Stamps
www.magentarubberstamps.com

Magic Mesh™
(651) 345-6374
www.magicmesh.com

Magic Scraps™
(972) 238-1838
www.magicscraps.com

Making Memories
(800) 286-5263
www.makingmemories.com

Marvy® Uchida
(800) 541-5877
www.uchida.com

Masterpiece® Studios
www.masterpiecestudios.com

McGill, Inc.
(800) 982-9884
www.mcgillinc.com

Mrs. Grossman's Paper Company
(800) 429-4549
www.mrsgrossmans.com

Mustard Moon
(408) 229-8542
www.mustardmoon.com

On The Fringe
www.onthefringe.net

On The Surface
(847) 675-2520

Pakon, Inc.
(866) 227-1229
www.pakon.com

Paper Adventures®
(800) 727-0699 (wholesale only)
www.paperadventures.com

Paper Company, The
(800) 426-8989

Paper Fever, Inc.
(800) 477-0902
www.paperfever.com

Paper Garden Inc., The
(210) 494-9602
www.papergarden.com

Paper House Productions
(800) 255-7316 (wholesale only)
www.paperhouseproductions.com

Pioneer Photo Albums, Inc.
(818) 882-2161
www.pioneerphotoalbums.com

Plaid Enterprises
(800) 842-4197
www.plaidenterprises.com

PrintWorks
(800) 854-6558
www.printworkscollection.com

Provo Craft®
(800) 937-7686
www.provocraft.com

PSX Design (Duncan Enterprises)
(800) 438-6226
www.psxdesign.com

Pulsar Paper Products
(877) 861-0031 (wholesale only)
www.pulsarpaper.com

Punch Bunch, The
(254) 791-4209
www.thepunchbunch.com

Ranger Industries, Inc.
(800) 244-2211
www.rangerink.com

Sakura of America
(800) 776-6257
www.sakuraofamerica.com

Sandylion Sticker Designs
(800) 387-4215
www.sandylion.com

Sanford
(800) 323-0749
www.sanfordcorp.com

Scrapbook Sally
(86) SBSally
www.scrapbooksally.com

Scrap in a Snap™
(866) 462-7627
www.scrapinasnap.com

Scrap Pagerz
(435) 645-0696
www.scrappagerz.com

Scrappin' Dreams
(417) 831-1882
www.scrappindreams.com

ScrapYard 329 LLC
(775) 829-1118
www.scrapyard329.com

Sizzix
(877) 355-4766
www.sizzix.com

Stamp Barn, The
(800) 246-1142
www.stampbarn.com

Stamp Doctor, The
(208) 342-4362
www.stampdoctor.com

Stampendous
(800) 869-0474 (wholesale only)
www.stampendous.com

Stampin' Up!®
(800) 782-6787
www.stampinup.com

Stampscapes™
www.stampscapes.com

Stickopotamus®
(888) 270-4443

Suze Weinberg Design Studio
(732) 761-2400
www.schmoozewithsuze.com

Sweetwater Express
(970) 867-4428
www.sweetwaterscrapbook.com

This n' That Crafts
(860) 485-1788
www.easymats.com

Tsukineko®, Inc.
(800) 769-6633
www.tsukineko.com

Two Busy Moms/Deluxe Designs
(480) 497-9005
www.twobusymoms.com

Westrim® Crafts
(800) 727-2727
www.westrimcrafts.com

Wordsworth
(719) 282-3495
www.wordsworthstamps.com

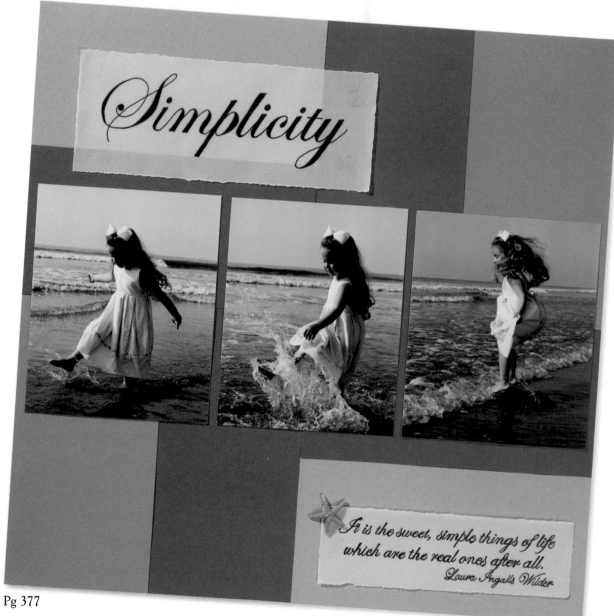

It is the sweet, simple things of life which are the real ones after all.
Laura Ingalls Wilder

Pg 377

Quick & Easy
SCRAPBOOK PAGES

100 Scrapbook pages you can make in one hour or less

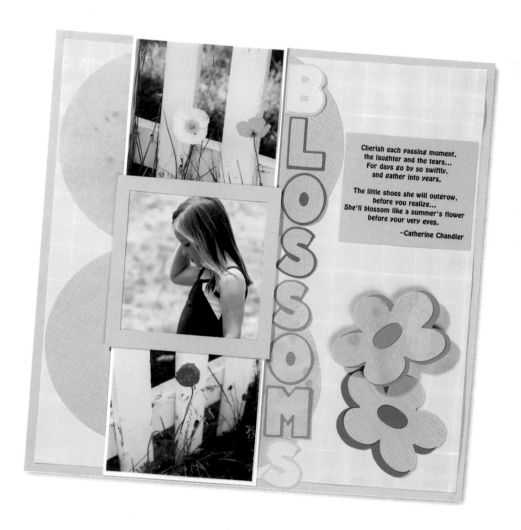

Cherish each passing moment,
the laughter and the tears...
For days go by so swiftly,
and gather into years.

The little shoes she will outgrow,
before you realize...
She'll blossom like a summer's flower
before your very eyes.

~Catherine Chandler

MEMORY
MAKERS
BOOKS

TABLE OF CONTENTS

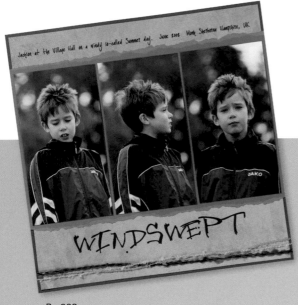

Pg 363

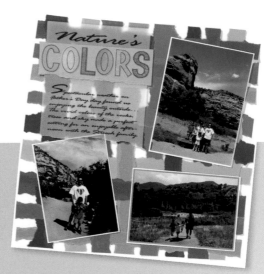

Pg 385

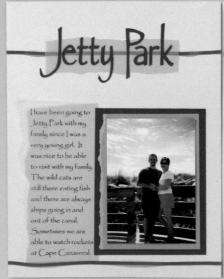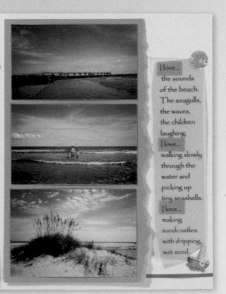

Pg 415

350

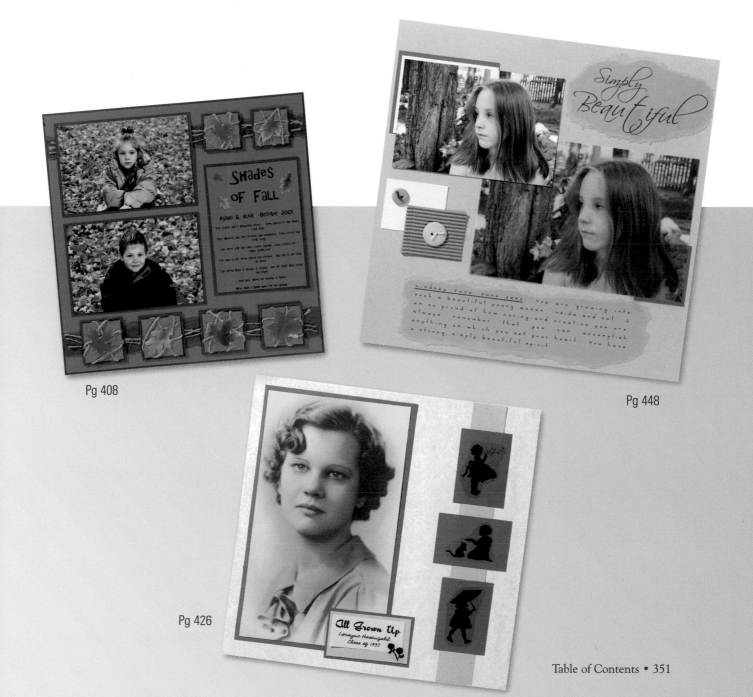

Pg 408

Pg 448

Pg 426

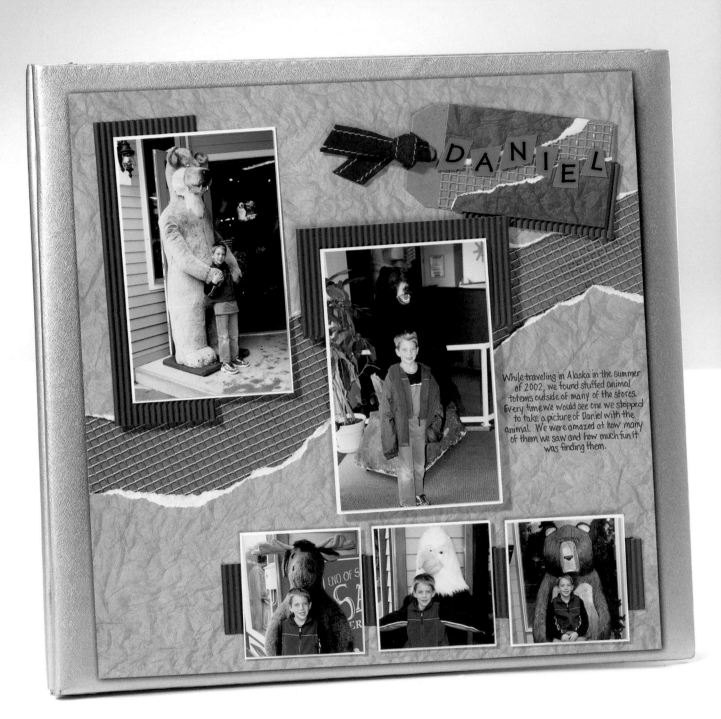

DANIEL

While traveling in Alaska in the summer of 2002, we found stuffed animal totems outside of many of the stores. Every time we would see one we stopped to take a picture of Daniel with the animal. We were amazed at how many of them we saw and how much fun it was finding them.

Introduction

Soccer practice. Homework. Meetings. Birthday parties. We are always being pulled in a dozen directions. It's no different at my house, where we're constantly on the go between school, work, home and church. Most days, I am fortunate if I get a peaceful moment, much less five or six uninterrupted hours to scrapbook!

Fortunately, there are ways to work around even the busiest of schedules so you won't have to compromise the hobby that you love. Inside our book, *Quick & Easy Scrapbook Pages*, you'll find numerous examples of attractive, easy-to-assemble layouts that most people can create in an hour or less. You'll also discover dozens of ways to simplify your favorite "complex" scrapbooking techniques, including creating your own backgrounds and unique title, border and mat treatments, as well as dozens of fun and fast ways to add embellishments.

For additional inspiration, we have also included a variety of staff and reader time- and money-saving tips, as well as a sampling of ready-to-use page-design templates, inspirational quotes and a quick tutorial on color-mood psychology. Use any of these techniques to help spice up the content of your pages!

The secret to creating gorgeous scrapbook pages is learning to make the most of the time you have—and not worrying about the time you don't. Complex-looking pages can actually be very easy to make, provided you have supplies on hand, an idea in mind and the enthusiasm to create.

Allow us to show you how!

Michele

Michele Gerbrandt
Founder of *Memory Makers* magazine

Getting Started

All of the scrapbook pages in this book are indeed quick and easy to create. You can make the process even smoother by investing time in preplanning and organization. Begin by setting up a workspace on which you can spread out your photos and memorabilia. The workspace should be out of the direct sunlight. Then sort your photos and memorabilia in a way which will make them easily accessible when you sit down to scrapbook. There are two recognized methods for sorting your materials.

Sorting Photos Chronologically

Gather all of your photographs into one pile. If the photos are still in their original envelopes with the negatives, transfer them to photo-safe envelopes.

- Label the contents of each envelope, or label the dividers in the photo-safe boxes. Include a "best-guess" date as to when the pictures were taken. If there is related memorabilia or journaling you want to include later, note it with a star next to the date.

- Sort the envelopes by date, assigning each envelope a number that will assist you in filing them in consecutive order. Place them in the box. Now, attack the memorabilia: Divide into categories such as *tickets*, *journals*, or *brochures*. Place the items in a labeled and dated memorabilia box.

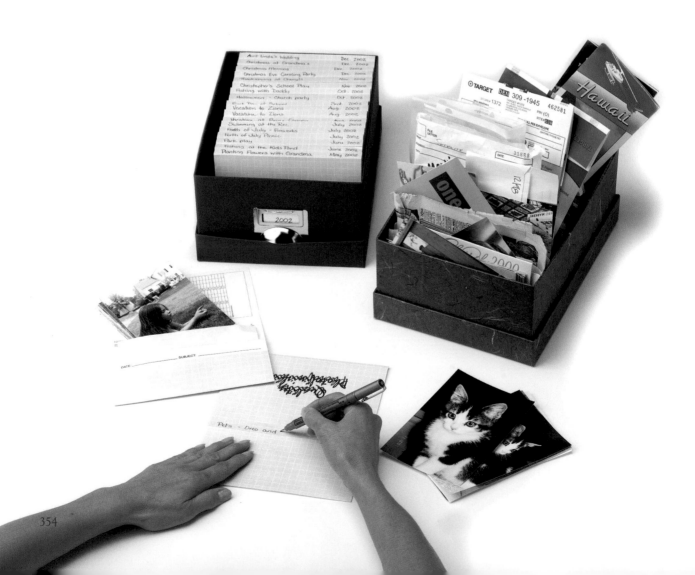

Sorting Photos By Theme

(Best for wedding, vacation or holiday albums)

Collect all photos and memorabilia. On sticky notes, write down the categories pertinent to your current project. For example, if you are working on a travel album, you may wish to sort the photos into groups such as *making plans*, *site-seeing* and *adventures*.

• Sort your photos by category into piles near the appropriate sticky notes.

• Re-sort the photos in each pile so they fall in logical order. This is, most often, the sequence in which you hope to place the photos in your album.

• Place the sorted piles in labeled, photo-safe envelopes and acid-free boxes, storing them until you are ready to scrapbook.

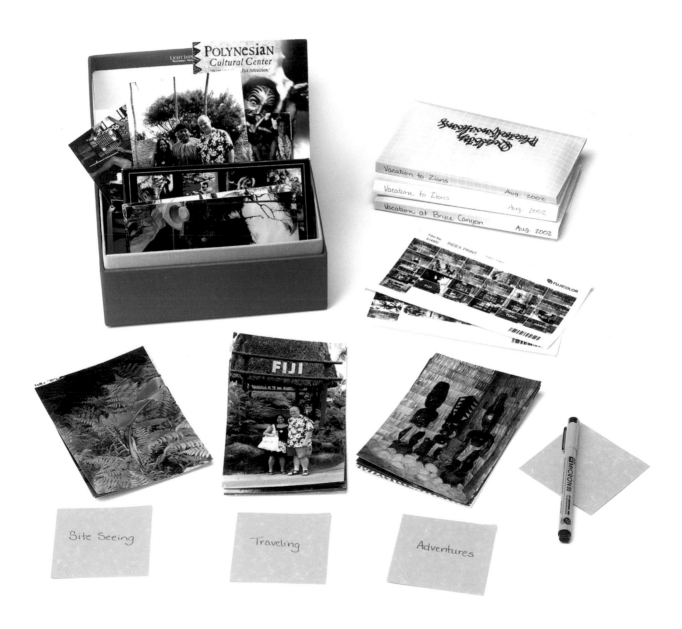

Tools

Like all hobbyists, scrapbookers must invest in a certain number of basics tools in order to create albums. While you're likely to find some tools, such as scissors, tweezers and a straightedge ruler, already reside in your utility drawer, there are others you will have to purchase.

Album, pages and page protectors

Albums come in four styles: three-ring binder, spiral, post or strap bound. The most popular and readily available sizes are 12 x 12" and 8½ x 11". Sturdy, well-constructed, expandable albums are the best and most durable choices, however all albums should be archival-quality environments for your photos and memorabilia. Page protectors, transparent sleeves that cover and protect scrapbook pages, should be made of nonreactive, PVC-free plastic.

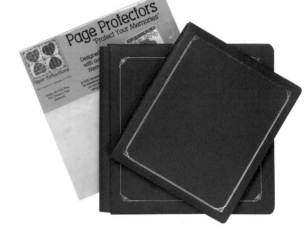

Pigment pens and markers

All scrapbook journaling should be done with pigment ink which is lightfast, fade-resistant, waterproof and colorfast. Pigment pens are available in an array of colors and tip widths which make journaling or embellishing easy and fun.

Adhesives

There are a wide range of glues and tapes available that make scrapbooking neat and precise. Adhesives include tape runners, photo mounting squares, glue pens, bottled glue, photo tape and glue dots.

Solid and patterned papers

Paper is used for page backgrounds, mats, frames and embellishments. Scrapbook paper, sold in single sheets, packets and booklets, comes in hundreds of colors and patterns. All should be pH neutral (acid-free) and lignin-free. Many varieties are also buffered.

Quick Tip: Clean ink and adhesive residue off of tools and repair tools before storing in a dry, dust-free place. Store all tools and supplies out of the sun. Albums should be stored in an upright position, however paper should be stored flat. Store die cuts and stickers within page protectors inside of binders.

Top Timesaving Tools

Beyond the basics, you may wish to invest in these timesaving tools. They are straightforward, fun to use and will help you make the very most of your scrapbooking time.

Nested Templates

Easy to store, easy to pack, easy to use. What more could you ask for? These popular "nested" templates quickly create the perfect shapes and sizes for multiple layers of photo mats. Talk about a timesaver!

Adhesive Remover

Correct a mistake without sacrificing entire sheets of paper. With a little bit of un-du, an incorrectly placed sticker or other embellishment comes right off your page. The page dries in just minutes with no evidence of the embellishment.

Computer

Of all the scrapbooking tools out there, this baby offers the most bang for your buck. In addition to providing easy access to inspirational quotes and scrapbooking Web sites, many software programs now exist to help you create attractive, unique page embellishments and fonts! Added bonus: Journaling might seem less intimidating with the help of spelling and grammar check!

The Xyron Machine

When applying adhesive to a variety of items, the Xyron machine is in a class by itself. The big advantage Xyron offers over regular adhesives is that it covers 100 percent of the sticking surface when you run items through the machine. This ensures that whatever you wish to make sticky will lie flat on your page and have less chance of catching on a page protector or ripping off the page.

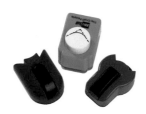

Corner Rounders

Corner rounders give photos a "finished" look instantly. A corner rounder is a good option for anyone who wants to keep it simple.

Clear Grid Ruler

This favorite quick and easy tool allows you to measure the width of a mat or border as small as ⅟₁₆". The rulers are available in the quilting section of your local fabric store or in office supply stores. They are relatively inexpensive ($8 to $13) and come in a variety of sizes, but the 12 x 2" size seems the best fit for scrapbooking.

Top-Loading Page Protectors

These protectors allow you to design your pages on background paper, then simply drop them into the page protectors. They also make it easy to rearrange your album pages without removing the protectors from the binding. Another creative use: Keep a few in your scrapbook bag for storing photos and supplies you plan to use later.

Personal Paper Trimmer

This compact tool makes a quick and easy accessory to any scrapbook project. Cropping photos, trimming mats or cutting thin paper strips takes no time at all with a trimmer. Compact enough to slip into a cropping tote, most personal paper trimmers come with several extra blades that are easy to change.

Supplies shopping checklist

Cut down the time you spend shopping for scrapbook supplies by determining exactly what you need to purchase before ever leaving the house. Photocopy this checklist and use it to preplan in order to make your shopping trip most efficient.

Organizational Supplies

- ☐ Photo box(es)
- ☐ Negative sleeves
- ☐ Photo envelopes
- ☐ Self-stick notes
- ☐ Memorabilia keepers
- ☐ Storage containers

ALBUM TYPES
- ☐ Strap
- ☐ Post bound
- ☐ Spiral
- ☐ 3-ring binder
- ☐ Mini
- ☐ Other

Preferred brand(s)

ALBUM SIZES
- ☐ 4 x 6"
- ☐ 5 x 7"
- ☐ 8½ x 11"
- ☐ 12 x 12"
- ☐ 12 x 15"
- ☐ Other

Preferred brand(s)

ALBUM FILLER PAGES
- ☐ 4 x 6"
- ☐ 5 x 7"
- ☐ 8½ x 11"
- ☐ 12 x 12"
- ☐ 12 x 15"
- ☐ Other

Preferred brand(s)

ALBUM PAGE PROTECTORS
- ☐ 4 x 6"
- ☐ 5 x 7"
- ☐ 8½ x 11"
- ☐ 12 x 12"
- ☐ 12 x 15"

Preferred brand(s)

ARCHIVAL QUALITY ADHESIVES
- ☐ Photo splits
- ☐ Double-sided photo tape
- ☐ Tape roller
- ☐ Liquid glue pen
- ☐ Glue stick
- ☐ Bottled glue
- ☐ Self-adhesive foam spacers
- ☐ Adhesive application machine
- ☐ Adhesive application machine cartridge
- ☐ Adhesive remover
- ☐ Other

Preferred brand(s)

SCISSORS & CUTTERS
- ☐ Small scissors
- ☐ Regular scissors
- ☐ Decorative scissors
- ☐ Paper trimmer
- ☐ Shape cropper(s)
- ☐ Craft knife

PENCILS, PENS, MARKERS
- ☐ Pigment pen(s)
- ☐ Photo-safe pencil
- ☐ Vanishing ink pen

RULERS & TEMPLATES
- ☐ Metal straightedge ruler
- ☐ Grid ruler
- ☐ Decorative ruler(s)
- ☐ Journaling template(s)
- ☐ Shape template(s)
- ☐ Letter template(s)
- ☐ Nested template(s)

ACID- AND LIGNIN-FREE PAPER
- ☐ Red
- ☐ Orange
- ☐ Yellow
- ☐ Brown
- ☐ Green
- ☐ Blue
- ☐ Purple
- ☐ Pink
- ☐ Black
- ☐ White
- ☐ Patterns

- ☐ Themes

- ☐ Vellum color(s)

- ☐ Mulberry color(s)

- ☐ Specialty paper(s)

- ☐ Other

Preferred brand(s)

STICKERS
Themes or types

DIE CUTS
Themes or types

PUNCHES
- ☐ Corner rounder
- ☐ Hand punch(es)
- ☐ Border(s)
- ☐ Decorative corner(s)
- ☐ Photo mounting
- ☐ Shape(s)

- ☐ Tweezers
- ☐ Wax paper
- ☐ Aluminum foil

RUBBER STAMPS
Themes or types

- ☐ Ink pad(s)
- ☐ Embossing powder(s)
- ☐ Stamp cleaner

Summer gives us so much —
strength, light, food. No car
trips on icy roads to gather
wilted produce imported from
far away, from parts of the
world where warmth lingers.
Instead, you can pick ripe
fruit from your own trees and
savor the taste of juicy fruit,
still warm from the sun.
Lauren gathered bushels of ripe
pears this year to make into
chutney. When we open them
this winter, I hope we'll be
able to taste the freshness, the
warmth and the joy that only
summer can give us. We can
savor the taste and dream of
those lazy days of summer.

Summer Fruits

Chapter 1
Layout & Design

Of those elements that contribute to the overall look of a complete scrapbook page, layout and design are among the most important. You could have the most powerful photographs, journaling and embellishments in the world, but if they are misplaced or if your color selection is off base, your page's "wow" factor falls flat.

Keep in mind that each scrapbooker has her own unique method for determining page layout. Some scrapbookers shuffle and rearrange pieces hundreds of times before finally stumbling upon a look they like. Others begin with a very specific concept in mind, then quickly move forward to bring it to fruition.

The most helpful theory to keep in mind when designing quick and easy scrapbook pages is that less is often more. Cluttering pages with extraneous embellishments or trying to fit too many photos and other elements on a page not only takes time, but muddies the final product.

So think sleek, lean and clean as you let the fun begin!

Templates

There are many ways to arrange your photos and memorabilia on a scrapbook page. You may keep everything in the center, scatter it across the border, or create a zig-zag pattern. While the choice is yours, you can use these pre-made page templates for additional inspiration.

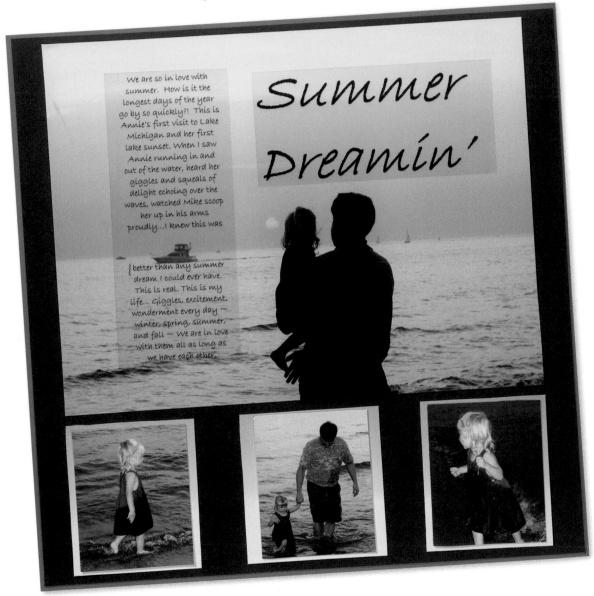

Summer Dreamin'

ENLARGE PHOTO FOR DRAMATIC PRESENCE

Cherri captures the beauty of an enchanting summer evening by using an enlarged photo to serve as the focal point of her page. Mount large photo on black background paper. Mat smaller photos on extra copy of sunset photo to complement colors in large photo. Print title and text on transparency; mount on large photo.

Cherri Weir, Lapeer, Michigan

Windswept

DRESS UP SIMPLE LAYOUT WITH FIBER

A succession of three enlarged, candid photos stands out on Mary Anne's simple, impactful layout. Print journaling and title on patterned paper (Faux Memories); layer over solid paper, leaving ¼" border. Mat all three photos on solid colored paper; tear top and bottom of matting before mounting on page. Embellish with fibers (Memory Crafts) wrapped along bottom of page.

Mary Anne Walters, Monk Sherborne, UK

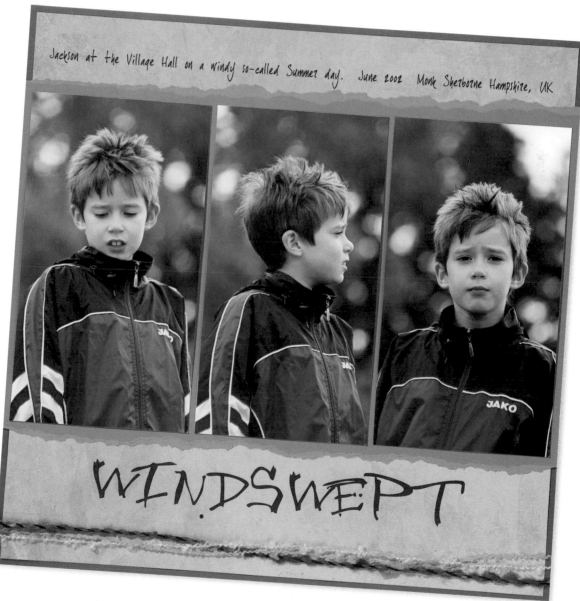

Jackson at the Village Hall on a windy so-called Summer day. June 2002 Monk Sherborne Hampshire, UK

Quick Tip: While a large photo provides a dramatic focal point for your spread, you can achieve the same effect by double matting a slightly smaller photo such as a 5 x 7".

Mother

PAPER TEAR BORDERS AND PHOTO MATS

Christina adds interest to simple black-and-white photos with tearing and photo mats. Tear solid and patterned papers (Mustard Moon); layer on page to create side borders. Mount large photo. Crop rectangles from solid paper to layer behind smaller photos; tear one side. Add torn paper strip; embellish with flowers (Emagination Crafts, EK Success) punched from solid and vellum papers. Glue seed beads (Crafts Etc.) to center of flowers. Print text on vellum; tear edges and mat on solid paper with eyelets (Doodlebug Design). Print balance of title on solid paper; silhouette-cut letters with a craft knife.

Christina Gibson, Jonesboro, Arkansas

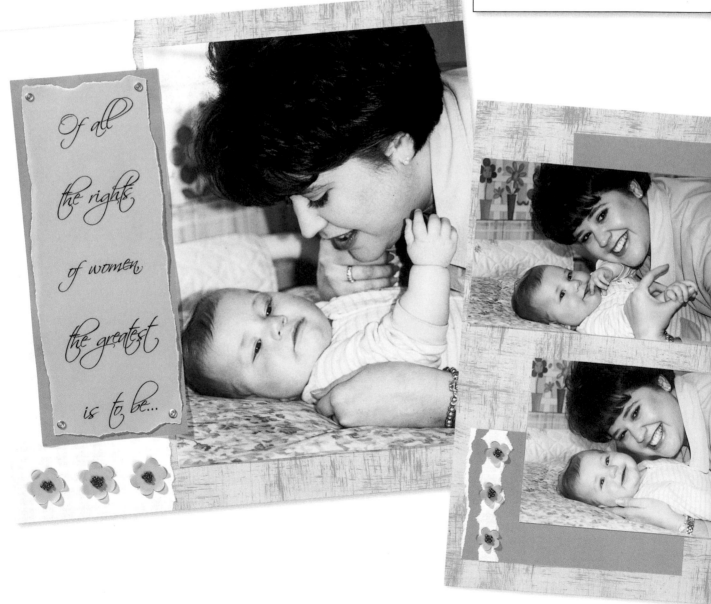

TITLE

photo

photo

a Mother

When do you scrapbook?

"I'm a stay-at-home mother of two children—an almost 4-year-old boy and a 9-month-old girl. While my daughter is napping, I try and get my son excited about working on our scrapbooks together. He has a table just his size next to my work station, along with his own special bin of supplies. I can usually get a couple of pages done while he works on his own book. I think he enjoys scrapbooking almost as much as I do!"

Diane Elderbroom, Wylie, Texas

"For me it's not a matter of finding time to scrapbook—I make the time, because it's important to me that my children understand their backgrounds. Even though I have a scrapbook room, I lay my 'in progress' pages on the kitchen counter until they're complete. This way I can work on them throughout the day while tending to my family's needs. I found once I started this routine, I was getting at least a page a day done."

Chrystal Wilson, Alexandria, Virginia

"My mom and I commit one evening a week to scrapbooking together, deemed Arts and Crafts Night. After enjoying a nice family dinner and tucking the kids into bed, we meet at the craft table for serious business, where prizes are awarded and winning pages are displayed. Sometimes, I invite another friend to join us. The time together has strengthened our relationship, is therapeutic, and just plain fun."

Lori Haas, Battle Ground, Washington

"I organize layouts into smaller projects, sorting and cropping my photos first, then planning bags with photos and embellishments as needed. I save large layouts for cropping parties. It's the 1-2 page layouts - life's tidbits - that I scrapbook at my small table in the family room, working around family activities. Scrapbooking is like my diary I never got started. It's briefly making sense of the day."

Lynne Moore, Henderson, Nevada

Cousins Photo Shoot

FEATURE A MULTI PHOTO LAYOUT

Beth captures the fun of a homemade photo shoot with a simple, balanced layout. Crop photos; arrange and adhere to page. Print journaling on vellum; tear and chalk edges. Use a template to create "Cousins" title. Punch flowers (Colorbök) and mini trees (McGill). Detail flowers and "Cousins" with metallic rub-ons (Craf-T) and chalk; mount on vellum journaling block. Cut heads off pins and adhere to flower centers. Print second journaling block directly on photo scrap.

Beth Rogers, Mesa, Arizona

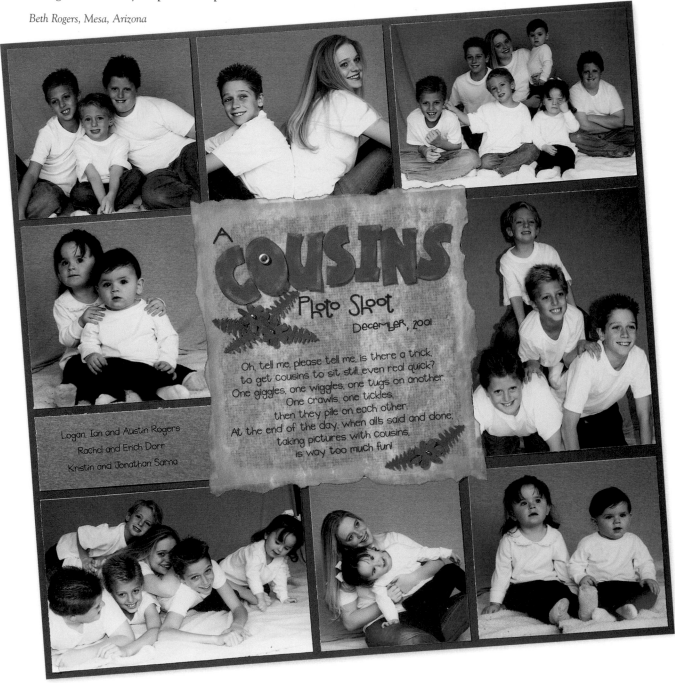

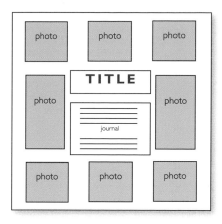

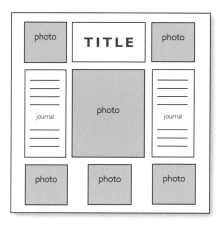

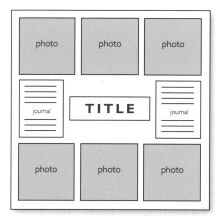

Variations

Use these templates to create variations of the Multi Photo Layout page (on left). All layouts will allow you to showcase numerous photos on a single page and still leave room for title and journaling.

How do you find time to scrapbook?

"Many of us at work are really into scrapbooking, so we have set up a table dedicated to working on our books. At lunch time (which could be at weird times of the day for some of us), we sit around working on our books. The best part is that we share a lot of our supplies, making things a little more fun, interesting and certainly cheaper!"

Molly Vincent, Ellicott City, Maryland

"Whenever we go on a 3-hour trip to Wisconsin to see family and friends, I trace letters on cardstock before we leave, cut them out and mat them for whatever title or titles I'm working on. My husband usually drives and it's hard for me to sit still for three hours anyway, so it makes the time go by faster. Next thing I know, we are there!"

Sheila Boehmert, Island Lake, Illinois

"Whenever my husband and I travel for work, I bring along a small file of pictures I want to work on next, then visit the local store and browse for new ideas and products I haven't seen at home. I also carry a 12 x 12" paper sleeve and resealable plastic bags to store the paraphernalia (such as travel brochures) I collect along the way. When I get home, I can place everything in one folder to enable me to get going quickly when I scrap."

Stephanie Hackney, Carlsbad, California

"One Friday each month, my girlfriends and I get together for some scrapbooking 'girl time.' Meeting in each others' homes and sharing lunches enables us more time to scrap. Sharing tools and ideas, along with lots of laughter, inspires both creative ideas and deepens our close friendship. Each time we scrap together is a blessing from God."

Pam Willis, Aiken, South Carolina

The thing I find easiest is to spend one night cropping pictures for several hours, usually at a workshop away from home. I also lay out my pages with sticker ideas and Post-it notes. Then, on nights when I'm really tired, I sit in front of the TV after the kids have gone to bed and simply attach photos to the pages. This way, I use one night to be creative, and the other to relax and just stick things down."

Rachelle St. Phard, East Windsor, New Jersey

Daydream

BALANCE PAGE WITH LARGE AND SMALL PHOTOS

Sandra offsets an enlarged photo of her daughter on the beach with two smaller snapshots nestled into the lower left-hand corner of the page. Print title and poem on background paper. Triple-mat large photo, first on mesh paper, then on patterned (source unknown) and solid papers. Layer small cropped photos over mesh paper and solid paper strip; embellish with seashells (U.S. Shell, Inc.).

Sandra Stephens, Eden Prairie, Minnesota

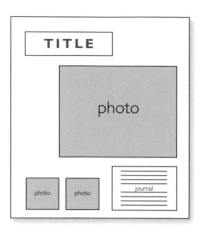

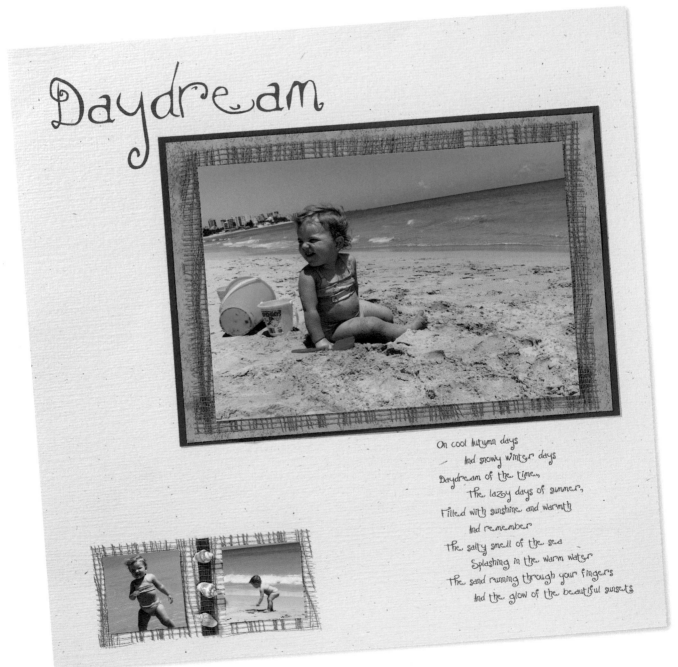

On cool Autumn days
And snowy Winter days
Daydream of the time,
The lazy days of summer,
Filled with sunshine and warmth
And remember
The salty smell of the sea
Splashing in the warm water
The sand running through your fingers
And the glow of the beautiful sunsets

Nothing Is Impossible

ILLUSTRATE PHOTO WITH TITLE QUOTE

A charming photo stands alone on Janice's simple and appealing layout. Print title quote on background paper; punch heart (EKSuccess) and mount. Print journaling onto solid-colored cardstock; cut paper strip and mount on page. Mat photo and mount.

Janice Carson, Hamilton, ON, Canada

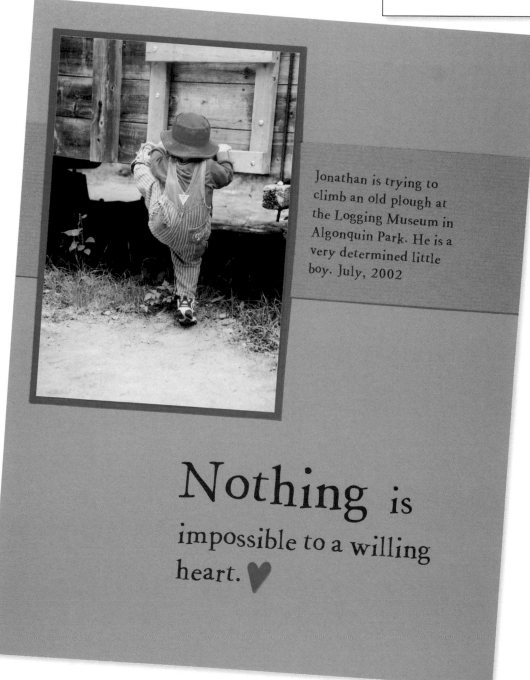

Jonathan is trying to climb an old plough at the Logging Museum in Algonquin Park. He is a very determined little boy. July, 2002

Nothing is impossible to a willing heart. ♥

The Calm

PAPER-TEAR PATTERNED PAPER BACKGROUND

Oksanna allows one photo to fill a two-page spread by extending gray matting onto the opposite page. Print part of title and journaling on background paper and photo mat. Diagonally tear patterned paper (Design Originals); mount at upper left and lower right hand corners of background paper. Triple-mat photo; use mat with journaling as the third photo mat. Slice gray paper strip with partial title for opposite page; tuck under torn patterned paper. Cut large title word from template (C-Thru Ruler). Adhere seashell stickers (Provo Craft) to title and photo mats. Stamp seashell design (Duncan); silhouette-cut and mount on page.

Oksanna Pope, Los Gatos, California

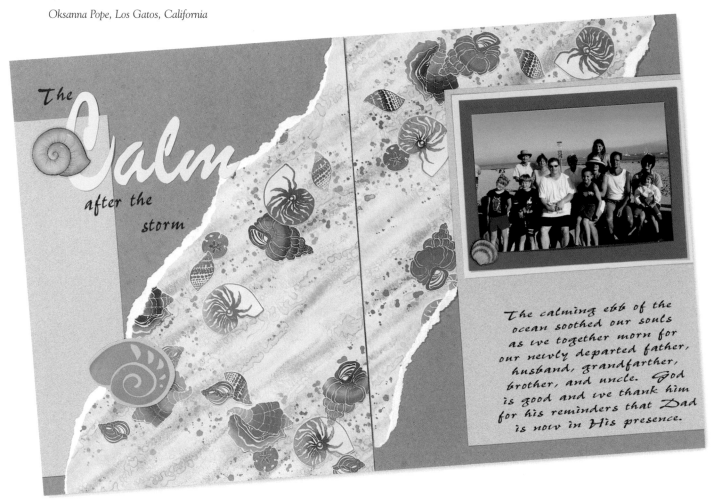

Silly

ADD DETAILS TO A SIMPLE LAYOUT

Andrea captures her daughter's smile on a simple layout dressed up with charming details. Mat embossed paper (Jennifer Collection) and one photo; mount both photos on page. Print title and journaling on vellum; cut to size and add chalk highlights. Attach eyelets (Impress Rubber Stamps) to title and text blocks. Tie fiber and mount sunglasses button (Jesse James). Attach fiber (source unknown) across middle of page, securing behind handmade paper. Lightly snip edges of fiber to achieve frayed look.

Andrea Hautala, Olympia, Washington

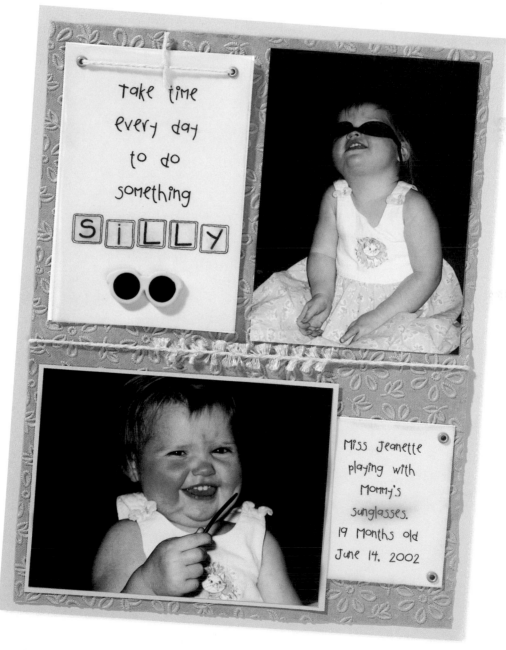

Color Selection

One of the first steps in designing a scrapbook page is to decide upon the color palette. These are the shades and hues you will use for background papers, mats, frames and embellishments. You can select colors for your pages in a number of ways.

Pull color from your photos

While you may be tempted to choose a color that dominates your photos, this may cause your photos to blend with their background, rather than pop off the page. Instead, select a secondary color from your pictures and use the primary color sparingly. Refuse to allow your color choices to be dictated by the theme of your page, if this means that colors and photos will clash. For example, if your daughter's Christmas dress is orange, you may wish to shy away from traditional red and green holiday layouts.

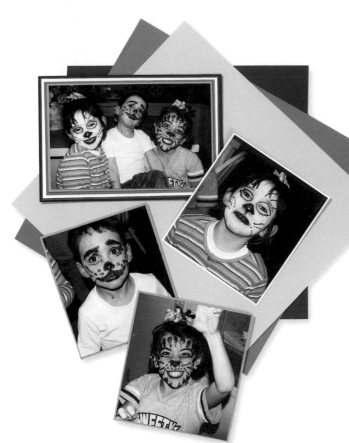

Color Psychology 101

Personality characteristics most commonly associated with colors:

Red—Power, intensity, passion, competition, sexuality

Orange—enthusiasm, vibrancy, flamboyance

—optimism, happiness, idealism, energy, imagination

Green—loyalty, intelligence, fertility, healing, ecology

Blue—peace, tranquility, harmony, trust, confidence

Purple—mystery, royalty, spirituality, creativity, unconventional

Pink—tender, feminine, romantic, affectionate, dainty

Gray—sadness, security, reliability, routine, lifeless

Brown—stability, simplicity, comfort, practicality, conservatism

Black—mournful, heavy, depressing, sophisticated, mysterious

White—cleanliness, purity, youth, simplicity, innocence

A Color Wheel

A color wheel is the perfect tool to help you find a variety of color combinations to complement or to contrast with the colors in your photos. A color wheel is easy to use. Point to your chosen color on the color wheel and arrows point you in the direction of great accent colors. Additional instructions included with the wheel will help you further utilize it. Learning to combine colors will bring new excitement to your layouts.

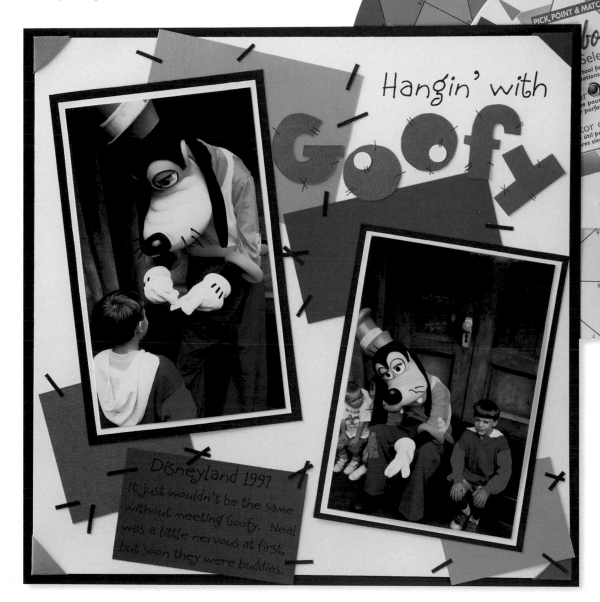

Hangin' With Goofy
COLOR SCHEME DEFINES PAGE

The golden color of Goofy's shirt as well as the jewel hues from the background curtain and children's clothes are perfect choices for this fun and simple design. The clean white background paper provides a neutral base for the vibrant page accents.

Torrey Miller, Westminster, Colorado

Color and Emotion

Studies show that exposure to certain colors elicits different emotions and behaviors in people by activating specific brain pathways, causing them to release particular neurochemicals. For example, yellow stimulates appetite while pink can accelerate healing. But how can this theory benefit your scrapbook pages? Use the chart below to help select the perfect colors to accompany your page's mood.

Sporty Colors like bright red, blue, yellow and green, are sharp, witty and unique. Looking at them, you can almost feel the energy taking fire within. Use them to scrapbook athletic events, such as football games, baseball practices or cheerleading tryouts. Or add a dash of excitement and sparkle to family activities, like trips to the amusement park, circus or zoo. They may be perfect to convey intense emotion.

Earthy Tones such as tan, chestnut brown, olive green and deep burgundy evoke a strong sense of inner peace, tranquility and well-being. They remind us of meaningful conversations with family and friends and can be used to help dispel loneliness. A great choice for scrapbooking nature-oriented activities such as hiking, camping, raking leaves or lazy Sunday afternoon strolls in the park.

Tropical Colors like bubble gum pink, teal, bright yellow and lime green are fun, exciting, whimsical hues. They charge the body with a playful sense of energy and vitality, instilling a rich sense of joyful freedom. Use these colors to scrapbook childhood activities such as birthday parties, swim meets and parades. Or, choose holiday-oriented themes, like dyeing Easter eggs.

Jewel Colors such as copper, gold, royal blue and deep purple command respect without being overbearing. They help convey the message that an individual is intelligent, well-traveled and has something important to say. The best activities to scrapbook with these "jems" are accomplishments—think graduations, promotions or special honors and awards.

Tranquil Colors such as slate blue, wintergreen and buttercup inspire feelings of refreshment and rejuvenation within your soul. By seeping into your conscience and silencing your innermost fears, they evoke those peaceful feelings experienced when reading, writing, sleeping in or cuddling with your significant other in front of the fireplace.

Dark Colors like navy blue, forest green and brick red are solemn, more sophisticated tones. Typically associated with maturity, stability and seriousness, use these hues to pay tribute to the elders in your life. A Father's Day page would be great!

Ethnic Colors like dandelion yellow, mahogany and plum are oozing with mystery and spice. They are perfect for scrapbooking the unfamiliar—maybe a first-time vacation to a far-away land, or a Saturday night salsa date with that hot, handsome stranger.

Cool Colors such as sky blue and sage green provide a calming ambiance by sweeping feelings of relaxation, focus and meditation throughout your body. A wonderful seasonal hue, cool colors are most commonly associated with winter, but can also convey feelings of peaceful summer afternoons as seen on "Simplicity" (page 377).

Country Tones like dusty red and frosted blue are most commonly associated with feelings of coziness, homeliness, and security—think momma's cute little white-picket-fenced house. The events you choose to scrapbook using these tones may vary. Perhaps a homemade chili dinner served around a warm fire?

Victorian Colors such as rusty gold and royal velvet conjure up images that are old-fashioned, awe-inspiring and even somewhat intimidating. Many people choose to use these colors on their heritage pages. Nothing says authentic 19th century better than the antique velvet shades of your great-grandmother's favorite dress!

Romantic Hues including soft pastels such as apricot, periwinkle and buttercup, have an interesting ability to halt the body's desire to stay angry. Exuding femininity and innocence, they are perfect for capturing life's precious, tender events like the birth of a baby, a spring wedding, Easter Sunday and any "girl themed" pages.

Chic Hues such as blue-gray, black and burnt sienna exude elegance, sophistication and class. Most commonly associated with intelligence, these colors are perfect for scrapbooking professional events like first days on the job, work presentations and public speaking endeavors or anything that screams "businesswoman in suit!"

Fever

USE MONOCHROMATIC COLOR SCHEME
TO ENHANCE LAYOUT THEME

Dee uses vibrant, lively colors to reflect her son's physical discomfort over a 102-degree fever. Tear edges of solid paper, chalking around torn edges. Mount on background paper; tear vellum and patterned paper (Paper Adventures) strips; layer at top and bottom of page. Cut title using template (Scrap Pagerz) and patterned paper; mat on solid paper and silhouette. Layer on vellum strip over fibers. Mat photos on torn patterned and solid papers. Print text on vellum; tear edges and mount. Embellish bottom of page with fibers, tag (Avery) and brads (American Tag Company).

Dee Gallimore-Perry, Griswold, Connecticut

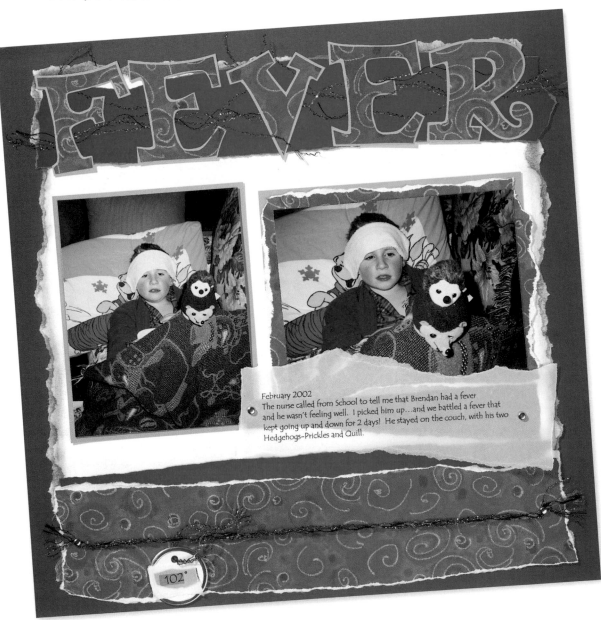

Simplicity

SET THE TONE WITH COOL COLORS

Jodi's choice of a cool color palette reflects the calm and carefree mood of her seaside photos. Build a color-blocked background by cutting rectangles in shades of green and plum; layer on page as shown. Mount photos on page. Trace type font lettering onto vellum; tear around edges and mount. Adhere starfish (Crafts, Etc.).

Jodi Amidei, Memory Makers
Photos, Kimberly Wall, Palm City, Florida

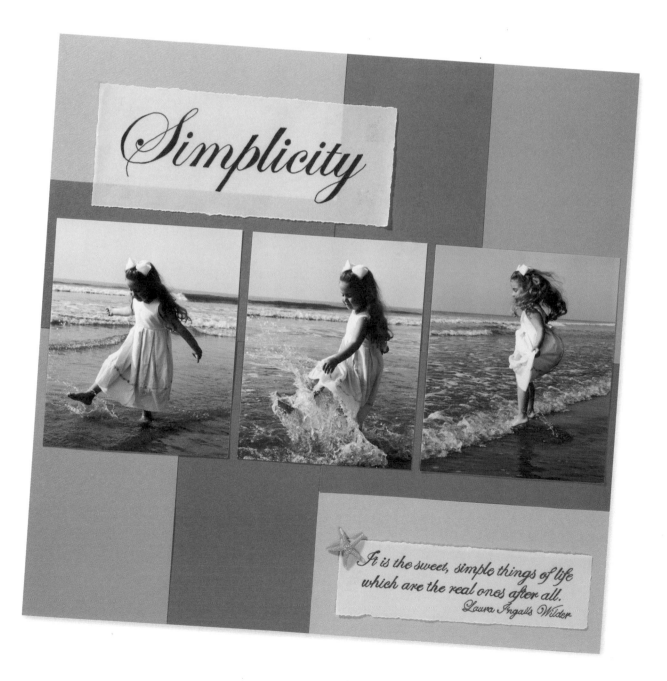

It is the sweet, simple things of life which are the real ones after all.
Laura Ingalls Wilder

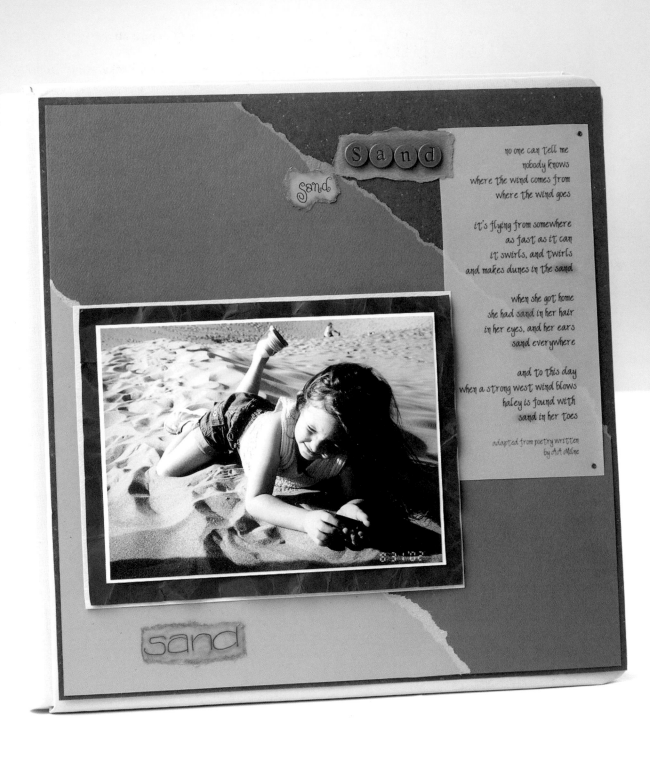

Sand

Sand

no one can tell me
nobody knows
where the wind comes from
where the wind goes

it's flying from somewhere
as fast as it can
it swirls, and twirls
and makes dunes in the sand

when she got home
she had sand in her hair
in her eyes, and her ears
sand everywhere

and to this day
when a strong west wind blows
haley is found with
sand in her toes

adapted from poetry written
by AA Milne

sand

Chapter 2
Backgrounds

One of the easiest ways to create an attractive scrapbook page is to design your own background. In doing so, you're assured of a one-of-a-kind scrapbook design. And you'll buy yourself hours of scrapbooking time by eliminating the need to rush about town in search of that perfect piece of paper to match your page theme.

In this chapter you'll find dozens of terrific quick and easy backgrounds that can be made by incorporating commonly used scrapbooking techniques including paper tearing, stamping and color blocking. These ideas can be customized for your page themes, whether it's a spread illustrating the steep granite mountains of Yosemite National Park or a bright, boldly colored page mimicking the cheery lines in a child's sweater.

Whether you're dressing, cooking or constructing album pages, you must begin by creating a basic form. The satin and lace, the icing and candy flowers or the matted and mounted photos will sit prettier on just the right foundation.

Pre-Made Product

Designed with super-easy layout in mind, pre-made backgrounds and page components come in a variety of colors, patterns and themes. Just place your photos, title and journaling.

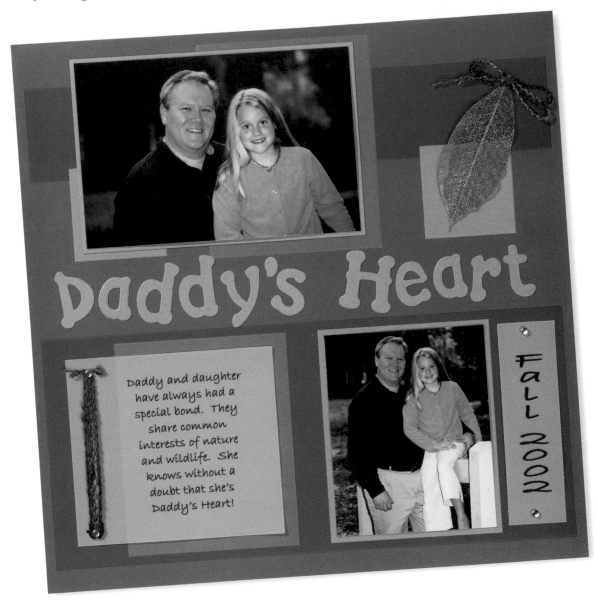

Daddy's Heart

EMBELLISH PREPRINTED PAPER

Valerie adds a personal touch to preprinted and designed background paper with textured embellishments. Mat photos; mount on background paper (All My Memories). Mount die cut letters (Accu Cut) at center of page. Print journaling and photo caption onto vellum; mount on page with small brads (Impress Rubber Stamps). Wrap fibers (On The Surface) around brads. Mount skeleton leaf (Graphic Products Corp.) on page; tie fibers into bow and mount on page.

Valerie Barton, Flowood, Mississippi

Portrait of an Artist

USE COORDINATING PAPERS TO ADD COLOR

Tracy used a coordinating patterned paper set (SEI) to create borders, mat photos and enhance text blocks with lots of color and style. Single, double and triple mat photos on solid and patterned paper. Slice strips of patterned paper; mount on page as a bottom and side border. Print title and text on vellum; mount over patterned paper with eyelets (Doodlebug Design). Adhere sticker letters (Colorbök) on title block.

Tracy Miller, Fallston, Maryland

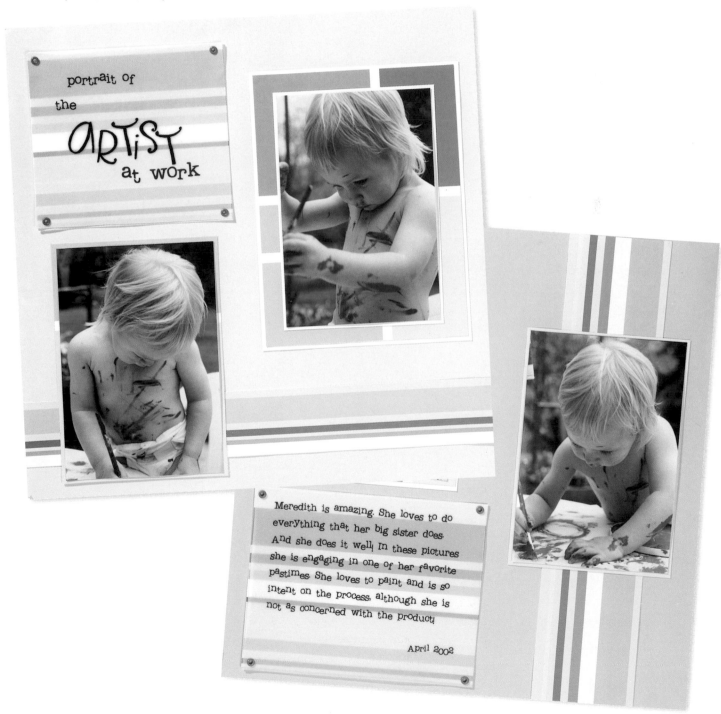

Straight Up

TEAR A STAMPED BORDER

Oksanna recreated the solid rock walls she encountered at Yosemite by stamping gray paper with different colors of ink before tearing and mounting on her page. Print title on solid and vellum papers. Mat one photo on vellum; tear on one side. Stamp sand (All Night Media) in various shades of gray and brown to resemble granite. Tear paper and mount at left side of page. Cut first letter of title from template (C-Thru Ruler); mount over torn paper. Layer vellum and photos on right page.

Oksanna Pope, Los Gatos, California

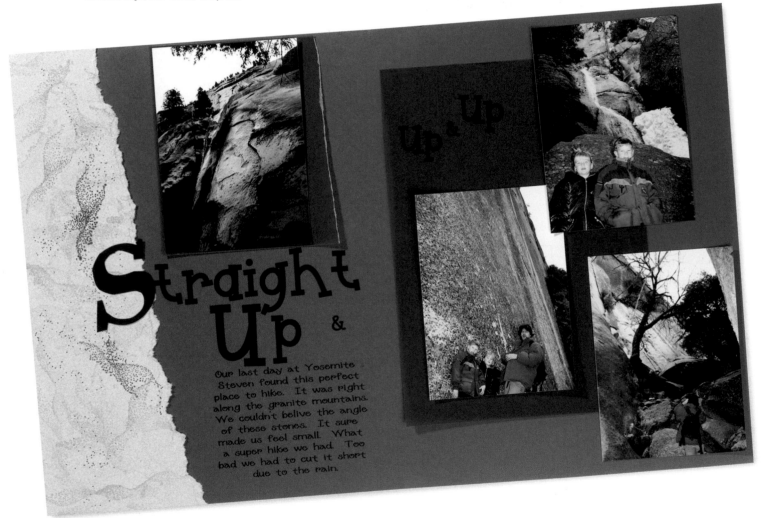

Quick Tip: Tearing paper of all textures and thicknesses offers a decorative edge that softens a page's look. Vary the direction, speed and angle of your tear to achieve surprising and spontaneous results.

Perspectives

ADD FIBER TO PAPER-TORN EDGES

Soft, delicate fibers border paper-torn edges on Jodi's monochromatic page. Follow the instructions below to complete this fun background. Slice window at bottom of page; attach memory keeper (C-Thru Ruler) and trim with fiber. Print journaling onto vellum. Stamp shadow boxes (Hero Arts) and title letters (Plaid Enterprises). Cut to size and layer on page with matted photos.

Jodi Amidei, Memory Makers
Photos, Torrey Miller, Westminster, Colorado

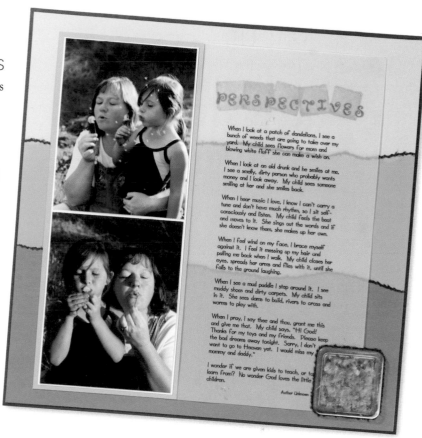

1 Vertically tear piece of darkest green cardstock into a rectangle approximately ⅓ the height of the original page. Tear medium green cardstock the same way.

2 Adhere dark green cardstock to medium green cardstock, overlapping slightly.

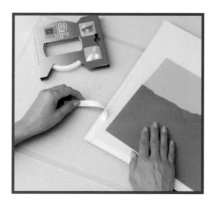

3 Mount dark and medium green cardstocks on light green cardstock.

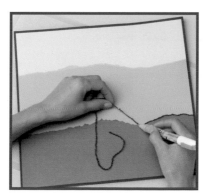

4 Using a fine-tipped glue pen, apply glue to torn edges; push fiber into glue. Work in small sections.

Aysha and I

WEAVE A TORN MULBERRY BACKGROUND

Trudy's softly woven mulberry background reflects the tenderness of a mother-daughter moment. Gently tear mulberry paper (PSX, Scrapbook Sally)into strips of various widths, using the method shown below. Loosely weave strips using an under/over technique; mount to white background. Print title and journaling onto vellum; mount on page. Mat photo on paper, leaving room at bottom for embellishing. Adorn title block and photo mat with colored fibers (DMC) and glass pebbles (Magic Scraps).

Trudy Sigurdson
Victoria, BC, Canada

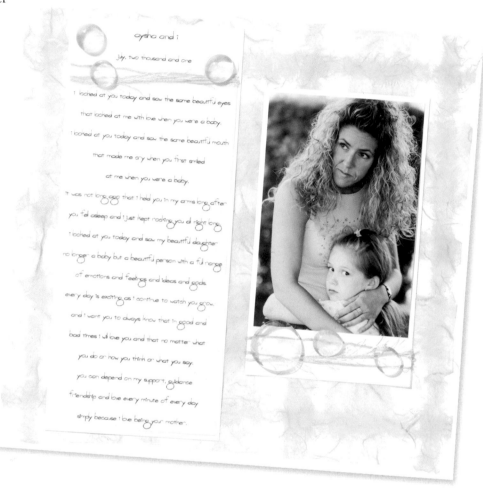

1 Line up grid ruler vertically across edge of mulberry.

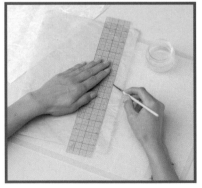

2 Dip paintbrush lightly into water and draw line down the edge of the paper, following ruler's edge.

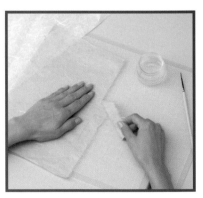

3 Gently tear mulberry along water-lined edge to create frayed look.

Nature's Colors

PAPER TEAR A COLORFUL BACKGROUND

Kelly pulls natures colors from her photos and weaves them into a vibrantly colored background. Tear approximately ½" paper strips from a variety of solid-colored papers. Weave together using the under/over technique. Single and double mat photos. Print partial title and journaling onto vellum, leaving room for balance of title. Cut title letters from template (EK Success) onto patterned paper (Karen FosterDesign); outline with black pen.

Kelly Angard, Highlands Ranch, Colorado

Color Blocking

Creating blocks of color to serve as the background pattern adds dynamic dimension to your pages. Experiment with tried-and-true, as well as less common, color combinations. Don't be afraid to use patterns as well as solids for a truly contemporary effect.

Friends

FRAME PHOTO WITH MUTED COLORS

Holly pieced together a simple color-blocked background of muted colors to frame a favorite childhood photo. Divide page into equal quadrants; cut solid-colored paper to fit quadrants and mount. Mat photo. Print title and photo caption on vellum (Close To My Heart); cut to size and mount.

Holly Van Dyne, Mansfield, Ohio

The Many Faces of Cade

HAND-STITCH PHOTO CAPTIONS

Candice chronicles the many expressions of her baby nephew's face on a patterned paper (Colorbök) that gives the illusion of a color-blocked design. Crop photos all the same size. Print title, journaling and photo captions on vellum (Keeping Memories Alive). Cut to size and hand-stitch onto page with embroidery floss (DMC).

Candice Cruz, Somerville, Massachusetts

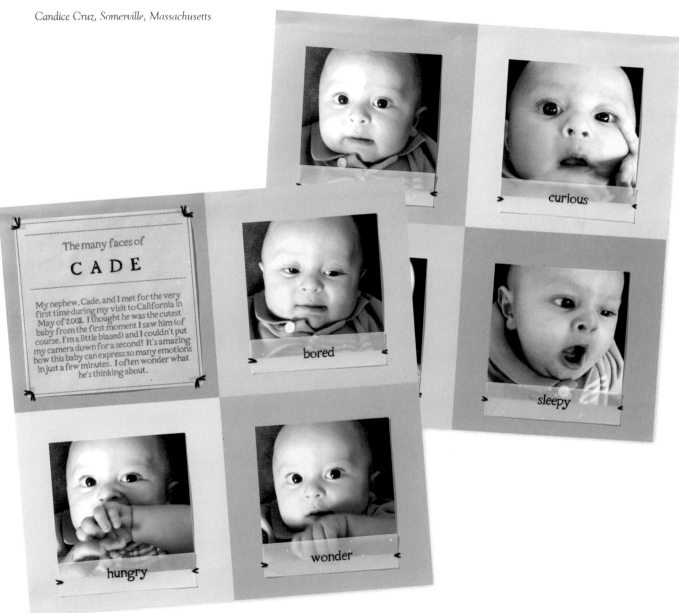

Quick Tip: Don't worry about a lack of journaling space on crowded scrapbook pages. Simply print portions of your journaling on vellum. Apply directly over photos, or portions of photos. Your images will shine through and your words will still be conveyed.

Autumn

COLOR BLOCK WITH PATTERNED PAPER

Katie ventured into unknown scrapbooking territory by using Twistel and a color-blocking design for her background. Divide page into three sections; cut coordinating patterned paper (Scrap Ease) into rectangles to fit each section. Mount on solid-colored background paper. Mount eyelets (Emagination Crafts) at each corner. Thread Twistel (Making Memories) through eyelets to frame page. Double mat photo on patterned paper and vellum; mount photo with clear corners. Cut large title letters from template (Scrap Pagerz); mat and silhouette cut. Print balance of title and photo caption onto solid-colored paper. Cut to size and layer under vellum strip.

Katie Swanson, South Milwaukee, Wisconsin

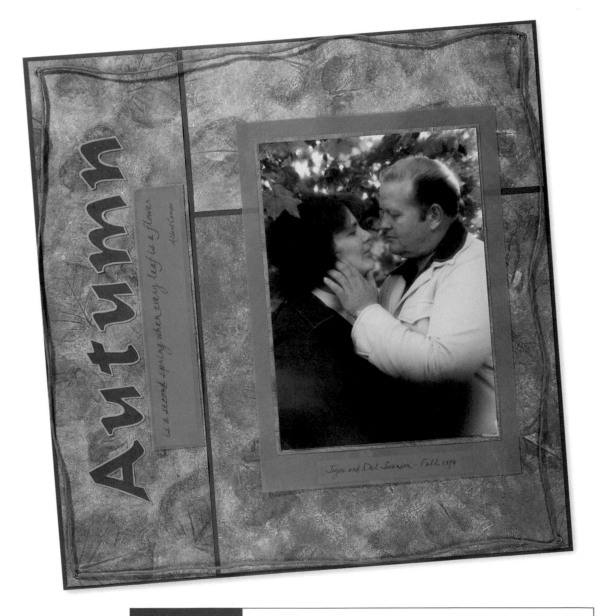

Quick Tip: Layer a piece of solid 8½ x 11" paper on top of a patterned piece of 12 x 12" cardstock for a quick, eye-catching matting effect (or, leave your background solid and layer patterned paper on top of it).

Freedom

DISTRESS PATTERNED PAPER

Diana uses coordinating papers from the same manufacturer to create quick and easy color-blocked pages. Print title and journaling onto patterned (Provo Craft) and vellum papers. Divide page into quadrants; cut patterned paper to fit sections, as shown in the steps below. Gently sand edges of all paper pieces with fine-grade sandpaper. Mat photo and mount. Layer tag with photo, printed vellum and patterned paper. Gently curl edges of torn patterned paper with finger for a worn look. Add eyelet (Creative Impressions) and stitched star button (Just Another Button Company); tie fiber through eyelet.

Diana Hudson, Bakersfield, California

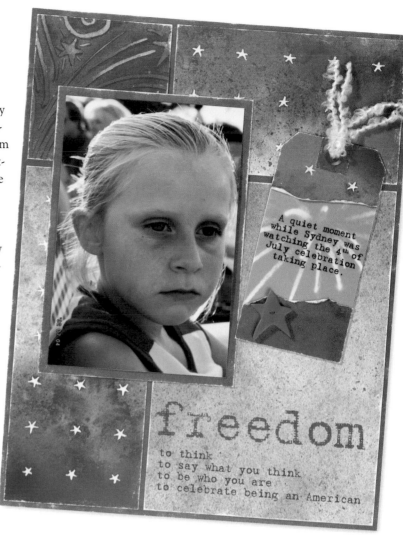

1 Using grid ruler, determine size of four blocks for background. Background sections may be any size you wish.

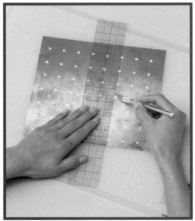

2 Cut out blocks using craft knife or paper trimmer.

3 Mount in sections to background paper using whatever adhesive you desire.

Jeanette Likes

SLICE A STRIPED BACKGROUND

Andrea finds inspiration for her page in her daughter's colorfully striped sweater. Slice strips of colored paper in varying widths; mount side by side on page. Print title, journal list and captions on vellum. Cut to size; mount on page with large eyelets (Impress Rubber Stamps) and clear vellum adhesive. Mount flower embellishments (Hirschberg Schutz & Co.).

Andrea Hautala, Olympia, Washington

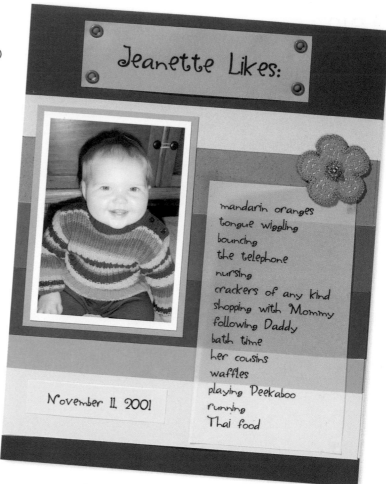

Somers Family Reunion

ADD DIMENSION WITH VELLUM LAYERS

Sara layers vellum scraps over torn mulberry to achieve a soft, color-blocked background look. Mount torn mulberry (Bazzill) square onto background. Mount vellum strips in a variety of dimensions over one another as shown. Print title and journaling onto clear vellum (Paper Adventures); cut to size and mount on page.

Sara Perlberg, Milwaukee, Wisconsin

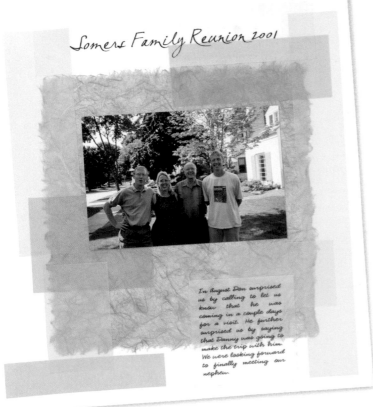

Leia

COLOR BLOCK A MONOCHROMATIC BACKGROUND

Shawn enhanced the natural setting of her photos with an elegant, monochromatic background. Begin by dividing page into quadrants; crop solid-colored paper to size. Mat photo on white paper; adhere decorative leaves (Graphic Products Corp.) at corners and mount over vellum onto page. Mount antique leather strap to page. Cut vellum frame for smaller photo; mount on white paper strip and over leather strap. Print title and text on vellum; layer on background and solid paper strip. Anchor text block in antique clip.

Shawn Baker, Maywood, Missouri

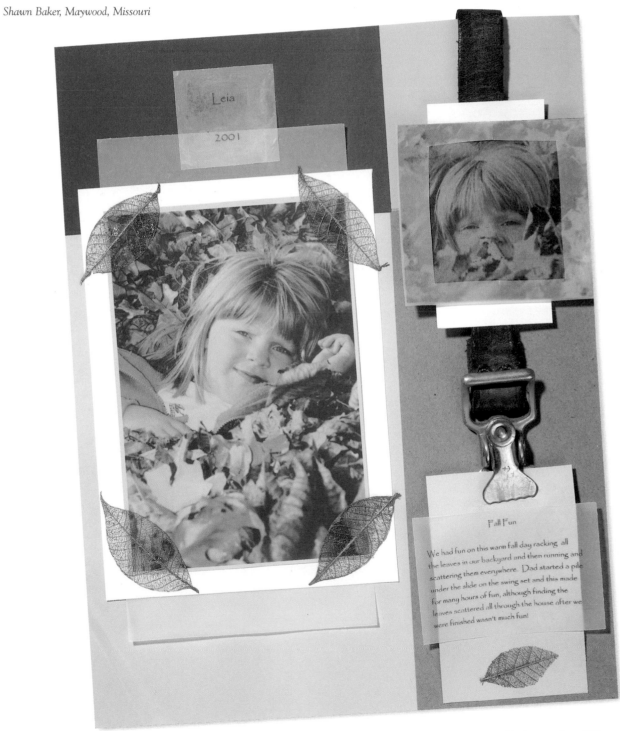

Haley Jo

STAMP SEASONAL COLOR-BLOCKED BACKGROUND

Torrey adds understated impact with seasonal trees stamped on a muted, color-blocked background. Divide page into four sections. Cut rectangles from solid-colored papers to fit sections. Stamp seasonal trees (Hero Arts) using Versa Mark (Tsukineko) creating a watermark effect. Print title onto paper. Mount all rectangles, leaving space between each piece. Mat photo; mount on background. Mount buttons (Making Memories) at photo corners.

Torrey Miller, Westminster, Colorado

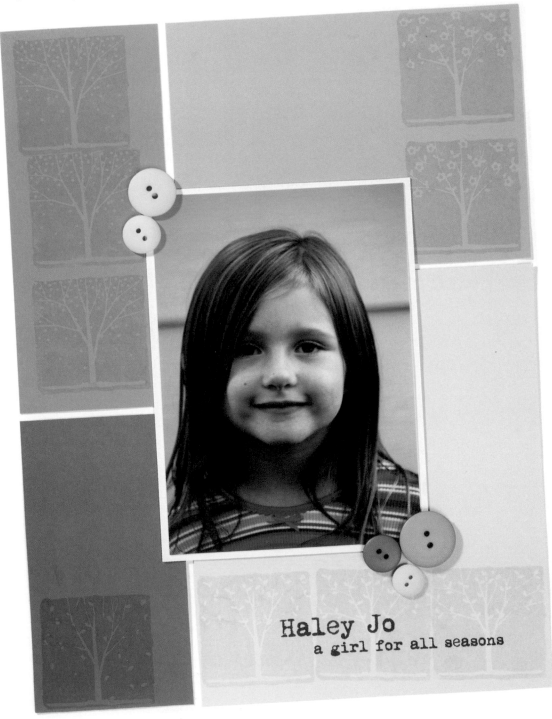

Blooms

STAMP A BACKGROUND

Jodi stamped a colorful background using a stipple brush, four colors of ink and a mosaic overlay (DieCuts With A View). Follow the steps below to create this stamped background. Double and triple mat photos. Freehand-write journaling; cut to size, stamp edges and mat. Stamp title letters (Hero Arts); cut to size and mat on two sizes of punched squares (Family Treasures). Stamp flower and leaf design (Hero Arts, DL Designs, Judi Kins); silhouette cut and mount.

Jodi Amidei, Memory Makers
Photos, Michele Gerbrandt

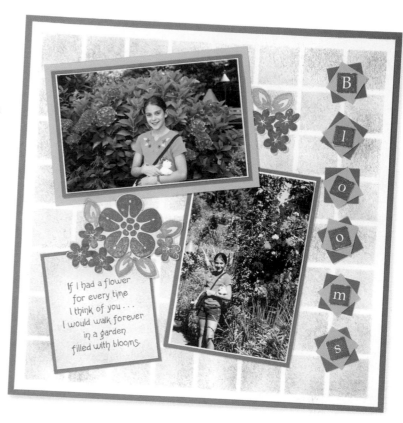

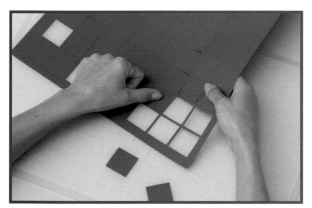

1 Punch out/remove squares in mosaic overlay.

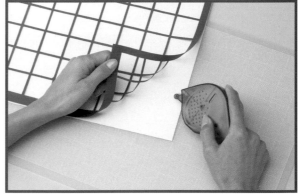

2 Using temporary adhesive, tape down edges of mosaic overlay to white background/cardstock.

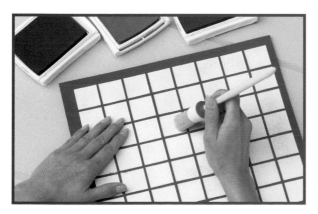

3 Lightly touch stipple brush to ink pad and "pounce" over entire mosaic overlay, varying intensity. Repeat with three other ink colors.

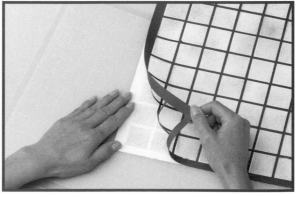

4 Remove mosaic overlay revealing beautifully stamped pattern.

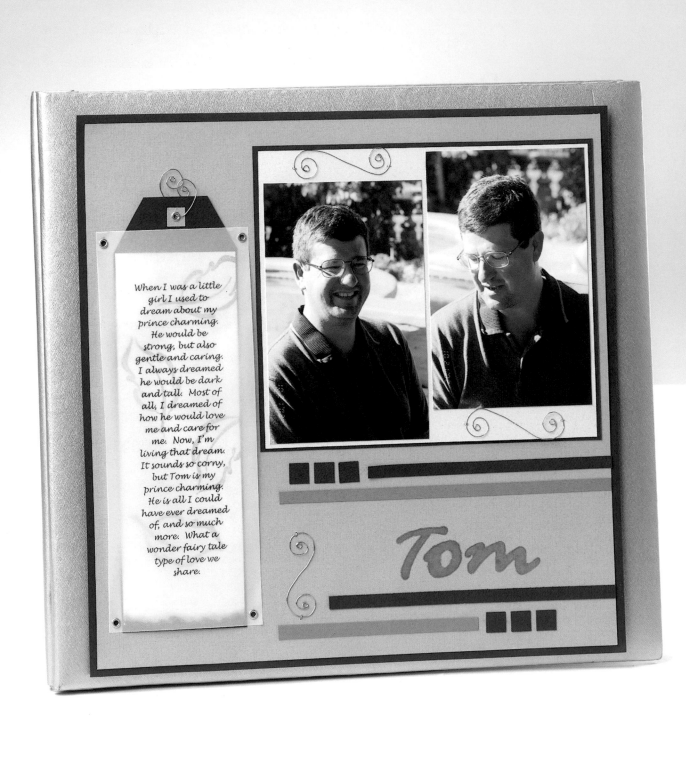

When I was a little girl I used to dream about my prince charming. He would be strong, but also gentle and caring. I always dreamed he would be dark and tall. Most of all, I dreamed of how he would love me and care for me. Now, I'm living that dream. It sounds so corny, but Tom is my prince charming. He is all I could have ever dreamed of, and so much more. What a wonder fairy tale type of love we share.

Tom

Chapter 3
Titles, Borders & Mats

The three basic elements of scrapbooking are photos, journaling and memorabilia. But experienced scrapbookers recognize that those important pieces are better showcased on beautiful pages that include titles, borders and matting.

A title heads a scrapbook page, acts as an important focal point and helps orient the viewer so she can be better prepared to put the pictures and journaling in perspective. Borders and mats bring balance and focus to featured photos. Titles, borders and mats all add an exciting artistic touch to a page.

In this chapter, there are dozens of quick and easy examples of outstanding title, border and mat treatments. Whether dressed up or down, these page ideas are sure to garner attention.

Titles

A strong title is a descriptive headline that sums up the theme of a scrapbook page. It can set the scene and supply basic information. Titles should also be a principal part of a page design. Handmade and pre-made tags are perfect for creative title treatments for a multitude of looks. You may also wish to dress up your titles by stenciling, adding stickers or using around-the-house materials.

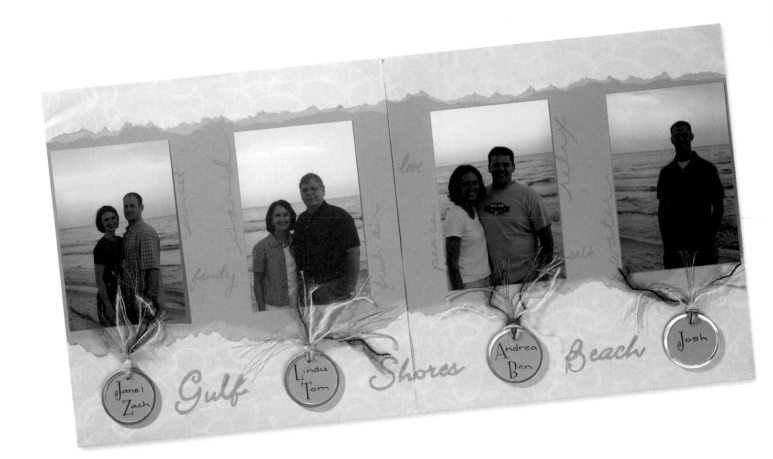

Gulf Shores Beach
IMPLEMENT TAGS INTO YOUR TITLE

Beautifully embellished tags enhance Andrea's page and serve as a creative place for photo titles. Tear solid-colored paper at top and bottom; mount over patterned background paper (Colorbök). Mount photos on torn paper; add descriptive words with light gray pen. Print title words; silhouette using craft knife. Embellish tags with fibers (Fibers by the Yard); adhere sticker letter capitals (Me & My Big Ideas/MAMBI) and pen remaining letters.

Andrea Steed, Rochester, Minnesota

Bloom Where You're Planted

PHOTO-EMBELLISHED HANDMADE TAGS

Christie's handmade tags provide a perfect spot for title words and cropped photos. Single and double mat photos. Print title words on solid-colored paper. Craft handmade tags around words; embellish with flower eyelets (Stamp Doctor), paper yarn (Making Memories), cropped photos and pen details. Use die-cut letters (Ellison/Provo Craft) for large title word; chalk around edges for dimension. Print journaling on vellum; mount on cardstock, shade with chalk and add paper yarn. Complete page with wire (Artistic Wire) and bead (Westrim) details.

Christie Scott, Trevor, Wisconsin

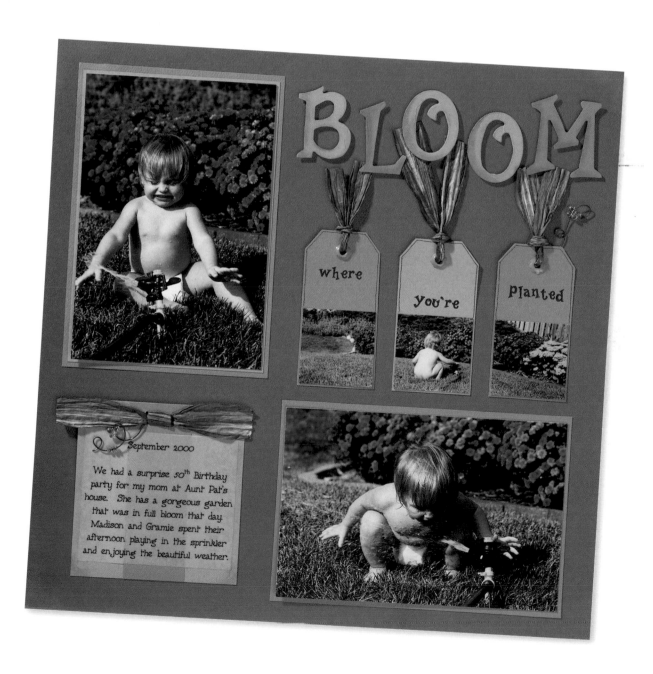

Little Man at Work

EMBELLISH WITH REALISTIC MATERIALS

Tina incorporates real building materials into her layout to enhance the construction theme. Cut drywall tape to width of page. Stamp with black ink and set with clear embossing powder. Mat photos; mount on matted background paper. Mount game tiles (Hasbro) as title. Print journaling onto vellum; cut to size. Double mat and mount with small brads (Hyglo/American Pin). Print construction sign from computer (Microsoft Clip Art); cut to size and mount.

Tina Baggott, N. Augusta, South Carolina

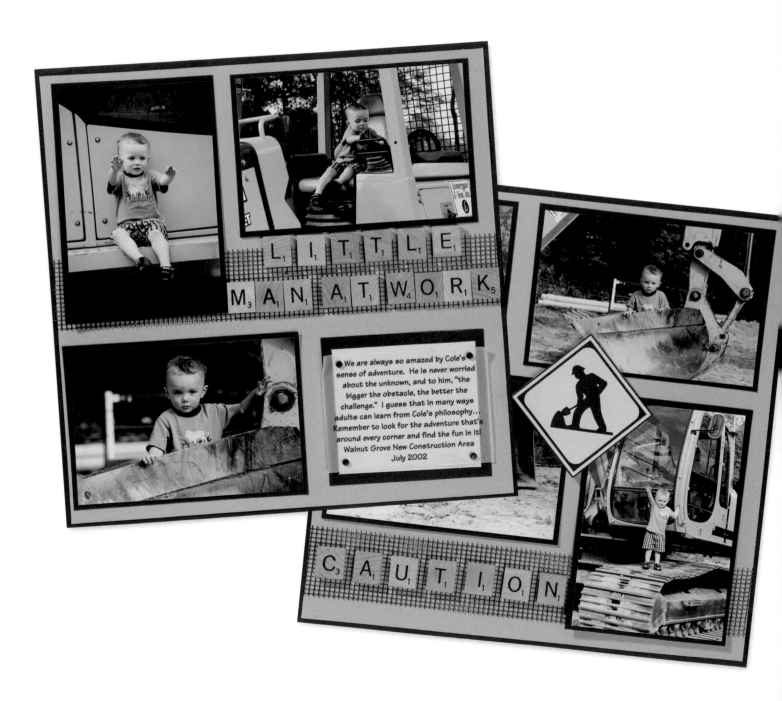

Creative Titles With Creative Materials

While there is a plethora of products available for scrapbookers who wish to create outstanding titles, you can find wonderful supplies for embellishing your work right in your own home. Check out your utility drawer, your sewing bin, toy boxes and art areas for bits and pieces that can be turned into works of art.

Kelli Noto, Centennial, Colorado

PLAYTIME

Letter tiles (The Paper Magic Group) linked together set the tone for playful pages. Mount tiles on background. Frame with paper squares cut in a variety of sizes; mount to back of matting as shown.

WILD THING

Add fuzzy texture to titles in the shape of letters with chenille pipe cleaners (Westrim). Bend pipe cleaners into letter shapes; mount on matted background. Adhere animal-print border stickers (Frances Meyers).

PARTY

Assemble iron-on fabric letters onto a double-matted strip for an interesting textured title. Adhere sticker strips (Mrs. Grossman's) to background in natural colors.

FINGER PAINT

Create a realistic title to showcase the works of your little artist by dipping alphabet-shaped cookie cutters into paint. Press onto paper; border with fingerpaint smudges around paper's edge.

LEGOS

Nothing makes a statement like the real thing; here thin lego pieces are mounted into letter shapes. Slice paper strips for border; mount around background edge with self-adhesive foam spacers.

SWEET BABY OF MINE

String a title of alphabet letter beads (The Beadery) on a sheer ribbon (Offray) for a delicate and easy title. Tie into bow at both ends. Mount on mulberry matted background.

Naming the Rabbits

EMBELLISH STENCILED LETTERS

Susan's layered and embellished title lends rustic charm to farm photos. Double mat photo in upper right corner; tear bottom of second mat and adorn with raffia bow. Mat photo to the left; mount eyelets (Impress Rubber Stamps). Tie raffia through eyelets; "hang" on page with small silver brad (Creative Impressions). Mount torn colored paper strip at bottom of page. Cut title letters from stencil (EK Success). Punch small circles with hole punch; add to letters. Intertwine raffia with title letters; mount with self-adhesive foam spacers. Print title and journaling on vellum. Cut to size; layer title strip on chalked bunny die cut. Mount journal block on solid paper with small silver brads. Adhere bunny sticker (Mrs. Grossman's).

Susan Kresge, Temple Terrace, Florida

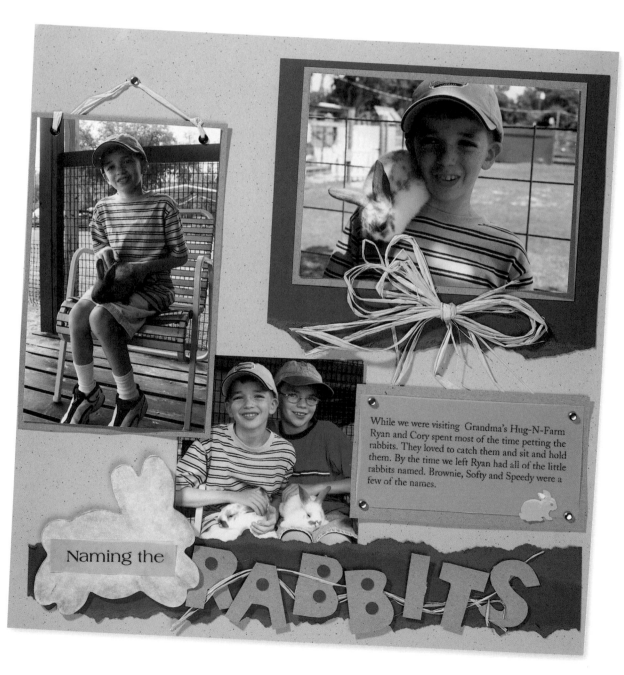

While we were visiting Grandma's Hug-N-Farm Ryan and Cory spent most of the time petting the rabbits. They loved to catch them and sit and hold them. By the time we left Ryan had all of the little rabbits named. Brownie, Softy and Speedy were a few of the names.

I Love My Daddy's Shirt

DRESS UP A TITLE

Most of Polly's inspiration comes from everyday life with her daughter, joyfully captured here. Mat patterned paper (Keeping Memories Alive); layer over solid background paper. Cut rectangles; mount down right side of page. Mat photos. Print journaling; cut to size and detail edges with pen. Freehand-write part of title; use template (EK Success) for other portion. Add pen and chalk details to title block; mat on torn paper. Tie jute to buttons; mount small heart button (Hillcreek Designs) on title block. Dangle black buttons with jute from punched holes on text block. Secure buttons to page with self-adhesive foam spacers.

Polly McMillan, Bullhead City, Arizona

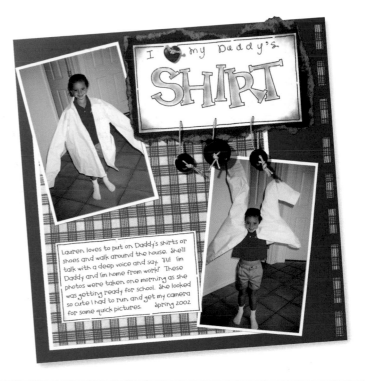

Six Ways to Use a Stencil

A stencil creates smooth, evenly spaced letters. It's up to you and your creativity how to decorate them!

Holle Wiktorek, Clarksville, Tennessee

SPRING

Trace and cut out letters from cardstock, outlining edges with blue marker. Embellish using template (C-Thru Ruler) randomly with 3-D stickers (Jolee Boutique) and mount on cardstock.

GIFT

Trace and cut out letters from cardstock. Stamp each letter (C-Thru Ruler); color in stamped area with markers. Embellish with handmade "for you" tag.

WEEDING THE GARDEN

Trace and cut out letters using template (C-Thru Ruler), then chalk. Add pen details to letters. Mount on cardstock, print words; draw weeds and chalk to complete.

PARTY

Using a stamp sponge (Tsukineko), pounce ink through stencil (C-Thru Ruler), concentrating on outside edges so they appear darker than the center section. Add pen details and mount on patterned paper then mount again on cardstock.

SNOW

Using chalk, brush through template (C-Thru Ruler), aiming strokes in one direction. Embellish with chalked snowflake punches (Paper Adventures) and double mount on cardstock.

USA

Mount three layers of torn coordinating paper onto cardstock. Trace letters through template (C-Thru Ruler) and cut out. Mount on cardstock.

Down by the Seashore

CUT TITLE LETTERS FROM LARGE STICKER

A large, horizontal sticker was creatively cut and layered into title letters for Lisa's page. Adhere sticker (Sandylion) to white cardstock strip; use Deja Views Spunky lettering template (C-Thru Ruler) for letters. Turn template over and trace letters backward on back of cardstock strip; cut out letters, paper tearing their tops. Cut title letters again from blue paper; layer and mount torn letter over blue letter. Mount small title letters on paper rectangles; detail with black pen. Tear white paper strips; mount. Adhere horizontal sticker onto blue cardstock strip; mount over white torn paper strip. Double mat photos. Mat journaling; adhere sticker letters (MAMBI) on journaling block. Make grid of string and brads (Making Memories) to link everything together.

Lisa Dixon, East Brunswick, New Jersey

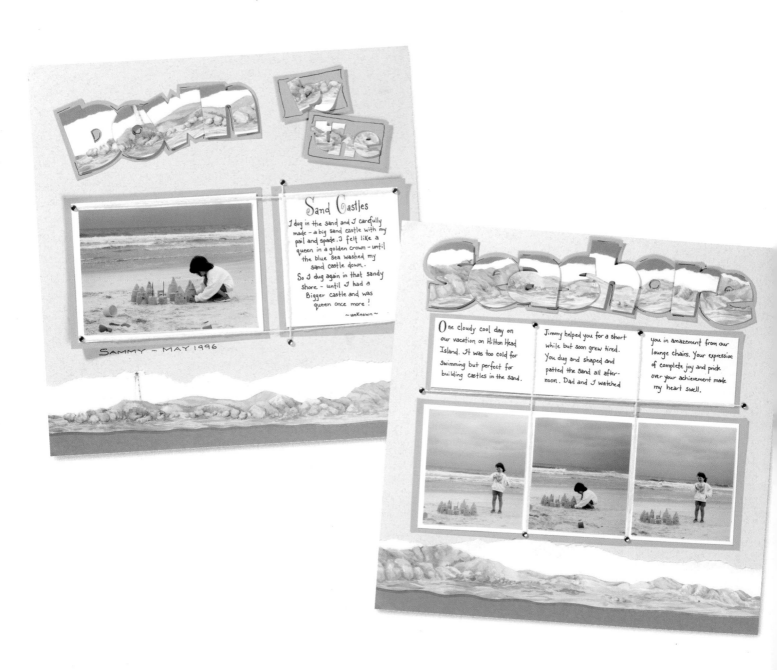

Heartbreaker

ADHERE A STICKER TITLE

Serafina captures the essence of her daughter's spirit with a one-word title. Layer solid-colored rectangle over patterned background paper (Scrap in a Snap). Adhere sticker letter title (Stickopotamus). Print journaling on vellum; adhere to page and embellish with pink ribbon (Stampin' Up!). Mat photos on opposite page on solid paper; mount over torn paper strip. Add heart buttons (source unknown) and ribbon embellishments.

Serafina Andolina,
Schenectady, New York

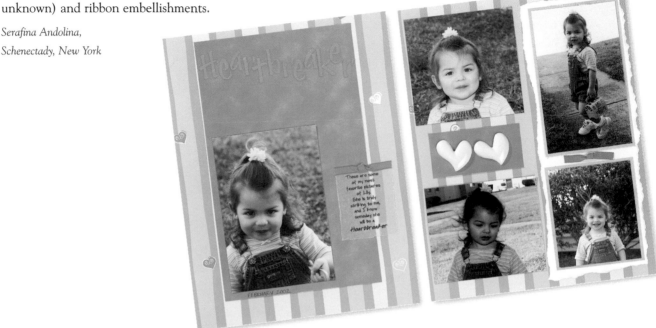

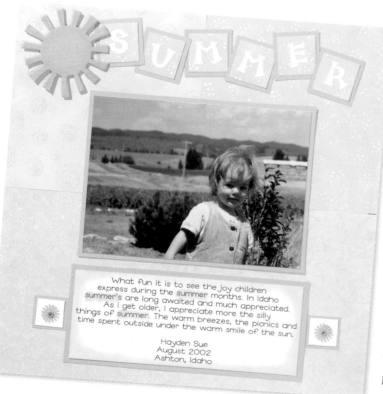

Summer Blocks

PUNCH SQUARES FOR TITLE LETTERS

Reeca's monochromatic color scheme gives warmth to an enlarged photo of her daughter. Cut one square of four complementary patterned papers (Provo Craft); adhere to page in quadrants. Punch squares in two sizes (Creative Memories) for title letters; layer as shown. Adhere sticker letters (EK Success) to squares. Chalk edges of sun die cut (Pebbles in My Pocket); mount. Print journaling; trim to size and mat. Add chalk details to highlight text and edges of text block. Punch small sun (EK Success); mount on small punched and matted square with eyelets (Doodlebug Design).

Reeca Davis Marotz, Idaho Falls, Idaho

Borders

Borders are the upper, lower and vertical edges of a scrapbook page. Decorative borders are design elements that embrace sections of a page, adding a portion of a frame. Borders can be made with creatively placed photos, punched shapes, stickers, color blocking or fibers to add quick and simple zip to any layout.

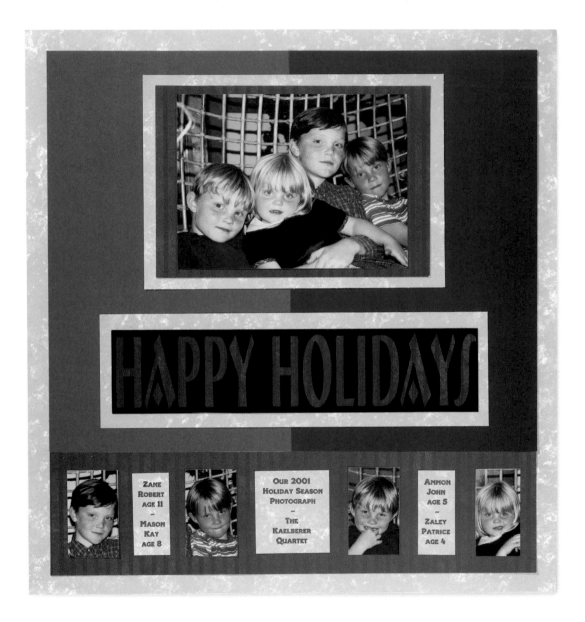

Happy Holidays

PIECE TOGETHER A PHOTO BORDER

Lisa highlights each child's unique personality on an eye-catching photo border. Double mat large photo on patterned paper (Mercer Motifs). Mount on matted color-blocked background. Adhere title sticker (Mercer Motifs) on patterned paper strip. Print photo captions onto patterned paper; cut to size. Mount on bottom border strip with cropped photos.

Lisa Kaelberer, Chyops, Bountiful, Utah

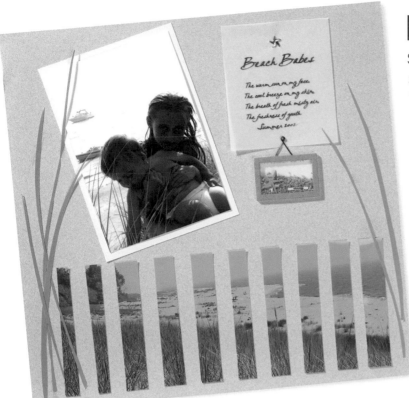

Beach Babes
SLICE A PHOTO BORDER

Simple slices of green paper accent Tammy's grassy seaside photos. Slice an enlarged photo at random intervals; mount at bottom of page leaving space between each slice to give the illusion of a panoramic photo. Mat photo; mount on speckled background paper (Bazzill). Slice thin, curved strips of green paper to resemble blades of grass; mount on page as shown. Print title and poem on vellum; add starfish nailhead (Jest Charming) and decorative shaker box (EK Success).

Tammy Gauck, Jenison, Michigan

When in Drought
PIECE TOGETHER A PHOTO BORDER

Torrey's photo border gives the illusion of a single panoramic photo, but is in fact the same photo duplicated and "spliced" together. Print title on solid-colored paper, tear into strips and layer on page. Single, double and triple mat photos. Hang sunflower charms (Charming Pages) from handmade wire (Artistic Wire) swirls. Print journaling on vellum; trim to size and run through Xyron machine before adhering over photo. Stamp sunflower (PSX) and silhouette shape; mount on title strip using foam spacers for added dimension.

Torrey Miller, Westminster, Colorado

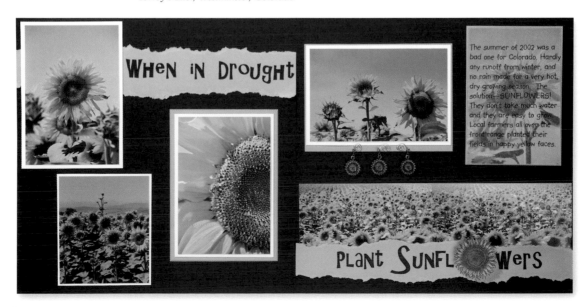

Megan

PUNCH A GEOMETRIC BORDER

Angie assembled this portrait page of her daughter in less than 15 minutes
with the help of geometric-shaped punches. Mat photo; cut photo corners
with decorative scissors (Provo Craft). Punch eight "v" shapes with chevron
punch (Family Treasures) from coordinating patterned papers (Paper
Adventures) for each border. Mount on page as shown. Punch squares for
center of borders and title letters. Adhere sticker letters (Paper Adventures)
for title.

Angie Villandre, Westfield, Indiana

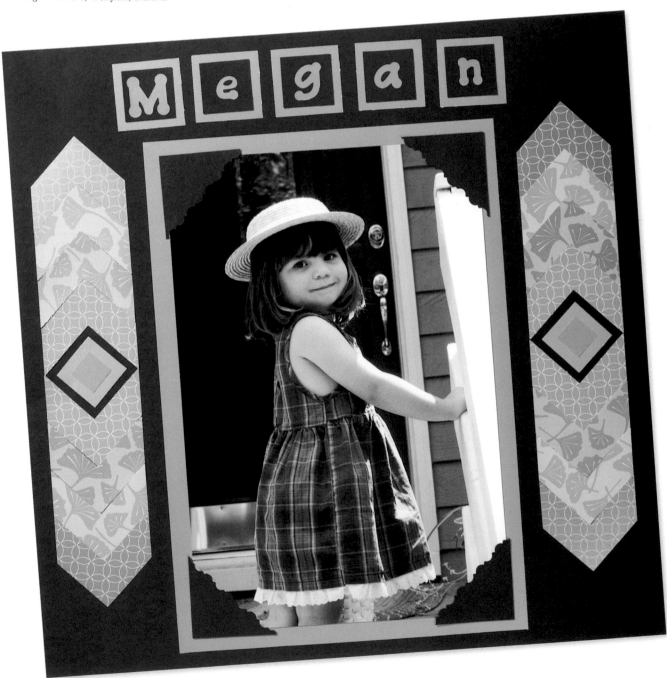

Daddy and Jarod

PUNCH A DELICATE BORDER DESIGN

A punched border from patterned paper gives a lacy look to Tracie's page. Double mat photo on patterned paper (Scrap Ease); mount on background paper. Slice border strips from patterned papers; trim one strip with decorative scissors. Use border punch (Emagination Crafts) on other paper strip. Steps for creating a neat continuous border are shown below. Layer both strips on left side of page as shown. Print title onto vellum (Paper Adventures). Paper tear to size and mount. Punch heart (Punch Bunch); tie fiber (source unknown) into bow and mount on heart.

Tracie Zody, Richmond, Virginia

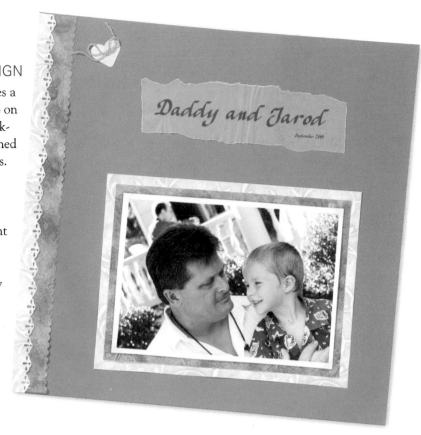

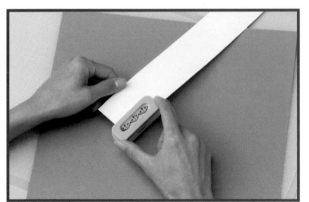

1 Punch the first design on edge of paper.

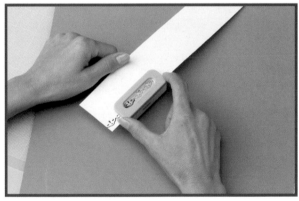

2 To create continuous borders, align edge of punch so patterns overlap. The end of your first punch pattern should overlap with the beginning of your second.

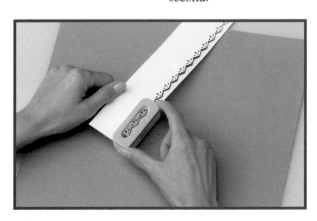

3 Continue punching down the edge of paper until the border is complete.

Among the Giants

ADD DIMENSION TO A STICKER BORDER

Large tree stickers are layered with foam spacers to add dimension to Kelly's paper-torn border. Paper tear monochromatic strips; layer and attach with eyelets. Adhere tree stickers (Provo Craft) to ivory cardstock; silhouette-cut around image. Layer on paper-torn border with self-adhesive foam spacers. String hemp cord through eyelets; secure at back of page. Double mat photos with solid and patterned (Scrap Ease) papers; mount. Adhere sticker letters (Debbie Mumm, Creative Imaginations).

Kelly Angard, Highlands Ranch, Colorado

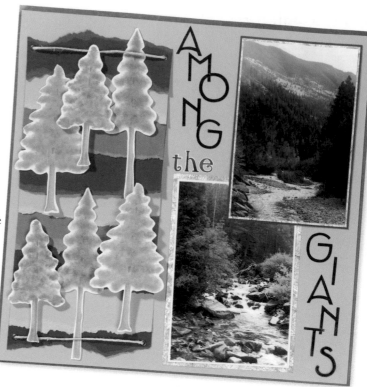

Quick Tip: Instead of spending a ton of money on new lettering stickers, improvise with your leftovers: With a little creative rearranging, a backward "3" becomes an "E," an upside down "7" becomes an "L," and a trimmed "O" becomes a "C." Bonus: You might even stumble upon a new font!

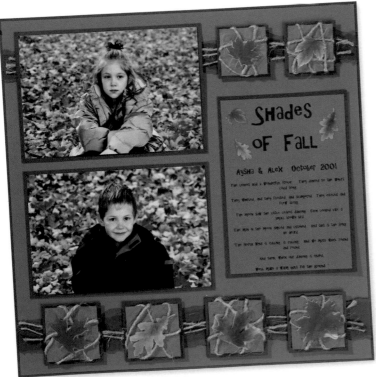

Shades of Fall

CRAFT A DIMENSIONAL STICKER BORDER

Trudy's rustic, dimensional border is topped with colorful leaf stickers that look authentically real. Layer solid papers for background. Tear paper strips for borders at top and bottom of page; mount strips of twine (Earth Goods) on top. Cut 1½" and 2" squares; crumple paper and wrap with twine before matting. Adhere leaf stickers (Creative Imaginations); mount squares over border strips. Print title and journaling; cut to size and mat. Complete page by matting photos and adding small leaf stickers to journaling block.

Trudy Sigurdson, Victoria, BC, Canada

Sticker Borders

Add oomph to borders with artistic, versatile and easy-to-apply stickers. Layer, cut, scene build and much more!

Trudy Sigurdson, Victoria, BC, Canada

SEASHELL

Build a dimensional sticker border with a strip of seashell stickers (Provo Craft) cut into squares and reassembled. Mount on double-matted border strip with self-adhesive foam spacers.

FLOWERS

Tulip bulbs burst into full bloom from layered torn paper strips. Gently slice leaves from stems on flower stickers (Provo Craft); dust sticky side with powder to remove tackiness; set aside. Adhere flowers to torn paper strip. Mount with self-adhesive foam spacers. Add another torn paper strip across the bottom using self-adhesive foam spacers.

SNOWFLAKES

Sheer vellum snowflake stickers dusted with powder (Autumn Leaves) keep their translucent beauty while mounted on blue-and-white fiber strands (On The Surface) with self-adhesive foam spacers.

BUTTERFLIES

Colorful butterflies look as if they're about to take flight because of a clever dimensional layering technique. Mount butterfly stickers (Colorbök) on border strip. Punch square shape into butterfly. Mat square on solid-colored paper; mount over punched area with self-adhesive foam spacers.

DAISY

Delicate daisy stickers (Frances Meyer) are mounted on double-matted rectangles and tied with sheer ribbon bows to matting. Use this easy idea with a variety of stickers and fibers to match the theme of your page.

CHRISTMAS LIGHTS

Add a string of snow-covered Christmas lights to a holiday border with sheer sticker bulbs dusted with powder (Provo Craft) and mounted with self-adhesive foam spacers. Slice wavy border from white cardstock; decorate with shaved ice (Magic Scraps) to give a sparkly, snowy effect.

The Great Toilet Paper Caper

ZIG ZAG A SOFT FIBER BORDER

Andrea captured the chaos of a toddler's curious mind with a comical title and dimensional border. For left page, vertically tear solid green paper; mount white brads (Hyglo/American Pin) 1½" apart on each side. Adhere torn paper over patterned paper (Colors by Design) with self-adhesive foam spacers. Zig zag chenille fiber (Lion Brand Yarn), securing under brads. Mat photo on large rectangle, leaving room for title block. Print title in various fonts and colors. Cut to size and block together. For right page, tear patterned paper and mount as a border. Mount photos. Print journaling; cut to size and mat, tearing bottom.

Andrea Hautala, Olympia, Washington

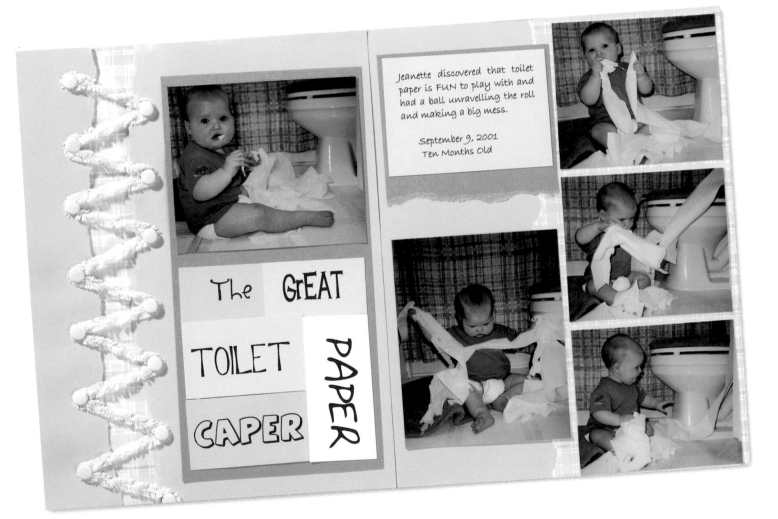

> **Quick Tip:** Avoid repeating the same old words over and over and over and over again. Pick up a thesaurus (or use one available on your computer) to track down fresh words that convey similar meanings. Your journaling will become vibrantly more interesting.

Forever

WRAP A SOFT FIBER BORDER

Holly wanted to make sure attention wasn't detracted from a treasured photo, so she opted for a simple layout with short, concise journaling. Mat photo on solid paper; mount on speckled background paper. Print title and journaling on white paper; cut to size. Color title letters with colored pencils. Mat on solid paper torn at the top before mounting on page. Create a soft border by wrapping chenille strands (Lion Brand Yarn) around the bottom of the page. Make your fiber border more stable by following the steps illustrated below. Tie into a bow to secure.

Holly Van Dyne, Mansfield, Ohio

Photos, Keepsake Photography, Mansfield, Ohio

1 Cut approximately ⅛" notch where you want your fibers to start.

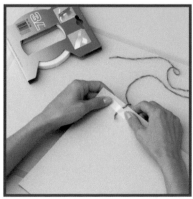

2 On back side, thread fibers through the notch and attach with an adhesive or double-sided tape.

3 Continue notching edges as you wind fiber around to create border. Attach at end or tie into a bow.

Yoda

LINE UP A COLOR-BLOCKED BORDER

Tara features her cat's unique personality with a journaling block full of precious pet nicknames. Create a quick and easy border of monochromatic colors by cutting 1 x 4" rectangles; mount down left side of page. Mat photos; mount on page. Print journaling; cut to size. Mat die-cut letters (Ellison/Provo Craft); silhouette cut.

Tara Gangi, Hewitt, New Jersey

Giraffe

ASSEMBLE A COLOR-BLOCKED BORDER

Oksanna assembled a visually interesting color-blocked border from a variety of solid and patterned papers. Cut rectangles in various lengths and widths; layer at top of patterned background paper (Karen Foster Design). Cut title letters from two templates (EZ2Cut, C-Thru Ruler); mount over color-blocked border. Double and triple mat photos; detail with hand-drawn design around second mat of one photo. Stamp ethnic designs (All Night Media); cut to size and double mat. Tie fiber (Adornaments by EK Success) at center of stamped design and mount. Adhere corrugated die-cut giraffe (DMD).

Oksanna Pope, Los Gatos, California

My Special Balloon
COLOR BLOCK A GEOMETRIC BORDER

Trudy assembled a monochromatic geometric border to offset soft floral details. Print title and journaling onto white paper; mat and mount on matted background paper. Mount enlarged photo. See the steps below to make this striking border. Before adhering daisy stickers (Paper House Productions) with self-adhesive foam spacers, lightly dust back of sticker with small brush dipped in baby powder to prevent sticker from adhering to page.

Trudy Sigurdson, Victoria, BC, Canada

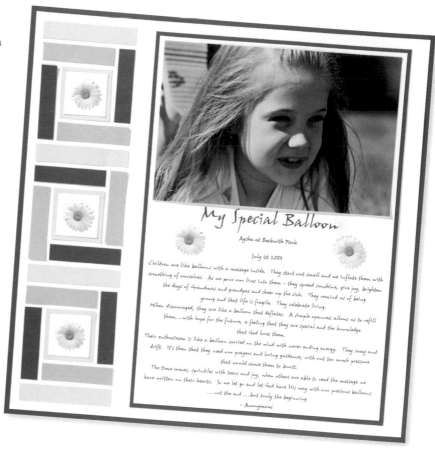

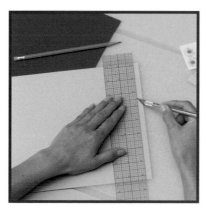

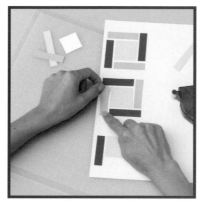

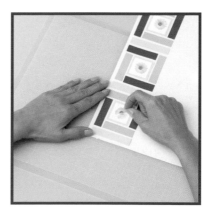

1 Cut or punch:
 3 white squares 1¼ x 1¼"
 3 light purple squares 1½ x 1½"
 4 light purple rectangles
 2¾ x ½"
 6 medium purple rectangles
 ½ x 2⅛"
 6 dark purple rectangles ½ x ⅛"

2 Assemble rectangles and squares along vertical border as shown. Adhere.

3 Adhere sunflower stickers to center of each square with self-adhesive foam spacers.

Mats

Matting, the act of attaching a piece of paper to the back of a photo before mounting the shot, helps a picture visually jump off a page. It separates the photo from other page elements by providing an island or frame for the shot. Mats can be simplistic or highly adorned with ribbons, fabric, torn paper and three-dimensional embellishments.

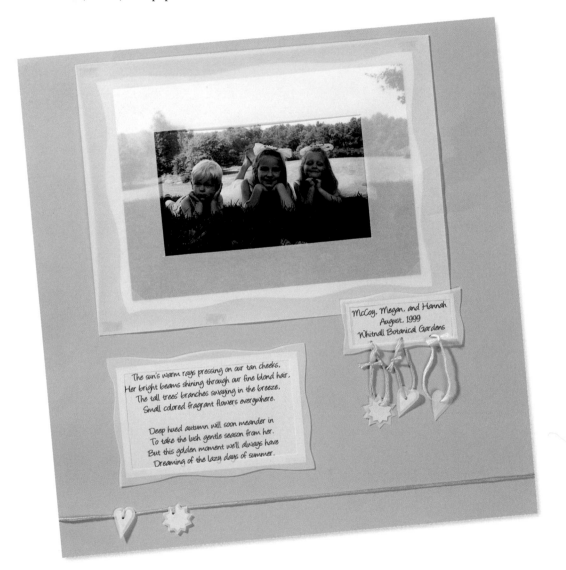

McCoy, Megan and Hannah
FRAME A PHOTO WITH A VELLUM OVERLAY

Katie focuses on a favorite photo by creating a vellum overlay "window" to achieve a frosted-looking frame. Mat photo on solid paper; add curves using a decorative ruler as a guide. Cut vellum "window" with a craft knife. Print title and text; trim to size and cut vellum "windows." Punch shapes (EK Success) from vellum and solid papers. Hang shapes from title block and across bottom of page with embroidery floss (Designs for the Needle).

Katie Swanson, South Milwaukee, Wisconsin

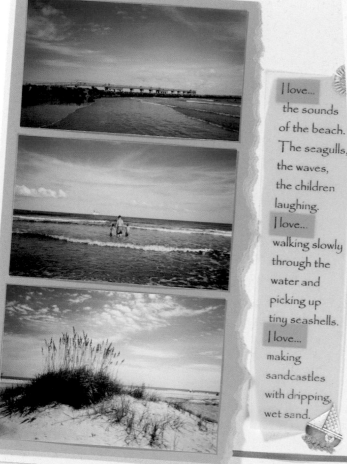

I love...
the sounds
of the beach.
The seagulls,
the waves,
the children
laughing.
I love...
walking slowly
through the
water and
picking up
tiny seashells.
I love...
making
sandcastles
with dripping,
wet sand.

I have been going to
Jetty Park with my
family since I was a
very young girl. It
was nice to be able
to visit with my family.
The wild cats are
still there eating fish
and there are always
ships going in and
out of the canal.
Sometimes we are
able to watch rockets
at Cape Canaveral.

Jetty Park

STACK PHOTOS ON MATTING

Antuanette's paper-torn matting provides the perfect look for a trio of seaside photos. Mat three photos on one large piece of solid-colored paper; tear one side of matting. Double mat photo for left page; tear one side of first mat. Mount satin ribbon (Offray) horizontally at top and bottom of pages. Print title letters; silhouette-cut with craft knife. Layer over vellum strip before mounting. Print journaling onto vellum; cut to size. Layer vellum over small paper strips to highlight words in text block. Adhere sea-related stickers (Debbie Mumm).

Antuanette Wheeler, Center Hill, Florida

Chris

TEAR A COLOR-BLOCKED PHOTO MAT

Jodi combines paper tearing and color blocking to make a colorful photo mat for her page. Tear varying-length paper strips in two colors; layer at bottom of page over matted, patterned background paper (Scrapbook Wizard). Mount Sizzix die-cut letters and stars (Ellison/ Provo Craft) to paper strip and background paper; detail letters and stars with black pen. Tie buttons with pearlized thread (DMC); mount on stars. Mat photos together. Follow the steps below to create the colorful blocked mat. Tear paper square for journaling block; write with black pen.

Jodi Amidei, Memory Makers

Photos, Diane Amidei, Erie, Colorado

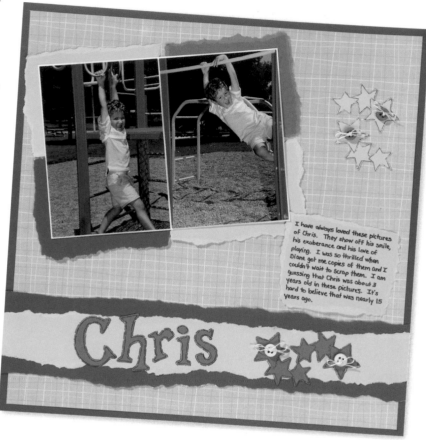

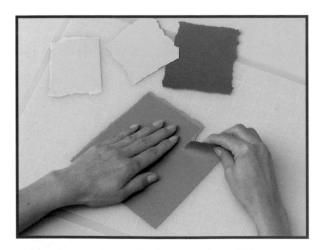

1 Tear various rectangle shapes in three different colors of cardstock.

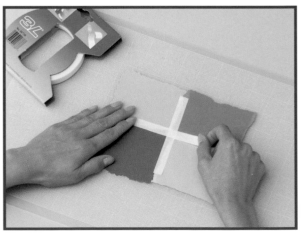

2 Adhere all four pieces together on backside with photo tape.

Zest

COLOR BLOCK A FUNKY FRAME

Kelli's funky, color-blocked photo frame seems to jump off the page thanks to its wavy design and dimensional mounting. Use wavy cutting system (Creative Memories) to cut strips of monochromatic paper; mount together using double-sided tape. Trim frame edges and cut window with craft knife. Mount over photo with self-adhesive foam spacers. Freehand-draw and cut title letters; mat and silhouette cut. Mount with self-adhesive foam spacers. Print journaling; cut to size and mount.

Kelli Noto, Centennial, Colorado

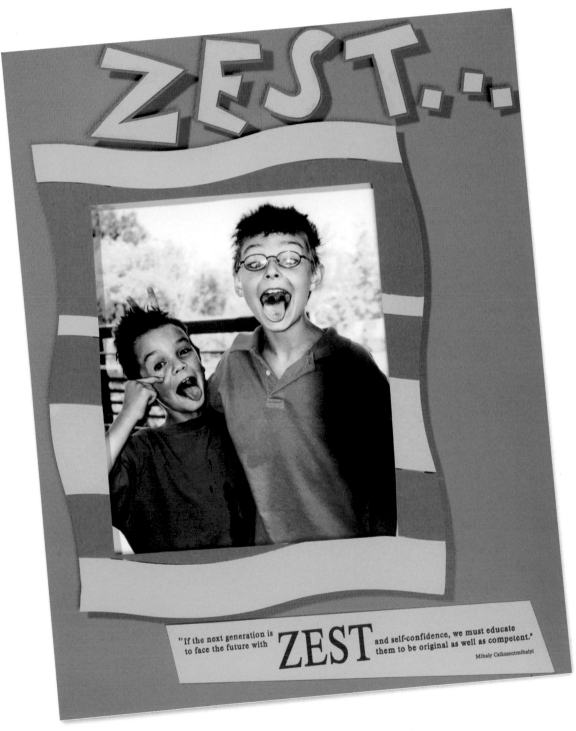

Name

ADD INTEREST TO PHOTO MATS

Oksanna's adorned photo mats add visual interest to a simple, elegant layout. Print journaling on patterned (EK Success) and solid papers. Layer patterned paper (EK Success) over solid paper for background. Triple mat photo on upper page slightly askew; add freehand design on third matting with black pen. Double mat photo on right page; stamp dragonfly (All Night Media) on two edges of second matting. Add details with gold dimensional paint (Duncan). Adhere title letter stickers (C-Thru Ruler).

Oksanna Pope, Los Gatos, California

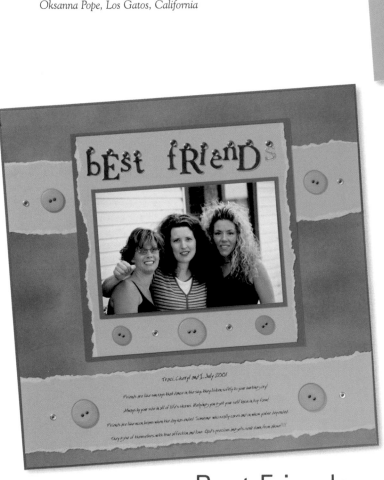

Best Friends

EMBELLISH PHOTO MATS

Trudy's triple-matted photo is highlighted with metal title letters and simple embel-lishments. Layer subtle patterned paper (Karen Foster Design) over solid paper. Print journaling on solid paper. Paper tear wide strips; embellish with eyelets (Eyelet Factory) and buttons (Making Memories) before mounting on background. Triple-mat photo; tear sides of second mat and add embellishments as shown. Attach metal title letters (Making Memories) with eyelets to second mat.

Trudy Sigurdson, Victoria, BC, Canada

Six Ways to Adorn Your Mat

Make your mat matter with torn paper, ribbons, eyelets and other supplies that turn a plain mat into a work of art.

Valerie Barton, Flowood, Mississippi

BLUE
Torn paper strips layered horizontally and vertically over a matted photo provide a creative way to cover the date stamp on a photo.

ORANGE
Nestle a photo under an embellished fold-over mat. Cut second mat 1 to 2" larger than first. Score paper with bone folder; tear edge of matting before folding over photo. Mount die-cut leaves (Dayco); embellish with chalk (Craf-T).

GREEN WITH YELLOW RIBBON
String ribbon through eyelets for a charming way to frame a photo. Attach eyelets (Doodlebug Design) on mat as shown; weave ribbon through eyelets, securing at back of matting.

PURPLE
Weave thin paper strips at corners for an interesting and dimensional photo frame. Slice 12¼" paper strips. Mount strips to matting around photo; weave with under/over technique at corners.

TURQUOISE/ORANGE
Embellish paper-torn matting with a string of colored buttons. Mat photo; tear horizontally at bottom and mat again. String buttons (Making Memories) on fiber (On The Surface). Mount diagonally at upper left corner; secure at back of matting.

OLIVE GREEN
Lace a fold-over mat with hemp cord to add a rustic feel to photo mats. Punch small shape through fold-over matting; lace hemp cord (Westrim Crafts) through holes and secure on back of matting.

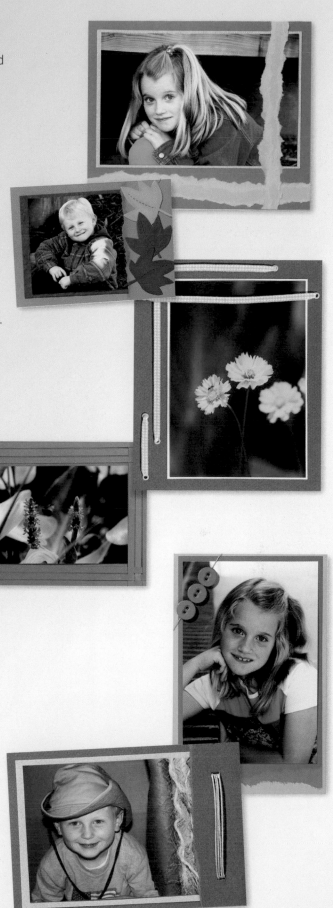

A Mothers pride

Alex, you bring more joy to my life than you will ever know. You are a sweet, loving & sensitive child & I hope you never loose those wonderful qualities.

My heart is filled with such love when you tell me that I am prettier than a sunset and more cuddly than your teddy bear. I will love you forever.

I love it when you want to sit close to me and cuddle, and it really touches my heart when you come up to me wanting to give me hugs and kisses just because.

When you were born & I found out I had a son, I didn't know what I was going to do with a boy. But now I know that all I need to do is to love you.

alex july first

two thousand one

Chapter 4
Embellishments

Whether your favorite outfit is a gorgeous red gown, a simple black dress or a knockout silk suit, it's not complete without accessories. It doesn't take much dressing up to turn stunning into spectacular, just a pair of diamond earrings or a slender gold necklace! And, just as accessories make an outfit, embellishments add that extra *je ne sais quoi* to your scrapbook page.

Scrapbook embellishments range from very simple pre-made to extremely extravagant handmade. The type and portion of embellishments you add to your pages speaks worlds about your personal flair. From photo tags, stamped borders, beaded titles and vellum matting, to ribbon edgings and paper-pieced hearts and flowers, you'll find a showcase of ideas within this chapter to help you dress up your scrapbook spreads.

Pre-Made Embellishments

Stop by your local craft or scrapbook store and you'll find racks of pre-made embellishments. They are created to move straight out of the package and onto your scrapbook page. Pre-made embellishments come in thousands of theme and color schemes. Just place and admire.

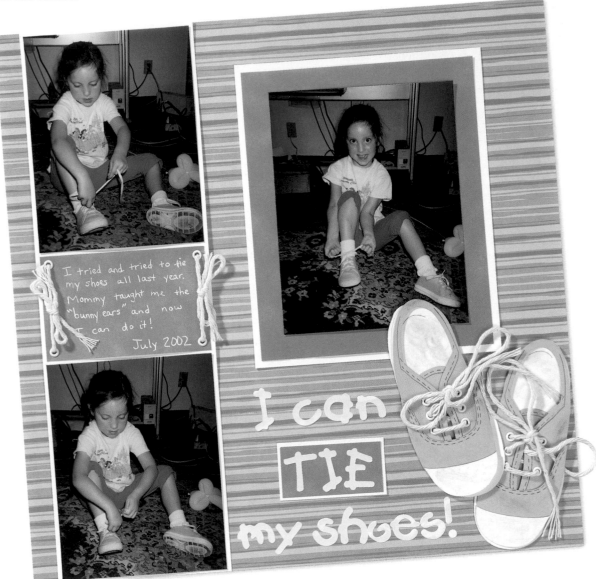

I Can Tie My Shoes!

ACCENT DIE CUTS WITH REALISTIC DETAILS

Melissa illustrates her daughter's new achievement with realistic-looking laser die cuts. Mat photos on a 4" wide strip of white paper, leaving room in the middle for journaling. Cut journaling block; mount with eyelets (Impress Rubber Stamps) and tie with string. Mount on left side of page over patterned background paper (Making Memories). Double mat large photo. Assemble tennis shoe die cuts (Deluxe Cuts); detail with chalk (Craf-T), eyelets and string. Adhere title sticker letters (Provo Craft) and matted paper rectangle.

Melissa Ackerman, Princeton, New Jersey

Just Fishing

ASSEMBLE A COLLECTION OF PRE-MADE ACCESSORIES

Jill accents heritage photos with a charming collection of fishing accessories. Double mat speckled background paper. Cut wavy background from patterned paper (source unknown); mount along bottom of page. Punch green plants (Family Treasures); layer on page. Adhere pre-made fishing accessories (EK Success). Mat photos; mount on page. Cut title letters from template (EK Success). Print journaling; cut to size, mat and mount.

Jill Cornelius, Allen, Texas

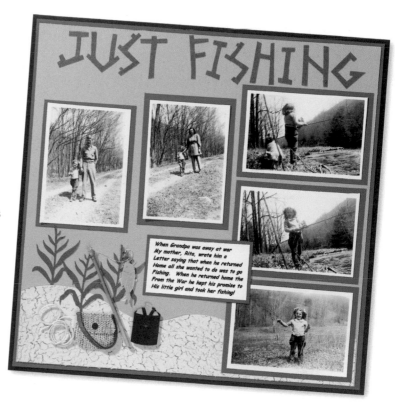

Mom & I

COLLAGE PRE-MADE EMBELLISHMENTS

Torrey gives pre printed embellishments a new look by creating a collage of dimensional images. Paper tear strips of solid-colored paper; mount diagonally on opposite corners. Cut large square of red paper with decorative scissors; mount at center of background paper, slightly askew. Mat and layer photos. Cut apart pre printed embellishments (EK Success) with regular and decorative scissors. Casually arrange on page, mounting some with self-adhesive foam spacers. Print journaling; cut to size and mount.

Torrey Miller, Westminster, Colorado

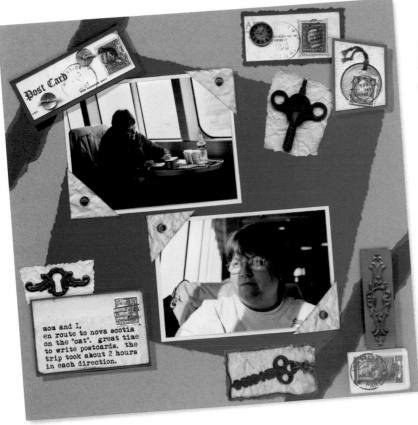

Paper-Torn Embellishing

Tear paper into strips or shapes and reassemble to create pictures or patterns. Paper tearing can be applied to paper of all textures and colors. Use a pattern, or freehand tear and apply the pieces in mosaic or collage patterns. The choice is yours.

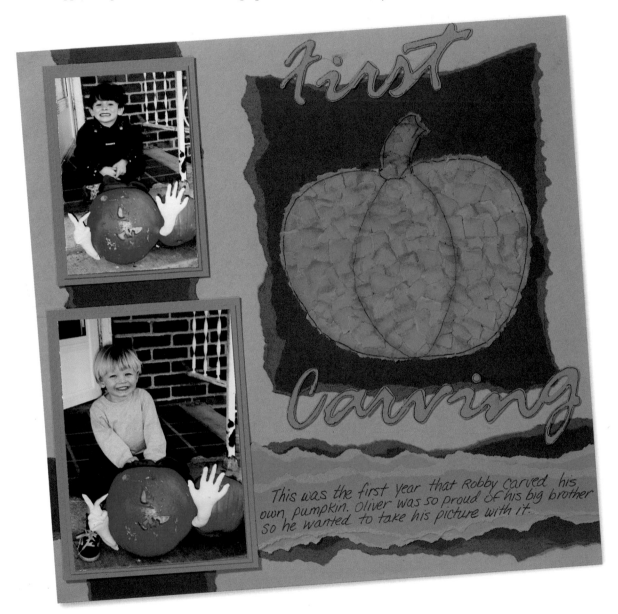

First Carving

CRAFT A PAPER-TORN PUMPKIN

Shannon crafted her own seasonal masterpiece out of small pieces of torn paper. This easy technique is achieved by tearing small pieces of complementary-colored paper and then layering them into a desired shape. It may be helpful to first sketch the shape onto background paper to serve as a guide. Add chalk and pen lines for depth and definition once placement is complete. Double mat photos; layer over torn paper strip. Cut title letters using template (EK Success). Journal on torn paper strip.

Shannon Taylor, Bristol, Tennessee

By the Sea

PAPER-TEAR A SEASIDE SCENE

Beverly's use of color and texture sets the tone for a peaceful seaside scene. Mat photos on solid paper torn on two sides and chalk around all edges. Add eyelets (Club Scrap) at corners and layer over torn mulberry paper before mounting on patterned background paper (Club Scrap). Cut palm tree and sun from templates (C-Thru Ruler). Paper tear shapes and run through crimper (Fiskars) for texture. Chalk around edges for added depth; layer sun over torn mulberry. Handcraft tags; add eyelets and mulberry strips before layering. Print text. Cut title and text blocks; chalk around edges before layering on tags.

Beverly Sizemore, Sulligent, Alabama

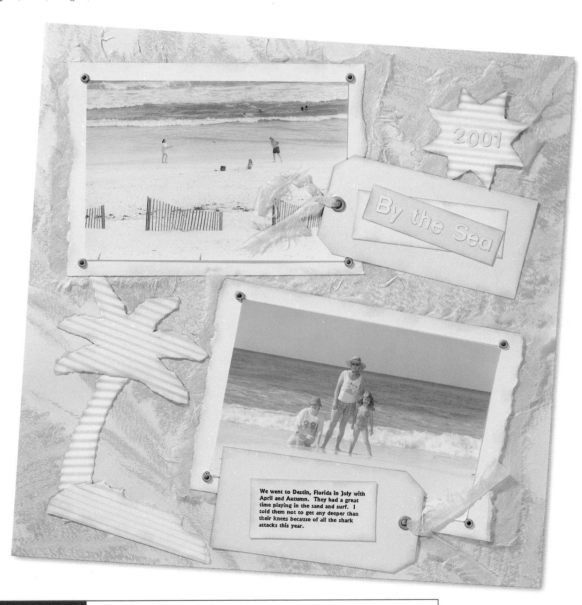

Quick Tip: For smoother results, use a paintbrush dipped lightly in water to outline paper shapes before tearing them.

Sticker Embellishing

It's easy as pie to add a splash of color, whimsy or grace to a page using stickers. Available in a rainbow of colors and an endless variety of themes, stickers are a speedy antidote for any humdrum page.

God Bless America

SHOW SPIRIT WITH PATRIOTIC STICKERS

Jennifer adorns her patriotic page with seasonal stickers that show her true Fourth of July spirit. Double mat red paper for background. Double mat photo. Print journaling; mat and adhere sticker kids (EK Success). Cut title block to size and mat; adhere "America" sticker (EK Success) and small black sticker letters (Provo Craft). Adhere firecracker and star stickers (EK Success).

Jennifer Blackham, West Jordan, Utah

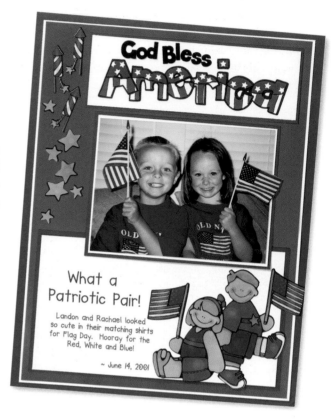

All Grown Up

ADD CHARM WITH SILHOUETTE STICKERS

Lori's monochromatic heritage layout is elegantly highlighted with a simple silhouette sticker border. Slice solid paper strip; mount over patterned paper (Liz King) at right. Cut rectangles from solid paper; adhere silhouette stickers (Okie-Dokie Press) before mounting on paper strip. Mat large photo; mount on page. Print title onto vellum; cut to size and double mat. Adhere flower sticker (Okie-Dokie Press).

Lori Streich, Sioux Falls, South Dakota

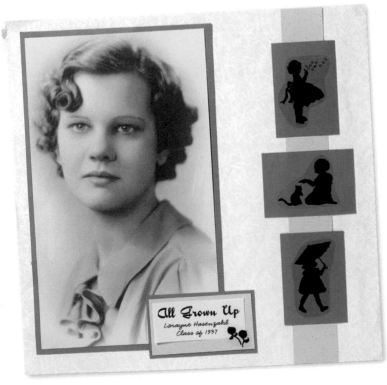

Hit the Trail

ADHERE A STICKER TITLE

Jennifer chooses to anchor sticker accents to paper strips so they aren't floating on her page. Slice large photo at random intervals; mount on cardstock, leaving space between each slice. Print journaling on solid-colored paper; mat and mount on matted patterned background paper (Rocky Mountain Scrapbook Co.). Mat photos; mount. Slice two strips of colored cardstock; adhere stickers (Karen Foster Design) and attach small brad (Impress Rubber Stamps). Adhere sticker title (Karen Foster Design) and hiking boots on journaling block to solidify theme.

Jennifer Blackham, West Jordan, Utah

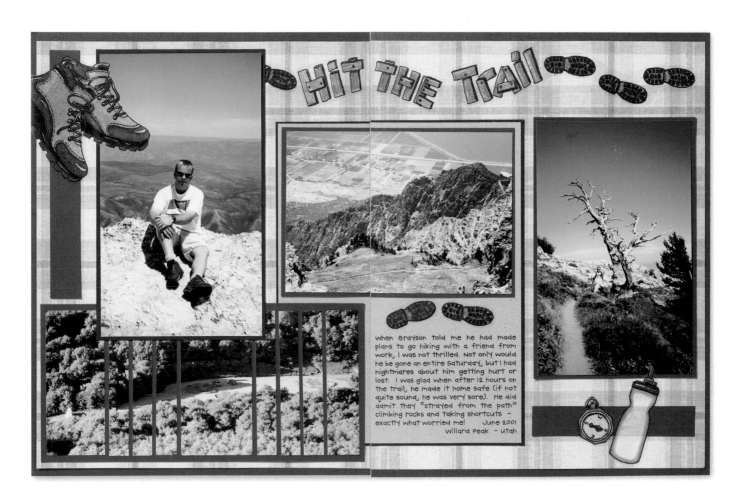

Quick Tip: Once a month, get your friends together for a scrapbook supply swap. Invite your guests to bring along their leftover stickers, paper scraps, stamps, (that adorable firefighter paper doll you bought three years ago but haven't yet used)—and trade with each other. Remember, one person's junk is another scrapbooker's treasure!

Chalk Embellishing

Chalk, that schoolyard staple, has made its way to scrapbooking. Use it to colorize torn-paper edges, die cuts, journaling blocks and other elements, adding highlights and dimension.

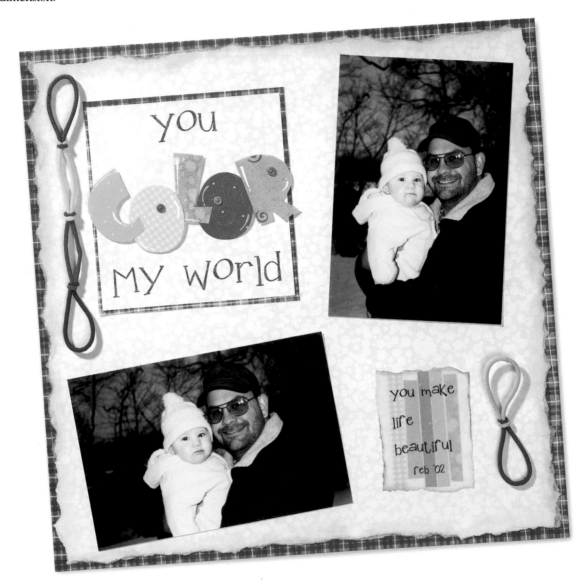

You Color My World

CHALK A RAINBOW BORDER

Christina couldn't resist using bright ponytail bands as a perfect page embellishment. Tear edges of patterned paper (Mustard Moon), chalking around them in various colors to give a rainbow effect. Mount on patterned paper (Mustard Moon). Print part of title and journaling on vellum and patterned papers. Cut title block to size and mat on patterned paper. Cut large title letters from template (Scrap Pagerz) and a variety of patterned papers. Add eyelets (Doodlebug Design) to letters before mounting on title block with self-adhesive foam spacers. Tear edges of journal block and chalk (Craf-T). Layer over patterned paper strips. Mount looped ponytail bands to page.

Christina Gibson, Jonesboro, Arkansas

Summer

DRESS UP TEMPLATE LETTERS

Victoria illustrates the sandy shades of summer with heavily chalked torn paper and title letters. Mat photos before layering on page. Tear speckled paper; chalk heavily, as shown in illustrations below, with various shades of brown to resemble sand colors in photos. Layer at bottom of page. Cut title letters from template (Provo Craft); outline with black pen and shade with chalk before matting on black paper. Silhouette-cut letters before mounting on page. Paper tear sun; journal with black pen.

Victoria Jiminez, Harrah, Oklahoma

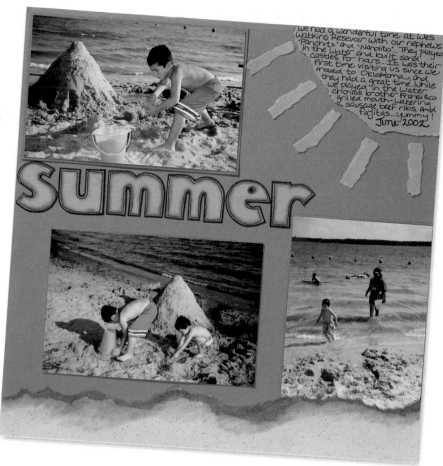

1 Tear border from a sheet of sand-colored paper. Steady the sheet with one hand while using the other to carefully rip the page from top to bottom.

2 Using chalk and a cotton swab, gently rub chalk on torn edge to add dimension, texture and color.

Quick Tip: To save money, substitute any non-oily, powder-based makeup like eye shadow or blush for chalk on your pages.

Punch and Die-Cut Embellishing

Punches, those individual paper cutting tools that create perfect decorative shapes, are just right for dressing up borders, corners, titles and much more. Layer them or use them alone for "wow" effects.

Pumpkins

PUNCH A PLAYFUL BORDER

Jenna knows that scrapbooking inspiration can be found anywhere—even bathroom floors! The variety of punched circles shown here are the product of Jenna's never-ending search for great ideas. Mat photos on solid-colored paper. Punch a variety of circle sizes (½", ¾", Marvy; 1", Family Treasures) out of complementary-colored papers. Cut title letters using template (Scrap Pagerz). Cut larger circles with circle cutter.

Jenna Beegle, Woodstock, Georgia

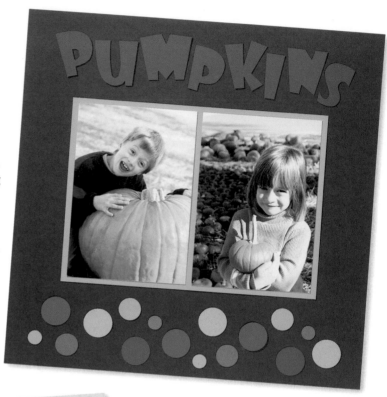

Big Adventure

DANGLE A TAG IN YOUR TITLE

Janice's choice of warm, patterned papers provides an understated background for black-and-white photos. Cut green paper (EK Success) in half; mount over yellow paper (EK Success). Slice paper strip; mount at top left of page. Cut circle from patterned paper (Avery); adhere sticker letters (Provo Craft). Dangle tag from loop tied in embroidery floss (DMC); mount horizontally, securing to page back. Print partial title and journaling on vellum. Cut balance of title. Cut suns using templates (EK Success); mount on matted squares of patterned paper.

Janice Carson, Hamilton, ON, Canada

Dress Up Punches

Punched shapes are great embellishments in and of themselves, but dress them up and they go from simple to sensational.

Holle Wiktorek, Fayetteville, North Carolina

Nestle a punched star (Marvy) amongst tinseled strands (Magic Scraps) for a glittery effect.

Add eyelets to a paper-torn sunflower's center; surround with punched petals (EK Success).

Punch a heart silhouette (EK Success) from aluminum to frame a small photo. Embellish with twisted wire (Artistic Wire) at top of tag.

Add pen detail to a simple punched starburst (EK Success) before mounting on torn paper strip.

A small button (Making Memories) adorns a bright punched sun (Marvy). Mount eyelet (Making Memories) on tag and tie with hemp cord.

Wrap a punched maple leaf (Marvy) with thin wire (Artistic Wire) before mounting with self-adhesive foam spacers.

Give texture and visual interest to punches with mesh (Avant Card). Adhere mesh to cardstock before punching tree (EK Success). Layer shape over paper-torn scrap. If using thicker mesh, simply punch shape from cardstock first, then adhere mesh under shape.

Pen and chalk details give dimension to a punched birch leaf (Marvy). Mount on printed vellum (EK Success); tear edges before mounting on handmade tag. Attach star eyelet (Stamp Doctor) and raffia.

Adorn a heart-shaped punch (Marvy) with a plastic safety pin and pen detail to enhance baby-themed artwork.

Punch a window into a tag, small envelope or a border strip for a charming view. Add clear jewels (Westrim) to punched snowflakes (Crafts, Etc.); mount under punched window.

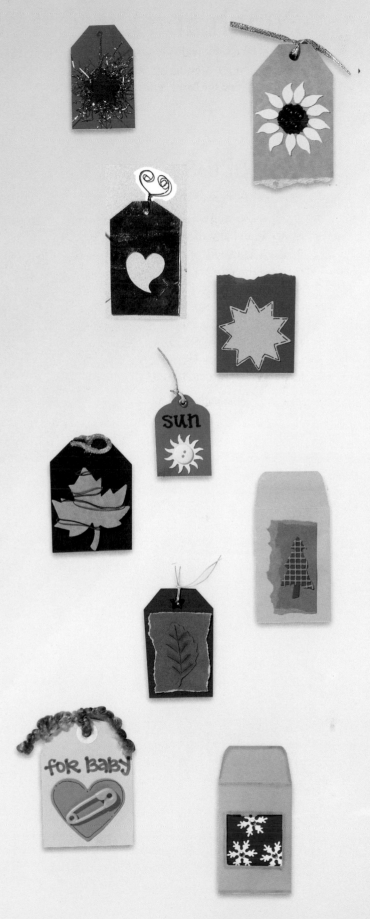

Stamp Embellishing

Rubber stamps are versatile tools for adding spark to scrapbook pages. With thousands of patterns and inks in a rainbow of colors, you can create delicate borders, lacy corners, dressed-up die cuts and jazzy page accents.

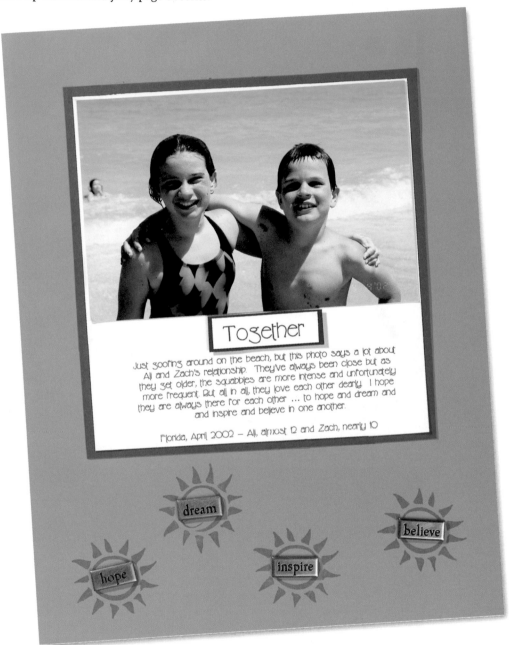

Together

ADD SHINE WITH METAL WORD EYELETS

Lisa's simple border incorporates a stamped design with metal word eyelets. Print title and journaling. Mount photo on journaling block and mat. Cut title to size; mat and mount with self-adhesive foam spacers. Stamp sun designs (DeNami Design) on background paper. Mount word eyelets (Making Memories) over stamped design.

Lisa Simon, Roanoke, Virginia

432

Pure Wonder
STAMP A SIMPLE DESIGN

Anne's goal of creating a simple, clean page was met by using a variety of embellishments. Single and double mat photos. Attach eyelets (Stamp Doctor) to bottom of matting; thread fiber (Rubba Dub Dub) through eyelets. Layer over patterned paper (Paper Loft) and mat. Print title and journaling; cut to size and mount. Hand cut large word for title. Attach eyelets at top and bottom of opposite page, threading fiber through. Cut rectangles from solid paper; mat with dark paper. Stamp leaf (Stampin' Up!) and shadow square (Hero Arts). Attach eyelets and fibers.

Anne Heyen, New Fairfield, Connecticut

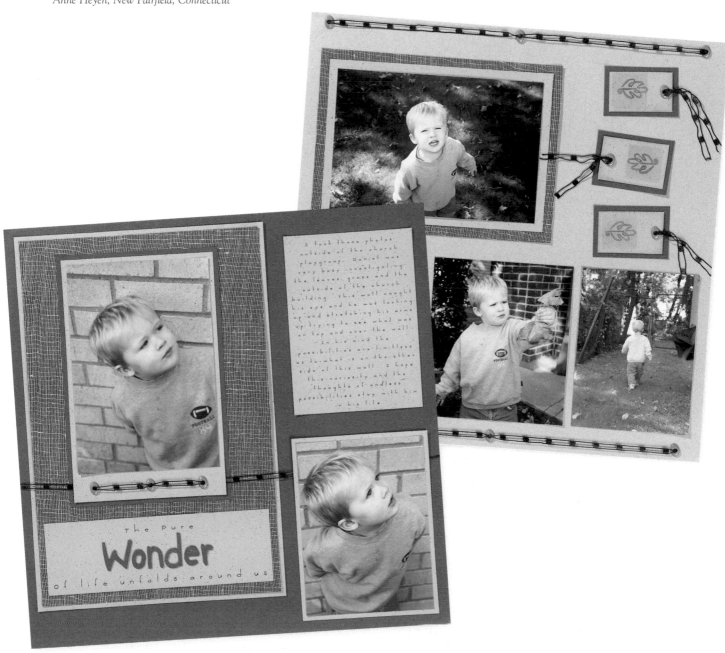

Kindness

LACE A STAMPED BORDER

Oksanna cut out stamped images of peaches and laced them together with ribbon for a simple, fanciful border that complements her page's theme. Print journaling onto vellum (DMD); mount vellum rectangles over patterned paper (Carolee's Creations). Mat two photos. Stamp peaches (All Night Media) on solid paper; cut to size with decorative scissors. Punch (Fiskars) small holes in stamped images; lace ribbon (Offray) through and arrange as shown. Cut title from template (EZ2Cut) in two colors; layer on page to create shadow effect. Complete title with black pen.

Oksanna Pope, Los Gatos, California

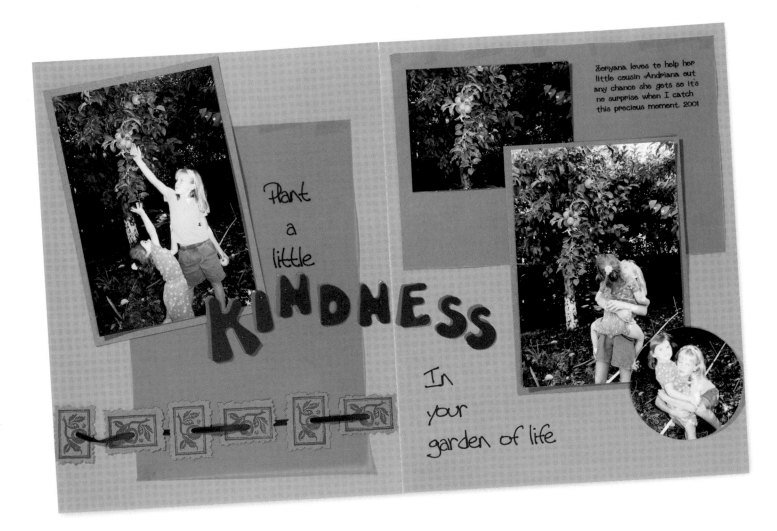

Autumn Days

DANGLE EMBOSSED STAMPED IMAGES

Falling leaves drift peacefully along Heidi's color-blocked border. Punch small squares (Family Treasures) and leaves (EK Success) from complementary solid-colored papers. Slice corrugated paper strip; mount. Cut title letters from template (Frances Meyer); overlap and mount. Follow the instructions below to emboss the large leaf accents and add buttons; mount on title strip. Mount cropped photos. Hand write balance of title on paper strip; punch small hole and tie hemp cord (Darice). Mount with self-adhesive foam spacers.

Heidi Schueller, Waukesha, Wisconsin

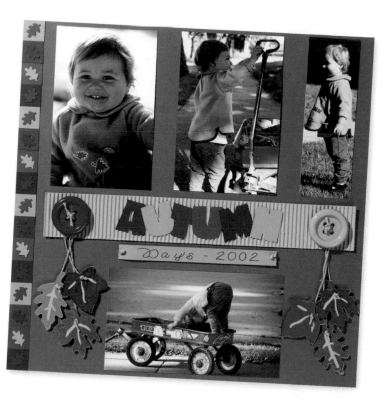

1 Stamp image on cardstock, being careful to press the stamp firmly and evenly on the paper. Do not rock.

2 Lightly sprinkle clear embossing powder over stamped image. Take care to cover all of the image evenly.

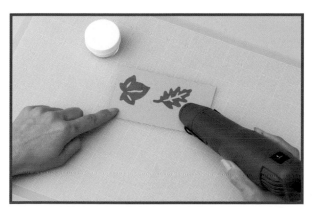

3 Use heat gun to melt powder.

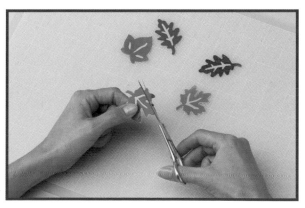

4 Cut out embossed images. Punch small holes and attach hemp, knotting at front of leaves. Tie cords together; attach to buttons.

Tag Embellishing

Tags are available in many sizes, colors and shapes. Use them as embellishments in your page design or as platforms for titles and journaling. Spruce them up or dress them down as you desire.

Sam's Fishing Hat
ADD SIMPLE EMBELLISHMENTS TO TAGS

Kathy's clean lines and simple tag embellishments keep the focus of her page on the color-tinted black-and-white photo. Double mat photo; layer on patterned paper (source unknown) embellished with eyelets (Stamp Doctor) and embroidery thread (On The Surface). Print journaling; trim to size and mat. Slice paper strip for title; adhere sticker letters (Making Memories) and mat. Embellish tags (Avery) with patterned paper, punched shapes (McGill) and embroidery thread.

Kathy Olson, Madison, Wisconsin

Our Daughters
ADORN TAGS WITH PAPER SCRAPS

Embellished tags tied with ribbon and adorned with jewels add charm to Kelly's page. Divide page into four sections; cut solid and patterned (Treehouse Designs) paper to fit sections. Mount on solid-colored paper, leaving space between each section. Color block mat for top photo; tie ribbon around matted photo. Double and quadruple mat bottom photos on solid and patterned papers. Cut photo corners with decorative scissors; mount. Wrap fibers (Making Memories) on opposite corners. Embellish tags with paper scraps; adhere title sticker letters (MAMBI). Mount flat-backed jewels (Magic Scraps) and chalk around edges. Tie ribbon and fibers on tags.

Kelly Angard, Highlands Ranch, Colorado
Photos, Stacey Heckert, Highlands Ranch, Colorado

Fiber Embellishing

Fiber, ribbon, string, thread, yarn, floss, jute and other textiles are increasingly popular with scrapbookers. Use them to suspend titles, wind around borders or decorate other page elements such as tags and frames.

Today You Are You
FRAME A PHOTO WITH RIBBON

Jane captures the sweet essence of her daughter with a photo delicately framed with sheer ribbon and flower nailheads. Tear patterned and embossed vellum (K & Company); mount at lower left-hand corner of page. Mount photos on page. Frame one photo by attaching sheer ribbon (Stampin' Up!) with flower nailheads (Jest Charming) at corners. Print text onto vellum; tear edges and mount on page. Affix nailheads to complete page.

Jane Rife, Hendersonville, Tennessee

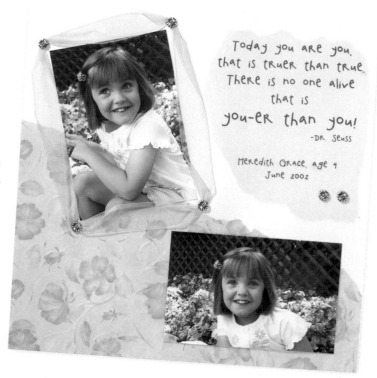

Lauren
ADD A FEMININE BORDER

Valerie surrounds a sweet photo of her daughter with strips of delicate satin and sheer ribbon. Double mat photo. Cut title from computer-printed font with craft knife. Mount ribbon (Offray) to page as shown, wrapping ends around the back of the page. Hand cut tag; punch hole and embellish with pressed flowers and ribbon.

Valerie Simon, Carmel, Indiana

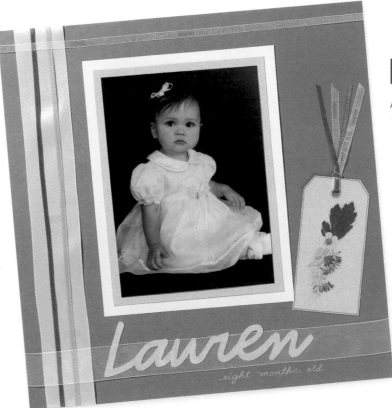

Cunningham Falls State Park

SECURE EMBELLISHMENTS WITH FIBERS

Tina's first experience with the sights and sounds of fall is elegantly displayed with realistic embellishments. Mat photos on solid-colored paper; tear two edges. Mat largest photo; attach eyelets (Making Memories) and string fiber (On The Surface) vertically on matting. Cut rectangles to mat skeleton leaves (Graphic Products Corp.) upon; attach eyelets and crisscross fibers over leaf. Print journaling, leaving room for highlighted sticker words. Adhere sticker letters (Creative Memories); cut to size and tear. Paper tear title strip; adhere sticker letters (Colorbök).

Tina Kistinger, Pasadena, California

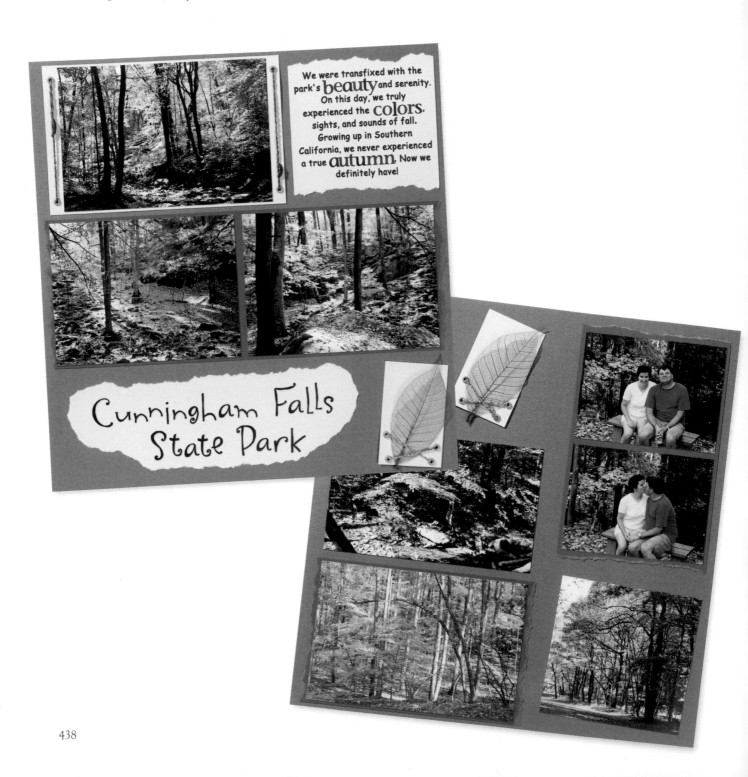

Fiber Embellishments

Yarn, thread, hemp and other fibers add texture and dimension to tags, titles, borders and other elements.

Kelli Noto, Centennial, Colorado

UNDER THE SEA:

Metallic and cotton fibers frayed at the edges replicate underwater plant life. Punch letters (EK Success); mount on matted background paper. Tear thin cork for bottom of sea. Adhere fish stickers (Stickopotamus). Cut large and small fiber strips (Magic Scraps); fray edges and mount.

CELESTIAL TAG:

A soft combination of fibers (On The Fringe, Magic Scraps) in natural colors adds interest to a distressed tag. Stamp tag with celestial design (Rubber Stamps Of America); ink background and detail edges. Crumple tag and flatten out before tying fibers.

STITCHED FLOWERS:

Add homemade charm to borders with hand-stitched flowers. Lightly pencil flower shape; pierce holes with hole piercer before stitching. Mount button tied with fiber. Double mat designs.

FACES:

Trim fibers into the perfect hairstyle to frame faces of all cultures. Cut or punch ovals and circles for faces. Detail with pen and chalk; mount eyes. Cut fibers (Quilter's Resource Inc., DMC, EK Success) for hair; mount.

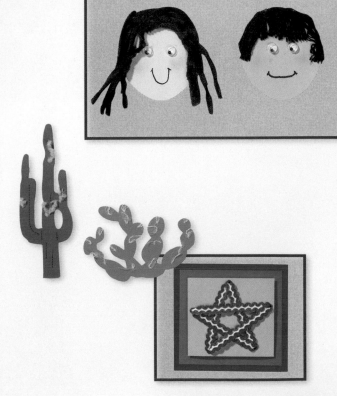

CACTUS:

Detail cactus die-cuts with realistic-looking prickles. Punch small holes in die cuts; tie fibers through holes.

STAR:

Decorative rickrack threaded through large eyelets makes for a colorful, eye-catching embellishment. Mount large eyelets (Darice) at points of star. Thread rickrack (Magic Scraps) through eyelets in shape of star.

Wire Embellishing

Solid, stiff and strong, wires can add a masculine feel to your scrapbook pages. When threaded with beads, or strung with ribbons or floral punches, wire can easily drift from rustic to elegant. The beauty of wire is its flexibility.

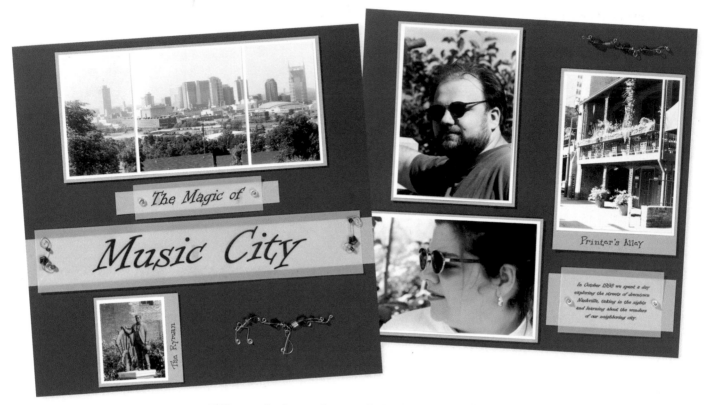

The Magic of Music City

DANGLE WIRE MUSICAL NOTES

In order to keep her page from looking too formal, Jessica added whimsical wire "jewelry" creatively shaped into musical notes. Double mat photos; mount on page. Print title and journaling onto vellum. Cut to size; mount over solid-colored paper strips. Embellish with wire (Darice) and bead (Halcraft) designs; mount with adhesive, as shown below.

Jessica Mobley, Thompson Station, Tennessee

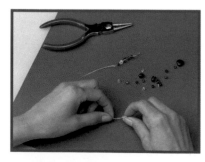

1 With round-tip pliers, bend wire into desired shape, adding beads as desired.

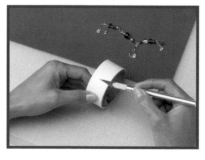

2 Pick up glue dot with the tip of a craft knife.

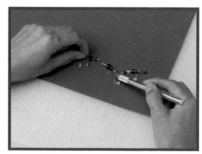

3 Adhere glue dot to a bead and place the bead on the page. Continue adhering until firmly attached.

Family

NESTLE PHOTOS IN WIRE SWIRLS

Torrey displays photos, title and journaling in creative, handcrafted wire swirls. Tear patterned vellum (Frances Meyer) and layer over background paper stamped with clear pigment ink (Tsukineko) in a swirled design (Uptown Design). Cut triangles; mount at two corners of background paper. Double mat photos. Print title and journaling; cut to size and tear edges. Follow the instructions below to create these interesting wire photo holders. Nestle photos, title and text block in wire design; mount title and one photo with self-adhesive foam spacers.

Torrey Miller, Westminster, Colorado

Photos, Heidi Finger, Brighton, Colorado

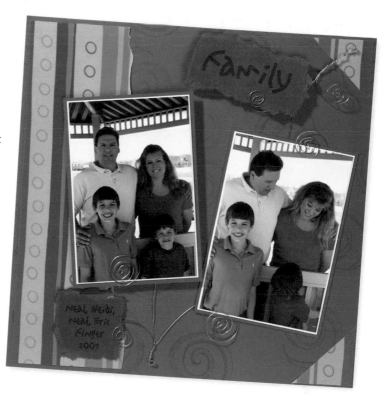

1 Cut three 10" pieces of thin wire for each holder. Twist wires into spirals, leaving 3-4" for stem.

2 Twist three spiraled wires together at ends to create the "stem" of the photo holder.

3 To attach to page, position wire on desired place on the page. Use an awl or needle to poke holes on either side of the wire.

4 Create a "U" out of another piece of wire and poke ends through pre-punched holes.

5 On backside of paper, bend "U" back to secure wire. Add more "U" pins if needed to secure wire.

Beads

Round, square, sparkly or opaque, beads are everywhere. String them on fiber or wire to create "necklaces" for your scrapbook page. Glue them in the center of punches or sticker designs for added dimension.

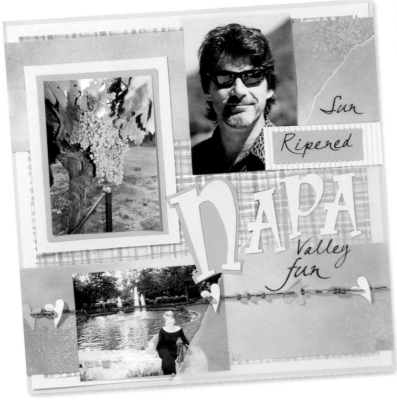

Napa Valley

STRING A BEADED BORDER

Oksanna accents a beautifully layered page with an elegant string of beads and punched hearts. Double-mat patterned paper (Karen Foster Design); slice 3½" wide strips to mount at top and bottom of page. Double mat one photo; mount all photos on page. Print partial title on vellum and solid papers. Diagonally tear vellum; mount at lower right-hand corner. Cut title block; mat on corrugated paper and layer over vellum. Cut large title word with template (C-Thru Ruler); mat largest letter and silhouette cut. String punched hearts (All Night Media) and beads (source unknown); mount horizontally, securing to back of page.

Oksanna Pope, Los Gatos, California

Love for a Lifetime

EMBELLISH PUNCHED SHAPES
WITH BEADS

Shannon highlights one of her all-time favorite photos with bead-embellished hearts. Triple-mat enlarged photo. Print title and journaling; cut to size and mat. Silhouette-cut the word "love"; mat and silhouette again. Punch hearts (Marvy) from paper and two-sided adhesive tape (Art Accents). Layer adhesive on hearts before affixing beads (Westrim).

Shannon Taylor, Bristol, Tennessee

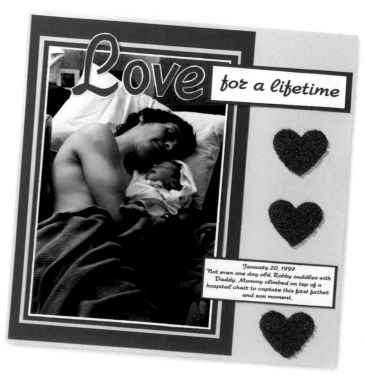

Sweet Smile

ADD SPARKLE WITH BEAD CLUSTERS

Valerie combines a variety of embellishments to add sparkle and texture to mother-daughter portraits. Slice strips of vellum and patterned (Mustard Moon) papers; mount horizontally. Mount fiber (Cut-It-Up). Cut two rectangles from solid and patterned papers; mount at upper left and lower right corners. Cut mesh (Avant Card) designs; mount. Mount clusters of beads (Westrim) with crystal lacquer (Sakura Hobby Craft) to form checkerboard design as shown below. Stamp die cut 1" squares (Accu Cut) with title letters (Stampin' Up). Mount on page. Journal with blue pen.

Valerie Barton, Flowood, Mississippi

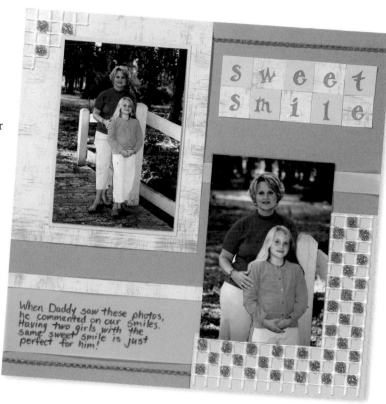

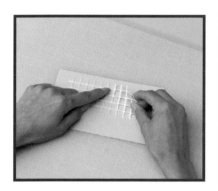

1 Attach Magic Mesh to cardstock. It is self adhesive.

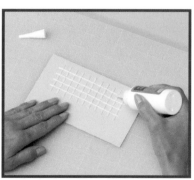

2 Fill squares in Magic Mesh with crystal lacquer.

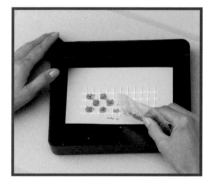

3 Pour beads into crystal-lacquered square and allow to dry. Use tidy tray for neatness.

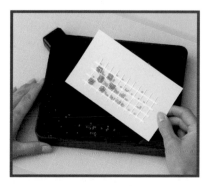

4 Shake off excess beads into tidy tray. Allow lacquer to dry.

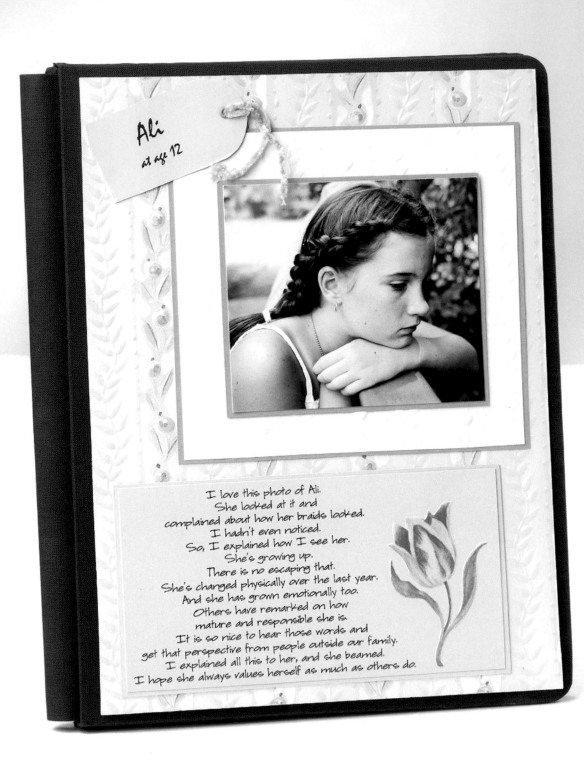

Ali

at age 12

I love this photo of Ali.
She looked at it and
complained about how her braids looked.
I hadn't even noticed.
So, I explained how I see her.
She's growing up.
There is no escaping that.
She's changed physically over the last year.
And she has grown emotionally too.
Others have remarked on how
mature and responsible she is.
It is so nice to hear those words and
get that perspective from people outside our family.
I explained all this to her, and she beamed.
I hope she always values herself as much as others do.

Chapter 5
Journaling

If you could be there in person every time your album was opened, you could recount the story behind each page. However, in most cases this kind of hands-on sharing of information simply isn't possible. Therefore, it is imperative to record your thoughts and feelings in print on your pages so your spreads can speak for themselves. That's why scrapbookers journal.

Through journaling, you'll assure that future generations know who that bright-eyed child in the photograph is, where the photo was taken, when and why. Journaling is your voice, your artistic statement and your interpretation of the world. No two people are exactly alike, nor are two journaling styles the same. Find your style and your voice and your pages will truly reflect your individuality.

What Is a Weed?

STAMP A JOURNALED QUOTE

Greta found the perfect quote to accompany photos of her son exploring a field of dandelions. Single and double mat photos; tear sides of second mat and chalk around edges. Attach flat-top eyelets (Stamp Doctor) at corners of second matting. String fiber (On The Surface) around matting, secure under flat-top eyelets. Tear side border strip on one side; chalk around edges and distress with ink splotches. Stamp quote (Hero Arts). Wrap border with fibers and wire strand adorned with beads and charms. Mount to page with flat-top eyelets.

Greta Hammond, Goshen, Indiana

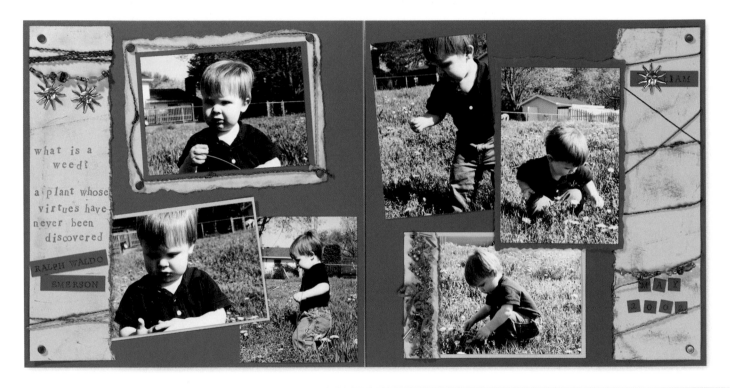

Cool Quotes

Of all days, the day on which one has not laughed is the one most surely wasted.
Sébastien-Roch Nicolas de Chamfort

Friendship is a single soul dwelling in two bodies.
Aristotle

I'm not afraid of storms, for I have learned how to sail my ship.
Louisa May Alcott

The world is a book, and those who do not travel, read only a page.
Saint Augustine

Shoot for the moon, even if you miss, you'll land amongst the stars.
Les Brown

The longer I live the more beautiful life becomes.
Frank Lloyd Wright

Those who dream by day are cognizant of many things which escape those who dream only by night.
Edgar Allen Poe

Proud to Be an American

ENHANCE PHOTOS WITH SONG-LYRIC JOURNALING

A moving patriotic song sets the perfect tone for Beckie's page. Single and double mat photos on solid and metallic papers. Cut rectangle from gold metallic paper; mount vellum to back of frame. Tear hole from vellum's center; mount photo behind. Print song lyrics on vellum. Slice vellum into strips and layer over photos. Embellish with twisted red and blue fibers (Fibers by the Yard) secured with small gold brads (HyGlo/American Pin). Print title; silhouette cut. Embellish corrugated die-cut star (MPR Associates) with torn paper and eyelet. Dangle flag charm (Zip Clips) with gold embroidery thread (DMC). Mount decorative tag (source unknown) at bottom of right page; frame with eyelets and silver thread (DMC).

Beckie Reaster, Deltona, Florida

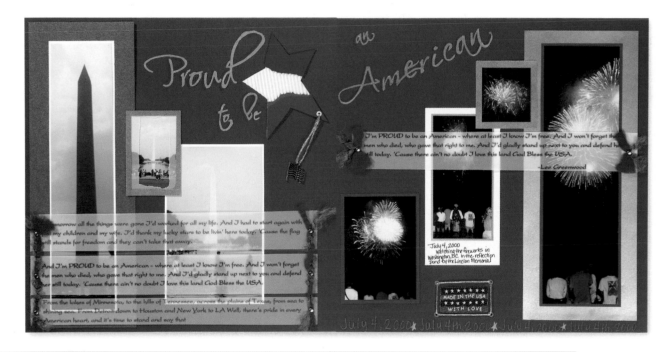

There is no more lovely, friendly and charming relationship, communion or
company than a good marriage.
Martin Luther

Some people come into your life only for a moment but leave footprints on your heart
that last forever.
Unknown

Progress involves risks. You can't steal second and keep your foot on first.
Frederick Wilcox

We do not know the true value of our moments until they have undergone the test of memory.
Georges Duhames

Only those who dare to fail can ever achieve greatly.
Robert Francis Kennedy

You never really leave a place you love—You take part of it with you,
leaving part of you behind.
Unknown

Keep your face to the sunshine and you cannot see the shadows.
Helen Keller

Don't cry because it's over—smile because it happened.
Dr. Seuss

Simply Beautiful

ENHANCE PHOTOS WITH REFLECTIVE JOURNALING

Jane celebrates her daughter's inner spirit with reflective journaling about who she is, and who she is becoming. Pair an enlarged photo, printed on vellum, with sentimentally journaled thoughts. Offset smaller photo with matted paper square behind upper left-hand corner. Print title and journaling; paper-tear edges before matting on page. Thread buttons (Making Memories) with fibers (On The Surface) before mounting on paper squares.

Jane Rife, Hendersonville, Tennessee

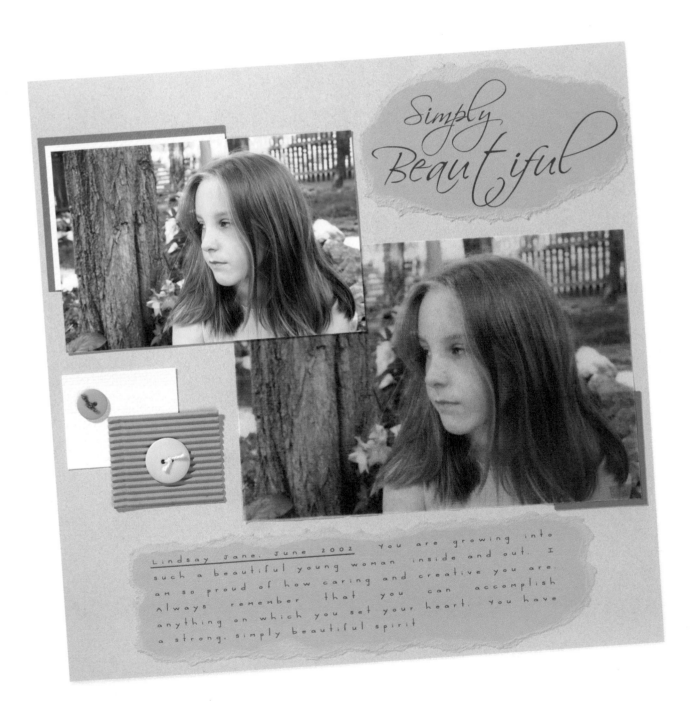

A Man of Style

DOCUMENT A FAMILY MEMBER'S LIFE

A short, concise biography full of fond memories helps Kelly learn about the father-in-law she never met. Mount matted and cropped photos on matted background paper. Adhere sticker border (Creative Imaginations) on solid paper; silhouette cut and layer at left side of page. Adhere sticker letters (Creative Imaginations) on patterned paper (Colorbök). Frame title block with solid paper strips mitered at corners. Chalk edges for dimension; stitch buttons and mount on frame. Print biography onto patterned paper, leaving room for sticker letter. Mat on solid paper; mount to page with gold photo corners. Embellish with fibers (EK Success) and stitched buttons.

Kelly Angard, Highlands Ranch, Colorado

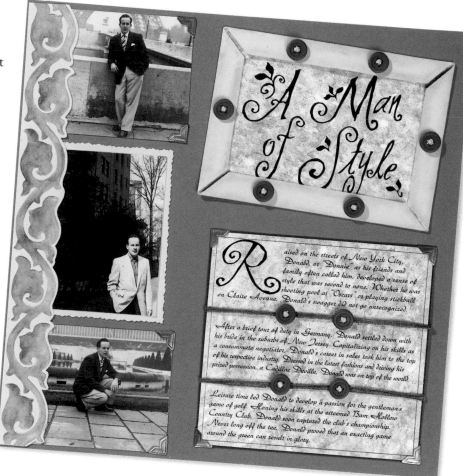

Successful Interview Techniques

- Schedule interviews as far ahead as possible to avoid possible scheduling conflicts.
- Brainstorm questions prior to the interview. Ask yourself, "What would I, as an outsider, want to know about this person?"
- Observe your subject's vocal tone, appearance, expressions and gestures. Note them in your writing.
- Ask open-ended questions (rather than yes/no questions) which leave your subject room to expand upon answers.
- Use body language to encourage your subject, including nods and vocal affirmations.
- Take notes during an interview.
- Double-check facts for spellings and dates.

Friends

EXPAND A TITLE INTO JOURNALING

Diana expands her stamped title into an acrostic poem that describes a special friendship. Crumple and iron paper before stamping title (Hero Arts) and printing text on background paper. Add texture to contrasting narrow strip of cardstock by spraying both sides of cardstock with water until very damp. Crumple paper; smooth out and iron without steam until dry. Layer over background paper; mount with flat-top eyelets (Doodlebug Design). Print photo captions on vellum; trim to size and clip (Clipiola) to textured paper. Paper-tear rectangle; mount 3-D sticker (EK Success).

Diana Hudson, Bakersfield, California

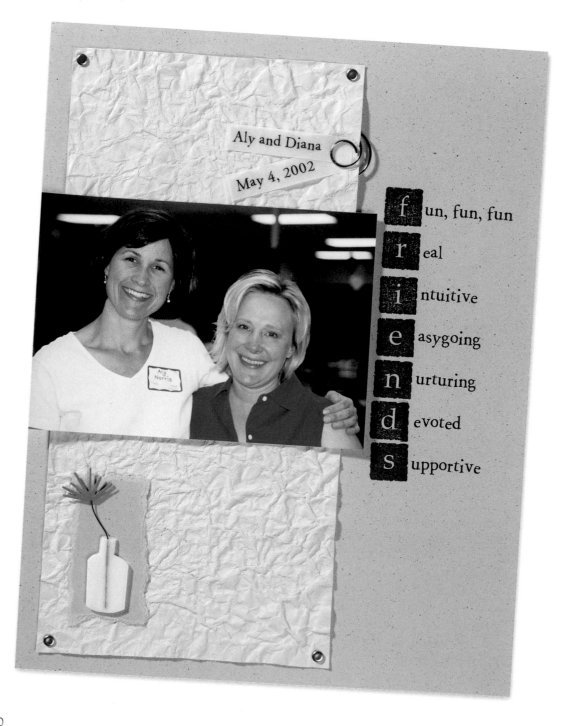

Ethan

ILLUSTRATE A PERSONALITY WITH ADJECTIVES

Mary surrounds photos of her son with descriptive words detailing his personality and appearance. Layer solid and patterned (Making Memories) papers for borders and backgrounds. Attach fiber (Lion Brand Yarn) across top of page and border. Mat photos on solid and patterned (Making Memories) papers. Double mat large photo with paper yarn-wrapped (Making Memories) cardstock; mount with self-adhesive foam spacers. Adhere sticker letters (MAMBI) to matted rectangles. Cut rectangle for title; adhere sticker letters (Colorbök), mat and attach buttons (Making Memories).

Mary Faith Roell, Harrison, Ohio

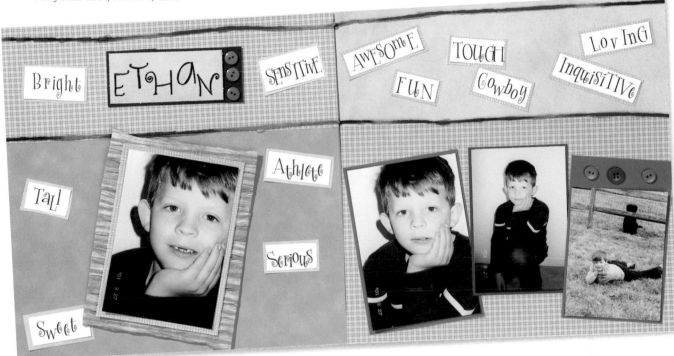

Here's just the right adjective
Use the list below to help spark your imagination.

A ~ athletic, artsy, academic, adventurous, ambitious, active

B ~ bold, bright, beautiful, brainy, brave, busy, boastful, blunt

C ~ creative, cute, cuddly, courageous, confident, carefree

D ~ daring, dreamer, dainty, dramatic, driven, down-to-earth

E ~ energetic, eccentric, excitable, eager-to-please, elegant

F ~ friendly, flirtatious, fun, flamboyant, faithful, full of life

G ~ go-getter, gifted, generous, gentle, gullible, goal-oriented

H ~ happy-go-lucky, humble, hardworking, honest, headstrong

I ~ intelligent, intuitive, impulsive, idealistic, independent

J ~ joker, jovial, joyous, jolly, judgmental, juvenile, jaunty

K ~ kind, keen, kindhearted

L ~ lovely, lucky, lovable, lazy, loyal, liberal, liar

M ~ mysterious, messy, modest, magnetic, mellow, mature

N ~ naughty, neat, nice, naïve, nitpicky, nimble

O ~ outgoing, overachiever, optimistic, open-minded

P ~ practical, perfectionist, popular, passionate, polite, picky

Q ~ quiet, quick, quirky, quixotic, quarrelsome

R ~ responsible, romantic, rowdy, reliable, religious, risk-taker

S ~ shy, smart, stubborn, sensitive, spiritual, superstitious

T ~ talkative, trustworthy, thoughtful, talented, trusting

U ~ unique, unconventional, unpredictable, unruly, upbeat

V ~ vibrant, vain, vivacious, vulnerable, visionary, vindictive

W ~ worldly, well-liked, willful, wise beyond his/her years

X ~ x-pert, x-tremist, xenophobic

Y ~ youthful, young-for-his/her-age, yappy

Z ~ zany, zestful, zealous, zingy, zippy

Take the Christmas Picture!

CAPTURE HIDDEN THOUGHTS

Although Peggy loves getting a perfect holiday portrait of her girls, the process requires lots of patience, a sense of humor, and a creative mind! Mount photos on red patterned paper (Crafter's Workshop). Tear top of matting, attach eyelet (Prym-Dritz) and fibers (Quilter's Resource Inc.). Attach fibers horizontally along page bottom, leaving space for captions. Print captions onto patterned paper (Crafter's Workshop). Trim to size and detail around edges with black pen. Print title words; cut to size and mat. Print word "trying" on velvet paper; silhouette-cut and mount on vellum. Attach eyelets at top; bend wire adorned with beads (JewelCraft) to resemble hanger. Attach to page with small brad (Impress Rubber Stamps).

Peggy Kangas, Pepperell, Massachusetts

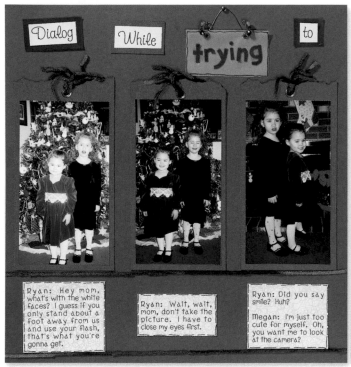

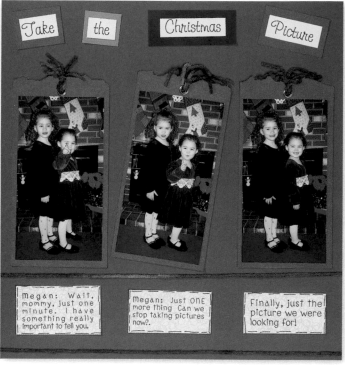

Quick Tip: Find great quotes in songs and poems, quote-of-the-day calendars, Web sites, quote books (A favorite: "The 2,548 Best Things Anybody Ever Said" by Robert Byrne), interviews with experts, political and inspirational speeches, posters and greeting cards.

I Am Growing

NARRATE JOURNALED BORDERS

Stacy gives her pup a voice with first-person journaling narrating his first year of life. Slice two strips of colored paper, one ¼" larger than the other; layer at outer edges of solid paper. Lightly stamp border with paw prints (Close To My Heart) and background paper with dog-related images (Close To My Heart)using Versa Mark ink (Tsukineko). Double mat small photos. Lightly stamp blue cardstock with bones (Close To My Heart); mat large photo with stamped cardstock. Slice thin strips of dark blue paper; mount diagonally over opposite corners of matted photo. Cut title letters with template (Scrap Pagerz) from blue stamped cardstock. Mat and silhouette cut. Print journaling list on vellum; mount.

Stacy MacLaren, Tucson, Arizona

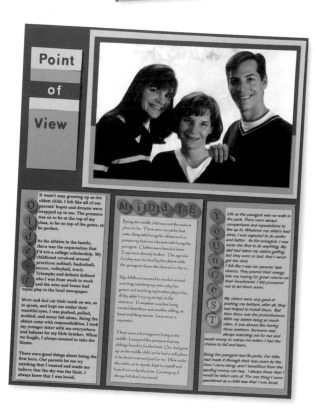

Point of View

LET PERSPECTIVE JOURNALING DO THE TALKING

Kelli gives each subject in her photo a voice detailing what it was like growing up together. Double mat photo; use two colors of paper for first matting. Slice strips of complementary-colored paper; mount together for a small, color-blocked title border. Punch title letters (Family Treasures) and mount. Print journaling. Cut to size, mat and mount. Mount metal alphabet brads (Making Memories) to matting.

Kelli Noto, Centennial, Colorado

What Not to Do in Jamaica

Journal The Unusual

Holly created a unique way to journal about honeymoon photos with a comic list of memories. Color block a background with monochromatic shades of brown by layering rectangles of various dimensions. Mat photos. Craft journal tags by cutting computer-printed journaling to size and laminate. Mount large eyelets (Prym-Dritz) and tie fibers (source unknown). Cut title letters from templates (C-Thru Ruler and Scrap Pagerz); detail with black pen on small letters. Mat large letters and silhouette cut.

Holly Van Dyne, Mansfield, Ohio

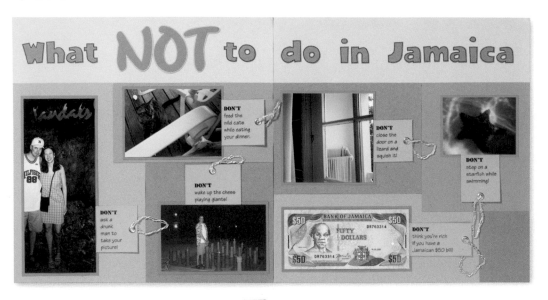

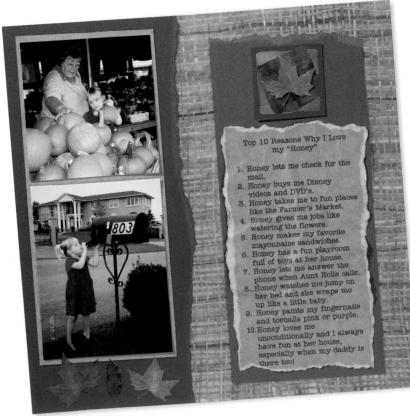

Top 10 Reasons

JOURNAL A LIST OF LOVE

Holle chronicles a little girl's love for her grandma with a clever "top 10" list. Double mat photos; tear right side of second mat; mount on page as a left-side border over patterned background paper (Frances Meyer). Print journal list; tear edges and crumple. Mat on solid paper; tear across top. Mat leaf sticker (Karen Foster Design); mount on journal matting. Adhere leaf stickers to left side border.

Holle Wiktorek, Fayetteville, North Carolina

Christmas Eve Checklist

DETAIL HOLIDAY TRADITIONS

Dee designed a clever checklist detailing her family's Christmas Eve traditions. Layer torn solid and patterned (Doodlebug Designs) paper over patterned (Paper Fever) and solid background papers. Triple mat photo; tear edges of second matting. Attach matted photo to page with eyelets (Stamp Studio) Print checklist and title text. Cut to size; outline with black pen. Cut or punch 1" squares; mat and adhere to page with self-adhesive foam spacers. Cut title letters and check marks from template (Provo Craft). Mat title letters, silhouette and add outlines with black pen. Mount check marks onto matted squares. Handcut tag at page bottom; mat and attach eyelet and fiber (DMC).

Dee Gallimore-Perry,
Griswold, Connecticut

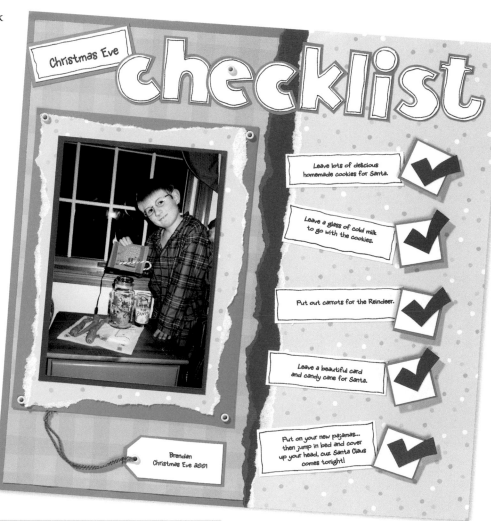

Creative Things to Put in a List

- Best/Worst Dates Ever
- Life Lessons I Have Learned
- Songs That Make Me Cry
- Coolest Family Traditions
- Best Movies Ever Made
- Favorite Family Memories
- Significant Career Highlights
- Best Gifts Ever Received
- Wildest Thing I Ever Did
- Most Respected People and Why
- Ickiest Foods or Ickiest Fashions
- What I MUST Remember to Tell My Grandchildren Someday

100 Percent Boy

LIST INGREDIENTS FOR A PERFECT RECIPE

Torrey came up with the perfect recipe for a page that screams "100 Percent Boy!" Tear solid-colored paper strip; mount on background paper. Double mat photo; partially layer over torn paper strip. Mount die-cut title letters (Ellison/Provo Craft); detail with black pen. Layer die-cut ladybugs (Ellison/Provo Craft); mount on page. Create recipe card on computer and print journaling.

Torrey Miller, Westminster, Colorado

Della Osborne

CELEBRATE SOMEONE'S LIFE WITH A TIMELINE

In Jodi's heritage, nobody goes unnoticed! Mount photo five times. Use embroidery floss (DMC) to create a border around the third mat by blanket stitching into punched wholes. Across patterned paper (Anna Griffin), draw and stitch timeline. Attach timeline journaling blocks. Mount patterned paper on darker colored cardstock.

Jodi Amidei, Memory Makers

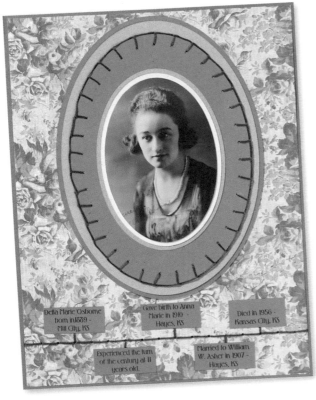

Serene

GIVE DEFINITION TO PHOTO SUBJECT

Desiree clearly defines a serene moment with dictionary journaling. Color block background with natural shades of cardstock. Print text on ivory cardstock before mounting on page. Add texture to photo matting by crumpling ivory cardstock; flatten and add definition with chalk. Attach eyelets; weave hemp cord through eyelets and mount on page.

Desiree McClellan, Decatur, Alabama

```
Serene
Se*rene",   n.
1. Serenity; clearness;
calmness. [Poetic.] The
serene of heaven."
```

Priceless

CREATE A JOURNALING TAG

Jodi documents the story behind a found treasure on a fiber-tied tag. Mat patterned paper (Scrap Ease); mount large rectangle of solid paper at center. Mount fiber (EK Success) horizontally over solid paper; secure behind page. Single and double-mat photos; mount center photo with self-adhesive foam spacers for dimension. Print title and journaling onto solid paper; cut to size and mount on tag. Tie fibers (EK Success) onto tag.

Jodi Amidei, Memory Makers

35 Uses for Your Golden Retriever

PUT TOGETHER A THEMED ALBUM

Katie created a lighthearted, pet-themed album for her husband that became his favorite holiday gift! Make a simple themed album by printing consistent borders and text. Use your computer to keep the letters tidy. Mat photos; mount on pages.

Katie Nelson, Murray, Utah

35 Uses
for
Your
Golden
Retriever

Bed Warmer

Safety Inspector on
all stuffed animals

Great Interview Questions

PAST

Where were you born?

What is your first memory?

What did you do for fun as a child?

What lessons did you learn "the hard way"?

What did you get away with that your parents never knew about?

PRESENT

Who are the most important people in your life and why?

What is a typical day like for you?

What are your greatest accomplishments? Failures?

What are your hobbies?

What is your biggest dream?

Describe yourself using only three adjectives.

What are your best qualities? Worst?

FUTURE

What do you want to change (or stay the same) in your life?

What is the one dream you fear you'll never be able to fulfill?

What challenges do you anticipate in the future?

If you could have one wish, what would it be?

What's one thing you know now that you wish you knew then?

Quick Tip:

During an interview don't forget to ask your subject if she has any old photos. She may let you make copies to use in your scrapbook. Old photos are also great for sparking memories.

Once Upon a Time

WRITE A PERSONALIZED FAIRY TALE

Kelly wrote a modern-day fairy tale about a few favorite princesses who teach lessons of love and friendship. Print story on vellum, leaving room for illuminated letter. Cut to size; detail with black pen around edges. Cut window for photo in vellum with craft knife. Mount over photo and matted background paper (Frances Meyer) with flower eyelets (Making Memories) at corners. Silhouette-cut large letter printed from computer; mat on glittery paper (Paper Adventures). Mount flat-backed jewels (Magic Scraps) on letter and page. Double and triple mat photos.

Kelly Angard, Highlands Ranch, Colorado

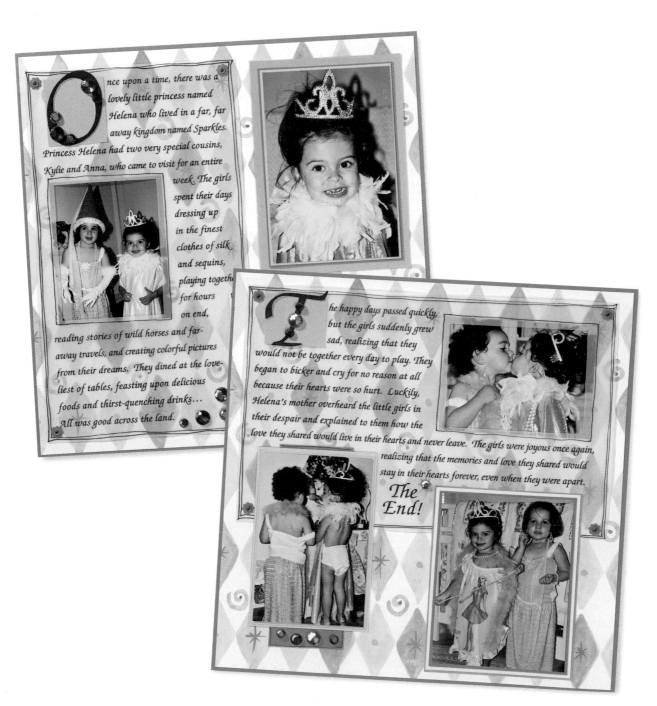

Gallery

More beautiful quick & easy scrapbook pages for inspiration.

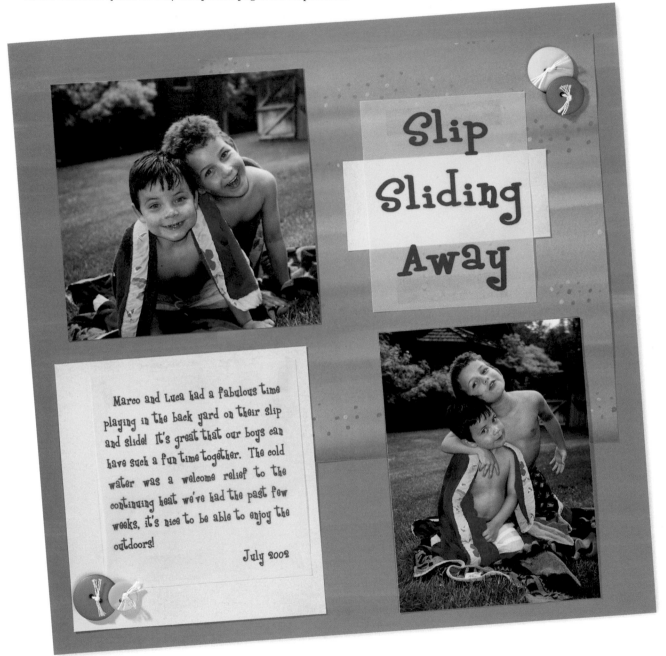

Marco and Luca had a fabulous time playing in the back yard on their slip and slide! It's great that our boys can have such a fun time together. The cold water was a welcome relief to the continuing heat we've had the past few weeks, it's nice to be able to enjoy the outdoors!

July 2002

Slip Sliding Away

DRAW ATTENTION TO PHOTOS

Brandi's simple layout keeps her photos as the focal point of the page. Cut large square of patterned paper (Scrappin' Dreams); layer over patterned background paper (Magenta). Mount cropped photos. Print title and journaling onto vellum; mat on yellow patterned paper strip and square. Tie buttons (Making Memories) with embroidery thread; mount on page.

Brandi Ginn, Lafayette, Colorado

Photos, Joann Brennan, Centennial, Colorado

Blossoms

BRING PHOTO IMAGES TO LIFE

Large flower die cuts adorn Torrey's colorful page of blossoms. Cut large circles from patterned papers (Karen Foster Design, Paper Adventures); layer on matted patterned paper (Doodlebug Design). Mat photos; layer over circles as shown. Die cut title letters and flowers (Accu Cut). Mount on page; give dimension to flowers by mounting one with self-adhesive foam spacers. Print journaling; cut to size and mount.

Torrey Miller, Westminster, Colorado

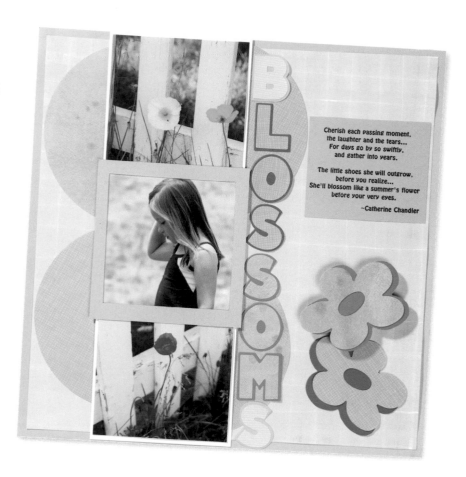

> Cherish each passing moment,
> the laughter and the tears...
> For days go by so swiftly,
> and gather into years.
>
> The little shoes she will outgrow,
> before you realize...
> She'll blossom like a summer's flower
> before your very eyes.
>
> ~Catherine Chandler

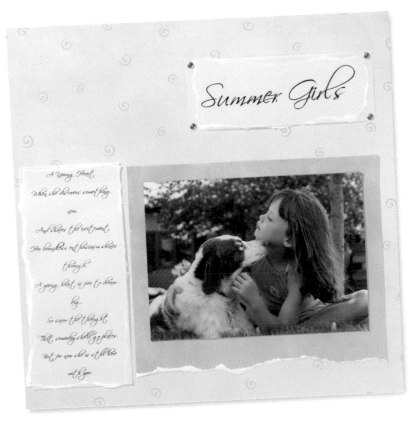

Summer Girls

HAVE THE COLOR SET THE MOOD

Soft pastel-colored, patterned papers set the tone for a sweet summer moment between friends. Mat photo on patterned paper (Karen Foster Design). Tear bottom edge of matting; mount on patterned background paper (Making Memories). Print title and journaling onto vellum. Cut to size and layer over torn patterned paper (Karen Foster Design). Mount title to page with eyelets (Doodlebug Design).

Brandi Ginn, Lafayette, Colorado
Photo, Lori Whyte, Visalia, California

Frye Cove Park

HIGHLIGHT EYE-CATCHING BACKGROUND

Andrea layers colored vellum on her color-blocked background for a simple and striking effect. Print title and journaling onto background paper. Print selected words on blue paper, leaving space to tear around edges. Mount directly over previously printed word. Cut rectangles of varying dimensions from blue and green vellum; layer on page as shown. Mount photo.

Andrea Hautala, Olympia, Washington

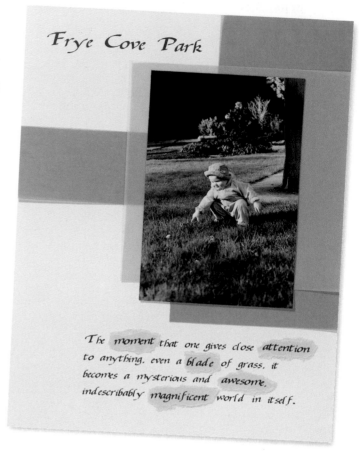

Brothers

CALL ATTENTION TO A
SPECIAL PICTURE

Donna "hangs" a favorite photo of her sons on a page framed with unevenly cut paper strips. Mat photo; cut to size and tear all sides of matting. Punch small holes through matted photo. Tie embroidery thread with beads (Magic Scraps) to photo; hang from brad (Hyglo/American Pin) attached to page. Print title and journaling; cut to size and tear edges. Punch small holes in title/text block; secure to page with embroidery thread and brads.

Donna Goodman, Seville, Florida

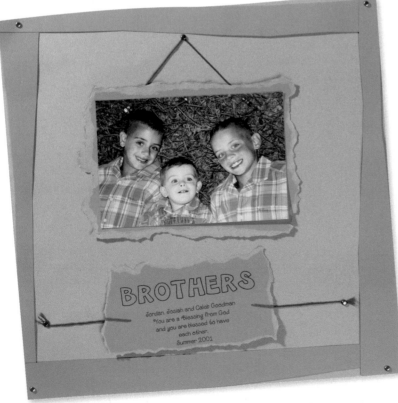

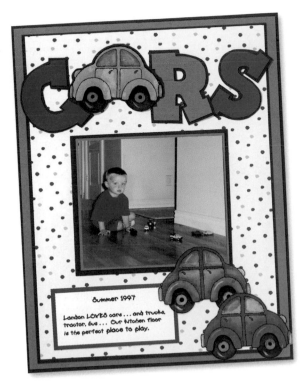

Cars

INCORPORATE STICKERS INTO TITLE

Jennifer highlights her love of stickers by using a large car sticker in her title. Double mat photo. Mount over triple-matted patterned paper (Paper Patch). Print text; cut to size and mat. Cut title letters from template (Scrap Pagerz); mat and silhouette. Adhere car stickers (Provo Craft) in title and page bottom.

Jennifer Blackham, West Jordan, Utah

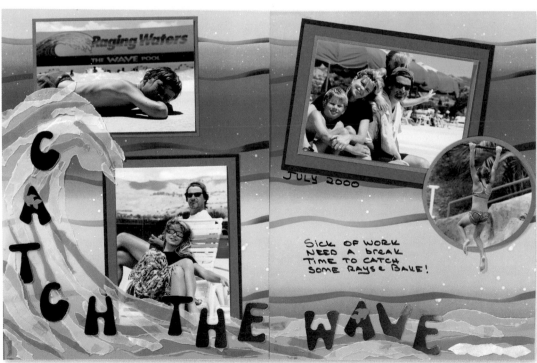

Catch the Wave

TEAR A SPECIAL DESIGN

Oksanna crafted an enormous swooping wave from torn pieces of colored vellum. Tear strips of clear, blue and silver vellum in various widths and lengths; layer on page in desired shape over patterned background paper (Design Originals). Highlight wave with clear dimensional paint (Duncan). Single, double and triple mat cropped photos. Cut title letters from template (EZ2Cut); add punched fishes (EK Success) on letters.

Oksanna Pope, Los Gatos, California

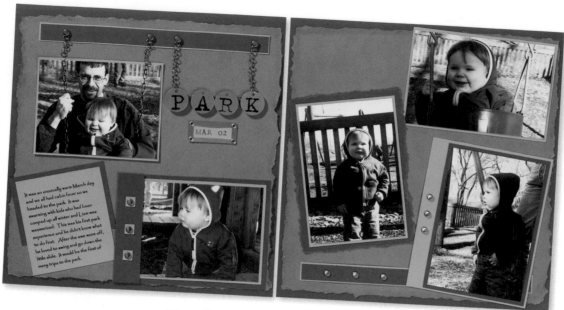

Park

SHOWCASE METAL EMBELLISHMENTS

Greta showcases her keen eye for simplistic detail with a black-and-white photo layout. Mat solid, torn paper with lightly chalked edges. Slice 1" strip; mat on top and bottom of both pages. Single mat photos. "Hang" one photo with linked jump rings (source unknown). Attach to matted strip with flat-top eyelets (Stamp Doctor). Mount metal letters (Making Memories) with self-adhesive foam spacers. Link letters with artist's wire (Artistic Wire); hang. Stamp date (Hero Arts); frame with metal tag (Making Memories) and attach with eyelets (Making Memories). Print journaling; cut to size and layer over solid paper square. Double mat three photos; add flat-top eyelets to left side of one and paper tear another. For bottom left photo, cut second mat 1½" longer on left. Fold over photo; attach eyelets over small punched squares.

Greta Hammond, Goshen, Indiana

Time

USE EVERYDAY SUPPLIES TO CREATE BORDER

Andrea borders the top of her page with layered embellishments torn from a greeting card. Layer patterned paper (C-Thru Ruler) over solid paper for background. Mount sheer ribbon (Offray) across top of page; secure ends around back of page. Mount flower embellishments torn from greeting card. Double mat photo; mount. Print journaling two times from computer onto two colors of solid paper. Cut one to size for journal block; ink around edges and center to soften stark white color. Highlight text by cutting out specific words on alternate-colored paper and mounting over previously printed word.

Andrea Hautala, Olympia, Washington

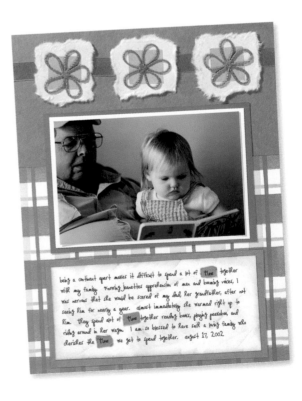

Dr. Seuss

PRESERVE A PRICELESS MEMORY WITH A QUOTE

Andrea captures her daughter's personality with a reflective poem adorned with creative paper clips. Print poem, separating lines so each can be cut apart. Cut to size; detail around edges with black pen. Mat two text blocks with patterned paper (Provo Craft); slice corrugated paper strips and mount horizontally at top and bottom of page. Attach swirled paper clips (Target) to text blocks; mount. Mat photo and mount.

Andrea Hautala, Olympia, Washington

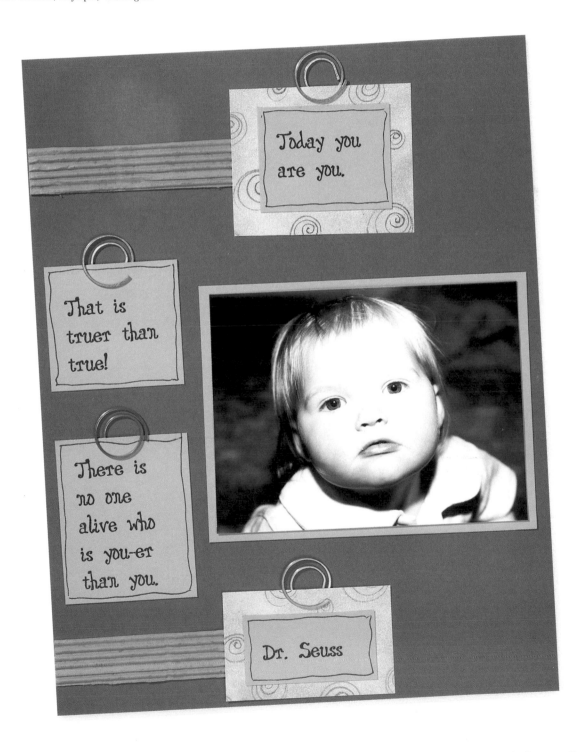

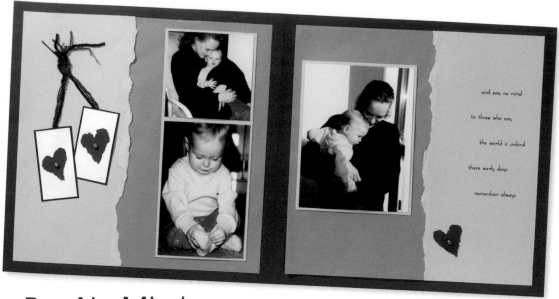

Pay No Mind

CREATE A DELICATE BORDER

Torn paper provides a soft, textured border for a meaningful poem and the simple embellishments on Cindy's page. Mat solid paper. Print poem on yellow cardstock; tear one side and layer over solid-colored paper at outer edges. Mat photos; mount. Handcut hearts; tear around edges. Mount on page and on matted paper rectangles with eyelets (Stamp Studio). Tie fibers (Fibers by the Yard) together; secure ends under matted paper rectangles.

Cindy Sherman, Columbia, Tennessee

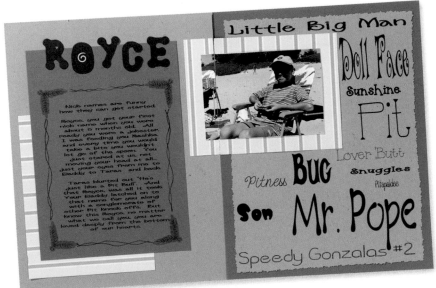

Royce

GIVE "VOICE" TO A UNIQUE PERSONALITY

Oksanna brings her son's personality to life with a number of nicknames creatively displayed on the page. Print journaling on solid-colored paper. Cut to size; trim with decorative scissors. Detail journal block with leaf stickers (Provo Craft) and hand-drawn design with black pen. Layer over patterned paper (Anna Griffin) rectangle. Cut title letters using a template (EZ2Cut); add punched swirls (All Night Media). Mat photo on patterned paper; slice and mount on both pages.

Oksanna Pope, Los Gatos, California

Curiosity

LET LAYOUT DEFINE MOOD

Emily captures the natural curiosity of her toddler with an interesting, rustic layout. Crop photos; mount on patterned paper (Scrap Ease). Cut mat into quarters, crumple and loosely attach pieces together with cotton thread (Making Memories) wrapped around small brads (Creative Impressions). Mat large photo on distressed photo mat. Print title and journaling on solid paper. Cut to size and mount.

Emily Marjamaa, Fort Collins, Colorado

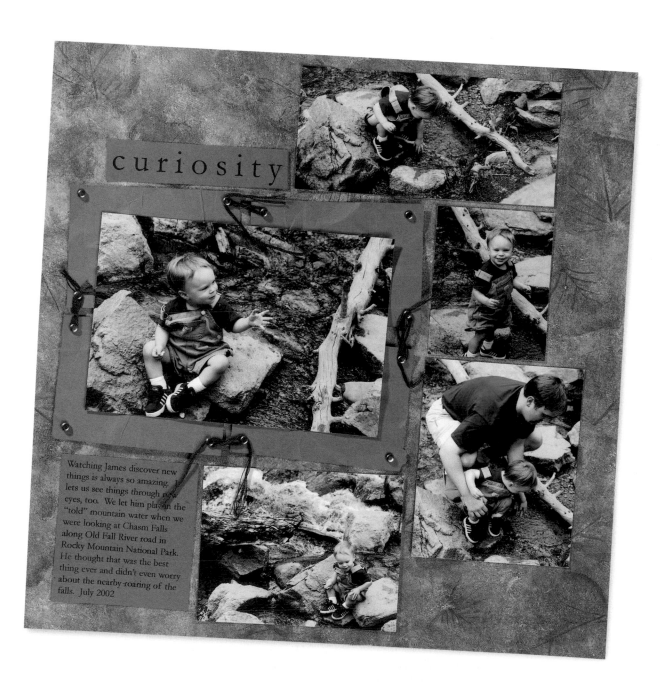

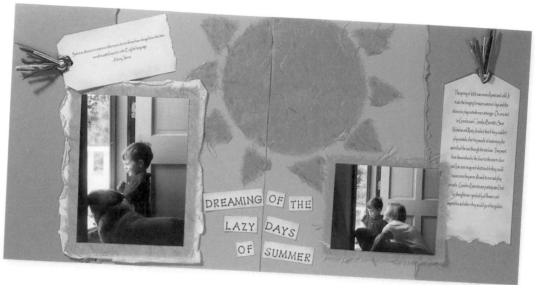

Dreaming of Lazy Days

CREATE A SEASONAL FEEL

Amy layers soft textures in warm colors inspired by her favorite season of the year.
Tear solid-colored paper borders; gently curl torn edges with fingers. Tear mulberry
paper into geometric shapes; assemble into sun as shown. Single and double mat pho-
tos on torn mulberry and solid papers; curl edges in same fashion as borders. Print
quote and journaling onto solid-colored paper. Handcut into tag shape; punch hole at
top and tear at bottom. Tie raffia to tags. Stamp title letters (Stamp Craft by Plaid
Enterprises) to paper strips; cut to size and mount.

Amy Barrett-Arthur
Liberty Township, Ohio

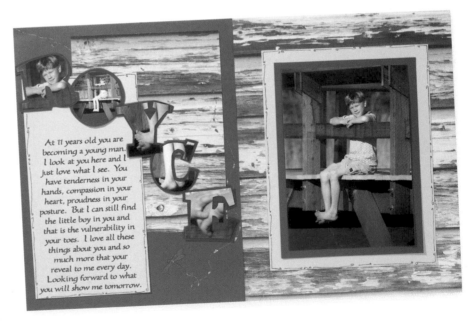

Royce

LET THE PHOTO SAY IT ALL

Oksanna focuses in on a few favorite details with partial images of her son displayed
in the page's title. Layer patterned paper (Provo Craft) square over solid background
paper. Print journaling on solid-colored paper; detail with hand-drawn design around
edges with black pen before mounting. Cut photo title letters from template (C-Thru
Ruler); mat and silhouette cut. Stamp dragonfly (All Night Media); add gold hand-
drawn design around page with metallic dimensional paint (Duncan) and gold gel pen.

Oksanna Pope, Los Gatos, California

Glossary of scrapbook terms and techniques

Acid-Free

Look for scrapbook products—particularly pages, paper, adhesives and inks—that are free from harmful acids that can eat away at the emulsion of your photos. Harmful acids can occur in the manufacturing process. Check labels for "acid-free" and "photo-safe."

Archival Quality

A nontechnical term suggesting that a substance is chemically stable, durable and permanent.

Border

The upper, lower and side edges or margins of a scrapbook page. Sometimes refers to a border design that is handmade or manufactured and attached to a page.

Chronological

Arranged in order of time occurrence as it pertains to the sorting, organizing and/or placement of photos and memorabilia throughout your album.

Design

A visual compostion or pattern of photos, journaling and accessories that ultimately becomes a finished scrapbook page.

Embellishments

Page accents you can make or buy. Can include stickers, die cuts, stamped images, punch art, beads, buttons, rhinestones, sequins, pens, chalks, inkpads, charms, wire, ribbon, embroidery floss, thread and much more.

Journaling

Refers to handwritten, handmade or computer-generated text that provides pertinent details about what is taking place in photographs.

Layout

To put or spread photos and memorabilia in readiness for scrapbooking or a sketch of a scrapbook page design.

Lignin-Free

Paper and paper products that are void of the material (sap) that holds wood fibers together as a tree grows. Most paper is lignin-Free except for newsprint, which yellows and becomes brittle with age. Check product labels to be on the safe side.

Matting

The act of attaching paper, generally cropped in the shape of a photo, behind the photo to separate it from the scrapbook page's background paper.

Memorabilia

Mementos and souvenirs saved from travel, school and life's special events—things that are worthy of remembrance.

Page Protectors

Plastic sleeves or pockets that encase finished scrapbook pages for protection. Use only PVC-free protectors.

Photo-Safe

A term used by companies to indicate they feel their products are safe to use with photos in a scrapbook album.

Preservation

The act of stabilizing an item from deterioration by using the proper methods and materials manufactured to maintain the conditions and longevity of the item.

PVC or polyvinyl chloride

A plastic that should not be used in a scrapbook, it emits gases, which interact with and cause damage to photos. Use only PVC-free plastic page protectors and memorabilia keepers. Safe plastics include polypropylene, polyethylene, and polyester or Mylar.

Title

A general or descriptive headline put on a scrapbook page that sums up its overall theme.

Daniel, page 352

DOCUMENT A SPECIAL VACATION

Thanks to this memorable layout, Michele will always treasure memories of her family's summer trip to Alaska. Diagonally tear middle from sheet of patterned paper (Karen Foster Design). Place mesh (Avant Card) mounted on brown cardstock inside gap. Mount photos on white cardstock; place on strips of corrugated dark green cardstock. Adhere pictures. Repeat same technique as seen on the backgound to make the tag (DMD). Place sticker letters (Mrs. Grossman's) on shapes. Add leather strap (Crafter's Workshop) and journaling.

Jodi Amidei, Memory Makers
Photos, Michele Gerbrandt

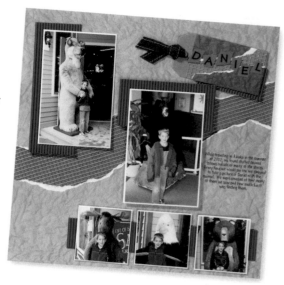

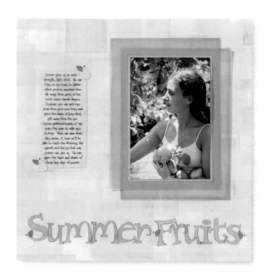

Summer Fruits, page 360

CAPTURE THE ESSENSE OF A SEASON

Jenna's simple, pastel layout perfectly mirrors the carefree feeling of summer. Cut mats out of two different colors of vellum; chalk edges. Mount double-matted photo on chalked vellum pieces. Journal on vellum; chalk; adhere in place with pear stickers (EK Success). Cut letters using lettering templates (Scrap Pagerz); chalk edges before adhering.

Jenna Beegle, Woodstock, Georgia

Sand, page 378

USE CORRESPONDING COLORS TO ACCENT A THEME

Jodi captured the beauty of her daughter's sand dune experience with a layout that looks as though it were carved right out of sand! Triple mount photo on cream, then crumpled brown, then cream cardstocks. Place pop-dots between two outermost layers of cardstock. Tear two different colors of lighter brown cardstock and mount on third, darker brown color. Hand-letter two titles; tear edges; accent with chalk. Adhere eyelet letters (Making Memories) for third title. Print journaling on vellum. Using chalk, highlight the word "sand" on backside of vellum. Attach with eyelets.

Jodi Amidei, Memory Makers

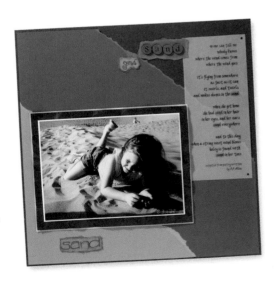

Tom, page 394

SHOWCASE MATCHING TITLES, BORDERS AND MATTING

Jodi reminisces on her husband's finer qualities with a sentimental, co-ordinating layout. Mat photos on light green cardstock, leaving room for wire embellishments. Add wire embellishments; re-mat in dark green. Cut thin paper strips and squares for title. Using a stencil (EK Success), dab ink from a stamp ink pad (Stampin' Up) through to spell name; add wire embellishments. Stamp leaf image over homemade tag; mat in dark green. Print vellum journaling; adhere over tag with eyelets (Impress Rubber Stamps).

Jodi Amidei, Memory Makers

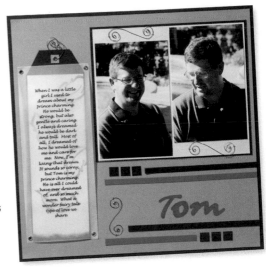

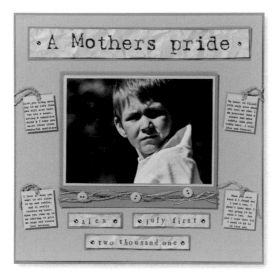

A Mother's Pride, page 420

LET THE TAGS DO THE TALKING

Trudy highlights a few of the things she loves most about her son by printing them on individual, homemade tags. Mount enlarged photo; adorn with fibers and buttons along bottom edge (Magic Scraps; Making Memories; On The Surface). Pop out picture with pop dots. Print journaling and cut into small square tags. Print titles and word blocks; crumple. Adhere to page with brads.

Trudy Sigurdson, Victoria, BC, Canada

Ali, page 444

JOURNAL YOUR INNERMOST THOUGHTS

Lisa shares her feelings about watching her daughter grow up in this truly personal poem. Triple mat photo on sage and cream-embossed papers (K & Company). Create tag (Ellison/Provo Craft); tear edges and add fibers. Print journaling; mount on light pink cardstock. Add flower sticker (K & Company).

Lisa Simon, Roanoke, Virginia

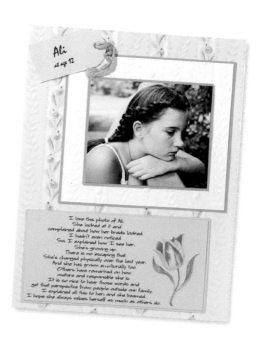

Professional Photographers

Keepsake Photography
254 Park Ave. West
Mansfield, OH 44903 419-522-8363

Joann Brennan
Centennial, Colorado

Contributing Memory Makers Masters

Valerie Barton, Brandi Ginn, Diana Hudson, Torrey Miller, Kelli Noto, Heidi Schueller, Trudy Sigurdson, Holle Wiktorek

Sources

The following companies manufacture products featured in this book. Please check your local retailers to find these materials. We have made every attempt to properly credit the items mentioned in this book. We apologize to any company that we have listed incorrectly or the sources were unknown.

3L Corp.
800-828-3130 3lcorp.com

Accu-cut®
800-288-1670 accucut.com

All My Memories
888-553-1998 allmymemories.com

All Night Media, Inc.
800-782-6733

American Pin
800-821-7125 americanpin.com

American Tag Company
800-223-3956 americantag.net

American Tombow
800-835-3232 tombowusa.com

Anna Griffin, Inc.
888-817-8170 annagriffin.com
(wholesale only)

Art Accents (merged with Provo Craft)
877-733-8989
artaccents.com

Artistic Wire, Ltd.™
630-530-7567
artisticwire.com

Autumn Leaves
800-588-6707 autumnleaves.com
(wholesale only)

Avant Card avantcard.com.au

Avery Dennison Corporation
800-462-8379 avery.com

Bazzill Basics Paper
480-558-8557 bazzillbasics.com
(wholesale only)

Beadery®, The
401-539-2432 beadery.com

Blumenthal Lansing Co.
563-538-4211

Carolee's Creations®
435-563-1100 carolees.com

Charming Pages
charmingpages.com

Close To My Heart®
888-655-6552 closetomyheart.com

Club Scrap™
888-634-9100 clubscrap.com

C.M. Offray & Son, Inc.
800-344-9727 offray.com

Colorbök™
800-366-4660 colorbok.com
(wholesale only)

Colors By Design
800-223-3130 cbdcards.com

Crafter's Workshop, The
877-CRAFTER thecraftersworkshop.com

Craf-T Products
507-235-3996

Crafts Etc! (formerly Stampabilities)
800-888-0321 craftsetc.com

Creative Imaginations
800-942-6487 cigift.com

Creative Impressions
719-577-4858 creativeimpressions.com

Creative Memories®
800-468-9335 creative-memories.com

C-Thru® Ruler Company, The
800-243-8419 cthruruler.com

Cut-It-Up™
530-389-2233 cut-it-up.com

Darice, Inc.
800-321-1494 darice.com

Dayco
877-595-8160 daycodiecuts.com

Debbie Mumm®
debbiemumm.com

Deluxe Designs
800-96-DELUX deluxecuts.com

DeNami Design Rubber Stamps
253-437-1626 denamidesign.com

Design Originals
800-877-7820 d-originals.com

DieCuts With a View™
801-224-6766 diecutswithaview.com

DMC Corp.
973-589-0606 dmc–usa.com

DMD Industries, Inc.
800-805-9890 dmdind.com

Doodlebug Design Inc.™
801-524-0050

Duncan Enterprises
800-438-6226 duncan-enterprises.com

EarthGoods™
earthgds.com

EK Success
800-524-1349 eksuccess.com

Ellison® Craft & Design
800-253-2238 ellison.com

Emagination Crafts, Inc.
630-833-9521 emaginationcrafts.com

Eyelet Factory, Inc.
801-582-3606 eyeletfactory.com
(wholesale only)

Ez2Cut/Accu-cut
800-646-0010 ez2cut.com

Family Treasures, Inc.®
800-413-2645 familytreasures.com

Faux Memories
813-269-7946 fauxmemories.com

Fibers by the Yard
405-364-8066 fibersbytheyard.com

Fiskars, Inc.
800-500-4849 fiskars.com

Frances Meyer, Inc.®
800-372-6237 francesmeyer.com

Graphic Products Corporation
800-323-1660 gpcpapers.com

Halcraft USA, Inc.
212-376-1580 halcraft.com

Hasbro
800-844-3733 hasbro.com

Hero Arts
800-822-4376 heroarts.com

Hillcreek Designs
619-562-5799 hillcreekdesigns.com

Impress Rubber Stamps
206-901-9101
impressrubberstamps.com

Jest Charming
702-564-5101 jestcharming.com
(wholesale only)

Jesse James & Co., Inc.
jessejamesbutton.com

JewelCraft, LLC
201-223-0804 jewelcraft.biz

Judi-Kins
800-398-5834 judikins.com

Just Another Button Company
618-667-8531 (wholesale only)
justanotherbuttoncompany.com

K & Company
888-244-2083 kandcompany.com

Karen Foster Design
801-451-9779 karenfosterdesign.com

Keeping Memories Alive™
800-419-4949 scrapbooks.com

Lion Brand Yarn
212-243-8995 lionbrand.com

Magenta Rubber Stamps
magentarubberstamps.com
(wholesale only)

Magic Scraps™
972-238-1838 magicscraps.com

Making Memories
800-286-5263 makingmemories.com

Marvy Uchida
800-541-5877 uchida.com

McGill, Inc.
800-982-9884 mcgillinc.com

Me and My Big Ideas
949-589-4607 meandmybigideas.com
(wholesale only)

Microsoft
microsoft.com

MPR Associates, Inc.
336-861-6343

Mrs. Grossman's Paper Co.
800-429-4549 mrsgrossmans.com

Mustard Moon
408-229-8542 mustardmoon.com

On The Fringe
onthefringe.net

On The Surface
847-675-2520

Paper Adventures®
800-727-0699 paperadventures.com

Paper Fever Inc.
800-477-0902 paperfever.com

Paper House Productions
800-255-7316 (wholesale only)
paperhouseproductions.com

Paper Loft, The
801-254-1961 paperloft.com

Paper Patch®, The
800-397-2737 paperpantry.com
(wholesale only)

Pebbles in my Pocket
800-438-8153 pebblesinmypocket.com

Pioneer Photo Albums, Inc.®
818-882-2161 pioneerphotoalbums.com

Plaid Enterprises, Inc.
800-842-4197 plaidenterprises.com

Provo Craft®
800-937-7686 provocraft.com

Prym-Dritz Corporation
www.dritz.com (wholesale only)

PSX Design™ (Duncan Enterprises)
800-438-6226 psxdesign.com

Punch Bunch, The
254-791-4209 thepunchbunch.com

(wholesale only)

Quilter's Resource, Inc.
800-676-6543 quiltersresource.com

Rocky Mtn. Scrapbook Co.
801-785-9695 rmscrapbook.com

Rubba Dub Dub Artist's Stamps
209-763-2766
artsanctum.com/RubbaDubDubHome.html

Rubber Stamps of America
800-553-5031 stampusa.com

Sakura of America
800-776-6257 sakuraofamerica.com

Sandylion Sticker Designs
800-387-4215 sandylion.com

Scrapbook Sally
86-SBSally scrapbooksally.com

Scrapbook Wizard™, The
801-947-0019 scrapbookwizard.com

Scrappin' Dreams
417-831-1882 scrappindreams.com

Scrap in a Snap
866-462-7627
scrapinasnap.com

ScrapPagerz
435-645-0696 Scrappagerz.com

Stamp Doctor, The
208-342-4362 stampdoctor.com

Stamp Studio
208-288-0300

Stampin' Up!®
800-782-6787 stampinup.com

Stickopotamus
888-270-4443

Treehouse Designs
877-372-1109 treehouse-designs.com

Tsukineko®Inc.
800-769-6633 tsukineko.com

un-du® Products, Inc.
888-289-8638 un-du.com

Uptown Design Company™
800-888-3212 uptowndesign.com

U.S. Shell, Inc.
956-554-4500 usshell.com

Xyron Inc.
800-793-3523 xyron.com

Westrim® Crafts
800-727-2727 westrimcrafts.com

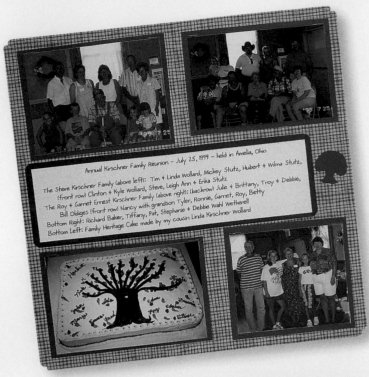

Annual Kirschner Family Reunion - July 25, 1999 - held in Amelia, Ohio

The Steve Kirschner Family (above left): Tim + Linda Wollard, Mickey Stutz, Hubert + Wilma Stutz,
(front row) Clinton + Kyle Wollard, Steve, Leigh Ann + Erika Stutz
The Roy + Garnet Ernest Kirschner Family (above right): (backrow) Julie + Brittany, Troy + Debbie,
Bill Oldiges (front row) Nancy with grandson Tyler, Ronnie, Garnet, Roy, Betty
Bottom Right: Richard Baker, Tiffany, Pat, Stephanie + Debbie Wahl Wetherell
Bottom Left: Family Heritage Cake made by my cousin Linda Kirschner Wollard

Pg 81

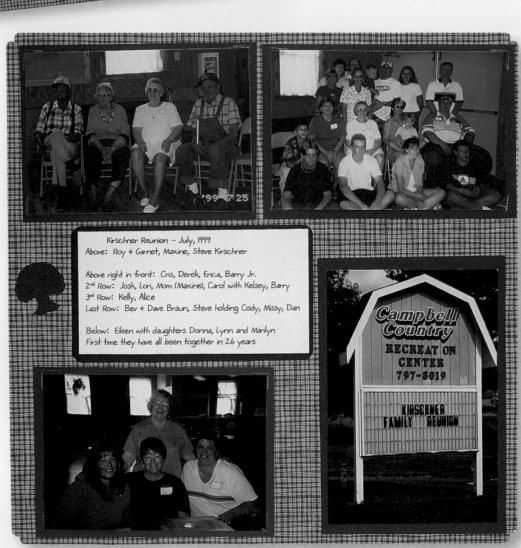

Kirschner Reunion - July, 1999
Above: Roy + Garnet, Maxine, Steve Kirschner

Above right in front: Cris, Derek, Erica, Barry Jr.
2nd Row: Josh, Lori, Mom (Maxine), Carol with Kelsey, Barry
3rd Row: Kelly, Alice
Last Row: Bev + Dave Braun, Steve holding Cody, Missy, Dan

Below: Eileen with daughters Donna, Lynn and Marilyn
First time they have all been together in 26 years

474

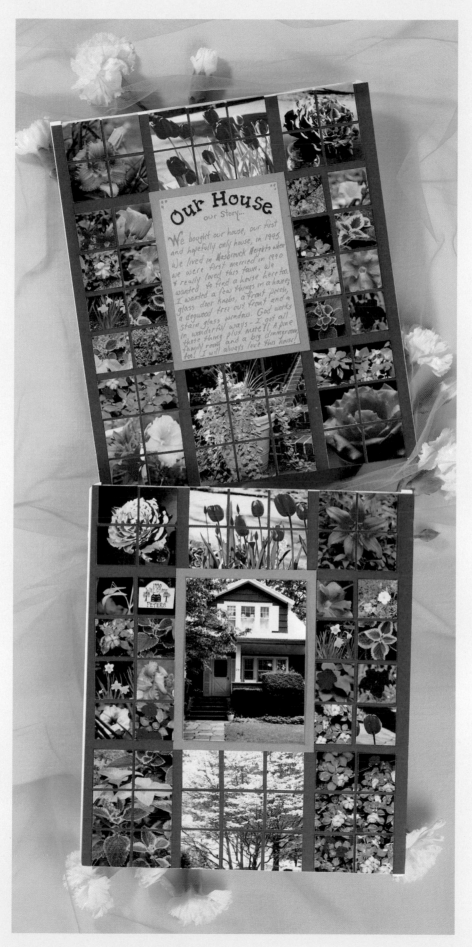

Pg 241

HISTORY OF MEMORY MAKERS MAGAZINE

May 1996
The first issue of *Memory Makers*, the very first scrapbook magazine—was mailed.

September 1996
The first full edition of *Memory Makers* mailed to 4,000 charter subscribers.

June 1997
Memory Makers moves out of Michele Gerbrandt's in-laws' basement and into an "official" office.

January 2001
Three separate *Memory Makers* special issue publications added per year.

December 2000
Memory Makers is the number-one selling scrapbook magazine in the U.S. as reported by newsstand distributors.

August 2000
Memory Makers' Michele Gerbrandt brings scrapbooking to TV with the show, "Do it Yourself Scrapbooking."

July 2001
Memory Makers is acquired by F+W Publications.

March 1998
Memory Makers hosts its first Croppin' Cruise.

September 1998
Memory Makers goes bimonthly, while also increasing the number of pages in each issue.

September 1998
Memory Makers publishes its first book, *Punch Your Art Out 1.*

March 2000
Memory Makers holds its first Page for the Cure contest to support the Susan G. Komen Breast Cancer Foundation.

June 1999
Memory Makers' receives 20,000th page idea submission.

July 2002
The first Camp Memory Makers is held in Grand Rapids, Michigan.

December 2002
Memory Makers is the number-one selling scrapbook magazine in the U.S. as reported by newsstand distributors.

477

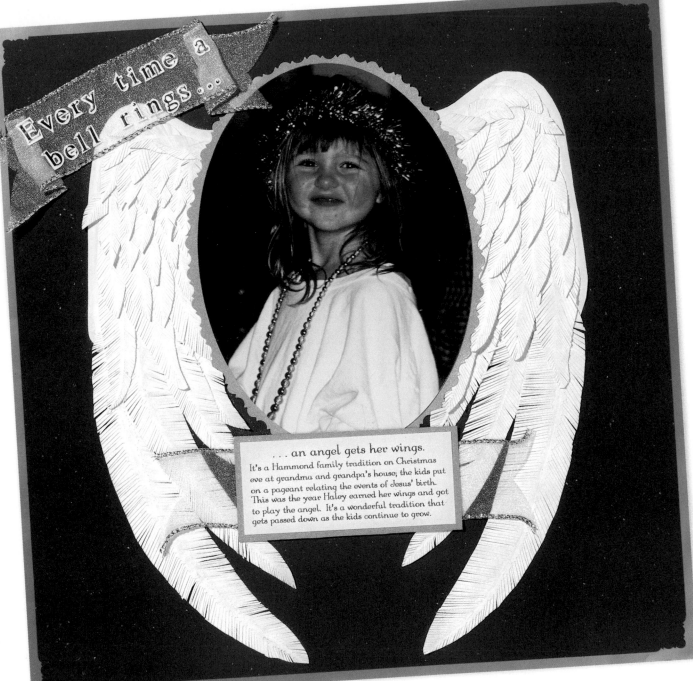

Every time a bell rings...

. . . an angel gets her wings.

It's a Hammond family tradition on Christmas eve at grandma and grandpa's house; the kids put on a pageant relating the events of Jesus' birth. This was the year Haley earned her wings and got to play the angel. It's a wonderful tradition that gets passed down as the kids continue to grow.

Pg 276

478

EXPLORE YOUR FAMILY HISTORY!

Immortalize your family's cherished photos, documents and memorabilia for generations to come. Crafting Your Own Heritage Album shows you how to showcase and preserve the special people, stories, traditions and keepsakes of your ancestry. Even if you've never attempted a heritage album before, you'll create elegant, timeless pages as you learn to incorporate journal entries into each layout, mount and protect three-dimensional mementos, organize and restore old photographs and use archivally safe materials to preserve your family's photos, records and heirlooms.

More than a scrapbook, your heritage album will be a priceless family resource and one of the most rewarding projects you'll ever undertake.

1-55870-534-1, paperback, 128 pages

Unlock the precious stories and ancestral information hidden within the details of your family photos. In this illuminating guide, genealogical photo expert Maureen Taylor shows you how to gain this in-depth perspective on your family's special history, step by step. Using Taylor's proven methods of analysis and interpretation, you'll learn how to identify and verify the people in your photos, locate additional family photographs, confirm and validate your findings and expand your genealogical skills.

Your photos will reveal more about your genealogy than ever before. Take this guide and watch your ancestors' cherished images spring to life with detail and accuracy.

1-55870-527-9, paperback, 148 pages

Maureen Taylor provides all the basic information you need to care for your family photographs. She outlines in straightforward steps how to add value to your home collection by applying the concepts that conservators and photocurators use every day. You'll learn how to organize your photos, identify types of damage and select a restoration expert to repair each type. You'll also learn how to display your collection in a stunning scrapbook, electronic archive or family home page.

You'll also find special appendices for sources of family photographs, along with important addresses for conservators, magazines, suppliers, societies, organizations, restoration services, archival storage facilities, Web sites and more.

1-55870-579-1, paperback, 192 pages

Learn how to use social history-the study of "ordinary people's everyday lives"—to add depth, detail, and drama to your family's saga. Author Katherine Scott Sturdevant provides you with the instruction you need to accurately investigate your family's unique history, including their daily lives, family photographs, oral histories, home sources, and material folk culture. You'll also learn how to build and sharpen your research skills.

Each chapter is packed with examples, tips, charts, and checklists to help you get the results you want. You'll learn how the world helped shape your family— and how your family helped shape the world.

1-55870-510-4, paperback, 176 pages

The material in this compilation appeared in the following previously published Memory Makers and Betterway Books, and appears here by permission of the authors. (The initial page numbers given refer to pages in the original work; page numbers in parentheses refer to pages in this book.)

Braun, Bev Kirschner.	New Ideas for Crafting Heritage Albums © 2001.	Pages 1, 4-125, 128 (5-127)
Editors of Memory Makers.	Outstanding Scrapbook Pages © 2003.	Pages 1, 4-127 (129-251)
Editors of Memory Makers.	Sizzling Seasonal Scrapbook Pages © 2003	Pages 1, 3-95 (252-347)
Editors of Memory Makers.	Quick & Easy Scrapbook Pages © 2003	Pages 1, 4-127 (348-473)